L

LESSONS OF *R*OMANTICISM

❧ A CRITICAL COMPANION

Edited by Thomas Pfau and Robert F. Gleckner

DUKE UNIVERSITY PRESS DURHAM AND LONDON 1998

© 1998 Duke University Press
All rights reserved
Printed in the United States of America on acid-free paper ♾
Typeset in Scala by Tseng Information Systems, Inc.
Library of Congress Cataloging-in-Publication Data
appear on the last printed page of this book.

CONTENTS

ACKNOWLEDGMENTS

*T*he work assembled in this volume grew out of the 1994 conference on "The Political and Aesthetic Education of Romanticism" at Duke University, which the editors had the privilege of organizing. From the many stimulating and focused presentations at the conference come the essays now gathered here. Our principal debt thus is to all the participants who made the original conference such a productive experience, and to those among them who subsequently agreed to prepare more fully developed essays. The resulting volume has greatly benefited from the abiding interest and commitment of these contributors, who over three years of preparation continued to assist the editors by providing all kinds of information and responding in good humor to seemingly unending streams of correspondence. Thanks are also due to the very capable editorial and production staff of Duke University Press. In particular, we wish to express our gratitude to our project editor, Paula Dragosh, and to the manuscript's copyeditor, Estelle Silbermann, for their dedicated, meticulous, and ever cheerful attention to this project during its later stages.

T. P. and R. F. G.

LESSONS OF ROMANTICISM

Introduction. Reading beyond Redemption:

Historicism, Irony, and the Lessons of Romanticism

THOMAS PFAU

The historian is a prophet facing backwards.—Schlegel

Grounding is philosophizing. Thinking is poetry.
("Ergründen ist filosofieren. Erdenken ist Dichten.)—Novalis

Among the motifs of cultural criticism one of the most long-established and central is
that of the lie: that culture creates the illusion of a society worthy of man which does not
exist; that it conceals the material conditions upon which all human works rise, and that,
comforting and lulling, it serves to keep alive the bad economic determination of existence.
This is the notion of culture as ideology, which appears at first sight common to both the
bourgeois doctrine of violence and its adversary, both to Nietzsche and Marx. But precisely
this notion, like all expostulation about lies, has a suspicious tendency to become itself ide-
ology. . . . To identify culture solely with lies is more fateful than ever, now that the former
is really becoming totally absorbed by the latter, and eagerly invites such identification in
order to compromise every opposing thought.—T. Adorno, *Minima Moralia*

*M*ost intellectuals (particularly those reckless enough to
have ventured into the professional minefield of editing
a collection of highly diverse critical voices) will probably
agree that the subject of Romanticism tends to give rise to complex ques-
tions, even strong convictions, yet offers few conclusive answers. Mystified
by this state of affairs some seventy years ago, Arthur Lovejoy was already
prepared to abandon all hope for an objective definition of Romanticism.
After sketching out the term's complex genealogy and pathology within
the history of ideas, Lovejoy proposed the remedy of an investigation that
would render "psychologically intelligible how such manifold and discrep-
ant phenomena" as are customarily associated with the Romantic period
"have all come to receive one name." To do so, he suggested, would entail
a patient sifting through the seemingly inexhaustible "verbal confusions"
of the concept of Romanticism and its unlimited capacity to corrupt "the

movement of thought in the past century." In short, the study of such confusions "might make it easier to avoid them" (Lovejoy 8). To be sure, Lovejoy's intellectual manifesto is likely to elicit a skeptical, even incredulous response in today's highly professionalized academic disciplines and subdisciplines, whose theoretical and methodological sophistication and self-awareness might make Lovejoy's Enlightenment positivism appear to be rather naive. Yet Lovejoy's own argument soon anticipates that skepticism, for only a few lines after outlining his ambitious program for a recovery of Romanticism as a meaningful term, he appears to sacrifice the entire project to what, at first glance anyway, seems a lexical pseudosolution promising little more than an infinite regress: "Any study of the subject should begin with a recognition of a *prima-facie* plurality of Romanticisms, of possibly quite distinct thought-complexes"; and, taking almost cruel pleasure in confounding the very expectations for a clear definition that he himself had raised only moments before, Lovejoy further insists that even "when certain of these Romanticisms have in truth significant elements in common, they are not necessarily the same elements in any two cases" (9). From here on, it is all downhill until, in the last paragraph of his essay, Lovejoy succinctly describes Romanticism, particularly in its German incarnation, as having brought forth, "from a single root, both an 'apotheosis of the future' and a tendency to retrospection" (22).

In light of the negative evidence amassed by Lovejoy, it would follow that (historical) knowledge, whether it has been produced by the modern historian of ideas or his Romantic predecessor in the field of poetic retrospection, is always pseudoknowledge. It is, in fact, coeval with a utopian (and originally Romantic) apotheosis with which, we are told, it shares "a single root." In order to articulate the purpose of a critical anthology dedicated to Romanticism and Pedagogy, it may be important to further trace what Lovejoy here so dimly and wearily hints at: the idea of a quasi-conspiratorial dialectic between the various academic disciplines and subdisciplines of historical retrospection and the utopian or eschatological motivation realized by such academic pursuits, as it were "in a finer tone." Precisely this ambivalent mission—of "objective" comprehension and a submerged (subjective) interest in the redemption of that object by the very activity of its sociohistorical or stylistic comprehension—has given rise to, refined, *and* institutionalized two seemingly opposed paradigms of reading. Somewhat elliptically, the first of these may be characterized as the practice of a strictly text-immanent reading. It produces knowledge in the guise of a spontaneous, unpremeditated, and irrefutable revelation and, according to a tradition reinforced from Coleridge's *Statesman's Manual* (1816) to T. S. Eliot's late writings on Christianity and culture, such reading takes the crypto-Anglican, New Critical form of a hermetic exegesis of texts. Both at

a technical and institutional level, this paradigm of reading reinforces its own, constitutive premise: that of the literary artifact as a simulacrum of "life" itself, something organic, inviolable, and sacred. The first prominent dissenter from the New Critical paradigm, Northrop Frye, thus speaks of an empathetic or "pre-critical" mode of reading aimed at the reader's progressive identification with the literary work by submitting to the holistic effect of its discrete rhetorical functions. Under this dispensation, what is called "comprehension" coincides ultimately with the reader's belated self-recognition as a construct or effect of the literary text's operations:

> [T]he end of reading or listening is the beginning of critical understanding, and nothing that we call criticism can begin until the whole of what it is striving to comprehend has been presented to it. Participation in the continuity of the narrative leads to the discovery or recognition of the theme, which *is* the narrative seen as total design. This theme is what, as we say, the story as been all about, the point of telling it. What we reach at the end of participation becomes the center of our critical attention. (Frye 123)

Predictably, this paradigm of reading as the affective emulation of a text's organic rhetorical design—appropriately named "The Road of Excess" (this being the Blakean title of Frye's well-known essay)—would sooner or later be perceived as begging the question of comprehension by drawing our attention to the apparently dialectical relationship between object and method in criticism. While few readers today would suppose that a definition of Romanticism as the object of our cognitive pursuits could be established before the actual work of criticism begins, the alternative hypothesis—namely, that any understanding of the period is contingent on the specific critical methodology at work—proves more of a truism than a resolution. Still, that alternative, perhaps best exemplified by Romantic Historicism, has for nearly two decades articulated most authoritatively the postmodern discontent with the New Criticism's preemptive faith in the scriptural strength of the poetic word. To this aesthetic conception of the poetic text as a type of secular Scripture—one whose prosodic and narrative balance was meant to fortify supposedly "fallen" audiences against the impingements of their dis/harmonious world—the New Historicism has responded with ambitious, counter-intuitive narratives. Indeed, for some time now, a comprehensive historicist critique of the Romantic ideology has been unfolding with (counter)conspiratorial intensity, arguing in so many ways that the period's subtle, figural idioms were fundamentally aimed at *aestheticizing* the period's political, gendered, and economic antagonisms, thereby effectively preempting any possible consciousness *of* those antagonisms.

Before turning to the analysis of some of the theoretical contradictions intrinsic to the project of historicism (old and new), a few remarks, more speculative in kind, are in order about the wide spectrum of interpretive functions covered by narrative form, beginning in early Romanticism yet extending all the way to contemporary criticism. What I propose is to tease out how a logic endemic to some philosophical, gothic, and prophetic narratives in early Romanticism turns out to be replicated in today's accounts of historicist and materialist criticism as they purport to circumscribe for us the overall intelligibility of that period. Naturally, such an undertaking rests on hypotheses of its own, and the principal one can be formulated thus: The narratives of early Romanticism and the postmodern critique of its ideological efficacy are grounded in the same epistemological paradigm, that of forms conspiring against their belated discernment, and they perpetrate the same moral utopia, that of an absolute evaluation of the other performed from a putatively value-free and clairvoyant position. In short, the fantasized authority of "writing under the guise of reading, which is to say, believing under the guise of doubt" (Mileur 10)—the dream of belated clairvoyance that I will shortly trace in Blake, Godwin, and Kant—continues to be reproduced, however unwittingly, by the languages of contemporary criticism. The basic features of that mostly negative (and almost entirely nonironic) fantasy may be reiterated as follows:

1. As in any conspiracy, its critic (or analyst) disavows responsibility for its existence; that is, from the vantage point of those occupied with its critical articulation, a conspiracy is by definition always "elsewhere," specifically in the past. Such a premise effectively revives the New Criticism's faith in a formal-rhetorical analysis untainted by any methodological or material presuppositions. Behind the figure of conspiracy, then, stands the dream of criticism as a form of revelation, a mode of producing knowledge indemnified from all charges of methodological complicity in the construction and articulation of its objects.

2. There also exist conspiracies of a nonintentional kind, perhaps best known through Freud's account of the preemptive, counter-transferential strikes launched by the unconscious against its impending, critical (dis)articulation. In such a case, the absence of intentionality—and its eventual reconstruction (as the agency of the unconscious) through the work of analysis—renders a conspiracy "subjectless" or transindividual. According to that model, it is precisely the incompleteness or dysfunctionality of an individual or a community that furnishes the symptom that will, in due course, produce its belated analysis. The alleged muting of an authentic historical understanding by the specious eloquence of aesthetic forms (among other ideological mechanisms)—arguably the pivotal axiom

of contemporary historicism—exhibits striking parallels with psychoanalytic accounts of trauma as a conspiracy not merely located in the past but defining that past as having preemptively conspired against its critical articulation in the present.

3. In order to defend against (and thus overcome) the traumatic resistance of the past to its critical articulation, the present devises complex, counter-intuitive methods of reading ("against the grain"). Method and disciplinarity thus enact postmodernity's longing for salvation in specialized discursive forms and forums. However, in their almost exactly inverse reconstitution of those ideological obfuscations ascribed to the past, our critical methods of reading also tend to display a distrustful, even paranoid quality. Even so, such an aggressively counter-intuitive, and avowedly counter-conspiratorial, quality is commonly hailed as confirmation of the enlightened, postideological potential of our critical present, and as evidence of great disciplinary prowess in our historical moment.

4. Finally, this project of a critical reconstruction and overcoming of what has been called Romanticism's aesthetic ideology—the trauma preventing a historical configuration from achieving a more valid (i.e., more reflexive) sense of its own historicity—also reinforces the authority of its practitioners. For it allows us to glimpse, as it were, "in progress," the methodological and conceptual agonies of the historicist critic martyred by the opacity of that aesthetic tradition. After all, it takes a heroic effort to reclaim the past by sustaining critical dissent from the symptomatic aesthetic surfaces deemed to have "conspired" so lastingly against a more authentic understanding of that past.[1]

My (slightly facetious) catalog aims to highlight a paradox already noted by others, namely, that recent historicism and cultural criticism frequently premise their institutional and methodological authority on an obliquely moral charge against their aesthetic objects (be they texts and their writers, or other artifacts, their producers and consumers): to be what they properly *ought* to have been, past representations should have given the type of account now furnished by historicism itself. Before we can hope to conceptualize Romanticism with any specificity, it seems imperative for us to demarcate that concept's conspiratorial potential with some precision: Is it strictly confined to the historical moment of its aesthetic output, or is it the coefficient of postmodernity's critical commitment to "identify[ing] and interrogat[ing] the . . . representational choices" (Levinson, *Rethinking Historicism* 18) of Romantic writing itself? So formulated, the methodological and disciplinary questions raised by Romanticism begin to coalesce with those concerning the implicit cognitive limits and eschatological motives of its historicist conceptualization today. As we shall see, these conceptual

preliminaries will ultimately prompt us to rethink comprehensively the relationship between Romanticism and Pedagogy, the issue so centrally explored in this collection of essays.

In the view of the historicist tradition originating in Spinoza, and extending via Herder, Ernesti, Hegel, Schleiermacher, Dilthey, and Gadamer to the New Historicism of today, it is no longer plausible to approach texts as autonomous and expressive embodiments of determinate intentions. Rather, texts ought to be understood as modular forms necessarily embedded and operative within (and at least partially determined by) a twofold grid of coordinates: the diachrony of what Hans-Georg Gadamer had elaborated so magisterially as a transindividual "process of tradition" (*Überlieferungsgeschehen*), which, in turn, can be partitioned into an infinite number of synchronic relations (e.g., Hirsch's notion of contextualism). These two, largely complementary forms of historicism can ultimately be traced back to Hegel's conception of philosophy as a sustained reflection on the phases of historical time that will result in our becoming conscious of the very rationality that guided both the historical process *and* its narrative reflection. Hegel's system, that is, conceives of all individual meaning (*Meinung*), along with the formal-aesthetic particulars of its appearance, as beckoning the philosophical master-narrative to redeem it from its vagrant and contingent existence within the flux of time. The "critical" intelligibility of the local, the particular, and the contingent involves its transformation from a merely incidental meaning into a functional component of the macrohistorical process that is being reflexively articulated in the philosophical present. In order to uncover its immanent, critical truth, then, all local or individual expression (*Äusserung*) must undergo a partial alienation (*Entäusserung*) from itself. This totalization of historical process first conceived in the idealist figure of *Reflexion*—yet covering the entire political spectrum from Hegel to Ranke, and from Marx to Lukacs and (as some have argued) Jameson and Althusser[2]—institutes and empowers criticism as the profession of a specific metalanguage. Perhaps, as Theodor Adorno has suggested, it is on account of its intrinsic fatigue—or a "bourgeois coldness that all too eagerly endorses the inevitable" (90)— that the past appears so eager to surrender its aesthetic forms and contingent beliefs to an account whose professed universal, value-free logic will spare them the indignity of any further struggle with competing forms and beliefs.[3] Notwithstanding their otherwise discordant claims and emphases, the grand historical narratives of speculative, positivist, and materialist thought associated with the names of Hegel, Ranke, and Marx all share a deeply instrumentalist understanding of historical criticism, be it on behalf of a nation in the process of reconstituting itself (Hegel's and Ranke's Germany after 1815 and 1871, respectively) or by breaking epistemological

and political ground for a (socialist) community conceivable only as the emancipation from the contradictions of that dominant bourgeois society and its official historiographers. Truly *avant la lettre,* Friedrich Schlegel already perceived a new intellectual and potentially institutional strategem of nation building to be on the rise, and he responded to it with his characteristic blend of impatience, distrust, and witty irreverence: "The two main principles of the so-called historical criticism are the Postulate of Vulgarity and the Axiom of the Average. The Postulate of Vulgarity: everything great, good, and beautiful is improbable because it is extraordinary and, at the very least, suspicious. The Axiom of the Average: as we and our surroundings are, so must it have been always and everywhere, because that, after all, is so very natural" (*Philosophical Fragments* 3, no. 25).

By now, of course, grand philosophical narratives appear not only highly unpopular but, for some time, have been subjected to intense theoretical scrutiny. Hegel's reflexive sublation of intentionalism into a history of freedom has been displaced by a seemingly incompatible model of historicism, at once suspicious of the old historicism's epistemology and strenuously dissenting from its implicit (Protestant bourgeois) morality. From this postmodern perspective, the objectivist assumptions of traditional *Historismus* are just as untenable as the objectivization of the aesthetic perpetrated by the New Critics' scrupulous textualism or the affective complicity in the literary work exhibited in the phenomenological studies of Roman Ingarden, Lucien Goldman, Georges Poulet, or the early Geoffrey Hartman. As an alternative, then, the recent development of Romantic Historicism views any criticism premised on the autonomy of aesthetic form, the writing subject, or grand historical narratives as unconsciously indulging (or consciously participating) in a far-flung intellectual and material conspiracy: that of occluding the political and economic significations transmitted by the text and, furthermore, maintaining an order presumed to be morally and materially inequitable, if not outright oppressive.[4] Thus the New Criticism's interpretive covenant between text and critic is essentially dismissed as obfuscating the critic's alleged failure to detect and respond to the oblique social determinacy of the aesthetic in general, and the encrypted referentiality of Romantic writing in particular. While opposing the New Critical paradigm of reading as a formal technique designed to recuperate eschatological structures in vernacular and prosodic forms—thereby contributing, in T.S. Eliot's formulation, to "the organization of values and [the] direction of religious thought" (4)—contemporary New Historicism appears energized by utopian hopes of equal intensity. Characterized in transparently Hegelian terms as "the completed form of criticism" (McGann 56), this approach produces knowledge in the form of two closely intertwined (liberal) utopias: that of a steadily

advancing and eventually all-encompassing, "deeply interpretive" contextualism, and the fantasy of retroactively liberating the aesthetic object from the "visible darkness" (to use Marjorie Levinson's allusive phrase) of its own referential obfuscations.[5] Predicated on a set of heavily revised Marxist and psychoanalytic concepts, historicism has reconceived literature as an intuitive or unconscious knowledge that, being untranslatable into direct propositional form, came to be encrypted in aesthetic forms specifically available at its historical moment, as for example the affective concision of the shorter lyric or the inwardness ventriloquized in the "mazy motion" of Romantic autobiographical narrative.

Central to the historicist project is its own, narrative unfolding of a dialectic between the critic operating "as [a] privileged, essential subject" (Levinson, *Rethinking Historicism* 30) and the text, now gradually unraveled as containing its own (unconscious) other, one said to have been silenced by the self-privileging eloquence of the aesthetic. In opposing the volubility of its own critical narrative against the referential autism of the period's aesthetic, Romantic Historicism has effectively sought to rewrite and change—not the future but the past, a past allegedly forestalled by the (unconscious) conspiracy of its formal-aesthetic values and practices. For Marjorie Levinson such a "self-consciously belated" (*Wordsworth's Great Period Poems* 12) critical practice mobilizes "our consciousness to *cure* the past of its objectivity: in effect, its pastness." Thus the "origin coalesces as a structure, one which is really, suddenly, there in the past, but only by the retroactive practice of the present" (*Rethinking Historicism* 28, 23). It is not entirely clear whether we are to read Levinson's account as a bizarre and overdetermined endorsement or as a reductio ad absurdum, a sly critique of the historicist's unabashedly self-privileging view of the present—one "edified but not *changed* by its scholarly operations" (*Rethinking Historicism* 29; emphasis in original).[6]

We are thus faced with a paradoxical, indeed uncanny, resemblance between the Hegelian and the New Historicist notion of totality. Where Hegel's narrative affirms the power of the idea (and thereby, indirectly, its own narrative authority), the New Historicist inescapably traces all heterogeneous matter back to an equally monolithic idea of power. Like Hegel's "cunning of reason," the postmodern idea of power as a nonintentional yet ubiquitous (or structural) effectivity, appears implacable, even revolutionary (like Marx's famous definition of Capital) in its assimilation of all heterogeneous and discordant matter. Yet where the rule of the Hegelian idea was still credited with legitimacy—though less in a moral or ethical sense than on account of its logical exclusivity—the postmodern historicization of the Real conceives of power almost entirely as a malevolent, conspiratorial dynamic.[7] The speculative movement of Hegel's historiogra-

phy of reason—the narrative self-realization of the idea of freedom—thus contrasts with New Historicism's static account of the essential impossibility or illusory nature of freedom. Nonetheless, the end result of these two paradigms remains virtually identical: that is, Hegel's oppressively holistic narrative of the becoming of freedom is effectively inverted by postmodernity's specious liberation of the individual through the knowledge of its inescapable extrinsic determinacy.[8] In each case, the operation of criticism (*Reflexion*) unfolds in an insistently counter-intuitive manner, namely, as the present subject's attempt at recovering from the past by sublating all detail, be it incomplete or oppressive, into the order of discourse and knowledge. Criticism emerges as the postmodern idea of practice, a strictly virtual pursuit aimed at the retroactive liberation, or salvation, of the past from its inauthentic symbolic order. In the end, historicism appears caught up in one of two versions of epistemological redundancy: the first of these conceives critical knowledge as the belated discovery of an independent developmental logic, one brought to completion by the unconscious rationality of historical process; the second version, inversely, denies all notions of process and, positing in its stead the continuous displacements and deceptions of power, ends up with the negative knowledge of the critic's irremediable abjection. It may say a lot, not only about the institutions and practices of historicism but also about Western culture's intuitive sense of history for the past two hundred years or so, that its critical representations designed to render the past comprehensible are continually predicated on an *extreme* form of affect, be it one of euphoria or despondency.

My assessment of historicism as a deeply conflicted intellectual project also raises several spiritual and ethical questions, and I will shortly consider them in more explicit form. First, however, we may have to pursue a little further the curious epistemological filiations between the allegedly false, erroneous, or partial (because expressive and aesthetic) phenomenal order known as the past and the intellectual countermeasures formalized and institutionalized in the present under the generic name of "critique." The recuperative interest in past phenomena—shared by Hegelian and Foucauldian thought, however different the valences attached to the resulting knowledge—is perhaps best thrown into relief by Walter Benjamin's brilliant reflections on historicism as a phantasmagorical interplay between danger and redemption. In his sixth thesis on the concept of history, Benjamin argues that "to articulate the past . . . means to seize hold of a memory as it flashes up at a moment of danger. . . . Th[at] danger affects both the content of the tradition and its receivers. The same threat hangs over both: that of becoming a tool of the ruling classes. In every era the attempt must be made anew to wrest tradition away from a conformism

that is about to overpower it" (*Illuminations* 255). And yet, insofar as the historicist's "image of happiness is indissolubly bound up with the image of redemption," historicism's moment of analytic mastery proves unstable. For precisely that past, Benjamin now argues, had already "carrie[d within itself the] temporal index by which it is referred to redemption. There is *a secret agreement* between past generations and the present one. Our coming was expected on earth. Like every generation that preceded us, we have a *weak* Messianic power, a power to which the past has a claim" (*Illuminations* 254; italics mine). "Critique" thus emerges as a moment of interference between an intuitive commitment to action and an encroaching consciousness of one's epistemological abjection, because, in Geoffrey Hartman's words, "the field of action . . . includes the past: its relation to the crisis at hand." Thus perplexed, "criticism approaches the form of fragment, pensée, or parable: it both soars and stutters as it creates the new text that rises up, prankishly, against a prior text that will surely repossess it" (75, 82).

Benjamin's idea of an unconscious compact between the formal and material sedimentations of the past, and the critical narratives of the present seeking to redeem both that past from its aesthetic involutions and the critic's present from entrapment by the aura of such a past, constitutes among other things a cautious reformulation of Kant's most ambitious philosophical hypothesis: that of an all-encompassing teleological configuration of our faculties of cognition with their so-called objects. As Kant argues in some detail in his Introduction to the *Critique of Judgment,* our reflexive apprehension of that teleological bond gives rise to the aesthetic universality of pleasure (*Lust*) associated with what Kant calls "knowledge in general" (*Erkenntnis überhaupt*), a pleasure merely exemplified in our "aesthetic judgment" on the beautiful but, in fact, constitutive of all cognitive practice. Kant's overarching hypothesis of an inherently unprovable, quasi-conspiratorial agreement (*Übereinstimmung*) between the dynamic form of human knowledge and the (supposedly) immutable form of its objects reverberates in Benjamin's reflections. And yet, while illuminating the redemptive motives undergirding a historical critique premised on an inscrutable "secret agreement" between the present and the past, Benjamin also hastens to remind us of the modern critic's "*weak* Messianic power," a power less conferred by the past than purloined from it. The uneasy relationship between the "Theses on the Concept of History" and the more affirmative, even strident programs of New Historicist and Materialist critique is the result of Benjamin's profound sense of despair over any instrumentalist and totalizing model of cognition. At its most cautious, then, historicist practice can be understood as the postmodern academic expression of a simultaneously nostalgic *and* utopian yearning or, in Benjamin's vocabulary, as vicariously manifesting the deep-seated

"messianic" longing for a cognitive equilibrium between the past and the present that identifies the critic "inextricably [as] a figure of pathos *and* aesthetic play" (Hartman 84). By contrast, in its more systematic (Hegelian) incarnation as a retroactive mastery or sublation (*Aufhebung*) of the past as the inadvertent prefiguration of present clairvoyance, the project of historical cognition betrays "our fascination with technique, with neat solutions and totalitarian harmonies" (Hartman 83). There is ample reason, then, not to hail our postmodern, scrupulously reflexive models of ideological critique as insuring a rational, conclusive, and guaranteed overcoming of the representational surfaces customarily assembled under the heading of a "romantic aesthetic ideology." In fact, what renders this antithesis between aesthetic surfaces, said to have lured Romanticism's historical subjects into a consumptive suspension of disbelief, and the methodological acuity of contemporary historicism offering salvation to a past allegedly ensnared by its own "prolific" imaginary ultimately insupportable is the startling fact that the same opposition turns out to be a constitutive feature on Romantic narratives. That is, the oppositional model at issue loses its critical force once we examine how philosophical, fictional, and prophetic narratives of early Romanticism are predicated on precisely those conspiratorial, redemptive forms of intellectual production subsequently mobilized as a means of overcoming the period's "aesthetic ideology."[9] Three short examples may help clarify the point.

My first case in point involves the ambiguous temporal logic prevailing in Blake's early prophecies, books whose commitment to illumination is informed by the alleged spiritual and political oppression said to have issued from Albion's past and by the writer's hope for a retroactive "correction" or "redemption" of that past from the "ninefold darkness" of priestcraft, tyranny, and reason. Recent historicist work has drawn our attention to the often inextricable lines of division between the eschatological beliefs of London's millenarian, mostly artisan communities during the 1780s and 1790s and the fervent rationalisms of intellectuals like Paine, Priestley, Thelwall, Spence, or Godwin.[10] Blake's *Book of Urizen* frames this antagonism as one between faith and law, between the radical antinomian "energy" of the present and the oppressive traditionalism of the state and state religion, as well as the implacable rationalism perceived to have dominated the opposition to these institutions. Such ideological tensions ultimately converge in the rhetorical tension between prophetic "words articulate, bursting in thunders" and "the Book / Of eternal brass, written in . . . solitude" (plate 4a, lines 4, 32–33). Consequently, Blake's early prophetic books offer themselves as the contrary of these oppositions by

continually shifting back and forth between implementing belief as an unconditional intuition and critically reflecting on a past now understood to have significantly shaped the emergence of *all* beliefs. Blake's Lambeth books predict no plausible or fantasized future, nor do they aim to recover some empirical past. Instead, their mesmerizing visual and rhetorical patterns urge readers to "illuminate" (or "retroactivate") a past that has not yet been lived and experienced precisely because it was occluded from vision by the dullness of empirical memory and repressed sensuality. Much like contemporary critiques of ideology, that is, Blakean prophecy seeks not to predict a determinate future but to respond to the false determinacy of the past. Put differently, it seems intent on recovering an as yet unrealized, imaginative past from the one that had usurped its place and that had gradually reproduced itself through the oppressive psycho-political institutions of memory, morality, and state-sponsored art. Blake's *Book of Urizen* gives vivid expression to this conflict in the recurrent motif of division (see fig. 1), including Urizen's fragmentation of eternity into history ("dividing / The horrible night into watches" [plate 9, lines 9–10]) and Los's agonized recollection of eternity ("White as the snow on the mountains cold") now rapidly consumed by general "Forgetfulness, dumbness, necessity!" (plate 10, lines 23–24). Exaggerating Urizen's instinctual fear of the "myriads of Eternity" contained in everything particular, Blake rewrites received myths of creation and rationalist theories of progress in precise accordance with the defensive and pathologizing attitude toward the body that these accounts had once inaugurated. Sensual, embodied humanity can now be remembered only a fortiori, that is, as the physiological torment of birth and aging, with Blake's text here recalling the skeletal figure of plate 7 (fig. 2):

> A vast Spine writh'd in torment
> Upon the winds; shooting pain'd
> Ribs, like a bending cavern
> And bones of solidness, froze
> Over all his nerves of joy.
> And a first Age passed over,
> And a state of dismal woe.
> (Copy D, plate 9, lines 37–43)

To the prophetic voice of Blake's *Book of Urizen,* the past always begs to be redeemed from the mythic involutions of its own unconscious. And yet, to attempt such a redemption is to repeat the very Urizenic project of dominating eternity that, the prophet's voice tells us, had produced the aesthetic and political horrors of our empirical history to begin with. This paradox manifests itself formally in Blake's nonperspectival portrayal of iconic figures gazing into the void of historical time and becoming conscious of the

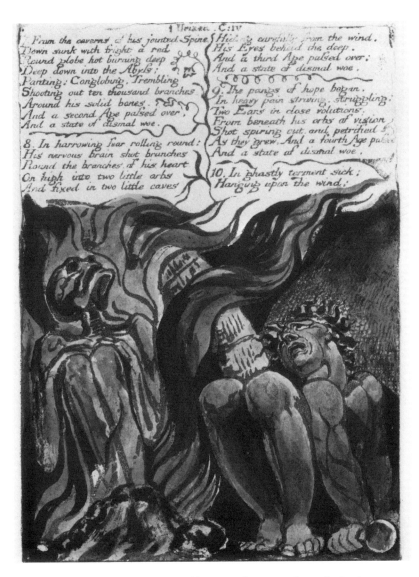

Figure 1. "From the caverns of his jointed Spine" (*The Book of Urizen*, Plate 9, Copy B, Pierpont Morgan Library, New York, PML 63139).

past's ineffable monstrosity. Furthermore, the pivotal division of eternity into two distinct states, embodied by Los and Urizen, also casts doubt on the ultimate desirability of historical knowledge. For the intellectual capital of such knowledge would almost certainly lead to the resurgence of a (Urizenic) unconscious within ourselves, implacably conspiring against the infinity and integrity of our spiritual intuitions. Given our inescapable

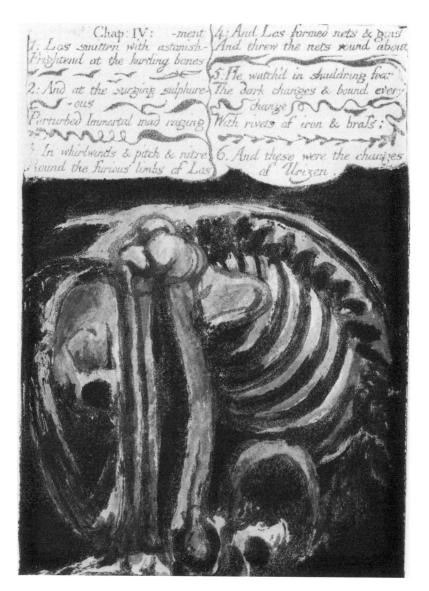

Figure 2. "Los smitten with astonishment" (*The Book of Urizen*,
Plate 7, Copy B, Pierpont Morgan Library, New York, PML 63139).

implication in the Urizenic terror unfolding from the past and still "surg-
ing sulphureous / Perturbed Immortal mad raging" (plate 7, lines 4–5;
fig. 2), the utopian overcoming of history through its completion as critical
knowledge is no longer possible.

And yet, even in a world, like Hamlet's, where the pale cast of thought

has seemingly corroded the individual's native hue of resolution, all is not lost; for Blake's idea of the book is itself an attempt to mobilize what Walter Benjamin was to call our *"weak Messianic power,"* that is, the materially and spiritually vivid illumination of a catastrophic history that, *from its very beginning and by virtue of that beginning,* has compromised all means for our recovery from it. To grasp that inescapable "nexus of guilt among the living" (*der Schuldzusammenhang von Lebendigem*) (*Selected Writings* 307)— a phrase defining what Benjamin understood as myth and what we may call ideology—is to contemplate, actively and imaginatively, a past of which we, our curiosity, and our expressive capabilities are all joint (and irremediably corrupt) effects; plate 14 of Blake's *Book of Urizen* dramatizes that moment:

> Thus the eternal prophet was divided
> Before the death image of Urizen
> For in changeable clouds and darkness
> In a winterly night beneath
> The Abyss of Los stretch'd immense
> And now seen now obscured to the eyes
> Of Eternals the visions remote
> Of the dark separation appear'd.
> As glasses discover Worlds
> In the endless Abyss of space
> So the expanding eyes of Immortals
> Beheld the dark visions of Los,
> And the globe of life trembling
> (Copy D, plate 14; fig. 3)

Most vividly, plate 6 depicts Los, "Groaning! gnashing! groaning!" over his own "wrenching apart" (fig. 4)—defeating his arms' desperate attempt at preserving his bodily integrity—the primordial crisis (Gr. *krinein* = division) already imaged so luminously on plate 7 (fig. 2). It is the vivid illumination of a mind traumatically divided ("rifted with direful changes") between the vivid, and often oppressive, experience of its historical existence—a quasi-Burkean past choked with the implacable moral law of tradition—and the anxious, if doomed, quest for techniques capable of rendering that past existence intelligible and thereby ensuring our survival. Appropriately enough, the plate's iconic force—reminiscent of nonperspectival medieval representations—grows out of the violent contrast between the "depthless" *Gestalt* of Los trapped "in dreamless night" and his gaze of catastrophic expectation (reinforced by the toothless, seemingly disfigured mouth). Specifically, his eyes show Los craving nothing so much as perspective and distance on "formless unmeasurable death." Blake's figure, which utterly dominates the plate, strikingly anticipates

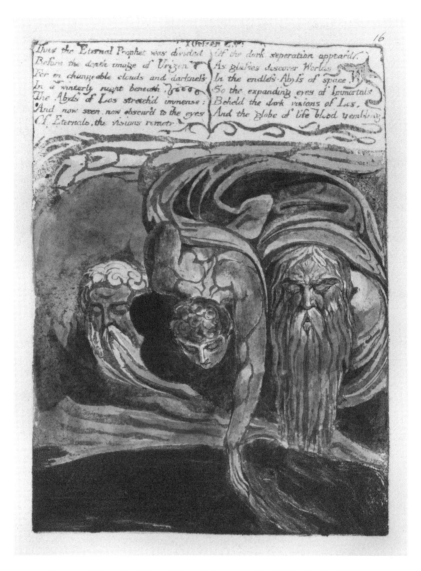

Figure 3. "Thus the Eternal Prophet was divided" (*The Book of Urizen*, Plate 14, Copy B, Pierpont Morgan Library, New York, PML 63139).

Walter Benjamin's account of Paul Klee's *Angelus Novus,* the "angel of history": "His eyes are staring, his mouth is open[.] . . . His face is turned toward the past. Where we perceive a chain of events, he sees one single catastrophe which keeps piling wreckage upon wreckage and hurls it in front of his feet. The angel would like to stay, awaken the dead, and make whole what has been smashed. But a storm . . . irresistibly propels him into

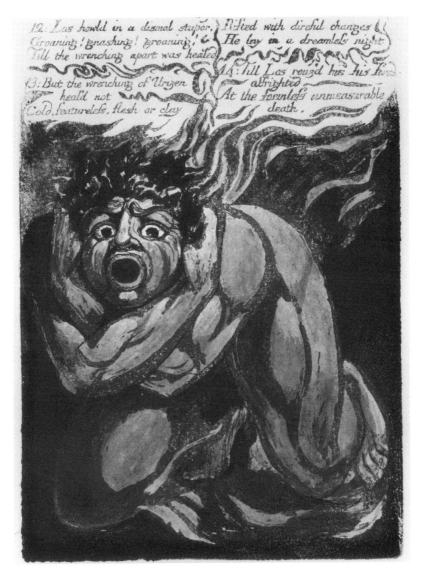

Figure 4. "Los howld in dismal stupor" (*The Book of Urizen*,
Plate 6, Copy B, Pierpont Morgan Library, New York, PML 63139).

the future to which his back is turned, while the pile of debris before him
grows skyward. This storm is what we call progress" (*Illuminations* 258). In
Blake, as in Benjamin, the image is itself the most vivid and forceful articu-
lation of perspective as a moment of conflict or interference: that between
a fantasized, authoritative, and conclusive mode of historical cognition and
the abject intuition that any intellectual promise of epistemological self-

sufficiency inevitably resurrects the nefarious (Urizenic) forces of history from which it was purported to redeem us. The images of Blake, in other words, are anticlassical and, in the best sense of the word, postmodern, for they articulate a purposely oblique (depthless) pathos. That is, they no longer conceive pathos as the timeless verity of a self transfigured in the semblance (*Schein*) of the aesthetic; instead, they "illuminate" pathos as the moment of catastrophic recognition that no mere image (or concept, or critical narrative) will *ever* reconstitute the spiritual and cognitive equilibrium whose loss they themselves dramatize with such intensity. Analogously, Benjamin's ninth thesis—itself but "the written space of a contradiction"—offers a fleeting glimpse of history as the source of a wholly new kind of pathos, the suffering of a subject "who is denied the image as a place of repose or as an icon blasted out of the past" (Hartman 77, 78).

My second example of the curious affinity between Romantic fictional and disciplinary constructs and what Paul Smith has analyzed as a "kind of 'meta-paranoia' [underlying the] humanist practice" (97) of contemporary historicism involves Godwin's *Caleb Williams* (1794). Believing himself persecuted by Falkland's "eye of Omniscience," whose unrelenting gaze Caleb's invasive behavior had so artfully courted, Caleb concedes that "my sensations [in London] at certain periods amounted to insanity" (316). The novel's original ending heightens our sense of the plot's undecidability by observing how Falkland's fetishistic attachment to "his reputation" as something to remain "for ever inviolate" curiously "harmonized with the madness of my soul" (339). Precisely this paranoid lucidity prompts Caleb—terminally imprisoned both by material walls and by his own, unconfessed compulsions—to embark on writing the very story of his life now available to us as *Caleb Williams,* the novel. Drawing sustenance to the very end from the negative fantasy of his unending persecution and impending destruction, Caleb notes: "I feel now a benumbing heaviness, that I conceive to have something in it more than natural. I have tried again and again to shake it off. I can scarcely hold my pen. Surely—surely there is no foul play in all this. My mind misgives me. I will send away these papers, while I am yet able to do so" (345). Thus Caleb winds up his account by reinforcing once more the very conspiratorial affect that we encounter in the book's familiar opening paragraph: "My life has for several years been a theatre of calamity. I have been a mark for the vigilance of tyranny" (5). And if Caleb the protagonist concludes his tale of woe by furnishing Caleb the narrator with his conspiratorial hypothesis, the latter's first-person voice in turn reproduces a self-confirming logic plotted (once again in

advance) by the author himself. Thus Caleb's opening, subtly equivocal assurance that "my story will, at least, *appear* to have that consistency which is seldom attendant but upon truth" (5) echoes Godwin's 1832 account of the composition of *Caleb Williams:* "I felt that I had great advantage in . . . carrying back my invention from the ultimate conclusion to the first commencement of the train of adventures upon which I proposed to employ my pen. An entire unity of plot would be the infallible result; and the unity of spirit and interest in a tale truly considered, gives it a powerful hold on the reader, which can scarcely be generated with equal success in any other way" (349–50). Writing one's own story thus amounts to a compulsive and hermetic game of *fort/da,* an elaborate attempt at reasserting symbolic governance over a reality intuitively grasped as utterly inchoate and in need of symbolic condensation. The novel's tightly wrought plot achieves that control by neatly balancing the negative romance of Caleb's persecution of, and eventually by, Falkland against Caleb's (and Godwin's) narrative enthrallment of his readership. Just as Caleb's decision to set himself "as a watch upon my patron" induces in him "a new state of mind"—"watchful, inquisitive, suspicious, full of a thousand conjectures as to the meaning of the most indifferent actions" (112–13, 128)—so Godwin's authorial conduct of "employing my metaphysical dissecting knife in tracing and laying bare the involutions of motive" of his subjects caused him to feel "in a high state of excitement" during the composition of his book (351, 350). In a deceptively straightforward manner, the novel thus develops Caleb's professed innocence and Falkland's alleged corruption as two mutually discrediting metonymic series, the one compulsive and the other premeditated. Such a design effectively baits the reader's analytic proclivities by hinting regularly at the symptomatic quality of either protagonist's behavior. The conspiracy at issue, then, is not contained *in* the text but perpetrated *by* it; for no matter how thorough our interpretive industry, the vigilant logic undergirding *Caleb Williams* will ultimately defy all closure precisely because it had baited the analytic industry meant to produce such closure in the first place. To that end, the novel repeatedly "plants" evidence in the form of countless "mysterious fatalities" and "instantaneous impulse[s]" of character and circumstance, details designed to instill in the reader an (illusory) consciousness of analytic mastery that will eventually be dismantled by the book's political and psychological developments. Recalling, nearly forty years later, his excited state of mind during the composition of *Caleb Williams,* Godwin tells us how he had resolved to "write a tale, that shall constitute an epoch in the mind of the reader, that no one, after he has read it, shall ever be exactly the same man that he was before" (350).

That same, utterly transformative ambition harbored and so defiantly asserted by Godwin and Blake also undergirds Kant's *Critique of Pure Reason*, the last example to be considered here. Again, the stated goal (and the intellectual hypothesis) of the narrative is that it, the text, will constrain the audience to reconceive its cognitive relationship to phenomena ostensibly external to the subject. Kant thus opens his argument not with an outright rejection of the concept of experience but with the curious hypothetical statement that "experiential knowledge might quite possibly be already something composite (*ein Zusammengesetztes*) of what we receive by way of intuition and of what is spontaneously furnished by our cognitive faculties (*Erkenntnisvermögen*), an additive (*Zusatz*) that we cannot distinguish from the basic matter [of experiential data] until extended practice has drawn our attention to this circumstance and has schooled us to make discriminations in this manner" (1787 version B: 1–2; my translation). In this introductory sentence, Kant offers two, mutually confirming, claims: first, that the possibility of knowledge rests on something logically prior to the deceptive primacy of experiential data and, also, prior to our intuitive mechanisms for the reception of such data; and, second, that in order to grasp such a counter-intuitive theory of knowledge, we must effectively abandon all hope for speedy proof and submit to the "extended discipline" (*lange Übung*) of transcendental reflection. Not surprisingly, Kant's *Critique* offers itself as the best or, in any event, the only manual for such mental calisthenics. In other words, he "*constructs* theoretical entities that serve his purpose. There is no empirical confirmation of Kant's hypothesis, however, since what counts as experience, and also as confirmation, is created by our acceptance of that hypothesis" (Rosen 25).

Kant's concept of experience as grounded in an imperceptible synthesis of our intuitive and conceptual powers will yet have to confront its ultimate, repeatedly deferred presupposition: whether to view mind itself strictly as one more *effect* of this synthetic transcendental apparatus or, alternatively, to argue that mind (as "pure self-consciousness") actually governs this synthesis itself a priori. Recognizing that his term "transcendental" has been functioning in ways virtually indistinguishable from "hypothetical," Kant calls the question: does mind exercise rational governance over "its" representations (including those of "itself"), or is it merely a contingent and logically belated effect of its own subterranean synthetic activity? Given the apparent impossibility of justifying a project whose internal organization rests on our acceptance of a hypothesis about matters *prior to* experience—thereby precluding all verification or falsification *by* experience—Kant introduces a new type of preconscious symbolization in order to ensure both the self-conscious integrity of the philosophical subject known as apperception and the rationality and legitimacy of its

representations as knowledge. This symbolic activity is introduced under the name "schematism" and is further characterized as a "product and, as it were, a monogram, of pure a priori imagination, through which . . . images themselves first become possible." Posited as the hidden capstone for Kant's analytic edifice, however, this schematism—troped with such revealing poignancy as a "monogram"—must perforce remain inscrutable and indemonstrable.[11] As Kant notes, "in its application to appearances and their mere form, . . . [the schema is] an art concealed in the depth of the human soul, whose real modes of activity nature is hardly likely ever to allow us to uncover, and to have open to our gaze" (183). The Kantian schema curiously recalls Blake's Urizen—that cocooned embodiment of Reason—philosophy's ultimate presupposition of "silent activity / Unseen in tormenting passions; / An activity unknown and horrible; / A self-contemplating shadow / In enormous labours occupied" (*Book of Urizen*, plate 3, lines 17–22). In Kant's transcendental theory, then, all justification is necessarily internal, a metonymic chain of hypotheses that, by virtue of their repeated usage as pseudo-explanations, congeal into valid components of what Kant calls "transcendental reflection." Having charged all possible experience with conspiring to claim independence when, in fact, it is utterly incapable of representing itself, Kant's *Critique of Pure Reason* seeks to remedy the situation by offering its own hypothetical account as a logically viable answer to this conundrum. Kant's answer comes in the form of something he calls "transcendental schematism," a subterranean synthetic activity designed to restore the epistemic coherence of the subject and its world from which Kant's argument, until just now, had taken such pains to estrange us. The kind of conspiratorial hermeneutics here at issue has been described as "a method for begging the question on a grand scale," which is to say, a "method for proving things, independent of empirical appeals, by demonstrating that they are self-evidently presupposed by what is (supposedly) self-evident" (Smith, 1988, 128).

A circular structure of retroactive prophecy, of correcting the past from the plight of its illusory and oppressive cohesion, thus governs not only the prophetic and fictional narratives of Blake and Godwin but also Kant's contemporaneous project of philosophy as transcendental discourse. The fetish of cognitive autonomy—so jealously pursued by Godwin's Caleb Williams and Blake's Urizen—also structures the *Critique of Pure Reason*. In so doing, it causes Kant's narrative to display the same ambivalence of hubris and hypothesis, mythic violence and performative skill, that choreographs the relationship between Caleb and Falkland, or Los and Urizen in those narratives. Pivoting on the *strictly hypothetical* agency of

a "transcendental reflection" charged with detailing all formal (a priori) constraints on human cognition, Kant's philosophical narrative thus reproduces the very circularity for which it purports to offer a rational accounting. From here, then, it is no great leap toward the postmodern academic project of a thorough ideological critique and historical comprehension, a project whose metaphoric overtones of a "hands-on" activist practice aimed at a definitive "grasp" of the past betrays its affinity with Urizen's, Falkland's/Caleb's, and indeed Kant's fetish of an independent, all-encompassing, and unscrupulously efficient mode of cognition. We may have good cause, then, to read prophetic, fictional, and philosophical arguments of the kind just examined as hubristic attempts at exposing an allegedly illusory or potentially uncontainable otherness—that is, the utter indeterminacy of the noumenon in Kant, the inscrutable impulses and cathections of Caleb, and the ever "expanding eyes of Immortals" in Blake. In alarmingly similar manner, the discourse of postmodern ideological critique also appears to unfold with an intellectual concision virtually indistinguishable from the formal-stylistic integrity of those historical representations whose aesthetic obfuscations it purports to correct. It may not be surprising to find a number of recent critics drawing our attention to the persistence of a strong formalist current within the New Historicist project. However deleterious, such persistent formalisms also bespeak a deep-seated blindness to the ironies slumbering just beneath the surface of methods whose practitioners seek to anchor their intuitions and passions in a grid of objective propositions and rigorous methods. This resilience of the New Critical aesthetic, meanwhile, constitutes not only a disciplinary echo of Coleridge's and Wordsworth's faith in the simulation of subjective affect in organic textual forms; it also reproduces the outline of Benjamin's more critical, quasi-postmodern understanding of representation (be it textual, imagistic, cinematic, architectonic) as a comprehensive simulation of formal (pseudo)experiences designed precisely so as to allow individuals and communities to defend against the threat of an utterly inchoate and ineffable history.

In the prefatory musings on his late book, *The Rhetoric of Romanticism*, Paul de Man draws our attention to the peculiar circumstance that "the apparent coherence *within* each essay is not matched by a corresponding coherence *between* them." Sensing an imminent shift from the rhetorical to the historical dimensions of the Romantic text, Paul de Man continues in an ironic, even self-deprecating, manner by observing that,

> as far as the general question of romanticism is concerned, I must leave the task of its historical definition to others. I have myself taken refuge in more theoretical inquiries into the problems of figural language. . . . I feel myself compelled to repeated frustration in a

persistent attempt to write as if a dialectical summation were possible beyond the breaks and interruptions that the readings disclose. The apparent resignation to aphorism and parataxis is often an attempt to recuperate on the level of style what is lost on the level of history. By stating the inevitability of fragmentation in a mode that is itself fragmented, one restores the aesthetic unity of manner and substance that may well be what is in question in the historical study of romanticism. Such is the cost of discursive elegance . . . (viii–ix) [12]

The ironies in this passage abound, indeed increase exponentially; for if we feel tempted by the historicist project, de Man insists, we will eventually also have to address the contradiction between its totalizing methodological imperatives and its incompletion as an empirical practice. To this impending recognition of historicism as a type of liberal utopia in disciplinary form, we may choose to respond with further reflections on the general status of the humanities, historical knowledge, and the aesthetic's resistance to definition, and so on, though such reflections could logically no longer be sanctioned by any authority other than that of the critic writing. Even then, and in inverse proportion to its "discursive elegance," the articulate project of rhetorical analysis displays traces of those historical concerns whose utopian and implausible character it seeks to evade. In de Man's Schlegelian preface—itself something of an extended, self-ironizing aphorism—statements of criticism have been pared down to articulate traces of the (now abandoned) historicist fantasy of our complete critical purchase on that past. [13]

The "prolific" fragmentation into numerous Romanticisms predicted (perhaps with a hint of Urizenic mischief) by Arthur Lovejoy so many decades ago has thus produced two equally troubled and truly post-Romantic responses: first, the particularist approach of the New Historicist and materialist inquiries that, by now, have fragmented the "field" of Romanticism into discrete nationalisms, regionalisms, and localisms (ranging from studies of Irish, Scottish, and Welsh Romanticisms to vivid and detailed accounts of Clare's Northamptonshire or Blake's Lambeth) and the geopolitics of Romanticism's early imperial and colonial cultures. In a similar vein, the conception of Feminist Romantic Studies—that is, the editorial and critical projects aimed at defining a gendered Romanticism "of their own"—may also be seen as the product of an almost instinctually "liberal" academic tradition whose practitioners react to the perceived incompatibility of critical paradigms of Romanticism by splitting that difference rather than sharpening its terms to the point that unpremeditated insight and learning can occur. Observing the precarious tendency of intellectual pluralism to slide into cognitive fatigue and moral indifference, Adorno sometime ago repudiated an "aesthetic tolerance that simply acknowledges

works of art in their limitation, without breaking it, [and] leads them only to a false downfall, that of parallel existence (*Nebeneinander*) which denies the claims of a single truth."[14] To the extent that the quest for a definition of Romanticism has bequeathed us a more precise sense of epistemological crisis, the historicist spirit in which localisms, particularisms, and pluralism have been proffered as solutions perpetuates the (utopian) longing for a unified field-theory for Romanticism by dispersing it in a number of increasingly solipsistic specializations with political valences of their own. As Alan Liu has argued, this paradigm of extensively fragmented historicisms has thus left us with the inherently formalistic paradox of the critic as "a subject looking into the past for some other subject able to define what he himself, or she herself, is; but all the search shows in its uncanny historical mirror is the same subject he/she already knows: a simulacrum of the poststructuralist self insecure in its identity. . . . Whereas before the action of the Hero discovered historical plurality to be literary unity, the 'expressive' action of the new hero, modern subjectivity, discovered just the reverse. *History* was now the dominating unity that had to be expressed as literary plurality" ("Power" 733, 737).[15]

The larger question to be addressed by the methods of cultural historiography (of which Romantic studies is a vital part) is how to respond to a past that has defined the rhetorical, disciplinary, and institutional mechanisms that the historical positivism of the last century and the New Historicism of ours have been devising in the hope of transcending that past. As the narrative models of Kant, Godwin, and Blake variously demonstrate, any attempt at redeeming the past either through exhaustive contextualization or by articulating its contradictions through a "self-consciously belated" hermeneutics of disbelief is to take the bait of hypothetical narratives that rose to prominence in an age of rapidly collapsing revolutionary ideals. Having thus anticipated, indeed predetermined, the professedly "critical" future responses to its aesthetic and philosophical output, Romanticism also defines for us the larger methodological and critical stakes of the humanities today. Once again, Benjamin offers suggestive hints for reconfiguring our own critical moment with that of its historical object. Arguing, as so often in his early writings, against the restrictive positivist appropriation of Kant's critical philosophy by the Neo-Kantians, Benjamin contends that any philosophy contented with explaining "the true . . . in terms of correct understanding" is a "theory of knowledge, but just that— a theory." For as long as it is being construed exclusively as a matter of technique, epistemological practice

> can never hit upon the unity of existence, but only upon new unities of various conformities to laws, whose integral is "existence." However, the original and primal concept of knowledge does not reach

a concrete totality of experience in this context, any more than it reaches a concept of existence. But there is a unity of experience that can by no means be understood as a sum of experiences, to which the concept of knowledge as teaching is *immediately* related in its continuous development. (*Selected Writings* 107–9)

The question of criticism is thus always more than academic, and answers to it will have to be larger in scope than can be hoped for from disciplinary or methodological adjustments. Given our strong intuition that the past conspired in the manufacture and transmission of the very intellectual methods and institutions through which we might attempt to comprehend and redeem it, criticism arguably should continue to be written with dedication, albeit not the dedication to the transient methodological and thematic predilections of a "profession." Rather, Benjamin suggests, "the object of this teaching [*Lehre*], this totality of experience, is religion, which, however, is presented . . . in the first instance only as teaching" (*Selected Writings* 109). Academic "field work"—teaching and writing—should proceed with genuine critical fervor, though the strength of our critical intuitions will no longer be underwritten by the methodological coherence of a given critical idiom, nor by the indignant acuity with which critical languages conduct their topographical survey and mapping of history as a complex aggregate of aesthetic, economic, and religious obfuscation. For inasmuch as the study of history now appears to have exhausted its disciplinary resources—having recognized them, finally, as belated "effects" or unconscious "supplements" engendered by the very *object* of its study, the past—questions of criticism will cease to be merely intra-institutional matters, in which form they could always be solved by following curricular and methodological paths of our own devising. Instead, they replay the same ethical dilemma that, in the view of current critiques of ideology, past aesthetic models of representation had allegedly foreclosed. The *telos* of knowledge thus would surrender the utopianism endemic to *any* abstract rationalist process in favor of an arguably more fluid dynamic of teaching, a process no longer governed by the formal-technical correctness of disciplinarians but, ideally, by the ethical responsibility variously met by the choreography of knowledge as a process whose continued existence (and afterlife) we locate in writers and their audiences.

The lesson of Romanticism thus could never be plausibly determined by the pursuit of greater methodological and professional sophistication that currently undergirds the ongoing project of tabulating that period's philological and aesthetic forms and their supposed ideological implications. For Benjamin, as for Schlegel, Novalis, or Coleridge (to name only a few provocative figures), knowledge implies something holistic, not cumulative, and it lives on the intensity of its articulation, not on the conceptual

and evidentiary scope of a technique. "Isn't whatever can't be multiplied after a certain point just as much a historical entity [*Einheit*] as something that can no longer be divided?" Schlegel asks.[16] And if indeed "all systems [are] individuals just as individuals are systems at least in embryo and tendency" (*Athenaeum* 242:51), then the critical project of historical knowledge amounts to an attempt at clarifying and symbolizing intuitions of an ethical or, in Kant's and (partially) Schlegel's language, "practical" motivation: "The subject of history is the realization of all that is practically necessary" (*Athenaeum* 90:29). In Schlegel's and Benjamin's alternative to the fetish of an objectivism that continues to legitimate, even now, various critical approaches as epistemologically correct and (at least by implication) as politically and morally necessary, criticism no longer names a professionalized method but, as a conversation ceaselessly questioning its longing for narrative authority, it (like Schlegel's concept of *Bildung*) pivots on a subtle dialectic of disillusionment and freedom, irony and religion. At his most Blakean, Schlegel effectively suggests that discursive conventions and methods are obfuscations of responsibility for the knowledge that the critic purports to communicate. Yet, when thought of as what Schlegel and Benjamin refer to as a holistic culture (*Bildung*) or teaching (*Lehre*) respectively, knowledge constitutes a total mediation of the self; in an uncannily Blakean turn of phrase, Schlegel thus insists that a true "mediator is one who perceives the divinity within himself and who self-destructively sacrifices himself in order to reveal, communicate, and represent to all mankind his divinity in his conduct and actions, in his words and works. If this impulse is not present, then what was perceived was not divine or not really his own. To mediate and to be mediated are the whole higher life of man and every artist is a mediator for all other men" (*Philosophical Fragments* 98; no. 44). Such teaching is precisely *not* moralizing but an irreducible transferential and counter-transferential production of the self through the cultivation of the other, and vice versa. In Schlegel's words, "no occupation is so human as one that simply supplements, joins, fosters" (99; no. 53). No longer a simple matter of technique or doctrine, teaching and knowledge unfold with the full ironic consciousness of their disciplinary and conceptual impossibility. To speak of irony here, Schlegel insists, is not to concede epistemological defeat. Indeed, it could spell defeat only for those craving personality rather than individuality, personalities whose exaggerated sense of self accounts for their failure to understand criticism as "work that divinely surpasses every intention" (99, 107; nos. 60, 136). To put it in positive terms, the irony at stake is "the clear consciousness of eternal agility," and a criticism undertaken in this spirit strongly resembles the antinomianism of what Blake calls illumination or what Schlegel defines as virtue, namely, "reason transformed into energy"(100, 96; nos. 63, 23).

Crucial to the idea of criticism as a unique mode of intellectual production is its ability to maintain a speculative, indeed constitutive, distance to its intellectual object or issue. Some of the more thoughtful accounts of intellectual practice (by no means always compatible)—including those of Adorno or Heidegger—thus insist on a cautious, reflexive attitude toward method (be it positivist or dialectical), particularly because any outright identification with a given method invariably entails a fetishization of the objects or issues supposedly rendered intelligible by it. In the final analysis, fetishization always comes down to some form of projection, something echoed by Alan Liu's description of "the New Historicism [as] in effect a profoundly narcissistic method" ("Power" 746). We may thus view the exigencies of Romantic historicism as an instance of "negative transference," that is, as affirming the wholly contentless lucidity of the critic through an axiomatically suspicious critical narrative that purports to name, in the form of an indictment, its *essential* other: the past. Commenting on "the inability of historicism to specify a social or political good that historicism might help to achieve," Steven Cole offers this summation: "What historicism wants is evaluation without values. . . . The politics of romanticism is located somewhere else, and as yet historicism has done nothing to indicate where that somewhere else might be" (Cole 48–49). In other words, a method of purely formal or technical correctness will produce a knowledge so rigidly circumscribed as to privilege the formal competence of that method's practitioners to the virtual exclusion of all intuitive or ethical matter.[17]

My arguments here against a purely formal-logical style of analysis committed to overcoming the past as a repository of allegedly deleterious aesthetic forms and political values—and against the oddly contentless exegetical confidence of postmodern critiques of ideology—recall the analogous break of the Jena Romantics with the formalisms of Fichte's philosophy of 1795–97. Arguably the most probing and articulate member of that group, Novalis insisted that by paring down the idea of *Reflexion* to a mere form or technique, criticism could never generate values and, consequently, could never enrich and cultivate (*bilden*) the individual.[18] Where the "raw discursive thinker" mobilizes his scholastic technique to assemble an "intellectual artifact" (*Gedankenkunststück;* 2.314), a genuinely searching, poetic conception of intellectual life would be the "living reflection" (*lebendige Reflexion;* 2.316), a process aimed at defining "real philosophy" (*reale Philosophie*) as a "lived theory" (2.318). For Novalis, language itself embodies this repudiation of systematic philosophy in favor of a poetic, living "cultivation" (*Bildung*) of intuitions that thought knows will never entirely merge with *any* discursive or propositional form. Thus his "magic" conception of language renounces any epistemology premised on "general

signs" and, instead, enjoins thought itself to conceive of "each word as one of conjuring" (*Beschwörung;* 2.313). Thought, however, not only destabilizes its objects by drawing them into the sphere of subjective intelligibility; for corresponding to this transfiguration of an "other" into knowledge is a fundamental transfiguration of the self: "I can experience something only by assimilating it to myself; it is, consequently, both an alienation (*Alienation*) of myself and a dedication or transformation of a foreign substance into mine: the new product differs from both factors" (2.340–41). Like Fichte, whose lectures he attended in 1795, Novalis understands all critical reflection as containing systematic intentions. Yet unlike his teacher, Novalis identifies it as the "purpose" and "destiny" (*Bestimmung*) of all critical thought to be translated into expressions of an intensity and lucidity that will effectively transfigure the self: "The act of leaping beyond one's self [*des sich selbst Überspringens*] is always the highest—the point of origin— the *genesis of life*" (2.345).

Where Schlegel speaks of *Bildung* and *poiesis* as a dream of narrative mastery continuously succumbing to irony, Novalis views intellectual practice as modernity echoing an irrecuperable mysticism: parallel to its intuitive grasping of an object, thought is constrained by the reflexive awareness that it will only ever achieve an etiolated or provisional relationship to life. While translating its intuitions into a knowledge that will prove inevitably contingent and provisional, thought does so already aware that it can approach its intuitions *only* in the alienated and belated modality of critical reflection. From Schlegel and Novalis to Benjamin and Adorno, the question forever pressing is that concerning the distance we ought to maintain toward the objects of knowledge—as well as toward the affect generated by our knowing—while exploring the complex historical and aesthetic phenomena of romantic culture.[19] Adorno in particular insists on a certain degree of "irresponsibility, of blitheness springing from the volatility of thought." Whereas the Marxist and Nietzschean hermeneutics of suspicion risks deteriorating into a self-privileging and totalizing negative politics, Adorno rejects Materialism (cf. epigraph) because it "reduces the detachment of thought to a reality, [one] that reality itself no longer tolerates." Instead, he contends, thought must retain a speculative (though no longer systematic) quality, "an element of exaggeration, of over-shooting the object, of self-detachment from the weight of the factual."

> As soon as thought repudiates its inviolable distance and tries with a thousand subtle arguments to prove its literal correctness, it founders. If it leaves behind the medium of virtuality, of anticipation that cannot be wholly fulfilled by any single piece of actuality; in short, if instead of interpretation it seeks to become mere statement, every-

thing it states becomes, in fact, untrue. . . . If, on the other hand, it tried to claim its distance as a privilege, it would act no better, but would proclaim two kinds of truth, that of the facts and that of ideas. That would be to decompose truth itself, and truly to denigrate thought. Distance is not a safety-zone but a field of tension. (126–27)

To conceive of criticism as a practice no longer constricted by the self-privileging methods and false utopian motives of retroactive mastery, we will have to gauge the distance between the institutional settings and discursive practices that we continue to inhabit, and our intuitive understanding of what "critical" practice might—indeed *ought to*—be. If Novalis disconcerts us by transforming criticism into the uncompromisingly individual, even mystical domain of transcendental poetry, Benjamin and, even more so, Adorno balance the Romantic account by drawing our attention to the inherent risks of any intellectual position that is radically antiformalist and antisystematic. Far from glamorizing the tensions and impasses contained in the notion of Romantic irony as some breathtaking epistemological advance—such as can be observed in the discourse of antifoundationalism today—Adorno seems fully aware that both the mystical or antinomian affirmations of the individual in writers like Novalis and Blake *and* the retroactive disarticulation of their faith by the accounts of positivist or dialectical historicisms will invariably restrict knowledge either to something supposedly authentic yet incommunicable, or to a discursive yet wholly negative matter; in both instances, the terms of such knowledge appear strictly (indeed often narcissistically) controlled by its producer.

And yet, notwithstanding its partial blindness to that conundrum, the concept of *Bildung* operative in writers like Godwin, Blake, or the Jena Romantics often enough anticipates Adorno's description of intellectual activity as inherently divided between its declared focal point and the reflexive awareness of thought as abiding at an unbridgeable remove from "its" objects. At their best, writers like Blake and Novalis anticipate the ideal of Romantic pedagogy as a process in which the narrative fantasy of organic development is continually punctured by the interventions of thought, at once unrelentingly reflexive and provisional. Rather than seeking to overcome the antagonisms between epistemological technique and ethical motivation, Novalis and Schlegel conceived transcendental poetry itself as the medium in which to inscribe the irreducible tension between knowledge as a formal pursuit (criticism) and as a dynamic intuition (life). Following the Jena Romantics' idea of *poiesis,* we may thus conceive of criticism in terms of ethics rather than technique, a mode of thinking, teaching, and writing always obligated to reflect on (though never able to indulge in) the seduction of methodological and narrative closure. For any

attempt to reify the past in purely discursive and conceptual form invariably loses all perspective or distance on the ideological dynamics of the present in which such belated knowledge is being produced and circulated. As Lee Patterson has put it, "To apply the conditions of our scholarship to life is an almost inevitable transaction, but it in fact denatures, because it dematerializes, our historical existence. Indeed, the lines of influence ought really to run the other way, from our lives to our scholarship" (63).

The remarkable collusion between the cultural output of Romanticism—in the broader sense of European cultural history as it unfolds between the later eighteenth and the mid-nineteenth century—and the historicist methods committed to identifying and resolving the enigmas and antagonisms of that output suggests that one of the motives encoded in the formal and material practices of the Romantic aesthetic involved the emergence of criticism (and its institutional forums) as a desirable and legitimate supplement to that aesthetic. Given the logic of Romanticism's critical, fictional, and prophetic narratives examined earlier, the project of a belated, "critical" articulation of Romanticism's allegedly symptomatic (or aesthetic) ideology may, in fact, constitute but a repetition, a supplemental effect *of* that very symptom. In reconsidering our present technologies of critical knowledge as having been shaped, a fortiori, by the very culture that these technologies hope to possess in conceptual and disciplinary form, we may not only accept but, perhaps, welcome Schlegel's distinction between criticism as a form of intellectual conquest ("a laborious game of dice with hollow phrases") and as the reflexive experience of the *Idea,* that "continual self-creating interchange of two conflicting thoughts." Romanticism, we find, is an idea in the spirit of Schlegel's definition: "An idea is a concept perfected to the point of irony" (*Athenaeum* 121:33). Schlegel's concept of irony thus throws into relief the undecidable place of criticism (*Kritik*): Can it legitimately hope to correct (retroactively, as it were) Romanticism's ideological entanglements, or is that period distinguished by having bequeathed us the irony of a critical enterprise vacillating between a quest for conceptual and methodological authority and a reflexive understanding of that quest as an impossible one? The unending supersession of one critical paradigm by another—effectively adding up to a concise history of cultural institutions and politics over the last hundred and fifty years or so—also suggests that, being so intricately bound up with this irony, Romanticism has survived by continually reinventing itself through its belated other, the reader, the philologist, the critic, the cultural prophet, the liberator of marginalized or otherwise forgotten voices, forms, media, and traditions.

Indeed, it appears that the idea of Romanticism—whether we choose to limit it to a merely heuristic fiction or pronounce it as a dignified (if polyvalent) critical object—was simultaneously prepossessed and retroactively

defined by the critical potential slumbering beneath, say, the enigmatic textual surfaces of the Wordsworthian ballad, the transparently nostalgic historicism of Scott's fiction, or the encryption of economic and gender politics in the shrewd choreography of voices in Jane Austen's novels. The same teleological bond may also be found to account for the over-whelmingly institutional understanding of our own cultural modernity, quite arguably an echo of the same psychology that caused various Lon-don middle-class communities and Regency provincial towns and cities to pursue and realize their quest for an abiding cultural capital in the inter-active forums of widely subscribed literary reviews, new symphony halls, or sumptuous art exhibits and galleries that redefined taste as "educated yearning . . . accompanied by an exchange of goods and money" (Eaves 47).[20] Without diminishing the role of other demographic, regional, and spiritual communities fashioning their own aesthetic, it could be said (and I have argued the point in greater detail elsewhere)[21] that the most abiding and powerful bequest of the Romantic aesthetic involves the ideal of an enlightened, liberal, and formal-aesthetically discriminating middle-class consciousness, a vision that to this day commands enormous (perhaps ex-cessive) moral and cultural credit. Above all, its sustained authority appears vested in the highly pragmatic and flexible symbolization of its interests as seemingly universal, quasi-natural beliefs. Hence, in shrewdly intuitive ways, the Romantic bourgeoisie avoided any unmediated, fully explicit, and self-conscious articulation of its beliefs. For to do so would have con-strained it to become conscious of its historically contingent, "interested" situation and, before long, would have vitiated its presumptive moral credit. Both in the formal-aesthetic and disciplinary-institutional sense, the cultural movements and figures examined in the following essays thus constitute part of Romanticism's constitutive and sheltering investment in *mediation,* that is, in the negotiating by individuals of their economic and moral interest (and the ambivalences typically associated with it) through the dynamics of community, and in turn configuring the interests of communities through aesthetic and contiguous discursive modes of rep-resentation. Long ago—and much to the surprise and dismay of the more orthodox core of a temporarily vibrant Marxist community in the United States—Kenneth Burke argued that communities rest on a symbolic infra-structure, specifically on certain rhetorical forms particularly suited to sustaining a given community's beliefs by "expressing" them in the form of aesthetic "ideas" and "forms."[22] Eschewing the adversarial dynamics of public discourse in the affective, private concision of an expressive aesthetic, the various constituencies of Romanticism's new demographic paradigm, the Nation, thus seek to preserve their political unconscious with what Hegel was to call "the cunning of reason." In other words, com-

munity rests on a (Kantian) aesthetic pleasure (*Lust*), a state of eloquent not-knowing, which has been characterized as the submerged cunning of our vernacular culture, a "continuous flow of diurnally enacted genial relationships which constitute unaffected moral association" (Oakeshott 68).

It may thus be sensible to take up the idea, first advanced by Morse Peckham some twenty-five years ago, of giving Romanticism a *functional* rather than "attributional construction." To argue that "the problem of understanding Romanticism is the problem of locating with accuracy its problem" (Peckham 218, 217) is to trace the evolution of the bourgeois aesthetic as the reflex of an inherently divided, specialized, and alienated culture. Such a society, Schiller had argued, ought to seek redemption from the alienated consciousness of its own modernity in the exclusive sphere of aesthetic simulacra, a community of individuals joined by their "virtual" (symbolic) productivity and expertise, and by hermeneutic experiences that would incrementally mediate them with the idea of the State itself. Premised on, and further nourished by, their self-confirming, near-axiomatic faith in a shared quasi-universal sensibility, the "middling" classes — whether rural, provincial, or metropolitan; vested in manufacture, trade, or the professions — appear all but inextricable from this cultural capital. Indeed, the relationship between class and culture is intricately dialectical in that the distinctness and continued viability of a middle class is premised on its being scrupulously discriminated from the allegedly desiccated cosmopolitanism of "polite" culture and from the presumptive "vulgarity" of lower-class artisan life. The integrity and truly representative character of this demographic formation thus depends on its ability to transfigure previously vernacular modes of production into aesthetic forms that are to emerge as the new gold standard of national culture.

To understand Romanticism's idea of aesthetic education as the development of a representative type of symbolic proficiency in a large number of individuals is thus also to relate questions of genre (however implicitly) to larger political and economic issues. If only at a provisional, synecdochic level, then, this collection of essays also wishes to draw attention to the continuities between the textual, musical, and visual encoding of the period's various incarnations of a "demographic unconscious." As the rich array of contributions makes so abundantly clear, the study of Romanticism's diverse cultural communities invariably begins by scrutinizing distinctive material and discursive practices devised in an (often unselfconscious) attempt to secure a more precise and abiding type of affect for their participants. Central to the project of shaping such communities, ranging from the salon culture to the imagined demographic body of a nation of "Britons" is, once again, the effectivity of the aesthetic as an obliquely pedagogical endeavor. As I have argued earlier on, we have good

cause to conceive criticism as an instance of self-conscious crisis, a fleeting moment of negotiation between our fantasy of an objective methodological purchase on the past (and hence on our own present) and our simultaneous, abject awareness that such a project, far from being objective, might effectively reproduce the very terrors of history from which it purports to shelter us in the commodity form of critical knowledge. If the response to a consciousness of crisis ought to be, as I have also argued, one of ethical commitment to unfolding that crisis in the various forums and modes of teaching—the pursuit whose humanity, as Schlegel had suggested, lies in the fact that it "simply supplements, joins, fosters" (*Philosophical Fragments* 99; no. 53)—the essays in this collection, taken cumulatively, do just that. What weighs more, they do so by exploring how the elaboration of communities in the Romantic period essentially followed the same logic: that of producing community and stability through the subtly regulative play of an aesthetic model continually anticipating and predetermining the conditions and terms of its belated critical reception and elaboration.

Notes

1 In his study of the idioms of contemporary criticism, Jean-Pierre Mileur draws our attention to its shared "sense of the heroism of renunciation—a sense that something of value, something of desire must be traded away in exchange for moral and intellectual authority. Unfortunately, when imaginatively inadequate or unsatisfying use is made of that authority, criticism lapses into nostalgia, pines for what it has renounced" (10). More recently, Steven Cole has worked out several analogous incongruities in the rhetoric of Romantic Historicism, such as the paradox that its "pursuit of a self-consciousness unmediated by any ideological content has produced an escalating standard of critical purity," an almost contentless "ethereal insistence that the primary purpose of criticism is to resist any complicity with social or cultural structures of power" (36, 37).

2 See Lee Patterson's reading of Jameson and Raymond Williams (48–57) and Steven Cole's insightful account of the logical tensions intrinsic to Romantic Historicism's understanding of agency and value.

3 As Lee Patterson notes, "the methodological assumption [of traditional historicism] that historical context can produce interpretive correctness inevitably serves to stigmatize the discordant, the variant, and the deviant as incorrect—as, in effect, nonexistent" (45). Adorno's account of positivism is, if anything, even more pointed.

4 For a general account of the critical transformation here alluded to, see Frank Lentricchia, *After the New Criticism;* Geoffrey Hartman, *Criticism;* Jean-Pierre Mileur, *Critical Romance;* and Paul de Man's discussions of Husserl, Georges Poulet, and Formalist Criticism in *Blindness.*

5 Levinson, *Wordsworth's Great Period Poems* 25. Her allusions are to *Paradise Lost* (1.63) and to *The Book of Urizen* (plate 4, line 17).

6 For an incisive reading of Levinson's conception of historicism, see Steven Cole, 44–48.

7 The notions of conspiracy and of a structural (nonintentionalist) conception of power

are not incompatible. In fact, as Gordon Wood has shown, the late eighteenth century witnessed a widening in the gap between *intentions* avowed by the individual and the *effect* of actions supposedly taken to realize such intentions. Inasmuch as the rise and (temporary) legitimacy of conspiratorial modes of explanation respond to that contradiction, "conspiracy" can be understood as an explanatory mechanism designed to *preserve* the idea of intentionality, if only in substantially modified form. Shifting from an originary to an inferential concept, intention now appeared knowable only by reading retroactively, something to be traced from (discordant) effects back to the (hidden) cause of an agency either unconscious of its desires or seeking to obfuscate its true objectives. Needless to say, an agency thus reconstructed existed entirely at the mercy of individuals or institutions committed to its (belated) interpretation, and nothing that the subject in question might say or show in an effort to disavow intentions now ascribed to him or her could possibly dispel its inferential construction by an other. On the epistemological and historical aspects of conspiratorial hermeneutics, specifically in 1790s England, see n9 below.

8 Steven Cole makes similar observations (48): "Just as Hegel found that only the standpoint of a transhistorical totality allowed *Geist* to *forgive* the failings of experience, so historicism fantasizes a future from whose standpoint our present occlusion from the Real might in turn be redeemed" (emphasis in original).

9 On the historical origins of conspiratorial models of argumentation in the Romantic period, see Gordon Wood, "Conspiracy"; Jerome Christensen, "Detection"; Alexander Welsh, *Strong Representations*; and my own "Paranoia." On the conceptual interest of paranoia and conspiracy for humanist practice, see also Paul Smith, *Discerning the Subject* 83–99; and Michael Dummett, "Can an Effect Precede Its Cause?" and "Bringing about the Past," in *Truth*.

10 See the works by E. P. Thompson, Iain McCalmain, Jon Mee, and David Worrall.

11 For accounts of the centrality and logical convolutions of the Kantian schematism, see Martin Heidegger, Ernst Cassirer, and Ernst Robert Curtius. As I have argued elsewhere, the crisis of the subject at the very moment of its logical determination becomes itself the point of origin for an essentially *narrative* conception of philosophy in the work of F. W. J. Schelling, who paid particularly close attention to the schematism in his early writings. See my *Idealism* 8–36.

12 The figure of thought offered in this passage mirrors, at the level of theory, de Man's earlier qualification of literary history as a series of textual and rhetorical models of progressively greater demystifying capacity. In his 1967 essay "Criticism and Crisis," he notes "how certain developments in nineteenth-century realism . . . can be interpreted as a gradual demystification of romantic idealism. This leads to a historical scheme in which romanticism represents, so to speak, the point of maximum delusion in our recent past, whereas the nineteenth and twentieth centuries represent a gradual emerging from this aberration, culminating in the breakthrough of the last decades that inaugurates a new form of insight and lucidity, a cure from the agony of the romantic disease. Refining on what may appear too crude in such a historical scheme, some modern critics transpose this movement within the consciousness of a single writer and show how the development of a novelist can best be understood as a successive process of mystifications and partial demystifications. . . . The function of the critic then naturally becomes coextensive with the intent at demystification that is more or less consciously present in the mind of the author" (*Blindness* 13–14).

13 Levinson offers a similar understanding of the transferential character of historicist practice (*Rethinking Historicism* 12–15). See also Frances Ferguson ("On the Num-

bers"), who argues that Meyer H. Abrams's thesis of the French Revolution as the pivotal and all-encompassing historical context for British Romanticism "provide[d] a formal version of politics, the political [being] waged through implicit means." In an equally formalist inversion of that thesis, "Pluralism, the critique of and escape from generalization and collectivization, becomes for McGann both a scholarly method and a political program" (475, 479).

14 *Minima Moralia* 75–76; I have modified the translation slightly.

15 Recently, David Simpson addressed a further mutation of what Levinson had called the New Historicism's version "of history as the ongoing proliferation of minimal units" ("On the Numbers of Romanticisms" 479), namely, the marked displacement of comprehensive critical narratives by the increasingly self-referential habits of "storytelling, anecdotes, and conversation in current academic criticism" (Simpson 64–71). Indeed, it seems highly improbable that an imaginative response to the problem of historical knowledge should be found in the curious hybrid of professionalism and hedonism that has lately been offered up under titles such as *Confessions of the Critics* or, in more generic form, as "experimental critical" writing. The first to draw attention to the dubious attempt at compensating for the conceptual and logistical inconveniences of macrohistorical and macrotheoretical analysis with such an "*ersatz* kind of ethics, a privileged, privatized hedonism" was Terry Eagleton. To theoretically *and* historically proficient critics (and to the majority of contributors in this volume), this "new style of meditation on the body, on pleasures and surfaces, zones and techniques" (Eagleton 7) remains a politically suspect dissimulation of the critics' affluent professionalism in the form of languid prose reminiscences wholly devoid of *any* transpersonal intellectual agenda and responsibility. It hardly needs to be pointed out, then, how such an idiom replicates the rhetorical form (and the evasive politics) of those canonical works of Romanticism over whose critical analysis it so evidently despairs.

16 In his *Athenaeum* fragments, having argued that it is impossible to study history without hypotheses, Schlegel goes on to state that "if one refuses to recognize this, then the choice is surrendered to instinct, chance, or fate; and so one flatters oneself that one has established a pure solid empiricism quite a posteriori, when what one actually has is an a priori outlook that's highly one-sided, dogmatic, and transcendental" (*Philosophical Fragments* 48–49; no. 226).

17 As Cole further notes, "the evasion here of ethical argument, the refusal to specify precisely what the 'objective Real' might be, and to explain why it is a good thing, typifies historicist accounts of romanticism. . . . Perhaps the greatest indication of the failure of historicism is the impossibility of its own position producing the politics it wants to defend" (48–49).

18 *Werke*, vol. 2. For a translation of some of these fragments, known as Logologische Fragmente, see Novalis, *Philosophical Writings*. All translations here are my own, and the parenthetical citations follow the German edition.

19 See Lee Patterson's insistence "that historical criticism must abandon the hope of any theoretical foundation and come to rest instead upon its own historically contingent moment, and upon convictions that find their final support within experience" (48).

20 See, for example, Joel Sachs, or, for the professionalization and institutional reification of the visual arts, John Barrell and Morris Eaves.

21 See my *Wordsworth's Profession*, especially pp. 19–37, 143–51.

22 See Frank Lentricchia's account (21–38) of Kenneth Burke's highly controversial address to the 1935 American Writers' Congress.

Works Cited

Adorno, Theodor. *Minima Moralia: Reflections from Damaged Life*. Trans. E. F. N. Jephcott. London: New Left Books, 1974.

Barrell, John. *The Political Theory of Painting from Reynolds to Hazlitt*. New Haven: Yale UP, 1986.

Benjamin, Walter. *Illuminations*. Trans. Hannah Arendt. New York: Harcourt, 1968.

———. *Selected Writings, 1913–1926*. Ed. Marcus Bullock and Michael W. Jennings. Cambridge: Harvard UP, 1996.

Blake, William. *The Urizen Books*. Ed. David Worrall. Princeton: Princeton UP, 1995.

Cassirer, Ernst. "Kant and the Problem of Metaphysics: Remarks on Martin Heidegger's Interpretation of Kant." *Kant: Disputed Questions*. Ed. Moltke Gram. Chicago: Quadrangle Books, 1967.

Christensen, Jerome. "The Detection of the Romantic Conspiracy in Britain." *South Atlantic Quarterly* 95.3 (1996): 603–27.

Cole, Steven E. "Evading Politics: The Poverty of Historicizing Romanticism." *Studies in Romanticism* 34.1 (1994): 29–49.

Curtius, Ernst Robert. "Das Schematismuskapitel in Kant's *Kritik der Reinen Vernunft*." *Kantstudien* 19 (1914): 338–66.

de Man, Paul. *Blindness and Insight*. 2nd, rev. ed. Minneapolis: U of Minnesota P, 1983.

———. *The Rhetoric of Romanticism*. New York: Columbia UP, 1984.

Dummett, Michael. *Truth and Other Enigmas*. Cambridge: Harvard UP, 1978.

Eagleton, Terry. *The Ideology of the Aesthetic*. Oxford: Blackwell, 1990.

Eaves, Morris. *The Counter-Arts Conspiracy: Art and Industry in the Age of Blake*. Ithaca: Cornell UP, 1992.

Eliot, T. S. *Christianity and Culture*. New York: Harcourt, 1977.

Ferguson, Frances. "On the Numbers of Romanticisms." *ELH* 58 (1991): 471–98.

Frye, Northrop. "The Road of Excess." *Romanticism and Consciousness*. Ed. Harold Bloom. New York: Norton, 1970. 119–32.

Gadamer, Hans-Georg. *Warheit und Methode*. 4th ed. Tübingen: I. C. B. Mohr, 1975.

Godwin, William. *Caleb Williams*. Ed. Maurice Hindle. Harmondsworth: Penguin, 1988.

Hartman, Geoffrey. *Criticism in the Wilderness*. New Haven: Yale UP, 1980.

Heidegger, Martin. *Kant and the Problem of Metaphysics*. Trans. James S. Churchill. Bloomington: Indiana UP, 1965.

Kant, Immanuel. *Critique of Judgment*. Trans. J. H. Bernard. New York: Hafner, 1951.

———. *Critique of Pure Reason*. Trans. Norman Kemp-Smith. New York: Macmillan, 1965.

Lentricchia, Frank. *Criticism and Social Change*. Chicago: U of Chicago P, 1983.

Levinson, Marjorie. *Wordsworth's Great Period Poems*. Cambridge: Cambridge UP, 1986.

———. *Rethinking Historicism*. London: Blackwell, 1989.

Liu, Alan. "The Power of Formalism: The New Historicism." *ELH* 56 (1989): 721–71.

Lovejoy, Arthur O. "On the Discrimination of Romanticisms." *English Romantic Poetic*. London: Oxford UP, 1975. 3–24.

McGann, Jerome. *The Romantic Ideology*. Chicago: U of Chicago P, 1983.

Mileur, Jean-Pierre. *The Critical Romance*. Madison: U of Wisconsin P, 1990.

Novalis [pseud.]. *Werke, Tagebücher, Briefe*. Ed. Hans-Joachim Mähl. 3 vols. Munich: Hanser, 1978.

———. *Philosophical Writings*. Trans. and ed. Margaret Stoljar. Albany: State U of New York P, 1997.

Oakeshott, Michael. *On Human Conduct*. Oxford: Clarendon, 1991.

Patterson, Lee. "Historical Criticism and the Claims of Humanism." *Negotiating the Past.* Madison: U of Wisconsin P, 1987. 41–74.

Peckham, Morse. "On Romanticism: Introduction." *SiR* 9 (1970): 217–24.

Pfau, Thomas. *Idealism and the Endgame of Theory.* Albany: State U of New York P, 1994.

———. "Paranoia Historicized: Legal Fantasy, Social Change, and Satiric Meta-Commentary in the 1794 Treason Trials." *Romanticism, Radicalism, and the Press.* Ed. Stephen C. Behrendt. Detroit: Wayne State UP, 1997. 30–64.

———. *Wordsworth's Profession: Form, Class, and the Logic of Early Romantic Cultural Production.* Stanford: Stanford UP, 1997.

Rosen, Stanley. *Hermeneutics as Politics.* New York: Oxford UP, 1987.

Sachs, Joel. "London: The Professionalization of Music." *Music and Society: The Early Romantic Era.* Ed. Alexander Ringer. Englewood Cliffs: Prentice-Hall, 1991. 201–35.

Schlegel, Friedrich. *Philosophical Fragments.* Trans. Peter Firchow. Minneapolis: U of Minnesota P, 1991.

Simpson, David. *The Academic Postmodern and the Rule of Literature.* Chicago: U of Chicago P, 1995.

Smith, Barbara Herrnstein. "Belief and Resistance: A Symmetrical Account." *Critical Inquiry* 18 (1991): 125–39.

Smith, Paul. *Discerning the Subject.* Minneapolis: U of Minnesota P, 1988.

Welsh, Alexander. *Strong Representations.* Baltimore: Johns Hopkins UP, 1992.

Wood, Gordon. "Conspiracy and the Paranoid Style: Causality and Deceit in the Eighteenth Century." *William & Mary Quarterly* 39.2 (1982): 401–41.

∽ VARIETIES OF *BILDUNG*

IN EUROPEAN ROMANTICISM

AND BEYOND

Romanticism, *Bildung*, and the Literary Absolute

MARC REDFIELD

*T*he notion of Romanticism has led a disputatious life ever since its uncertain beginnings in the Romantic era. In the first half of the twentieth century, as the term's use shifted slowly but irreversibly away from that of literary polemic and toward that of an academic term—away, that is, from overtly ethical and axiological battles and toward historical and hermeneutic ones—the famous debate between A. O. Lovejoy and René Wellek caused scholars to speculate whether Romanticism existed in a more than nominal fashion as a coherent entity.[1] The subsequent institutional history awards the victory to Wellek, who claimed that it did, but the production and reproduction of Romanticism as an academic field does not in the end render Romanticism a less uncertain phenomenon.[2] The difficulties it poses for the literary historian are well known. Romanticism is used to characterize diverse historical moments in national literatures and to privilege specific writers or movements at the expense of others; at the same time, as a style or "system of norms" (Wellek 2), it seems ensnared in recurring contradictions, with a mode that is variously utopian and despairing, naive and self-conscious, humanist (Abrams) and satanic (Praz). The larger significance of these literary and academic paradoxes revolves around their denoting, as Maurice Blanchot remarks, a Romanticism that has also stood for a "political investment," one with "extremely diverse vicissitudes, as [Romanticism] was at times claimed by the most reactionary regimes (that of Friedrich Wilhelm in 1840 and the literary theoreticians of Nazism), and at other times . . . illuminated and understood as a demand for renovation" (163). If the term now primarily serves an academic institutional arrangement, it nonetheless comes burdened with enough cultural significance to pose the conundrum of our own historical identity.

For the difficulty Romanticism presents is not simply that of a contradictory entity, but rather that of a phenomenon that has to a great extent

shaped our attempt to grasp it. Romanticism designates the historical emergence of a modern understanding of history, along with ideas of revolution, democracy, the nation and its literature, literature and its criticism, and the cultural and pedagogical institutions that convey and reproduce such ideas. Literary historians and critics know a particularly circular version of this predicament, which may help explain why polemics against Romanticism so visibly mark the literary-critical record: the embarrassment of indebtedness is all the more irksome when the very terms of one's polemic—an opposition, say, of romanticism to classicism—derive from the movement one wishes to castigate and escape.[3] Not restricted to a preprofessional era, this double bind recurs persistently in contemporary academic criticism, sheltered though we now might be within a scholarly bureaucracy. The Romantics may no longer be undergoing chastisement of the sort meted out by Babbitt or Hulme, but Romanticism is still being accorded the treatment of an ideology available for debunking—a debunking that then is found to consist in the remarkably Romantic endeavor to "return poetry to a human form" (McGann 160).[4] Yet an obscurity persists at the heart of these paradoxes. We have not gained much by claiming to be inside a Romanticism we cannot properly define, which may not, in fact, have an identity within which we could dwell. This obscurity is displayed in literary studies as a tension between literature and the Romantic aesthetic that defines literature as such. Texts that have seemed particularly Romantic—those of Shelley, for instance, or Rousseau or Schlegel—have in their long, curious history been judged at once irreducibly literary and yet unsatisfactory or flawed. More recently, academicians have had to confront Romanticism as the matrix of literary theory, whose various forms draw inspiration from the slippage between a text and its aesthetic or critical reception—from the fact, in other words, that literature seems able to mean both too much and too little to be reducible to the pleasure of an intuition, or to the stability of an intention or a well-wrought form. With Romanticism defining the terms of its own debate, we need to account for it as a phenomenon that not only calls itself into question, but also seems to slip away from its own standards and its own critical language, resulting in criticism that inhabits a constant, though usually only half-acknowledged, state of crisis.

The focus of this essay, an instance of critical crisis and its half-acknowledgment, is appropriate to the theme of this section: the status of the notion of the bildungsroman, or novel of education, in literary studies. The idea behind this genre is at once a commonplace and a minor embarrassment, and its vicissitudes replay in dramatically compressed form the paradoxes at work in the concept and history of Romanticism. Few critical terms, let alone German ones, have achieved comparable success, both within and without the academy; yet the moment one takes seriously

the definitions and implications of the word "bildungsroman," it appears to lose most or all of its referential purchase. A bildungsroman ought to be a novel that represents and enacts *Bildung,* which means considerably more than education, as will be seen; for now, we may simply observe that students of the genre are typically obliged to grapple with the possibility that the object of their study does not exist at all. Scholars who can hardly be accused of a weakness for oversophisticated literary theory (see, e.g., May) have wondered whether even Goethe's *Wilhelm Meister's Apprenticeship,* given the theatricality of its plot and the passivity of its eponymous hero, can be said to belong to a class of novels it supposedly exemplifies. I have sought to elaborate elsewhere the intriguing aspects of this paradox; here this seemingly modest aporia may be summarized as a tension between what literature provides and what criticism would like to receive.[5]

Or perhaps the tension rests in criticism, which seems unable either to abandon the idea of the bildungsroman or to muzzle its skepticism. However, as soon as we seriously inquire after the ontology of criticism, which is to say after that of the literature on which it depends, we engage a problem of some complexity, which has been brilliantly elaborated by Phillippe Lacoue-Labarthe and Jean-Luc Nancy in *The Literary Absolute,* their study of German Romanticism. Building on the work of Walter Benjamin and Maurice Blanchot, Lacoue-Labarthe and Nancy analyze the philosophical structure of the idea of the literary text as a "self-conscious" text, an idea now commonplace but which emerged fully for the first time in the work of Romantic writers, as an aspect of the Romantic development or elaboration of modern aesthetics. Conceptualized with more precision, the self-conscious text unfolds into the model of a text that generates its own theory: "theory itself as literature," as Lacoue-Labarthe and Nancy put it, "or, in other words, literature producing itself as it produces its own theory" (12). The literary text becomes what it is—literary—in reflecting on its own constitution and thereby inscribing within itself the infinite task of criticism, hollowing out a space for readers who, in engaging the text, repeat the production of the text as it generates its own self-understanding. This self-understanding always lies on the horizon, because each production of the text in turn calls out for a further moment of completion. Literature is thus inexhaustible; it is an infinite, reflective, fragmentary movement, Schlegel's "progressive universal poetry," which Blanchot depicts as "a veritable conversion of writing: the power for the work to be and no longer to represent" (165).

Lacoue-Labarthe and Nancy rightly insist that "we ourselves are implicated in all that determines both literature as auto-critique and criticism as literature" (16): the institutions of modern literary criticism would be inconceivable in the absence of this self-knowing and self-producing lit-

erary space. On the one hand, literature is the "all," as Blanchot points out: it concerns everything, to the point of conveying Being itself in an intuitive, unmediated moment of insight. On the other hand, it is what one approaches endlessly, through specialized, technical processes of mediation. The absolute character of the text's truth calls for manuscript editions and variorum editions, biographies, memoirs, and all the minutiae of scholarship, as well as for the reiterated acts of interpretation we call criticism proper. One may thus claim in the abstract what the historical record confirms: not only is there no literature without criticism, but the history of the idea of literature is the history of the institutionalization of literary study. It must also be noted, however, that a contradiction very fruitful of discourse is at the core of this institution. Literature is both infinitely populist and irreducibly elitist in its aspirations, at once avant-gardist and archival in nature. As a consequence, a tension persists between academic and anti-academic discourse about literature (a literature that is always being "betrayed" by the scholarly reverence it elicits); between scholarship and criticism in the academy; and between poetics and hermeneutics in criticism. The critical endeavor, however, is as irreducible as it is conflicted, since it embodies the very self-consciousness of the literary text. Indeed, criticism has thoroughly displaced philology in the twentieth-century academy partly because the former's appeal to the "opacity" and "inexhaustibility" of the literary text (Warner 11, 16) results in the full integration of the literary absolute as an institutional rationale.[6]

Larger metaphysical and political issues are at stake in the development of literature as theory than the modest scope of academic literary criticism would lead one to conclude. For in modeling the autoproduction of reflection, Lacoue-Labarthe and Nancy emphasize, literature is finally an absolute not of poetry but of "poiesy or, in other words, production":

> Romantic poetry sets out to penetrate the essence of poiesy, in which the literary thing produces the truth of production in itself, and thus, as will be evident in all that follows, the truth of the production *of itself*, of autopoiesy. And if it is true (as Hegel will soon demonstrate, *entirely against* romanticism) that auto-production constitutes the ultimate instance and closure of the speculative absolute, then romantic thought involves not only the absolute of literature, but literature as the absolute. (12; italics in original)

The literary absolute thus "aggravates and radicalizes the thinking of totality and the Subject" (15), and thereby becomes the privileged other of philosophy, at once the object of philosophy's desire and an excess toward which philosophy must maintain a reserve. For our purposes two

consequences bear emphasizing. (1) This "Subject" remains in proximity to and possibly depends upon a linguistic model, since the thought of literature provides the Subject with its most immediate and exemplary self-image, though not necessarily with a fully reliable image: Hegel's hostility to Romanticism constitutes only one event in the well-known story of philosophy's profound ambivalence toward literature. This ambivalence, about which more remains to be said below, arguably informs even Lacoue-Labarthe and Nancy's analysis of it. (2) The Subject, in its historicity, comes into being as *Bildung*, "the putting-into-form of form" (Lacoue-Labarthe and Nancy 104). Although the complex itinerary of the concept of *Bildung* in German and Western European intellectual history can only be suggested here, it is instructive to recall Hans-Georg Gadamer's authoritative description of *Bildung* in *Truth and Method*, lest it be imagined that Lacoue-Labarthe and Nancy are overstating their case. Since *Bildung* is grounded in a linguistic model — in the literary absolute as the autoproductivity of language — Gadamer unsurprisingly claims that this concept's signifier already contains in miniature a fusion of process, telos, and self-representation: "In *Bildung* there is *Bild*. The idea of 'form' lacks the mysterious ambiguity of *Bild*, which can mean both *Nachbild* ('image,' 'copy') and *Vorbild* ('model')" (12). And since *Bildung*, as the representation of its own striving, "remains in a constant state of further continued *Bildung*," it achieves the autoproductivity of nature: "It is not accidental that in this the word *Bildung* resembles the Greek *physis*. Like nature, *Bildung* has no goals outside itself." Such natural acculturation is necessarily universal in its destiny: "It is the universal nature of human *Bildung* to constitute itself as a universal intellectual being" (13).

Signifying both *Nachbild* and *Vorbild*, *Bildung* encloses the structure of mimesis itself, which, through the temporalizing prefixes *nach* and *vor*, becomes the structure of typology: *Bildung* mirrors and prefigures its own fulfillment in history. *Bildung* draws out the political project inherent in the literary absolute (as Subject) by drawing out autoproduction as education. The autoproduction of the literary or speculative absolute lies in its representing-itself-to-itself, its identifying with itself: its process or historicity consists in its ongoing identification with an identity that is its own. *Bildung* makes overt the aesthetic or speculative absolute's pragmatic claim to realize itself in the phenomenal world — to form and inform pedagogical and historical process. Aesthetics in this sense *is* aesthetic education, as Schiller's influential treatise *On the Aesthetic Education of Man* suggests:

> Every individual man, one may say, carries in himself, by predisposition and determination [*der Anlage und Bestimmung nach*], a pure ideal Man, with whose unchanging oneness it is the great task of his being,

in all its changes, to correspond. This pure Man [*reine Mensch*], who makes himself known more or less clearly in every subject [*Subjekt*], is represented by the State, the objective and as it were canonical form in which the diversity of subjects seeks to unite itself. (Letter 4, par. 2)

It would be difficult to find a more compact rendering of the essence and itinerary of *Bildung,* which appears here in its full anthropological determination as the aesthetic unveiling of "man," a pragmatic process of autoproduction-as-identification that is both predestined and a "great task." The temporal unfolding of history separates the subject from the Subject, and it is in the gap of this temporal difference that the political force of *Bildung* inheres. It is not simply that the subject discovers the objective form of its own ideality in the State, though this is certainly consequential for the generally conservative political character of aesthetic ideologies. It is even more crucial, however, that the difference between subject and Subject allows the latter to reveal itself "more or less clearly" depending on the stage of development that the former occupies. Any particular subject, to the precise extent that it remains particular, will always be moving toward full self-realization, just as every determinate State will remain "more or less" what Schiller calls a "dynamic state," moving toward the "moral" or Aesthetic State that forms the telos of *Bildung.* However, as an aesthetic event, *Bildung* demands phenomenal manifestation: this is to say, that it requires a figure, a *Bild,* exemplifying and prefiguring the identity underlying *Bildung*'s difference and deferral. In the concordant discord of history, then, certain subjects and states can, indeed must, become exemplary. They will always fall short of their own exemplarity, but exemplarity inheres in this very shortfall: *Bildung,* as Gadamer says, "remains in a constant state of further continued *Bildung.*" It is thus inherent in the logic of aesthetic education that Schiller's treatise should regress from the universalist promise of its title to the less democratic model of history suggested in the text's conclusion: "as a need, [the aesthetic state] exists in every finely attuned soul; as a realized fact, we are likely to find it, like the pure Church and the pure Republic, only in some few chosen circles" (27.12). And as a discourse of exemplarity, *Bildung* or aesthetic education acquires a fully hegemonic character: the "few chosen circles" of subjects capable of identifying with the universal Subject are the social groups that are by definition capable of representing mankind to itself. These few acquire the ability to identify with "pure ideal Man" by actualizing, through acculturation, their inherent human ability to perform an aesthetic judgment — a disinterested, formally universal judgment that enacts the individual subject's point of contact with the formal universality of humanity, thus providing the subject with what Schiller calls "the gift of humanity itself"

(21.5). And since the process of acculturation or *Bildung* that actualizes this potential will always in turn be found to have manifested itself most purely in a historically specific site (classical Greece; Germany, England, or, more generally, Europe; the educated classes; the male psyche; and so on), the narrative of *Bildung* has real political significance and is in fact inseparable not just from the rhetoric of class struggle and colonial administration in the nineteenth century, but more generally from the very thought of history itself, as the "individual narrative of self-formation is subsumed in the larger narrative of the civilizing process, the passage from savagery to civility, which is the master narrative of modernity" (Lloyd 134).[7]

This account of *Bildung* is admittedly sketchy, given that, as Lacoue-Labarthe and Nancy remark, the concept "brings together shaping and molding, art and culture, education and sociality, and ultimately history and figuration" (36), but it returns us to the task—mercifully limited in some respects, far-reaching in others—of understanding what happens when *Bildung* acquires the suffix *Roman* and the institution of criticism is forced to confront more directly its origins in the question of literature. As already indicated, the findings are ambiguous. It should at least be more obvious at this point why studies of the Bildungsroman generally display a deep investment in this genre's existence, since it can now be established that the bildungsroman exhibits a certain modality of the literary absolute in offering itself as the literary form of *Bildung*. If, as Lacoue-Labarthe and Nancy claim, the literary absolute "aggravates and radicalizes the thinking of totality and the Subject," and if *Bildung* names the actualization of the Subject as pedagogy—as the story of an "education in life"—then the notion of the bildungsroman returns us to the literary armed with what Schiller would call "the determination [we] have received through sensation": the literary will now be absolute only as a mirror for the anthropological subject of *Bildung*.[8] And if criticism depends upon literature (as theory) to furnish it with the model of its own possibility, and if the bildungsroman is the pragmatic, humanist rewriting of literature-as-theory, then it is understandable that criticism as an institution, like Lacan's infant before its mirror, should perform a "jubilant assumption of its specular image" when faced with the notion of this genre—and should therefore find itself subject to a certain irreducible paranoia, since, as we have seen, the bildungsroman is quite possibly a "phantom" genre (Sammons 239).

And since the literary object recedes from the genre that purports to subjectify it, the question of the literary absolute and its relation to aesthetics must be taken up again. Lacoue-Labarthe and Nancy occasionally suggest literature's irreducibility to the Subject, but their pathbreaking study tends to underplay or forget the most incisive gesture in Walter Benjamin's thesis: his contention that Romantic criticism understands "reflection in

the absolute of art" to be in the strictest sense *nonsubjective,* an "I-less re-flection" *(Ich-freie Reflexion;* 40).[9] "What is at stake in Benjamin's account," Samuel Weber affirms, "is nothing less unusual, idiosyncratic, or, if you prefer, original, than the effort to elaborate a notion or practice of 'reflex-ivity' that would not ultimately be rooted in the premise of a constitutive subject" (310). Weber's commentary elucidates nonsubjective reflection in terms of what Benjamin calls "the irony of form," which Weber unpacks as "a practice of writing which, precisely by undermining the integrity of the individual form, at the same time allows the singular 'work' to 'survive'" (315). Rather than represent an internalization of reflection as subjectivity, this irony would reside in the excess of form over its own self-constitution *as* form: in the mechanical linguistic repetitions that destroy the singularity of the artwork while permitting it to emerge. This mechanical element in art is what Benjamin calls the prosaic, and criticism, Benjamin writes, exists as a strange form of presentation [*Darstellung*] of this prosaic nucleus:

> Criticism is the presentation of the prosaic kernel in each work. The concept "presentation" is thereby to be understood in the chemical sense, as the generation of one substance [*Erzeugung eines Stoffes*] through a determinate process to which others are subjected [*unter-worfen*]. This is what Schlegel meant when he said of Wilhelm Meister that the work "does not merely judge itself, it also presents itself [*stellt sich dar*]." (109)

Commenting on this difficult passage, Weber draws attention to its sacri-ficial logic: "The romantic idea of criticism thus turns out to consist in a process of 'subjection': 'others' are subjected so that something can *matter.*" And then, tacitly reversing the poles of Benjamin's chemical analogy, he continues: "As a result of this subjection to the other, criticism 'stellt sich dar,' *sets itself forth,* sets forth, departing from itself to become something else, something lacking a proper name and which Benjamin, and after him de Man, will call 'allegory'" (317; emphasis in original). It is perhaps not im-mediately clear how or to what criticism subjects itself in this passage, but Weber's proposed reversal, though unexplained, is consequent: criticism is always the criticism or "Darstellung" of itself, and thus is a subjection of itself to an alterity which is itself. All of the terms in this sacrificial story can in fact be substituted for each other, as Benjamin's passive and para-tactic syntax allows either "criticism" or the "prosaic kernel" to occupy the place either of "the one substance" or of the "others." It must be noted that this narrative is still essentially that of *Bildung,* when *Bildung* is unfolded to its full dialectical model and understood as the ironic understanding of its own impossibility. But there is another story mapped onto the sacrifi-cial and substitutive one both in Benjamin's text and in Weber's, legible in

the political term "subjection": the story of an *Unterwerfung,* a sub-jection or "throwing under" of a plural otherness. In this sense the anonymous "others" in Benjamin's sentence have no existence except as placeholders for the violence of the "determinate process" of *Darstellung:* they are thus irrecuperable, inaccessible to the substitutive process that they make possible. The sacrificial exchange, which leads back to the autoproductive world of natural production (*Erzeugung*) and *Bildung,* could not exist without this violent *Unterwerfung,* which nonetheless remains radically heterogeneous to it. The "thrown-under" others thus reiterate an alterity irrecuperable to, yet constitutive of, the *subject;* this is also to say that they mark the mechanical insistence that Benjamin, deliberately contesting the subjectivist model of irony, terms the "irony of form." Criticism, the "presentation" of this irony, is thus the figure of its own unwitting and unstoppable "subjection," an ongoing throwing-under of understanding that, as Weber reminds us, is what "Benjamin, and after him de Man, will call 'allegory.'"

What this might mean becomes clearer on examining the passage to which Benjamin refers us in Friedrich Schlegel's famous essay on *Wilhelm Meister.* For Schlegel, *Wilhelm Meister* is so "thoroughly new and unique" a text that it can only be understood "in itself [*aus sich selbst*]" (133); when reading it we must exercise what Kant would call a purely reflective judgment, deriving our generic concept [*Gattungsbegriff*] from the object in its particularity:

> Perhaps one should thus at once judge it and not judge it—which seems to be no easy task. Luckily it is one of those books that judge themselves, and so relieve the critic of all trouble. Indeed, it doesn't just judge itself; it also presents itself [*stellt sich auch selbst dar*]. (133–34)

Critical representations of the text "would be superfluous [*überflüssig*]." But the strange order of *Darstellung* that Benjamin read in the formation of the literary absolute insures that a certain reading, however superfluous, will be called for. A few sentences later we read that the novel "disappoints as often as it fulfills customary expectations of unity and coherence," and that it in fact fails to judge itself insofar as it fails to pass from the level of the particular to that of the general—a failure that signals the return of the formerly "superfluous" reader:

> If any book has genius, it is this one. If this genius had been able to characterize itself in general as well as in particular, no one would have been able to say anything further about the novel as a whole, and how one should take it. Here a small supplement [*Ergänzung*] remains possible, and a few explanations will not seem useless or superfluous

[*kann nicht unnütz oder überflüssig scheinen*]. . . . [T]he beginning and
the ending of the novel will generally be found peculiar and unsat-
isfactory, and this and that in the middle of the text will be found
superfluous and incoherent [*überflüssig und unzusammenhängend*].
And even he who knows how to distinguish the godlike from artistic
willfulness will feel something isolated in the first and last reading, as
though in the deepest and most beautiful harmony and oneness the
final knotting of thought and feeling were lacking. (133–34)

The text judges itself but does not judge itself; it accounts for its own
particularity but fails to inscribe itself in a genre (*Gattung*). And the
reader, initially suspended between judging and not judging, then made
überflüssig by the text's self-reflexive power, finally becomes a supplement
(*Ergänzung*) that is *nicht überflüssig*. This reader, a master reader who
knows how to distinguish "the godlike from artistic willfulness," performs
an aesthetic judgment and necessarily finds the text wanting—just as
critics once found Shelley or Rousseau or Romanticism wanting, and just
as Hegel, in the *Aesthetics*, was to find Schlegel's work of an "indefinite
and vacillating character," "sometimes achieving too much, sometimes too
little" (63). But nothing could be more suspect than this magisterial act of
judgment, for it has been generated by the text's inability to account for
itself—a predicament replayed in the lucid incoherence of Schlegel's own
theoretical narrative.

Theory, here, is "literary" precisely to the extent that it is unable to
know its own origin, as the literary recedes from theory in the very act
of constituting it. Theory becomes theory out of self-resistance: a paradox
nicely exemplified by Lacoue-Labarthe and Nancy's *The Literary Absolute*,
which achieves its insight into the Subject's dependence on literature only
by remaining blind to what Benjamin conveys to us as literature's dis-
ruptive *subjection* of the Subject.[10] In thinking about such "subjection" in
rhetorical terms as a nonsubjective, formal irony, Benjamin remains faith-
ful to Schlegel's own much-misunderstood presentation of irony. In the
passage just examined, for instance, irony must be thought of precisely
in Benjamin's terms as an excess of exemplarity or of form, a surplus or
remainder that produces the judging subject by disrupting the dialectical
passage from particular to general. When Schlegel goes on to character-
ize *Wilhelm Meister* in terms of "the irony that hovers over the whole
work" (137), he is referring to a textuality that, in this most exemplary
of texts, is *überflüssig und unzusammenhängend,* "as though in the deepest
and most beautiful harmony and oneness the final knotting of thought
and feeling were lacking."[11] And thus when Lacoue-Labarthe and Nancy
observe that irony is "the very power of reflection or infinite reflexivity—

the other name of speculation" (86), they are in a crucial sense very far from Schlegel and paradoxically close to the formulations that Hegel directs against Schlegel in the name of speculative thought, when he defines irony in the *Aesthetics* as "the principle of absolute subjectivity" (67) and condemns its "concentration of the ego into itself, for which all bonds are snapped and which can live only in the bliss of self-enjoyment. This irony was invented by Friedrich Schlegel, and many others have babbled about it or are now babbling about it again" (66).

When Hegel goes on to insist, in the raised tone that so frequently accompanies his discussions of irony, that "if irony is taken as the keynote of the representation, then the most inartistic of all principles is taken to be the principle of the work of art" (68), he is identifying criticism's failure as a failure to prevent irony from causing criticism to fail to become criticism. Literature is another name for this failure, and the bildungsroman is an exemplary site in which criticism's failure and its failure to fail become legible as the simultaneous co-implication and incompatibility of literature and aesthetics, thanks to the illegibility of "the most inartistic of all principles," irony. Irony, in this sense, may be termed Romantic, but only if one understands Romanticism as another version of the literary event: the event of a literariness "absolute" only in its irreducibility to a subjectivism and a humanism that it nonetheless inspires.

Notes

1 For a survey of the history of the term "Romantic," see Wellek 2–22.

2 To say this is not in any way to deny that the term "Romanticism" functions quite effectively as what John Rieder calls a "sign of specialization" within the bureaucratic university — that is, as a sign that "projects a blandly obvious homogeneity of endeavor to the outside, and yet constitutes itself internally as a continual reworking and redefinition of its substance" (9), thereby allowing a "field" to be marked out, funded, and reproduced. The institutional power of the term does not close off its uncertainty, however, insofar as Romanticism may be understood to name the emergence of, among other things, the modern pedagogical institution itself, particularly as regards the study and teaching of literature, as we shall see.

3 For a representative text from the modernist period, see Hulme. The opposition of classicism to romanticism was popularized by A. W. Schlegel and Mme de Staël in the early nineteenth century; see Wellek 8–9.

4 Compare with Woodmansee, who claims that the associationist aesthetic of Francis Jeffrey "rings refreshingly current" when contrasted with the "abstraction from . . . local affiliations or 'interests'" demanded by "Coleridgean" notions of art (127, 132). Woodmansee's binary exaggerations (conjuring a Jeffrey whose aesthetic is devoid of all "abstraction," a Coleridge hostile to "local affiliations") labor in the service of a Romantic humanism that remains unquestioned. This is as good a place as any to note the appearance of Francis Jeffrey in McGann, who, confronting "the now widespread

idea that Romanticism comprises all significant literature produced between Blake and the present," ventriloquizes the famous opening sentence of Jeffrey's hostile review of the *Lyrical Ballads:* "This will never do" (20). It is a curious moment: a prominent, late-twentieth-century Romanticist performs a flashy act of identification with British Romanticism's symbolic opponent, precisely at a point in McGann's text in which McGann's own involvement in Romanticism is being summoned up and negotiated.

5 See my *Phantom Formations*, especially ch. 2, from which the foregoing and all subsequent paragraphs in the present essay have been extracted and adapted.

6 I thank John Rieder for drawing my attention to Warner's essay. Graff provides the classic account of the struggle between philologists and belletristic critics during the early years of the integration of literature into the university in the United States. For a history of English studies in Britain, see Baldick, and for the development of professional literary study in France, Germany, and Spain, see, respectively, Compagnon, Hohendahl, and Godzich and Spadaccini.

7 This "master narrative" is interwoven through the modern bureaucratic state in numerous ways, not the least as the story of what Friedrich Kittler calls the socialization ("Über die Sozialisation"), and Michel Foucault the disciplining, of subjects. Exemplary or aesthetic pedagogy occurs not just as metanarrative but as the concrete and microscopic practices summarized as the civilization or socialization of a self. The institutions responsible for *Bildung* in this sense would include the nuclear family, the schools, and certain forms of mass media, as well as the university; and, as Kittler suggests, the institution of literature has an important role to play in this scenario: not just as a discourse exemplifying national or ethnic identity, but as a pedagogical instrument central to the production of "individuals" on all levels of the socialization process. See Kittler, *Discourse Networks* 3–173, for a discussion of the new centrality of the mother in primary education around 1800 (such that she becomes the *Bildnerin*, the erotic site of *Bildung*'s origins [50]) and an analysis of coeval developments in German educational bureaucracies and in technologies of pedagogy and reading. Kittler's reading of the role of the bildungsroman in this context is most fully laid out in his long essay "Über die Sozialisation." For a Foucauldian reading of *Bildung*, see von Mücke 161–206. For a helpful study of the idea of *Bildung* in nineteenth-century German thought, see Bruford.

8 See Schiller, letter 20, par. 3. My citation from Schiller alludes to the aesthetic moment proper in his theory: the point at which the subject, having passed through sensuous determination and developed the autonomous power of reason, must harmonize these faculties in a moment of disinterested free play: "we must call this condition of real and active determinability the *aesthetic [den ästhetischen]*" (20.4; Schiller's italics).

9 The "strictest sense" in this context is Fichtean.

10 The resistance of theory to itself is one of the central themes of the work of Schlegel's closest modern reader, Paul de Man; see the title essay in *The Resistance to Theory* (3–20). For a shrewd critique of Lacoue-Labarthe and Nancy's *Literary Absolute* along de Manian lines, see Newmark.

11 Irony here is the "permanent parabasis" of Schlegel's famous Fragment 668; see the *Kritische Friedrich-Schlegel Ausgabe* 18: 85.

Works Cited

Abrams, Meyer. *Natural Supernaturalism: Tradition and Revolution in Romantic Literature.* New York: Norton, 1971.

Baldick, Chris. *The Social Mission of English Criticism, 1848–1932*. Oxford: Clarendon, 1983.

Benjamin, Walter. "Der Begriff der Kunstkritik in der Deutschen Romantik." *Gesammelte Schriften*. Ed. Rolf Tiedemann and Hermann Schweppenhäuser. Frankfurt: Suhrkamp, 1974. 7–122.

Blanchot, Maurice. "The Athenaeum." Trans. Deborah Esch and Ian Balfour. *Studies in Romanticism* 22.2 (1983): 163–72.

Bruford, W. H. *The German Tradition of Self-Cultivation: Bildung from Humboldt to Thomas Mann*. Cambridge: Cambridge UP, 1975.

Compagnon, Antoine. *La Troisième République des lettres, de Flaubert à Proust*. Paris: Seuil, 1983.

de Man, Paul. *The Resistance to Theory*. Minneapolis: U of Minnesota P, 1986.

Foucault, Michel. *Discipline and Punish: The Birth of the Prison*. Trans. Alan Sheridan. New York: Vintage, 1979.

Gadamer, Hans-Georg. *Truth and Method*. New York: Crossroad, 1982.

Godzich, Wlad, and Nicholas Spadaccini, eds. *The Crisis of Institutionalized Literature in Spain*. Minneapolis: Prisma, 1988.

Graff, Gerald. *Professing Literature: An Institutional History*. Chicago: Chicago UP, 1987.

Hegel, G. W. F. *Aesthetics: Lectures on Fine Art*. Trans. T. M. Knox. Oxford: Clarendon, 1975.

Hohendahl, Peter. *The Institution of Criticism*. Ithaca: Cornell UP, 1982.

———. *Building a National Literature: The Case of Germany, 1830–1870*. Trans. Renate Baron Franciscono. Ithaca: Cornell UP, 1994.

Hulme, T. E. "Romanticism and Classicism." *The Collected Writings of T. E. Hulme*. Ed. Karen Csengeri. Oxford: Clarendon, 1994. 59–73.

Jeffrey, Francis. "The Excursion, being a portion of the Recluse, a Poem. By William Wordsworth." *Edinburgh Review* 47 (Nov. 1814): 1–30.

Kittler, Friedrich A. "Über die Sozialisation Wilhelm Meisters." *Dichtung als Sozialisationsspiel: Studien zu Goethe und Gottfried Keller*. By Gerhard Kaiser and Friedrich A. Kittler. Göttingen: Vandenhoek und Ruprecht, 1978. 13–124.

———. *Discourse Networks, 1800/1900*. Trans. Michael Metteer, with Chris Cullens. Stanford: Stanford UP, 1990.

Lacoue-Labarthe, Philippe, and Jean-Luc Nancy. *The Literary Absolute: The Theory of Literature in German Romanticism*. Trans. Philip Barnard and Cheryl Lester. Albany: State U of New York P, 1988.

Lloyd, David. *Anomolous States: Irish Writing and the Post-Colonial Movement*. Durham: Duke UP, 1993.

Lovejoy, A. O. "On the Discriminations of Romanticisms." *PMLA* 39 (1924): 229–53.

May, Kurt. "'Wilhelm Meisters Lehrjahre,' ein Bildungsroman?" *Deutsche Vierteljahrsschrift für Literaturwissenschaft und Geistesgeschichte* 31 (1957): 1–31.

McGann, Jerome J. *The Romantic Ideology: A Critical Investigation*. Chicago: U of Chicago P, 1983.

Newmark, Kevin. "*L'absolu littéraire*: Friedrich Schlegel and the Myth of Irony." *MLN* 107 (1992): 905–30.

Praz, Mario. *The Romantic Agony*. Trans. Angus Davidson. Oxford: Oxford UP, 1970.

Redfield, Marc. *Phantom Formations: Aesthetic Ideology and the Bildungsroman*. Ithaca: Cornell UP, 1996.

Rieder, John. "The Institutional Overdetermination of the Concept of Romanticism." *Yale Journal of Criticism*. Forthcoming.

Sammons, Jeffrey. "The Mystery of the Missing *Bildungsroman*, or: What Happened to Wilhelm Meister's Legacy?" *Genre* 14 (1981): 229–46.

Schiller, Friedrich. *On the Aesthetic Education of Man, in a Series of Letters.* Bilingual edition. Ed. and trans. Elizabeth M. Wilkinson and L. A. Willoughby. Oxford: Clarendon, 1967.

Schlegel, Friedrich. "Über Goethes Meister." 1798. *Kritische Friedrich-Schlegel Ausgabe.* Ed. Ernst Behler. Vol. 2. Munich: Paderborn, 1967.

von Mücke, Dorothea. *Virtue and the Veil of Illusion: Generic Innovation and the Pedagogical Project in Eighteenth-Century Literature.* Stanford: Stanford UP, 1991.

Warner, Michael. "Professionalization and the Rewards of Literature: 1875–1900." *Criticism* 27.1 (1985): 1–28.

Weber, Samuel. "Criticism Underway: Walter Benjamin's *Romantic Concept of Criticism.*" *Romantic Revolutions: Criticism and Theory.* Ed. Kenneth R. Johnston et al. Bloomington: Indiana UP, 1990. 302–19.

Wellek, René. "The Concept of 'Romanticism' in Literary History." *Comparative Literature* 1.1 (1949): 1–23, 147–72.

Woodmansee, Martha. *The Author, Art, and the Market: Rereading the History of Aesthetics.* New York: Columbia UP, 1994.

The Inhibitions of Democracy on Romantic Political Thought: Thoreau's Democratic Individualism

NANCY L. ROSENBLUM

*C*omparative studies of romanticism demonstrate how a common set of criticisms is textured and refined in response to particular political cultures, and one purpose of this essay is to demonstrate that Thoreau's aversions to ordinary society and claims of exceptionalism are American variations on familiar romantic themes. Their interest for political theory is in the way Thoreau tempers his romantic criticism in deference to the inhibitions of American democracy—how democratic equality and the necessary minimum of respect for others constrain his romantic impulses to self-distancing and detachment.

Romanticism's interest for political theorists is heightened if social criticism translates into constructive political thought. The standard repertoire of justifications for democracy includes protecting popular interests, moral education through political participation, and democratic deliberation as the ideal mechanism for distributive justice. Thoreau proposed another, distinctively romantic justification: democracy as the political order that best corresponds to the romantic sense of infinite potentiality. For all its failed revolutionary promise and the massive shame of slavery at its heart, Thoreau saw American democracy as the most hospitable order yet devised for the intense experience and expression of a many-sided self—by potentially innumerable individualists. The inhibitions of democracy both shape Thoreau's social criticism and enable him to move beyond romantic aversion and disassociation to positive reconciliation.

Romantic Aversion and Social Criticism

Thoreau's litanies of discontent with the prosaic, outpourings of ridicule and disdain, and defiant gestures of isolation and retreat are familiar to any student of romanticism—English, continental, or American. He shares the general romantic critical agenda, which entails contrasting heightened

experience and the insufferably mundane. "Wherever a man goes, men will pursue and paw him with their dirty institutions, and, if they can, constrain him to belong to their desperate odd-fellow society" (*Walden* 171). The quiet desperation of his neighbors, "always on the limits, trying to get into business and trying to get out of debt" (*Walden* 6), struck Thoreau as it has every romantic, as averse to poetry and philosophy and finally unproductive: "The twelve labors of Hercules were trifling in comparison with those which my neighbors have undertaken . . . but I could never see that these men slew or captured any monster or finished any labor" (*Walden* 8). Few comments could be more disdainful of the American belief in the dignity of work and the public obligation to work; whereas even Frederick Douglass defined freedom as industry and enjoyment of gains—as the very opposite of the degraded labor of slaves—Thoreau saw slavery of another kind. Those commonly deemed good citizens, he wrote at his most aggressive, "put themselves on a level with wood and earth and stones . . . [They] command no more respect than men of straw or a lump of dirt. They have the same sort of worth only as horses and dogs" ("Resistance" 66).

When Thoreau writes "Our foe is . . . the all but universal woodenness of both head and heart, the want of vitality in man . . ." ("Plea" 162), he says "our" here, but "I" and "you" are the dominant pronouns.[1] "It is evident what mean and sneaking lives many of you live," he writes in *Walden* (6), "seeking to curry favor . . . lying, flattering, voting, contracting yourselves into a nutshell of civility, or dilating into an atmosphere of thin and vaporous generosity." His criticism is accompanied by familiar assertions of romantic exceptionalism. The thought that "authors are a natural and irresistible aristocracy in every society, and, more than kings or emperors, exert an influence on mankind" is nothing new (*Walden* 103). Neither is Thoreau's affinity for extraordinary souls: "If one listens to the faintest but constant suggestions of his genius, which are certainly true, he sees not to what extremes, or even insanity, it may lead him; and yet that way, as he grows more resolute and faithful, his road lies . . ." (*Walden* 216). His description of the expressive imperative could have been written by any number of Romantics, by Nietzsche: "I perceive that, when an acorn and a chestnut fall side by side, the one does not remain inert to make way for the other, but both obey their own laws, and spring and grow and flourish as best they can, till one, perchance, overshadows and destroys the other. If a plant cannot live according to its nature it dies; and so a man" ("Resistance" 81).

Nothing makes Thoreau's aversion clearer or is more calculated to "épater la bourgeoisie" than his recurrent attack on domesticity. Antidomesticity comes in several modes (Byron's don Juan despised petty contentments, for example), but romantic militarism is the most power-

ful, whether it takes the form of exhilarating revolutionism or the cult of Bonaparte. Even the conservative Chateaubriand lamented that "the palace of the Tuileries, so clean and soldierly under Napolean, began to reek, instead of the smell of powder, with breakfast odours which rose on every side . . . everything resumed an air of domesticity" (290). Militarism's attraction for romantic sensibilities is clear: war is not work; heroism is not business as usual; the army is a brotherhood of soldiers, which Alfred de Vigny described as a "sacrificial family" (107) and which excluded women, who are held responsible for the breakfast odors Chateaubriand despised.

From his early essay, "The Service," to his last essays on John Brown, Thoreau resorts to military terms to describe his self-reliance and detachment from the unabidably prosaic: "You must live within yourself, and depend upon yourself, always tucked up and ready for a start, and not have many affairs" ("Resistance" 78). Of course, in his political tracts Thoreau's rejection of domesticity served a specific purpose: by not needing to rely on government's protection for family and property he demonstrates the seriousness of his disavowal of political allegiance. But the dominant impetus is romantic aversion to the drearily mundane, and Thoreau's self-distancing from everything domestic is thorough. He entertains no alternative republican vision of the family as a school of civic virtue. He does not single out bourgeois family life for attack, or find in the poor moral relief from the middle-class household's obsession with luxury and consumption. Thoreau's description of John Field's home and family in *Walden* communicates unrelieved revulsion. Instead of the innocent Wordsworthian child, there is a "poor starvling brat" and a "wrinkled, sibyl-like cone-headed infant," and there is Field's wife "with round greasy face and bare breast thinking to improve her condition one day; with the never absent mop in her hand, and yet no effects of it visible anywhere" (*Walden* 204).[2] The sentimental family as haven turns stifling: household echoes haunt, and life "breathes its own breath over and over" (*Walden* 208). Thoreau will have none of it: "I kept neither dog, cat, cow, pig, nor hens, so that you would have said there was a deficiency of domestic sounds; neither the churn, nor the spinning-wheel, nor even the singing of kettle, nor the hissing of the urn, nor children crying, to comfort one" (*Walden* 127). And no women.[3]

Thoreau's romantic assaults and claims of exceptionalism are repeatedly offset, however, by the inhibitions of democracy. He confronts American democracy as an unalterable social and political reality, but he takes its principal tenets as his own, and democratic equality constrains his disdain and impulse to withdraw. The problem for Thoreau is how to announce his estrangement without adopting an aristocratic ethos, without violating the primary inhibition of democracy by characterizing individuals

as constitutionally unequal by birth, and without making it impossible to retain the modicum of respect for others without which democracy is pure formalism. It is one thing to call his neighbors "a distinct race from me by their prejudices and superstitions, as Chinamen and Malays are" ("Resistance" 83) and to feel that "*they* are our Austrias, and Chinas, and South Sea Islands" ("Plea" 121). It is another to indulge romantic exceptionalism in terms of unyielding biological or dispositional differences. Thoreau occasionally crosses the democratic line: differences of constitution, not streams and mountains, "make the true and impassable boundaries between individuals and between states" ("Plea" 122), for example, or, most threatening to democracy: "not all men can be free, even" ("Last Days" 149).

So a dizzying internal movement jogs Thoreau's writing—Romantic revulsion and self-distancing, but also backtracking from aloofness and tentative reconciliation in repeated succession.[4] The village Cape Codders are beautiful "only to the weary traveler, or the returning native, — or, perchance, the repentant misanthrope," Thoreau writes, leveling and immediately retracting the charge of philistinism (*Cape Cod* 30). His essays are littered with apologetic addenda and jogged by self-conscious halting: "This may be to judge my neighbors harshly" ("Resistance" 83). Hesitations and asides stand alone or are embedded in critical propositions: "When we heard at first that he [John Brown] was dead, one of my townsmen observed that 'he died as the fool dieth'; which, pardon me, for an instant suggested a likeness in him dying to my neighbor living" ("Plea" 118). Rhetorical devices for checking himself form just one element in the larger movement of Thoreau's thought in response to the inhibitions of democracy.

Responsiveness to the Inhibitions of Democracy:
Detachment and Doing Good

There is nothing new about a program of isolation as a condition for imaginative receptivity and creation, and Thoreau is famous for situating himself at some remove from daily society on the "neutral ground" of Walden Pond or Mount Ktaadn. The insights of literary critics who see escapism and displaced political criticism in romantic naturalism are blunted in Thoreau's case, since his political essays were contemporaneous with his writing about nature, and even the latter contains overt social commentary. In any case, no argument has yet been made to justify the assumption, implicit in this widespread charge of "displaced criticism," that a perfectly just or ideal society would undercut the imperative to withdraw to nature or render the experience of undisturbed feeling and immediate unity superfluous. Thoreau represents both his Wordsworthian appreciation of the "inde-

scribable innocence and beneficence of Nature" (*Walden* 138) and his "hard primitivism," the sublime experience of "Vast, Titanic, inhuman Nature," "more lone than you can imagine" (*Maine Woods* 64), as vital to well-being.[5]

Nonetheless, Thoreau's accounts of his withdrawal to Walden and Ktaadn do hold political interest insofar as they reflect his responsiveness to the inhibitions of democracy. The claim that both Walden Pond and the Concord jail are a "far country" is unremarkable except by contrast—Byron and Shelley were actual expatriates. In this company, Thoreau's romantic orthodoxies are less notable than the fact that he does not allow detachment to fatally separate him from his neighbors. We know that Walden Pond was within range of Concord, and Thoreau remarks on how close the Maine forests were. Both are available to anyone, and neither is more than a partial and temporary retreat.

More important, Thoreau's choice of escape is less hostile than alternative modes of romantic separation from society: the bohemianism of the pseudo-outlaw or proletariat or the dandyism of an aristocracy of sensibility, Coleridge's elite "pantisocracy," Byronic militancy, Promethean nay-saying, vulgar Nietzscheanism, or Napoleonism. Thoreau did not contemplate the bitter retreat of the wounded soul to a garret or some other scene of martyrdom. There is every difference between being driven mad by the slights of philistines and being drawn to Walden Pond. D.H. Lawrence's thought that "absolutely the safest thing to get your emotional reactions over is NATURE" (qtd. in Sayre 1) is confirmed in Thoreau's testament: "the most sweet and tender, the most innocent and encouraging society may be found in any natural object" (*Walden* 131). The point is precisely that Thoreau does *not* remove to some better company, real or imagined; there is no elite circle of beautiful souls or exclusive republic of letters. He does not indulge in the "soft primitivism" of the South Seas with its challenge of an ideal community or create domesticated pastorals; on the contrary, "from the desperate city we go to the desperate country." If Thoreau's declarations of solitude and self-reliance seem to cross the boundary out of democratic society, the affront is modulated and the way back kept open. In a dialogue in *Maine Woods,* Thoreau has Mt. Ktaadn advise him to return home.

A second instance of the inhibition of democracy at work is the way in which Thoreau tempers his most provocative exhibition of romantic exceptionalism: his repudiation of the common moral duties that accompany Christian and secular egalitarianism and that were vigorously promoted by the churches and reform societies of New England. His townsmen and women are devoted in many ways to the good of their fellows, Thoreau observes, but the profession "Doing-good" does not agree with his constitution (*Walden* 73). His references to "benevolent societies" are always

ironic, and he calls self-styled reformers the greatest bores of all. He wishes "one at least may be spared to other and less humane pursuits." His defiance borders on the unconditional: "Probably I should not consciously and deliberately forsake my particular calling to do the good which society demands of me, to save the universe from annihilation" (*Walden* 73).

Thoreau's disclaimer of the obligation to do good turns out to be neither misanthropy nor sheer romantic egotism. He means that too many have made it their mission to mind others' business when they should mind their own; that is Thoreau's definition of a good neighbor and the unexceptional caution behind "man is the artificer of his own happiness." A more profound point underlies the claim that "self-emancipation even in the West Indian provinces of the fancy and imagination,—what Wilberforce is there to bring that about?" Thoreau is advising that slavery is a *summum malum* but liberation per se is not a *summum bonum* (*Walden* 8). There is none. Absolute injustice does not have a positive counterpart. Emancipation offers little clue to the goods that are valuable or to a well-spent life ("be not *simply* good—be good for something"; emphasis in original). Ordinary philanthropy is premised on an array of assumptions about well-being and a good society Thoreau found doubtful. "Economy" is his exhaustive assessment of his own "necessaries of life," but they do not hold for everyone, or even for him for long. Because needs cannot be stereotyped, compassion always rests on untenable ground: "Love for one's fellow-man in the broadest sense" is not true philanthropy (*Walden* 74).

What is? "Be sure that you give the poor the aid they most need, though it be your example which leaves them far behind" (*Walden* 75). For Thoreau, the relation between personal life and social reform is the unplanned, unintended effect of heroic individuality. "I want the flower and fruit of a man; that some fragrance be wafted over from him to me" (*Walden* 27). True philanthropy is the spread of a constant superfluity, which costs the hero nothing and of which he is unconscious: "broadcast and floating in the air," seeds of virtue take root (*Walden* 164).

This definition of doing-good is a retreat from Thoreau's show of indifference to others. Still, it seems to confirm a romantic disregard for ordinary moral duty. There is only the weakest family resemblance to the benign moral influence preached by his friend Bronson Alcott. Thoreau's great man is a force of nature—a meteor, volcano, or vital seed—not defined by his exemplary relation to society, uncommitted to civic virtue or aristocratic service, a philanthropist despite himself.[6] Thoreau seems at his most detached and transcendental here, preoccupied with the ineffable "fragrance" of the hero and genius. But even here, on the subject of the influence of greatness, the inhibitions of democracy are at work. Tortuously

but decisively, democratic inhibitions recall Thoreau from imaginative flight to neighborly concern, from exceptionalism to equality.

It is worth considering this dynamic in some detail. Thoreau translated Aeschylus's *Prometheus Bound*, but his heroes, unlike that quintessential romantic rebel, are not gods or supermen. He drew his pantheon of heroes from wide reading in history and literature, but he found men he likened to heroes among his small local acquaintance: a Native American Penobscot, Joe Polis; the antislavery raider John Brown; the Concord woodcutter Alek Therien, a "true Homeric man." Nothing could be farther from Julien Sorel's lament in *The Red and the Black* that greatness has gone from the world and Napoleon's "fatal memory will keep us from ever being happy." Emerson, who wrestled with the same inhibitions of democracy as Thoreau, called his heroes "representative men," but except for Napoleon, Emerson's heroes are all unrepresentative great thinkers.[7] Carlyle's heroes are deliberate men of action like Cromwell (Carlyle 246). Emerson and Carlyle complement one another, Thoreau observes critically: they omit Christ, and a practical hero like Columbus, and "above and after all, the Man of the Age, come to be called workingman, it is obvious that none yet speaks to his condition" (Carlyle 238). Carlyle especially exaggerates the heroic in history: "The common man is nothing to him [Carlyle]," (244–45). The opening passage of *On Heroes* says as much: "The history of what man has accomplished in this world, is at bottom the History of the Great Men who have worked here" (3). The rest are there to be commanded.[8]

Thoreau never doubts that some men are extraordinary, but the inhibitions of democracy ward off the antidemocratic politics of genius that typically follow. There is no natural aristocracy to legislate or govern in Thoreau's political thought. There is no Nietzschean will to power. Thoreau's heroes do not excite erotic attachment, arouse collective passions, cultivate disciples, or inspire the cult of personality and mass mobilization that are often characterized as the political expression of romanticism. Certainly, Thoreau had no use for passive reverence. The hero serves others by showing us what we can be and do. He is an exemplar of individuality. So there is no absolute gap between the extraordinary individual and the rest. Anyone can learn from the spectacle of greatness.

Thoreau brings together romantic heroism and that article of faith shared by every party in America—the possibility of improvement. "We are all great men" is not a fact but a democratic aspiration. Thoreau preserves the necessary modicum of respect and intuitive understanding:

> Most men, even in this comparatively free country, through mere ignorance and mistake, are so occupied with the factitious cares

and superfluously coarse labors of life that its finer fruits cannot be plucked by them. Their fingers, from excessive toil, are too clumsy and tremble too much for that. . . . We should feed and clothe him [the common man] gratuitously sometimes, and recruit him with our cordials, before we judge of him. The finest qualities of our nature, like the bloom on fruits, can be preserved only by the most delicate handling. Yet we do not treat ourselves nor one another thus tenderly. (*Walden* 6)

The democratic hearth of Thoreau's account of heroism and genius follows from his notion of an exemplary life: for greatness to have historical effect the hero must be recognized. Consent is a principal democratic inhibition, and we see it operating in Thoreau's essays on John Brown. For Harper's Ferry to be the beginning of the end to slavery, John Brown must be acknowledged as great. Thoreau is apprehensive: "when a noble deed is done, who is likely to appreciate it? They who are noble themselves" ("Last Days" 148). His neighbors are not, and he pleads, "Do yourself the honor to recognize him." Thoreau is palpably relieved when other abolitionists come round to his view of Brown as heroic: "the *living* North, was suddenly all transcendental" ("Last Days" 147).

Democratic Individualism: Consent and Disobedience

The chief inhibition of democracy operates on Thoreau personally: he cannot "cast his whole influence" without his countrymen's consent, a constraint he accepts as a moral, not just a practical, imperative. Thoreau writes about representative democracy where legitimacy depends on popular support. The difficulty he faced was less articulating the political promise of independence as he saw it, or knowing what is right, than his own standing, a question he poses at the outset of *Walden* and returns to in his essays: "Who is Thoreau that others should listen to him?" How is it that speaking for himself ("We commonly do not remember that it is, after all, always the first person that is speaking"; *Walden* 3), he can truthfully say he is appealing "from them to themselves"? English and continental romantics did not have this problem. Disappointed with the French Revolution, they could revolutionize literature and adopt political conservatism. Postrevolutionary generations of European romantics could give free rein to aristocratic expressions of genius when repulsed by prosaic affairs and hounded by philistines, boast that their true peers are great souls across the ages, or enjoy the delicious martyrdom of the poet *maudit*.

Thoreau speaks to his fellow citizens with startling directness.[9] He does not soliloquize, or pose as a Nightingale singing for his own consolation,

or talk to God or to kindred spirits only. He is unwilling to identify with Shelley's unacknowledged legislator. His acute self-consciousness is alien to prophetic speech. Thoreau is not a bard speaking for others; the challenge is precisely how to speak for himself, to them. He does not "wish to quarrel with any man or nation . . . to split hairs, to make fine distinctions, or set myself up as better than my neighbors" ("Resistance" 86). He intends to avoid the mistake of positioning himself too close or too far: "One cannot be too much on his guard in such a case, lest his action be biased by obstinacy, or an undue regard for the opinions of men" ("Resistance" 84). Sheer self-assertion — "giving a strong dose of myself" — will not do. He needs to rely, if not on fellow feeling, then on some common ground.

Thoreau could have attempted to establish his standing on common moral ground, in Tom Paine's terms, say, as men rather than American citizens, pronouncing the rights of man and the "we" of common sense. This Enlightenment bond assumed universal moral agency, self-evident moral truths, and resistance to tyranny (though not always institutional democracy). Shelley invokes it with "man, equal, unclassed, tribeless, nationless." But Thoreau is averse to radical universal claims and does not appeal to natural rights. He does not imagine all interests can be harmonized. And the centrality of paradox in his writing challenges Paine's common sense directly.

An alternative course was mapped out by a generation of continental romantics: Wilhelm von Humboldt, Friedrich Schiller, and Benjamin Constant. All three began with a notion of the development of each individual into "a complete and consistent whole" and soberly considered the political conditions for cultivating individuality.[10] They judged men and women too weak to withstand the exertions of a tutorial state, whether these derived from political absolutism or the rigorous demands of revived civic republicanism. Individuals cannot develop collectively and in public. They offered a romantic justification for liberal, limited government and a severe public/private divide: constitutional bulwarks against official intrusion into personal life insured self-protective withdrawal. A privileged private sphere and circle of friends constituted the only imaginable context for self-cultivation and expression. Thoreau did not follow Humboldt and Constant in privileging privacy and insisting on vigilant self-protection against the claims of politics.

In contrast, and in response to the inhibitions of democracy, Thoreau addresses his neighbors as citizens of Massachusetts and the United States, and speaks to his "countrymen" "practically, and as a citizen" ("Resistance" 64). He finds common ground with readers as democratic individuals. Both elements of "democratic individualism" need emphasizing. Thoreau defines America as a constitutional regime when he opens "Civil Disobe-

dience" with the reminder that American government is a recent tradition dating from the revolution ("Resistance" 63). With this, he rules out appeal to America's religious tradition and continuity with the chosen people and their city on the hill (even maintaining that the French Jesuits' mission and morals were superior to the Puritans'). Thoreau addresses individuals in their political capacity. They are ultimately responsible for the support of political authority that may fatally interfere with *his* business or make him an agent of injustice. Democracy invites them to "cast [their] whole vote, not a strip of paper merely, but [their] whole influence" ("Resistance" 76). Thoreau's point was that American democracy throws individuals back on themselves. For it is equally clear that he was interested in democratic individualism, not collective identity. He did not identify the people or nation, as Wordsworth and Herder had, with a common history and culture. History offered no firm common ground, in his view. Slavery confronted the promise of independence and rhetoric of liberation with a massive contradiction from the start, which is why Thoreau did not talk of original promises or breaches of compacts. Racial and cultural differences, including the great divide between north and south, insured that any appeal to the authentic voice of an American people was in bad faith. *Dred Scott* showed definitively that "the people" officially excluded slaves and freed men, whom Thoreau explicitly counted as fellow citizens.

To understand the powerful hold democratic individualism had on Thoreau we must recall that he confronted a host of virulent, systematic ideologies propounding ascriptive inequality—including biblical and scientific racial theories and quasi-romantic assertions of historical and cultural identity and hierarchy. These were not examples of liberal hypocrisy, or rare exceptions to a hegemonic liberal-democratic ideology, residual pockets of irrational prejudice. They were powerful, independent forces in American political life. It is bad history and an awful error of moral judgment (to which scholars of romanticism are prone) to assume the existence of a liberal-democratic consensus and to characterize every tension as self-contradiction *within* democratic principles. If the only political categories we recognize are absent feudalism and socialism and pervasive bourgeois liberalism, we are likely to imagine that the inhibitions of democracy operated on Thoreau unconsciously or against his will. We are also likely to underestimate his hesitation to embrace romantic exceptionalism and his impulse to resist the thought that differences are absolute and unbridgeable.

Democratic individualism is Thoreau's common ground. It remains to show that although romanticism is tempered, democratic individualism has not lost its romantic resonance altogether. It is there in his pre-

occupation with the experience of democracy, of consent and dissent, for men and women personally, particularly in his insistence that democracy means "giving a strong dose" of oneself ("Life" 155). Romantic individualism wants recognition—not only the equal moral recognition that is supposed to accompany the rights of man and citizen but recognition for one's unique particularity. Thoreau offers himself as an example of what it means to give a strong dose of oneself, and his self-seriousness as a demonstration of true democratic respect for individuality.

For Thoreau speaks only from personal experience of government, and only about what attracts his attention. Chattel slavery may be an enormous evil, but it becomes his affair only when it reminds him of "slavery of all kinds" and the need for self-emancipation, or when government tries to make him an agent of injustice—when it is forcibly impressed on him that southern slavery entails "slavery in Massachusetts." Not even great political questions are permitted to eclipse his personal perspective on events. No action is right, whether or not it is commonly deemed moral, if it is not expressive. That, and not political efficacy, is the standard for "casting one's whole influence." Thoreau abhorred organizations, for example, and *he* did not join the local Vigilance Committee that aided fugitive slaves, though he acknowledged them as quasi-governments committed to protecting the weak and dispensing justice. *He* did not attack a federal arsenal. "I quietly declare war with the State, after my fashion."

"Comparatively Good" Government and Democratic Reconciliation

Thoreau despised docility. But there is more to democratic individualism than resistance, and political philosophy's single-minded focus on Thoreau as an advocate of civil disobedience is misleading.[11] Opposition is not the defining element of his romantic political thought. Opportunities to "cast one's whole influence" arise as part of a life in which men and women have other affairs to attend to, Thoreau reminds us. More than once in discussing the antislavery movement he repeats the caution, "I do not think it is quite sane for one to spend his whole life in talking or writing about this matter, unless he is continuously inspired, and I have not done so" ("Plea" 133). This is the same partial, conditional quality that characterized his detachment and account of Walden. Thoreau's horizon, with its "own sun and moon and stars, and a little world all to myself" (*Walden* 130), designates a sphere of aesthetic delight, philosophical contemplation, "epiphanic moments"; it sets his experiences apart from the mundane lives of his disconsolate neighbors and is the emblem of undemocratic retreat. But his self-distancing is measured: "I wish to speak a word for Nature, for

absolute freedom and wildness, as contrasted with a freedom and culture merely civil"—only a word (qtd. in Richardson 225). Thoreau always has "several more lives to live."

In "Slavery" Thoreau's thoughts move from preoccupation with injustice and regret that "remembrance of my country spoils my walk" to the successful resumption of his consideration of the water lily in nature, "partner to no Missouri Compromise" (108). We know that just as often his thoughts moved in the other direction. And that at still other moments Thoreau "to some extent reckoned himself" among "those who find encouragement and inspiration in the present condition of things, and cherish it with the fondness and enthusiasm of a lover" (*Walden* 16).

More broadly, then, Thoreau's "little world all to myself" suggests that every standpoint is one among other possible worlds. It evokes diverse and changing horizons. It brings to mind Thoreau's subversive attack on higher law and his antifoundationalism, his skeptical search for the "hard bottom" in *Walden* (70–71): "Let us settle ourselves, and work and wedge our feet downward through the mud and slush of opinion, and prejudice, and tradition, and delusion, and appearance . . . through poetry and philosophy and religion, till we come to a hard bottom"—all the while confident that the search for a "Realometer" will be disappointed, and finally giving himself over to "fish in the sky, whose bottom is pebbly with stars" (70–71). Thoreau is no systematic epistemologist, and we do not find an exploration of perspectivism on the order of Nietzsche's. We do, however, get a picture of romantic plentitude and fluid perspectivism, and insight into the fact that each entails a corresponding view of democracy.

Thoreau puts the authority of a single standard or standpoint on American democracy in doubt each time he speaks of laws, policies, or political representatives as "comparatively good." America is a "comparatively free country," for example (*Walden* 6). The U.S. Constitution is "comparatively good," he writes, and so is the railroad that runs through Concord.[12] Thoreau does not intend to compare the relative merits of American institutions to others, actual or ideal. And he takes for granted the divergent evaluations social groups make of a set of facts: the railroad running through Concord did not have the same significance for the poor Irish immigrants who built it, southern slaves escaping by it, and those who benefited most from the expanding national economy. The point is that Thoreau's own response to the railroad is alternately disturbed and thrilled (like Marx's estimate of the awesome productive power of modern industry; *Walden* 116, 118). The comparative mode indicates Thoreau's lack of a single fixed perspective. It invites readers not only to attend to others' standpoints but also to recognize that they assume more than one themselves.

66 Nancy L. Rosenblum

Thoreau's great perspectivist set piece, which appears toward the end of "Civil Disobedience" ("Resistance" 86), surveys his shifting orientations toward the U.S. government and Constitution:

—*"Seen from a lower point of view, the constitution, with all its faults, is very good; the law and the courts very respectable."* Thoreau has in mind the obvious advances of representative democracy over monarchy and the way American federalism and separation of powers provide a useful "friction" in the machinery of government. Moreover, the ordinary activities of government are expedient, and Thoreau is happy to pay his highway taxes. Laws may even contribute to private life and virtue: "the effect of good government is to make life more valuable . . ." ("Slavery" 106). From this perspective, citizens accede to authority at no great cost, and to real advantage.

—Thoreau continues: The state and American government *"are even in many respects very admirable and rare things, to be thankful for."* He means that representative democracy is the best design for creating and undoing political authority, because it sets off its partial and conditional character. Elections indicate the dependence of government on the consent of men and women personally and individually, and democracy invites individuals to give a strong dose of themselves. Also "very admirable and rare" is the fact that federal and state constitutions enumerate civil and political liberties. Thoreau was no fond legalist, but he closely followed the judicial treatment of fugitive slaves Thomas Sims and Anthony Burns, and insisted that government refused to recognize the dignity of the individual when basic rights of citizenship, among them habeus corpus and due process, were being denied. Massachusetts' Personal Liberty Laws were estimable. Thoreau had his moments of political affirmation.

—" . . . *but seen from a point of view a little higher, they are what I have described them."* Thoreau repeats his "harsh and stubborn and unconciliatory" stand that the Constitution is a proslavery document ("Resistance" 74). From this point of view, withdrawal of allegiance and personal resistance may be felt imperatives. It need not take an injustice like slavery to occasion this harsh view, either; government also inhibits democratic individualism by imposing its discipline on daily life through militarist conversion of men into "small moveable forts," or by reinforcing the expectation that everyone should engage in the sort of labor that contributes to national economic growth. Thoreau wrote before the rise of the welfare and disciplinary state, but conformity and tyranny of the majority were familiar enough. He knew all about the way individuals unreflectively internalize norms—that is, what leads to self-enslavement and "lives of quiet desperation." Thoreau was inspired to resist when government "fatally interfered with my lawful business" ("Resistance" 107).

—Finally, *"seen from higher still, and the highest, who shall say what they*

[the Constitution and government] *are, or that they are worth looking at or thinking of at all?"* Thoreau can abide the cranking of the machinery of government so long as he does not have to assist in its smooth workings. "Those things which now most engage the attention of men, as politics and the daily routine, are, it is true, vital functions of human society, but should be unconsciously performed, like the corresponding functions of the physical body. They are *infra*-human, a kind of vegetation" ("Life" 178; emphasis in original). Thoreau has his moments of detachment when he practically does not recognize the state.

From this standpoint, Thoreau briefly imagines that democratic government could reciprocate his unconcern by allowing a few of its citizens to live aloof, "not meddling with it, nor embraced by it" ("Resistance" 89). He contemplates a government that admits the need to obtain personal consent for every public measure and allows for individual exemptions from every obligation—not only on the rare high ground of conscientious objection but whenever an individual's affairs compel disagreement. We should hesitate to see this libertarian vision as a definitive political ideal, however. For Thoreau also observes that "to act collectively is according to the spirit of our institutions," and he can imagine government activism and a strong tutorial state. Why should public projects stop with highways, he asks: "New England can hire all the wise men in the world to come and teach her." Villages should "take the place of the nobleman of Europe" and be patrons of fine arts. They should foster magnanimity and refinement (*Walden* 109). Ordinarily, when a regime is characterized as "comparatively good," the question for political theory is what is the best form of government? But Thoreau has no interest in utopia; these suggestions are brief asides. His standpoint "higher still" is neither a foundation for political idealism nor a justification for retirement to his own little world.[13]

For Thoreau, the question is always, "How much must an individual have to do with democratic government at all?" By posing the question and admitting that he "sometimes practically does not recognize it at all," Thoreau indicates his ongoing relation to democracy, however tentative and intermittent, and even if government's contribution to well-being is only comparatively important. From the standpoint "higher still, and the highest," he is not prescribing a permanent stoic shift of consciousness within or supersensible transcendence. The point is to refuse to permit res publica to work to the detriment of res privata. Thoreau's answer is clear: He is not wholly taken up with romantic aloofness or contemplative transcendence, with active opposition, moral appreciation, or expedient acquiescence. He assumes all of these standpoints on democracy.

When Thoreau designates the perspective from which government is hardly worth thinking about as "higher still," he leaves things in the com-

parative mode. He parenthetically adds "and the highest" but does not assert that one perspective is better or truer than the rest, or that one enlists higher capacities so that the true self is identified with resistance, say, or contemplation. He does not try to willfully center himself by fixing his sights on one horizon or another, or propose that true or not, one perspective should master the others, if only for the sake of psychological peace or personal integrity. Thoreau accepts sometimes unpredictable and contrary perspectives in himself, and the fact that some experiences and ends are incompatible and only "comparatively good." Nothing is gained by invoking higher law or plumbing the depths for some integral nature, whether for the purposes of political theory or life; he must exploit the discontinuity of "several lives." These are the grounds on which liberal pluralists like Isaiah Berlin concede the contribution of romanticism to political theory: it "has permanently shaken the faith in universal, objective truth in matters of conduct, in the possibility of a perfect and harmonious society . . ." (237).

Finally, as the several perspectives Thoreau laid out in "Civil Disobedience" indicate, laws and government not only look different depending on where he stands but also excite the exhibition of different aspects of oneself. Despite its injustices and inhibitions, Thoreau saw representative democracy as the political complement of the romantic self, in which it can feel at home. He would have agreed with George Kateb that "individuality's meaning is not fully disclosed until it is indissociably connected to democracy" (78).

Conclusion: Romantic Political Thought

I have argued that Thoreau's romanticism is tempered by the inhibitions of democracy, and that duly constrained, romanticism characterizes his political thought. What is romantic political thought? Since there is no reason to assume an alignment between political opinion and aesthetic sensibility, it cannot be defined in terms of the political ideas writers identified with romanticism happen to adopt. Nor is there any justification for identifying romantic political thought exclusively with revolution on the one hand or with conservatism, reaction, or, more accurately, imaginative nostalgia for Catholic medievalism, Hellas, or folk traditions on the other.[14] Political aspirations are particularly unhelpful in defining romantic political thought in America, where the powerful inhibitions of democracy leave their mark on every variation from utopian communitarianism to Thoreau's democratic individualism.

Whether it is associated with beautiful hierarchy or perfect equality in a community of friends, romantic political thought has the unifying feature of holism. What distinguishes the holism of romantic political ideals

from that of philosophical idealists like Hegel are the peculiar gratifications held out by the former. Romantic holism is aesthetic and psychological rather than metaphysical or sociological. The romantic sensibility can feel at home there because its infinite potentiality is somehow mirrored in political community. The poet may even be an acknowledged legislator. "The true sorrow of humanity consists in this;—not that the mind of man fails; but that the course and demands of action and of life so rarely correspond with the dignity and intensity of human desires," Wordsworth wrote, and romantic political thought is critical of any order that frustrates expressivism and correspondence (Wordsworth 192). When it proceeds beyond criticism, it envisions political community as a setting for romantic plentitude. This is not conventional political theory, of course. Romantic political thought is preoccupied less with justice and institutional design than with the presence or painful absence of complementarity between self and political world. Thoreau's political thought conforms to this rough definition.

Contemporary literary studies of romanticism emphasize the dark underside of holism and of the longing for correspondence between self and world.[15] They point up the fragmented quality of the self, the historical situatedness of the writer, and the way in which presumably authentic expressions of individuality—including both rebellion and detachment—are socially constituted, deconstructing grandiose romantic claims of "uninfluenced originality" and "creative imagination at once free and unfathomable."[16] Especially for romantic works devoid of explicit social content, critics set out to "expose these dramas of displacement and idealization" and the methods by which "the poem annihilates its own history, biographical and sociohistorical alike, and replaces these particulars with a record of pure consciousness." The "de-transcendentalizing" of Emerson is well under way.[17]

But American romantics, certainly Thoreau, seem to have anticipated the thrust of these demystifying, unmasking, perspectivist approaches. Consider these elements of Thoreau's writing:

—The political parameters of where we stand and what we see from there were evident to him: expansion and conquest, dispossession and enslavement govern one's view of American history, government, and culture. Thoreau distinguishes official ideology on the "original" settlement of America and the war of independence from the stories told by Native Americans and slaves: History "for the most part . . . is merely a story agreed upon by posterity." The Indian was the native of the New World ("three thousand years deep into time"), which was not really discovered at all; the Pilgrims were not the first European settlers ("New England commences only when it ceases to be *New* France"); and in *Cape Cod* Thoreau

undermines authoritative accounts of property claims based on colonization and dispossession. In "Life without Principle" (167–68), he asserts that even "broad and truly liberal" intellectuals "come to a stand against some institution in which they appear to hold stock" and "continually thrust their own low roof, with its narrow skylight, between you and the sky."

—Using the language of classical economics—profit, loss, labor, cost, speculation, and enterprise—Thoreau juxtaposes the promises and actualities of commercial and industrial growth, without subscribing to the competing ideology of republicanism and moral economy.[18]

—Thoreau reflects on the formation of public opinion: "The only book which America has printed, and which America reads," he insists, dismissing the Bible, is the daily newspaper ("Resistance" 100). He parodies elements of popular culture—advice books to young men of the business class on self-improvement, for example—and considers the significance for the reception of his work of the increased presence of novels in the literary marketplace.

—Thoreau's writings stand out from the romantic primitivism of his time for their lack of ethnocentrism, and in his vast, systematic, and appreciative reading, he is a thoroughgoing multiculturalist, reading the "scriptures of nations" and avowing the superiority of the Hindu *Laws of Menu* over the Christian Bible.

—Thoreau's scattered references to "former inhabitants" and "borrowing" add up to a series of sensitive reflections on appropriation (*Walden* 40). And he anticipates reader response: "a man receives only what he is ready to receive, whether physically or intellectually or morally. . . . We hear and apprehend only what we already half know. . . . Every man thus *tracks himself* through life, in all his hearing and reading and observation and travelling."[19]

—As for this self, Thoreau reports standing "remote from myself" as a spectator (*Walden* 135); he is "the scene, so to speak, of thoughts and affections," a "thoroughfare" (*Life* 172). He would rather be a passage for mountain brooks than for town sewers, but he has no illusion of self-control in this matter or even transparent self-understanding. It is not surprising that several of Thoreau's great set pieces are perspectivist riffs on the variability of how things look and what they mean depending on where we stand, and on the instability of anyone's standpoint, including his own.

The question for contemporary studies of romanticism is whether to leave matters here, with an analysis that portrays expressivism and holism as a reactive longing or romantic ideology, a suspect and inevitably failed pursuit. Or whether, this time with fragmentation and constraining contexts in plain view, to reconfirm romantics' positive efforts at resolution or reconciliation and at political thought.[20] I have argued that Thoreau's

"escapist" transcendence on the one hand and political resistance on the other are moments in a comprehensive vision of democracy as a political order that corresponds to the experience of individuality.

Of course, if holism is thought to require an organic conception of political community or a sacred or re-enchanted order, the judgment is certain to be that romantic political thought, including Thoreau's, fails. But romantic holism no more demands these than it does overarching metaphysical synthesis or emotional solidarism. It should be enough to show that a particular political order can be more hospitable than others to expressivism and can correspond more fully to "dignity and intensity of desire"—even if what is expressed is the interplay of contrary desires or perspectives, that is, romantic plenitude rather than underlying unity.

Notes

1 Leonard N. Neufeldt has counted these in *The Economist*. Thoreau is chanticleer, awake and alert; his neighbors are stagnant, asleep, little better than dead. See, for example, *Walden* 106. I will not pursue the relation Thoreau saw between anxiety of death and enervation and desperation. One of his most common accusations is that ordinary men are dead in life, might as well be dead, or are incapable of dying because they have not lived. Thoreau's Romantic "half in love" with death deserves study.

2 There is no reason to assume that the emergent sentimental family, with its changing roles for women was key here; Thoreau boasts self-sufficiency, not paternalism. It is worth noting that (like J. S. Mill) Thoreau had little to say about his mother, though she was active in the cause of antislavery reform and Thoreau lived at home most of his adult life.

3 The same abhorrence extended to other intimate attachments. Thoreau was at best mistrustful of romantic love. Friendship was a recurrent theme, but Thoreau preferred to think of friends as goads to self-improvement than as "false appreciation," comfort, or pleasure—which is why he would rather honor his friends in thought than keep their company. His yearnings appear to have been homoerotic, confined to his poetry and journals, though his relation to readers has been likened to a homosexual seduction. See Henry Abelove.

4 Stanley Hyman's characterization of *Walden*, and by implication Thoreau's work generally, as a movement from individual isolation to collective action is overly simple (178).

5 This is just one example of Thoreau's many-sidedness. The quintessential Romanticism described by Charles Taylor as the real world of nature and undistorted human feeling that frees us from the debased, mechanistic world has, for Thoreau, more than one aspect (456–57).

6 For a discussion of Thoreau's violent language and toleration of political violence, see Rosenblum, *Thoreau* vii–xxxi.

7 See Shklar. Shklar's article was the model for this section of my essay, and I have taken my title from her.

8 What Thoreau took from Carlyle was the militancy of his style, which in Thoreau became a conception of the act of writing. In his extended literary analysis of Carlyle, Thoreau praises the author in martial terms: he "meets face to face," "wrestles and

strives," "advances, crashing his way through the host of weak, half-formed, dilettante opinions," and finally "prevails; you don't even hear the groans of the wounded and dying" ("Thomas Carlyle" 223–24).

9 In contrast with the view of Stanley Hyman, who sees in Thoreau "the honest artist struggling for terms on which he can adjust to society *in his capacity as an artist*" (321; emphasis in original).

10 See Schiller's *On the Aesthetic Education,* Constant's "Spirit," Humboldt's *Sphere and Duties.* J. S. Mill would incorporate this version of romantic political thought in the chapter "Of Individuality" in *On Liberty.*

11 George Kateb argues: "The typical politics of the theorized democratic individual is the politics of no-saying."

12 John Brown understood his own position: "comparatively, all other men, North and South, were beside themselves" (Thoreau, "Last Days" 278–79). Daniel Webster's defense of the federal consensus over slavery was reprehensible; still, "comparatively, he is always strong, original, and, above all, practical" ("Resistance" 148).

13 This reading differs from the reading of those who see a liberal-democratic Thoreau: from Vernon Parrington's view that Thoreau revives early Jeffersonian principles; from the host of Thoreauvians, anti-Marxists, and anticollectivists who present Thoreau as a libertarian; and from those who uphold the "antinomian" theory according to which major American writers are visionary dissenters.

14 This point is made with regard to German Romantics by Schmitt: "Without changing its nature and its structure, which invariably remains occasionalist, romantic productivity can be linked to any other object of historical-political reality besides just the legitimate sovereign. . . . the king is no less occasional than a 'colossal' revolutionary hero, a bandit, or a courtesan" (123). For a summary of twentieth-century political readings of romanticism ranging from protofascist or collectivist to American pluralist readings, see Klancher.

 For an account of romantic liberalism, see Rosenblum, *Another Liberalism.*

15 According to Kroeber, few are the "critics in our time" who do not work from the premise "that art comes into being through injury or dislocation, a fault or fracturing of some kind, either psychological or sociological, perhaps both, and consequently, that the endless interpretability of a work of art is due not to its being a fountain forever overflowing but a *mise en abîme*" ("Shelley's 'Defense of Poetry'" 370). The oddity of the useful book from which this is quoted is its misleading title—*Romantic Poetry*—since the essays focus exclusively on six canonical English poets.

16 See McFarland 16.

17 See McGann 90. McGann has made a much more general claim for all romantic poets: "The grand illusion of Romantic *ideology* is that one may escape such a world through imagination and poetry. The great truth of Romantic *work* is that there is no escape, that there is only revelation (in a wholly secular sense)" (131).

 Perkins argues that the romantic ideology was formed at this time and not in the Romantic period itself (142).

18 For a review of the most recent historical analysis, see Wood.

19 Qtd. in Richardson 291. Works dealing with the reception of Emerson and Thoreau and the shifting history of the latter's canonization include those by Meyer, Buell, and Cayton.

20 Kateb contends that instead of seeing Emerson as concealing his ideological affinities to possessive or atomistic individualism, one should appreciate him for expanding the typology to include democratic individualism.

See Cavell, who argues that in response to skepticism, Thoreau produced an American scripture.

Berkovitch believes that Thoreau contributed to the "contradictory-conciliatory" symbol of America and its sacred mission, which allows for the coexistence of irreconcilable positions. "What makes *Walden* part of the tradition of the jeremiad is that the act of mimesis enables Thoreau simultaneously to berate his neighbors and to safeguard the values that undergird their way of Life" (*American Jeremiad* 186). See also Berkovitch, *Rites of Assent* 343n.

Works Cited

Abelove, Henry. "From Thoreau to Queer Politics." *The Yale Journal of Criticism* 6.2 (1933): 17–27.

Berkovitch, Sacvan. *The American Jeremiad.* Madison: U of Wisconsin P, 1978.

———. *The Rites of Assent: Transformations in the Symbolic Construction of America.* New York: Routledge, 1993.

Berlin, Isaiah. "The Apotheosis of the Romantic Will: The Revolt against the Myth of an Ideal World." *The Crooked Timber of Humanity.* New York: John Murray, 1969. 207–37.

Buell, Lawrence. "Henry Thoreau Enters the American Canon." *New Essays on Walden.* Ed. Robert F. Sayre. Cambridge: Cambridge UP, 1992. 23–52.

Carlyle, Thomas. *On Heroes, Hero-Worship, and the Heroic in History.* Berkeley: U of California P, 1993.

Cavell, Stanley. *The Senses of Walden.* New York: Viking, 1972.

Cayton, Mary Kupiec. "The Making of an American Prophet: Emerson, His Audiences, and the Rise of the Culture Industry in Nineteenth-Century America." *American Historical Review* 92.3 (June 1987): 597–620.

Chateaubriand, Vicomte Francois Rene de. *The Memoirs of Chateaubriand.* Ed. Robert Baldick. New York: Knopf, 1961.

Constant, Benjamin. "The Spirit of Conquest." *Constant: Political Writings.* Ed. Biancamaria Fontan. Cambridge: Cambridge UP, 1988.

Humboldt, Wilhelm von. *The Sphere and Duties of Government.* London: Chapman, 1854.

Hyman, Stanley. "Henry Thoreau in Our Time." *Thoreau: A Century of Criticism.* Ed. Walter Harding. Dallas: Southern Methodist UP, 1954.

Kateb, George. *The Inner Ocean: Individualism and Democratic Culture.* Ithaca: Cornell UP, 1993.

Klancher, Jon. "Romantic Criticism and the Meanings of the French Revolution." *Studies in Romanticism* 28 (fall 1989): 480–81.

Kroeber, Karl. "Shelley's 'Defense of Poetry.'" Kroeber and Ruoff. 366–72.

Kroeber, Karl, and Gene W. Ruoff, eds. *Romantic Poetry: Recent Revisionary Criticism.* New Brunswick: Rutgers UP, 1993.

McFarland, Thomas. "Field, Constellation, and Aesthetic Object." Kroeber and Ruoff. 15–37.

McGann, Jerome J. *The Romantic Ideology: A Critical Investigation.* Chicago: Chicago UP, 1983.

Meyer, Michael. *Several More Lives to Live: Thoreau's Political Reputation in America.* Westport: Greenwood, 1977.

Neufeldt, Leonard N. *The Economist: Henry Thoreau and Enterprise.* New York: Oxford UP, 1989.

Parrington, Vernon. *Main Currents in American Thought.* New York: Harcourt, 1930.

Perkins, David. "The Construction of 'The Romantic Movement' as a Literary Classification." *Nineteenth Century Literature* 45.2 (Sept. 1990): 129–45.

Richardson, Robert D. *Henry Thoreau: A Life of the Mind.* Berkeley: U of California P, 1986.

Rosenblum, Nancy L. *Thoreau: Political Writings.* Cambridge: Cambridge UP, 1996.

———. *Another Liberalism: Romanticism and the Reconstruction of Liberal Political Thought.* Cambridge: Harvard UP, 1987.

Sayre, Robert F., ed. *New Essays on Walden.* Cambridge: Cambridge UP, 1992.

Schiller, Friedrich. *On the Aesthetic Education of Man, in a Series of Letters.* New York: Ungar, 1974.

Schmitt, Carl. *Political Romanticism.* Cambridge: MIT P, 1986.

Shklar, Judith. "Emerson and the Inhibitions of Democracy." *Political Theory* 18.4 (Nov. 1990): 601–14.

Taylor, Charles. *Sources of the Self: The Making of Modern Identity.* Cambridge: Harvard UP, 1989.

Thoreau, Henry David. *Walden.* Ed. J. Lyndon Shanley. Princeton: Princeton UP, 1971.

———. *The Maine Woods.* Ed. Joseph J. Moldenhauer. Princeton: Princeton UP, 1972.

———. "Last Days of John Brown." *Reform Papers.* 145–54.

———. "Life without Principle." *Reform Papers.* 155–81.

———. "A Plea for John Brown." *Reform Papers.* 111–38.

———. *Reform Papers.* Ed. Wendell Glick. Princeton: Princeton UP, 1973.

———. "Resistance to Civil Government" [commonly referred to as "Civil Disobedience"]. *Reform Papers.* 63–90.

———. "Slavery in Massachusetts." *Reform Papers.* 91–110.

———. "Thomas Carlyle and His Works." *Early Essays and Miscellanies.* Ed. Joseph J. Moldenhauer and Edwin Moser. Princeton: Princeton UP, 1975. 219–67.

———. *Cape Cod.* Ed. Joseph J. Moldenhauer. Princeton: Princeton UP, 1988.

Vigny, Alfred de. *Military Servitude and Grandeur.* New York: George Doran, 1919.

Wood, Gordon S. "Inventing American Capitalism." *New York Review of Books* 9 June 1994: 44–49.

Wordsworth, William. "The Convention of Cintra." *Political Tracts of Wordsworth, Coleridge, and Shelley.* Ed. R. J. White. Cambridge: Cambridge UP, 1953. 117–93.

Between Irony and Radicalism:

The Other Way of a Romantic Education

KAREN A. WEISMAN

\mathcal{T}he title of this essay I take from Thomas Mann; in *Reflec-
tions of a Nonpolitical Man* he writes, "The intellectual must
choose between irony and radicalism; a third choice is not
decently possible." This translation (mine) of the German serves some se-
mantic play:[1] What is *between*? That is, what may serve as the in-between
on a continuum in which irony and radicalism are constituted as diametri-
cal opposites? For irony is the trope of distance; radicalism is the hallmark,
or is often said to be the hallmark, of engagement, and in the world of
Mann's modernism, choice is the defining feature of mature self-hood.
One chooses irony over the disappointments of radicalism; one chooses
radicalism over the self-satisfied sterility of irony. In any event, ultimately
one chooses; the human being is said to be a choice-making animal.

Paradigms shift, however, and so do our ways of thinking through the
vexed issues of human expression, which is to say that there is also a
change in our ways of educating, our ways of knowing. In the past ten
years or so, the critical/theoretical norms of cultural diagnosis have been
changing, and the very meaning of choice has itself come under an espe-
cially intensive scrutiny.[2] In an age of anti-essentialism, the very notion
of subjective agency is deeply problematic, and so choice can no longer
be simply taken for granted. The forms taken by this scrutiny, I argue,
can be best understood by tracking the contemporary response to the
culture of Romanticism. Where we once casually talked about Roman-
tic "nature" and its peopled landscapes, a repoliticized critical milieu
would interrogate the relationship between nature and culture—that is,
between pronouncements of the apparently natural and an all but effaced
ideological superstructure.[3] In the 1990s, then, we know ourselves as post-
Romantic insofar as Romanticism—variously conceived—is our defining
other. Not the modernist claims for fragmentation and formal disconti-
nuity, but rather the Romantic dreams of unity and transcendence and

prophecy are the ghosts that have returned to haunt us. "Make it new" is the famous rallying cry for modernism, especially a modernism that rejects a discredited Romantic sentimentalism. But the rallying cry of our current moment asks that the new be made newly worthwhile, politically exposed: nothing can be taken for granted. To be postmodern is to be post-Romantic. We are situated at once within and against the Romantic, planted on ground whose radical contingencies (so the theoretical story goes) we are only just coming to fathom.[4] If we go one step beyond (or behind, rather) these putatively new horizons, however, we may well see that our very cultural rebellion is consonant with the norms they claim to oppose. To be post-Romantic is very Romantic. Indeed, since Romanticism, our ways of knowing and of teaching the self, our ways of self-identification, have become equated with ways of novelty. But the hard implicit question is: Can it be real novelty if the desire for it is too clear about itself? For novelty stands in a peculiar relation to desire.

I will back up enough to provide a romantic take on the Romantic background implicit here. For I would submit that the contemporary drive to demystify the old cultural pieties about sublimity and artistic salvation in fact derives from Romantic standards of value, even though those cultural pieties are constituted as Romantic.[5] Since fictions of the self developing in a "state of nature" are central to this issue, the continental background is especially resonant. Jean-Jacques Rousseau, in his *Confessions, Reveries of the Solitary Walker* (1776), and other works, exerts himself to express a sense of his own selfhood, which, though not articulated in the terms of a general theory of identity, emphasizes an *experience* of self—the reader's experience of someone else's selfhood—that is unique enough to warrant public expression. In fact, remembering that *Émile* is a treatise on education, we do well to recall the subtle didacticism of even Rousseau's public self-absorptions. And what is the defining feature of that self's exceptionality? In *Reveries of the Solitary Walker*, Rousseau describes the process by which he came to write the *Confessions*:

> If sometimes I involuntarily concealed some blemish by presenting myself in profile, these omissions were more than made up for by other and stranger omissions, for I was often more careful to conceal my good points than my shortcomings. This is a peculiarity of my nature which men may well be forgiven for not believing, but which is no less true for being incredible. I often presented what was bad in all its baseness, but I rarely presented what was good in the most attractive light, and often I left it out altogether because it did me too much honour, and I would have seemed to be singing my own praises by writing my confessions. I described my early years without

boasting of the good qualities with which I was endowed by nature—indeed I often suppressed facts which would have given them too much prominence. (77)

It will surprise no one, perhaps, that Rousseau then goes on to describe two incidents constituting examples of especial goodness and virtue that he suppressed for the *Confessions*. It is not hard, in such self-ironizing moments, to see why deconstruction in particular taught us to be alert to the implicit ironies of Rousseau's postures. For deconstruction—so the cliché by now goes—was in fact essentially "reading" Romanticism (without *always* knowing it), or at least the Romanticism popularly propounded in the classroom.

The most obvious instance of this phenomenon is the institutionalization of Paul de Man's "Rhetoric of Temporality" (now most often cited as part of his 1983 collection of essays, *Blindness and Insight*) in the history of contemporary Romantic theory. De Man's interpretive rubric has itself been widely reproached for suppressing its own historicity, and so his broaching of the vexed questions about nostalgia in "Rhetoric" is especially relevant here: "Is romanticism a subjective idealism, open to all the attacks of solipsism that, from Hazlitt to the French structuralists, a succession of demystifiers of the self have directed against it? Or is it instead a return to a certain form of naturalism after the forced abstraction of the Enlightenment, but a return which our urban and alienated world can conceive of only as a nostalgic and unreachable past?" (198). De Man's urgent Romantic questioning is the inevitable response to the implicit demand Rousseau makes upon his readers: the *Reveries*, for example, requires that its readers register the experience of its author's destabilizing gestures. Here I am, he tells us, and I am very strange. Therefore, there is something to be uniquely *learned* from me. If Rousseau's mode of "narrativizing" his experience at once evidences and constitutes his uniqueness, then a direct causal relationship must be deduced between the self's novel strangeness and its didactic uses. Rousseau chooses irony. He believes it to be a radical irony, though its political valence is by no means clear.

As to arguable political valence, Wordsworth also comes to mind. In the familiar "Preface to the second edition of the *Lyrical Ballads*," he explains that his poetry—the poetry he identifies as new, as a challenge to received norms—strives for a language *"whereby ordinary things should be presented to the mind in an unusual aspect;* and, further, and above all, to make these incidents and situations interesting by tracing in them, truly though not ostentatiously, the primary laws of our nature" (71; italics mine). Here what is novel shocks us out of our complacency precisely because it lays bare an essentialist nature culled from an observation of the ordinary. Words-

worth's claims to originality on behalf of self-identity have become, lately, grounds for intense debate over the political valence of that challenge to complacency. "Tintern Abbey" has lately mobilized an entire economy of political critique, one in which the putative displacement of historical atrocities into a self-satisfied lyricism is presumed to be the sign of Wordsworth's nasty ideology. The dangers of Romantic solipsism are now seen to lie not only in the potential occlusion of the social self but also in an outright suppression of historical fact. Reading, for example, Wordsworth's difficult lines in "Tintern Abbey" about the "presence that disturbs [him] with the joy / Of elevated thoughts," Alan Liu charges that "Wordsworth revolves in his mind a counter-spirit whose anonymity at once mimes and denies the shuffling mob that first authorized his emergence as poet" (217). The "I" that claims to have felt that presence is likewise said to be "the great impersonator of history able to be anyone at any time . . . that makes reference inconsequential." In the discourse of New Historicism (for which Liu stands here as example), the novelty of Romantic subjectivity consists in fact in its narcissistic re-narrativizing of things as they are in the most soothing (imaginative) light. In this regard, de Man's worries would be tempests in a naively tiny teapot. Is cleansed perception truly radicalizing, then? Does it really teach us something we did not know before? Is the knowing of the self and the world as novel an unselfconscious resistance to all potential radicalism? These questions move us closer to the heart of those frequently asked in our contemporary moment, but I will first offer one last Romantic example. In the "Defence of Poetry," Shelley defines poetry as that which defeats the curse according to which we are bound to be subjected to the accident of surrounding impressions. His assessment of the necessity of novelty, itself haunted by the specter of Wordsworth's concern over the representation of ordinariness, continues to haunt our self-representations: "It reproduces the common universe of which we are portions and percipients, and it purges from our inward sight the film of familiarity which obscures from us the wonder of our being. It compels us to feel that which we perceive, and to imagine that which we know. It creates anew the universe after it has been annihilated in our minds by the recurrence of impressions blunted by reiteration" (505–6).

As far as critical prose is concerned, where have such dreams of aesthetic autonomy and epistemological certainty, such yearnings for a salvific language of essential selfhood, led us? Indeed, in what logical extreme of irritated saturation, as it were, has such faith in the value of a "good ole" Romantic education been resolved? In the introduction to *Rethinking Historicism: Critical Readings in Romantic History*, published in 1989 and boasting contributions by herself, Jerome McGann, Marilyn Butler, and Paul Hamilton, Marjorie Levinson asserts, "We have had more than

enough reflection on 'the new historicism'" (1). This is the very first sentence of her book, a decidedly New Historicist collection that intends, as she describes it on page two, a "drive towards dialectical closure [which] will produce a *new* set of terms for our encounters with the past" (2). By now, this impression of "more than enough already said" has become—to borrow terminology from Shelley—blunted by reiteration. That is, by the late twentieth century, the search for the novel has itself reached a saturation point, and so if history repeats itself and New Historicism interrogates the false consciousness of cultural repetition, we may well become not only blunted by reiteration but downright bored by it.

The realm of self-consciously avant-gardist contemporary poetry (as opposed to the contemporary formalist poetry represented by, for example, James Merrill) reiterates its understanding of Romantic formalism by twisting it into a destabilizing syntax. Often, it would assert that cultural norms cannot repeat themselves when they are radically inverted. But any medium that defines itself by a nervous resistance to its enshrined Other is doomed to trouble. Allen Grossman's poem "Of the Great House" opens with an invocation to poets that serves as a direct sign of anxiety over the would-be vatic poet's sterile postures:

> Let let let be
> to the poets
> praise,
> And shame.
> To the sighted singer, in a
> Passionate, laboring house. Praise!
>
>
> But
> To the blind singers among sleepy harvesters,—
> Everlasting shame. . .
> (101)

Or again, Charles Bernstein, often spoken of as inhabiting the forefront of a contemporary anti-Romanticism, writes "Verdi and Postmodernism" partly as a challenge to Byron's subtle fluency in "She Walks in Beauty":

> She walks in beauty like the swans
> that on a summer day do swarm
> & crawls as deftly as a spoon
> & spills & sprawls & booms.
> These moments make a monument
> Then fall upon a broken calm
> they fly into more quenchless rages
> than Louis Quatorze or Napoleon.

If I could make one wish I might
overturn a state, destroy a kite
but with no wishes still I grope
complaint's a God-given right.
(26)

This is a poetry meant to derive its efficacy from its resistance to a Roman-
ticism that, surely, it has enshrined as the standard against which all work
must situate itself. It is said to please, or to be worth the reading, because
we could all (so it seems to assert) profit from debunking a previously un-
contested Romantic lyricism. But I would argue that such poetry aspires to
a novelty that presupposes one fantastically duped reading audience. Does
anyone who has ever taught an undergraduate course in Romanticism still
believe that the average reader yearns for Snowdon and snowflakes?[6] It
only seems to work, that is, if we assume first that what we most want—
in an uncomplicated way—is a histrionic and pious Romanticism. That
accepted, we must then meet our desire in these boldly post-Romantic ex-
posures of it and feel better for a poetic "correction" of a most unfortunate
Romantic longing.[7]

Whether or not we are all so naive and so in need of such correction,
it simply makes no sense to contend that our students have imbibed a
Romantic sentimentalism before they have even been taught it.[8] What
we teach in the classroom, therefore, can be a different matter, and the
challenge we all face to effect a self-consciousness among our students—
especially in the context of the inviting allures of Romanticism—is the
challenge of helping them to understand the difference between a normal-
ized idea and a new idea. For it is not that there is nothing new to say about
the historiography of constructions of the Romantic: the raison d'être of
Levinson's collection of essays is this very historicizing of the impulse to
say new things, or at least the fiction *of* saying new things. But it is precisely
self-identification that is at issue. For, as I have already noted, it is the self
and how it is situated as self-consciously post-Romantic that is at the heart
of current Romantic theory, and indeed at the heart of much contempo-
rary aesthetic practice. Levinson and company are in the camp of those
who dismiss the efficacy of irony in favor of a criticism and culture that,
working against the grain, are offered as radicalizing. The stance against
a putative Romantic sterility, or naive piety, is by no means confined to a
small coterie of angry types. Many writers who are not self-identified New
Historicists, but who seek a culture emancipated from a perceived Roman-
tic propaganda, as it were, also negotiate Romanticism in the language of
the pioneer's battleground. In *Historicity*, for example, Siskin takes it as an
a priori given that scholars writing in the years before our current enlight-

ened days "perpetuated the past." He observes: "That they did so simply dramatizes how completely and invisibly the psychologized 'reality' of Romanticism has determined our understanding of ourselves and of our writing" (3). According to Siskin, then, the self as psychologized subject is a culturally determined and historically specific construct of Romanticism, one that has been naturalized into contemporary discourse because of the Romantic "lyric turn" that would transcend form and history. And for Jerome McGann, only a sociohistorical analysis of the past can prevent us from falling prey to the allures of Romantic norms. That sociohistory is the *educative prerequisite* to the reading of Romanticism, especially Romantic poetry of the variety that might make us feel good. The scenario is very familiar: The claim made in McGann's highly influential *Romantic Ideology* (1983), and reiterated in a series of subsequent monographs, is that as a culture we are blithely and unselfconsciously trapped within Romantic standards of value. Unless acquiescent in McGann's corrective guidance, we cannot study Romanticism because we are still living it; we cannot study ourselves because we are naive Romantics without knowing it. This is the "tough stuff" psychology of a teacherly wisdom. The Romantic New Historicists, and some others, have found Romantic irony impotent and sorely unanswerable to the pressures of historical actuality. And many in the academy have found the New Historicists' claims to critical radicalism, to quote Geoffrey Hartman, to be a "mimic war against the aesthetic" (19), or, to quote Gerald Graff, "the ultimate descent into the politics of silliness" (174), or, to paraphrase M. H. Abrams, the monothematic elaboration of a gray, joyless reading (326). Is there a ground *between* radicalism and irony that Romanticism helps us locate, and that our students of the post-'90s era might actually find themselves living? I believe that there is.

In William Hazlitt's essay "The Pleasures of Hating," first published in 1826 in *The Plain Speaker,* Hazlitt suggests, "We learn to curb our will and keep our overt actions within the bounds of humanity, long before we can subdue our sentiments and imaginations to the same mild tone. We give up the external demonstration, the *brute* violence, but cannot part with the essence or principle of hostility" (397). What is the secret of such persistent bad faith? For Hazlitt, too, it is the drive for novelty, as he later goes on to elaborate:

> It is not so much the quality as the quantity of excitement that we are anxious about: we cannot bear a state of indifference and ennui: the mind seems to abhor a *vacuum* as much as ever matter was supposed to do. Even when the spirit of the age (that is, the progress of intellectual refinement, warring with our natural infirmities) no longer allows us to carry our vindictive and headstrong humours into effect,

we try to revive them in description, and keep up the old bugbears, the phantoms of our terror and our hate, in imagination. (399)

Here radicalism is aestheticized into a kind of pathology of anger. Hazlitt's own histrionics smack of a controlled ironic posture, but when he mentions the "progress of intellectual refinement, warring with our natural infirmities" as characterizing the "spirit of the age," he perhaps opens a way into finding Romanticism's "other way," or at least a more healthful way.

Between "learning to curse" and the pleasures of hating,[9] between the exposed postures of radicalism and the sheltering distance of irony, falls the shadow of Romantic desire. To dismiss such specters as merely ironic, or to seek to guillotine them in the name of cultural radicalism, is finally to betray deep embarrassment over the pleasures and resonances of a good read. Culture—however defined—has since Romanticism at least "normally" located itself as the nexus of oppositional debate, the fulcrum on which desire can recover and redefine its beleaguered bearings. And I would submit that it is naive to suggest that opposition for the Romantics was generally conceived of as unidirectional, univocal, and beyond the taint of implicit collusion with the status quo. As Tilottama Rajan cautions, thinking primarily about the debates in current historicist theory, "If post-structuralism hollows out the lyrical moment, making its paradoxes into aporias, New Historicism simply accepts the image of Wordsworth it inherits, situating lyrics as a socially symbolic act of avoidance" (366).

What do these debates tell us about our Romantic education, the one we imbibed and the one we would pass on? Can we teach norms that are designed to challenge norms? Probably: Shelley claimed to abhor didactic poetry, not because he was uninterested in real populist issues—he took a lively part in the political-pamphlet mongering of Regency England—but because the "beautiful idealisms of moral excellence" (as he describes them in the Preface to *Prometheus Unbound*) were to serve for him as the objective correlatives of desire. Especially in the wake of recent work on newly disinterred Romantic authors, we must exercise caution when offering totalizing definitions of any epoch. All the same, what has come down to us as normative Romanticism is that which holds up images, or formations, that have for us the force of a compelling novelty. And such novelty holds our desire; that is, to be released from the recurrence of impressions blunted by reiteration we need a language whose novelty functions as a mirror of selfhood. Within this understanding, we seek moral excellence because its mode of representation in *Prometheus Unbound* reflects back to us an image of ourselves that is novel, virtuous, wise, and sexy. Historically, poetry masquerading as populist radicalism and poetry masquerading as mere Romantic irony have both failed; the other way for

aesthetics may well be the way of Jurgen Habermas's description of modernity, for example. In *Philosophical Discourse of Modernity,* Habermas suggests that "modernity can and will no longer borrow the criteria by which it takes its orientation from the models supplied by another epoch; *it has to create its normativity out of itself*" (7; emphasis in the original). Only our "orientation" within a defined normativity—as Habermas is at pains to point out—is never a matter merely of throwing up the past: desire, as the arch modernist (Eliot) reminds us, is always mixed with memory.[10]

In probing Romantic aspirations of novelty as the springboard of constructive engagement with the world and with the self, I am not presuming to propose a singular novelty. But we need to be reminded of such basic Romantic yearnings because the putative anti-Romanticism of much contemporary culture—often even the very criticism that claims we are victims of Romantic entrapment—announces itself as a break finally with the past, and a consequent ushering in of new ways of expression. And what is the anxiety about repeating the Romantic past if it is not a (very Romantic) desire for an autonomous self? Now to be fair, many contemporary critics and authors believe they can free themselves from the past only by subjecting themselves to an intense self-scrutiny in which they fully confess, as it were, their determination by historical and social contingencies. That is held to be the true hard lesson of so-called post-Romantic educators. But once performed, this operation is said to enable the freedom of "authentic" self-expression.

To look, then, at a recent example: so-called Language poetry—its penchant for sentimental prolixity notwithstanding—is sometimes offered as a revolutionary idea and *inherently* more responsible than Romantic formalism—though in such claims, formalism is usually itself naively constructed as traditional, unselfconscious, uninnovative, and inherently conservative. The previously cited poems by Bernstein and Grossman are good examples of this genre. In an essay entitled "The Third World of Criticism," which bemoans the ominous implications of received culture, McGann speaks of contemporary poetry, though he is really addressing the type most often identified with the self-conscious anti-Romanticism of the Language poets.

> When we read we construct our histories, including our futures. In our day, this peculiar Western moment, poetry's special contribution to the process—poetry's special form of "reading"—comes as a set of complicating and undermining procedures. Calling into question all that is privileged, understood and given, including itself, this poetry operates under the signs of Differences and, most especially,

of Change. And this poetry has thereby set us our models for reading the works that descend to us from "tradition." (106)

I would suggest that few procedures in formalist poetry are not "complicating," and further, that one person's "undermining procedure" is another's reflexive response. What McGann really seems to be worried about is the ascription of sameness, of doing it all over again, of being blunted by culture that looks, at least superficially, like reiteration.

One of Blake's "Proverbs of Hell" comes to mind: "Drive your cart and your plow over the bones of the dead" (7.2). (This may well recall us also to the familiar cry in revolutionary Paris, "Beneath the cobblestones, the beach!") We do not repeat the past; we drive our plows over it. And we do not merely take a place in the present; we are driven. But to drive over is to drive on top of, and to drive within. That is, heard first in our excursions into autonomous action and equally in our participation in dominant discursive practices is the noise of breaking bones. From the past, that is, we learn to overcome the past. And those lessons learned, we can only tell our students to digest and excrete them—not to *predigest* our own indignation (if that is what it may be), but to embrace, perhaps, the lessons about the fate of Romantic embraces. As far as *The Marriage of Heaven and Hell* is concerned, Blake's intended radicalism is clear enough. His irony is a very controlled, entirely conscious gesture directed at the fact that subversion announces *first* the bone-crackling sound of the dead. Between such radicalism and such irony falls a self that absorbs them both, honors them both, and then knows how to get going.

Notes

1 "Der geistige Mensch hat die Wahl (soweit er die Wahl hat), entweder Ironiker oder Radikalist zu sein; ein Drittes ist anstandiger Weise nicht möglich" (560). Walter Morris's (more exact) translation is: "The intellectual human being has the choice (as far as he has the choice) of being either an ironist or a radical; a third choice is not decently possible" (419).

2 According to the many studies seeking to identify the historicist, ideological backgrounds of a presumably discredited rhetorical critical practice, we have only recently become ready truly to demystify—and place in context—Romantic norms in which we have been utterly consumed. Discussing, for example, Wordsworth's assertions of selfhood, David Riede cautions that "this invention of the vast shadowy terrain of an autonomous self as at once the object and subject of literature is part of the invention of 'literature' as an autonomous yet somehow authoritative discourse, of literature as an entity transcending history" (118). Copley and John Whale, writing in their collection tellingly entitled *Beyond Romanticism: New Approaches to Texts and Contexts 1780–1832*, strive to define the novelty implicit in a criticism of Romanticism that is beyond such hoodwinking: "In this [historical] process Romantic criticism continues its struggle

simultaneously to define and be rid of itself, a doubleness symptomatic of the continuing dialectical relationship between Romantic construction and Romantic critique" (4).

3 Alan Liu's work is the most representative and most cited of these interrogations. Especially in his massive *Wordsworth*, he sees the Wordsworthian dialectic as grounded in a denial of historical reference. Reading Wordsworth's struggle, he summarizes the poet as follows: "The true apocalypse will come when history crosses the zone of nature to occupy the self directly, when the sense of history and Imagination thus become one, and nature, the mediating figure, is no more" (31).

4 Lindenberger's most recent book is an extreme example of the constitution of the contemporary critic as finally—though somewhat tragically—enlightened. He asks: "Can we learn to resist the rhetorical seductions of theories of romanticism? Can we distance ourselves from their characteristic assertions and dialectical turns? Doubtless such distancing will prove difficult, if only because literary study as institutionalized within the modern university itself shares in the romantic legacy" (80).

5 Clifford Siskin makes a similar point in *The Historicity of Romantic Discourse*. I am indebted to his discussion of the critical unselfconsciousness of those very critics proclaiming imaginative emancipation: "The price the literary historian pays is the inability to gauge his or her own historicity: the extent to which key aesthetic judgments and critical interpretations are but repetitions of Romantic formulations supposedly 'discovered' in the texts. To assume unself-consciously, for example, that a merging of the inner and outer constitutes a solution to any literary historical problem is itself a literary historical problem" (135).

6 In *Wordsworth's Great Period Poems*, Marjorie Levinson insists that she was led to her particular historicist position because her students found high Romanticism untenable. I do not think Levinson's theoretical position is the necessary or logical conclusion to the realization that undergraduates have lately become more world-weary, but her point is worth noting all the same: "While the high Romantic arguments I had learned as an undergraduate and in graduate school satisfied me, they did not seem to satisfy my students, whose interests were more worldly than mine and whose intelligence had a decidedly practical, empiricist cast. To accomplish a full reading of the Intimations Ode in the presence of this audience was to feel oneself performing, somewhat foolishly, an academic exercise" (ix).

7 Speaking of the L-A-N-G-U-A-G-E poets, Charles Altieri takes issue with the efficacy of divesting poetry of "first-person eloquence." His exasperation deserves consideration: "It seems to me that their models of agency require them to replace the lyrical subject by providing a mode of political power through their constructive activity. But without first-person terms they cannot attribute any positive or particular value to the poem's specific configuration except a purely formal one. Then, unhappy with formalism, they claim also that the very unmaking of the conventions of language will enable the reader to try other ways of composing worlds and testing values. Their poems however . . . cannot adapt or compete with the exemplary performances of possible states of subjectivity which the greatest lyrical poets leave as a legacy and a challenge" (195).

8 David Riede, for example, introduces his book *Oracles and Hierophants: Constructions of Romantic Authority* with an anecdote about his classroom experience. Describing his early teaching years, he confesses, "Like most students of Romanticism I had been working very much from within the Romantic tradition, attempting to offer my classes learned commentary on the canonical texts, and rarely criticizing the fundamental premises" (ix). According to Riede's narrative, he "woke up," as it were, in time to write the history of Romantic indoctrination.

9 *Learning to Curse* (1990) is the title of Stephen Greenblatt's book. This title is some-
 times thought to be an index of what some New Historicists teach.
10 I am thinking, of course, of the opening lines from *The Wasteland:*
 April is the cruellest month, breeding
 Lilacs out of the dead land, mixing
 Memory and desire, stirring
 Dull roots with spring rain.

Works Cited

Abrams, M. H. "On Political Readings of *Lyrical Ballads.*" Chaitin 320–49.

Altieri, Charles. "Wordsworth and the Options for Contemporary American Poetry." *The Romantics and Us: Essays on Literature and Culture.* Ed. Gene W. Ruoff. New Brunswick: Rutgers UP, 1990. 184–212.

Bernstein, Charles. *Rough Trades.* Los Angeles: Sun and Moon, 1991.

Blake, William. *The Marriage of Heaven and Hell. The Complete Poetry and Prose of William Blake.* Ed. David V. Erdman. Rev. ed. New York: Doubleday, 1982.

Chaitin, Gilbert, et al., eds. *Romantic Revolutions: Criticism and Theory.* Bloomington: Indiana UP, 1990.

Copley, Stephen, and John Whale, eds. *Beyond Romanticism: New Approaches to Texts and Contexts 1780–1832.* London: Routledge, 1992.

de Man, Paul. *Blindness and Insight: Essays in the Rhetoric of Contemporary Criticism.* 2nd, rev. ed. Minneapolis: U of Minnesota P, 1983.

Eliot, T. S. *The Wasteland. Complete Poems and Plays 1909–1950.* New York: Harcourt, 1971.

Graff, Gerald. "Co-optation." *The New Historicism.* Ed. H. Aram Veeser. New York: Routledge, 1989. 168–81.

Greenblatt, Stephen. *Learning to Curse.* New York: Routledge, 1990.

Grossman, Allen. *The Ether Dome and Other Poems.* New York: New Directions, 1991.

Habermas, Jürgen. *The Philosophical Discourse of Modernity.* Trans. Frederick G. Lawrence. Cambridge: MIT P, 1993.

Hartman, Geoffrey. " 'Was it for this . . . ?': Wordsworth and the Birth of the Gods." Chaitin 8–25.

Hazlitt, William. "On the Pleasures of Hating." *Selected Writings.* Ed. Ronald Blyth. Harmondsworth: Penguin, 1987. 397–410.

Levinson, Marjorie, ed. *Wordsworth's Great Period Poems.* Cambridge: Cambridge UP, 1986.

———. *Rethinking Historicism: Critical Readings in Romantic History.* Oxford: Blackwell, 1989.

Lindenberger, Herbert. *The History in Literature: On Value, Genre, Institutions.* New York: Columbia UP, 1990.

Liu, Alan. *Wordsworth: The Sense of History.* Stanford: Stanford UP, 1989.

Mann, Thomas. *Betrachtungen Eines Unpolitischen.* Frankfurt: Fischer, 1956.

———. *Reflections of a Nonpolitical Man.* Trans. Walter D. Morris. New York: Ungar, 1983.

McGann, Jerome J. *The Romantic Ideology: A Critical Investigation.* Chicago: U of Chicago P, 1983.

———. "The Third World of Criticism." Levinson, *Rethinking Historicism* 85–107.

Rajan, Tilottama. "The Erasure of Narrative in Post-Structuralist Representations of Wordsworth." Chaitin 350–70.

Riede, David G. *Oracles and Hierophants: Constructions of Romantic Authority.* Ithaca: Cornell UP, 1991.

Rousseau, Jean-Jacques. *Reveries of the Solitary Walker.* Trans. Peter France. Harmonds-
 worth: Penguin, 1986.
Shelley, Percy Bysshe. *Shelley's Poetry and Prose.* Ed. Donald H. Reiman and Sharon B.
 Powers. New York: Norton, 1977.
Siskin, Clifford. *The Historicity of Romantic Discourse.* New York: Oxford UP, 1988.
Wordsworth, William. "Preface to the Second Edition of *Lyrical Ballads.*" *Wordsworth's Liter-
 ary Criticism.* Ed. W. J. B. Owen. London: Routledge, 1974. 69–95.

Friendly Instruction: Coleridge and the Discipline of Sociology

REGINA HEWITT

*F*ew readers, in Coleridge's time or our own, would define *The Friend* as an instructional journal. Begun in 1809 to expound principles for politics, morality, and literature, it ceased publication after only twenty-seven numbers without, apparently, fulfilling its goals. It received more criticism for obscuring its topics than praise for illuminating them, and its principles remained, to borrow a generous term from David Erdman, "promissory."[1]

Whether we attribute the fate of *The Friend* to the complexities of periodical publishing in the 1800s (as Rooke does in her Introduction to *The Friend* for the *Collected Works*) or to the "muddy thinking and anxious equivocation" that often interfered with Coleridge's undertakings (as Coleman does in her book on *The Friend* [1]), we must still wonder what instruction Coleridge hoped to provide through *The Friend,* for he placed great emphasis on instruction as a goal for that journal. The aim of *The Friend,* he stated, is "to convey not instruction merely, but fundamental instruction; not so much to shew my Reader this or that Fact, as to kindle his own Torch for him, and leave it to himself to chuse the particular Objects, which he might wish to examine by it's [sic] light" (*Collected Works* 4.2: 276).[2] While encouraging readers to learn from him, however, Coleridge also seems to obstruct their progress. Reading *The Friend* requires both thought and attention, he lectured; it involves "difficult and laborious effort" and rewards only those who "derive pleasure from the consciousness of being instructed or ameliorated" (277). Given Coleridge's "hierarchical" or even "authoritarian" attitude toward his readers (Coleman 52–53) and the elusiveness (or illusiveness) of his principles, can we take the instructional nature of *The Friend* seriously?

I posit that we can do so by considering *The Friend* in the light of studies on how fields of learning take shape. In this essay, I will show that

Coleridge's plans for the periodical identify his goal as the creation of a discipline, and I will suggest that *The Friend* may yet fulfill its original aim.

Scholarship on disciplinarity shows that new fields of learning arise from their founders' dissatisfaction with the objects and methods of study in existing fields. Innovators go outside established intellectual territories to fill a perceived gap in the configuration of knowledge, but their work maintains ties with accepted fields. Emerging fields "are disciplined by other disciplines" (Messer-Davidow, Shumway, and Sylvan 19) that dictate the terms on which a new field can exist. The identity of a new field is shaped by its founders' responses to challenges from other fields. A novel inquiry becomes a field of learning when it achieves a recognized place within an existing configuration of knowledge. To take a frequently cited example from our own century, sociology became an established field in France when the Sorbonne recognized the distinctiveness of Emile Durkheim's work and made his position, originally a chair in education, a chair in sociology (Clark, "Emile Durkheim" 55; Lukes 359–60; Logue 151–79).

Because they aim to supplement existing ways of knowing, pioneers in new fields usually work as hard to assert the need for their proposed discipline as they do to define their objects and methods of study. The activities of valorizing a discipline—widely called boundary work since the publication of Thomas Gieryn's influential article on the topic—play an essential part in winning acceptance for a new field. Innovators rely on three strategies—distinction, alliance, and preemption—to create boundaries for a field. Distinctions and alliances determine where a new field can fit within an existing intellectual system: distinctions separate the new field from some established ones while alliances coordinate it with others; alliances are as essential as distinctions for the new field's independence, for they amount to endorsements of its legitimacy from respected sponsors (Brown 161). Preemption clears the field of amateurs, popularizers, and interested but uncommitted sympathizers, reserving it for specialists (Turner, "Prussian Professoriate" 111).

If we bring this information about disciplinarity to bear on Coleridge's claims for *The Friend,* we can recognize that periodical as an attempt to open up a new area of learning. Specifically, Coleridge proposed a field distinguished from but allied with those he named on the title page—politics, moral philosophy, and literature (3).[3] If successful, *The Friend* would have instructed a circle of readers in a particular line of thinking and added it to the given configuration of knowledge.

In our time, any such reconfiguring of knowledge would occur within an academic system, for universities now discipline our learning. In Coleridge's time and place, however, universities were peripheral to intellectual life. Reacting to the French Revolution, Oxford and Cambridge purged all

controversial subjects from their curricula. To make sure that students learned orthodox ideas about church and state, Oxford concentrated on received views of the classics, while Cambridge, formerly a pioneer in science, retreated from experimental methods; both schools replaced oral with written exams so as to curtail public debate (Rothblatt 267–95; Gascoigne 276–77). These reactionary measures dissociated universities from intellectual innovation.

In the absence of academic support for studying political, moral, or natural philosophy, people who thought seriously about these topics developed their ideas on the pages of journals and at the meetings of political clubs and professional associations.[4] In effect, this confederation of journals, clubs, and associations defined and organized fields of knowledge. New ways of thinking adjusted the boundaries if their advocates could sustain regular publication or other activity. Such adjustments are exemplified by the development of aesthetic theory and of applied science.

Abrams credits journals with fostering the idea of literature as aesthetic expression (145). Until late in the eighteenth century, "literature" served as a "comprehensive and inclusive term" for what we would now call philosophy and history as well as for poetry and fiction (Price 173–74; compare Abrams 136–37, 159–60). Some eighteenth-century philosophers explored an alternative configuration of knowledge—one grouping the latter kind of literature with the fine arts and making it a subject for contemplation rather than for analysis (Abrams 138–41, 155–83). Their work became widely known through the popular press: advocates supported journals devoted to appreciating belles lettres while reviewers in other journals continued pointedly to read literature in philosophical and political terms (145, 160). Given a space—however contested—among the hundreds of periodicals that circulated in eighteenth- and nineteenth-century England, literature became a subject for study, a field of learning.

Similarly, the idea of applied science became recognized, as groups such as the Lunar Society of Birmingham and the Royal Institution successfully challenged the idea of "pure" science defined by the Royal Society. Since the time of the Restoration, the Royal Society had resisted government regulation by claiming that science transcended political, practical, or personal interests (van den Daele 40–43; Proctor 25–38). Many eighteenth-century thinkers, however, wanted science to serve human needs. Founders of the Royal Institution hoped that scientific techniques could increase agricultural production (Berman 2), while members of the Lunar Society hoped that scientific theories could improve manufacturing processes (Schofield 140, 330, 373–77, 437–39). In effect, these organizations functioned as research institutes: they cultivated learning in one area—chemistry, for example—with the assumption that it would be

useful in other areas—such as pottery making at the Wedgewood's factory or farming on enclosed plots.[5] Their development of a research orientation—the cornerstone of modern learning—is more significant than any of their specific projects.

A research orientation defines knowledge as changeable and sees scholarship as the activity of adding to knowledge (Turner, "University Reformers" 528–31). These definitions arose in Germany during the 1790s, replacing the belief that knowledge is complete and transforming academic culture in that country. Instead of being repositories for inherited knowledge, universities became generators of new knowledge. The transformation culminated in the founding of the University of Berlin as a research institution (Gellert 5–11; Turner, "University Reformers" 506–29, "Prussian Professoriate" 115–19; Ziolkowski 227–308). The idea of scholarly research that arose in German universities is often opposed to the idea of applied research that arose in professional associations, but the opposition obscures the interest in manipulating knowledge that is common to both cases. In his study of professions, Abbott characterizes the nineteenth-century German professoriate as a quintessentially professional group, one that "denied all practicing forms of professionalism but the professoriate's own" (198). Disciplines and professions often shape each other's boundaries as universities serve as "arena[s] for interprofessional competition" (Abbott 196). Since Oxbridge clung to a notion of finite knowledge until well into the nineteenth century (Engel 311–12), scientific associations provided the sole forum in which Britons could explore the infinite possibilities for new learning.

Since scientific innovators often worked for social change, their professional associations tended also to be political organizations. Most members of the Lunar Society, for instance, sympathized with the French Revolution—a circumstance that compounded resistance to new ideas at conservative universities. Fearing correspondence between the Lunar Society and the student Society for Scientific and Literary Disquisition, Oxford banned the student group as part of its campaign against public debate (Rothblatt 266–67). While the link between innovative science and innovative politics frightened conservatives, it inspired such liberal thinkers as the young Coleridge, whose admiration for the "Lunaticks" has been documented by Ian Wylie. In fact, Wylie argues, both Coleridge's short-lived scheme for a pantisocracy and his more lasting perception of himself as a scientific and social leader show the influence of plans and ideas circulated among Lunar Society affiliates (36–38).

Political clubs themselves brought new ideas about government to the attention of almost all citizens. Since the 1790s, radicals and reformers had been able to perceive themselves as part of the alternative "social circle"

that Erdman describes in his book on Britons in France. Revolutionary enthusiasts hoped eventually to inspire change in all nations, and they spread their ideas through meetings, correspondence, and publications on the arts and sciences as well as on political topics (Erdman 70–74). Reports from spies for the British establishment reveal that officials feared this propaganda more than actual invasion or rebellion (226–27).

Clearly, anyone wishing to participate in the intellectual life of Britain at the turn of the nineteenth century would do so through some journal or association. By launching a periodical, Coleridge entered the mainstream of learning in his day.[6] His desire to attract a small group—ideally "four or five hundred"—of "fellow-labourers" (*Friend* 4.2: 277, 151), along with his description of *The Friend* as a paper "conducted by" himself (3), suggests a plan for forming a professional or scholarly association around the journal. Further evidence for Coleridge's interest in collecting innovative thinkers around *The Friend* comes from a letter he wrote to Humphry Davy, the celebrated chemist with connections to both the Royal Institution and the Lunar Society. Coleridge's letter states that readers of *The Friend* should be people "who by Rank, or Fortune, or official Situation, or Talents and Habits of Reflection, are to *influence* the Multitude" (*Letters* 3: 143; emphasis in original). Such readers would learn a particular way of thinking from Coleridge's essays and would apply it to the public policies they were in positions to shape.

Eventually, readers of *The Friend* could have refined Coleridge's line of thinking itself as they discovered the strengths and weaknesses of his ideas. The continuation of a line of thinking beyond a founder's own work is an important step in the creation of a field, and it often occurs through a professional journal. Durkheim's *Année Sociologique,* a journal he founded to promote work in sociology and to review work in allied fields, provides the most successful example of this occurrence. Taking the journal beyond Durkheim's personality but remaining attached to his theories, Durkheim's collaborators made the *Année* a symbol for a collective effort to study society in a new way.[7] Similarly, *The Friend* could have established a new discipline. In its periodical format, *The Friend* was open-ended; it could have continued indefinitely with the participation of interested and qualified readers.

Expecting Coleridge's readers to have taken over *The Friend* as Durkheim's took over *Année Sociologique* is reasonable in light of Klancher's research on the conduct of eighteenth- and nineteenth-century periodicals. Klancher shows that journals routinely elicited the participation of readers. Editors formed interest groups around their journals by drawing readers into a fictional "society of the text" (24). The practice of printing article-length letters from readers (or by editors pretending to write as

readers) blurred the boundaries between imagined and lived experience, thus suggesting that readers could become writers in the alternative world of the journal (21–24). Readers identified readily with writers and editors, since they could imagine themselves in those positions. As a result, each journal represented "a tightly knit community of readers and writers who revolve[d] between reading roles and writing roles" (Klancher 22).

Members of the *Friendly* community would have been early sociologists, for Coleridge consistently instructed readers to study the social contexts for the political, moral, and literary activities treated in the journal. His contextual approach distinguishes his projected discipline from that of politics, moral philosophy, and literature, while his concentration on those prominent areas courts allies for his field. A more detailed look at Coleridge's approach to these three allied areas clarifies the sociological nature of his work. In all cases, he analyzes how collective existence conditions the representative activities.

Coleridge's attention to social context is most obvious with respect to politics, which he described as more dependent on "the state of public Opinion" than on "the influence of particular Persons" (4.2: 107). In keeping with that description, he "exclud[ed] personal and party politics and the events of the day" from his agenda (4.2: 3). Coleridge's ability to envision the public as a collective social being with influence on and priority over individuals, governments, and laws is a hallmark of sociological thinking. Durkheim made that vision a prerequisite to sociological analysis (*Rules* 125–35), and he devoted as much energy as Coleridge to discrediting the individualistic explanations of political philosophers. In a detailed criticism of Rousseau, Durkheim argued that a social contract could not start a society, because contracts can occur only in a previously constituted society. Contracts depend on "a regulatory force that is imposed by society and not by individuals" (*Division of Labor* 158). Individuals accept contracts only if they accept their connection to something outside of themselves (*Division of Labor* 158–61; compare *Montesquieu and Rousseau* 137–38). For Coleridge, likewise, solidarity must precede the creation of any contract. Addressing the matter in *The Friend*, he asked: "What could give moral Force to the contract?" And answered: "The same sense of Duty which binds us to keep it, must have pre-existed as impelling us to make it" (4.2: 102). Coleridge even saw solidarity as necessarily preceding the ascendancy of the stronger over the weaker in which Hobbes placed the origin of society; such ascendancy would require some "previous union and agreement among the conquerors" (4.2: 98). In quarreling with Hobbes and Rousseau, Coleridge and Durkheim were clearing ground for a different approach to understanding human experience—one in which the social

fact of collectivity precedes the existence of governments or self-conscious individuals.

Coleridge further explored how society constrains individuals by comparing Rousseau with Luther. For Coleridge, the difference between the two lies in their social situations. However innovative Luther's thinking may have been, his criticism of contemporary religion was not an individual act. It remained within the bounds of a belief system shared through Scripture; it never ventured outside of that system to speculate on human reason as the source of all knowledge. The constraining effects of society show themselves in Luther's susceptibility to apparitions.[8] Though he criticized superstition, Luther was nevertheless capable of imagining that he saw the devil because he was not capable of imagining the sufficiency of reason to explain all things. In short, Luther's reforms were conditioned by the needs of his society; under different circumstances, he would have thought and acted differently (4.2: 113–21). Under different circumstances, Coleridge speculated, "might not a perfect Constitution, a Government of pure Reason, a renovation of the social Contract, have easily supplied the place of the reign of Christ in the new Jerusalem, of the restoration of the visible Church, and the Union of all Men by one Faith in one Charity?" (4.2: 121). Metamorphosing Luther into Rousseau, Coleridge argued that the reforms individuals may carry out depend on the collective force he earlier called "public Opinion" (4.2: 107).

The sociological view informing Coleridge's treatment of politics in *The Friend* likewise distinguishes his approach to topics from other allied fields. Turning to moral philosophy, he criticized Paley for abstracting moral absolutes from the context of human activity and insisted that a truly moral system is "suited to human nature" (4.2: 313–20).[9] He illustrated this correspondence through his biography of Sir Alexander Ball, which provides "useful knowledge" about adapting moral precepts to social contexts (4.2: 286). The biography of that figure was almost certain to command the attention of the influential readers Coleridge courted, and the example of Ball's statesmanship was well suited to show them the value of going beyond political and moral philosophy in conducting international affairs.

Because Coleridge finds context essential for understanding an individual's behavior, he writes at length about the precarious situation of Malta during the Napoleonic Wars (4.2: 299–308) before describing how Ball acted when the island came under siege. Coleridge's account of Ball's actions emphasizes the connection between the individual's behavior and his official role. Ball's position required him to protect British interests abroad and to promote the welfare of Malta. He managed both by respecting the Maltese. Unlike most of his peers, he neither boasted about British

superiority nor condescended to Maltese culture; consequently, he won the respect and cooperation of the native population in the British struggle against the French (4.2: 350–51).

Coleridge reinforces his contrast between Ball's attitude and that of other statesmen by reporting on an episode of insubordination during the siege. Ball refused to punish starving native soldiers who stole from the British army's bakery—even though their act was officially a capital crime (4.2: 352). Considering the circumstances of the theft, Ball concluded that following official guidelines would "outrage humanity by menacing Famine with Massacre" (4.2: 353). Ball's response illustrates the contextual approach to morality that Coleridge would substitute for Paley's abstract one. Ball acted most ethically by deviating from a standard code when a situation warranted. Had he simply privileged the needs of his own country and soldiers, had he inflexibly enforced military discipline, he would most likely have failed to inspire Maltese cooperation. In the abstract, diplomats should favor their own countries; in the abstract, officers should maintain a strict and regular discipline. In practice, however, these leaders risk their larger goals if they cannot evaluate when their abstract principles do or do not suit a given situation.

In calling attention to Ball's conduct by characterizing it as intelligent, responsible, and unusual, Coleridge implicitly criticized other leaders for their inability to adjust to circumstances. He offered *The Friend* as a means of instructing them in an appropriately contextual outlook, one that is necessarily sociological. The shortsightedness of Ball's contemporaries resulted from their political focus. Knowing that Malta lacked the "established Government" that would give it a political identity, they discounted the "unanimity" that gave the population a social identity (4.2: 355–56). They therefore could not conceive of Malta as a society that could cohere independently of—or in opposition to—British interests. Knowledge of solidarity would correct their misperceptions and redirect foreign policy more comprehensively than could the individual efforts of Alexander Ball.

Although Ball's conduct was exemplary, his thinking was not sociologically informed. He followed the dictates of prudence and conscience, which led him to treat all people justly (4.2: 351). Even if Ball had acted with sociological awareness, his example would have had little more effect unless others could follow a sociological line of thinking. Ball's failure to persuade British officials to let Maltese representatives sign the eventual treaty with France confirms the need for widespread sociological knowledge. According to Coleridge, British refusal to recognize Malta reduced Britain's chances of gaining willing cooperation from any small population in any future enterprise: all would fear being temporarily exploited and subsequently dismissed (356, 363). As long as British leaders failed to grasp such

concepts as the coherence of Maltese society, they would be unable to sustain cordial, stable, and enduring relations with many of their neighbors.

Through the biography of Alexander Ball, Coleridge showed readers that moral and political philosophy could not meet the demands thrust upon international relations by the Napoleonic Wars, and he urged them to supply the lack by studying society. Coleridge also called attention to the need to supplement moral and political philosophy on the home front by reprinting "Fears in Solitude" in *The Friend* (4.2: 24–25). Noting that Coleridge changed the title to "Fears *of* Solitude," Kroeber has argued that the reprinted poem conveys Coleridge's intensified fears that his criticisms of his government would isolate him from patriotic Britons (4.2: 85–93). In the context of the sociological project of *The Friend*, the reprinted poem encouraged leaders to see that his criticisms stemmed from his desire for a stronger national unity than politics alone could create.

In treating the third allied area, literature, Coleridge eschewed the aesthetic approach that made texts autonomous in favor of an approach that tied them to social interests. He thus allied himself with a traditionally philosophical view of literature but foregrounded his own concerns with the social contexts in which writing and reading occur. "Words are moral acts," he wrote, "and words deliberately made public, the Law considers in the same light as any other cognizable overt act" (4.2: 59–60). Coleridge addressed the implications of his analogy between verbal and physical conduct through a critique of British libel law.

According to Coleridge, juries cannot accurately determine whether a text is libelous by studying its content. They should examine "external Proofs of the author's honest Intentions" together with evidence of the intended readership (61), for in cases of libel, "the circumstances *constitute* the criminality" (60; emphasis in original). For Coleridge, a work intending to disrupt social order is libelous—even if it contains accurate information. For instance, an author who reveals another person's crimes undermines order by arrogating to himself as an individual the function of the court system as a whole (4.2: 67). Concerning criticism of a government in general, Coleridge classifies it as seditious libel only if it is likely to incite rebellion. He points out that discussion of alternative political ideas can substitute for political activism; therefore, publication of speculative material can actually foster greater coherence within a society than can suppression of such material (4.2: 61–67).

Interestingly, Coleridge's contextual approach to libel explains how he could dismiss as "wanton calumnies" descriptions of himself as a former Jacobin sympathizer (4.2: 26). Publication of such a description—even if accurate—may disrupt social order. Coleridge was not tried for treason during the 1790s when Jacobin sympathy could have had such an outcome,

so the later publication of a description of Coleridge as a Jacobin amounts to a trial by an individual. Furthermore, if the motives for such a description involve reviving Jacobin sympathy among Coleridge's admirers, publication would clearly divide society into factions; if the motive was to repress Jacobin sympathy by depriving Coleridge of his present audience because of his past beliefs, publication would still have a divisive effect, for it would prevent Coleridge from contributing his mature ideas to society.

Taken together, Coleridge's remarks on politics, morality, and literature in *The Friend* insert social knowledge among the fields that defined learning in his day. The principles Coleridge expounded in *The Friend*, then, are not pronouncements about politics, morality, and literature but rather methodological guides for studying them. As such, they are comparable to the principles Durkheim expounded in his *Rules of Sociological Method*. Among Durkheim's instructions on how to study something sociologically are two principles that coincide with Coleridge's approach: one concentrates on relational rather than individual behavior, identifying what factors restrain individual actions and how they do so (50–59), and one examines these factors, which include motives and values that are not directly observable, "through the real phenomena that express them" (70). Durkheim's own work, *Division of Labor*, illustrates these principles by examining legal codes as visible symbols of solidarity; Coleridge proceeds comparably by examining political, moral, and literary activity as visible symbols of collective life.

Durkheim wrote his *Rules*, along with numerous essays on the nature and history of sociology (*Montesquieu;* "Sociology"), to establish the boundaries of that field, allying it with and distinguishing it from the most important intellectual territories in the French academy. In addition, he cleared the field of amateurs with Coleridgean warnings about the rigors of the discipline, as in this passage from *Rules:*

> This set of rules will . . . seem very laborious for a science which up to now has demanded hardly more than a general and philosophical culture of its devotees. It is indeed certain that the application of such a method cannot have the effect of stimulating further common curiosity about sociological matters. . . . But this is not the goal towards which we strive. We believe, on the contrary, that the time has come for sociology to renounce worldly successes, so to speak, and take on . . . dignity and authority . . . enough to quell passions and dispel prejudices. (163)

If we accept Durkheim's calls for an exclusive and exacting sociology as an essential step in defining the discipline, we can better understand Cole-

ridge's preoccupation with his and his readers' "laborious effort" (277) as appropriate for the work of shifting intellectual boundaries.

An explanation for Durkheim's relative success and Coleridge's relative failure in instructing sociologists lies in the contexts for their lessons. Working within a university system, Durkheim could assume that his followers would be scholars with a commitment to research, even if they had not previously studied society. He could further assume that his journal would assist a process of institutionalization that would secure the existence of sociology within French universities. Working within a broader system, Coleridge could make neither assumption, for the concept of research was just developing in his time and the institutionalization of his work rested solely on the success of *The Friend*.

Recognizing, perhaps, his readers'—or his own—unpreparedness to carry out social research, Coleridge (re)placed his work in the more familiar fields of politics, philosophy, and literature after the demise of the periodical, though he moderated rather than abandoned his sociological perspective.[10] Reissuing *The Friend* in 1818, he presented it as one finished project instead of as an open-ended inquiry. He reconfigured the essays through an architectural metaphor, making them the steps of a staircase on which readers could climb to higher knowledge. For Rooke, this arrangement inspires readers to imitate the example of Sir Alexander Ball, whose biography appears near the top. Living his life with principles and imagination, as Coleridge would lead readers to do, Ball epitomizes "the good man" (xciv). Insofar as the revised *Friend* sets up an individual example for readers to emulate, it signals a turn back toward moral and political philosophy in Coleridge's thought. Yet insofar as the essays separately retain much of their sociological promise, the revised *Friend* memorializes Coleridge's aspirations toward a new field and discipline.

The Friend, however, is more than a memorial to the stillbirth of a discipline, a Romantic sociology that might have been. Its spirit animates contemporary scholarship in Romanticism. Increasingly, Romanticists conduct inquiries that socially situate late eighteenth- and early-nineteenth-century writing and reading practices and posit principles by which to relate them to those of our own era. Our preoccupation with the ideology, radicalism, ecology, dialogism, and gendered assumptions of Romanticism show an eagerness to realize a comprehensive study of the political, moral, and literary activities of Coleridge's time and of our own time. As we join scholars in other fields in readjusting the distinctions and alliances among us, we have the opportunity to organize the discipline projected in *The Friend* and insert it into an institutional structure that can support it. Coleridge may yet find eager students for his *Friend*ly instruction.

Notes

1 I borrow the term "promissory" from Erdman's Introduction to Coleridge's *Essays on His Times* for *The Collected Works of Samuel Taylor Coleridge* (3.1: lxvi).

2 For reasons that become clear later in this essay, I cite the periodical version of *The Friend,* which appears as an appendix to the later "rifacciamento" in the *Collected Works* (4.2).

3 Coleridge sometimes enumerated these areas differently, making them, for instance, literature, the fine arts, morals, legislation, and religion (4.2: 13). All enumerations seem reducible to the three on the title page.

4 Eighteenth- and early-nineteenth-century associations have not usually been classified as professional because they lacked the formal characteristics (educational and licensing requirements, codes of ethics) by which we have come to define professions. Revisionist scholarship on this topic, however, uses broader criteria to define professional groups. Most important, Abbott recognizes professions by their manipulation of abstract knowledge and their competition with each other for control of intellectual territory. The requirements, methods, and contexts for these activities vary with time and place (3–19). Abbott's approach makes it possible to extend the category of professional to earlier, less formal associations.

5 The extent to which these organizations should be considered precursors of research institutes is controversial. Schofield treats the Lunar Society as a research organization but makes no mention of the Royal Institution; Berman considers the Royal Institution a research organization but explicitly rejects Schofield's claims for the Lunar Society (Berman 70–71). What is most important is that both groups—and numerous others that Jacob identifies (156–69)—were working toward the idea of knowledge as developmental. Members may not have been fully self-conscious about research, but they were consciously antagonistic toward definitions of knowledge as unchanging.

6 Coleridge himself referred to the press as "the main river, the Thames, of our intellectual commerce" (*Friend* 67).

7 Articles by Clark compare *Année Sociologique* to a research institute and describe how Durkheim's sociology was institutionalized in France.

8 As Woodring points out, the passage on Luther also illustrates the constraining effects of the body on the mind, a topic of interest to Coleridge on medical and metaphysical grounds (80).

9 Lockridge's books on Coleridgean and Romantic ethics have placed Coleridge's position on Paley within the field of moral philosophy: Coleridge takes the position of an act-deontologist against Paley, the rule-utilitarian (*Ethics* 147, 132–33; *Coleridge* 235–50). Lockridge notes, however, that Coleridge does not consistently maintain this position but uses "a mixture of criteria" to judge right and wrong (*Ethics* 148). Indeed, Lockridge argues for Coleridge's "distinctiveness as a moralist": though he draws on many traditions, he does not conform to any one (*Coleridge* 200).

10 Coleridge's last work, *On the Constitution of Church and State,* remained sufficiently sociological to warrant inclusion in Nisbet's history of the discipline.

Works Cited

Abbott, Andrew. *The System of Professions: An Essay on the Division of Expert Labor.* Chicago: U of Chicago P, 1988.

Abrams, M. H. *Doing Things with Texts: Essays in Criticism and Critical Theory.* Ed., fwd. Michael Fischer. New York: Norton, 1989.

Berman, Morris. *Social Change and Scientific Organization: The Royal Institution, 1799–1844.* Ithaca: Cornell UP, 1978.

Brown, Richard Harvey. "Modern Science: Institutionalization of Knowledge and Rationalization of Power." *The Sociological Quarterly* 34 (1993): 153–68.

Clark, Terry N. "Emile Durkheim and the Institutionalization of Sociology in the French University System." *European Journal of Sociology* 9 (1968): 37–71.

———. "The Structure and Functions of a Research Institute: The *Année sociologique.*" *European Journal of Sociology* 9 (1968): 72–91.

Coleman, Deirdre. *Coleridge and* The Friend *(1809–1810).* Oxford: Clarendon, 1988.

Coleridge, Samuel Taylor. *Collected Letters of Samuel Taylor Coleridge.* Ed. Earl Leslie Griggs. 6 vols. Oxford: Clarendon, 1956–71.

———. *The Collected Works of Samuel Taylor Coleridge.* Ed. David Erdman. Vol. 3. Princeton: Princeton UP, 1968.

———. *The Collected Works of Samuel Taylor Coleridge.* Ed. Barbara Rooke. Vol. 4. Princeton: Princeton UP, 1978.

Durkheim, Emile. *Montesquieu and Rousseau: Forerunners of Sociology.* 1892. Trans. Ralph Mannheim. Fwd. Henri Peyre. Ann Arbor: U of Michigan P, 1960.

———. "Sociology and the Social Sciences." 1909. *Emile Durkheim on Institutional Analysis.* Ed., trans., introd. Mark Traugott. Chicago: U of Chicago P, 1978. 71–87.

———. *The Division of Labor in Society.* 1893. Trans. W. D. Halls. Introd. Steven Lukes. New York: Free Press, 1982.

———. *The Rules of Sociological Method.* 1895. Trans. W. D. Halls. Introd. Steven Lukes. New York: Free P, 1982.

Engel, Arthur. "Emerging Concepts of the Academic Profession at Oxford 1800–1854." *The University in Society.* Ed. Lawrence Stone. 2 vols. Princeton: Princeton UP, 1974. 1: 305–51.

Erdman, David. *Commerce des Lumières: John Oswald and the British in Paris 1790–1793.* Columbia: U of Missouri P, 1986.

Gascoigne, John. *Cambridge in the Age of the Enlightenment: Science, Religion, and Politics from the Restoration to the French Revolution.* Cambridge: Cambridge UP, 1989.

Gellert, Claudius. "The German Model of Research and Advanced Education." *The Research Foundations of Graduate Education: Germany, Britain, France, United States, Japan.* Ed. Burton R. Clark. Berkeley: U of California P, 1993. 5–44.

Gieryn, Thomas F. "Boundary-Work and the Demarcation of Science from Non-Science: Strains and Interests in Professional Ideologies of Scientists." *American Sociological Review* 48 (1983): 781–95.

Jacob, Margaret C. *The Cultural Meaning of the Scientific Revolution.* Philadelphia: Temple UP, 1988.

Klancher, Jon P. *The Making of English Reading Audiences 1790–1832.* Madison: U of Wisconsin P, 1987.

Kroeber, Karl. *British Romantic Art.* Berkeley: U of California P, 1986.

Lockridge, Laurence S. *Coleridge the Moralist.* Ithaca: Cornell UP, 1977.

———. *The Ethics of Romanticism.* Cambridge: Cambridge UP, 1989.

Logue, William. *From Philosophy to Sociology: The Evolution of French Liberalism, 1870–1914.* DeKalb: Northern Illinois UP, 1983.

Lukes, Steven. *Emile Durkheim: His Life and Work.* New York: Harper, 1978.

Messer-Davidow, Ellen, David R. Shumway, and David J. Sylvan. "Introduction: Disciplinary

Ways of Knowing." *Knowledges: Historical and Critical Studies in Disciplinarity.* Ed. Ellen Messer-Davidow, David R. Shumway, and David J. Sylvan. Charlottesville: UP of Virginia, 1993.

Nisbet, Robert. *The Sociological Tradition.* New York: Basic, 1966.

Price, John V. "The Reading of Philosophical Literature." *Books and Their Readers in Eighteenth-Century England.* Ed. Isabel Rivers. Leicester: Leicester UP; New York: St. Martin's, 1982. 165–96.

Proctor, Robert N. *Value-Free Science?: Purity and Power in Modern Knowledge.* Cambridge: Harvard UP, 1991.

Rothblatt, Sheldon. "The Student Sub-Culture and the Examination System in Early Nineteenth-Century Oxbridge." *The University in Society.* Ed. Lawrence Stone. 2 vols. Princeton: Princeton UP, 1974. 1: 247–303.

Schofield, Robert E. *The Lunar Society of Birmingham: A Social History of Provincial Science and Industry in Eighteenth-Century England.* London: Clarendon-Oxford UP, 1963.

Turner, Steven. "University Reformers and Professional Scholarship in Germany 1760–1806." *The University in Society.* Ed. Lawrence Stone. 2 vols. Princeton: Princeton UP, 1974. 2: 495–531.

———. "The Prussian Professoriate and the Research Imperative 1790–1840." *Epistemological and Social Problems of the Sciences in the Early Nineteenth Century.* Ed. H. N. Jahnke and M. Otte. Dordrecht: Reidel, 1981. 109–21.

van den Daele, Wolfgang. "The Social Construction of Science: Institutionalisation and Definition of Positive Science in the Latter Half of the Seventeenth Century." *The Social Production of Scientific Knowledge.* Ed. Everett Mendelsohn, Peter Weingart, and Richard Whitley. Dordrecht: Reidel, 1977. 22–54.

Woodring, Carl. "Vision without Touch: Coleridge on Apparitions." *The Cast of Consciousness.* Ed. Beverly Taylor and Robert Bain. New York: Greenwood, 1987. 77–85.

Wylie, Ian. "Coleridge and the Lunaticks." *The Coleridge Connection: Essays for Thomas McFarland.* Ed. Richard Gravil and Molly Lefebure. New York: St. Martin's, 1990. 25–40.

Ziolkowski, Theodore. *German Romanticism and Its Institutions.* Princeton: Princeton UP, 1990.

Keats and the Aesthetics of Critical Knowledge;

or, The Ideology of Studying Romanticism

at the Present Time

DAVID S. FERRIS

*A*t a time when the study of romanticism has turned away from the textual and linguistic emphasis of theory and pursued an increasing concern with literature as the reflection of pressing social, political, and historical issues, any return to such an emphasis would now appear to carry with it the taint of ideology. In our desire to be free from such a taint, we can surely be forgiven an aspiration to interpret the past according to a consciousness of history that would rigorously separate itself from the unquestionably ideological misreadings of its precursors. Yet, there is more at stake in such an aspiration. Not only does this desire to be modern imply a critique of romanticism as a theoretical inquiry into the name and nature of literature, but it also reasserts a confidence in the power of the critical faculty whose questioning set the stage for so many of the critical, theoretical, and literary documents that populate the romantic landscape. To dismiss this questioning as the ideological outpouring of an overwrought mind is to insist that literature may be best understood as a reflection of historical and political reality. From this conviction, history arises as the source of a critical power whose goal will always be the unmasking of ideology wherever literature occurs. At this juncture, history fills a vacuum left by a criticism unable to account for its power of judgment.

Within the climate fostered by current trends in romantic criticism there can be little incentive to question what we study in the name of literature, since any denial of the social, political, and historical preoccupations of modern criticism will appear to be simply ideological. The predictability of this response threatens to conceal what is actually at stake in this recognition. First, there is the need to have an example of ideology (since an example of ideology is always easier to attain than an account of what ideology is), and second, there is the opening of the past to a modernity in which our consciousness of history may be viewed. As already indicated,

this emphasis on ideology and history not only carries with it a criticism of reading romanticism as the source of a theoretical reflection, but it is itself the means of renewing a critical relation to literature that the theoretical inquiry undertaken by romanticism could not sustain. Thanks to ideology, criticism and judgment return in the guise of history, and they do so at the very moment when ideological criticism undertakes its classical gesture of denying the aesthetic any meaningful significance of its own while at the same time reserving the political and the historical as the source and the object of critical judgment. By depriving the aesthetic of a role in critical judgment, our modernity has in effect refused the only means that allowed Kant to account for judgment: the aesthetic idea (Kant 215). After this separation, what else can the aesthetic be but an example of beauty whose only purpose is to sustain an ideological understanding that must eventually succumb to the nemesis enacted by our historical and political modernity?

Once critical judgment is grounded in the historical, it is hardly surprising that the aesthetic should have little place within the contemporary study of romanticism. It goes without saying that an emphasis on social, political, and the historical issues—our critical modernity—demands that the aesthetic be regarded as an insignificant aspect of our relation to art. Yet this is hardly an unproductive or unmotivated insignificance. Our ability to recognize ideology derives from this insignificance. When all is said and done, the aesthetic has a use after all, since its insignificance becomes a sign of the political and historical forces it is said to disavow. What, then, is missing from this critique of the aesthetic (which is nothing less than the attempt to separate history from ideology) is an account of the role played by the aesthetic in sustaining the social, political, and historical understanding that arises in the name of a critique of ideology.

The aesthetic that sustains our critical modernity can hardly be confused with the beautiful—there is little that is beautiful about the social, political, or historical concerns now dominating the study of literature. Rather, the aesthetic names a mode of representation without which the historical inclination of current literary study is unable to determine the object of its inquiry. Yet the current dominant tendencies in literary study have been reluctant to reflect upon the necessity of this aesthetic, despite the fact that it guides and enables its most alluring insights—it is as if any admission of an aesthetic presence would be in direct antipathy to tendencies that wish to distance themselves from the theoretical inquiries they have consigned to the judgment of history. Ironically, through this aesthetic presence, what has been left behind, namely, the theoretical, returns to haunt the social, political, and historical concerns that have been the very source of its rejection.

While literary study has veered wholeheartedly toward the historical and away from the philosophical character of our recent theoretical history, this direction has fostered an increasing awareness of the political in both the literature we study and in the way we study it. It is this absorption into the political that has made the aesthetic most difficult to discern. Indeed, what could be further from the political than the insignificance of a poem's aesthetic qualities? Or, to show how our current understanding of politics in literature operates, what could be more political than the insignificance of a poem's aesthetic qualities? The evasion of the political is, as we are always being reminded, a political act. Given this state of affairs, the aesthetic must always (as the saying goes) already possess a political dimension. As a result, the aesthetic will always be understood as the representation of the political. But if the aesthetic is defined in this way, no reflection on its own status as a mode of perception, still less its role in the creation of the political, can take place, since the aesthetic will always be overshadowed by what it is not.

The means by which the aesthetic comes to represent the political arises from what Hegel recognizes by the name of negative determination.[1] By negating one thing, another is determined. Such a movement of negation is never simply negation. In the present example, the aesthetic, as the negation of the political, affirms the existence of the political by an act of refusal. This refusal, however, cannot take place unless the political or the historical has already determined its occurrence (what would there be to refuse if this had not already taken place?). Within such an understanding there can be no such thing as an aesthetic independent of the political or the historical. Simply speaking, there is no pure ideology that does not in some way corroborate with the political and historical position that announces its purity. In this case, the aesthetic is never a simple example of ideology, since it is always an example of the understanding it refuses—and by means of this same refusal. The question then is whether there can even be an example of ideology or whether by insisting upon its exemplariness, its purity, one insists upon the unexemplariness of one's own history if not one's own impurity.

The difficulties that afflict the discernment of the aesthetic as an example of ideology all derive from the need to separate the aesthetic from any understanding that affirms itself through another's ideology. This separation is described most commonly as an act of self-negation performed by what the historical and the political wish to exclude from themselves. The aesthetic, like the mimetician in Plato's *Republic*, must, in the end, practice self-condemnation and exile itself from historical and political significance. Only by recognizing how it is already political and

historically determined may it return to the critical fold, that is, only by recognizing what the aesthetic has always known (and which is also Plato's charge against the mimetician): its meaning is not its own.

At the point where the aesthetic denies itself and recognizes its repressed political and historical significance, it, in fact, becomes more aesthetic than ever and in a way that threatens the history and politics that sought to define it as ideology. To recognize ideology, the aesthetic must deny historical and political meaning, but, for there to be such meaning, the aesthetic must also affirm, albeit negatively, the political and the historical as its repressed subject. There is an irrevocable contradiction in this account of the aesthetic. Since the world of history and of politics is affirmed by an aesthetic that negates itself in order to grant meaning to this world, then neither history nor politics can become meaningful without such an aesthetic. The historical and political are dialectically tied to the mode of representation they must both reject in order to be either historical or political.

In the modern interpretation of romanticism, this dialectic has been nowhere more in evidence than in Jerome McGann's *Romantic Ideology*. Even though the culprit in McGann's case is not exactly contemporary literary theory (who would call either Hegel or Coleridge theoretical in the contemporary sense?), the response is the same. Consider the example of Hegel, whose aesthetics are limited to a form of self-representation that reflects what McGann calls romantic ideology albeit in its complete form (as opposed to Coleridge's romantic account of romantic art, that is, a fragmented account of a necessarily fragmented subject) (McGann 46–48). While the overdetermination present in these assertions are questionable on their own grounds, it is more constructive to question McGann's position by considering the role his overdetermination of Hegel plays in the promotion of a specifically romantic ideology (that is, why the "complete" form of ideology must always be present. Not satisfied with labeling Hegel's philosophy "self-representation," McGann goes so far as to condemn Hegel's treatment of the aesthetic as "'pure' theory" (47).[2] This "'pure' theory" indicates a closed account of romanticism; it is, in effect, an ideological account of romantic ideology, and, as such, McGann insists, it reflects neither romantic art nor even romantic ideology.[3] What McGann sets up through this account of Hegel is an account of art that has no relation to anything other than its own account of art. Predictably, this is not the only overstatement or rather misstatement of Hegel in a book that would sum up the "theory" of Hegel in three pages. Indeed, how can we accept an account of Hegel's treatment of the aesthetic that fails to distinguish between romanticism and what Hegel refers to as The Romantic Arts? As any reader of Hegel's *Aesthetics* must know the two are not the same: the former is only a moment in a period whose beginning Hegel

traces to the dissolution of classical art. This failure to recognize how Hegel understands the historical development of the aesthetic is a failure to recognize the dialectical dilemma that haunts criticism especially when it seeks to define ideology. Only such a failure can account for McGann's dismissal of what is in fact a sympathetic voice: when Hegel discusses writers now recognized as belonging to romanticism (and closest to the fragmentary theory McGann brands as romantic ideology in Coleridge), his remarks are not just critical but share that disapproval of mere self-representation that informs McGann's romantic ideology. For Hegel, what we now call romanticism is the moment in The Romantic Arts when art moves toward a purity, that is, it moves toward a total divorce from external representation. It becomes pure; it becomes, in effect, insignificant since it is only meaningful for itself.[4] It is at this point that one can see how Hegelian McGann's romantic ideology really is: at the moment he dismisses Hegel as pure theory, McGann has merely enacted what Hegel maps out as the historical passage of the aesthetic. To put this more succinctly, Hegel's account of the history of the aesthetic is the means by which McGann rejects Hegel in the name of history: the aesthetic (in the guise of history and politics) is criticizing the aesthetic in order to hide from itself, and, as McGann hopes, it does so in order to go where no aesthetic has ever gone.[5]

If the aesthetic has a habit of reappearing just when it has been dutifully dismissed as the source of ideological fantasy, then the aesthetic cannot be restricted to the formulaic understanding that prevails in the literary histories of our time. As Hegel's *Aesthetics* emphasizes, the aesthetic is not simply an expression of the timeless beauty of, for example, a Greek sculpture but is always the expression of a difference between what is represented and the means of representation.[6] The aesthetic is always appearance; it is always the representation of something different from itself[7] (and, as McGann should know, this is true even for self-representations of the self). Without this difference no such concept as the aesthetic could ever exist. But because this difference, essential to any theory of representation, does not itself belong to representation, it can always be overcome by viewing it as a sign of negation. Hence, the romantic ideology through which the difference between the aesthetic and its subject has been translated into the negative representation of history and politics. Here we can discern the point of confusion that always allows the aesthetic to return and represent the political and the historical: First, the aesthetic is said to only represent itself; then, second, this self-representation is said to indicate what it excludes. The whole possibility of ideological criticism requires the first statement; it turns upon the demand that the aesthetic is essentially meaningless—only then can it represent, by negation, the meaning it is said to exclude. Recognition of this insignificance is so crucial that it points

to the origin of historical and political criticism in a theory of the meaninglessness. By instituting a sharp distinction between the aesthetic, on the one hand, and the political and the historical, on the other, this theory allows the latter to deny any complicity with the object of its critique while using what it critiques as a means of representing itself. Such deniability is no stranger to politics, and the dialectic explicitly present in this treatment of the aesthetic is no stranger to criticism, whether ideological or not.

Since the ideological dismissal of the aesthetic also requires it to be confused with history and politics, we may be forgiven the suspicion that we have returned, with a change of terms, to a critical commonplace of the late eighteenth century—the commonplace that offers such memorable critical advice at the end of Keats's "Ode on a Grecian Urn": "Beauty is truth, truth beauty." Tautologies die hard. We would now say: "Aesthetics is politics, politics aesthetics," or even "Aesthetics is history, history aesthetics." Despite the similarity of our critical mottoes, it would not be true to say that we have returned to the eighteenth century. It would be truer to say that we are still struggling, critically speaking, to get out of the eighteenth century. What stands in our way is nothing less than romanticism, and no amount of ideological finger-pointing will allow us to evade this considerable obstacle and its reflection on the relation of historical knowledge and aesthetic understanding. To confuse this reflection on the aesthetic with an ideology of the aesthetic is to refuse romanticism in the name of ideology. This, however, is not the only confusion made in the name of ideology.

As the motto on Keats's Grecian urn states, beauty and truth appear to be simply interchangeable with one another. For the distinction that lies at the basis of all ideological criticism no such interchangeability can be envisioned: aesthetic and historical truth must be rigorously separated from one another, whether or not the subject is romanticism. Clearly, such a separation should distinguish our age from that of the critical commonplace expressed in Keats's ode. Unfortunately, the logic that allows this distinction and, hence, ideology, to be recognized is not such a one-way street. As a first step, this logic demands the interchangeability of its terms: a romantic ideology arises by arresting such interchangeability, and it is from this arrest that the history substituted in its place derives its critical force. Without this arrest, neither the political nor the historical can have any critical significance. As a result, the identification of ideology has no other critical purpose than to preserve criticism from the confusion of history and the aesthetic that lies at the origin of its own judgments.

If the recognition of ideology reveals a dependence on the confusion of the terms it wishes to keep separate, then ideological criticism feeds the context in which such claims as "every aesthetics is a politics" gain intellectual and critical currency despite the fact that they offer no more

knowledge than the celebrated commonplace of Keats's urn. Claims of this nature avoid the question of what the political or the aesthetic is: since one is always seen as the representation of the other, neither can be defined alone. This is particularly true in the case of the ideological dismissal of the aesthetic, since this dismissal can only define the political in terms of what the aesthetic excludes. Its subject defined in such a resolutely negative way, ideological criticism not only avoids distinguishing between the aesthetic and the political, but it also refuses to raise the question of what a politics divorced from aesthetics would be either in the context of literary interpretation or historically (since the word does have a history that, as Hannah Arendt points out, begins for us with the Greek τὰ πολιτικά [Arendt 49]). Indeed, how can we ever be taught anything about the relation of politics to aesthetics if the latter can only be seen through the other's eyes? But this failure of the aesthetic before the judgment of history and politics, does it sustain their claim to primary significance wherever art occurs, or does it belong to the history through which the aesthetic has been persistently mediated since the middle of the eighteenth century?[8]

To the extent that it sustains the primacy of politics and history, the aesthetic can only be a transitory concept that will always be denied significance whenever literary interpretation lays claim to political and historical knowledge. This state of affairs allows no room in which to raise the question of the aesthetic, since the interchangeability of the political and the aesthetic demands that the aesthetic always be thought as the representation of political understanding: one cannot be thought in terms of the other unless one is represented by the other. Yet it cannot be forgotten that whenever the aesthetic is said to be the representation of the political, the aesthetic is always the means of representation. Whether one likes it or not, one still needs the aesthetic whenever the political or the historical is evoked. As Keats's ode states, that is "all ye need to know." In such circumstances, the political and the historical persist in a conceptual realm that cannot divorce itself from the mediating power of the aesthetic understanding. If so divorced, the political and the historical would have to renounce their claim to meaning, a renunciation they are only too willing to make on behalf of the aesthetic and the theoretical. To be meaningful, the political allows itself to be represented by the aesthetic even to the extent of being indistinguishable from the aesthetic. Here, the central issue posed by the critical espousal of a romantic ideology is revealed: history and the politics it assumes are not the repressed content of the aesthetic but rather one of its representations. The aesthetic is not one critical approach among others; the aesthetic possesses a generality that is coextensive with the practice of criticism as well as the history in which this practice takes place. The discovery of ideology is the attempt to deny this state of affairs

and then police the distinction between a "pure" aesthetic on the one hand and history and politics on the other. As may be expected, the police in this case are aestheticians of such considerable dialectical dexterity that they can arrest themselves but put someone else in prison in their place.

The resourcefulness of this dialectical understanding is such that any critical interpretation, whether avowedly political or not, can always be analyzed as possessing some political intent. Armed with the power of the aesthetic, this dialectic can always see what is denied to sight. This pervasiveness of the aesthetic within criticism derives from its ability to serve as both a source of mediation and a mode of perception. This is why the aesthetic is so necessary in any attempt to define literature in terms of history, politics, sociology, and so on (and such attempts are unavoidable— otherwise what we teach as romanticism would of course be merely ideological). Thanks to the aesthetic and its ever attendant dialectic, literature is definitely not what Keats refers to as the "foster-child of silence and slow time" but rather the authoritative child of a criticism that reinforces not just what it mediates but also the unquestioned acceptance of mediation itself. In doing so, criticism has become the means par excellence for the interpretative commonplaces of a historically and ideologically safe modernity. But in so espousing this historically determined aesthetic, the criticism performed in the name of romanticism denies the critique that is so central to the poetic reflection of the Romantic period. Perhaps this is why we now teach in an age for which the study of poetry has become marginal to the study of literature. Perhaps this is why poetic reflection must be denied in the name of ideology.

This denial is never more at work than when we define romanticism as the historical moment from which we trace the aesthetic practices that have informed not just the modern interpretation of romanticism but also many of our critical endeavors. While the historicity of this moment could be located in an event—for example, the French Revolution—such an event does not provide an account of what relation persists between romantic poetry and *its* past. (As any historian—but not any literary historian—can testify, the events of the French Revolution were hardly poetic and are therefore unqualified to tell us about poetry.) What all this serves to indicate is the extent to which literary history has a fondness for adopting actual history whenever it turns away from "the silence and slow time" that characterize the history of literature, which, in Keats, is also the history of artistic endeavor.

To raise the question of Romantic poetry and its past is to reflect upon the historical and political implications of what we now study as romanticism. It is also to reflect upon the persistence within romanticism of questions that can, if one chooses, be traced to classical rhetoric and a

tradition that has as little in common with the ancien régime as it has with what now reigns as the political and aesthetic education of our literary modernity. It is no accident that the aesthetic understanding attributed to literature (and on which our ability to speak of literature as a politics is now based) directly opposes itself to such rhetorical traditions. What distinguishes these traditions is the fact that they were the first attempts to understand the figurative nature of the medium in which literature is written. Although these traditions are ignored by the aesthetic understanding through which literature is always viewed as the mediation of something else, no such thing as the aesthetic could exist without first being a witness to the figurative nature of literature studied by these traditions. To reject the aesthetic as the self-representation of an ideology is to reject at the same time the nature of the medium in which literature is produced. There is thus a denial of rhetoric built into the political and aesthetic education that would now dominate the study of romanticism; through this denial, romanticism is in the process of being given a political education, which is to say, it is being educated according to a political understanding that has already dismissed as aesthetic any understanding that does not accord with its determination of what can or should be mediated by literature. The etymology of education casts a cruel irony on this state of affairs, since such a closed approach is in fact leading us out of romanticism while foreclosing any questioning of the historical and political dismissal of the aesthetic that has come to define a modern education. From this, it should be clear that in matters of education we have not even progressed to Schiller's adoption of Kant since Schiller, at least, recognized the political necessity of the aesthetic. Rather than explore this issue by returning to Schiller and Kant, the following remarks will concentrate on Keats and, in particular, on the way in which a poetic reflection may use the aesthetic in order to develop its critique of judgment (for it is on judgment, as Kant observes, that any account of the social and the political must be grounded).[9] Only by taking up the questions posed by the figurative nature of literary language can one begin to understand the role played by the aesthetic understanding within romantic poetry and poetic drama. To the extent that such questions are posed by romantic poetry and to the extent that such questions first arise within the classical study of literary language, the historical and critical tradition that has traditionally understood romanticism as breaking away from romanticism will have to be rethought.

Two poems, one from October 1816, "On First Looking into Chapman's Homer," and the other published in 1820, the famous "Ode on a Grecian Urn," will serve as the texts in which Keats's reflection on the aesthetic may be examined. In both cases, this reflection takes the form of the relation of modernity to Greece, and in both cases this reflection is in-

volved with the question of judging history. In the former, this relation is explored through language and its translation, and in the latter by the relation of language (the poem) to an aesthetic object that doubles as an apparently historical artifact.

Keats's "Ode on a Grecian Urn" may seem at first an unpromising place to observe a critique of the very judgment necessary to any successful model of criticism, particularly one concerned with historical and political issues. But, above all else, what is at stake in criticism is a concept of judgment not determined by the aesthetic and political concerns it is meant to account for. A critique of judgment seems far-fetched in a poem whose aesthetic concerns seem to dominate all else; yet it is the domination of these concerns that is so frequently misread and so frequently dismissed, as if they expressed the totality of Keats's poetry. In the "Ode on a Grecian Urn" these concerns may be easily summarized. The poem is presumably about a classical object, a Grecian urn. From this urn the poet seeks knowledge about what it represents, or rather, to be more precise, the poet seeks knowledge about what the representations on the urn represent. Thus we may conclude that what the poet seeks knowledge about is, in fact, the urn's aesthetic status, that is, the poet is inquiring into the relation between aesthetics and knowledge, or, to use the poem's own words for this relation, truth and beauty. Furthermore, the knowledge sought from this relation is historical in nature, since the urn is described as representing scenes belonging to antiquity. In this case, the aesthetic understanding of the urn demands that the urn may only be understood according to the historical, political, and cultural events that define being Grecian. It is at this moment that the aesthetic becomes the means of representing historical knowledge as literature is defined as something other than literature. In this way, the aesthetic not only allows literature to be judged by history but also allows it to be overcome in the name of culture and history, whether that culture and history be Greek or otherwise.

To this point, Keats's "Ode on a Grecian Urn" reflects how the aesthetic seeks to appropriate a past that no longer has any historical significance of its own. The past in this case would be Greece as it is mediated by an urn that, we are told, is Grecian, or more precisely, it is *like the Greek*. The urn that forms the subject of this ode cannot be historical in the strict sense of the word. Moreover, as various commentators have pointed out, there is no urn that represents all that Keats says this Grecian urn represents.[10] If the adjective "Grecian" in Keats's title, as well as the later use of "Attic" as an adjective in the phrase "O Attic shape," is taken into account, then there is a clear indication that Keats's ode reflects but does not affirm the substitution of aesthetics as a judgment from which we can derive knowledge. That the urn is Greek is an aesthetic judgment, but this is not a fact according to

the language of the poem. To fail to read this fact is to permit a substitution through which the aesthetic judges historical as well as political knowledge.

Keats's relation to the Greek is complicated substantially by the persistence of antiquity as an adjectival rather than a substantial presence in the poem. This fact alone should caution us to tread carefully through the aesthetic history that views the rise of romanticism as the rejection of the classical. Most commonly, this rejection of the classical takes the form of a rejection of its presumed historical completion in eighteenth-century classicism. But what if our understanding of classicism were no more related to the classical than the urn of Keats's poem? The question of classicism is directly relevant to the issue under discussion here, since, through it, the classical has been rejected by a model of education that has favored the political and historical definition of romanticism—all else being mere ideology. But does romanticism mark the date from which a classical education (traceable to the trivium's insistence on grammar, rhetoric, and logic) loses its significance and is supplanted by a model of education based upon historical and political concerns? If romanticism does not mark such a date, then we must be careful to distinguish precisely what constitutes classicism on the one hand and the classical on the other.

For romanticism to be proclaimed as heralding a model of education defined by ideologically suspect aesthetic concerns, it must first oppose itself to classicism and all that it represents in the name of antiquity. In other words, romanticism must first effect nothing less than the completion of the classical, since this opposition could not be thought unless such a completion is assumed. This completion, which we recognize as the classicism of the eighteenth century, marks the advent of the aesthetic understanding that history has associated with romanticism. In general terms, what is expressed through the relation of romanticism to classicism is less a historical development than the possibility of defining something such as the classical in terms of its historical completion. The need to possess such definitions is hardly new, since one may already read it in the *Poetics* when Aristotle prefaces his analysis of tragedy with the comment, "For us, tragedy has now come to a standstill" (49 a15). In other words, for Aristotle, tragedy has ceased to develop and is therefore susceptible to definition. Given this pattern, what takes place in the relation of romanticism to classicism is more than a mere skirmish in the unending disputes of literary history (of which, it might be added, contemporary criticism is always the best witness). Rather, the relation of romanticism to classicism reenacts an essential critical paradigm of which the historical epochs of classicism and romanticism are only particular examples.

What is at stake in this paradigm can be perceived clearly if one recalls the most frequently cited statement from Hegel's *Aesthetics*, namely, his

announcement that "art is and remains for us a thing of the past" (*Werke* 13: 25). This declaration has all the familiarity we associate with remarks that allow us to condense to the gnomic a work as extensive as the *Aesthetics*. The significance of this remark is less well recognized than its currency in usually critical contexts would suggest. (If it were recognized, such a statement would be less easy to use as a means of dismissing an aesthetics still practiced throughout literary criticism). For Hegel, this statement heralds the moment at which art, that is, the aesthetic, is overcome—an overcoming that, in Hegel's case, occurs in the name of philosophy rather than a critical subject. The aesthetic in Hegel thus names a progressive understanding of the history of art, a history that is destined to produce the overcoming of art so that it will no longer possess a significance of its own but will be defined by what it is replaced with. What is at stake in such an understanding of the aesthetic is nothing less than the overcoming of literature, an overcoming that demands that art achieve its completion by becoming the representation of something other than art.

Significantly, for our current context, the moment that signals this overcoming in Hegel occurs at the end of what he refers to as the romantic era—precisely what we know as romanticism. What occurs in the canonical version of how romanticism is related to classicism is therefore anticipated in the relation of philosophy to romanticism as it is thought by Hegel. As a result, in Hegel, the fullest philosophical working out of the pattern to which the relation of romanticism to classicism belongs can be discerned. As Hegel makes clear, the overcoming of literature takes place in order to turn its language into the medium for conceptual understanding.[11] (For Hegel, the aesthetic gives way to the philosophical; for us, the aesthetic gives way to the political.) Arguably, literary history does not overtly proclaim such a Hegelian pattern for itself. Since we think of literary and critical history as progressing toward increased knowledge about the object of its attention, this pattern may be hard to discern. Yet even a cursory view of the contemporary state of criticism should at least indicate to us that such is not the case. Not only has the question of what literature is been subsumed by the self-determining nature of particular approaches that only see their own reflections (the rage of Caliban and the desire of Narcissus are equally present in this situation), but this has occurred under the aegis of an aesthetic understanding that persists in conceptualizing literature as if it were simply the aesthetic representation of history and politics (so that language emerges as the preeminent medium for such concepts, just as it becomes the preeminent medium for philosophy in Hegel once art has come to an end). In both cases, literature will be overcome in the name of a subject that can only define itself through this overcoming. For this reason, we should be hesitant to speak about the overcoming of the classical

in the name of romanticism, since what classicism represents is less an epoch in literary history than the possibility of transforming literature into the aesthetic representation of a critical subject—a moment that critical history has chosen to celebrate as romanticism although partisans of other periods could always make such a claim on behalf of their subject.[12]

In the 1816 sonnet "On First Looking into Chapman's Homer," Keats takes up the question of this transformation in a poem that is specifically concerned with a subject that would define itself in relation to a classical past.[13] Curiously, this past does not appear to be susceptible to being read. The sonnet's title reminds us that the poem arises from the act of looking into Chapman's Homer—even understanding this phrase figuratively, in the sense of inquiring into something, does not change the fact that the poet's relation to the language of this text is announced in terms of simply seeing rather than the understanding normally associated with an act of reading. This emphasis is reiterated in the opening lines:

> Much have I travelled in the realms of gold,
> And many goodly states and kingdoms seen;
> Round many western islands have I been
> Which bards in fealty to Apollo hold.
> (1–4)

As the locations described in these lines indicate, the poet is essentially a tourist who has traveled to both the political and poetic sources of antiquity. Thus the emphasis falls upon the visual, since one does not, after all, become Oedipus to go sightseeing. Yet the looking associated with the poet as tourist is an effect of reading, and of reading in a certain way. The phrase "realms of gold," if read as a figure for books, indicates that this poet is no ordinary traveler but a tourist who regards books as a means of visualizing "states and kingdoms," and as a means of possessing such sights as if they were direct experience. This substitution of visual experience for a text is confirmed in lines 3 and 4 when poets are described not by their works but by the islands they hold "in fealty" to their patron, Apollo. Since it is to these islands that the speaker in this sonnet claims to have traveled by means of "realms of gold," the classical must appear as the result of reading books as if they could be understood by regarding what cannot be seen, antiquity, as accessible to vision.

Keats's insistence on visual reference continues in the poem's only direct reference (unmediated by Chapman) to a Homer. Like the bards of Apollo, Homer is defined by a space, his "demesne." But here a difference is to be marked. Unlike the opening lines of the sonnet, what is known about Homer comes from the mouth of another rather than a "realm of gold": "Oft of one wide expanse had I been told / That deep-browed Homer

ruled as his wide demesne" (5–6). After its initial emphasis on the visual, the sonnet indicates the obvious fact about what takes place when we first look into its opening lines: the visual understanding offered by this sonnet does not arise from direct experience but from the site it would always leave behind, the site we would always travel away from so that books may become realms of gold, states, kingdoms, and so on. By making Homer known through the voice of another, Keats explicitly defines the source that is always to be left behind. The visual, which here responds to the invitation offered by any recognition of metaphor, is sustained by what neither the medium of the poem nor the mouth of another can reveal to sight. The opening lines of this sonnet may now be put back into their context if we remind ourselves that they, too, are spoken; they are what we have been told by the mouth of another, the mouth of the poet.

By insisting that the visual is an effect of the words in which it originates, the sonnet merely prepares us for the terms in which Keats defines his relation to the classical. If, in distinction to the Renaissance, antiquity arises for the eighteenth century not through texts but through aesthetic objects, then Keats's insistence on antiquity as something that has to be told indicates his distance from the visual aesthetic that fuels romantic Hellenism and its concept of history.[14] But as Keats's sonnet continues, the terms in which this relation is presented also undergo a complication. No longer is this relation simply based on a distinction between a text and objects of visual experience. Now a text occupies the place of antiquity, and it, too, becomes supplanted by a voice, albeit a voice not its own. Keats continues the last lines cited with the following statement: "Yet did I never breathe its pure serene / Till I heard Chapman speak out loud and bold" (7–8). In place of the tendency to understand antiquity in terms of its aesthetic objects, Keats calls upon the Renaissance in the form of Chapman's translations of Homer. Antiquity now speaks not through Winckelmann but through the text and voice of another. Only when Chapman speaks can Keats breathe the air of antiquity. That such emphasis is to be placed on breath as the means by which antiquity is received should not be overlooked. In its presentation of the poet's experience of antiquity, the poem indicates (and states first) that breath is what is essential. Only after this statement is given are we told that the poet heard Chapman. Through the ordering of these phrases, the poem gives the effect first, then turns to grammar in order to invert the syntactic arrangement and produce historical causality ("Yet did I never . . . till . . ."). An even finer observation still needs to be made here. It must also be added that although Keats says he hears Chapman speak, nowhere does he say that he hears the words of Chapman, never mind Homer. Keats only says that what is heard is a speaking out that is loud and bold. Is it to this loudness and boldness that

we are to attribute the breath of antiquity? The emphasis falls on the fact of Chapman speaking, and, as such, the poet's experience of Homer falls on the breath of Chapman. But isn't Chapman as dead as the Homer he is supposed to give breath to? What, then, does Keats breathe in?

In the course of its development, this poem enacts many substitutions: the Greek poets are spoken of in terms of the islands they hold; Homer is spoken of first by his demesne and then by Chapman's translation of his poetry; and now Chapman, the presumed source for the poem, is displaced by a subsequent reader. Chapman's translation, which gives breath to Homer, also requires breath. Through this chain we are led to believe, if the traditional view of Keats's relation to antiquity is accepted, that the essence of Homer's poetry is experienced. But by detailing this chain so explicitly does Keats not draw attention to the substitutions, not to mention the interchangeability of Chapman and Homer, that this experience requires in order to be recognized?

Such substitutions are further emphasized as the sonnet moves to the two similes that form its sestet. The similes are as follows:

> Then felt I like some watcher of the skies
> When a new planet swims into his ken;
> Or like stout Cortez when with eagle eyes
> He stared at the Pacific—and all his men
> Looked at each other with wild surmise—
> Silent, upon a peak on Darien.
> (9–14)

Both similes reassert the visual metaphors present in the opening lines of the sonnet. Rather than affirm the superiority of the visual over what is heard, these similes underline the role of the visual as a substitution for what the poet has understood as the poetry of Homer. As this is done, Keats also complicates the ability of the visual to fulfill such a role. By giving two similes for the experience that results from hearing "Chapman speak out loud and bold," Keats establishes a sequence in which the visual is subjected to the very substitution it ought to perform. Not only does this sequence question the role of the visual in the sonnet, but it does so by questioning the relation of the sestet to what goes before. The visual emphasis of the two similes suggests that Chapman, as the source of the experience presented in the poem, should be viewed as the source that first brings antiquity to sight. As the first simile would have it, the poet passes from one who breathes the "pure serene" to one who looks at the pure serene ("some watcher of the skies"). But rather than be inhaled, these skies become the backdrop for a new planet that, in a metaphor incongruous as to its immediate context, swims into the poet's ken or range of vision. By inserting

the incongruity of a swimming that takes place in the sky, Keats makes known (the verbal sense of "ken") the extent to which the attempt to reach or even travel to antiquity can only access antiquity by means of what is out of place. If antiquity can be reached in neither its poetic, linguistic, geographical, or historical context, then we will be forced to face the historical and cultural complications recorded by Keats's reflection on antiquity. To dismiss such complications as the aesthetic musings of an overwrought poet who knew no Greek is to invent a romantic ideology in order to refuse these complications. Here Keats's sonnet indicates that what McGann and others propose as the antidote to romantic ideology is nothing other than the fantasy of a radical ideology waiting for its planet to arrive.

Despite the important reflection that Keats's relation to antiquity offers for the historical and cultural determination of literature, there is more to Keats's relation to antiquity. The planet Keats speaks of is new—yet it appears within what is already known. According to this sonnet, Chapman's translation provides the means of knowing a figure from antiquity that was previously known only by hearsay ("had I been told"). It is this relation of the old to the new that would clarify the effect of hearing Homer through Chapman. Yet in terms of the simile, what belongs to the historical past is now known in terms of what does not yet have a history: a new planet. The simile is explicit in this regard; it unequivocally compares antiquity to the arrival of a new planet about which there is no previous knowledge. Antiquity, rather than being the return of what is old is presented by Keats as the arrival of the not yet known, the new, the modern. Antiquity, it would appear, has yet to happen; it, too, is waiting for the modern. Keats, however, places clear conditions on its historical occurrence in this poem: it can only come into meaningful existence across a translation, that is to say, it can only become meaningful in a voice not its own. Prior to this it is like an undiscovered planet; it may exist, but, to all intents and purposes, it is meaningless. As if all this were not enough to pose the difficulty of understanding antiquity, a historical incident recorded in Charles and Mary Cowden Clarke's *Recollections of Writers* makes clear that the translation cannot occur in its own voice either.

The incident recalled by Cowden Clarke tells of Keats's introduction to Chapman's translation of Homer. On this occasion, when Keats hears Chapman speak, not only does he listen to another, but he is transported into a state of staring by a passage from *The Odyssey* that describes Odysseus arriving out of breath and voice on the island of the Phaiakians. Cowden Clarke tells the story as follows:

> One scene I could not fail to introduce to him—the shipwreck of Ulysses, in the fifth book of *Odysseis,* and I had the reward of one of his delighted stares upon reading the following lines:

Then forth he came, his both knees falt'ring, both
His strong hands hanging down, and all with froth
His cheeks and nostrils flowing, voice and breath
Spent to all use, and down he sank to death
The sea had soak'd his heart through . . . (emphasis in original)[15]

In its commentary on Keats's sonnet this incident also records a move-
ment from what is heard to the visual, albeit a visuality in which nothing is
seen. Keats stares. Language leads to sight, but what is described remains
unseen, or rather, it remains untranslated as one sense fails to inform
another. At the same time, this failure operates within each of the senses
involved in this scene: hearing (as evidenced by the fact that each transla-
tion must find a voice different from its own if it is to give a meaning to a
voice whose place it has already taken) and sight (as evidenced by the fact
that the sestet offers two visual examples in order to recount what the poet
has heard). As the latter case indicates, the appearance of antiquity has an
unquestionable halting effect as the sonnet returns to the visual example
of its origin: looking.

In the second simile, Keats compares the effect of hearing Chapman's
translation of Homer to the arrival of Cortez on the isthmus of Panama.
The incongruity of this geographical location in a poem about the text
of a classical poet is not as easy to recuperate as the metaphor of swim-
ming. Nor is it easy to ignore how this sonnet ends with an explicit act of
looking that recalls the scene described in its title. On first looking into
Chapman's Homer now becomes on first looking at the Pacific. The look-
ing present in this ending also reenacts the scene described by Cowden
Clarke. In that scene, Keats looks at what he cannot see (itself one defini-
tion of staring), and what has prompted this state are the words describing
Odysseus emerging from the sea with no voice and breath left, emerging,
it seems, from the passage cited by Cowden Clarke, in order to die. Faced
with a figure of antiquity bereft of voice and breath, all that Keats can do is
stare, and it is this stare that is carried over into the second simile and an
occurrence that is meant, like the first simile, to describe the effect of an
antiquity that survives by traveling in a form not its own. As this second
simile states, breathing the pure serene of Homer does not lead to the
loud and bold voice of antiquity but to a silence in which Cortez stands
(Lat. *stare*) still staring. Brought to a halt in a gaze that does not see what it
looks at, antiquity appears not as a history to return to but as the unseeing
look through which antiquity is first seen (precisely the reputedly blind
Homer?). Here there will be no Odysseus rising from the Pacific: that
alone would be the fantasy of a history that would meet itself at the end of
its travels, the historical fantasy of the ideologically unbound.

A situation similar to the one Keats reflects upon in the sonnet on

Chapman's Homer translation may be discerned in Keats's ode if it is only read as the representation of an urn—whether Grecian or not is irrelevant at this juncture. As the representation of an urn, the poem describes what it is judged by (and to sustain this reading we have to ignore the fact that Keats describes the poem as an ode—that is, it is an address, not a description). Yet, as always in these situations, we can neither see what does the judging nor can we hear its judgment. The judge is, in Keats's words, "the foster-child of silence and slow time." Only when the poem speaks on behalf of the urn is any judgment given. And what does the critical subject represented by the poem say at this moment? It judges beauty to be truth and truth to be beauty. It would be difficult to find a truer, or, is it a more beautiful judgment? At the very point where the poem offers a judgment in the name of what the poem is about, this indecisiveness questions the very act of judgment that leads to a reading of this poem as representing either aesthetic indulgence or poetic truth. This is not, however, the first moment of questioning in this poem but rather the culmination of a sequence that begins as early as the first stanza, a sequence that suggests our attention should be turned to the necessity of representing the ode as an aesthetic or true statement.

As many commentators have rightly noted, the "Ode on a Grecian Urn" develops out of the sequence of questions that dominates its first verse.[16] In Keats's poem, these questions express less a desire for answers than an exploration of the relation of language to a historical event that, in the terms of this poem, would also include the relation of the poem to the object it views. Keats's presentation of these questions proceeds in such a way that they express an inability to know precisely what is being looked at. Consider these lines from the first stanza:

> What leaf-fring'd legend haunts about thy shape
> Of deities or mortals, or of both,
> In Tempe or the dales of Arcady?
> (5–7)

Presumably, if one knew what was being looked at on the urn, one could ask, "What deities are these?" or "What mortals are these?" To ask whether the shapes being looked at belong to deities or mortals is to state that one does not know how to decide between deities or mortals if one is to define the figures on the urn. This difficulty is compounded when the poet goes on to ask whether the urn depicts both deities and mortals instead of one or the other. At this point, one is justified in asking which question is in fact being asked by the poet. Or to put this another way, one can ask why it is that the poet asks a series of questions that confound rather than lead to understanding. Part of the problem that Keats points to in these lines is

that what is being looked at does not guide or define the poet's questioning. To know which god is represented on the urn presupposes that one knows that the figure is indeed the figure of a god. This is precisely what Keats does not know, and as a result these questions are suspended because they cannot define what they ask after. They lack the normal structure of a question in which what is asked after is already represented by the question (as in, what god is this? the figure is represented as a god by the question). As a result, Keats's questions indicate an insurmountable incompatibility between what can be said or heard (language) and what is seen.

To this point, Keats's poem is relatively uncomplicated, at least if we reduce it to an opposition between language and the visual. However, as all readers of this poem must have noticed there is no visual reference other than what Keats tells us in the poem. The incompatibility just referred to is therefore an incompatibility between what can be said or heard and *what is said* to be seeable. The difference introduced by this complication is immense. No longer can we read the poem as being about an urn, imagined or otherwise, that the poem describes and comments on; rather, we are forced to realize that what we had taken to be a visual object arises from questions that do not know what they are asking after. In short, through these questions, the poem develops a reflexive relation to its language, but this is not a self-reflexive relation, since, as we shall see, the only moment a self-reflexive relation occurs is by means of an assertion of voice, when, at the end of the poem, the urn is said to perform what the poem cannot achieve. Only by reading such a performance as being what it represents can a romantic ideology be constructed, and such a construction, as Walter Benjamin has pointed out, is nothing less than the source of the political.[17]

By this reflection on the visual, the questions in the first stanza of Keats's ode would seem to lead us into an area that raises issues quite distinct from those raised with respect to ideological criticism at the beginning of this essay. Yet in both Keats's sonnet and ode, the overdetermination—that is, the classicism of an aesthetically programmed model of historical and political meaning—has never been far away, since what would be represented by the visual is nothing less than the objective representation of the Greek world. That Keats's poem should resist the aesthetic understanding that permits language to become a means of accessing the visual is already an indication of the terms through which classicism may come into existence and in so doing supplant the classical. As an aesthetic category classicism demands the cultural and historical transparency of language, but, as I stated earlier, such a classicism is a mode of relation to literature rather than a historical epoch in the development of literature. This is why the overcoming of classical is an overcoming performed by a classicism that desires to see literature stabilized as a mode of aesthetic

representation—and this is the classicism that now dominates the interpretation of romanticism, despite the evidence of its poets.

This evidence is nowhere more apparent than in the infamous closing lines of Keats's ode:

> When old age shall this generation waste,
> Thou shalt remain, in midst of other woe
> Than ours, a friend to man, to whom thou say'st,
> "Beauty is truth, truth beauty,"—that is all
> Ye know on earth, and all ye need to know.[18]
> (46–50)

After having been teased out of thought by the attempt to determine what the poem represents, we are offered the consolation of a beauty that is also to be understood as truth. At the point where language fails to fulfill the demands of aesthetic representation, the urn is made to speak as if this device would overcome the aesthetic failing of the poet's language. For the urn to speak is to reassert the failing that the poem takes as the source of its language. What the poet cannot do has been displaced onto the urn, so that it may be both the speaker and what is spoken about. This is the point where a self-reflexive understanding is performed, but note that it only occurs as a means to preserve the aesthetic understanding that the poem cannot achieve. Not only is the urn represented as self-reflexive, since it is both what speaks and what is spoken about, but what it says would also take the form of the self-reflexive: "'Beauty is truth, truth beauty.'" If beauty is truth, then the phrase "Beauty is truth" means that beauty is beauty (just as aesthetics is politics means every politics is aesthetic).

At the heart of the aesthetic understanding through which literature would be overcome in the name of historical and political concerns, there is a tautology that not only sees knowledge and the aesthetic as being interchangeable but views art as the medium of this exchange. If Keats's poem resists the view that literature can be such an exchange, it is because language is not an adequate medium for the representation of what language represents. But if language cannot be an adequate means of representing language, then, this also means that the grounds of Keats's resistance can only foster what it wishes to resist. This is why the poem can say in closing "that is all / Ye know on earth, and all ye need to know." The aesthetic understanding is all we know whenever the claim to knowledge can only be supported by the necessity of the aesthetic understanding. But if this is so, then it is already compromised by its necessity, the necessity of a classicism that the political and aesthetic education of romanticism would now foster as the condition of a knowledge of its romanticism. Perhaps, if we would be less willing to confuse knowledge with necessity, there

would be no need to undertake the political and aesthetic education of a romanticism that our modernity has yet to catch up with. In such a case, the aesthetic would no longer need to be opposed to the political, since it would then be clear that the aesthetic is, in fact, the rhetoric of the political rather than an ideology to be opposed to history.

Notes

1. Such a mode of determination does not originate with Hegel, who is fond of citing Spinoza's statement "omnis determinatio est negatio" (see, for example, *Vorlesungen über die Geschichte der Philosophie* 20: 164). While the explicit recognition of negative determination may be traced to Spinoza, it is to Hegel that the systematization of negation as a mode of determination may be attributed.

2. McGann's scare quotes around "pure" indicate some hesitation about the purity of Hegel's aesthetic thought while at the same time asserting the necessity of this purity to the critical position McGann wishes to articulate.

3. McGann writes: "The Hegelian synthesis is a form of self-representation: it describes the idea of Hegel's philosophy and not Romantic art, nor even the Romantic ideology of art" (47).

4. In the introduction to the *Vorlesungen über die Ästhetik*, Hegel refers to sound as the last external material of poetry and then states that this last external characteristic is "in poetry no longer the feeling of sonority itself, but a *sign* that is meaningless by itself (*ein für sich bedeutungloses Zeichen*). . . . Sonority in this way becomes a *word* as a sound articulated in itself, the meaning of which is to indicate ideas and thoughts. . . . at this highest stage art now transcends itself" (*Ästhetik* 13: 122–23; translation mine).

5. McGann expresses this hope when he applauds the "method" of Heine as a method that "may be usefully examined if we wish to understand the limits of the Hegelian and Coleridgean models, and perhaps to go beyond them" (49). McGann's need to limit Hegel already suggests that the problem McGann's critical stance does not want to face is the problem of limitation, of determination, of negation.

6. In this way the aesthetic originates in Hegel with the symbolic. Even at the classical stage of its development, when the spirit has found a form most adequate to itself, the aesthetic still remains an external form to which the spirit is related by adequation. Take away this difference and there is merely the abstraction of nature.

7. In this respect, the aesthetic is structurally the same as allegory, at least in Walter Benjamin's definition: it is constituted by the noncoincidence of itself with its object (*Ursprung* 403, 406).

8. This mediation of the aesthetic as history may be traced to Winckelmann's *History of Ancient Art*. I have undertaken a fuller discussion of this mediation and its relation to the development of the concepts of culture and freedom in *Silent Urns*.

9. On the relation of taste, that is, aesthetic judgment, to society, see Kant 163–65. The necessity of an account of judgment has been little recognized within the project of critical interpretation despite the unrelenting practice of judgment within criticism. It would seem illogical to make judgments about the ideology of certain poetic practices without at least accounting for a nonideological form of judgment. It is precisely this form of judgment that Kant's third *Critique* could be said to concern itself with, and is also unable to ground without resorting to an aesthetic idea. Before rushing to pass ideological judgments on the aesthetic, it would be instructive to read Kant carefully.

(I note in passing that McGann's *Romantic Ideology* provides no evidence that Kant's *Third Critique*, one of the most important works in our critical and aesthetic traditions, has been looked into, never mind read carefully.)

10 For an account of the different sources that can be traced for Keats's urn, see Ian Jack 214–24.

11 See *Ästhetik* 13: 123.

12 A work such as Stephen Greenblatt's *Renaissance Self-Fashioning* could clearly be placed in the latter category.

13 It is difficult to know whether one should attribute the critical tendency to read this poem as an example of conventional Hellenism to the subtlety of Keats's argument in this sonnet or to criticism's unmitigated desire for something to disassociate itself from. One notable and recent exception to this tendency may be found in Forest Pyle (especially 76n28).

14 The principal figure behind romantic Hellenism is, of course, Winckelmann, whose *History of Ancient Art* established the relation of history to aesthetics that has been so fruitful to the subsequent development of the humanities. While the effect of Winckelmann's work is a past constructed as an aesthetic object, its cause, as recent research has pointed out, is based largely on written accounts of classical art—there being, in Winckelmann's time, only one surviving sculpture, the *Laocoön*, that could be authenticated from descriptions that came down from antiquity. See Alex Potts 12.

15 Charles and Mary Cowden Clarke, *Recollections of Writers* (1878), cited by John Barnard (Keats's *Complete Poems* 546n). Lattimore's translation of this same passage is considerably more prosaic: "Now he flexed both knees / and his ponderous hands; his very heart was sick with salt water, / and all his flesh was swollen, and the sea water crusted stiffly / in his mouth and nostrils, and with a terrible weariness fallen / upon him he lay unable to breathe or speak in his weakness" (Homer 5.453–57).

16 The tendency to view these questions as being unequivocally questions goes hand in hand with the tendency to read this ode alongside a material simulacrum of the urn that remains a distinct yet unresponsive subject, invisible yet there. It is rather to the role these questions play in creating such an urn that our attention should be directed. The questions are not simply serious, literal demands to know what is on the urn but the means by which such a knowing is simultaneously produced and denied without us ever seeing the urn in the question.

17 Walter Benjamin, in a letter to Martin Buber, offers a definition of the political in language that points to the political as a theory of objective representation, of language and act. See *Briefe* 1: 127.

18 Stillinger's edition of *Keats's Complete Poems*, which uses the third authoritative version of this poem from 1820, is used for these lines. This version assumes that the motto is something that the urn says (however figurative this saying must be). The shift from "thou" to "ye" can therefore be read as an address of the poet to the reader that is also a reflection on the motto. To consider the last line and a half as an address to the urn is incongruous, given the consistency of the poem's use of "thou" in its address to the urn. Likewise, to consider the "ye" as an address to the figures on the urn invites a level of incredulity matched only by assumption that the urn actually speaks. Lastly, to consider that the urn continues to "speak" does not change the relation of the motto to the words that follow it; they remained addressed to the reader and this is what is crucial to remember. Whether the urn "speaks" just the motto or the last two lines, the question developed in this reading does not change, since it is the necessity of the understanding performed in the voice of the urn that *the poem* directs our attention toward.

Works Cited

Arendt, Hannah. "Walter Benjamin: 1892–1940." *Illuminations.* Walter Benjamin. Ed. Hannah Arendt. New York: Schocken, 1969. 1–55.

Benjamin, Walter. *Ursprung des deutschen Trauerspiels. Gesammelte Schriften.* Ed. Rolf Tiedemann and Hermann Schweppenhäuser. 7 vols. Frankfurt am Main: Suhrkamp, 1974–1989. 1.1: 203–430.

———. *Briefe.* Ed. G. Scholem and T. W. Adorno. 2 vols. Frankfurt am Main: Suhrkamp, 1978.

Ferris, David S. *Silent Urns: Romanticism, Hellenism, and the Culture of Modernity.* Stanford: Stanford UP. Forthcoming.

Greenblatt, Stephen. *Renaissance Self-Fashioning: From More to Shakespeare.* Chicago: Chicago UP, 1980.

Hegel, G. W. F. *Vorlesungen über die Ästhetik. Werke.* Vols. 13–15. Frankfurt am Main: Suhrkamp, 1971. 20 vols.

———. *Vorlesungen über die Geschichte der Philosophie. Werke.* Vols. 18–20. Frankfurt am Main: Suhrkamp, 1971. 20 vols.

Homer. *The Odyssey.* Trans. Richard Lattimore. New York: Harper, 1975.

Jack, Ian. *Keats and the Mirror of Art.* Oxford: Clarendon, 1967.

Kant, Immanuel. *Critique of Judgment.* Trans. Werner S. Pluhar. Indianapolis: Hackett, 1987.

Keats, John. *The Complete Poems.* Ed. John Barnard. 2nd ed. Harmondsworth, UK: Penguin, 1977.

———. *Complete Poems.* Ed. Jack Stillinger. Cambridge: Belknap, 1982.

McGann, Jerome. *The Romantic Ideology.* Chicago: Chicago UP, 1983.

Potts, Alex. "La 'fin' de l'*Histoire de l'art* de Winckelmann." *Winckelmann: la naissance de l'histoire de l'art à l'époque des Lumières.* Ed. Edouard Pommier. Paris: Documentation française, 1991.

Pyle, Forest. "Keats's Materialism." *Studies in Romanticism* 33 (spring 1994): 57–80.

Winckelmann, Johann Joachim. *History of Ancient Art.* Trans. Alexander Gode. 4 vols. New York: Ungar, 1968.

Reading Habits: Scenes of Romantic Miseducation

and the Challenge of Eco-Literacy

MARLON B. ROSS

f romanticism serves to remind us of nature's place in human consciousness and of humanity's limits as a natural subject, then it seems appropriate to think of romanticism as a clean, nourishing stream watering the fields of ecology and environmentalism.[1] We should not be surprised, then, at the emergence of a new mode of literary interpretation labeled environmental, ecological, or green criticism.[2] This criticism seizes an opportune moment in the hope of returning nature to the center of scholarly romanticism and romanticism to the center of cultural influence. Challengers to humanist tradition (poststructuralists, historicists, feminists, and new cultural critics) seek to demonstrate that the idea of romantic nature is an illusional ideology to be resisted or overcome. Their differences notwithstanding both counterhumanists and romantic conservationists rely on the idea of revisionary reading—the need to return to touchstone texts in order to reread them, or read into them, the truths and errors unveiled by their critical approaches. As a tactical and strategic matter, I want to press this notion of revisionary reading as the sole form of analysis through which cultural struggles can be advanced or transcendentally healed, with cultural critics endeavoring to do the advancing and romantic conservationists the healing.

It may be that revisionary reading helps to reproduce literacy as though it were an unlimited resource—discouraging us from thinking ecologically about the material limitations of every act of reading. The consumption and marketing of revisionary readings of romanticism may distract us from thinking through the ways in which the resources for literacy are unevenly distributed across cultures and within cultures; in other words, the production of literacy may tend to simulate patterns of economic development and ecological wastage according to economic class and geopolitical region (e.g., "developing nations" versus postindustrial economies, the "inner cities" versus the suburbs). The answer to the ecological challenge

is not to abandon interventionist efforts, which have helped to fashion pro-gressive projects within revisionary reading. Instead, we must find ways of linking the progressive agendas to ecological concerns while mount-ing a self-critique of the ways in which these agendas may contribute to overconsumption and overdevelopment.[3]

Revisionary reading as presently practiced tends to direct us away from the question of what it would mean to read in a world beyond re/sources, in which nature's re-cyclical bounty was not taken as a given and as a mythic model for human imaginings. I slash through the word "resource" to in-dicate the ways in which the notion is divided against itself—the ways in which our current intellectual discourses and economic systems, despite the environmental revolution, have continued to conceptualize material *sources* as repeatable, replenishable properties, which can be reinvested and reinvented again and again without end (that is, as commodities).[4] I use the self-divided term also to indicate this contradiction: While the global economic system is based on scarcity (the notion that there could never be enough goods to distribute fairly to everyone), it is also based on sur-plus exchange, the idea that new material supplies can always be found to meet ever-intensifying, new demands.[5] This contradiction becomes espe-cially acute in intellectual labor. It is assumed that intellectual talent or skill (genius) is scarce, and yet the production of this talent requires a sus-tainable surplus of intellectual materials and products (books, computers, classrooms, and so on). While genius is defined in terms of rareness or scarcity, the re/sources of intellectual labor are supposedly infinite.

In the third volume of *Capital*, Marx spells out the difference between what might be called second-order industry, the turning of "raw materials" into commodities, and first-order industry, in which the labor is focused on gathering "raw materials." In second-order industry, "the growing pro-ductivity of labour," Marx writes, "is expressed precisely in the proportion in which a larger quantity of raw material absorbs a definite quantity of labour. . . . The value of raw material, therefore, forms an ever-growing component of the value of the commodity-product in proportion to the development of the productivity of labour" (108).[6] We might consider intel-lectual labor as a third-order industry, in which the material sources are used up at such a rate that they disappear (become thoroughly repressed). In reading a book, we forget the amount of first-order and second-order labor that went into the making of the book, not to mention the amount of material sources themselves—the trees for instance. The productive transformation of the tree into a book dematerializes its relation to words, making the printed word seem like an abstractable quality (a self-producing quantity or value) that transcends its grounding in "natural" (i.e., organic and inorganic material-energy) sources. It is this process of abstraction, or

what Marx calls alienation, that perpetuates the Eurocentric notion of "the human mind," despite the fact that human beings are deeply divided culturally, sexually, racially, economically, geopolitically, and vis-à-vis access to literacy and other material sources. Keeping the human mind singularly intact obscures and erases the myriad struggles over how to define and distribute various modes of knowledge, just as surely as keeping nature intact as the objective standard of truth denies the conflicting political and cultural agendas for shaping ecology as a dominant scientific discourse and environmentalism as a "global" movement that too frequently benefits the already powerful at the expense of the already impoverished.

I use the word "re/source" in the context of literacy, then, to mean the operation of this repression in our conceptions and habits of reading. On the one hand, "re/source" entails a particular conception of human beings' relation to words in which inorganic and organic materials are repressed in favor of a notion of words as self-repleting social capital—a commodified product that is invented, invested, and consumed as though it had no grounding in finite material sources.[7] On the other hand, revisionary reading demands the obsessive return to an actual material text, conceived as a repeatable, replenishable re/source. We return compulsively to check our impulses against influential objects of knowledge, those re/sources of cultural authority that give legitimacy to our own projects, so that the authority never dries up or withers away, but instead reproduces itself at infinitely higher levels of reading sophistication. The act of reading becomes the production of innovative knowledge from the unlimited stock of ever-reproducible citations, or what we ironically call primary and secondary sources.

This is the "high," serious mode of reproductive reading to which we commit ourselves, our students, and our publics. We set out to reread romanticism in terms of deconstructive play, or feminist critique, or the materialist-historicist method, or so-called green criticism, and by doing so, we intend to alter people's reading habits by making them rethink romanticism as an object of knowledge. The question is whether it makes any difference how we read—according to what model of what camp—as long as reading itself, representing the complex of all intellectual labor, remains a largely uncontested value that sublimates our dependency on material sources as well as our finiteness as socially divided, material subjects. As important as these critical revisions are, none of them makes us ask: Are there other ways of being literate and of spreading the sophistications of literacy? Might there be other ways of being literate that would not assume the word's immaterial, purely cultural existence, and thus would not posit a human mind with its infinite capacity for re/source renewal? In other words, can we take up the ecological challenge in terms answerable

through the strengths of our practices while highlighting the resonance between the material grounds for ecological thinking and the materialist interest within cultural-historicist critique?

We might start by reasserting that there is no human mind.[8] If we cannot say with scientific certainty that a self-enclosed ecosystem exists (i.e., if ecologists cannot agree on what defines any particular ecosystem), we can at least say that we experience in operative form an intricately bound network of ecosystems, whose survival our collective actions may either help or imperil.[9] Our words are bound up with this network, extracting material and energy from it without necessarily being politically accountable to it in a system focused on reproductive consumption. Our revisionary readings are intensely consumptive in that they thrive in and contribute to the contradictions of capitalist surplus exchange while not addressing the problem of resource distribution. Can we rethink the progressive traditions and institutional apparatuses of the discipline to promote a redistribution of literacy without falling into the trap of an anti-intellectual pursuit of jargon-free, putatively accessible language; naturally verifiable standards for human beings' actions; and ersatz human unity as a mirror of nature's metaphysical harmony?[10]

We can understand what is at stake in the perpetuation of inequitable revisionary or consumptive reading by considering the three contiguous sites that make up this kind of reading and that, as co-interdependent bases for high reading, became dominant in the romantic period: nature, political institution (state bureaucracy), and reading public. Each site, however, is really a "dis-place," a status-inflected cultural practice that displaces reading from its grounding in ecological and economic inequities in order to sustain a myth of its inherently benign or progressive cultural effects. As a displacing function, consumptive reading draws its provisional energies from elsewhere and produces effects elsewhere within the ecological-economic network, invisibly placing strains on other systems. The question is repeatedly posed by revisionary reading as to who will take control of these reading sites and rites, but the sites/rites themselves must be rigged in order for reading to take place at all. As the system is presently conceived, somebody has not to be reading, has not to have access to literacy, so that somebody else can read in this re/sourceful, high-culture, high-consumption manner. Even as we have attempted to abandon criticism as a kind of Arnoldian priestcraft aimed at constructing a social elite in which a monologic version of Eurocentric civilization could be vested, we have not wrestled enough with the consequences of capitalist professionalization—that is, the gaining of literary expertise measured by an economy of tenurable reproduction and consumption, making intellectual products merely individually or institutionally possessed private property.

It might at first appear that nature as a productive reading site would have died with the last high romantic writer, but conservationist criticism has, as already indicated, seized the moment to bring nature back.[11] Jonathan Bate proves that this dis-place still resonates very strongly, even at this late date. In *Romantic Ecology*, Bate attempts to cast Wordsworth as the seminal figure, the father, of ecological thinking, and he wants to make Wordsworth's resurrected corpus, his writings, a reproductive re/source or fetish object for the perpetual inspiration of the green movement.[12] If we want to place this view in ecological theory, we could call it the early phase of conservationism, a turn-of-the-century ethic motivated by nostalgia for a precapitalist valuation of land. In the United States, this movement was spawned amid the throes of grief over the loss of the frontier. Land conservationism recuperated the idea of the frontier by setting up an elaborate bureaucracy (including the establishment of land-grant universities) to subsidize farmers and ranchers in managing the fertility of the land; the idea was that what is lost materially, new lands to farm, can be retrieved scientifically through provident chemical and technological advances. The conservationists also set aside "precious," "sublime," "wild" land as federal and state forests and parks. By protecting these special enclaves, the idea of the frontier is salvaged symbolically, for these "nature preserves" synecdochically function as internally managed frontiers. These lands are represented as both fertile and wild, both bureaucratially managed and ideally unmanageable. Profits are made by clear-cutting some hardwoods, but other hardwoods, metonymically standing in for those cut, are held to be sacrosanct and thus untouchable. In Britain, a similar dynamic is at work, primary motivating factors there being the loss of the midlands to industrial blight and the guilt surrounding the genocide of noble savagery in the struggle for imperial lands, with their projected infinitude of natural re/sources.[13] Bate's appeal to this notion of ecology is consistent, for the motivating nostalgia for lost land accords perfectly with the motivating nostalgia for a lost (nature) poet.

We can understand the structure of conservationist logic by focusing on Bate's thesis statement: "But in some readings — and I hope to show that my reading of Wordsworth is one of them — the critic's purposes are also the writer's, and when this is the case there can be a communion between living reader and dead writer which may bring with it a particular enjoyment and a perception about endurance. . . . I shall argue that Wordsworth went before us in some of the steps we are now taking in our thinking about the environment" (*Romantic Ecology* 5). This statement reveals that it is not Bate's priority to provide an ecological critique, that is, to establish an ecological theory of literature; nor does it lie in the direction that the deep ecologist Arne Naess would call an ecosophy, which he defines as "a philosophical world-view or system inspired by the conditions of life in

the ecosphere" (38).[14] Instead, Bate's priority seems to be to establish the authority of one author over future discourse on the literature of ecology. Wherever we go, Wordsworth must precede us—Wordsworth as a seminal object of attention to whom we must always return if we are to possess real knowledge; Wordsworth as re/source.

In his statement Bate also establishes a proper patrilineage that will always take our ecological thinking back to England's green and pleasant land, Wordsworth's favored haunts. If Wordsworth fathers nature, or at least our contemporary *thinking about nature* (a distinction lost in Bate's account), then the female who births this abstraction may be Nature herself (forgive the Miltonic logic here), or it may be Ellen Swallow, the woman who mediates between hard science and popular sentiment, between theory and application, between original thinking and mass consumption of an idea. According to Bate, Swallow "appropriated [Ernst] Haeckel's word" ecology by popularizing it as an attitude toward the environment (36–37). In Bate's patrilineage, Swallow becomes an emanation of the romantics, as they "foreshadow" her application of the term "ecology" (40). This patrilineal family romance undermines Bate's ecological impulse, because it ignores the extent to which ecological thinking *should* (not that it always does) attempt to uproot such notions of a possessible nature—a proper reading of Nature owing its existence to any single individual, any single tradition, or any single country. It is not clear what is gained by making Wordsworth the repository of an ecological notion of nature, other than to increase the value of the poet's stock at a point when many are bidding low. This critical maneuver participates in what Chaia Heller has called "the cult of the romantic protection of nature": "Romantic ecology fails to challenge the patriarchal, state, and capitalistic ideologies and institutions of domination that legitimate the denigration of women" (219–20). Heller astutely points to a dynamic that characterizes much ecological thinking, from the nostalgic conservationist to the radical deep ecologist. In a romantic fashion, Nature becomes a symbolic lady in distress, whose salvation is determined by the heroic exploits of individual daring by expert environmentalists, who must intercede to save Nature from the ignorant and rapacious, and who in practice turn out to be childbearing poor women and people of color attempting to survive with few material sources in the aftermath of European and American colonial exploits.[15]

Accordingly, Bate's reading of Wordsworth's seminal role recapitulates the history of European colonization and imperialism. If Wordsworth should become a fetish object for the dissemination of ecological criticism, then we can be assured that alternate purveyors of ecological literacy will have a hard time finding clean air to breathe in. The irony of this maneuver is that on the one hand, it is so parochial, bringing our gaze back to a little

natural site called the Lake District, and that on the other hand, it is deeply sinister in its global effects. For it reenacts the capacity of the British Empire to administer its colonies from a comfortable seat on a piece of land preserved for human perception and appreciation, while robbing the material sources, despoiling the land, and dismantling sustainable ecological patterns established for generations in communities in the farflung colonies. What Wordsworth ignores, is ignorant of in his natural musings, is exactly what the British Empire ignored, was ignorant of in its dealings with the colonies. The Wordsworthian insight into nature's conservation approximates metropolitan blindness to ways of thinking about colonized people's earth relations.[16] Bate's cult of romantic ecology, however, repositions England as the re/source of authentic ecological knowledge, rather than depicting it as one of the historical masters of worldwide natural despoilation. As Ian Grandison has pointed out, even the term "green," so honorific in European-American environmental politics, resounds with Eurocentric arrogance, because it equates a particular landscape aesthetic valued by particular human beings with the norms of an environmental ethic—as if the brown deserts, prairies, and savannas were remote outposts of nature's eco-dynamics.[17] "Green" unintentionally operates as a metaphor for the obsessive priority given to England's green and pleasant land as a model and source for all takes on nature in a discourse that claims, through the legitimating mantle of ecology, to represent and speak for the interests of all global habitats and inhabitants.

In this sense, Bate's greening of Wordsworth accords a cornucopian view of ecology expressed by eco-theorists like J. E. Lovelock and Julian Simon. Lovelock's Gaian hypothesis conceptualizes the biosphere as a single cybernetic organism that adapts and regulates the chemical and physical environment for sustainable life, but this idea of a closed, self-regulating system does not lead Lovelock to call for a redistribution of material sources but rather to be more sanguine about the capacity of the ecosystem to police itself without human intervention.[18] He does not attribute the problem to industrial pollution, suburbanization, or resource depletion by overdeveloped countries. Since the "temperate" zones of Europe and America are supposedly less sensitive, if there is a problem, it is caused by "primitive" agriculture and overpopulation in the "Third World," the geopolitical sphere of the former colonies, which just happens to be more ecologically sensitive (111–22). As opposed to Lovelock, Julian Simon sees the environment as an open system in which human knowledge itself is the ultimate re/source, enabling us to create ever new ecological (i.e., scientific) answers as ever new environmental problems arise. Both of these writers, then, in different ways, are in line with romantic thinking. One personifies the Earth, Gaia, in a romantic manner by establishing an un-

breakable, intrinsically harmonious bond between humanity and Mother Earth; the other posits that the mind of man is infinite and thus re-asserts the idea that the human bond with nature is specially protected by an equation of infinitude on both sides. Holding onto Wordsworth as a re/source suggests that we do not need to alter radically our intellectual alliances, that we do not need to listen to the readings of "nature" practiced in those non-European traditions whose ecological literacy may offer more instructive epistemologies. Bate's ultimate act of male bonding, commun-ing with Wordworth's corpus in order to become his mouth, represses this potential for constructing an ecologically based literacy.

Although Karl Kroeber's *Ecological Literary Criticism* shares problems that are salient in Bate's work, its more complicated argument and strategy reveal other contortions and evasions entailed when some advocates of an ecological approach desire to demonize historicist and cultural criticism. By restoring notions of organic textuality and harmonious subjectivity, Kroeber thus attempts to diminish the impetus for cultural critique in lit-erary studies. His deployment of revisionary reading to reinstate canonical values may alert us to difficulties in such practices—difficulties that can be addressed partly by rethinking cultural-materialist approaches in the arena of ecological theory.

Making essentially the same argument as Bate, Kroeber attempts to borrow from "a 'feminist' understanding of nature" (7) and then to claim that the most important "forerunners" (19) of such understanding can be found in the "proto-ecological views" (5) of the male romantic poets, espe-cially Wordsworth. "Contemporary biological thinking . . ." he writes, "no longer identifies individuality with autonomy and separation. For leading contemporary biologists, the individuality of an organism is not definable except through its interactions with its environment, through its inter-dependencies" (7). Feminism here becomes an instrument for lodging seminal meaning in a male canon and in an analytical approach that femi-nists themselves have opened to inquiry and challenge. Kroeber's selective use of feminism enables him to exploit one aspect of feminist thought—an aspect highly debated currently among feminists, the ego-object rela-tions theory of 1980s feminists like Carol Gilligan—against another aspect of feminist thought, that which has most engaged poststructuralist and cultural-materialist critique.[19] Thus Kroeber attempts to use one kind of feminism to detach feminism in general from the larger project of cultural critique. As a result, feminism becomes a mere byway toward Kroeber's larger goal of legitimating ecological literary criticism as the heir apparent of feminism in the advance guard of critical practice in romantic studies. In turn, ecological criticism is supposed to work in tandem with the goal of re-storing canonical nature poetry to the center of the liberal arts curriculum.

This strategy is especially evident in the canonical bent of Kroeber's analyses. For instance, in suggesting that the "political biases of the romantic poets were far more various . . . as well as more complicated than recent critics admit," Kroeber points to "minor" poets as proof of the fallacies of cultural-materialist critics:

> Their mistake derives in part from not figuring into their political equations so-called minor poetry of the epoch. Even a superficial consideration of, say, Gifford, Campbell, Scott, and Southey along with just a few of the women poets of the day (Landon, Tighe, Robinson, More, Barbauld, etc.) demolishes the simplified ideological oppositionalism that has too often determined new historicists' political summations. (10)

This statement contains a number of odd contortions and evasions. First, Kroeber separates feminism from "new historicism," whereas, in actuality, the two modes are closely allied, often to the point of operating integratively in cultural studies. Second, "new historicists"/feminists have been the ones who have brought into view a much wider range of writers from the period, thereby doing exactly what Kroeber charges that they fail to do: diversifying our understanding not only of subject-identities (e.g., the cultural conditions of authorship and reception) but also of ideological complexities of the period. Third, Kroeber reinstates the canonical assumptions questioned by feminists and other cultural historicist critics when he exploits the "minor" literature—that is, makes them serve as mere mirrors or backdrops to dramatize the permanence, complexity, and fineness of the major authors. In Kroeber's analysis, the "so-called minor" writers do not chart alternate, decentering literatures, histories, periods, ideologies, subject-identities, conceptions of nature, critical approaches, and the like, as theorized, for instance, by Gilles Deleuze and Felix Guattari.[20] Instead, the minor reverts to an unreconstructed mastering romanticism whose voice comprises the big five (minus Blake, given his radically implacable interrogation of naturalizing discourse). Fourth, by trying to meld feminism into humanist, canonical ecology, Kroeber dismisses the various ways in which feminist historicists *within romantic studies* have radically challenged the very notion of romanticism he wants to perpetuate, the one in which cultural-historical knowledge is bounded by the extant texts of five male authors, thus turning all other writers of the period into pale reflections or "superficial" exemplars of their expression.

In his close readings of canonical texts, Kroeber subsumes the new feminist insights by placing them in the mouths of the male poets—causing them to become full masters of their own engendering. He does so frequently by inverting what feminists have suggested about the historical

conditions and cultural traditions within which these writers, as masculine subjects, are inextricably intersubjected. Kroeber takes everything back to the assumption of a recoverable, actual male author and his monologic meaning, when meanwhile many feminists are talking about "author effects" operating in particular gender formations. Rather than following through with his observation that ecological criticism should explore texts through "interdependencies" and "'intersubjective' connections" (7), Kroeber analyzes in such a way as to inscribe autonomous, evolving, selfmastering subjects, familiar geniuses authoring insights about their "interdependencies"; he does not see texts that enact and inhabit intersubjective environments. Thus in revising feminist takes on "Nutting," Kroeber rereads the poem as Wordsworth's "reshaping of self to become capable of respecting and cherishing external nature" and as "addressing the feminine component within himself" (64). Such a reading unintentionally rigidifies the narrator's dominant masculinity by pacifying "the feminine" and subordinating it to a reformed "component within" an active masculine self, instead of subjecting the gendered terms to an intersubjective analysis. Through Kroeber's revisionary reading, nonetheless, Wordsworth is supposed to become the most capable ecofeminist, though only a "proto" one. As a protofeminist ecologist, Wordsworth deserves to retain his seminal position as father of nature and a re/source of transcendent knowledge relating the unified, transgendered human subject to a constantly regendered nature.[21] It does not seem to matter that this nonfeminist consequence contradicts Kroeber's impulse to borrow from feminist method.

Finally, despite Kroeber's reference to the "minor" subjects, his book not only ignores the potential for a self-critique through a minority discourse but also dismisses the single instance of such a discourse when it is taken up. This is manifested by Kroeber's treatment of Mary Shelley, whom feminist historicists have extensively engaged precisely because of her compelling minority interrogation of romantic nature and intersubjectivity. Relegating Shelley to the realm of "moral relevance" and ecological irrelevance as far as "the very progress of science since Shelley's time" (29) is concerned, Kroeber curiously duplicates the separate spheres of feminine moral influence versus masculine scientific progress that Shelley begins to disrupt in her novels. "Mary Shelley's story," he writes, "strikes many intelligent readers as somewhat silly—a characteristic that helps to explain why the story has been kept alive as much by comedic and parodic versions as by the novel itself or its 'serious' dramatizations" (29). The continuing mass culture and science fiction interest in *Frankenstein*, not to mention the intelligent feminist-historicist interest, paradoxically becomes proof of that novel's silliness, its inappropriateness as a supposedly innovative canon of foundational ecological literature. What is at stake in Kroeber's

insistence on Mary Shelley's minor (in the traditional sense) status for eco-
logical criticism despite the admitted permanence of interest in her work?
What is at stake in Kroeber's refusing to engage, with "even a superficial
consideration," any of the other "minor" writers that historicist-feminist
scholars of romanticism have been exploring for more than a decade?

The question is quickly answered by pointing out that the most influ-
ential book arguing for the renovation of liberal arts through a focus on
ecological theory and practice (rather than classical texts and interpreta-
tion) ascribes to Mary Shelley a remarkable place in the ecological canon.
In *Ecological Literacy*, David Orr cites *Frankenstein* as a key text for under-
standing the relation between the cognitive limits of science, the impulse
toward power, and the dilemmas of modernization (12–13, 93, 110). He
does not mention any of the romantic poets in his analysis of founda-
tional ecological literature; nor are any included in his extensive reading
list for a proposed ecology-based liberal arts curriculum. How could the
leading educational environmentalist be guilty of such a glaring oversight,
if romantic poets constitute the foundation of environment knowledge? [22]

When Kroeber writes about ecology as though it were a unified subject,
rather than one engaged in or shaped by scientific and ideological conflict,
he must do so to have ecology represent a natural standard of objective
truth making. In fact, a book like Orr's represents one side of one ideologi-
cal divide within environmental studies. It is as much Orr's aim to prevent
poststructuralist, cultural-materialist theories and practices from gaining
an even broader hearing than they already have within environmental
studies, and within academe more generally, as it is to make a bid for
ecology to replace the classics as the core of the liberal arts curriculum. [23]
Ironically, then, Orr's aim is similar to that of the literary conservationists,
except that where he would replace their classical literary texts with a list
of ecological classics, they want to shore up the crumbling walls of the old
literary canon through traffic in ecological concepts. And, of course, the
two canons exhibit significant overlap and, even more important, signifi-
cant omissions. Although Orr includes a section on patriarchy and one on
nonviolence in his curriculum, nowhere does he mention race, racism, en-
vironmental racism, or environmental justice. [24] By proffering ecology as a
scientific, objective handmaiden to natural truth, humanist ecologists like
Orr imply that its ideological neutrality neutralizes the need for an ongoing
critique of race, region, gender, sexuality, and class—enabling us to recap-
ture "a new unity of scientific, ethical, aesthetic, and religious intuitions"
(Orr iv). Ecology begins to look like a very safe place (like the suburbs)
in which to erase the specter of multiculturalism and its social, political,
economic, and environmental pressures. For ecology appears to unite the

human family in a common cause—nature—and against a common foe—demons of pollution, resource depletion, species contamination, and so on.

In reality, the human "family" is anything but united around ecological observations or environmental policy. Too often, making the suburbs safe for nature has meant placing potentially toxic recycling centers and toxic waste dumps in central cities, rural areas, and postcolonial regions, where the poor, the politically disempowered, and people of color tend to live. If ecology were a purely objective science and environmentalism a movement that united humanity, there would have been no reason for the concept of environmental racism or for the environmental justice movement. In *Environmental Advocacy*, Bunyan Bryant spells out the ways in which cultural critique must be explicitly central to any just ecology or any environmental program and argues that environmentalists should start from a position of understanding their own "ideological praxis." He calls for an upfront ideological method, which he labels "action research," based on a "different epistemology," one that recognizes that "the historical process bounds the experience in such a way that the action researcher is an extension of that history and all its traditions, values, and norms, which predetermine conditions for viewing society and acting upon it" (76–77).[25] He goes even further, suggesting that ecological issues are inescapably political and economic in nature (i.e., they are caused by and can be solved only through a redistribution of political and economic power). The work of Bryant and others in this movement relies heavily on ideas and methods developed in the fields of cultural critique since the 1960s (feminism, African American studies, postcolonial studies, poststructuralism, liberation pedagogy, cultural studies). The environmental advocacy stance, against human ecologists like Orr, demands that we recognize ecological science as operating through ideology in a postindustrial, postmodern historical context, fraught with sexual, racial, and economic divisions that cannot simply be wished away. An interdisciplinary intellectual coalition between this movement and cultural criticism offers an exciting opportunity to forge an eco-cultural perspective.

The desire to retreat from cultural analysis helps explain why romantic ecologists have positioned cultural historicism as the focal antagonist of an ecological criticism. Kroeber's unease with multiculturalist critique becomes palpable as the book draws to a close: "Ecological criticism, instead of studying works of literature in self-defensively exclusivist terms, nationalistic, ethnic, or ideological, seeks to discover each work's contribution to comprehensive possibilities of interactivity. . . . Ecological criticism, in brief, would reestablish on every level the significance of diversity. The importance of diversity, and ultimately of uniqueness, has

been threatened by recent postmodern separatist critics as seriously as by earlier modernist proponents of 'universals'" (140–41). Despite the lack of attention to period diversity in Kroeber's own analysis, I hesitate to suggest that this is mere lip service to cultural diversity. In fact, the distortion goes much deeper, possibly deriving from a greater anxiety, the same anxiety that prompted some 1960s activists to abandon the difficulties of liberation politics for an environmental activism that reduces divisive ecological issues to the call of a peaceful Mother Earth. When Kroeber says that he wants to liberate criticism from "endlessly subdividing itself into defensive parochialisms of spirit" (141), he eloquently voices, not without some merit, the fear of cultural balkanization that expresses the current backlash against a variety of multicultural agendas. This gesture, however, unfairly blames cultural critics for a "spirit" of social divisiveness along the lines of gender, race, sexuality, class, and region by asking us to forget that cultural critics have helped expose such divisions by taking them seriously as objects of study and by helping to give voice to those oppressed and marginalized by these divisions.

Finally, though, Kroeber's resistance to multicultural historicism shortchanges his ecological project most by leaving us with a kind of diversity — both biological and cultural — that looks uncannily similar to a new critical tone, style, and method. Comparing literary reading to Barbara McClintock's feminist practice of science, Kroeber writes:

> This attitude of humble intimacy, of passing through the artificial constructs of subject-object distinction, should strike a profoundly responsive chord in some literary critics. It is analogous, at any rate, to my own experience in reading poetry. That experience is one of empathetic engagement, of being caught up with the emotional development of the words, a paradoxical loss of self in an enhancement of subjective emotionalized understanding. It is to this learned capability of responsiveness that I attribute my pleasure in rereading fine poetry endlessly, always finding new surprises and wonders, amazed at how much I had before more than looked in what I thought were familiar lines. That my experience is not merely idiosyncratic I deduce from the fact that the colleagues I most admire seem, like me, unable to make much use of old notes when teaching familiar poems. (34)

Indeed, anyone trained under the tutelage of Matthew Arnold and the powerful pedagogical traditions, like New Criticism, issuing from his view of the literary and culture must necessarily be tempted by this description of the pleasures of rereading "fine poetry endlessly." Certainly not idiosyncratic, this kind of revisionary reading is deeply rooted in a variety of cultural habits and institutions, some useful and some not, but all in

need of a continued, thoroughgoing critique—however wistfully some of us may proceed with it. This Arnoldian-Keatsian aesthetic recalls the new critical paradoxes wherein a great poem self-actualizes into a well-wrought artifact through the trained critic's commonsense understanding of the great (European) tradition.[26] He equates the idea of the text's organic complexity with the ecological value of evolutionary diversity in the gene pool. Likewise, the uniqueness of the work of art resonates with specieslike evolutionary singularity. This natural harmony through diverse uniqueness also sounds familiar when we consider its kinship to the Augustan *concordia discors,* which itself greatly influences the concept of romantic nature. The romantic ecological approach, like romanticism itself, must waffle between dissecting empiricism and totalizing imagination, between an overnaturalized human subject and an overhumanized natural object, between individuated uniqueness and harmonious wholeness of the work of art, while seeming to transcend the untheorized vacuum between these binaries. If ecological intersubjectivity means going beyond such recuperated subject-object binaries, as Kroeber perceptively claims, it must also mean a radical deconstruction of this innocently naturalized "pleasure" of escaping into a poem's body aestheticized as another self. In the aptly titled essay, "Intimate Distance," Shane Phelan warns against the kind of comfortable intimacies that Kroeber's celebration of aestheticized reading evokes: "The questions of sexuality and ecology, to name only two fields of nature discourse, can never be resolved by simply opposing human activity/ies to 'nature.' . . . Nor can we deal with them by assimilating ourselves unproblematically into nature. The only nature that we can lay full claim to is the intimate distance of human existence, a nature that belies any full claims" (59).

Because romantic ecology tries to wed the absolute factuality of ecology as natural science to the absolute value of imagination as sublime aesthetics, each term disguises the threat of the other. Eco-cultural criticism must remain suspicious of this Wordsworthian wedding without discounting its seductions for those weary of social division and enamored of an untroubled nature peeping from behind global environmental catastrophes. Mindful of such seductions, feminist theorist Donna Haraway in *Primate Visions* and ecological historian William Cronon in *Changes in the Land* offer very different exemplary ways of proceeding toward an eco-cultural approach. Whereas Haraway more boldly constructs the ideologies that render primate studies a seductive science over the last hundred years, Cronon more cautiously traces the changes in culture that can never be separated from changes in ecology, despite the seductions of the easy binary between "native" and "invasive" species. Both scholars complicate and challenge the notion that ecological science can find a pure ground (a pure

nature) from which scientists can issue observations that need merely to be applied to environmental problems or literary-historical texts. Through her concept of the cyborg, Haraway wrenches our comfortable notion of a permanent humanity.[27] Through his insight that precolonial American Indians, too, act historically in changing the land, Cronon forces proponents of science (in this case, landscape restoration) beyond a comfortable romanticizing of the "native" land as an ideal static state achievable by reference to European presettlement. Both scholars remind us that history, ideology, and culture become more, not less, crucial to an ecological critique.

On the one hand, cultural critics feel compelled to respond to, as I have done here, the nostalgia for a Wordsworthian dispensation that drives romantic ecology. On the other hand, as long as we compulsively return to Wordworth's literary corpus, denying its state as a deteriorated corpse, we will remain stuck in revisionary reading and stuck inside the abstractions we imagine residing inside Wordsworth's head. At what point do we bid farewell to an object of study? At what point do we contest the terms in which literacy is constituted by *objects for study,* given that the objectification of knowledge in these terms guarantees making an object appear as either an infinite source for, or an inescapable aftereffect of, an infinite human mind?

Most recent critics have focused their efforts on the other dis-places of romantic reading: the reading public and especially the historical-political institution. The reconstruction of institutional reading was initiated by the clearing procedure of deconstruction. Paul de Man pointed to the ways in which the subject-object binary blinded us to the intentional rhetorical structures within texts. In *Blindness and Insight,* he demonstrates how this ongoing bout between subject and object is a shadowboxing match. The "real structures," he suggests, can be discerned in the intertextual struggle between the subjectivity found in time, which he calls allegory, and the subjectivity lost out of time, which he calls irony (188). Whereas allegory fractures time in the reading process by deferring the subject-reader's capacity to reference antecedents as fully actualized meanings, so irony fractures the subject-reader itself, forcing the reader to turn against himself when recognizing that his past ignorance may be nothing more than a sign for its present illusion of knowledge.[28] "[T]he target of . . . irony," de Man writes, "is very often the claim to speak about human matters as if they were facts of history. It is a historical fact that irony becomes increasingly conscious of itself in the course of demonstrating the impossibility of our being historical" (211). De Man interrupts the interminable cycle of natural objectification (seeing nature as an external re/source for human knowledge, here for *historical* knowledge) by clearing the site of nature from the act of reading. There are only subjects (readers) acting in

time here, and in a time that itself must be subjectified and unknowable. Paradoxically, de Man's brilliant move to demystify the natural object by making the subject an object of its own reflection in the act of reading is itself an interminable cycle. De Man substitutes for the subject-object, mind-nature alterity a commensurate allegory-irony, time-subject alterity. This, then, is revisionary reading at its best.

We must ask, however, what it means for literacy that de Man's subject can read only its own self-alienation. Reading thus becomes obsessive in that reading is everywhere; it is all that we can do when trying to do something else. There is in de Man a dread of reading, and bravely he faces this dread—by reading. It is the kind of sacrifice he describes the romantic writers themselves enacting when they forsake the illusion of symbolic subject-object reconciliation by moving on to the harsh unrealities of allegory and irony. What motivates this reading dread? Could it be the excessiveness of print itself, in a culture where rereadings are amassed so readily that reading loses its revelatory value? For de Man reading occurs literally nowhere—not in the utopian sense but in the sense of there being no there there, no outside, no history, no point of reference except other readings. Such a view of literacy could be delivered so cogently only by someone existing in a culture where literacy can not only be taken for granted but also where a dearth of literacy is unimaginable.

The same effect results from Jacques Derrida's concept of reading as play. Whereas de Man stoutly faces down his dread, Derrida revels in what he sees as a universal excess, an ever renewable re/source of reading pleasure, in some ways akin to Kroeber's Keatsian aesthetic. Likewise, Derrida's deconstruction of the privilege of status given to speech over writing misrecognizes an irrefutable reality: speech can only be easily incorporated into writing where writing—and I would add print—is abundantly accessible and "excessible." Those in a place where literacy is scarce owing to the unequal distribution of material sources may conceptualize the relation between speech and writing in a drastically different way from conspicuous consumers of the word such as we. Moreover, Derrida, with his idea of "presence" (the metaphysical error of believing that our words can embody or express full, immediate meaning), is blind to the way that words enable us to consume meaning as fully embodied, commodified objects. This is what we do every time we buy another book for our private libraries, or every time we check out a book from an overstocked research library, or every time we access a text from a newly computerized on-line library. It is not so much that meaning is absent in words, for meaning is constantly being (re)produced and consumed at a rapid rate in postindustrial societies. What is absent instead are the material conditions that enable this consumption of meaning to occur seemingly without eco-

logical cost or economic consequence. Derrida's error consists in focusing on the substance and form (the putative meaning) of words, rather than on the larger ecological-economic distribution and formation of particular structures of reading. He clings to the classic European notion of "word-ness" as an immaterial or dematerialized abstract quality. In its celebration of the pleasures of reading, therefore, deconstruction perpetuates and intensifies an imperialist logic, which takes the excessive consumption of reading materials in European-American societies and reads this excess as a pleasurable virtue rather than as a potential mode of postcolonial waste.

Historicist critics have found it necessary to reground reading, by taking advantage of a deconstructionist clearing of land in order to try to see how readings are determined, not by natural objects but instead by institutional objectives in cultural history. Levinson's now famous reading of "Tintern Abbey" deconstructs Wordsworth's nature site to reveal the machinery of industrial capitalism and the social cost of homeless misery that accompanies it. The poem, she argues, encourages us to overlook the political and economic casualties that disturbed nature's landscape by erasing the beggars from the reading experience. Through her research she uncovers or recovers these casualties—the homeless hordes—and retraces the ways in which their absence from the poem leaves traces in its logic and structure (*Wordsworth's Great Period Poems* 34–37). Levinson's critique invites the reader to identify with these lost objects, the oppressed and repressed homeless people, by restoring their subjecthood as historical agents while complicating our relation to the great poet and his prophetic words.[29] Levinson's reading results in the self-conscious irony of the belated critical reader, now historicized and alienated by Levinson's critique, being more aligned with the poet than with those unhoused "vagrant dwellers" in search of a historical home. We are tied to Wordsworth by our habits of reading, by the sophisticated re/sourcefulness of our literacy; we are distanced from the homeless beggars by their illiterate, illegible anonymity. Moreover, our own critical alienation from the text mimics the poet's feeling in the poem of a "presence that disturbs" as he hears "the still, sad music of humanity" (*Poetical Works* 164). Like him, we make legible our own melancholy, always at the expense of unlearned, unnamed hordes who haunt the shadows of our words. They cannot read Wordsworth's poem; they cannot read our critical recoveries. Their absence, their anonymity, the condition of hording that characterizes their alienation from us, incommensurately accords with our condition of word hoarding, which characterizes our alienation from them. What does it mean to read in order to discover the misery of others that we would prefer to read in order to forget?

Liu's *Wordsworth* reminds us how the fate of revisionary reading hinges on an ever escalating consumption of materials. I mean this in the sense

that I think Liu also means it: in order to recover a historicist Wordsworth, we have to dig through much buried material. Wordsworth's memory is strewn across the annals of history in materials that seem to keep intact a peculiar historic moment. I also mean this in a more basic sense. It costs a great deal in terms of intellectual and material sources to remember Wordsworth in this way. Although the production, reading, and reviewing of this book helps revise the way we read Wordsworth and history, it also reinforces the way we allocate reading as a re/source: the energy we put into rereading Wordsworth versus the materials we read somewhere else. The intelligent massiveness of Liu's book gives us hope that it can circumvent becoming what every *thing* must ultimately be: a lost object, subject to decay, death, and oblivion.[30]

We keep burying romanticism, losing it as an object, in order to rediscover the power of reading as an objective. If this is a form of mourning, a refusal to let go out of a fear of losing ourselves in death, then reading, in this sense, must be romantic: constantly losing and finding ourselves as subjects by finding and losing the dearest and direst objects of our attention. Our obsession with historicizing the material conditions of romantic composition, then, rehearses a sociopsychic order encouraged by habitual revisionary reading. We think that the power of reading can break the ever escalating cycle of consumption whereby we need ever more materials, re/sources, to produce ever more refined achievements of culture. Historicist reading may need an ecological critique that is based not on green nostalgia but on the future we hope to open up and absent ourselves from.[31] Our most "advanced" modes of critique remain ensconced in the bureaucratic institutions that underwrite our historicist critiques. Institutions embody intentions that extend beyond the current collective groups of individuals who make decisions within those institutions — they embody the intentions of the dead.[32] We tend to concentrate on the content and form (that is, the meaning) of the texts we read as supplying the objects of knowledge that we must critique. Sometimes we read institutions themselves as objects of critical knowledge, as Gerald Graff does in *Professing Literature,* yet our reading habits condition us to target historical content and form of the institution as the basis for this knowledge. Academic institutions may be placed in a network of economic and political influences, as John Guillory does in *Cultural Capital.* Despite their usefulness, such studies, however, remain within the paradigm of re/sourceful, reproductive reading. They assume that increased knowledge necessarily produces enhanced life: the institutional creed of the modern university. In this sense, research is intimately tied to re/source. The purpose of the research institution, as intended by the dead capitalists who originally financed the centers of learning, is to perpetuate the idea that more knowledge in itself creates a

higher standard of living for all, a more democratic culture, a more productive world economy. By assenting to the standards of re/sourceful research, we not only carry out the wishes of the robber barons but also reproduce the conditions of their conspicuous consumption. This notion of productive knowledge serves to repress the question as to how our institutional knowledge manipulates material sources; how research, with its presumption of an infinite progress of the mind, consumes material sources at such a rapid rate that the basis of research in the unequal distribution of material sources disappears. Research defines the structure of high-level consumption in which our reproductive readings operate, a structure so deeply embedded that it becomes invisible in the act of reading itself.

Andrew Ross issues an important caution:

> I have always assumed that most people in this world would rather have a surfeit of information (whatever that means) than a scarcity. But information is not intelligence or knowledge. . . . To my mind, the most useful critiques of information culture are still those that focus on the economic organization of information and its technologies, ever advancing new and profitable ways of restricting access to information and making it an ever-more scarce commodity. Contrary to the image glut school of thought, which leads the moral crusade against the overavailability of information, it is quite clear that getting access to information today is just as uneven and as expensive as ever. (224)

Although I largely agree with Ross's assessment, I do not think it is so easy to separate the anxieties about information glut from the realities of uneven distribution. Just as there is a structural economic link between ever advancing ways of new profit and ever advancing organizations of restricted access in order to create scarcity, so there is a vital link between the structure of knowledge as an ever advancing re/source of unlimited information and the uneven distribution of intellectual materials within domestic and across global markets. Until we begin to direct our attention to these structural conditions, we shall never get a tactical hold on our economic-ecological role as producers of knowledge.[33]

As a pedagogical site, the reading public is no less cantankerous than nature or the institution. It appears to be a no-place, sometimes in the utopian sense, sometimes the dystopian sense. Too distressed to confront the specter of the reading public, Wordsworth himself nostalgically depicts the struggle for literate knowledge as a battle between formal institutions (Cambridge University) and Nature as natural tutor.[34] The romantic notion is that institutions always unintentionally miseducate, but that geniuses rise above flawed institutions through nature's (mis)education of a higher human mind. This theory overlooks the fact that reading cannot occur

outside of institutions, since words carry within them the institutions that enforce them. As opposed to the romantic nature reader, who is suspicious of the effects of technology on the reading process, even while exploiting those technologies to enhance that process, the reading public or non-professional reader embraces "advances" in production and distribution because such changes tend to expand accessibility to reading products, as well as to the notion of accessibility itself. Therefore we must resist the temptation to condescend to new technologies and jargons and must reject the apocalyptic dream proffered by the mere consumption of such technologies and jargons.

Like romantic nature reading, the reading public appears to operate outside of institutions. In its moment of cultural consolidation, the reading public was coded by liberal readers like Thomas Paine, William Hazlitt, and Francis Place as a leveling phenomenon that authorized individuals to think independently, that is, outside the ancient regime of hegemonic (for them, tyrannical) institutions. In liberal ideology, reading represents political freedom, individual self-improvement, and the immediate pleasure of whimsical knowledge undisciplined by figures and institutions of authority. In this sense, de Man, Derrida, Roland Barthes, and their followers form a long lineage reaching back to Paine and Hazlitt. The peculiar third-order labor of reading creates a sense of liberation from both the industrial labor of the working classes and the stodgy, canonical classical learning associated with reading in the upper classes. The reading public is freed from the physical labor of the masses, who are too tired to learn the habit of reading, even if they know how to read, and also freed from the false leisure of the classically schooled upper-class gentlemen. Freed into the metaphysical labor of reading, the reading public forgets the physical contained within metaphysics, a forgetting that imagines a certain autonomy and superiority in the middling state. For the pleasure of the reading public is not (upper-class) leisure, in the sense of time unencumbered by the pressures of making a living, but instead freedom from state (institutional, bureaucratic) interference. This reading is conceived as freedom for opportunity (and opportunity for freedom) snatched in spare moments from the (other) productive pursuits of making a living by making profits. Reading in these opportune moments both constitutes and represents freedom: the readers' social, economic, political, and psychic progress within the state and, ironically simultaneously, independence from the state, to which they owe that freedom to progress.

In *The Autobiography of Francis Place,* the liberal, middling-class Place reads to learn outside of flawed institutions, but like the upper-class Wordsworth, who must turn his insider status into a natural condition, Place makes his outsider status a progressive position. Because he is not

encumbered by the traditional dogmas and canons taught to his betters at Cambridge and Oxford—because he does not have to read in preestablished forms, so to speak—he can read whatever and however he likes. He can read for the future (for self-improvement, for economic profit, for the progress of science), and his very act of reading helps to invent that future as surely as it enables him to predict fluctuations in the economy or to anticipate promising scientific inventions and natural discoveries. A Londoner by trade, Place has no time for Wordsworthian nature. His nature comes all bound up in "natural history" books that teach him to find nature in a rather bookish reading of natural science. We might be prone to mistake Francis for Wordsworth's Matthew, toiling away his "meddling intellect." Although meddling and middling are not the same, they are close enough for the purpose of understanding the romantic anxiety about bookish readers. Like Place, many people from the middling ranks had begun to spend their spare time reading whatever interested them at the moment. It is not Wordsworth's fear of disciplining institutions that drives him out to consult nature's book (he, after all, values Cambridge enough to stay and earn his degree); rather, it is the apparent similarity between the leisurely self-discipline required in obtaining a Cambridge education and the opportune self-improvement enjoyed by individuals like Place. Reading itself becomes indiscriminate, promiscuous, enabling individuals to meddle where they do not belong.

Place's middling-class reading, not yet formally institutionalized, may not imbibe nature's "beauteous forms of things." Nonetheless, the notion of natural reading misshapes Place's project as a kind of naturalizing science and tends to make us forget that the reading public is itself an institution, determined by structures as formal and disciplinary as Cambridge itself. Place may not be reading the Cambridge canon, but he is reading from a rapidly emerging canon of practical knowledge being fostered by the new dissenting academies. Place educates himself according to the dictates of these very utilitarian, disciplining institutions.

Furthermore, Place's reading is determined by which books publishers are prone to publish, which in turn is based on which books the reading public is prone to buy. This circular book marketing process uncannily follows the logic of high-cultural, high-consumption institutional reading. Place can purchase or borrow only the books that are available, and the books that are available are determined by what publishing institutions imagine readers like Place are willing to purchase. This circular reasoning enables Place to feel as though he has freedom of choice, and it also gives him a sense of forward movement, as upward mobility, defined by his movement away from a social class where reading (material) is scarce. To become a member of the reading public, then, is to become free to

consume reading materials as though there were no limit to the materials consumed. This concept of the reading public would make it more appropriate to be dubbed the reading *private,* for it misconstrues the private context of this reading experience (practiced alone in a domestic setting, silently in one's head rather than by reading aloud to an assembled group in a public space) as a form of freedom from the state. The private context of the reading public hides the ways in which the term "public" does apply. The materials and labor silently consumed in the reading act were once common property, and the moment of private consumption can never restore these common properties to their former public condition, even when the reading results in scientific discoveries that promise to enhance the living standards of everyone. What touts itself as liberating progress (self-improvement, scientific progression, civilizing development, liberalizing freedom) or as a re/sourceful investment that will return a profit turns out to be an exhausting loop of no return.

Making Place the middle ground of our reading practice tends to duplicate the process of reading as both middling (the making of a bourgeois practice of consumption) and meddling (robbing Peter to pay Paul, or in this case robbing Wordsworth to pay Place), but it leaves the old ecology of literacy intact. Much of our cultural materialist criticism is concerned with demonstrating how the class origins or gender of a writer alter our notion of the conditions for reading and writing, and we tend to emphasize the sociopolitical consequences of reading one text (from the lower-class, for instance) rather than another (from the elite canon, for instance). While middle- and lower-class readers and writers like Place may broaden the textual forms and meanings within reproductive, revisionary reading, focusing on class and gender attributes in this manner does little to alter the procedures of re/source reproduction functioning within such reading habits.

We think it makes a difference to our reading habits that Blake is from the artisan class. But what does it mean that one of our most radical authors, according to Jerome McGann,[35] is also a reader who distrusts the technology that makes reading more accessible to a mass audience? Unlike most of the Jacobin sympathizers of the time, Blake was deeply suspicious of print technology, so much so that he helps us develop a habit of reading that internalizes print phobia. A poem like "The Little Black Boy," a brilliant exposition of the pedagogy of the oppressed, displays how little colonial boys necessarily mislearn the lessons of the oppressors, and how oppressors necessarily miseducate the oppressed, only to provide the oppressed with a potential weapon in the very weapon of education being used to oppress them.[36] And yet, despite so brilliant an exposition, Blake's great fear was that his own script would be misread as scripture, that they would be rigidified by mass print and by a passive reading public. Despite

Jean Baudrillard's warning that passivity itself can be an effective mass weapon against hegemony (19–48), when we teach we use every arm in our arsenal to defend against such passivity. We bring mass culture into our classrooms either to romanticize it or to reveal its demonizing power. Some of us celebrate it, in deconstructive or Baudrillardian fashion, as the ultimate act of resistance. Some of us combat it as an erosion of revisionary active reading. Our hope, either way, is to educate our students out of the mass and into Language, Theory, History, or Culture. For to celebrate the mass as resistance is just as surely to fall out of the mass into critical culture. We want to make our students agents despite themselves or, more precisely, double agents, who can actively spy on mass culture while merely being spectators within it.

Shifting the object of attention (from upper-class to lower-class object as knowledge) is certainly one way to try to de-enervate this mass passivity, to overcome the problem of compulsively returning to authoritarian, high fetish objects, but such a shift does not solve the question as to whether it is possible to have literacy without constituting the mechanisms of reproductive reading. Taking ecological literacy seriously would pose a challenge to the institutional value of reproduction as an end in itself, which undergirds not only our research but also our teaching, our standards of judgment, our disciplinary boundaries, and our entire academic culture. What would an educational system look like if it replaced reproductive record keeping with a redistributive global literacy?

I do not have the answers to these questions. Indeed, the best I can do, in conclusion, is to offer two contrary scenes of miseducation based on the paradigms of reading that have dominated our practices thus far. I refer to two scenes from Blake's *Songs of Innocence*. The first, from the title page, depicts an institutional site, a scene of civilization or socialization. A maternal tutor sits bolt upright with an open book in her lap; two children, a girl and a boy, lean upon her lap with their faces bent down into the open book. She is teaching them to read by reading to them; they are learning how to read by reading her book, the book she has deemed appropriate for them.

The second scene, the illuminated print facing the poem "The Little Black Boy," depicts a "natural" site, which turns out ironically to be a colonial situation. The little boy is seated on his mother's lap as, pointing to the sun, he recites a lesson, which, no doubt, he has learned, not from a book, but from the mouth of a European missionary. The little black boy has supplanted the book in the maternal lap—has become the book that he cannot read. He has learned the same lesson, however ineptly, as that learned by the little (white) children. Is the little black boy's bungling merely a reproductive misreading, or is it an act of resistance to reproductive reading that suspends the prospect of a kind of literacy that might

open up an alternate relation with nature? We frequently read such scenes as warnings against the dangers of dogma and authority. The little boy's words are oppressive because he repeats them unwittingly, unlike our revisionary readings. Even if his words are revisionary, a new interpretation of the Europeans' dogma, what difference does it make as long as the words trap him in an exchange that sustains an unequal relation?

Until we admit ecological thinking into our reading—not romantic ecology but a culturally grounded, materialist ecology—until we admit that reading in order to reproduce objects of knowledge alone is inherently a form of high consumption, until we admit that reading is not play except for those who have the privilege of having learned to read so well that they can afford not to take words too seriously, and until we admit that reading is always a loss of something more than merely signifying meaning, we will always remain heady romantics. Our reading will not be in vain, but it will also always be merely an act of reading.

Notes

1 Ecology comprises the study of living organisms' relations with one another and their interactions with their environment. For a fuller definition, see I. G. Simmons 5. I use the word "environmentalism" to denote the political practices entailed in shaping legislation, institutions, behaviors, and policies that determine how human individuals and social groups use and interact with other living organisms as well as their environment. Environmentalists base their ideological principles and political strategies on the "scientific" findings of ecologists.

2 The term "green criticism" has been applied to a range of critical approaches, some of which contradict each other. The criticism that, borrowing from poststructuralism and cultural studies, offers a social constructionist critique of ecological, environmental, and nature discourses differs markedly from that which has begun to receive attention and carry the mantle of ecological criticism in romantic studies. I want to show why the latter approach is insufficient insofar as both a radical environmentalism and cultural analysis are concerned. The former approach, because it attempts to extend and transform cultural criticism through ecological concerns, holds much greater promise. For excellent examples of the former kind, see the essay collection edited by Bennett and Chaloupka, *In the Nature of Things*. To keep the distinction between the two criticisms clear, I will refer to the latter as "green" or "conservationist" criticism, and to the former as eco-cultural criticism.

3 By revisionary reading I mean the practice of reproducing interpretations of canonical texts to refine their meaning and reaffirm their literary and cultural significance. I would go so far as to say that revisionary reading has heretofore been the most progressive aspect of literary studies in that it has enabled successive generations of scholars to challenge and rethink not only canonical texts but also canonical methods of thinking about texts. A naturalist criticism explicitly endangers most the racially oppressed and marginalized, sexual minorities, and the economically oppressed—all of whom have made *discursive* gains owing to the breakdown of a naturalist discourse. The question is whether, given the reinvigoration of the notions of family values

and the politically incorrect and the greening of those committed to canonical texts and practices, we must seek to rethink the tactics of these progressive approaches by placing them theoretically within the arena of a materialist ecology, multicultural value, and the nonprofessional reader. For a spirited, lucid, persuasive definition, defense, and contextualization of revisionary reading, see Marjorie Levinson's "Revisionist Reading." Levinson's essay has been helpful to me in my rethinking of this essay from its original draft as a conference paper.

4 Although this issue is directly related to the legal construction of intellectual property as an economic ground for knowledge, it is unfortunately not possible to pursue the connection here. For a cultural analysis of intellectual property, see Woodmansee and Jaszi.

5 Even though Thomas Malthus and Adam Smith take opposite sides of the scarcity argument—Malthus arguing that population growth among the lower ranks signals danger to a national body and Smith that such growth is natural and betokens a healthy state—both economists assume that scarcity is a *natural* condition of the economic and ecological structure (see *Essay on Population* 14–15 and *Wealth of Nations* 96–99 respectively). The problem is that the environmental concern with resource depletion so easily turns into the capitalist assumption of a natural scarcity. A cultural approach to environmentalism helps to remind us that the structure of consumption and distribution of material sources can account for ecological issues without assuming that scarcity justifies vast inequities in terms of class, gender, sexuality, race, region, and political power.

6 I interpret this to mean that the more efficient industrial capitalism becomes in exploiting machinery and human labor, the more inefficient it becomes both in demanding ever greater supplies of raw materials and in providing ever more excessive commodities for inequitable consumption.

7 I borrow the concept of "cultural capital" from Pierre Bourdieu's *Distinction,* in which Bourdieu writes: "These conditions of existence, which are the precondition for all learning of legitimate culture, whether implicit and diffuse, as domestic cultural training generally is, or explicit and specific, as in scholastic training, are characterized by the suspension and removal of economic necessity and by objective and subjective distance from practical urgencies, which is the basis of objective and subjective distance from groups subjected to those determinisms" (54). "Economic power," he adds, "is first and foremost a power to keep economic necessity at arm's length. This is why it universally asserts itself by the destruction of riches, conspicuous consumption, squandering, and every form of *gratuitous* luxury" (55; Bourdieu's italics). We could substitute the phrase "eco-cultural necessity" for "economic necessity." See also John Guillory's excellent definition of Bourdieu's concept (viii–ix).

8 Chaia Heller challenges the use of the term "human" in ecological literature: "The romantic ecologist constructs a big, flat category called 'human' and holds this abstract human responsible for the destruction of nature. However, it is unclear just who is subsumed under this category of human" ("For the Love of Nature" 226). Green critics have attacked Alan Liu's first statement in his "litany of broken faiths": "*There is no nature*" (38; italics in original). They curiously misread this statement as a denial of any phenomenal existence outside the mind, a reading Liu is careful to repudiate from the outset. Liu's statement logically leads to others, one of which is: "*There is no self or mind*" (39). I would point out, in answer to the conservationists' charge that the science of ecology disproves the social construction of nature, that ecology can neither prove nor disprove anything concerning the metaphysical abstracting of a nature beyond

particular observations about particular interconnected phenomena (any more than astronomy can prove or disprove that there is a transcendent deity ruling the heavens). The moment we speak "nature," we also assume a purposiveness behind or within nature that is unsupported by scientific theory or empirical methods. Indeed, as many eco-culturalists have argued, dominant ecological practices rely on nature as a discursive foundation through various metaphysical assumptions, some of which conflict with the empirical methods employed to gather observations about material phenomena. My intention is to support Liu's statement by refocusing on the question of the process of abstraction as the mystical link between "mind" and "nature"—showing what is at stake ideologically in the conservationists' gravitating toward such concepts.

9 David Demeritt writes: "These attacks [by historians of science] on scientific objectivity erode the epistemological foundation that many environmental historians seek to build beneath their wider critique of modern society and its relations with the biogeochemical environment. If scientists cannot claim to represent nature truly, then environmental historians cannot rely upon ecology to provide the truth about nature. Ecology may be a preferable science to nuclear engineering, but it cannot claim to occupy a privileged vantage point from which to represent nature more accurately than other sciences" (27). For an insightful qualification of this argument, see William Cronon's response to it, "Cutting Loose or Running Aground?" For a historical account of the problem of reading nature accurately, see Neil Evernden's *Social Creation of Nature* (particularly 6–16).

10 Those who complain about jargon, intellectual masturbation, and divisive political agendas as liabilities of literary studies tend wrongly to assume that there is a common, universal language to be uncovered beneath the arcane, inbred sophistications of literary language, rather than a swirl of heterogeneous discourses that we tap into variously in different social contexts. In "Damaged Literacy," Morris Dickstein's attack on "adversarial" reading (historicist-culturalist criticism), nostalgia for "the common reader," and the American myth of bootstraps opportunity relies on this notion of a corrupted common language. In "Revisionist Reading," her answer to Dickstein, Levinson points out the fallacies in these assumptions. For another version of the nostalgia for a common language, see Karl Kroeber's *Ecological Literary Criticism* (140).

11 In addition to Bate and Kroeber, James McKusick practices the conservationist type of green criticism I am challenging.

12 In "Cyborgs to Gargoyles," Marjorie Levinson offers a counter-humanist critique of Bate's position. She rightly suggests that Bate is reduplicating "the rhetoric of intervention to revive the primitivist, essentializing, aestheticizing, and protectionist views of nature that arose in the early 19th century in response to despoilations brought about by industrial capitalism" (1). As she points out, Bate attempts to use the nature-mind alterity in order to preserve nature for human perception and appreciation, and she locates this view ideologically as a "conservative humanist position," reenacting what used to be called "nature worship." Peter Manning's critique is persuasive from a humanist stance: "Advocacy of green values thus seizes the moral high ground, reducing the New Historicists to an outdated 'hegemonic regime' ripe for overthrow.... [Bate] stands as a conservative pleading for a return to the certainties of the past, when nature was simply and magnificently nature and readers were harmoniously common" (279).

13 For an intriguing account of how colonialism has helped to shape the discourses of ecological environmentalism, see Richard Grove's *Green Imperialism*, which calls into question the romantic conservationists' attempt to totalize the origins of ecology

in high European (especially British) romantic readings of nature. Grove locates the emergence of ecology and environmentalism in what Mary Louise Pratt calls "contact zones": "the interactive, improvisational dimensions of colonial encounters so easily ignored or suppressed by diffusionist accounts of conquest and domination" (7).

14 I cite Naess not because I agree with the tenets of the deep ecology movement but to demonstrate one of the ideological divides within ecology. For a brief, on-target critique of deep ecology from an eco-culturalist stance, see Bunyan Bryant's *Environmental Advocacy* (27–29).

15 It is also revealing to contrast Heller's account of Ellen Swallow's role with Bate's notion of her as a popularizer (see Heller 233–34).

16 This is not intended to suggest that all colonized peoples' traditional practices are necessarily ecologically viable—only that the conservationist approach intrinsically risks dismissing the potential of non-European understandings of material sources and ecological relations.

17 Based on a conversation, October 1994. Following this logic, environmentalists are now calling eco-spaces that have been severely damaged by industrial pollution "brown lands." Cheri Lucas Jennings and Bruce H. Jennings also point to the significance of color in evading the ways in which race and economic class shape the sciences of agricultural ecology and the policies of "organic" farming. These sciences and policies result in a "practice of culling environmentally sound 'green' products for our children's health from a wholly unsound 'brown' environment fostered in their production. Brown is the color of the insecticide wash engineered to be rinsed from the peel without a trace by the time it reaches our table. Brown is the color of the irrigation ditch and contaminated soil left behind. And brown is the color of the 'other' skin incidentally present in the field when growers spray the fruit" (177).

18 In "Romantic Ecology Revisited," Bate approvingly cites Lovelock as providing a "new myth" or new way of "conceiving of the planet" (161).

19 For an excellent critique of the kind of feminism Kroeber borrows, see Shane Phelan's "Intimate Distance" and all of the essays in Greta Gaard, *Ecofeminism*.

20 I am struck especially by these statements in Deleuze and Guattari's "What Is a Minor Literature?": "There is nothing that is major or revolutionary except the minor. To hate all languages of masters" (26). And then: "To make use of the . . . linguistic Third World zones by which a language can escape, an animal enters into things, an assemblage comes into play. . . . Create the opposite dream: know how to create a becoming-minor" (26–27). Also see the essays in JanMohamed and Lloyd's *Nature and Context of Minority Discourse*.

21 When Kroeber makes the "dearest Maiden" "an address to the feminine self within the poet" (63), he repossesses "the feminine" even more than if the narrator is read as addressing an actual or imagined female other like Dorothy Wordsworth. I have no quarrel with culling a "feminine" Wordsworth, though this is definitely not the effect of Kroeber's overall reading. According to Kroeber's reading, however, it becomes very difficult to understand why protection of nature must be a feminine "component" of the self, leaving "untouched" the masculine whole in which this component takes on meaning. Such an image raises larger questions concerning the construction of environmental stewardship as feminine caretaking in such a way as to reaffirm the theory of the separate sexual spheres. This is once again the cult of romantic nature that Chaia Heller has attacked. Laura Claridge anticipates and challenges an interpretation like Kroeber's; she points out that male romantic poets must address the feminine "within," given the cultural imaginings of natural maternity and maternal nature,

but that such an address is necessarily fueled as much by anxieties of impotency (of various kinds) as by engagement with feminine otherness (see *Romantic Potency*, especially 35–93).

22 The only writer Orr includes from the British romantic period is Thomas Malthus — certainly an important figure in ecological literature but one whose philosophy was anathema to the canonical romantic poets, and someone besides who represents an alternate view in relation to a totalized romantic periodizing of the literature. (Kroeber weds Malthus to a totalizing romanticism by suggesting a resonance between him and Keats [see 88–90].) Orr is more generous with American romantics, for he includes in his ecological curriculum Herman Melville (93, 110, 123) and Henry David Thoreau (122–126, 161), no doubt owing to an unarticulated American nationalism undergirding his putatively global curriculum. The problem with Orr's ecological education program is that it is still largely based in Eurocentric, metaphysical canon building.

23 He advocates, for instance, discriminating between "deconstructive or eliminative postmodernism" and "constructive or revisionary postmodernism," in an attempt to retain notions of scientific objectivity and monologic meaning and to overcome the challenges posed by poststructuralist and cultural-materialist thinkers (iii–vi).

24 However, Orr is more cognizant than the literary ecologists of the important place of multiculturalism in an environmental agenda. See, for instance, his critique of Alan Bloom in ch. 6 (especially 98–100). Unfortunately, this cognizance tends to disappear from his proposed curriculum. It would be interesting to inquire why mainstream environmentalists attempt to absorb feminist insights while resisting addressing issues related to race, poverty, and postcolonialism. It makes me wonder to what extent ecology, like nature, can serve as an erasing screen.

25 See also the essays in Bryant's *Environmental Justice* and Bob Higgins's *Race and Environmental Politics*. For a radically different approach to environmental education based on this activist paradigm, see Bryant's *Social Change, Energy, and Land Ethics*.

26 Kroeber's reading approach also seems to hark back to the sort of history-of-topics method practiced so well by Joseph Warren Beach in *The Concept of Nature*. Beach reads romantic poetry as the culminating literary response to a concept of nature modeled on an Enlightenment "hybrid" bred from Newtonian science and Christian humanism (10). He thus suggests that romanticism represents the last gasp of nature before it is smothered by the pressures of modernism. Beach intriguingly surmises that modernists seek to replace this no longer compelling hybrid with "a sense of social solidarity — class solidarity or the solidarity of a classless race" (9). This idea seems to me prescient, anticipating as it does the quarrel between modern humanists (anxious to mobilize an ideal of transcendent humanity against a reality of social divisions) and postmodern multiculturalists (eager to expose the construction of social identities as the basis for troubled solidarities), as well as a quarrel between humanist and materialist Marxists.

27 See also her *Simians, Cyborgs, and Women*, as well as Jane Bennett's "Primate Visions and Alter-Tales," for a discussion of how cyborgian thinking may help to problematize the tendencies of naturalizing humanity and humanizing nature, tendencies that erroneously assume that they move us beyond the subject-object, human-nature binary.

28 My use of the impersonal pronoun in referring to the personal identity of the reader is intended to stress the process of alienation and impersonalization intrinsic to de Man's theory.

29 This distancing effect is brilliant in that it alienates the reader from the poem's aesthetic, making it difficult to read the poem without remembering the absent beggars. Consequently, Levinson's book has remained controversial for readers who want

simply to admire Wordsworth and who feel deeply the resonances of the truths (and errors) uttered through the poem.

30 It is interesting that Liu's current project reads materials elsewhere—and critically overlooked, powerful, yet perishable, fugitive, ad hoc materials at that. In examining the discourses and material forms of corporate culture in relation to the millennial dream of apocalyptic technology, Liu is working toward what I would consider an eco-cultural criticism. Perhaps the logic of burying Wordsworth in the previous project is borne out in his current one.

31 This is perhaps the obverse of Levinson's statement in her manifesto "The New Historicism": "We do *to* the past what it could not do *for* itself. We see it clearly in the idea of it" (55; italics in original).

32 This may sound like hoodoo, but the association is intentional. West African vodun practices contain the insight that the dead can exercise their intentions on the living, and that the faithful must be ever watchful of falling under the spell of these influences, while recognizing that the total eradication of ancestral influence is neither desirable nor possible. (For a description of these religious beliefs, see George Eaton Simpson's *Black Religions* 68–70.) It might be instructive to think of canonical writers as *dead* ancestral influences, to honor while exorcizing, to caution while warding off.

33 This is not to suggest that academic culture is intrinsically anti-ecological, or that citations, footnotes, authorities, and the like are in themselves nostalgic/reactionary. It is to suggest, however, that the structure of intellectual discourse in modern research institutions can be reconceptualized, and, more particularly, that those of us engaged in college teaching and research cannot be satisfied with reforming the canon, the curriculum, and the dynamics of the classroom. For further analysis of the relation between recent critical paradigms and institutional changes within academe, see my essay "Contingent Predilections."

34 In his biography of Wordsworth, Stephen Gill reduplicates this pattern by suggesting that Wordsworth needed nature as a way of getting the human mind to transcend the miseducating effects of all human institutions (27–42).

35 "In the face of various, often radical, dislocations within the social and cultural orders, Blake . . . developed an activist and contestatory poetics" (McGann 43).

36 For a persuasive reading along these lines, focusing on Blake's implicit critique of both the children's book market and the colonialist discourse of the benighted African, see Alan Richardson 153–166.

Works Cited

Bate, Jonathan. *Romantic Ecology: Wordsworth and the Environmental Tradition*. London: Routledge, 1991.
———. "Romantic Ecology Revisited." *Wordsworth Circle* 24 (1993): 159–62.
Baudrillard, Jean. *In the Shadow of the Silent Majorities*. Trans. Paul Foss, John Johnston, and Paul Patton. New York: Semiotext(e), 1983.
Beach, Joseph Warren. *The Concept of Nature in Nineteenth-Century English Poetry*. New York: Russell, 1936.
Bennett, Jane. "Primate Visions and Alter-Tales." Bennett and Chaloupka 250–65.
Bennett, Jane, and William Chaloupka, eds. *In the Nature of Things: Language, Politics, and the Environment*. Minneapolis: U of Minnesota P, 1993.
Blake, William. *The Illuminated Blake*. Ed. David Erdman. 1st ed. Garden City, NY: Anchor/Doubleday, 1974.

Bourdieu, Pierre. *Distinction: A Social Critique of the Judgement of Taste*. Trans. Richard Nice. Cambridge: Harvard UP, 1984.

Bryant, Bunyan. *Social Change, Energy, and Land Ethics*. Ann Arbor: Prakken, 1989.

———. *Environmental Advocacy: Concepts, Issues and Dilemmas*. Ann Arbor: Caddo Gap, 1990.

———, ed. *Environmental Justice: Issues, Policies, and Solutions*. Washington, D.C.: Island Press, 1995.

Claridge, Laura. *Romantic Potency: The Paradox of Desire*. Ithaca: Cornell UP, 1992.

Cronon, William. *Changes in the Land: Indians, Colonists, and the Ecology of New England*. New York: Hill and Wang, 1983.

———. "Cutting Loose or Running Aground?" *Journal of Historical Geography* 20.1 (1994): 38–42.

Deleuze, Gilles, and Felix Guattari. *Kafka: Toward a Minor Literature*. Trans. Dana Polan. Minneapolis: U of Minnesota P, 1986.

de Man, Paul. *Blindness and Insight: Essays in the Rhetoric of Contemporary Criticism*. 2nd, rev. ed. Minneapolis: U of Minnesota P, 1983.

Demeritt, David. "Ecology, Objectivity and Critique in Writings on Nature and Human Societies." *Journal of Historical Geography* 20.1 (1994): 22–37.

Dickstein, Morris. "Damaged Literacy: The Decay of Reading." *Profession* (1993): 34–40.

Evernden, Neil. *The Social Creation of Nature*. Baltimore: Johns Hopkins UP, 1992.

Gaard, Greta, ed. *Ecofeminism: Women, Animals, Nature*. Philadelphia: Temple UP, 1993.

Gill, Stephen. *William Wordsworth: A Life*. Oxford: Oxford UP, 1990.

Gilligan, Carol. *In a Different Voice: Psychological Theory and Women's Development*. Cambridge: Harvard UP, 1982.

Graff, Gerald. *Professing Literature: An Institutional History*. Chicago: U of Chicago P, 1987.

Grove, Richard H. *Green Imperialism: Colonial Expansion, Tropical Island Edens, and the Origins of Environmentalism, 1600–1860*. Cambridge: Cambridge UP, 1995.

Guillory, John. *Cultural Capital: The Problem of Literary Canon Formation*. Chicago: U of Chicago P, 1993.

Haraway, Donna. *Primate Visions: Gender, Race, and Nature in the World of Modern Science*. New York: Routledge, 1989.

———. *Simians, Cyborgs, and Women: The Reinvention of Nature*. New York: Routledge, 1991.

Heller, Chaia. "For the Love of Nature: Ecology and the Cult of the Romantic." *Ecofeminism: Women, Animals, Nature*. Ed. Greta Gaard. 219–42.

Higgins, Bob. *Race and Environmental Politics: Drawing New Connections*. Dudley, MA: Nicholas College, 1992.

JanMohamed, Abdul R., and David Lloyd, eds. *The Nature and Context of Minority Discourse*. Spec. issue *Cultural Critique* 6 (1987): 1–220.

Jennings, Cheri Lucas, and Bruce H. Jennings. "Green Fields/Brown Skin: Posting as a Sign of Recognition." Bennett and Chaloupka 173–94.

Kroeber, Karl. *Ecological Literary Criticism: Romantic Imagining and the Biology of Mind*. New York: Columbia UP, 1994.

Levinson, Marjorie. *Wordsworth's Great Period Poems: Four Essays*. Cambridge: Cambridge UP, 1986.

———. "The New Historicism: Back to the Future." *Rethinking Historicism: Critical Readings in Romantic History*. Ed. Marjorie Levinson et al. New York: Blackwell, 1989. 18–63.

———. "Cyborgs to Gargoyles: Romantic Postmodernism." Unpublished manuscript.

———. "Revisionist Reading: An Account of the Practice." Unpublished manuscript.

Liu, Alan. *Wordsworth: The Sense of History*. Stanford: Stanford UP, 1989.

Lovelock, J. E. *Gaia: A New Look at Life on Earth*. 1979. Oxford: Oxford UP, 1987.

Malthus, Thomas. *An Essay on the Principle of Population*. 1798. Cambridge: Cambridge UP, 1992.

Manning, Peter J. "Reading and Writing Nature." *Review* 15 (1993): 275–96.

Marx, Karl. *Capital*. Ed. Frederick Engels. Vol. 3. New York: International Publishers, 1967.

McGann, Jerome J. *Social Values and Poetic Acts: The Historical Judgment of Literary Work*. Cambridge: Harvard UP, 1988.

McKusick, James. "From Coleridge to John Muir: The Romantic Origins of Environmentalism." *The Wordsworth Circle* 26.1 (1995): 36–40.

Naess, Arne. *Ecology, Community and Lifestyle*. Trans., ed. David Rothenberg. Cambridge: Cambridge UP, 1989.

Orr, David W. *Ecological Literacy: Education and the Transition to a Postmodern World*. Albany: State U of New York P, 1992.

Phelan, Shane. "Intimate Distance: The Dislocation of Nature in Modernity." Bennett and Chaloupka 44–62.

Place, Francis. *The Autobiography of Francis Place*. Cambridge: Cambridge UP, 1972.

Pratt, Mary Louise. *Imperial Eyes: Travel Writing and Transculturation*. New York: Routledge, 1992.

Richardson, Alan. *Literature, Education, and Romanticism: Reading as Social Practice, 1780–1832*. Cambridge: Cambridge UP, 1994.

Ross, Andrew. "The Ecology of Images." *South Atlantic Quarterly* 91 (1992): 215–38.

Ross, Marlon B. "Contingent Predilections: The Newest Historicisms and the Question of Method." *Centennial Review* 34.4 (1990): 485–538.

Simmons, I. G. *Interpreting Nature: Cultural Constructions of the Environment*. London: Routledge, 1993.

Simpson, George Eaton. *Black Religions in the New World*. New York: Columbia UP, 1978.

Smith, Adam. *An Inquiry into the Nature and Causes of the Wealth of Nations*. Vol. 1. Oxford: Liberty Classics, 1976.

Woodmansee, Martha, and Peter Jaszi, eds. *The Construction of Authorship: Textual Appropriation in Law and Literature*. Durham: Duke UP, 1994.

Wordsworth, William. *Poetical Works*. Ed. Thomas Hutchinson and Ernest de Selincourt. Oxford: Oxford UP, 1936.

Postmodernism, Romanticism, and John Clare

THERESA M. KELLEY

*M*y remarks in this essay shuttle between two recent works of fiction and the writing of John Clare to suggest how postmodernism—as theory as well as fictional practice— reiterates and thereby foregrounds the sense of extremity and strangeness that haunts Romanticism. Put more contentiously, this essay considers how postmodernism—when it is not a late-blooming species of modernism—revisits Romanticism with something like the ferocious yet dry intensity of John Clare, both sane and mad. What I mean by such claims follows from my understanding of modernism as alienated consciousness, eager to break with its antecedents in order to rid itself of the mess of history and culture.[1] If this account of modernism sounds a little like Walter Benjamin's reading of Klee's "Angel" as an apocalyptic observer who looks backward on the ruins of civilization and calls what he sees history,[2] it is because Benjamin's theory of history is the critical angel who guards and joins both isms.

As recent theorists have noted, this theory entails a view of allegory that is particularly sympathetic to postmodernism. Consider, for example, how the alienated figure of Benjamin's angel directs Fredric Jameson's analysis of allegory in the present time:

> If allegory has once again become somehow congenial for us today, as over against the massive and monumental unifications of an older modernist symbolism or even realism itself, it is because the allegorical spirit is profoundly discontinuous, a matter of breaks and heterogeneities, of the multiple polysemia of the dream rather than the homogeneous representation of the symbol. Our traditional conception of allegory—based, for instance, on stereotypes of Bunyan— is that of an elaborate set of figures and personifications to be read against some one-to-one table of equivalences: [yet] . . . such equiva-

lences are themselves in constant change and transformation at each perpetual present of the text. ("Third-World Literature" 73)

Elsewhere Jameson reads Los Angeles's Bonaventure Hotel as the monumental sign of postmodernism's devilish compact with late capitalist culture (*Postmodernism* 55–66). Here he offers allegory's "breaks and discontinuities" as evidence of something quite different and almost certainly better—the "polysemia" found in dreams and, to extend the cultural logic of this declaration, the welter of differences and voices found in postcolonial literature and criticism. This praise owes a good deal to Craig Owens's influential essay on the terrain shared by allegory and postmodernism:

> Decentred, allegorical, schizophrenic . . . —however we choose to diagnose its symptoms, post-modernism is usually treated, by its protagonists and antagonists alike, as a crisis of cultural authority, specifically of the authority vested in Western European culture and its institutions. ("Discourse of Others" 57)

These definitions of allegory under the sign of the postmodern are, however, more univocal than allegory itself, which remains quite capable of mobilizing stereotypical figures whose one-to-one equivalences we might prefer to relegate to an older, now discarded allegorical tradition. I offer two brief but instructive examples—one Romantic, the other postmodern. The eponymous protagonist of Shelley's *Mask of Anarchy* deliberately advertises the diffused presence of allegory's will-to-power across the political landscape of England in 1819. For if that power is brutally manifest in Shelley's rigidly allegorical names for government leaders such as "Murder" who has a "mask like Castlereagh," it is as much to be feared on the "liberal side of the question" in the figure of Anarchy itself (Shelley 301–10). The aging dictator in Gabriel García Márquez's *Autumn of the Patriarch* conveys a similar point, with at least as much figural irony. Even after he grows old and goes mad (or madder), his power is emblematically dispersed among his parts—an elephantine foot, a once-legendary phallic member, and so on. Belonging as it does to the body of postcolonial literature and theory to which Jameson's reading of allegory refers, *The Autumn of the Patriarch* is a cautionary tale. It shows us that even the allegorical vision of postcolonial literature can be more troublesome than salvific.

With this reservation in mind, we can better assess the explanatory and theoretical power of the allegory that Jameson and Owens admire for its eccentricities, its "breaks and discontinuities" from expectations developed by canons and critics. As I understand the instructive core of this power, it concerns the temporality and historicity of figures made in time and narrative and, as such, subject to the vicissitudes of their making.[3]

In the theory of modern allegory Benjamin introduces and Paul de Man extends, decay and ruin are the controlling figures of those vicissitudes.[4] I argue here that what makes the intersection between history or historicity and allegory compelling has more to do with the eccentric and difficult positions allegorical figures take up.

So construed, allegory's modern career is well marked in Romanticism but especially visible and admonitory in Clare's writing, where his stubborn sense of being at the edge of the culture puts the alien, fractured sensibility of allegory into high relief. Precisely because Clare was always marginal and oppositional, his writing and life (that old Romantic song and slippery divide) offer an instructive point of entry into the larger domain of allegory's survival into modernity and postmodernity, where allegory is similarly thrown into relief by its difference from mimetic or realist norms.

Working within and against this realist, experiential disposition, allegory spectacularly performs the enabling paradox of figuration in general. As Gary Stonum puts that paradox, "Even the most valiant attempt at lively figuration, one that might dazzle the rhetorically untutored, can thus be expected to reveal the deathly cogs of a tropological automaton" ("Surviving Figures" 207). For the rhetorically tutored as well, allegory's modern career toward and away from automation warrants notice. Precisely because it acts as a foil to its other self—the cultural authority of figures that move in lockstep to perform fixed meanings—allegory is a capable figure in and for Romanticism and postmodernism.

My analysis begins with two recent novels—David Malouf's *Remembering Babylon* (1993) and Russell Hoban's *Riddley Walker* (1980)—in which Clare is a ghostly textual figure, at once marked and tacitly assumed, who hovers like a proleptic and hobbled Romantic angel of the future and the past. At the beginning of *Remembering Babylon*, Malouf uses verse by Clare and Blake to fix his reader's apocalyptic backward look at the story he tells of Gemmy Fairley, whose early life includes a hand-to-mouth, abused existence as a London street boy, involuntary slavery as a cabin boy on a slave ship, being tossed overboard near the coast of Australia's outback, and living with aborigines for sixteen years until he perches on a fence around a colonial settlement at the edge of the wilderness. To the astonished children of Scottish settlers, he announces with a stutter, "I am a British object."

The epigraph Malouf selects from Clare's poetry imagines a time when "strange shapes and void afflict the soul," when "the moon shall be as blood the sun . . . the stars shall turn to blue and dun," and "heaven and earth shall pass away." At that time, Clare's speaker asks, "wilt thou / Remember me." In Malouf's novel the question belongs to Gemmy, though he never has the words to ask it. After he is beaten by a member of the colony that has sheltered him for over a year and is placed with an eccen-

tric beekeeping lady who can ensure his safety, he eventually takes some exercises written in a school notebook because he believes them to be the written story of his life, then disappears back into the wilderness. One of them and not one of them, Gemmy is a deep source of trouble because he brings the colonists sharply up against their own isolation at the bare scraped edge of a terrifying unknown world peopled by aborigines.

Clare's presence in Hoban's novel is less overtly marked but in the end more pervasive. *Riddley Walker* is a postnuclear fiction set in southeast England on a ring of terrain whose eccentric hub is, or was, Canterbury. The characters speak a language of their own that looks something like a phonetic transcription of a lower-class south London dialect in which compressed, altered forms of late-twentieth-century English barely survive.[5] In this fractured, mysterious speech environment, the protagonist Riddley Walker does what his name implies: he tries to riddle out the mysteries and history of the nuclear blast and the present era, and he keeps on walking around the ring of changes and episodes that is, for better or worse, energized by what's left of Canterbury, called Cambry in the novel.

The "EUSA" story Riddley and other characters tell is the story of the thermonuclear power plant that the U.S.A. created or detonated, or both, near Cambry. How to figure out what to do about the power that remains in the superstitious, burned-out, and, again, aboriginal civilization that the novel presents is the problem before all the characters. Riddley confronts it in the last pages of the novel by "roadying" on, with others now following him, having learned what he could from a strange dog and even stranger human characters like his "Ardship." What Riddley Walker does as he walks is try to map a terrain, its inhabitants, and events as though all were or might be signifiers of a coherent system or world that he knows in the sense of inhabiting it, but can't quite grasp.

The postmodern dilemmas these novels imagine for the past and for the future usefully foreground several Romantic features of John Clare's writing. The first is rhetorical pathos. In 1841, after nearly six years of incarceration in an asylum at High Beach in Epping Forest, Clare managed to escape. In a brief manuscript now called *Journey out of Essex,* Clare described his eighty-mile walk from Epping Forest back to Northborough. Although he had initially worked out an escape plan that would have involved hiding in a Gypsy camp where he was well known and would have been safe among companions, the Gypsies left before he could get to them. When he makes his break on his own, he jauntily provides himself with an allegorical companion. "Having only honest courage and myself in my army," he writes, "I led the way and my troops soon followed" (Clare, *Autobiographical Writings* 153).

This pilgrim's progress, like that of many a Romantic traveler, requires

losing his way until he meets an acquaintance coming out of The Labour in vain Public house. From him, Clare finds "the way." Supplemented by the names of other inns along the way, including "The Ram" and "The Plough," Clare's allegorical touch is light and slyly ironic about his own laboring past (154, 156–57). Nonetheless, this is no easy journey without food or money except what little he can beg. At one moment he rests on a flint heap, at another a Gypsy woman warns him to stay off the main road or he will be "noticed" (158). Clare nonetheless keeps to the main road, because, sensibly enough, he fears losing his way again, which he later does. He continues, hoping to find, as he puts it, his "two" wives, Mary Joyce and Patty Turner, unwilling to believe that Mary Joyce had died almost six years earlier. The journal closes with a letter to this Mary, written from Northborough. There, he says, he is "homeless at home" with Patty. He closes, "My dearest Mary, Your affectionate Husband, John Clare" (160–61). It is not accidental that critics of Clare so frequently quote his haunting phrase for how he feels when he finally gets home—"homeless at home."

Riddley Walker is the repeated verbal figure of the pathos that hovers everywhere in the record of Clare's life and writing, but especially in the 1841 *Journey*. From the moment early in the novel when his father is crushed to death, Riddley is on his "oansome," befriended from time to time by characters who seem prophetic or admonitory but never stay long. A "connexion" man like his father, he is invited to offer his own "tells"— half-inscrutable, allegorical interpretations of events and old stories. Like Riddley Walker, Clare manages to keep going against all odds, nearly always semidetached from the subcultures in which he moves. His *Journey* is an extended figure for his life as a writer who keeps going, whether sane and poor or delusory and incarcerated, in a voice and diction that are local, phonetically spelled, barely punctuated, down-to-earth (as they say), even coarse—like Riddley Walker's.

From Helpston, from Northborough, and from the two asylums where he spent the rest of his span of life, Clare asks "wilt thou Remember me" in ways that bind memory and history to those local details that are the fraught, inadequate particularity of Romanticism. As Malouf's double epigraph helps us recognize, Clare is Romanticism's Gemmy, a figure and speaker so outside and so marginal that he is in, and one whose career was, mostly for the worse, the objective correlative of the English Romantic marketing strategy (and publishing house), which gave posterity the mature work of the cockney John Keats and the early poetry of the "peasant poet" John Clare. Clare might well have growled "I'm a British object" after his publishers rewrote, repackaged his writing so that it would conform to their understanding of what it ought to be.[6]

A second, implicit resemblance between Clare and the fictional worlds

of Hoban and Malouf concerns their figural management of the material world. Whether that world is presented as geography, landscape, or particular things, it is persistently emblematic. Malouf trenchantly suggests the strong Romantic pathos that colors this assumption in *Remembering Babylon*, where Gemmy's capacity to recognize the secrets of the natural world reminds the white settlers of their lack of connection to the world they now inhabit:

> When Mr. Frazer and Gemmy go out botanizing, Gemmy deliberately illuminates some parts of that landscape and out of a kind of religious sense of what is proper keeps other parts of it dark. When Gemmy moves through the landscape, something happens; Mr. Frazer moves through it and nothing happens. . . . This book is not about a purely Australian experience. It is about an experience of landscape or a relationship to the world that is cleared in a place like Australia, or in these people's situations, because all the other kinds of explanations and comforts are taken away from them. This absence makes them ask the question: what is man's place in the world. (Papastergiadis 87).

Malouf goes on to argue that back in a small village in Scotland or England where someone like Frazer was born, he would have been and remained completely at home, sure of his place and its significance.

Clare's botanical knowledge of local names and ecological systems makes him a prescient Romantic forecast of principles now identified with deep ecology—the organicist and philosophical counter-argument to postmodern fragmentation (McKusick, "'A language . . . ever green'"). But because of who he was and when he lived, he learned, then had to forgo the rooted sense of place Malouf imagines for men like Clare who did not emigrate. His predicament as a laborer who knew his locality intimately, even as it became an alien place, specifies the tragic but enabling sense of alienation and other speech that complicates his Romantic sense of place. Even here Clare's situation is not as exceptional as we might imagine. Consider, for example, Wordsworth's "Lines composed a few miles above Tintern Abbey," where the poetic syntax hovers between a forged link between landscape, recollection, and mind and repeated doubts about being able to sustain such links (*Poetical Works* 2).

Clare, in his plangent efforts to identify what a piece of common land like Helpstone green meant before it was "inclosed," insists on the cultural need for such places, even as he acknowledges just how absolutely that need cannot be satisfied. Clare, who frequently used the spelling "inclosure," thereby marks etymologically the literal outcome of British parliamentary acts of enclosure (McKusick, "John Clare and the Tyranny of Grammar" 261). For "inclosure" was, as Clare was no doubt aware, the

legal and statutory form throughout this period of English history (*OED*). This preference for the Anglo-Saxon "in-" over the "en-" form derived from Norman French also makes the linguistic return to ancient English custom and law that Clare cannot make for the land.[7] When Clare speaks as "Swordy Well," a natural wetland whose botanic variety he prized before it was made a sand and gravel quarry, the lamination of speech and loss is more openly rhetorical. Speaking for what no longer exists, "Swordy Well" insists on its cultural and ethical value:

> The gipseys camp was not affraid
> I made his dwelling free
> Till vile enclosure came and made
> A parish slave of me . . .
> Of all the fields I am the last
> That my own face can tell
> Yet what with stone pits delving holes
> And strife to buy and sell
> My name will quickly be the whole
> Thats left of swordy well
> (*John Clare* 152)

Like Clare's other jeremiads against enclosure and the landed aristocracy, this one bitterly recognizes the irony of speechifying loss. Names without places and faces will not suffice.

When Hoban uses place names that echo Clare's 1841 *Journey* and other autobiographical writings, he punningly redistributes the Romantic value of naming places such that their emblematic function becomes more overt. Echoing Clare's remark about an inn named The Ram, Hoban reassigns the name to an island separated from the mainland by a bay named Ram Gut (Ramsgate). The demotic language he invents to specify the geography of southeast England is a wildly allegorical elaboration of Clare's coarse dialect speech: "Do It Over" (for Dover), "Sel Out," "Moal Arse," the island "Dunk Your Arse," and "Bernt Arse." This trio of place names, particularly the last, echoes one of several local names Clare records for a will-o'-the-wisp, "Jenny Burnt Arse" (Clare, *Autobiographical Writings* 8). "Pooties," Clare's name for snail shells, reappears in Hoban's novel as the female puppet figure Pooty (Judy), whose staged altercations with Punch get more violent and more evidently allegorical as the novel proceeds (*John Clare* 477–79; *Riddley* 205). Hoban's novel transforms the flint heap that Clare rests on one night into multiple postnuclear, iron-age work sites, a bitterly ironic rendition of Romanticism's desire to go back to the future.

Hoban's Riddley Walker is a larger-than-life version of Clare himself, the inveterate walker who is by his own account fascinated with riddles and

riddling. On one occasion Clare comments that he "never unriddeld the mystery" of old superstitions about an ivied tree that was eventually cut down; on another he recalls a farmer who liked to "unriddle the puzzles for prizes" or "rhyme new charad[e]s reddle rebuses on a slate"—like the poet Clare (*Autobiographical Writings* 35, 40).

The equally strange dialect speech of *Riddley Walker* dramatizes the demotic, excessive, figural, and, in a word, allegorical tendencies of Clare's writing. Whether in or out of asylums, he kept writing and railing in poems that are, as Riddley would call them, "tells"—tales that carry his history and that of his terrain forward as if to admonish us from another world. For Clare, the gradual disappearance of that world demands not the backward glance of a fleeing Benjaminian angel but an intensive rearguard campaign that takes the form of a verbal history whose local or idiosyncratic grammar, diction, spelling, and punctuation matter as much as the stories they tell.[8]

What these postmodern fictions and we learn from Romanticism is the power and estrangement of foreign or dialect speech. In Malouf's *Remembering Babylon*, Gemmy can barely recall a few words of his native English after years of living with Australian aborigines. When he steps into the Scottish colonist settlement and stutters, "I am a British object," he gets a word wrong but tells the truth about the colonists (whose rough Scottish dialect Malouf also reproduces) and himself. Earlier in England and now among colonial settlers, he is at once alien and uncannily familiar. On both grounds, he must be abjected as the unwanted mirror image of who and where they are. Although he speaks several aboriginal dialects, he is virtually inarticulate in English, the language others use to describe him to still others. Gemmy's identity is the linguistic property of others, even sympathetic others, because they construct his identity as they speak for as well as against him. The narrative reversal at the crux of this novel—the moment when several aborigines meet Gemmy on the edge of the English settlement to warn him about the barbarity of the whites (118)—echoes Clare's pervasive sense that he is the "odd man out" whether sane or not: "homeless at home" and homeless among the English poets.

Throwing his voice into Crabbe, Byron, and abandoned wetlands, then taking up points of view more sympathetic to hunted animals than their human hunters, Clare is a more self-consciously ironic ventriloquist than Edward Bostetter's analysis of this Romantic activity would suggest.[9] Taking up where Clare left off, Riddley becomes one of the puppeteer voices in Goodparley's traveling minstrel show. Riddley Walker's reiterated uncertainty about whether he plays Punch, or Punch or someone else "plays" him, gives way in Malouf's novel to the haunting figure of Gemmy. Puppet or ventriloquist, Clare points up the weird mix of automatism and

pathos in that figure, whether we find it in Kleist's *Puppentheater* or in Benjamin's use of the figure of a chess-playing automaton to explain his theory of history.

Insofar as it is a delusory narrative written by someone who is no longer sane, Clare's 1841 *Journey* registers a Romantic consciousness not unlike the disjointed worlds and narrative frames of postmodern fiction. From this perspective, the figure of John Clare gone mad might seem little more than a fractured representation of Romanticism—a mirror whose distortions suggest a postmodernist vision otherwise alien in spirit and method to Romantic writing. Or, we might argue, Hoban and Malouf's novels project a refracted image of Clare's madness by turning it inside out. In the charred, survivalist world of postnuclear "civilization," characters will and do kill to find out the secrets of atomic energy, apparently willing and eager to "do it over." On the edge of the Australian outback, Scottish colonists imagine Gemmy as a demonic, violent alien, even as his aboriginal companions hover in a clearing at the edge of the wilderness to console and protect him from the strange, spiritless company he must now keep.

The local details of Clare's poetic choices persistently call readers back to linguistic difficulties and resources I take to be fundamental to Romanticism. Consider, for example, his objection to the Linnaean system for generating names for birds and plants, compared with the local names he preserves by recording them in a "natural history" that he began after reading Gilbert White's 1789 *Natural History of Selborne*. The faults Clare and other early-nineteenth-century critics found with Linnaean classification were its narrow basis (only the reproductive features of plants were discussed) and limited usefulness, since plants with similar reproductive features might have nothing else in common. Clare's natural history was never completed or published, in part because his publishers were eager to maintain his public persona as an uneducated peasant poet, but also because he resisted their efforts to substitute Latin classificatory distinctions for local names.[10]

On occasion Clare's botanical ideology looks more playful, more radically figural, than programmatic. In the late sonnet "The Maple Tree," for example, he uses the hemlock's Latin identification as a member of the family Umbrelliferae to describe how the hemlock's "white umbel flowers" look against the higher branches of the maple.[11] This reversion to Linnaean terminology would be hard to miss in a poem that otherwise favors local diction. The opening five lines read:

> The Maple with its tassel flowers of green
> That turn to red a stag horn shaped seed
> Just spreading out its scalloped leaves is seen

Of yellowish hue yet beautifully green
Bark ribb'd like corderoy in seamy screed.
(*Later Poems* 2:1025)

In Clare's time and place "screed" could refer to a strip of rough material like corduroy, a strip of land, or even a lengthy piece of writing (Chambers 253). Used in the nineteenth century to make clothes for laborers, "screed" insures a local economy of sympathies between laborers and the laboring poet who hasn't got a strip of land or a lengthy piece of writing—just a sonnet whose figure of "bark ribbed like corderoy" stands up and stands for this poet and this place. So do those "umbel" flowers. Not humble at all, they show how Linnaean terms can be put to descriptive and local English use.

Clare's diction, like his grammar, phonetic spelling, and punctuation, polemicizes the Romantic poetic sensibility that intends to trespass on conventional forms and language.[12] Like the Gypsies he visited often and wrote about, Clare poaches on the linguistic property of others in ways that figure anew Romanticism's borders not as term limits but as the places where raids occur, where excess yields its double effect of transgression and demotic vitality, an instructive because exaggerated version of Shelley's argument in the *Defense of Poetry* that only vitally metaphorical language can be creative.

As refigured by Malouf's Gemmy and Hoban's Riddley Walker, Clare's writing witnesses elements of postmodernism that have attracted little notice in postmodern theory. Against the claim that postmodernism is an anti-aesthetic whose fragmented and de-centered sensibility is unanswerable to history, let alone critique,[13] Clare, Riddley Walker, and Gemmy understand surmise and construal as the work at hand. Despite the difficulty and inscrutability of the worlds each inhabits, all persist against well-defined odds in their efforts to piece or hold together the meaning of those worlds, attentive to particulars as though they were emblematic details within an allegorical image or narrative frame. In an irony that is fully sanctioned by the nature of allegory, what keeps this enterprise from being symbolic even in the case of Clare, whose ecological organicism would seem to favor the Romantic symbol, is the problematic nature of the task as well as the materials at hand. It just isn't possible to sustain or even arrive at the sense or conviction of the whole that Coleridge assigns to the symbol.

If this is allegory by default, it is so because the world is difficult to piece together, conflicted and conflictual by turn, and because human observers are just that—sublunary, eccentric, and limited. They riddle on and muddle through, keeping as much of the spirit and matter of what they learn as they can. The figure whose history and place in history darkens this

view is Malouf's Gemmy, not because he has no interest in botanical and lexical bits of a larger system—since he is patently interested in just these things—but because his story and his place in history argue so ferociously against the survival of all this evidence and, above all, Gemmy himself.

By reading Clare in and through the postmodern worlds of Hoban and Malouf, we learn that Romanticism at its extremities is the heart of the matter. More precisely put, we learn that as a poet and writer on natural history Clare figures Romantic excess—the radical, loosened speech at once engaged and put off in Wordsworth's Preface to the *Lyrical Ballads*. For what we discover in Clare's natural history writing against the Linnaean taxonomy but in favor of local names; his stubborn and frustrated campaign against conventional grammar, spelling, and idiom; and his class-driven and class-scarred railing against those socially and economically "above" or "beside" his own class and station (such as it was or could be)—is someone who had to speak in opposition, at extremities, to speak as and for common land and animals, for whom no one else speaks.

Postmodern fiction conveys much in a little of Romanticism's prospective education of a postmodern sensibility that has too frequently been called anti-Romantic. Alan Liu has identified one way to calculate such contacts: Romantic localism, detailism, and particularity[14]—terms as descriptive of Clare's aesthetics as they are new historicist and postmodernist watchwords. One apparent sign of this impulse within Romanticism is its claim to use the language, as Wordsworth puts it, "of men speaking to men."[15] Clare evidently takes this linguistic principle to an extreme that Wordsworth's strictures about adopting a "selection" of ordinary speech try to foreclose. The trajectory that takes us from Clare's radical particularity to a postmodern random array of individual subjectivities and objects is not hard to follow.

Yet because the figures used to map it appeal to the impersonal screen of cyberspace, with webs, links, internet sites, and interfaces, this postmodern vision of Romanticism tends to efface pathos. I grant the informality and friendliness that this format may sponsor. My point is instead that its brilliant intricacy of electronic pathways and nodes prompts a figural and theoretical discourse that is often seduced by cognitive systems that can be mapped, diagrammed, and thereby made into thin if dense lines— not faces.[16]

Against this reading of Romantic and post-Romantic culture, we can array John Clare. For his position at the extremity of Romantic speech and figure suggests how pathos, the extremity of feeling that legitimates strong, even exaggerated and excessive figures, invests Romantic speech and Romantic faces with a surprising resilience—not unlike his ability to keep going for eighty miles from Epping Forest to Northborough, without

some of his wits and without food. The pathos of the postmodern worlds and journeys of Malouf's Gemmy and Hoban's Riddley Walker is close kin to the highly rhetorical, highly speechified pathos of Romantic figures, including the figure of Clare "roadying on." Because pathos marks the extremities of figures and narratives invented in its wake, it is crucial to the signifying practices of Romantic and postmodern writing. Without it, both are at their extremities, awash in disoriented, isolated particularity. With it, both are plangent evidence of the desire to figure and refigure those extremities in order to think about where, how, and whether individual subjects figure in their worlds.

Educated by the version of Romanticism Clare's writing objectifies, novelists like Hoban and Malouf give that education back to us as we look through their postmodern subjectivities to Clare and then through his late, alienated Romantic subjectivity to its radical poetic project. If this looking within and through different historical lenses is in one sense to submit to massive distortions as one or several subjectivities bend around and back to meet as tangents on their own extremities, this refraction is also the signifying mark of literary history as stories made by bending matter and figure toward different trajectories.

Notes

1 The term "modernism" here refers to twentieth-century literature and culture up to about 1960. Whether or not the era thereafter is most usefully called contemporary or postmodern is one prong of my argument. By contrast, "modernity" refers to the long arc of Western culture that begins in the seventeenth century and continues into the present. See Habermas, *Philosophical Discourse of Modernity* 1–22; Johnson, *Birth of the Modern;* and Reiss, *Discourse of Modernism.*

2 Benjamin, "Theses on the Philosophy of History" 257–58.

3 For a Derridean analysis of how figural traces inflect the sense of history available to culture, see Marian Hobson's "History Traces."

4 See de Man, "Rhetoric of Temporality," in *Blindness and Insight* 187–228; "Autobiography as De-facement" and "Shelley Disfigured" in *Rhetoric of Romanticism* 67–82 and 93–124. The view of temporality de Man develops in these and other essays is the basis for the relation I offer between a sense of history that is deeply opposed to the global assurance of Romantic historiography and allegory. My differences with de Man's theory of allegory concern his, and Benjamin's, elevation of disfiguration and decay. I contend that these are neo-Hegelian symptoms, not the instructive core of allegory's survival in modernity.

5 Porter reads the language of Hoban's novel as a deconstructive universe in which puns register the decaying shelf life of language and postnuclear culture.

6 For a summary of Clare's disagreements with his publishers, see Lucas, *John Clare* 12–24.

7 McKusick argues further ("Grammar" 268–70) that Clare's polemical view of grammar and spelling made him sympathetic to the kind of lexical choices Nathaniel Bailey

makes and discusses in his *English Dialect Words of the Eighteenth Century* as shown in the *Universal Etymological Dictionary of Nathaniel Bailey*, edited by William E. A. Axon.

8 Clare's views on this point are well known. See *John Clare*, editors' introduction xix–xxi.

9 See, for example, Clare's parody of Crabbe's "My Mary" (*John Clare* 59–62), his long asylum poem *Child Harold* in *Later Poems*, and *Swordy Well* (*John Clare* 147–52). McKusick discusses Clare's poetic defense of hunted animals ("'Language . . . ever green'" 238–39).

10 White, *The Natural History and Antiquities of Selborne*. Grainger discusses Clare's reading of Gilbert White in her introduction to *The Natural History Prose Writings of John Clare* xli–l.

11 Chambers notes this Latinate designation (253).

12 See Heaney, "John Clare," and Lucas, "Clare's Politics."

13 See, for example, essays in Foster, *Anti-Aesthetic*; Owens, "Allegorical Impulse"; and Jameson, "Third-World Literature" and *Postmodernism* 55–66.

14 Liu, "Local Transcendence."

15 Wordsworth added the term "selection" to the Preface after 1800 (Preface to *Lyrical Ballads, Prose Works* 1:123).

16 The current project supervised by Robert Essick, Morris Eaves, and Joseph Viscomi to put all of Blake's graphic images on the Internet will bring some Romantic faces to the computer screen. My point, though, concerns the way the discourse of cyberspace may elide pathos.

Works Cited

Bailey, Nathaniel. "English Dialect Words of the Eighteenth Century." *Universal Etymological Dictionary of Nathaniel Bailey*. Ed. William E. A. Axon. London: English Dialect Society, 1883.

Benjamin, Walter. "Theses on the Philosophy of History." *Illuminations*. Ed. Hannah Arendt. Trans. Harry Zohn. New York: Schocken Books, 1978. 253–64.

Bostetter, Edward. *The Romantic Ventriloquists*. Seattle: U of Washington P, 1963.

Chambers, Douglas. "'A love for every simple weed.'" Haughton, Phillips, and Summerfield 238–58.

Clare, John. *Autobiographical Writings*. Ed. Eric Robinson. New York: Oxford UP, 1983.

———. *The Natural History Prose Writings of John Clare*. Ed. Margaret Grainger. Oxford: Clarendon, 1983.

———. *John Clare*. Ed. Eric Robinson and David Powell. New York: Oxford UP, 1984.

———. *The Later Poems of John Clare*. Ed. Eric Robinson and David Powell. 2 vols. Oxford: Clarendon, 1984.

de Man, Paul. "The Rhetoric of Temporality." *Blindness and Insight*. 2nd, rev. ed. Minneapolis: U of Minnesota P, 1983. 187–228.

———. "Autobiography as De-facement." *The Rhetoric of Romanticism*. New York: Columbia UP, 1984. 67–82.

———. "Shelley Disfigured." *Rhetoric of Romanticism*. 93–124.

Foster, Hal, ed. *The Anti-Aesthetic: Essays on Postmodern Culture*. Port Townsend: Bay Press, 1983.

García Márquez, Gabriel. *The Autumn of the Patriarch*. Trans. Gregory Rabassa. New York: Harper, 1976.

Habermas, Jürgen. *The Philosophical Discourse of Modernity*. Trans. Frederick Lawrence. Cambridge: MIT P, 1987.

Haughton, Hugh, Adam Phillips, and Geoffrey Summerfield, eds. *Clare in Context.* Cambridge: Cambridge UP, 1994.

Heaney, Seamus. "John Clare: A Bicentenary Lecture." Haughton, Phillips, and Summerfield 130–47.

Hoban, Russell. *Riddley Walker.* New York: Simon, 1980.

Hobson, Marian. "History Traces." *Post-Structuralism and the Question of History.* Ed. Derek Attridge, Geoff Bennington, and Robert Young. Cambridge: Cambridge UP, 1987. 101–16.

Jameson, Fredric. "Third-World Literature in the Era of Multinational Capitalism." *Text* 15 (1986): 65–88.

———. *Postmodernism, or, the Cultural Logic of Late Capitalism.* Durham: Duke UP, 1991.

Johnson, Paul. *The Birth of the Modern.* New York: Harper, 1991.

Liu, Alan. "Local Transcendence: Cultural Criticism, Postmodernism, and the Romanticism of Detail." *Representations* 32 (fall 1990): 75–113.

Lucas, John. "Clare's Politics." Haughton, Phillips, and Summerfield 148–77.

———. *John Clare.* Plymouth, UK: Northcote, 1994.

Malouf, David. *Remembering Babylon.* New York: Pantheon, 1993.

McKusick, James. "'A language that is ever green': The Ecological Vision of John Clare." *University of Toronto Quarterly* 61 (winter 1991/2): 226–49.

———. "John Clare and the Tyranny of Grammar." *Studies in Romanticism* 33 (summer 1994): 255–77.

Owens, Craig. "The Allegorical Impulse: Toward a Theory of Postmodernism, pt. 2." *October* 13 (summer 1980): 59–80.

———. "The Discourse of Others: Feminists and Postmodernism." *The Anti-Aesthetic: Essays on Postmodern Culture.* Ed. Hal Foster. Port Townsend: Bay Press, 1983. 57–82.

Papastergiadis, Nikos. "David Malouf and Languages for Landscape: An Interview." *Ariel* 25 (July 1994): 83–94.

Porter, Jeffrey. "'Three Quarks for Mister Mark': Quantum Wordplay and Nuclear Discourse in Russell Hoban's *Riddley Walker.*" *Contemporary Literature* 31 (1990): 448–69.

Reiss, Timothy J. *Discourse of Modernism.* Ithaca: Cornell UP, 1982.

Shelley, Percy Bysshe. *Shelley's Poetry and Prose.* Ed. Donald H. Reiman and Sharon B. Powers. New York: Norton, 1977.

Stonum, Gary. "Surviving Figures." *Hermeneutics: Questions and Prospects.* Ed. Gary Shapiro and Alan Sica. Amherst: U of Massachusetts P, 1984. 199–211.

White, Gilbert. *The Natural History and Antiquities of Selborne.* Ed. Paul Foster. New York: Oxford UP, 1993.

Wordsworth, William. *Poetical Works.* Ed. Ernest de Selincourt and Helen Darbishire. Vol. 2. Oxford: Clarendon, 1949.

———. *Prose Works.* Ed. W. J. B. Owen and Jane W. Smyser. Vol. 1. Oxford: Clarendon, 1974.

IMAGES AND INSTITUTIONS

OF CULTURAL LITERACY IN

ROMANTICISM

The Lessons of Swedenborg; or, The Origin of

William Blake's *The Marriage of Heaven and Hell*

JOSEPH VISCOMI

On the 27th of January last [1788] a chapel, called the New Jerusalem Church, was opened in Great Eastcheap, London, by a sect of mystics, who consider Swedenborg as a prophet sent from God to establish the true doctrines of Christianity. They have a set form of prayer, on the model of that of the established church, and read chapters taken from the writings of Swedenborg as lessons. — *Analytical Review* 2 (1788): 98

[Blake] . . . would allow of no other education than what lies in the cultivation of the fine arts & the imagination — H. C. Robinson (Bentley, *Blake Records* 543)

*T*his is the second of three essays on the evolution of William Blake's *The Marriage of Heaven and Hell*.[1] The first argues that Blake began *Marriage* with plates 21 through 24, began executing the work without a completed manuscript, and that *Marriage*'s disjointed structure is partly the result of its production history. It reveals that *Marriage* evolved through four to six distinct printmaking sessions in the following order: 21–24; 12–13; 1–3, 5–6, 11, 6–10; 14–15, 4; 16–20; and 25–27.[2] *Marriage*'s structure may also have been partly influenced by literary models, such as Menippean satire, or by the Higher Criticism's theory "that the Old Testament was a gathering of redacted fragments" (Essick, "Representation"). These models, though, if present, appear to have come into play only after Blake wrote and etched plates 21–24, which constitute a sustained attack on the Swedish mystic Emanuel Swedenborg (1688–1772).[3] Because the four plates form an autonomous text and are quarters cut from the same sheet of copper, and because that sheet was the first of seven cut, the text appears to have been conceived as an independent, anti-Swedenborgian pamphlet. It became instead the intellectual core of what became the *Marriage*, helping to generate twenty of its subsequent twenty-three plates. The only extant printing of plates 21–24 supports the pamphlet hypothesis.[4]

The present essay, which extends the first, argues that plates 21–24 do, indeed, form an autonomous text; that they are, unlike the other textual units, thematically, aesthetically, and rhetorically coherent; and that their textual and visual coherence supports the hypothesis that they were initially conceived as an independent pamphlet. Throughout its examination of plates 21–24, it identifies the primary Swedenborgian texts and themes that Blake refers to and/or satirizes. The third essay, by tracing many of these themes and texts through the remaining textual units in the order in which the units were produced, reveals how *Marriage* evolved through its production. By examining visual and verbal connections heretofore obscured, particularly those between printmaking and Swedenborg, it helps to reveal Blake's mind at work, locate where in practice execution and invention appear to intersect, and distinguish Blake's original from final intentions. The last essay reveals that *Marriage,* in effect, is a series of variations on themes raised on plates 21–24 instead of on plate 3, as is commonly thought (e.g., Bloom, *Introduction;* Miller; Nurmi; Punter), that Swedenborg, though mentioned only on plates 3, 19, 21, and 22, figures pervasively throughout *Marriage,* and that graphic allusions, which usually set into play the reflexivity associated with formalism, serve to evoke or communicate the unrepresentable—the spirit incarnate in a creative work of art.

The present essay, then, necessarily refers backward and forward, supporting theories already presented while also providing the textual and thematic grounds for a new reading of *Marriage.* But it stands firmly on its own as well, for it provides the first reading of plates 21–24 as they appear to have been initially written, that is, as an autonomous text preceding the composition of—and without the visual and verbal referents provided by—the *Marriage.* Read closely in this light, the aesthetic issues underlying Blake's theological critique of Swedenborg, as well as Blake's idea of himself as visionary artist and the relation between original artistic creation and prophecy, come into sharp focus.

"Swedenborg is the Angel sitting at the tomb" (Marriage, plate 3)

The Swedenborgian New Jerusalem Church emerged in 1788 from a separatist group of the Theosophical Society. The society was founded in London in 1783 by Robert Hindmarsh and other Swedenborgians to promote "the Heavenly Doctrines of the New Jerusalem, by translating, printing, and publishing the Theological Writings of the Honourable Emanuel Swedenborg" (Hindmarsh 23). It had evolved from a group of Swedenborgians meeting in the early 1780s at the house of the Rev. Jacob Duche in Lambeth (Paley 16), and it was modeled after the Manchester Printing

Society, which began in 1782 to print and publish Swedenborg's works in English (Hindmarsh 7). Blake may have attended one of the society's weekly Thursday night meetings, for he refers to "the society" in his annotations to paragraph 414 of his copy of Swedenborg's *Wisdom of Angels Concerning Divine Love and Divine Wisdom* (1788) (Erdman, *Complete Poetry and Prose of William Blake* 608, hereafter cited as E). It is not clear, however, if Blake is talking about the Theosophical Society as originally constituted or the separatist group, that "part of the general body" led by Hindmarsh and others that had by April 1787 resolved itself "into a new Society for promoting the establishment of an External Church." The proposal to establish a sectarian religion of Swedenborgianism was, of course, a matter of debate (Hindmarsh 55 passim; Schuchard 44–46; Thompson 129 passim). The proposal, presented 17 April 1787, was "negatived by a small majority, on the grounds that the proper time for separating from the Old Establishment was not yet arrived. A few individuals of the Society, however, thought otherwise." The first regular meeting of this "new Society," which called itself "The Society for Promoting the Heavenly Doctrines of the New Jerusalem Church," was held on 7 May 1787, when it resolved unanimously to find a place of worship. They continued to meet with the larger group until 5 November 1787 and opened their rented Eastcheap chapel as the New Jerusalem Church on 27 January 1788 (Hindmarsh 54–55, 59n).[5]

As a reader of Swedenborg, Blake almost certainly received the *Circular Letter* sent by the separatist group on 7 December 1788 to "all the readers of the Theological Writings of the Hon. Emanuel Swedenborg, who are desirous of rejecting, and separating themselves from the Old Church . . . and of fully embracing the Heavenly Doctrines of the New Jerusalem" (122). The *Letter* called for the General Conference that Blake and Catherine Blake attended during Easter Week (13–17 April) of 1789. The *Letter*'s 42 "propositions" were resolved unanimously at the conference, and these 32 "resolutions," along with prefatory and concluding remarks, were published as the conference's *Minutes* by Hindmarsh in 1789 (see n32).[6]

Because Swedenborg's writings were discussed at Swedenborgian meetings and at the five-day conference, Blake's familiarity with Swedenborgianism was, no doubt, more extensive than the three books that he is known to have read and annotated (*A Treatise Concerning Heaven and Hell, Wisdom of Angels Concerning Divine Love and Wisdom*, and *Wisdom of Angels Concerning Divine Providence*). Books read at the Theosophical Society's weekly meetings included "the untranslated writings of Swedenborg . . . particularly . . . the *Apocalypsis Revelata*, which treats so copiously of the consummation or end of the Christian Church, the Last Judgment, the Second Coming of the Lord, and the Descent of the New Jerusalem, or the establishment of the New Church upon earth." Works read in transla-

tion included the *Treatise on Influx, or the Intercourse between the Soul and Body*, the *Treatise Concerning Heaven and Hell*, and *True Christian Religion, Containing the Universal Theology of the New Church* (Hindmarsh 25). Hindmarsh's splinter group no doubt kept up the practice of forming study groups throughout 1788. Indeed, it was encouraged in resolution 30 of the 1789 General Conference, which recommended that "all the readers and lovers of the Theological Works of Emanuel Swedenborg . . . form themselves into societies distinct from the Old Church, and to meet together as often as convenient, to read and converse on the said Writings, and to open a general correspondence for the mutual assistance of each other" (*Minutes* 129).[7]

John Flaxman, the sculptor and Blake's close friend since the early 1780s, was an ardent Swedenborgian and may have been the first to introduce Blake to the mystic's theological writings. According to Erdman, "what most attracted Blake in the new psychology and the new religion" was their "positive benevolism, their invitation to mine beneath the codified meanings with which kings and priests had restrained and perverted Life, and their promise that the infinite vital power of the genius in every man could be released through Love" (*Blake* 128). According to Schuchard, Blake probably "found a congenial—even inspirational—milieu among Masonic Illumines," who she claims "were the driving force behind the Swedenborgian movement" (40). Thompson notes that Blake found confirmation for "thinking in 'correspondences' (but this, under other names, is of the very nature of poetry)," as well as encouragement to "speak of objectifying his insights as visions or as conversations with spirits" (134). And no doubt Blake found attractive Swedenborg's comments about the spirituality of sex ("conjugal Love in itself is spiritual" and "is only from the Lord," *True Christian Religion* n. 847). Nevertheless, whatever had drawn Blake to Swedenborg had lost its appeal by the time he read *Wisdom of Angels Concerning Divine Providence* (1790). In his annotations, he accused Swedenborg of "priestcraft" and "predestination" (E 610), the latter accusation requiring Blake to "interpret . . . in a deliberately hostile sense" (Paley 21), since proposition 21 of the *Circular Letter* and nn. 479–85 of *True Christian Religion* expressed clear opposition to the concept of predestination. The accusation of priestcraft, which appears directed more at Swedenborgians than Swedenborg, is on firmer ground when used to explain, at least in part, why Blake broke with Swedenborg. Exactly when and how quickly or slowly this break occurred, however, are matters of debate.

Erdman believes that Blake changed his mind when, in *Divine Providence*, he "discovered the more conservative side of Swedenborg" (*Blake* 128). Presumably, this discovery was made the year of the book's publication, which jibes with Blake's own internal dating on plate 3 of the *Marriage* (fig. 1).[8]

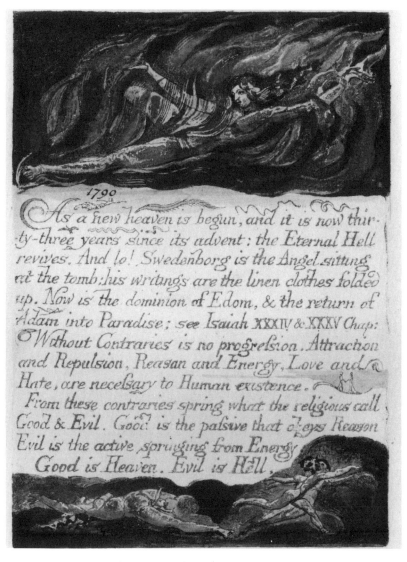

Figure 1. *The Marriage of Heaven and Hell* (Plate 3, Copy F,
Pierpont Morgan Library, New York, PML 63935).

But Erdman dates *Marriage* circa 1790–1793 (E 801), because he detects
allusions in "A Song of Liberty" to a historical event that occurred in fall
1792 and mistakenly assumed that a 1793 engraving was printed with
Marriage copy B, one of the first copies printed.[9] While Erdman recognizes
that the *Marriage* plates were executed out of order, he does not comment
on how execution reflects composition or how the plates could be recon-

structed into sheets and grouped to reveal the chronology of production. Hence his dates of composition give the impression that *Marriage* was in progress for three or more years and that Blake composed all the various units of *Marriage* before etching the plates. They give, in other words, the impression of Blake working in a conventional manner, writing and revising the manuscript over a long period, and finally etching plates, albeit out of order, from a fair copy of the completed manuscript. Even when "A Song of Liberty" is treated as a coda to the *Marriage* and the latter is dated 1790, the fact that *Marriage* was never issued without "Song" implies, at the very least, that Blake was in no hurry either to etch or issue the work. Ferber neatly expresses this sense of composition, inferring from plate 3 that Blake left "the New Church . . . [in] 1790" but "wrote and engraved" the *Marriage* "between 1790 and 1793" (91, 89). A three-year composing process suggests more than dawdling, indecisiveness, or substantial revising. It also suggests that Blake's hostile attitude toward Swedenborg evolved slowly through the composing of *Marriage,* an impression bolstered by *Marriage* as it is now read, with Swedenborg being mentioned only on plates 3 and 19, and then perfunctorily so, before the vociferous, ad hominem attack on plates 21–24. A 1790 date, however, combined with a chronology of production that places plates 21–24 as the first *Marriage* plates written and executed, means just the opposite, that *Marriage* originated in and evolved quickly from anger rather than culminating in it—and that Blake was anything but tentative about expressing his temper or criticism.

Obviously, I agree with Erdman that the *Marriage* was a work in progress (my study on its evolution demonstrates that), but I believe that it was composed and executed in sections over months, not years. In the first essay, which examines how and why plate production reflects composition, I relied on earlier arguments, mostly technical, for dating *Marriage* 1790, because my intention was to give a sense of the intensity with which Blake could work. Here, where the objective is to give a sense of his relation with Swedenborg, dating *Marriage* correctly is even more crucial. Did Blake reject Swedenborg very gradually or abruptly? Did he discover his deepest objections in writing *Marriage,* or did he voice these objections in an illuminated text that grew to include subjects more overtly political, theological, and metaphysical, subjects that Swedenborg came to represent and that he would develop in the Lambeth books? Examining the events in the New Church in 1789–91 will help answer these questions and strengthen the argument that *Marriage* was composed and executed in its entirety in 1790.

If, as Erdman believes, Blake's change of mind began with Swedenborg's *Divine Providence,* then it began nearly a year after the first General Conference and possibly not until after the second General Conference, held in April 1790. Howard agrees, suspecting that Blake was disgusted by

the "changes in the nature of the [Swedenborgian] movement" from Theo-sophical Society to Church, particularly as expressed by the second Confer-ence (23 passim). To support their claims that "Blake, always a scorner of sectaries, quite evidently did not join those ceremonially inclined who were endeavoring to establish the New Church as a sect with an ordained priest-hood" (Erdman, *Blake* 128), both scholars point to Blake's antinomian re-sponse to external worship, moral law, and clerics, and to his statement that "The Whole of the New Church is in the Active Life & not in Ceremonies at all" (E 605). Paley concurs, stating that "events within the New Jerusa-lem Church c. 1790–91 almost certainly contributed to Blake's rejection of Swedenborgianism." These events and issues included the preparation of a "catechism," the approval of "minister's garments," a "hymn book," a "form and order of worship," and the affirmation of the necessity of "living according to the Ten Commandments" (22). Yet if the break began in 1790 or later, then Blake apparently did join "those ceremonially inclined"—at least for a year or more. Or are we to assume that he was ignorant of the *Circular Letter*'s origin and intent? Did Blake not know it came from the group that had opened "a chapel, called the New Jerusalem Church" in January 1788? The seeds to all the events that Erdman, Howard, and Paley see as contributing to Blake's gradual rejection of Swedenborgianism were present in the *Circular Letter* of December 1788 and the *Minutes* of the 1789 conference. These include the catechism (resolution 10), external forms of worship (propositions 34 and 35, resolutions 22 and 23), strict adherence to the Ten Commandments (resolution 10), and Swedenborg as divinely inspired (resolution 1), all subjects criticized in *Marriage*.

Either Blake's doubts about Swedenborg set in earlier than supposed, possibly within a few months after the first General Conference (1789), or other events contributed to his change of mind—or both. A close ex-amination of Blake's annotations to *Divine Love and Divine Wisdom* (1788) reveals his earliest recorded doubts—and his willingness to suspend criti-cism (e.g., "surely this is an oversight," E 602). There is no evidence he attended the New Jerusalem Church before or after its first conference, or that he would have wanted to join a group that had "a set form of prayer, on the model of that of the established church" (*Analytical Review* 2 [1788]: 98).[10] Blake signed the Minute Book at the first session of the General Conference as a sympathizer and not as a member of the Church (pace Davies 49).[11] He signed in "as a prerequisite to attendance" (Bentley, *Blake Records* 35), which does not prove staunch support; we do not know if Blake stayed for the whole five days of the conference, or if "events at the General Conference" itself shook his faith, as Bellin and Ruhl suggest (121). We do know that there was a whole lot of shaking going on shortly after that first conference, or, as Thompson puts it: "There was a thun-

dering row and probably two or three different rows. First sex and then the French Revolution reared their ugly heads" (136). While unraveling the various disputes is difficult, since the pages from 4 May 1789 to 11 April 1790 are missing from the New Church's Minute Book, Thompson and Paley reconstruct persuasively. In particular, the latter, notwithstanding his belief that Blake may have changed his mind as late as 1791, provides the evidence that strongly suggests that he did so much earlier.

The most controversial debate within the New Church in 1789 was over translating Swedenborg's *Conjugial Love* [sic], which contains passages that describe the nakedness of angels in an overtly sexual heaven, and passages permitting bachelors of the Church to take mistresses and married men with "unchristian wives" (i.e., wives who are not members of the New Church) to take concubines (Paley 22–24). The controversy led to the expulsion of Hindmarsh and five other prominent and founding members of the New Church, an act that Blake must have regarded with alarm, making him "all the more aware of the gap that separated him from the majority of English Swedenborgians" (Paley 24; see also Thompson 137).[12] Augustus Nordenskjold and Carl Bernhard Wadstrom, two of the expelled, had been planning with other abolitionists to "set up a free community of whites and blacks on the west coast of Africa" on the principles of the New Church, including those governing marriage and concubinage as they interpreted them (Paley 17). Blake was almost certainly aware of and interested in the plan. Moreover, like Blake, Nordenskjold and Wadstrom were ardent supporters of the French Revolution, the political event that the majority of Swedenborgians feared and rejected (Paley 22), placing themselves firmly (and, by 1791, publicly) on the side of the state and its established church. Blake appears to have been sympathetic to those exiled and may have read their expulsion as an omen. In this light, the word "marriage" in the title and Blake's overtly sexual imagery throughout *Marriage*—but particularly on plate 3, which alludes to the French Revolution, and on plate 21, which, as will be shown, was the first image drawn and pictures Blake in all his naked and divine humanity—reflects his sympathies as well as his criticisms of the Church's conservative positions.

Blake appears more likely to have become disillusioned with Swedenborg in 1789 than later, probably within a few months after the first General Conference, if not by the conference itself, and for ideological as well as theological reasons. Signs of that break are already present in "The Divine Image" in *Songs of Innocence* (1789).[13] The break was certainly completed by or in 1790, the publication date of *Divine Providence*, though Blake's expression of it may have been motivated by the second General Conference. An earlier rather than later date for Blake's rejection of

Swedenborgianism is consistent with the technical evidence that indicates *Marriage* was composed and executed in 1790.

Blake's criticism of Swedenborg was not without precedent—and the precedents further support the thesis that Blake's rejection of Swedenborgianism was completed by or in 1790. The *Analytical Review,* published by Joseph Johnson, Blake's friend and sometimes employer, had been criticizing Swedenborgian texts since 1788 (Mee 51n35; Howard 31). They were "unintelligible," "ingenious reveries" that should never "be treated seriously" (3 [1789]: 459).[14] Johnson's reviewers displayed the defensiveness of the attacked as well as the skepticism of the rationalist. If Swedenborg's claims were true, then they, in their faith and concept of God, were mistaken. The reviewers' feigned weariness in the face of Swedenborg's voluminous output also signified impatience with claims that the New Church and its doctrines were new. Reviewers sought to discredit such claims by citing Swedenborg's sources or accusing him of excessive repetition (5 [1789]: 64). Citing precedent was also an indirect way to undermine Swedenborg's claim to have been divinely inspired (*Minutes* [resolution 1]: 125; *True Christian Religion* n. 779). For example: "'[T]here is nothing (saith Solomon), new under the sun.' What! not Swedenborgianism?— NO. If its principles be analysed, it will be found to be nothing more than a repetition of the mystical doctrine of Plato concerning the abstract contemplation of the First Good, Intellect, and the World of Ideas, and of a whole train of ancient and modern Theosophists. . . . Why then all this boast of a new religion? and why is Emanuel Swedenborg to be followed as a second Messiah?" (8 [1790]: 332–33).[15]

Blake's critique of Swedenborg may have been partially motivated or shaped by discussions with friends in the Johnson circle, and/or by any of the critiques in the *Analytical Review.* Like Johnson's reviewers, Blake appears a little defensive. He dismisses Swedenborg—however, not because he talked to angels but because he believed them. In this, he constructs a critique far more radical than those in the *Analytical Review,* for he not only cites Swedenborg's sources to discredit Swedenborg's claim to be new, but he also discredits the sources. He attacks both new and old church, thereby setting up a conflict other than the one imagined by Swedenborgians or their critics. Blake's conflict, dramatized by angels and devils, is between Religion and Art, and the satiric inversion of the dramatis personae is in part suggested by Swedenborg himself. If he talks to angels, then Blake talks to devils. With angels and devils come the associated metaphors of place and vision, of being above the surface or below it, of seeing only the surface or appearance of things or seeing the infinite, which is hid. These metaphors provide the grounds for accusing Swedenborg of copying the

letter of the Word and not, as he claimed, its indwelling spirit. Blake's distinguishing of the true from false ironically mimics Swedenborg's mission while raising the aesthetic contraries of authentic and fake, original and imitation. Thus the issue becomes not only whether Swedenborg is new, or whether such claims constitute boasting and intellectual vacuity, but also what originality means and how it is established and recognized. Swedenborg's ultimate failure is not that his writings are old, but, as we will see, that they are not old enough, failing to originate from those sources manifest in the works of "Ancient poets" and real biblical prophets.

Blake's criticism of Swedenborg in pamphlet form may have been motivated by the *Circular Letter*, the pamphlet that invited him to the first General Conference, or by that conference's *Minutes*, which were published in 1789 as a pamphlet by Hindmarsh. Whatever its initial motivation, Blake's entering into ongoing religious, political, and aesthetic debates was characteristic, and doing so through a privately printed pamphlet would not have been unusual for him — or the period.[16]

"Uprose terrible Blake in his pride" (E 500)

The primary objectives of plates 21–24 are to undermine Swedenborg's credibility and to champion Blake as visionary artist. The former objective requires Blake to demonstrate that Swedenborg's "spiritual" or "internal sense" of scripture was not divinely inspired and that the New Church was neither "new" nor "distinct from the Old [Christian] Church" (*Minutes* [resolutions 1, 15, 21, 30, 32]: 125–27). The latter objective requires Blake to expose the spiritual meaning of imitation and to position himself as authentic visionary whose readings of the Word revealed its original poetic sense. He realizes both objectives simultaneously in the opening illustration. Our gaze is immediately transfixed by a beautiful, young naked man sitting on top of a mound with a skull under his left knee (fig. 2). Turned toward us, with legs apart and genitalia prominently displayed, he looks heavenward, in a gaze reminiscent of the piper's in *Innocence*'s frontispiece and that of the tiny figure in "The Divine Image" raised by the Lord. The gaze returns in *Marriage* with the Eagle and Leviathan, both emblems of creative energy and genius (see essay 3), and the entire figure will be used again in *America* plate 8 (1793) and *Death's Door* in *The Grave* (1808). The juxtaposition of heavenly gaze and overt sexuality startles. In *Marriage*, the figure is read as the resurrected supine body of plate 14, where it lies in flames under a hovering female. But, as argued in the first essay, plate 21 was written and executed many plates before plate 14, and hence when composed, the naked man almost certainly had no visual or textual referent other than "I," the first word of plate 21. If Blake speaks in his own voice, as

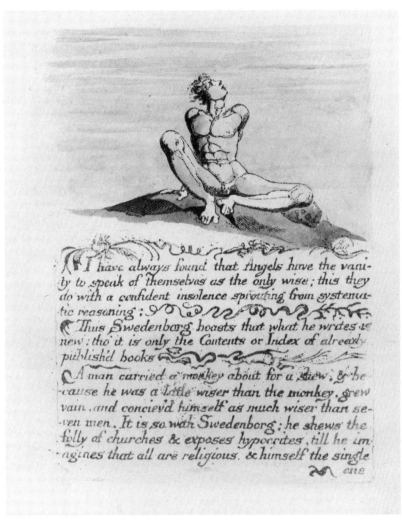

Figure 2. *The Marriage of Heaven and Hell* (Plate 21, second state,
Copy C, Pierpont Morgan Library, New York, PML 17599).

is strongly suggested by the concluding "Note" on plate 24 referring to his
forthcoming "Bible of Hell," then the figure is probably meant to represent
Blake. But what is Blake's idea of himself? Is he the New in opposition to
the Old, the Regenerated Man in opposition to the so-called New Church?

Blake pictures himself about to rise, as picking himself up, a gesture
suggesting his readiness to assert himself and announce the beginning of
the new age. In picturing himself, though, he uses traditional and Sweden-
borgian iconography. In light of the former, Blake is the rising, transfigured

Christ. The mound and skull indicating a tomb are characteristic of Golgotha, "the place of the skull," which, according to medieval legend, was the burial place of Adam.[17] Christ is the second Adam or "last Adam" (1 Cor. 15.45–49), whereas Adam is the original from which all humans have sprung. Blake's identifying himself with Christ and the original becomes clearer two plates later, when the devil, proclaiming an incarnational God, describes Christ as one who, presumably like Blake and Adam, "acted from impulse; not from rules" (plates 23–24). The connection between Blake, Christ, and Adam will be further clarified on plate 3, where Christ's resurrection is connected to Adam's return: "Swedenborg is the Angel sitting at the tomb; his writings are the linen clothes folded up. Now is the dominion of Edom, & the return of Adam into Paradise."[18] The passage associates Swedenborg with death, as an angel left behind attending an empty tomb. The unused garments are Swedenborg's writings, which are closed, or "folded," and thus unread—or no longer read or needed. Also cast off are external forms of worship, in that Swedenborg likens the New Church's ceremonial laws to its clothing (*True Christian Religion* n. 55). More significant, the image of unused clothing suggests a naked Christ—which is how he is pictured on plate 21. Ironically, a naked Christ is Swedenborgian, for "those in the inmost heaven . . . are not clothed . . . because they are in innocence, and innocence corresponds to nudity" (*Treatise Concerning Heaven and Hell* n. 179). Nudity also suggests man's prefallen state (see Gen. 3.7, 21), and thus Adam's return to that shameless, paradisiacal state.

In all his naked glory, Blake proceeds immediately to attack Swedenborg's credibility by accusing his primary sources of being vain, insolent, and mechanical. He states: "I have always found that Angels have the vanity to speak of themselves as the only wise; this they do with a confident insolence sprouting from systematic reasoning" (plate 21). By implying that angels are too vain and arrogant to be "wise," and that their approach to the Wor[l]d is grounds for insolence, not insight, Blake criticizes Swedenborg, two of whose book titles begin with the words "the wisdom of angels concerning" and whose interpretation of the Bible's "internal sense" is based on his "science of correspondences" or system of analogies that links every perceived thing and event to its spiritual counterpart and cause.[19] According to Swedenborg, angels understand this science, and so did the "most ancient people" of Adam's Church, "who were celestial men," but "at this day that knowledge has been so entirely lost that it is not known what correspondence is" (*Treatise Concerning Heaven and Hell* n. 87). "Thus Swedenborg boasts that what he writes is new" (plate 21).

Blake's stunningly self-assured opening sentence presupposes not only an awareness of "news from the spiritual world" (see n14), but also his own visionary powers, an assertion meant to erase as well as amplify the

differences between himself and Swedenborg.[20] Blake agrees that powers once ours are now lost, but not with Swedenborg's claim that he exercises them well or exclusively. Blake places Swedenborg in the angel's "party," which is characterized by a lack of vision and is foiled by the "Devils party" (plate 6), whose members include the creative minds and mystics Blake admired, such as Paracelsus, Boehme, Dante, Shakespeare, and Christ (plates 22–23). To this party, Blake will add Milton, Isaiah, Ezekiel, and, most tellingly, the "Ancient poets," his version of Swedenborg's "most ancient people." With "enlarged & numerous senses," they "animated all sensible objects with Gods or Geniuses . . . placing it under its mental deity. Till a system was formed." To Blake, the original system of correspondences was an inherently creative process resulting in "poetic tales," which, however, were eventually perverted into "forms of worship" by a "Priesthood" able to "abstract the mental deities from their objects." "Thus men forgot that All deities reside in the human breast" (plate 11). Yet while visionary powers possessed by all are forgotten by most, they are exercised by more than Swedenborg allows and thus are not grounds for vanity or conceit. Being so aligns one with the "Priesthood."[21]

The conflict between priests and poets on plate 11 recapitulates that between angels and devils, which, as expressed on plates 21–24, is one between originality and imitation, creativity and systematic reasoning. Indeed, Swedenborg's angelic sources are suspect not only because they are insolent and vain, but also because they are copyists—and poor ones at that. What "Swedenborg boasts . . . is new" is "only the Contents or Index of already publish'd books." Swedenborg fails, in other words, to see that what he records is both public knowledge and woefully incomplete, amounting merely to the systematic portions of books published by others. Swedenborg, then, is a mere imitator, one who "only gives us a sort of Duplicates of what we had, possibly much better, before; increasing the mere Drug of books, while all that makes them valuable, *Knowledge* and *Genius*, are at a stand" (Edward Young 10). "Thus Swedenborg," by following the lead of followers, necessarily fails at being "new." An "Ancient poet" he is not, for he fails to embody the "Poetic Genius," which Blake identifies as "the Spirit of Prophecy," the ultimate source from which "The Religions of all Nations are derived." He also identifies it as the "True Man," "the true faculty of knowing" (E 1, 2), and, in his annotations to Swedenborg's *Divine Love and Divine Wisdom* (1788), as "the Lord" and "the Lord's Divinity" (E 603); in his later writings and prophecies, he identifies it as Imagination (e.g., E 663–64). The concept of the Poetic Genius will enter *Marriage* explicitly on plates 12–13, the next two plates Blake executed (see essay 1), where it is identified as "the first principle" of "human perception." But implied throughout plates 21–24, particularly

in the members of the devil's party, is the idea that Swedenborg's work is unoriginal because it does not originate—grow or sprout—from the origin, does not manifest the "Poetic Genius," or "the Lord" Christ. It lacks, in other words, Imagination, the source of perception and vision.

Angelic sources cannot compete with "Poetic Genius." For Blake, great works of art, not metaphysics, manifest God, and if for Blake "God is a Man . . . and finds his being in human acts of creation," then any one "who achieves greatness in art is God to the extent of being himself constituted by his own creative acts"(Bloom, Introd. 20). In manifesting God, great works of art manifest the origin of creativity and prophecy; or, put another way, the most original works originate or sprout from or are closest to the origin of creation, which, as Blake will dramatize on *Marriage* plates 6, 14, and 15, is hell. Even with Shakespeare and Dante as models, though, the creative mind will be at best a glorious follower if it follows the letter instead of the spirit—or, in terms of *Marriage's* topographical metaphor, if it fails to visit "hell" or the "abyss." Blake changed the location in later works, but he retained the idea of having to visit the origin: "The Man who never in his mind & Thoughts traveld to Heaven Is No Artist" (E 647). The idea that by "travelling" to the origin of creativity one can return to the glory of the ancients without imitating them was not new. Edward Young had argued that the modern poet should not imitate Homer's work but take "the same method, which Homer took, for arriving at a capacity of accomplishing a work so great. Tread in his steps to the sole Fountain of Immortality; drink where he drank, at the true Helicon, that is, at the breast of Nature: Imitate; but imitate not the Composition, but the Man. For may not this Paradox pass into a Maxim? viz. 'The less we copy the renowned Antients, we shall resemble them the more'" (20–21).

The idea that Swedenborg lacked imagination, that he did not go deep enough or visit hell, is represented by his refusal to talk to devils. "He conversed with Angels who are all religious. & conversed not with Devils who all hate religion, for he was incapable thro' his conceited notions." Hence, he "has not written one new truth" but "has written all the old falshoods" (plate 22). Failure to converse with devils means relying exclusively on systematic reasoners at the expense of poetic genius. It also punctures any claim to speak as an authority on Hell—or on much of anything else. He has not "written one new truth"; by "new truth," Blake presumably means unknown or no longer known, since throughout the *Marriage*—and Swedenborg's writings—truth is something to be recovered or returned to, like the truths of the most ancient people/poets, always there but hidden or forgotten until displayed by the authentic artist/prophet. It is not possible, then, to write new truths, in the sense of creating them, but it is possible to create new and original works of art that manifest and express

truths. Blake seems to accuse Swedenborg of claiming the impossible and failing at the possible.

As a "conceited" angelic agent thinking he already knows all there is to know, Swedenborg becomes the model for the "devourer," who "only takes portions of existence and fancies that the whole" (plate 16). Rather than possessing truth exclusively, Swedenborg excludes the very acts that could assist him in seeing fully. That truth and perception are impeded and falsehood propagated by one's "notions" or system of thought is a major theme in *Marriage* that not coincidentally echoes Swedenborg's relentless attack on the Christian Church. "As long as men adhere to, and are influenced by, the Faith of the Old church, so long the New Heaven cannot descend to them" (*Minutes* [resolution 7] 127). Of the "Notions," "common Beliefs," and "prevailing Opinions" that constituted this "Faith" and prevented the masses from "understanding the spiritual Sense of the Word" (*True Christian Religion* nn. 768–69), two of the most fundamental are believing "Redemption to have consisted in the passion of the cross" and professing one God while actually praying to a "Trinity of Divine Persons" or "Trinity of Gods" (*True Christian Religion* nn. 132, 172).[22] Just as Blake vociferously denies and satirically inverts Swedenborg's claims of possessing original knowledge, he ironically turns Swedenborg's recognition that precepts determine perception against him, subjecting Swedenborg to his own rationale. Why should Swedenborg be believed when his sources, like those of the Old Church he criticized, were much repeated but erroneous? What lessons has he to teach Blake when all his knowledge concerning God is derived not from the Poetic Genius but from systematic reasoners and incomplete or abridged texts?

Vainly basking in light not worth sharing undermines Swedenborg's credibility as seer. Yet he "shews the folly of churches & exposes hypocrites" (plate 22). Blake compliments, though, to expose a greater fault. Swedenborg believes "that all are religious. & himself the single one on earth that ever broke a net" (plates 21–22), but, as noted, such exposition is neither new nor grounds for boasting or thinking oneself singular—or free of Religion's entangling net. Indeed, Swedenborg's believing himself free only underscores how thoroughly pervasive the net is. Blake's compliment also raises the specter of hypocrisy, of prophet become priest, for Swedenborg "conversed" only "with Angels who are all religious," his "conceited notions" preventing him from imagining value among those different from himself (plate 22). Swedenborg's claim to have broken from "the religious" is as inherently contradictory as the Old Church professing one thing and believing another. In short, the claim is either false or hypocritical. In either reading, Blake again denies the New Church's claim that it is "new" and "distinct from the Old Church." Far from being distinct or origi-

nal, Swedenborg and his followers are like what they criticize, a similarity determined by Swedenborg's angelic sources representing organized religion and by the absence in Swedenborg's discourse of the Poetic Genius.

Like revolutionaries before and after him, Swedenborg became what he criticized, co-opted by the establishment he sought to expose as usurpers of truth. That Swedenborg serves orthodoxy in the name of resistance, that his sources are tainted, and that he belongs to the very world he criticizes would have seemed preposterous to both Swedenborgians and their critics. Blake reduces the visionless and insufficiently visionary to the same "party" because the perception of both "sprouts" exclusively from "angelic" texts, on the letter of the Law instead of the genuine indwelling spirit of the Word. As implied by the devil metaphor, Swedenborg, like the churches before him, failed to read "infernally," to go sufficiently below the surface or consult what they feared most, satisfied instead with mere portions of what is already known, with "the Contents or Index of already publish'd books." In criticizing Swedenborg in this light, Blake criticizes all churches, old and new, and creates on plates 21–24 a set of dialectics or contraries that manifest the essential opposition between Blake and Swedenborg. These contraries include devils and angels, art and religion, liberation and oppression, original and imitation, and they appear to have assisted in generating others in subsequent plates, including energy and reason, prophets and priests, producers and devourers. Contraries, as Blake will acknowledge on plate 3, "are necessary to Human existence," and "Without [them] is no progression." Failure to acknowledge their co-existence—that is, failure to perceive below the morally defined surface of good and evil—results in "a recapitulation of all superficial opinions" (plate 22), which necessarily retards both social and individual progress.[23]

Blake's accusation that Swedenborg conversed *only* with angels, whose incomplete vision he copies, needs to be read in light of assertions made by Swedenborg, who states "that from the first Day of my Call to this Office, I never received any Thing appertaining to the Doctrines of [the New] Church from any Angel, but from the Lord alone, whilst I was reading the Word" (*True Christian Religion* n. 779). These claims are expressed in the first resolution of the 1789 General Conference, which states that Swedenborg's theological works "are perfectly consistent with the Holy Word, being at the same time explanatory of its internal sense in so wonderful a manner, that nothing short of Divine Revelation seems adequate thereto," and that they "contain the Heavenly Doctrines of the New Church," which "he was enabled by the Lord alone to draw from the Holy Word, while under the Inspiration and Illumination of his Holy Spirit" (*Minutes* 126). Swedenborg's claim to be divinely inspired while reading scripture, of knowing its "internal sense" and the doctrines of the New

Church from the Lord himself, underlies two essential claims made by the New Church. First, "That Now is the Second Advent of the Lord, which is a Coming, not in Person, but in the power and glory of the Spiritual Sense of his Holy Word, which is Himself"; and second, "That this Second Coming of the Lord is effected by means of his servant Emanuel Swedenborg, before whom he hath manifested Himself in Person, and whom he hath filled with his Spirit, to teach the doctrines of the New Church by the Word from Him" (*Circular Letter* [prop. 39, 40]: 124; see also *Minutes* [res. 25]: 128, and *True Christian Religion* nn. 776–79). By posing as Christ and opposing Swedenborg, Blake denies Swedenborg's claim to be divinely inspired and a genuine prophet of the Lord. Blake thereby undermines the very foundation of the New Church while sanctioning his own readings and announcements as genuinely prophetic.

Indeed, Blake, Jeremiah-like, chastises his readers for believing Swedenborg's idea of himself. Blake's tone is assertive, with the "rebellious optimism" and "disputatious confidence of *All Religions are One* and *There is No Natural Religion*" (Eaves, Essick, and Viscomi 116). "Now hear a plain fact . . . And now hear the reason . . . Have now another plain fact" (plate 22). The tone is itself an anti-Swedenborgian gesture, very much *not* in the spirit of the president's request to the first General Conference "that each member in delivering his sentiments, will ever keep in mind the necessity of humility, and guard against every domineering spirit that might attempt to infest his mind, by persuading him that he alone is in the true light, or that his judgment is superior to that of others" (126). Blake will have none of that, believing instead that "Severity of judgment is a great virtue" (E 585). He is not all accusation, though, for he allows angels and Swedenborg to implicate themselves. They fail to heed the president's admonition against vanity and, despite being the "only wise," miss Blake's "plain" facts. Their failure to see unadorned truth implies either blindness or deception—or both. It also reinforces the ideas that perception is determined by preconceptions—or "notions"—and that Swedenborg, presumably unlike Blake in his text, preaches to the converted and thus "propagates" rather than challenges his audience's preconceptions.

By revealing Swedenborg's sources as biased and incomplete and Swedenborg as a nondiscriminating copyist, Blake sets into play an aesthetic, as opposed to a religious, hierarchy. At top and bottom are originality and imitation, qualities manifest in master artist and student. To Blake, Swedenborg's prodigious publication record is inconsequential because his models are insubstantial and unoriginal, exactly the criticism he will level against those students and artists preferring color to line (i.e., working in the Flemish and Venetian painting styles).[24] Swedenborg's writings are less valuable than the theosophical "writings of Paracelsus or

Jacob Behmen [Boehme]," which, in turn, are less valuable than "those of Dante or Shakespear." From the texts of the former, "Any man of mechanical talents" can "produce ten thousand volumes of equal value with Swedenborg's," and from the latter texts "an infinite number." The value of what is produced, however, must be kept in perspective: "Let him not say that he knows better than his master, for he only holds a candle in sunshine" (plate 22).[25] At the heart of Blake's poetically described break with mimetic tradition is Joseph Addison's adage that "an Imitation of the best Authors is not to compare with a good Original" (1: 484).

If Swedenborg appears more than a follower or journeyman prophet, Blake implies, it is only in the way that a man "a little wiser than the monkey" appears superior (plate 21). Blake's analogy also implies that Swedenborgians, in their unquestioning admiration of their master, are like monkeys, imitation humans taking the imitation prophet as the real thing, the candle as the sun. While he is not the great man they believe him to be, they are, ironically, right to want to adore the great, as Blake explains in the following "Memorable Fancy" (plates 22–24). This narrative parodies Swedenborg's Memorable Relations, which "contain particular Accounts of what had been seen and heard by the Author in the spiritual World, and have in general some Reference to the Subjects of the Chapters preceding them" (translator's note in *True Christian Religion*, 3rd ed., 1795).[26] While Blake parodies the form of Swedenborg's Memorable Relations, he examines seriously the nature of God, one of Swedenborg's most persistent subjects. Blake's debaters, like those in many of the Memorable Relations, are a devil and angel, who, in presenting mutually exclusive ideas of God, provide "infernal" and "internal" readings of the Word.

"The Devil Quotes Scripture" (anon.)

The devil's God is incarnate, the very kind Swedenborg warns against: "Let every one beware of falling into that execrable Heresy, that God hath infused himself into Man, and that he is in them, and no longer in himself" (*Divine Love and Divine Wisdom* n. 125). Resolution 10 from the *Minutes*, in support of propositions 1, 23, and 42 in the *Circular Letter*, states "that the Lord and Saviour Jesus Christ is the Only God of Heaven and Earth, and that his Humanity is Divine. That in order [for] salvation, man must live a life according to the Ten Commandments, by shunning evils as sins against God" (127; see also *True Christian Religion* nn. 283–331). The question of God's Divine Humanity, along with that of the Trinity, were central issues of Swedenborgianism. The devil, however, appears to have been reading Blake instead, particularly *There is No Natural Religion* plate b12, which states: "Therefore God becomes as we are, that we may be as

he is." The devil also appears aware of Blake's "The Divine Image," which expresses the antinomian idea that human virtues embody the divine (see n13). Like the angel (and Swedenborg), the devil believes in the Divine Humanity, that is, that Christ's humanity is divine, but, like Blake, he also believes that Humanity itself is Divine because Christ was human. Thus, we should love most the greatest humans, for in them God is most apparent or manifest. This logic underlies the devil's assertion: "The worship of God is. Honouring his gifts in other men each according to his genius. and loving the greatest men best, those who envy or calumniate great men hate God, for there is no other God." [27] To what sounds like an artist defending his outsider status, the angel shouts: "Thou Idolater, is not God One? & is not he visible in Jesus Christ? and has not Jesus Christ given his sanction to the law of ten commandments and are not all other men fools, sinners, & nothings?" (plate 23). The angel's God is the external, powerful, vengeful, and thoroughly orthodox creature of the Old Testament and Decalogue, having nothing to do with inferior beings like man. His Christ is strictly by the book, echoing resolution 10 and the first of Swedenborg's five "Particulars of Faith," that "God is One, in whom is a Divine Trinity, and that He is the Lord God and Saviour Jesus Christ" (*True Christian Religion* n. 3).

To refute the angel's concept of God, the devil reads the acts of Christ in their "infernal sense" (for the acts, see Eaves, Essick, and Viscomi 220 nn. 15–20; see also Blake's "The Everlasting Gospel" [Erdman, *Complete Poetry* 518–25]). He argues the antinomian position that Christ had broken the externally imposed moral code and was "all virtue" because he "acted from impulse, not from rules" (plates 23–24). By being so, regardless of consequences, he is the model for the poets/prophets Isaiah and Ezekiel and the poet/artist Blake (plates 12–13 and 6, 10, 14, and 15). Like Christ, their job is to raise others "into a perception of the infinite" (plate 13) and not merely to *describe* the infinite or visionary potential, which, Blake implies, is at most Swedenborg's great accomplishment. Because "Jesus Christ is the greatest *man,* you ought to love him in the greatest degree," and not because he sanctioned Mosaic law or is powerful. [28] As Bloom notes, "Greatness here means artistic greatness" (Introd. 20), but Blake appears also to be punning on Swedenborg's idea of the "Greatest Man." According to Swedenborg, "the universal heaven resembles the human form" and is called by angels "the Grand (Maximum) and Divine Man," and "a man in the greatest and most perfect form is heaven" (*Treatise Concerning Heaven and Hell* nn. 59–60). [29] The angels' failure to see Christ as a man provides more evidence that angelic "notions" or preconceptions of heaven and hell determined their—and Swedenborg's—perception. Blake will continue to express and dramatize this idea on *Marriage* plates 3, 12–13, 6–7, 4, and 16–20.

The truth of the devil's argument is evinced by the angel's fiery conversion: he "stretched out his arms embracing the flame of fire & he was consumed and arose as Elijah" to "become a Devil." Temporary conversions occur in Swedenborg's Memorable Relations; devils granted permission to visit heaven for debate are always convinced of the angels' positions, but they forget the truth after returning to hell. Blake reverses such encounters, with the angel converted on his own turf and perception affected by the argument and not the environment. The "consumed" angel puns on Swedenborg's "consummation," used in its sense of "last judgment," which is also how Blake will use it on plate 14 ("the whole creation will be consumed and appear infinite and holy.") Blake also inverts Swedenborg's use of the Elijah metaphor to describe angelic conversion: "I was permitted to see how the spirits of that earth [Jupiter], after they have been prepared, are taken up into heaven and become angels. There then appear chariots and horses bright as with fire, by which they are carried away like Elijah" (*Earths in Our Solar System* n. 82). The angel's conversion dramatizes the ironically rationalist proverb from Hell: "Truth can never be told so as to be understood and not be believ'd" (plate 10)—a proverb, as we shall see, probably written but not yet executed on copper. The conversion suggests what might have happened to Swedenborg had he talked to devils, refutes the predestinarianism that Blake (falsely) accused Swedenborg of defending (see n7), and implies that changing one's mind—as Blake had about Swedenborg—could be positive, the topic explicitly addressed in the Leviathan episode of plates 17–19. Most significantly, conversion—the raising of others into a perception of the infinite—provides the model for the relation between Blake's illuminated text and its reader, and, in general, between original art and its audience.[30]

As the devil triumphs over the angel, Blake triumphs over Swedenborg, and this parallel identifies Blake—as well as Jesus, Elijah, Shakespeare, and Dante—as a member of the devil's party, thereby strengthening the ideas that Religion's contrary is Art and that Jesus is the ideal artist. Like Swedenborg, Blake resembles the company he keeps; he appears to represent himself as genius worthy of respect and admiration, as artist wrongly neglected for following his own impulses. In presenting himself as Swedenborg's contrary, the original to his imitation, Blake presents himself as a master. The sign of his mastery, though, lies not only in his tone, the manner in which he corrects Swedenborg and his followers as though they were wayward students, but also in the form of his text. It reproduces the appearance of handwriting and drawing in metal, but it does so not as facsimile or imitation. The appearance results from Blake's actually writing and drawing with the tools of the writer and artist, in pens and brushes with a liquid medium directly on the copper plate, a tech-

nique Blake termed "illuminated printing" and that he knew was original and new. In the Note that ends the text, Blake announces more works in this technique and from the infernal perspective.

"The Bible of Hell"

Recall that resolution 30 of the General Conference recommended that "all the readers and lovers of the Theological Works of Emanuel Sweden-borg . . . form themselves into societies distinct from the Old Church . . . meet together as often as convenient, to read and converse on the said Writings, and to open a general correspondence for the mutual assistance of each other" (Minutes 129). In the Note, Blake acknowledges having formed his own reading group, where he and his "particular friend," the converted angel (or new devil), read the Bible in its "infernal or dia-bolical sense," that is, in its original poetic sense. Blake reveals that he studies the Bible directly and not through Swedenborg and that he, un-like Swedenborg, talks to devils and trusts the ability of others to read as visionaries. His reading, though, is apparently for the "mutual assistance" of the group's members, since sharing the "infernal sense" or teaching this mode of reading, Blake says teasingly, is conditional: "The world shall have [it] if they behave well" (plate 24). He promises the world, however, "The Bible of Hell," a title shockingly confrontational, without conditions or reading instructions, "whether they will or no" (plate 24). Presumably, this "Bible" will consist of Blake's "Writings," expressing the wisdom of devils to counter the wisdom of angels. Blake offers his works with the spiritual authority he denies Swedenborg and with the bravado of an artist independent of audience and market, an independence proclaimed three years later in Blake's prospectus for illuminated books.[31] Such indepen-dence exemplifies acting from impulse and not rules, behavior that Blake will continue to remind us in Marriage characterizes artists and prophets. The work Blake announces as forthcoming combines in its title both prophecy and art; like the latter, it is not financially predicated, but it is, like the former, predicated on the needs society is unaware of having. The visionary artist's prophetic responsibilities raise the themes of limited and illimited perception and the relation between art and audience, topics that will also be further explored throughout Marriage.

In effect, of course, Blake's audience has already been given a taste of the "infernal sense" via the devil's reading of Christ's life. Of course "in-fernal" is meant to parody Swedenborg's "internal" sense, but the manner in which Blake announces it and "The Bible of Hell" is itself parodying Swedenborg and Swedenborgians. Resolution 25 of the first General Con-ference states "that the Second Advent of the Lord, which is a Coming in

the internal sense of his Holy Word, has already commenced, and ought to be announced to all the world" (*Minutes* 128). And so it has, though not as the Swedenborgians imagined. The Note's two-part message appears modeled on Swedenborg's announcement in *True Christian Religion:* "Inasmuch as the Lord cannot manifest himself in Person . . . and yet he foretold that he should come, and establish a New Church, which is the New Jerusalem, it follows, that he will effect this by a Man, who not only can receive the Doctrines of that Church in his Understanding, but also publish them in Print" (n. 779). Moreover, the last resolution of the *Minutes* announced yet another conference, and announcing forthcoming books at the end of pamphlets and books was typical of Hindmarsh, who listed Swedenborg's books in translation, Latin, and in press.[32]

Given that "The Bible of Hell" is announced at the end of plate 24 and that plates 21–24 precede the composition of the *Marriage,* it is reasonable to suppose that Blake is referring to the *Marriage* itself, as it was anticipated at the time of his anti-Swedenborgian text, or to the Proverbs of Hell, which presumably Blake was compiling at the time of the announcement (they were executed in the third stage of the *Marriage's* evolution). Or it may refer to a work that was to include the Proverbs of Hell, which were clearly meant as an ironic inversion of the Bible's Book of Proverbs, "the archetype of wisdom literature" (Villalobos 248). Blake's proverbs, as Lansverk has recently demonstrated, continue the attack on Swedenborg, particularly on his dualism and passivity (61 passim).[33] Indeed, Blake's foregrounding proverbs was itself an anti-Swedenborgian gesture, for Proverbs was one of the Biblical texts that Swedenborg excluded from his list of thirty-three chosen books of Holy Writ for "not having the Internal Sense" (*Circular Letter* [prop. 12]: 122). If, as will be argued, the announcement is directed at "all the readers" and critics of Swedenborg, then foregrounding the proverbs strengthens the hypothesis that they were meant as the "Bible of Hell" or its first volume. So does ending plate 24 with a proverblike statement—"One Law for the Lion & Ox is Oppression"—which appears to provide a taste of what will come, whether we "will or no."[34]

As argued in essay 1, *Marriage* appears to have grown from what were originally two separate projects: an anti-Swedenborgian pamphlet and the anticipated "Bible of Hell," stitched together with introductory material and a few more parable-like stories (e.g., "Memorable Fancies"), creating a disjointed structure that Blake may have had in mind for "The Bible of Hell," possibly in parodic imitation of the "fragment-hypothesis of the Higher Criticism, the theory that the Old Testament is a gathering of redacted fragments" (Essick, "Representation"; see also his *William Blake* 142 passim). Blake appears to have changed his mind about publishing an independent pamphlet—or a collection or "Bible" of individual pam-

phlets—and decided instead to publish a group of interrelated variations on themes raised in some form or another on plates 21–24. If this is what happened, then *Marriage* came into being in form and content through its production, with many of its units modeled on the structure of plates 21–24 and their objects of satire broadened from Swedenborg to the socio-religious system he came to represent.

In proposing that the proverbs may have been the original "Bible of Hell" or its first projected volume, I do not mean to dismiss completely the commonly held view that it refers to *The [First] Book of Urizen, The Book of Ahania*, and *The Book of Los*. These works of 1794 and 1795 are so identified because *Marriage* was thought to be in progress till 1793, and because, like the Bible's, their texts were divided into two columns and offer a counter-myth to Genesis (or the First Book of Moses). They may indeed have been influenced by Blake's initial idea for a series of discrete, infernal texts without being the works he had in mind when the project was first announced in 1790. Still four and five years away, these works were certainly not the next ones taken up, let alone in progress in 1790. An analogous situation is that of *Songs of Innocence* and *Songs of Experience*, separated by four or five years. Did Blake know in 1789 that he was going to complement the earlier work with *Songs of Experience*? Or did the intervening work, particularly the *Marriage*, affect Blake's understanding of his own earlier work, seeing in *Songs of Innocence* a mental state requiring a "contrary"? Not only did Blake often change his mind about projects, but he regularly revised those he did produce. Indeed, Blake so consistently revised works he returned to that Essick, describing Blake's tendency to continue invention through execution, has coined the phrase "creative revisionism" (*William Blake* 163) to describe this aspect of his work. The second states of *Our end is come* and *Joseph of Arimathea* come immediately to mind, the latter reinterpreting a figure from the Sistine Chapel that he had engraved as a student, and the former being retitled *The Accusers*. The inclusion of poems from *Songs of Innocence* into *Songs of Experience* also exemplifies Blake's willingness to revise his first thoughts. Or are we to think that Blake planned to move from *Marriage* to *Urizen* but was interrupted by unplanned— and unbiblical-looking—*Gates of Paradise, Visions of the Daughters of Albion, America*, and *Europe*? To imagine that Blake put aside one original project or manuscript to work on four others is to ignore how gradually his mythology and powers as a mythologist evolved from book to book—and how the books themselves evolved. It is to imagine a composing process and a Blake far different from the ones I am proposing in this three-part study.

When printed as a separate unit, plates 21–24 have the feel and look of a pamphlet, and, like good satire, they parody the form and language of their subject. The sections of each chapter in Swedenborg's *True Christian Religion*, for example, consist of distinct (and mostly numbered) paragraphs setting forth the facts, followed by one or more "Memorable Relations." Throughout the text are the translator's notes commenting from the bottom of the page. Blake's text consists of eight (unnumbered) paragraphs, followed by "A Memorable Fancy" and a Note that identifies the type of reading given by the devil and updates the reader about past and forthcoming events. These three features—statement, narrative, and note—provide the well-defined beginning, middle, and end of the effective pamphlet. Rhetorically, these features can also be viewed as exposition, confirmation, and conclusion, with the exposition introduced by an entrance.[35] The entrance, which must catch the audience's attention, is beautifully and yet confrontationally realized by the illustration of Blake's divine humanity (illus. 2); the exposition, which sets forth the facts, defines the terms, and presents the issues to be proved, consists of distinct paragraphs forcibly explaining why Blake thinks Swedenborg is neither new nor original. The following narrative, in which an angel and devil debate the nature of God, functions as the confirmation in that it sets forth through the two parties the arguments for and against Swedenborg's idea of God, the central issue dividing the two visionaries. The text closes with a Note notifying readers about Blake's own study group and teasingly promising more infernal readings and infernal texts. As first written and printed, with Nebuchadnezzar not yet executed (see n4), the Note was the entire conclusion; it restates Blake's basic premise that "infernal sense" is better than "internal sense," and it leaves the reader wanting—or fearing—more.

Two other textual units in the *Marriage* (plates 5–10 and 16–20) appear to have been influenced by the structure of plates 21–24. They, too, include statement, "Memorable Fancy," and Note, but Blake placed these other Notes (on plates 6 and 17) *before* the "Memorable Fancies," thereby preventing their units from having a sense of full closure. These other Notes were written in the third person and are more like the translator's notes that comment on Swedenborg's texts. Compared to these and the other units, plates 21–24 appear more of a piece and fully cognizant of the four-page pamphlet format. The Note, by virtue of the narrator's "I" and the converted angel "who is now," returns the reader to the "I" and "now" of plates 21 and 22, the beginning of the text. When reading the four plates on a conjugate sheet folded as a pamphlet (as in *Marriage* copy K),

the reader necessarily returns to plate 21 (page 1) after reading plate 24 (page 4), moving from defeated oppression to the liberated New Man.

The inclusion of the vignette below the Note may have been an afterthought, determined in part by the text running short, leaving the bottom half of plate 24 blank. Adding a vanquished, long-bearded man at the bottom of the plate (fig. 3) created a stark contrast with the resurrected, youthful figure and made good thematic and aesthetic sense. That old man, though, was not chosen randomly or merely to create a visual dialectic between new and old, or liberty and defeat. He is the mad Nebuchadnezzar, the Babylonian king who "was driven from men, and did eat grass as oxen" (Dan. 4.33). He was also "a traditional archetype of the regal oppressor," and a "depiction of him in his madness could hardly fail to strike viewers . . . as an attack on George III, the most celebrated lunatic of the times" (Carretta 162).[36] As obvious—and probably more pertinent—to Swedenborgians was the connection between Nebuchadnezzar and Swedenborg, who believed the "four Churches" that preceded the New Church "are described by the Statue that appeared to Nebuchadnezzar in a Dream, Chap. ii. and afterwards by the four Beasts ascending out of the Sea, Chap. vii" (*True Christian Religion* n. 760). Swedenborg points specifically to Nebuchadnezzar's dream in Daniel 2.44 as foretelling the New Church as the last and eternal church: "And in the days of these kings shall the God of heaven set up a kingdom, which shall never be destroyed: and the kingdom shall not be left to other people, but it shall break in pieces and consume all these kingdoms, and it shall stand forever." This passage, reprinted in the *Minutes* of the first General Conference (130), was no doubt well known to Blake.

Traditionally, Nebuchadnezzar represents God's power to chasten and subdue the proud, but that reading presupposes the angel's vindictive God and not Blake's Christ. In fact, Nebuchadnezzar accepts Jehovah when he recognizes Daniel's gift of interpretation (2.47). Despite his admittance, Nebuchadnezzar afterward continued to worship golden idols (Dan. 3.2–14). He cast into a fiery furnace Daniel's three friends, but seeing them walk unharmed with "the form" of a fourth man, who "is like the Son of God" (Dan. 3.25), he again converts, and he threatens to kill anyone who speaks against Daniel's God.[37] One year after Daniel interprets another of his dreams, he is driven mad and loses his kingdom (4.31–33). But while this is the Nebuchadnezzar that Blake pictures, he appears to have in mind the king's next stage:

> And at the end of the days I Nebuchadnezzar lifted up mine eyes unto heaven, and mine understanding returned unto me, and I blessed the most High, and I praised and honoured him that liveth for ever,

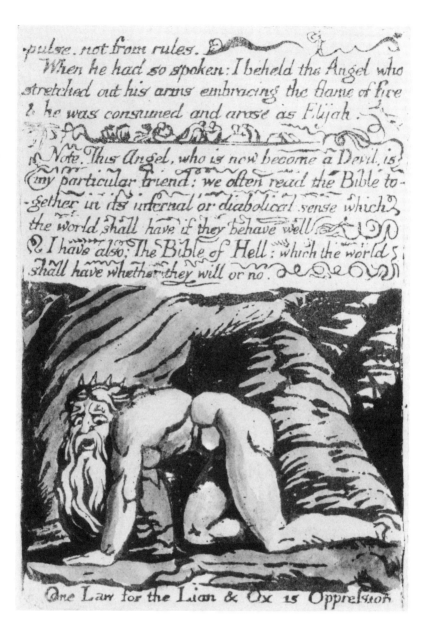

-pulse. not from rules.

When he had so spoken: I beheld the Angel who
stretched out his arms embracing the flame of fire
& he was consumed and arose as Elijah.

Note. This Angel, who is now become a Devil, is
my particular friend: we often read the Bible to-
-gether in its infernal or diabolical sense which
the world shall have if they behave well.

I have also: The Bible of Hell: which the world
shall have whether they will or no.

One Law for the Lion & Ox is Oppression

Figure 3. *The Marriage of Heaven and Hell* (Plate 24, second state,
Copy c, Pierpont Morgan Library, New York, PML 17599).

198 Joseph Viscomi

whose *dominion* is an everlasting *dominion*, and his kingdom is from *generation to generation.*

And all the inhabitants of the earth are reputed as *nothing* and *he doeth according to his will in the army of heaven* and among the inhabitants of the earth: and none can stay his hand, or say unto him, What doest thou?

At the same time my *reason returned unto me;* and for the glory of my kingdom, mine honour and brightness returned unto me; . . . and I was established in my kingdom. . . . (Daniel 4.34–36; italics mine)

The return of Nebuchadnezzar's reason enables him to return to society, but it also prevents him from understanding God other than as a perverted extension of himself, as a powerful creature indifferent and unanswerable to man. His God recalls that of the preconverted angel: "Thou Idolater, is not God One? . . . and has not Jesus Christ given his sanction to the law of ten commandments and are not all other men fools, sinners, & *nothings?*" (plate 23).

An ironic inversion of the angel's conversion, Nebuchadnezzar's madness invalidates the angel's theological position and, like the angel's original vanity, dramatically refutes the reliability of Swedenborg's sources. The dreams of demented kings eating grass are not, after all, a solid basis for claiming one's Church prophetically realized. Indeed, while Swedenborg claims that Nebuchadnezzar's dream prophesies "dominion" for the New Church, Blake will prophesy on plate 3 that "Now is the dominion of Edom, & the return of Adam into Paradise," implying salvation lies in returning to the state represented by the "most ancient church" of Adam, rather than joining the Swedenborgian New Church. And Blake will imply on plates 14 and 15, through the "infernal method" of the "Printing house in Hell," that his and not Swedenborg's writings will be the means of returning and will pass from "generation to generation."

The single, defeated figure of Nebuchadnezzar, by representing both Swedenborg and George III, fuses (New) church and state, conflates religious doctrine that conditions thought with political law that restricts action. His dehumanized form represents and results from his antihuman act of oppression and points to its contrary, the Human Divine pictured on plate 21. The postures of these two contrary figures form part of Blake's criticism of Swedenborg's doctrine of correspondence. Blake presents himself as newly resurrected, youthful and vibrant, out in the open, open physically, and with eyes open to the heavens (illus. 2). In stark contrast, he places Nebuchadnezzar in a constricted space before the trunks of giant trees (see fig. 3), self-enclosed though aware of the reader's scorn (cf. the "Application" in *There is No Natural Religion* and the color print of *Newton*

for similar gestures of limited perception). These postures correspond to those who, according to Swedenborg, understand "what correspondence is" and those who do not. The latter have "removed [themselves] from heaven by the love of self and of the world," having "regard only to worldly things" and "reject[ing] . . . spiritual things" as being "too high to be subjects of thought." The former are best exemplified by "the most ancient people," who were of Adam's Church and "who spoke with angels, and the Lord Himself was often seen by them and instructed them" (*Heaven and Hell* n. 87). Picturing Swedenborg, who claims the lost knowledge of correspondence, as "removed from the world" and himself as sensually looking heavenward, like Adam and those of his church—these are among Blake's most brilliant satiric inversions, inversions that appear to have provided the models for Los and Urizen.

Conclusion: "If this is your Heaven, give me Hell"

The pamphlet's objectives are clear—to denounce Swedenborg and to champion Blake—and it clearly realizes both and more. It denies Swedenborg's claims that the New Church is "distinct" and that his "internal sense" of the Word is divinely inspired. It accuses him of being like the church he criticizes, of reading unimaginatively, and of writing unoriginally. It shifts the debate from metaphysics to aesthetics and tarnishes Swedenborg by painting him as an oxymoron, the proud copyist, while identifying true prophecy as Art and Blake as that greatest artist, Christ. It dramatizes the major divisive issue between Blake and Swedenborg as a debate between a devil and angel about the nature of God—whether God is incarnate or external and abstract, associating the former kind with imagination and art and the latter with reason and law. And it announces "The Bible of Hell," an announcement reflecting Blake's confidence in himself, since it had yet to be executed. This bold confidence is evident from the start, in Blake's tone, through his idealized self-portrait, and by the literary and prophetic company he keeps. And it is evident in Blake's publishing his thoughts in a radically original and autographic form. Indeed, the aesthetic issue of originality is raised by, as well as in, the pamphlet when Blake compares himself to Swedenborg and announces both a new mode of reading and new texts to read. Blake's belief in originality was especially remarkable in an age, and as a member of a profession, more respectful of imitation, and around it he built his history and theory of art, which consistently equates originality with individual genius, liberty, and the nation's spiritual health. In short, the pamphlet reads like a dramatic manifesto on aesthetics in which the central debate is over God.

Blake moved from defending Swedenborg against his critics, denounc-

ing them as "mercenary & worldly" with "no idea of any but worldly gain" (E 606), to criticizing Swedenborg and his sources without joining Swedenborg's conventional critics. By the end of *Marriage*, though, Blake seems to be thanking Swedenborg for helping to generate the work and to illuminate Blake's mind to himself. At the foot of *Marriage* plate 20, Blake wrote what was probably the last line of *Marriage* proper (see n2): "Opposition is true Friendship." Between the axiom ending the pamphlet and this one lies *Marriage* and Blake's complex and sometimes ambivalent attitude toward Swedenborg, an ambivalence perhaps evinced in the deletion through coloring or color printing of that line from most copies of *Marriage*. Years later, in *Milton*, Blake states, "O Swedenborg! strongest of men, the Samson shorn by the Churches" (E 117), and in *A Descriptive Catalogue:* "The Words of this visionary are well worthy the attention of Painters and Poets; they are foundations for grand things; the reason they have not been more attended to, is, because corporeal demons have gained a predominance" (E 546). Late in his life, Blake told Robinson that he read the Bible in its "spiritual sense" and that Swedenborg "was a divine teacher" who had "done much & will do much good[;] he has correct[e]d many errors of Popery and also of Luther & Calvin." But Blake also told Robinson that Swedenborg was "wrong in endeavor[in]g to explain to the rational faculty what the reason cannot comprehend." Blake continued to pair Dante and Swedenborg, and though he considered "their visions of the same kind," he still believed the former "was the greater poet" (Bentley, *Blake Records* 312).[38]

To C. A. Tulk, a Swedenborgian, Blake is reported to have said that "he had two different states; one in which he liked Swedenborg's writings, and one in which he disliked them. The second was a state of pride in himself, and then they were distasteful to him, but afterwards he knew that he had not been wise and sane. The first was a state of humility, in which he received and accepted Swedenborg" (Bentley, *Blake Records* 38). Paley suspects that these states may refer to literal and metaphorical readings (31), whereas Bentley finds that "the last two sentences read suspiciously like a New Church rationalization of Blake's extremely vocal mockery" in *Marriage* (38n1). And yet, the report of Blake's recollection of his "pride" rings true, at least as regards the pamphlet. In accusing Swedenborg of being vain, proud, imitative, and self-deluded, Blake reveals a curious mix of pride, anger, confidence, authority, and defensiveness, a mix that forces readers to ponder the source of Blake's anger and his intended audience.

The idea that Blake broke with Swedenborg out of disappointment over the importance given to ceremony and priests does not explain his contemptuous critique. We all hear a "strong sense of outrage," but can we, like Bloom, say that it is caused by Blake's finally realizing "how lim-

ited the affinity [with Swedenborg] actually was" (Introd. 1)? I hear an anger disproportionate to disagreement and suspect it was fueled by a sense of being fooled, of having signed on and been temporarily a joiner, something he had not been before or after his attending the first General Conference. Blake seems to be redirecting anger outward and away from himself. He creates an angel who changes his Swedenborgian mind, but he himself seems too proud to admit explicitly that he changed his own views. The closest he comes is on plate 3, where he implies that Christ/Blake cast off the linen garments that were Swedenborg's writings, implying that he had once worn them, albeit as a dead body, but now does not. Instead, he insists in his opening sentence that he has *always* found angels to be vain, implying that he had always thought the same about their mouthpiece—or at the very least that he has *never* been fooled by angels but has only recently found Swedenborg to be one, to be of the very party Swedenborg himself criticized. But with whom is Blake trying to set the record straight? Who was the pamphlet's intended audience?

In 1862, Samuel Palmer wrote Anne Gilchrist, recommending that she exclude *Marriage* from the *Life of William Blake* (1863). He did not think the British press or public had the requisite sense of irony to understand Blake's seemingly unchristian statements. He believed one would need to know that "Blake wrote often in anger and rhetorically"—that if provoked by a pretender's cant, he would adopt the ironic stance of "If this is your Heaven, give me Hell" (Bentley, *Blake Records* 319). Indeed, Andrew Cooper finds the work so ironic and "disjointed," and the devil so peremptory, that he cannot imagine Blake having any "real interest in reaching an audience" (51–52). Howard, on the other hand, argues that Blake intended to reach the widest possible audience, one consisting of both angels and devils, and that he wrote with members of the New Jerusalem Church as well as the anti-Swedenborgian Johnson circle in mind (20). This perfectly reasonable hypothesis has been recently questioned by Mee and Scrivener on the grounds that Blake's "bold assertions of visionary experience" (Scrivener 103) and his "enthusiasm . . . would probably have alienated the intellectuals . . . as much as similar features of Swedenborg's writings" (Mee 51).

If we focus on just the pamphlet, the idea that Blake intended *Marriage* for a diversely constituted audience of Swedenborgians, ex-Swedenborgians, and critics may become more palatable. Blake appears to be addressing the "readers of Swedenborg," for whom his first sentence needs no context other than the one they themselves bring. His former Swedenborgian associates would be dismayed by encountering a man who is intent on exposing as a lie the *Minute*'s claim that "there was not a single dissentient voice among us" (130), and on informing them that they were mistaken about him as well as about Swedenborg. To exclude

Swedenborgians in favor of their critics would be to assume that Blake was preaching to the converted, that he did not take seriously the prophetic mantle he defines—or want his many Swedenborgian allusions, puns, and inside jokes to be understood. But neither can a lay audience be excluded. Blake's friends in the Johnson circle, such as Sharp and Priestly, along with some of the writers of the *Analytical Review* who had low opinions of Swedenborg in particular and "news from the spiritual world" in general, would at one level be impressed and/or entertained, finding more evidence of Blake's genius, wit, and originality—and temper.

On the one hand, Blake seems always keen on speaking his mind and on differentiating true from false: "The Vision of Christ that thou dost see / Is my Visions Greatest Enemy," and "Thy Heavens doors are my Hell Gates" (E 524). Blake has it both ways: by parodying Swedenborgian rhetoric, imagery, and events, he attacks Swedenborg even more roughly than the *Analytical Review* does, but he does not attack Vision. His critique is analogous to the reviewers' criticism of Swedenborg's conception of God but not God. On the other hand, Blake's visionary episodes are fictions and were not presented as authentic or quasi-autobiographical episodes. It could be argued that Blake's personal advocacy of vision is not easily discernible through the layers of irony and parody, and thus that his work was safe for rationalist consumption. It cannot be argued, however, that his attack on religion and the religious is obscure. This criticism would have been more offensive than his pseudovisionary episode, which could be read less as millenarian enthusiasm and more as typical underworld satire, as "news from hell" or a "dialogue of the dead" (Tannenbaum 74).

To Blake, both Swedenborg's followers and critics are like conceited angels worshiping Nebuchadnezzar's God. His refusal to differentiate Swedenborgians from rationalists and other systematic reasoners strongly suggests that he would not have retreated from or feared to offend one or the other. To believe that he acted so cautiously is to dismiss the nature of satire, which is to tweak the noses of even those who cheer you on, smugly thinking they are on the side of the angels. Indeed, they are. Mostly, though, it is to ignore entirely "terrible Blake in his pride."

Notes

1 The first essay is entitled "The Evolution of William Blake's *The Marriage of Heaven and Hell* and the third, "The Caves of Heaven and Hell: Swedenborg and Printmaking in Blake's *Marriage*."

2 Plate 4 was written and executed late, but exactly where in the chronology of plate production is not clear; plates 14–15 may have been executed as part of the third stage, along with plates 1–3, 5–11, or, with plate 4, they may have constituted a fourth stage in the evolution of *Marriage*. Plates 25–27 ("A Song of Liberty") may not have been written

and executed as part of *Marriage*, though the text was executed on three copper plates left over from the production of *Marriage* and apparently executed very near or at the same time as *Marriage*'s final section (see essay 1). Before plates 25–27 were printed as part of *Marriage*, they were printed at least twice as separate monochrome pamphlets, i.e., copies M and L, the former untraced but described in an auction catalog as missing the "Chorus" on plate 27. Assuming that the "Chorus" was not masked, the printing sequence (M, L, *Marriage*) is indicated by plate 27 being in its first state in copy M.

3 Blake's Swedenborg is so distorted and one-dimensional that his reasons for taking him seriously seem puzzling. As Michael Ferber rightfully reminds us, however, Swedenborg was much admired in Europe and America in the late eighteenth century and throughout the nineteenth. Even many nonfollowers respected and praised him—Goethe, Coleridge, Balzac, and Emerson among them (90). The extent of his extraordinary, prolific career and influence can be gauged by the essays in Larsen; for Blake's knowledge of and relation to Swedenborgianism, see Davies, Howard, Paley, Thompson, and Bellin and Ruhl; to see how thoroughly Swedenborg permeates *Marriage*, both thematically and rhetorically, see Eaves, Essick, and Viscomi 119 passim and the third essay of this study. The present essay cites Swedenborg frequently and generously to give a sense of his rhetoric and Blake's ear for satirizing it.

4 Referred to as *Marriage* copy K, this printing is neither an incomplete copy of *Marriage* nor a set of proofs. Plates 21 and 24 are in their first states, with the former missing white lines in the hill and the latter missing the illustration of Nebuchadnezzar and the axiom. I suspect that Blake added these features while still thinking in terms of the four-plate unit rather than the larger work of which it became part, because second states usually followed first quickly, as is evinced by the first and second states of plate 27, in copies M and L respectively (n2). In any event, plates 21 and 24 are not proofs, for they were printed as a unit with plates 22 and 23, which were in their final states, and the four plates were as carefully printed as copy L. Indeed, plates 21–24 were printed in black ink on both sides of one conjunct half sheet of paper, which when folded formed a pamphlet with the following configuration: 21/22-23/24. The two plates of the inside form were carefully aligned to one another and registered onto the paper, and the plates of the outside form were registered to them. Equally revealing, the borders of all four plates were carefully wiped of ink so they would not print, a feature Blake employed almost without exception when printing illuminated books between 1789 and 1795, but one unnecessary for pulling working proofs. For a detailed description of *Marriage* copy K and two separate printings of "A Song of Liberty," see essay 1.

5 The name "New Jerusalem" is from Revelation 3.12 and 21.2, passages that Swedenborg believed prophesied the "New Church," the fifth and final Church, which he claimed superseded the old Christian Church, itself preceded by three Churches identified with Adam, Noah, and Israel. Swedenborg dates the end (or "Last Judgment" or "Consummation") of the old Christian Church and beginning of the New Church as 1757 (*True Christian Religion* nn. 753–790 [references to Swedenborg's works are by section number(s) when preceded by "n." or "nn."]; see note 8). For the Theosophical Society's appeal to and initial links with Freemasonry, the Universal Society, and the "Illuminati"—and speculation as to why Hindmarsh sought to cover those links—see Schuchard 42–45 and Thompson 129–45.

6 For an account of the first General Conference, see Hindmarsh 79–84, 97, 101–8, reprinted with the *Minutes* and *Circular Letter* in Bellin and Ruhl 121–31.

7 Most of the propositions in the *Circular Letter* are derived from *True Christian Religion*, parts of which Blake probably read as well as heard. He acknowledged that *The spiri-*

tual Preceptor, his untraced tempera painting, was "taken from the Visions of Emanuel Swedenborg, Universal Theology n. 623" (*A Descriptive Catalogue,* E 546).

8 Blake proclaims confidently on plate 3 that "it is now thirty-three years since [the] advent" of "a new heaven," explicitly alluding to Swedenborg's proclamation that a "Second Advent" and a "New Heaven" began in 1757 and that he is the Lord's vehicle (*True Christian Religion* nn. 772–778). Blake would have known these central doctrines as they were expressed in propositions 38–40 of the *Circular Letter* or in resolution 25 of the *Minutes* (see below). When added to 1757, the number "thirty-three" yields 1790, the "now" of Blake's passage. Blake was born in 1757, making 1790 his thirty-third year; in *Marriage* copy F, Blake penned in the date to anchor the allusion. Of course, "thirty-three" more obviously alludes to Christ's death and resurrection, an allusion confirmed by the plate's second sentence: "And lo! Swedenborg is the Angel sitting at the tomb; his writings are the linen clothes folded up." "Thirty-three years" identifies Blake's life with Christ's and aligns both with the recently revived "Eternal Hell," the creative energy symbolically manifest in the French Revolution and the *Marriage.*

 Technically, the 1790 date applies to the set of plates that plate 3 belongs to; the plates preceding it may be earlier, as I speculated in *Blake* 237, though I believe this is unlikely, given the echoes on plates 21–24 of passages in the first issue of *The New Jerusalem Magazine* and in the *Analytical Review* 5 (both 1790; see note 23 and below). Following plate 3 and its associated plates were plates 14–15, 4, 16–20, and 25–27, which seem materially and textually to have been executed not long afterward.

9 Erdman's dates were followed by most editors and scholars (e.g., Ostriker, Stevenson, Keynes, Grant and Johnson, Bentley). For the full argument for dating *Marriage* 1790 and not c. 1790–93, see Eaves, Essick, and Viscomi 113–16 and Viscomi, *Blake* ch. 26.

10 The Church's first service (January 1788) consisted of a "ceremony written by Hindmarsh" and "conducted by his father, a former Methodist minister" (Bellin and Ruhl 121).

11 There were seventy-seven signers at the conference, fifty-six of whom were identified as church members, and then an additional eighteen names, which is the list the Blakes were on (Thompson 133).

12 In August 1789, the expelled members (save Hindmarsh) formed The Universal Society for the Promotion of the New Jerusalem Church. In 1790, they published six issues of *The New Jerusalem Magazine.* The same year, the increasingly conservative Hindmarsh began publishing a competing journal, *The New Magazine of Knowledge Concerning Heaven and Hell,* which ran for twenty issues. Hindmarsh's magazine was part of his successful attempt to regain control over the Eastcheap congregation (Thompson 140–42). The concubine issue raised its head again one hundred years later, in America, and had similar repercussions (Meyers 46 passim).

13 Thompson persuasively reads "The Divine Image" as an anti-Swedenborgian poem, showing that it expresses the concept of incarnation—of God being embodied in human virtues (146 passim)—which Swedenborg rejects (*Divine Love and Divine Wisdom* n. 125). Its counterpart, "A Divine Image," certainly is anti-Swedenborgian, as is "To Tirzah" (Thompson 149 passim), and both of these poems (pace E 800; Bentley, *Blake Books* 414–17) could have been written and executed c. 1789–90 (see essay 1, n17).

14 The dismissive and caustic tone in the brief review of Peter Provo's *Wisdom's Dictates,* a collection of maxims mostly taken from Swedenborg, was typical: "The disciples of Baron Swedenborg having determined that the best means of propagating the doctrines of the New Jerusalem church will be by publications from the press, we are

likely to have our patience frequently exercised by attending to long communications from the spiritual world. Well, we must read, though it be often with weary and distracted attention" (5 [1789]: 352). The review of *The Wisdom of Angels Concerning Divine Love and Divine Wisdom* is equally sarcastic: "More news from the spiritual world! If this be not angelic wisdom, it is something so wholly beyond the comprehension of our weak intellects, that it must needs relate to beings of a very different order. But our business is analysis: yet, gentle reader, what can we do, when the different chapters or sections, are 432 in number, and the table of contents occupies 22 pages!" (5 [1789]: 352). In place of analysis, the reviewer quotes verbatim the contents page for pt. 2, apparently believing it was self-evidently opaque.

15 Joseph Priestley, one of Johnson's most prolific authors, wrote *Letters to the Members of the New Jerusalem Church* in 1791. Though printed in Birmingham, the letters were revised in London and sold at Johnson's shop. Like Johnson's reviewers, Priestley found precedent for Swedenborg's doctrines, and, as Howard points out, Priestley conversed with Hindmarsh and other Swedenborgians before publishing his letter (30). Presumably, he also spoke to ex-Swedenborgians as well. Two such creatures in the Johnson orbit were William Sharp and his fellow engraver, William Blake. Sharp had joined the Theosophical Society in 1784, though by 1790 he was a follower of Richard Brothers. The appendix to his *Letters* suggests that Priestley may have spoken with Blake. It reproduces much of n.61 of Swedenborg's *Concerning the Last Judgment and the Destruction of Babylon* (London, 1788), the source of Blake's Leviathan imagery on *Marriage* plates 17–19. A recently discovered letter by Keri Davies from September 1794 (presented at the Blake 1794–1994 conference at Strawberry Hill, July 1994) verifies what has long been suspected, that Blake sold or at least showed copies of illuminated books at Johnson's shop in the early 1790s.

16 When printed, *Marriage* copy K was, at four pages, the second longest continuous illuminated text; the longest was *Thel*, at five pages of text (plates 3–7) plus a title but still minus the motto and concluding plate (see essay 1). It belonged to an age of published sermons, essays, and lectures, of pamphlets on religious, aesthetic, political, and economic debates and controversies (see Aspinall 152, 436–38, and the bibliographies in Hole and Wood). Johnson himself was a prolific publisher of pamphlets, as the extensive "catalogue of Books and Pamphlets" published in the *Analytical Review* indicates. In 1790, he had hired Mary Wollstonecraft, whose "daily occupation" was "translating from the French the political pamphlets of the day, which at this time met with a ready and rapid sale, and in writing criticisms on them as well as upon other subjects, for the Analytical Review" (Knowles 1: 162). Blake expressed his respect for the form when complimenting Paine, whom he credited with "overthrow[ing] all the armies of Europe with a small pamphlet" (E 617), referring presumably to *Common Sense* (1776).

17 The association between Adam and Christ is commonplace in paintings and prints of the Crucifixion, which invariably place a skull at the foot of the cross to represent Adam. (In the reworked version of this image, *America* plate 8, the skull is more clearly drawn.) Adam is also mentioned or implied on *Marriage* plates 2 and 3.

18 Blake conflates John 20.5–12 and Luke 24.12 with Mark 16.6 and Matthew 28.3–6, in that the former evangelists record two angels (in shining garments) and linens at the resurrection, and the latter record one angel (also dressed) but no linens. The resurrection imagery is possibly an allusion to Easter Week, when the New Church's first and second General Conferences were held. Throughout the *Marriage*, Blake associates Swedenborg with heaven, angels, and passivity and Christ with devils, hell, and energy (plates 6, 22–23). In this light, the "new heaven" embodies the tombed or dead rather than living Christ. "Tomb" may allude also to the fact that Swedenborg's tomb was

opened twice in 1790, only to reveal the unresurrected mystic and an overwhelming stench (Paley 25-26).

19 The word "systematic" suggests that Blake may also be alluding to Swedenborg's claim that he was "prohibited [from] reading dogmatic and systematic theology" until "heaven was opened" to him. This claim accompanied his denial of having read Boehme and was published "early in 1790" in *New Jerusalem Magazine* (p. 73; qtd. in Paley 27). Swedenborg, however, apparently did read Boehme in his youth, and Blake appears to have read Swedenborg "through hazes which arose probably from similar Behmenist fires" (Thompson 133 and n12; on Blake and Boehme, see also Davies, Punter, and Aubry). Blake, however, inverts Swedenborg's causality, implying that Swedenborg's heaven grew out of—or sprouted from—"systematic reasoning." A vision "owing to your metaphysics" (plate 19) is how Blake will later articulate the concept of perception determined by precepts. Blake may have derived his vegetation metaphor of "sprouting" from the *Circular Letter*'s proposition 7, which addresses the same concept: doctrines of the Old Church "ingraft in . . . infant minds principles diametrically opposite to those of the New Church, and consequently hurtful to their salvation" (122).

20 "The Lucianic or News from Hell tradition" (Tannenbaum 75) would have prepared Blake's audience for "news from the spiritual world," as would the Swedenborgian context, which presupposes discussions with angels—and vice versa. Note 846 of *True Christian Religion*, which was read at the first General Conference (Bellin and Ruhl 126), begins: "I was once raised up as to my Spirit into the Angelic Heaven, and introduced to a particular Society therein; and immediately some of the wise Ones of the Society came to me and said, What News from Earth?"

21 As Linnell explains, "Blake claimed the possession of some powers only in a greater degree that all men possessed and which they undervalued in themselves & lost through love of sordid pursuits—pride, vanity, & the unrighteous mammon" (Bentley, *Blake Records* 257; see also 317).

22 These two errors "hath perverted the whole Christian Church, so that nothing spiritual is left remaining in it" (*Circular Letter* [prop. 4]: 122). Hindmarsh identified them as fundamental (9 passim, 24, 51), and they are mentioned in resolutions 2, 5, 9, 10, 22, 23, and 26 of the *Minutes*. Blake agreed with Swedenborg about the atonement, likening the Crucifixion to blood sacrifice (see *Book of Los* [E 90-94] and *Ghost of Abel* [270-72]), and he appears to agree with Swedenborg about the Trinity. "Know that after Christs death, he became Jehovah. But in Milton; the Father is Destiny, the Son, a Ratio of the five senses. & the Holy-ghost, Vacuum!" (*Marriage* plate 6).

23 The *Marriage* associates this progress with the coexistence and healthful tension of contraries (plate 3). It also, however, links it to an awareness of the Poetic Genius, a single point of origination from which all is derived. As essay 1 notes, the metaphysical framework of contraries, which theoretically implies a "dialectical symmetry" (Eaves, Essick, and Viscomi 121) and thus the idea that opposing views are equally valid—or invalid, partisan, and ironic—is undercut in practice by the satiric convention of turning the world upside down. Just as Blake and the devil's positions are favored, so, too, is the concept of Poetic Genius over contraries. As a philosophical satirist, Blake sets out to restore Poetic Genius to its "rightful hegemony" (Tannenbaum 88). Moreover, that the devil speaks for Blake on plates 21-24 is indicated by Blake's reworking "many of the same themes some years later and in his own voice in 'The Everlasting Gospel'" (Thompson 173). For the view that Blake never "speaks straight" (Bloom, "Dialectic" 49) and *Marriage* lacks an authoritative voice, see Gleckner 71-116, Cooper, and Miller.

24 For Blake's criticism of the Venetian and Flemish schools of painting, see his anno-

tations to Reynold's *Discourses* (c. 1808) (E 635–62), *Descriptive Catalogue* (1809) (E 528–51), and *Public Address* (c. 1810) (E 578–82).

25 Blake will again allude to Swedenborg's many volumes on *Marriage* plate 19, where, carrying them as an anchor or heavy weight, he "sunk from the glorious clime, and . . . into the void."

26 At the opening of the first General Conference, n. 851 of *True Christian Religion*, which defines a Memorable Relation, was read (Bellin and Ruhl 126). "I am aware that many, who read the Memorable Relations . . . will conceive that they are the Fictions of Imagination; but I protest in Truth that they are not Fictions, but were really seen and heard . . . in a State when I was broad awake; for it hath pleased the Lord to manifest Himself to me, and to send me to teach the Things relating to his New Church . . . for which Purpose he hath opened the Interiors of my Mind, or Spirit, by Virtue of which Privilege it was granted me to have Commerce with Angels in the spiritual World, and at the same Time with Men in the natural World."

27 Blake echoes Lavater's axiom: "He who hates the wisest and best of men, hates the Father of men, for, where is the Father of men to be seen but in the most perfect of his children?" Blake substituted the word "love" for "hate," underlined the last fifteen words and wrote: "this is true worship" (E 596). Lavater also wrote: "He who adores an impersonal God, has none; and, without guide or rudder, launches on an immense abyss that first absorbs his power, and next himself." Blake underlined the sentence and wrote: "most superlatively beautiful" (E 596). In the *Marriage,* Blake's opposition to the idea of an impersonal, external God is expressed at the bottom of plate 11, where a man flees a sky God by swimming in an "immense abyss," and, just above that, worshippers kneel before a headless figure standing with a sword. To Swedenborg's *Divine Love* n. 11, that "In all the Heavens there is no other Idea of God than that of Man," Blake responds: "man can have no idea of any thing greater than Man . . . But God is a man not because he is so perceived by man but because he is the creator of man" (E 603). The concept of an incarnate God expressed on *Marriage* plate 23 was echoed on plate 3 and restated explicitly and precisely on plate 16 as "God only Acts & Is. in existing beings or Men." See also *Jerusalem* 91: 4–12 (E 251).

28 To Lavater's claim that the "greatest of characters . . . was he, who . . . could see objects through one grand immutable medium, always at hand, and proof against illusion and time, reflected by every object, and invariably traced through all the fluctuation of things," Blake wrote: "[T]his was Christ" (E 584).

29 Blake describes heaven as "One Man" when perceived from a distance and a "Multitude of Nations" when perceived nearby in *Vision of the Last Judgment* and *Vala* 1:469–75 (E 556–57, 310–11). On plate 23, though, could Blake be punning on the London location of the Swedenborgians' General Conferences, which were held in a hired chapel in Great East Cheap (also spelled Great Eastcheap)?

30 Thompson argues that Blake's angel, who turns "blue," "yellow," and finally "white pink," alludes to a Memorable Relation published in the first issue of *The New Jerusalem Magazine* (Jan. 1790), which records a devil whose face turned from "white living" to "dead pale" to "black" (141). For another possible reference to this issue of the magazine, see n119.

31 "No Subscriptions for the numerous great works now in hand are asked, for none are wanted; but the Author will produce his works, and offer them to sale at a fair price" (E 693). Blake priced *Marriage* at 7s. 6d. (E 693), the same price as *Divine Providence*, which Hindmarsh began advertising in 1789 as being "now in Press . . . 6s. to subscribers and 7s.6d. to nonsubscribers."

32 Publishers regularly affixed lists of publications and announcements of forthcoming works at the back of their books. But the Swedenborgian context suggests that Blake may be alluding to Robert Hindmarsh, Swedenborg's publisher, who published his *Catalogue of the Printed and Unprinted Works of the Hon. Emanuel Swedenborg* in 1785 for 30d. He appended an updated list of books and their prices to all the Swedenborgian books he printed and/or sold. The last page of *Extracts from the Doctrines of the New Jerusalem Church* (Birmingham, 1789), a thirty-six-page pamphlet, lists twenty-one books in translation. The last pages of *Short Account of the Hon. Emanuel Swedenborg and His Theological Writings* (London, 1790) list thirty-four books, including ten in Latin. Both lists include the *Minutes of a General Conference of the Members of the New Church held in Great East Cheap, London, in April, 1789*, which is priced in the latter list at six pence. By 1795, at the back of the third edition of *True Christian Religion*, forty-five books were listed, including ten in Latin and excluding the *Minutes*. Little wonder reviewers complained about yet "more news from the spiritual world."

33 Lansverk's study is the most extensive to date on Blake's proverbs and their relation to the Bible and other predecessors, and on the proverbial form of expression in Blake's other illuminated books. For the literary, biblical, and performative contexts of the proverbs, see also Niimi, Villalobos, Holstein, and Edwards. On thematic grounds, Nurmi and Ferber have speculated that the Proverbs of Hell may have been intended as or to form part of Blake's Bible of Hell (79, 102 respectively), though neither explains why the former are in the work that announces the latter. Lansverk argues that *Marriage* is itself sprinkled throughout with maxims, parables, fables, and riddles, making it Blake's version of the Book of Proverbs (95).

Blake's proverbs are actually closer to aphorisms than proverbs (Edwards 46), and as such they appear to have been influenced in part by Lavater's *Aphorisms on Man* (1788). Blake may have read or been familiar with Dr. Trusler's *Proverbs Exemplified* of 1790. He probably knew of the Swedenborgian *Psalms of David, with a Summary Exposition of the Internal Sense*, published in 1789 and sold by Hindmarsh for three shillings. He seems certainly to have known Peter Provo's *Wisdom's Dictates*, "a collection of maxims and observations concerning divine, and spiritual truths. . . . Extracted . . . particularly from [the works] of Emanuel Swedenborg," published in 1789 and sold by Hindmarsh for 1s. 6d. and, as noted, briefly reviewed in Joseph Johnson's *Analytical Review* 5 (1789): 352.

34 According to W. M. Rossetti, Blake wrote on the verso of an undated drawing "in title-page form, 'The Bible of Hell, in Nocturnal Visions collected. Vol. I. Lambeth.'" (Gilchrist 2: 240). This apparent sketch for a title page, untraced since 1876 (Butlin 221v), confirms that Blake intended "The Bible" to be a separate work, as announced on plate 24. No such work is extant, but the phrase "visions collected" calls to mind "I collected some of their Proverbs" (plate 6), raising the possibility that Hell's Bible was to be the seventy proverbs—that is, a collection of challenging infernal truths—or that it was to be a collection of various infernal texts, a series of discrete and similarly printed illuminated pamphlets written from the infernal perspective that included the proverbs.

Announcing enthusiastically works not yet completed, started, or ever executed seems characteristic of Blake. His *French Revolution* (1791), printed as a sixteen-page pamphlet, exists in a single copy and was advertised as being one of seven books, all of which were supposedly "finished, and will be published in their Order" (E 286). But no evidence exists to prove they were ever written. In his advertisement for illuminated books (1793), Blake announced the "small book of Engravings" entitled *The History of England* (E 693), of which there is no trace. Imagining new projects as being

multivolumed also appears characteristic of Blake, who titled *The Book of Urizen* as the "First Book" and *Milton* as being "in 12 Books."

35 These four parts represent Aristotle's reduction of the seven parts of the classical oration (Lanham 112). The first to discern a structure to the seemingly structureless *Marriage* was Max Plowman, who defined it as being in three parts—a prologue, six chapters, and an epilogue—and defined the chapters as consisting of statement followed by illustrative narrative framed by illustrations (xxiii). Nurmi also sees a tripart structure at work, with the thematic focus moving from perception to contraries and back to perception (76).

36 George III lapsed into porphyria-induced madness in the fall of 1788, which lasted until early spring 1789. The progress and treatment of the king's madness was exhaustively reported in the press (Carretta 162). Erdman has argued convincingly that Blake used the mad king (as well as Shakespeare's Lear) around 1789 as a model for Tiriel, who was "King of the west" (E 284; *Blake* 121-23). Tiriel as tyrant and hypocritical lawgiver anticipates Urizen, and, as is suggested by the borrowing of the axiom on plate 25 from *Tiriel* (E 285), he may have influenced the idea to depict Swedenborg as a demented king. Blake was apparently reading Swedenborg when composing *Tiriel*, for Tiriel's brother Ijim was probably derived from Jiim, mentioned in *True Christian Religion* n. 45, which describes "diabolical Love" as "the Love of Self."

37 Daniels' friends were named Shadrach, Meshach, and Abednego. Blake is believed to have executed a painting entitled *Shadrach and his companions coming from the Fiery Furnace*, c. 1825, which is now untraced (Butlin 776). This episode is echoed in *Marriage* plate 6: "the Jehovah of the Bible being no other than he who dwells in flaming fire. Know that after Christs death, he became Jehovah." If Christ is of the devil's party, then so is Jehovah, and the angel's vindictive God is inferred from Mosaic Law and not vision.

38 See Paley 28-31 for a discussion of Swedenborg in Blake's later works.

Works Cited

Addison, Joseph. *The Spectator*. Ed. Gregory Smith. Everyman's Library, 4 vols. London: Dent; New York: Dutton, 1961-63.

Aspinall, Arthur. *Politics and the Press c. 1780-1850*. London: Home & Van Thal, 1949.

Aubrey, Bryan. *Watchmen of Eternity: Blake's Debt to Jacob Boehme*. New York: UP of America, 1986.

Bellin, Harvey, and Darrell Ruhl, eds. *Blake and Swedenborg: Opposition Is True Friendship*. New York: Swedenborg Foundation, 1985.

Bentley, G. E., Jr. *Blake Records*. Oxford: Clarendon, 1969.

———. *Blake Books: Annotated Catalogues of William Blake's Writings in Illuminated Printing*. Oxford: Clarendon, 1977.

Bloom, Harold. "Dialectic of *The Marriage of Heaven and Hell*." *William Blake's "The Marriage of Heaven and Hell"*. Ed. Harold Bloom. New York: Chelsea, 1987. 49-56.

———. Introduction. *William Blake's "The Marriage of Heaven and Hell"*. Ed. Harold Bloom. New York: Chelsea, 1987. 1-24.

Butlin, Martin. *The Paintings and Drawings of William Blake*. 2 vols. New Haven: Yale UP, 1981.

Carretta, Vincent. *George III and the Satirists from Hogarth and Byron*. Athens: U of Georgia P, 1990.

Circular Letter. London, 1788. Rpt. Bellin and Ruhl. 122-25.

Cooper, Andrew, M. *Doubt and Identity in Romantic Poetry*. New Haven: Yale UP, 1988.

Davies, J. G. *The Theology of William Blake*. Oxford: Oxford UP, 1948.

Eaves, Morris. *The Counter Arts Conspiracy: Blake in the Age of Art and Industry*. Ithaca: Cornell UP, 1992.

Eaves, Morris, Robert N. Essick, Joseph Viscomi, eds. *The Early Illuminated Books*. Princeton: Princeton UP, 1993.

Edwards, Gavin. "Repeating the Same Dull Round." *Unnam'd forms: Blake and Textuality*. Ed. Nelson Hilton and Thomas Vogler. Berkeley: U of California P, 1986. 26–48.

Erdman, David V. *Blake: Prophet against Empire*. Princeton: Princeton UP, 1954.

———, ed. *Complete Poetry and Prose of William Blake*. Commentary Harold Bloom. Rev. ed. New York: Doubleday, 1988.

Essick, Robert N. *William Blake and the Language of Adam*. Oxford: Clarendon, 1989.

———. "Representation, Anxiety, and the Bibliographic Sublime." *Huntington Library Quarterly*. Forthcoming.

Ferber, Michael. *The Poetry of William Blake*. London: Penguin, 1991.

Gilchrist, Alexander. *Life of William Blake*. 2 vols. London: Macmillan, 1863; 2nd ed., 1880.

Gleckner, Robert F. *Blake and Spenser*. Baltimore: John Hopkins UP, 1985.

Grant, John E., and Mary Lynn Johnson. *Blake's Poetry and Designs*. New York: Norton, 1979.

Hindmarsh, Robert. *Rise and Progress of the New Jerusalem Church*. Ed. Rev. Edward Madeley. London, 1861.

Hole, Robert. *Pulpits, Politics and Public Order in England: 1760–1832*. Cambridge: Cambridge UP, 1989.

Holstein, Michael E. "Crooked Roads without Improvement: Blake's Proverbs of Hell." *Genre* 8.1 (1975): 26–41.

Howard, John. "An Audience for *The Marriage of Heaven and Hell*." *Blake Studies* 3 (1970): 19–52.

Keynes, Geoffrey, ed. *The Complete Writings of William Blake*. London: Oxford UP, 1966.

Knowles, John. *The Life and Writings of Henry Fuseli*. 3 vols. London: H. Colburn and R. Bentley, 1831.

Lanham, Richard A. *A Handlist of Rhetorical Terms*. Berkeley: U of California P, 1968.

Lansverk, Marvin D. L. *The Wisdom of Many, the Vision of One: The Proverbs of William Blake*. New York: Peter Lang (series 4, English Language and Literature, vol. 142), 1994.

Larsen, Robin, et al., eds. *Emanuel Swedenborg: A Continuing Vision, a Pictorial Biography and Anthology of Essays and Poetry*. New York: Swedenborg Foundation, 1988.

Mee, Jon. *Dangerous Enthusiasm: William Blake and the Culture of Radicalism in the 1790s*. Oxford: Clarendon, 1992.

Meyers, Mary Ann. *A New World Jerusalem: The Swedenborgian Experience in Community Construction*. Westport: Greenwood, 1983.

Miller, Dan. "Contrary Revelation: *The Marriage of Heaven and Hell*." *Studies in Romanticism* 24 (winter 1985): 491–509.

Minutes of the First General Conference of the Members of the New Jerusalem Church. London: Hindmarsh, 1789. Rpt. Bellin and Ruhl. 125–30.

Niimi, Hatsuko. "The Proverbial Language of Blake's *Marriage of Heaven and Hell*." *Studies in English Literature* (1982): 3–20.

Nurmi, Martin, K. *William Blake*. Kent: Kent State UP, 1976.

Ostriker, Alicia, ed. *William Blake: The Complete Poems*. New York: Penguin, 1977.

Paley, Morton. "'A New Heaven Is Begun': William Blake and Swedenborgianism." *Blake / An Illustrated Quarterly* 13 (1979): 64–90. Rpt. in Bellin and Ruhl. 15–34.

Plowman, Max, ed. *The Poems and Prophecies of William Blake*. New York: Everyman's Library, 1927.

Priestley, Joseph. *Letters to the Members of the New Jerusalem Church, formed by Baron Swedenborg.* Birmingham: Thomson, 1791.

Punter, David. *Blake, Hegel, and Dialectic.* Amsterdam: Rodolphi, 1982.

Schuchard, Marsha Keith. "The Secret Masonic History of Blake's Swedenborg Society." *Blake / An Illustrated Quarterly* 26 (1992): 40–50.

Scrivener, Michael. "A Swedenborgian Visionary and *The Marriage of Heaven and Hell.*" *Blake / An Illustrated Quarterly* 21 (winter 1987–88): 102–4.

Stevenson, W. H., ed. *Blake: The Complete Poems.* 2nd ed. London: Longman, 1989.

Swedenborg, Emanuel. *A Treatise Concerning Heaven and Hell.* London: Phillips, 1778.

———. *A Treatise Concerning the Last Judgment and Destruction of Babylon.* London: Hindmarsh, 1788.

———. *True Christian Religion, Containing the Universal Theology of the New Church.* 2nd ed. London: Hindmarsh, 1786; 3rd ed., 1795.

———. *The Earths in Our Solar System, Which are Called Planets.* Boston: Massachusetts New-Church Union, 1910.

———. *A Compendium of the Theological Writings of Emanuel Swedenborg,* including *Wisdom of Angels Concerning Divine Love and Wisdom; Wisdom of Angels Concerning Divine Providence; Apocalypse Revealed.* Comp. Samuel M. Warren. 1875; rpt. New York: Swedenborg Foundation, 1974.

Tannenbaum, Leslie. "Blake's News from Hell: *The Marriage of Heaven and Hell* and the Lucianic Tradition." *ELH* 43 (1976): 74–99.

Thompson, E. P. *Witness against the Beast: William Blake and the Moral Law.* New York: New Press, 1993.

Villalobos, John. "William Blake's 'Proverbs of Hell' and the Tradition of Wisdom Literature." *Studies in Philology* 87 (spring 1990): 246–59.

Viscomi, Joseph. *Blake and the Idea of the Book.* Princeton: Princeton UP, 1993.

———. "The Evolution of William Blake's *The Marriage of Heaven and Hell.*" The *Huntington Library Quarterly* 58.3–4 (1997).

———. "The Caves of Heaven and Hell: Swedenborg and Printmaking in Blake's *Marriage.*" *Blake in the Nineties.* Ed. David Worrall and Steve Clark. London: Macmillan, 1998.

Wood, Marcus. *Radical Satire and Print Culture: 1790–1822.* Oxford: Clarendon, 1994.

Young, Edward. *Conjectures on Original Composition.* London, 1759.

Coleridge's Lessons in Transition:

The "Logic" of the "Wildest Odes"

H. J. JACKSON

*W*e know that Coleridge was an educator and a champion of education all his life. One of the options that he considered when he began to have to earn his living was teaching, which he thought of doing either as a master in his brother George's school, or more independently as a tutor in a private family, or in partnership with his then-friend Basil Montagu. He began inauspiciously with Charles Lloyd, who went mad. But as time went on he tried out a variety of pedagogic arrangements that worked rather better: formal lessons for his own children and the Gillman boys, public lectures in London and in Bristol, private study with medical friends, and so on. About 1822 he advertised a class in logic, seeking "five or six men, who are educating themselves for the Pulpit, the Bar, the Senate, or any of those walks of Life, in which the possession and the display of intellect are of especial importance" (*Logic* lix). Several of his publications are overtly didactic: *Aids to Reflection* was addressed to young men embarking on professional training (particularly the ministry), and the "Treatise on Method" was composed as the preface to an encyclopedia before being rewritten as a special section of the 1818 *Friend*. Coleridge's last major work, the monograph *On the Constitution of the Church and State* of 1829, famously proposes to recognize and give political power to a distinct class that Coleridge there calls the "clerisy" (46–47) and elsewhere "men of education" (*Shorter Works* 920).

Somewhere about the midpoint of his career, Coleridge tried to express his idea of the aim and proper outcome of the educational process. "What is that which first strikes us, and strikes us at once, in a man of education?" (*Friend* 1: 448). His answer was that no matter how brief the encounter or how trivial the subject, the conversation of such a man would reveal a certain habitual mental discipline or "method." Method, he explained, demonstrates the ability to envisage the whole while unfolding the parts; it "implies a *progressive transition*" (457; emphasis in original); further, it

"supposes . . . progressive transition without breach of continuity" (476). Now this all sounds very fine, but how is it done, and how do we learn to do it? Although the importance of the doctrine of method has long been recognized in Coleridgean circles and several able and eminent critics have demonstrated its value as an explanatory tool,[1] the technique of transition, by which method is manifest, so far lacks clear definition. In this essay I shall explore the phenomenon of transition to find out what it meant to Coleridge and his contemporaries, explain how it may be related to other issues in rhetoric and logic, and consider some of the social and political implications of the Coleridgean version of it.

Wordsworth provides a useful starting point with the somewhat mysterious sentence that he appended as a note to "Tintern Abbey" in 1800: "I have not ventured to call this Poem an Ode; but it was written with a hope that in the transitions, and the impassioned music of the versification, would be found the principal requisites of that species of composition" (*Poetical Works* 2: 517). The conjunction of "transitions" with "music" here might suggest that Wordsworth had in mind "transition" in the specialized sense associated with musicians, namely "the passing from one key to another, modulation" (*OED*); but since he uses the word casually and familiarly, as though assuming that all his readers would know what he meant, this technical meaning seems unlikely. On similar grounds we can dismiss the possibility that he might in this context be invoking "transition" in the sense of *transitio* or *metabasis,* that figure of rhetoric that explicitly signals the passing from one subject to another.[2] The consensus among modern commentators is that what Wordsworth was referring to had something to do with the sequence of ideas in the poem,[3] and in this conclusion we are supported both by the common usage of the period and by the language of standard and representative critical guides. Samuel Johnson, who described the greater (Pindaric) ode in the *Dictionary* as characterized "by sublimity, rapture, and quickness of transition," defined "transition" in turn as the "passage in writing or conversation from one subject to another," and although this broad general definition would naturally accommodate the overt practice of *transitio,* the requirement of quickness rules out *transitio* in the case of the ode. Johnson appears to have considered Pindar's odes in general as deficient in "smoothness of transition and continuity of thought," but he praised Cowley for an ode in which "the thoughts, which to a reader of less skill seem thrown together by chance, are concatenated without any abruption" ("Cowley" 47, 43). Hugh Blair, likewise, deplores the undisciplined composition of odes in which the poet "gets up in the clouds; becomes so abrupt in his transitions; so eccentric and irregular in his motions, and of course so obscure, that we essay in vain to follow him, or to partake of his raptures"; the "transitions from thought to

thought" must at least, he says, "preserve the connection of ideas, and shew the Author to be one who thinks, and not one who raves" (3: 132). "Transition" in this context evidently denotes not the thoughts themselves but an especially smooth and rapid way of linking them. Neither Blair nor Johnson implies that transitions in the ode need or ought to be clearly articulated.

Out of this background emerges the apparently paradoxical statement that Coleridge makes about an aspect of his own schooling at the hands of Mr. Bowyer: "I learnt from him, that Poetry, even that of the loftiest, and, seemingly, that of the wildest odes, had a logic of its own, as severe as that of science; and more difficult, because more subtle, more complex, and dependent on more, and more fugitive causes" (*Biographia* 1: 9). Coleridge's word is not "transition" but "logic," and the reader may wonder whether there has not been a change of topic here, perhaps even the flagrant sophism of *metabasis eis allo genos* ("transition into another kind") that Coleridge, using the Greek equivalent of the Latin *transitio*, liked to catch in other people's work (*Aids* 223n26). But when we take into account the commonplaces of discussions about the ode, and remember that in the eighteenth century treatises on logic could be subtitled "the art of thinking,"[4] it is clear that Coleridge is not making any new claims for the ode, and that the provocative word "logic" is a kind of hyperbolic translation of Johnson's point about transition: even in the ode, the thoughts should ideally be "concatenated without any abruption." His statement marks a change of angle or emphasis rather than a change of topic, for it suggests that mental activity and the representation of mental activity need to be defined less narrowly than before and recognized wherever they occur. The ode supplies an example of unusual literary sophistication that nevertheless falls within the bounds of logic broadly considered.

Coleridge's own odes exhibit the kind of concatenation of thought that he and Johnson had in mind, although it is difficult to use them without extensive quotation. Because they were expected to change course without warning, Pindaric odes in English were often preceded by prose statements that helped readers to keep their bearings. Coleridge's *Ode to the Departing Year* (1796) begins with such an "Argument":

> The Ode commences with an address to the Divine Providence that regulates into one vast harmony all the events of time, however calamitous some of them may appear to mortals. The second Strophe calls on men to suspend their private joys and sorrows, and devote them for a while to the cause of human nature in general. The first Epode speaks of the Empress of Russia, who died of an apoplexy on the 17th of November, 1796; having just concluded a subsidiary treaty with the Kings combined against France. The first and second Anti-

strophe describe the image of the Departing Year, etc., as in a vision. The second Epode prophesies, in anguish of spirit, the downfall of this country. (*Complete Poetical Works* 1: 160)

In this raw form, the ideas of the *Ode* certainly cry out for rationalization as a linked set. In the poem itself, the overriding situation of prophetic vision, the narrative drift from past to future, and the consistent use of Revelations as a source of imagery bind one section to another in a conventional and convincing way. By the time Coleridge wrote *Dejection* he had no need of an "Argument"; and he had all along been experimenting with formally less ambitious meditative poems that he called "desultory" poems (*Religious Musings*), "reflections" (*Reflections on Having Left a Place of Retirement*), or "conversation" poems (*The Nightingale*), until he achieved the almost perfect modulation of ideas that we associate with *This Lime-Tree Bower My Prison* and *Frost at Midnight*.

The extreme case of the ode, however, brings to our attention several significant features of Coleridge's doctrine of transition. In the first place, if logic and method denote a whole process of consecutive, sequential, purposeful mental activity, the ode highlights the role of transition in that process (or the representation of it), because transitions in the ode are said to be especially quick, as Johnson put it, or—to adopt Coleridge's word—fugitive, and consequently may appear to be absent altogether. In Part 4 of his very influential *Logick*, Isaac Watts, turning to matters of "disposition and method," urges his readers to remember to "*Keep your main End and Design ever in View,*" to avoid "*huge Chasms or Breaks,*" and to "*Acquaint yourself with all the proper and decent Forms of Transition from one Part of a Discourse to another, and practise them as Occasion offers*" (364). Along with all his classically educated contemporaries, Coleridge knew what those "proper and decent Forms" were: when he has occasion in published work to mention "the too common transition *in contraria*" or "the transition . . . from the giver to the gift," for instance, it does not occur to him that there is any need for further explanation (*Shorter Works* 1023, 1281). Peacham (175) lists seven common ways (from the equal, from the unequal, from the like, from consequents, etc.) and gives examples, as "I have staied too long in lamentable matters, I wil now make mention of some pleasant reports." It seems to have been generally accepted that in ordinary public discourse the speaker would deliberately draw attention to the passage from one subject to another, but that in poetry it would more elegantly go unmarked.

Second, it is clear that under normal circumstances, the "logic" of such advanced forms as the ode is accessible only to a rather special audience, one equipped to recognize the transitions when they occur—in other words, to an audience educated along the same lines as the author. This

fact is implicit in Johnson's account of Cowley's ode ("to a reader of less skill" the collection of thoughts appears arbitrary) and indeed in Coleridge's tribute to the "method" of the man of education—it takes one to know one.[5] Recent studies of audience formation in the Romantic period touch on this point. Tim Fulford has written persuasively about Coleridge's desire for "an audience gained by participation in a sympathetic coterie" (31). And Jon Klancher, taking a broader view, has carefully analyzed Coleridge's attempt, in a period of expansion and subdivision of readerships, to "construct an audience that was *also* an institution" (151) by writing in a style so convoluted that only an initiate could follow it (152, 157).

Coleridge's convoluted prose style was achieved partly through his understanding of poetic forms such as the ode. The final lesson to note in this brief study of transition in the ode is that lyric poetry gave Coleridge a model for richer, subtler, and more challenging forms of transition than were generally taught in the logic manuals or encountered in public discourse. His own statement about the logic of the ode implies a recognition of this possibility, and several casual remarks show that he was well aware of precedents for what he aspired to do. In a note on *All's Well,* for instance, he writes appreciatively of Shakespeare's "manner of connection by unmarked influences of association from some preceding metaphor. This it is which makes his style so particularly vital and organic."[6] (It is important to remember that in Coleridge's view, Shakespeare was not merely linking ideas by a chain of associations but linking them methodically, according to some leading idea; hence "vital and organic.") In a Latin metrical exercise of about 1819 Coleridge observes that "Lyric Poetry requires a more condensed style and fewer *words* of connection than the narrative or Virgilian Verse does. What is *expressed* in epic poetry may often be *understood* (subintelligitur) in Lyric" (*Shorter Works* 811). What Coleridge, with his contemporaries, knew about transition from the practice of poetry was carried over into his prose. He became an adept in the art of suppressed or concealed transition.

Supporting what Coleridge might have learned from the poetic tradition was another, much humbler literary form, the familiar letter. In the rhetorical system of the late eighteenth century, it, too, was licensed to suppress transitions. The standard view is articulated and exemplified in a playful passage by Samuel Johnson, taken from a letter written to Hester Thrale (*Letters* 3: 237):

> Now you think yourself the first Writer in the world for a letter about nothing. Can you write such a letter as this. So miscellaneous, with such a noble disdain of regularity like Shakespears works, such graceful negligence of transition like the ancient enthusiasts. The pure

voice of nature and of Friendship. Now of whom shall I proceed to speak? Of whom but Mrs. Montague, having mentioned Shakespeare and Nature does not the name of Montague force itself upon me. Such were the transitions of the ancients, which now seem abrupt because the intermediate idea is lost to modern understandings.

The affectation of "graceful negligence of transition" was one of the conventions of the letter form, which aimed to create an impression of private, intimate, spontaneous talk—the "pure voice of nature and of Friendship." As Johnson observes, the trick of such seeming negligence is to leave out "the intermediate idea": in this case, he can pass from Shakespeare to Elizabeth Montagu without "abruption" and yet without having to explain that Mrs. Montagu had written a book extolling Shakespeare's works as "the greatest monuments of the amazing force of nature" (3: 11), because his correspondent already knows that, and he knows that she does. In other words, letters are under the same broad obligation to be logically coherent as any other verbal composition, but like the ode they are privileged by being permitted shortcuts, in the matter of transition, on the basis of common ground between writer and reader. In fact, the more elliptical the transitions, the more artful and fully personalized the letter becomes. Coleridge's letters are masterpieces of their kind, for he writes in such a way as to make almost every correspondent into an intimate.

For a fine example in which both subject and form are relevant to the topic of transition, we may consider part of a letter that he wrote to a recent acquaintance, William Sotheby, on 13 July 1802 (*Collected Letters* 2: 810). Sotheby had suggested that Coleridge might translate Salomon Gessner's prose poem *Der erste Schiffer*. Coleridge has decided against it:

> It is easy to cloathe Imaginary Beings with our own Thoughts & Feelings; but to send ourselves out of ourselves, to *think* ourselves in to the Thoughts and Feelings of Beings in circumstances wholly & strangely different from our own/ hoc labor, hoc opus/ and who has atchieved it? Perhaps only Shakespere. Metaphisics is a word that you, my dear Sir! are no great Friend to/ but yet you will agree, that a great Poet must be, implicitè if not explicitè, a profound Metaphysician. He may not have it in logical coherence, in his Brain & Tongue; but he must have it by *Tact*/ for all sounds, & forms of human nature he must have the *ear* of a wild Arab listening in the silent Desart, the eye of a North American Indian tracing the footsteps of an Enemy upon the Leaves that strew the Forest—; the *Touch* of a Blind Man feeling the face of a darling Child—/and do not think me a Bigot, if I say, that I have read no French or German Writer, who appears to me to have had a *heart* sufficiently pure & simple to be capable of this or any thing like it.

At first sight this passage looks insanely erratic. It begins with a statement about the difficulty of dramatic empathy; switches abruptly to metaphysics; introduces an Arab, an Indian, and a Blind Man; and then makes disparaging remarks about continental writers. But a train of thought can be traced through it. Coleridge is pointing out that Gessner's subject requires that we put ourselves in the position of characters who are utterly remote from ourselves. This, he observes, is a difficult thing to do, and poor Gessner has not been able to pull it off—not surprisingly, because apart from Shakespeare few writers can. Shakespeare could do it because he was not only a great poet but also a great philosopher of human nature, not a formally trained philosopher but someone with a highly developed natural philosophical capacity. Like his contemporaries and countrymen, Gessner falls short of the Shakespearean ideal. In the development of this argument Coleridge takes for granted some of the transitional ideas that a less fully attuned reader would need—the connection between dramatic empathy and metaphysics, for instance—but he makes a consecutive argument all the same, and the pivotal word "*Tact*" carries a submerged meaning (the sense of touch) that triumphantly unites Shakespeare with the Arab, the Indian, and the Blind Man. This is not incoherence but intensity and compression of thought; its method or logic is not rational but metaphoric.

The letter was traditionally supposed to be a substitute for conversation. The record of Coleridge's celebrated powers as a talker bears witness to his ability to get from one subject to another without losing the thread of his discourse, as long as the listener was attuned and attentive. One of the most interesting accounts is De Quincey's (2: 152) of how Coleridge "swept at once, as if returning to his natural business, into a continuous strain of eloquent dissertation, certainly the most novel, the most finely illustrated, and traversing the most spacious fields of thought by transitions the most just and logical, that it was possible to conceive. What I mean by saying that his transitions were 'just' is by way of contradistinction to that mode of conversation which courts variety through links of *verbal* connexions." De Quincey offers a contemporary's appreciation of Coleridge's exceptional skill at the art of transition and makes it clear that this is an intellectual accomplishment superior to the laborious verbal practice of *transitio* (which seems to be the sense of "*verbal* connexions"). Coleridge invokes the same distinction when he says in the *Biographia* (1: 195) that in Cowper's poem *The Task* "the connections are frequently awkward, and the transitions abrupt and arbitrary."

De Quincey ends his tribute to Coleridge's gifts as a speaker by assuring the reader "that logic the most severe was as inalienable from his modes of thinking as grammar from his language" (2: 153)—and indeed the two are complementary as the invisible underpinnings of thought and language.

Transitions of the kind favored by Coleridge are similarly invisible, occurring in the blank spaces between sentences or stanzas. They conform to Coleridge's general preference for energy over matter in physical models of the universe and for mystery over evidence in the area of religious faith. The governing metaphor for all these phenomena could be the haunting image of the water-insect in the *Biographia* (1: 124): we see the insect move, but what counts is the movement itself. So it ever is with matter and mind in Coleridge's countermaterialist philosophy: "All connexion is of necessity given by the mind itself" (*Shorter Works* 1023), and all proof of the intangible powers of the mind is to be cherished. Transitions belong not to the literal content of a text but to its conceptual structure, not to its diction but to its syntax, not to its parts but to the unarticulated relationship between the parts. They constitute a challenge both to the writer and to the reader or critic, because if they are not present or if they go unnoticed, the work will appear disjointed and confused. They are therefore capable also of constituting a bond between the writer and the reader, both of whom must be properly taught in order to be aware of the unexpressed connection. The passage that culminates in the image of the water-insect is itself a good example of Coleridge's practice: though the long paragraph takes the form of a logical argument, even majors in English can point out the flaws in the reasoning; what gives it credibility and coherence—indeed, power—is an underlying pattern of thought that remains unarticulated until the figure of the insect appears.

In contrast to the superior, seamless style of thought and of writing that he advocated, Coleridge condemned the "unconnected, epigrammatic," "aphorisming," "asthmatic," "crumbly," "friable" prose associated with the French and with English writers under French influence; and the noun-based theory of language associated with Locke, Horne Tooke, and Coleridge's own former collaborator Wordsworth.[7] "[L]anguage is not, was not, and never will be the mere vehicle of representing external objects or simple information," he declared in his Shakespeare lectures (*Lectures* 1: 272). The locus classicus of the dispute between himself and Wordsworth is chapter 17 of the *Biographia*, where Coleridge flatly contradicts Wordsworth's famous assertion that country dwellers "hourly communicate with the best objects from which the best part of language is originally derived," Coleridge maintaining instead that whereas the rustic uses language only "to convey *insulated facts*"—and in this is not far removed from "the brute creation"—"the educated man chiefly seeks to discover and express those *connections* of things, or those relative *bearings* of fact to fact, from which some more or less general law is deducible" (2: 52–53; emphasis in original). This social distinction is even more sharply drawn in a less frequently cited passage in chapter 18 (2: 58):

We do not adopt the language of a class by the mere adoption of such words exclusively, as that class would use, or understand; but likewise by following the *order*, in which the words of such men are wont to succeed each other. Now this order, in the intercourse of uneducated men, is distinguished from the diction of their superiors in knowledge and power, by the greater *disjunction* and *separation* in the component parts of that, whatever it is, that they wish to communicate. There is a want of that prospectiveness of mind, that *surview*, which enables a man to foresee the whole of what he is to convey, appertaining to any one point; and by this means so to subordinate and arrange the different parts according to their relative importance, as to convey it at once, and as an organized whole.

Here as elsewhere, Coleridge represents methodical utterance as normative and as attainable only through education. This view was probably welcome to his readers, for with its half-Latin title, its range of learned reference, and its untranslated passages in classical languages, the *Biographia* is unmistakably restricted to an educated audience. For Coleridge, however, the appeal to an educated middle class was a lifelong pattern. His very first separate publication, *The Fall of Robespierre*, identified him on the title page as "S. T. Coleridge, of Jesus College, Cambridge"; the 1796 *Poems, on Various Subjects*, which appeared after he had left the university without a degree, were "by S. T. Coleridge, Late of Jesus College, Cambridge"; for the *Biographia* and most later works he was "S. T. Coleridge, Esq.," thus claiming gentlemanly status; and at the end of his career, in *Church and State*, where, as I have pointed out before, he proposed the formation of a distinct and powerful learned class, he was "S. T. Coleridge, Esq., R.A., R. S. L." But Coleridge's preoccupation with method, and hence with transition, goes beyond personal class anxiety and the need to capitalize upon the asset of a good education. In *Romanticism, Nationalism, and the Revolt against Theory*, David Simpson shows that Coleridge in effect redefined method in the process of participating in the formation of a national identity.

Simpson's book is concerned with a national myth that crystallized about the time of the French Revolution, to the effect that the English are in certain important ways different from both the French and the Germans, but especially the French: specifically, they are down-to-earth, pragmatic, commonsense empiricists. They are devoted to minute particular matters of fact and they put no faith in abstract systems. Simpson is able to take the deep mistrust of system and its identification with the French back to the sixteenth century and the Ramist promise of a single pattern of reasoning, accessible to all and applicable to any topic. In the disputes arising from this promise, certain red-flag terms emerged: "logic," "method," and

of course "theory." Ramus's work is a *Logike;* Descartes wrote a *Method;* in the eighteenth century, Condorcet pressed the cause of method and Condillac produced another *Logic;* in England there were the Methodists. What they all had in common was a democratic conviction about natural intelligence and a faith in some single, simple, often diagrammatic "system" of mental discipline as a means to train and, as we might say, empower that intelligence. The English could fight back, it seemed, only by presenting themselves as plodding positivists. But then Coleridge came along and, in Simpson's splendid phrase, he "scrambl[ed] the familiar codes" (60) and set out to prove that it was possible to be English but methodical, systematic but not democratic, and a theorist in a distinctly English way. He took over, notably in the "Essays on Method," a vocabulary that had been associated with the French rationalists and egalitarians and claimed it for the best and brightest Englishmen—for Bacon, for Shakespeare, and for himself. What Simpson says about method is true of "transition" also: Coleridge scrambled the codes by carrying over into the realm of logic and method concepts and techniques that had formerly belonged only to the arts and to private discourse. But he made it quite clear that his kind of method, involving concealed transition, was not available to everyone, and that even to construe it required either learning or genius. Although Coleridge's program may appear to be self-serving and could hardly be called revolutionary, at least it is not as fatalistically class-bound as some of the recent avatars of this ancient debate—*The Bell Curve,* for example—since it offers education as a means of transcending the class one is born into.

Richard Rorty has recently proposed that the person who makes progress in the intellectual world is not the one who introduces new arguments but the one who changes the vocabulary, using old words in new ways or introducing new words (Coleridge did both) and so constantly shifting the ground, changing the subject (77–78). On the international political scene, Coleridge had some influence on the definition of a national identity and on the denial of a monopoly in theory to the French. At a local level, he really very effectively fended off an assault from below by claiming method for the educated exclusively and by displaying in his writing a complex, sophisticated, artful alternative to both the vaunted plain style of the radicals of his own country and the step-by-step transparency of Enlightenment reasoning. It was one of his main contributions to the anti-Jacobin agenda of England in the early nineteenth century.

Notes

1 Notably Snyder, Jackson, and Christensen; Klancher and Simpson are discussed separately below.

2 The chief classical source is *Ad Herennium* (attributed to Cicero) 4.26.35: "Transition is the name given to the figure which briefly recalls what has been said, and briefly sets forth what is to follow next, thus: 'You know how he has just been conducting himself towards his fatherland; now consider what kind of son he has been to his parents.' " Peacham (175), using the Greek form "metabasis," defines it as "a forme of speech by which the Orator in a few words sheweth what hath bene alreadie said, and also what shal be said next." He cautions the speaker not to be long-winded about it.

I am grateful to my colleagues Michael Dixon, Carol Percy, and George Rigg for guiding me through the rhetorical tradition of *transitio*.

3 It should be said, however, that critics regularly express some doubt as to what Wordsworth meant, and that they are by no means of one mind about it. Some take "transition" as having to do with mood, an interpretation that is at odds with the usage of the time. Some suggest a design based on the traditional stanzaic structure of the Pindaric ode. See Hartman 27, Johnson 59, Curran 76–77, Mason 205.

4 Translated from the French of Antoine Arnauld and others, the Port-Royal *Logic, or The Art of Thinking* was a standard textbook; Condillac's was therefore called *Logic, or The First Developments of the Art of Thinking;* and see Watts.

5 In "Christabel," Coleridge tried to educate his own audience by introducing a prose preface in 1816. There he attempted to explain his meter as varied only "in correspondence with some transition, in the nature of the imagery or passion" (*Complete Poetical Works* 1: 215).

6 Coleridge's note is in the British Library copy of Shakespeare's *Works*, ed. L. Theobald (London, 1773) 3: 25–29: shelf mark C 45 a 21.

7 For samples of Coleridge's habitual diatribes against absence of connection, see *Biographia* 1: 39 and n1, and 1: 292. On his advocacy of a connected style, see Barrell 69–74, Christensen 186–270, and Klancher 151–59; and on his language theory, McKusick, especially 33–52, 113–15.

Works Cited

Ad Herennium. Trans. Harry Caplan. Loeb Classical Library. Cambridge: Harvard UP, 1954.

Barrell, John. *Poetry, Language, and Politics.* Manchester: Manchester UP, 1988.

Blair, Hugh. *Lectures on Rhetoric and Belles Lettres.* 7th ed. 3 vols. London, 1798.

Christensen, Jerome. *Coleridge's Blessed Machine of Language.* Ithaca: Cornell UP, 1981.

Coleridge, Samuel Taylor. *Complete Poetical Works.* Ed. E. H. Coleridge. 2 vols. Oxford: Oxford UP, 1912.

———. *Collected Letters.* Ed. Earl Leslie Griggs. 6 vols. Oxford: Clarendon P, 1956–71.

———. *The Friend.* Ed. Barbara E. Rooke. *The Collected Works of Samuel Taylor Coleridge.* Vol. 4. Bollingen Series 75. 2 vols. Princeton: Princeton UP, 1969.

———. *On the Constitution of the Church and State.* Ed. John Colmer. *The Collected Works of Samuel Taylor Coleridge.* Vol. 10. Bollingen Series 75. Princeton: Princeton UP, 1976.

———. *Logic.* Ed. J. R. de J. Jackson. *The Collected Works of Samuel Taylor Coleridge.* Vol. 13. Bollingen Series 75. Princeton: Princeton UP, 1981.

———. *Biographia Literaria.* Ed. James Engell and W. Jackson Bate. *The Collected Works of Samuel Taylor Coleridge.* Vol. 7. Bollingen Series 75. 2 vols. Princeton: Princeton UP, 1983.

———. *Lectures 1808–1819: On Literature.* Ed. R. A. Foakes. *The Collected Works of Samuel Taylor Coleridge.* Vol. 5. Bollingen Series 75. 2 vols. Princeton: Princeton UP, 1987.

————. *Aids to Reflection.* Ed. John Beer. *The Collected Works of Samuel Taylor Coleridge.* Vol. 9. Bollingen Series 75. Princeton: Princeton UP, 1993.

————. *Shorter Works and Fragments.* Ed. H. J. Jackson and J. R. de J. Jackson. *The Collected Works of Samuel Taylor Coleridge.* Vol. 11. Bollingen Series 75. 2 vols. Princeton: Princeton UP, 1995.

Curran, Stuart. *Poetic Form and British Romanticism.* New York: Oxford UP, 1986.

De Quincey, Thomas. "Samuel Taylor Coleridge." *Collected Writings.* Ed. David Masson. Vol. 2. London, 1896.

Fulford, Tim. *Coleridge's Figurative Language.* New York: St. Martin's, 1991.

Hartman, Geoffrey H. *Wordsworth's Poetry 1787–1814.* New Haven: Yale UP, 1964.

Jackson, J. R. de J. *Method and Imagination in Coleridge's Criticism.* London: Routledge, 1969.

Johnson, L. M. *Wordsworth's Metaphysical Verse.* Toronto: U of Toronto P, 1982.

Johnson, Samuel. "Cowley." *Lives of the English Poets.* Ed. George Birkbeck Hill. 3 vols. Oxford: Clarendon, 1935. 1: 1–69.

————. *Letters.* Ed. Bruce Redford. The Hyde Edition. Vol. 3. Princeton: Princeton UP, 1992.

Klancher, Jon P. *The Making of English Reading Audiences, 1790–1832.* Madison: U of Wisconsin P, 1987.

Mason, Michael, ed. *William Wordsworth and S. T. Coleridge. Lyrical Ballads.* Longman Annotated Texts. London: Longman, 1992.

McKusick, James C. *Coleridge's Philosophy of Language.* New Haven: Yale UP, 1986.

Montagu, Elizabeth. *An Essay on the Writings and Genius of Shakespear.* London, 1769.

Peacham, Henry. *The Garden of Eloquence.* Facsimile of the 2nd ed., 1593. Gainsville: Scholars' Facsimiles, 1954.

Rorty, Richard. *Contingency, Irony, and Solidarity.* New York: Cambridge UP, 1989.

Simpson, David. *Romanticism, Nationalism, and the Revolt against Theory.* Chicago: U of Chicago P, 1993.

Snyder, Alice D. *Coleridge on Logic and Learning.* New Haven: Yale UP, 1929.

Watts, Isaac. *Logick: or, The Right Use of Reason in the Enquiry after Truth.* 9th ed. London, 1751.

Wordsworth, William. *Poetical Works.* Vol. 2. Ed. E. de Selincourt. 2nd ed. Oxford: Clarendon, 1952. Rept. 1965.

Some Romantic Images in Beethoven

MAYNARD SOLOMON

*A*lways impatient with the written word and ever eager to return to his music, Beethoven was prone to slips of the pen. Quill flying, mind wandering, he would place on his letters such improbable dates as A.D. 1089 and A.D. 1841 (Tyson 6–7). He would render the village of Heiligenstadt as "Heiglnstadt." Or, responding to a dear friend who felt that he had been neglected, he would write: "You believe that my goodness of heart has diminished. No, thank Heaven, for what made me behave to you like that was deliberate, premeditated wickedness on my part . . ." (Anderson 1: 21). Fortunately, when he proofread that letter with Franz Wegeler, he modified the word "deliberate" by an interlineated "no."

Such errors provide a happy hunting ground for those who like to turn up interesting new confirmations of the psychopathology of everyday life. Thus, I was pleased but not at all surprised when, in the course of investigating Beethoven's religious outlook, I found what appeared to be a clear mental error—what Freud's translators liked to call a "parapraxis" or "symptomatic action." On a leaf of sketches dated late September 1815 (British Library, Department of Manuscripts), Beethoven addressed himself to God: "Almighty in the forest! I am happy, blissful in the forest: every tree speaks through Thee [*jeder Baum spricht durch Dich*]" (Kalischer 2: 291n). Surely, I thought, Beethoven meant to say, "Thou speakest through every tree." Perhaps, but another quite explicit marginal notation of circa 1815 makes it difficult to read the evidence in so conventional a way: "It is indeed," wrote Beethoven in stammering phrases on a loose folio sheet (presently on loan to the British Library), "as if every tree in the countryside spoke to me [*als ob jeder Baum zu mir spräche*], saying 'Holy! Holy!' In the forest, enchantment! Who can express it all?" (Nohl, *Beethoven's Brevier*, 104n; *Führer* 110).

Well, then, perhaps this was no slip of the pen; perhaps Beethoven really

did mean to describe the tree as some superior form of deity. Momentarily dissatisfied with Freud, I turned my thoughts to Sir James Frazer and I wondered whether Beethoven, like Frazer, had spent some imagined moments in Diana's sacred grove and sanctuary at Nemi. How interesting it would be to demonstrate that Beethoven's nature worship was so deeply rooted that it sometimes bordered upon more primitive forms of belief. Perhaps, I thought, what I had always taken in Beethoven as something close to childlike gullibility was really a carefully controlled streak of primitivism, existing in a tension with his indestructible conscious adherence to Reason.

This brought to mind a curious passage in the diary of Beethoven's friend, Therese von Brunsvik. She recalled Beethoven's visits to her family's Hungarian estates in the years after 1800, where he was initiated into what she termed the "circle of chosen spirits who formed our social republic," these spirits being the Brunsvik siblings and their dearest friends. She described the scene:

> A circular place in the open was planted with tall linden trees; each tree bore the name of a member of the society. Even when we mourned their absence we spoke with their symbols, conversed with them and let them teach us. Very often, after bidding the tree good morning, I would question it regarding this and that, whatever I wished to know, and it never failed to make reply! (La Mara 64; Sonneck 34–35)

The rational historian within me finally sprang to life, objecting that such rituals could not have been merely a sentimentalized kind of phallic worship; they must have derived, at least in part, from the "freedom tree" plantings by Republicans, Jacobins, and latter-day Rousseauians of that era. After all, the Brunsviks, like Beethoven, were adherents of Republican ideals and enlightened thought: Brunsvik père was an enthusiast of the American Revolution and Therese Brunsvik recalled, "I was brought up with the names of Washington and Benjamin Franklin" (La Mara 58). But how could one ignore the overtones of pagan ritualism that seemed to lie on the surface of her story? Vaguely my thoughts turned to the Cosmic Tree that Mircea Eliade's primitive initiates climb as they seek the center of the world, the "sacred pole" that some call the Tree of Life and others equate with the Cross on Calvary.

Clearly I was caught in a traffic jam of overly luxuriant interpretations. Seeking a quick exit, I yielded to an access of skepticism. Perhaps Beethoven's verb, "to speak," was only intended to express his belief that the majesty of God suffuses every one of his creations. Perhaps what he "really" meant was something quite conventional, such as: "Through Thy

power every tree is endowed with a particle of your Being." Well, yes, "every tree speaks through Thee" could be interpreted in that way; but it would be difficult to read the phrase, "Every tree in the countryside spoke to me," in that way.

Unable to resolve the issue, I let it rest for several years. But the subject was later revived when I opened Novalis's novel *Heinrich von Ofterdingen* and read its hero's initial musings:

> Once I heard tell of the days of old, how animals and trees and cliffs talked with people then. I feel as though they might start any moment now and I could tell by their looks what they wanted to say to me. (Novalis, *Schriften* 1: 101; *Henry von Ofterdingen* 15)

Later, Heinrich realizes that it is the poet's calling to restore the peaceable kingdom by taming ferocious animals, arousing gentle inclinations in humans, and awakening what he called "the secret life of the woods and the spirits hidden in trees" (Novalis, *Schriften* 33). And I soon learned that Novalis had no monopoly on this secret life. A few hours of further research disclosed the friendly speech of trees in many German works published not long after 1795, including Tieck's *William Lovell*, Friedrich Schlegel's *Lucinde,* as well as in writings by Hölderlin, Günderode, and E. T. A. Hoffmann, to say nothing of the Brothers Grimm. "The mute forest speaks its maxims, giving lessons to the mountains," writes Hölderlin in "Unter den Alpen gesungen" (2.1: 44). "The woods reply not," writes Schiller in "Die Götter Griechenlands," as though in counterpoint, "and the ocean, / Unheeding, churns th' eternal foam" (*Schillers Werke* 1: 194; *Works* 159).

There is no need to multiply examples. It seems that I had stumbled upon one of the image-metaphors through which several of Beethoven's contemporaries conveyed their beliefs, particularly their views of divinity and nature. What had appeared to be a curious personal image, an idiosyncratic phrase, or even a slip of the pen, turned out to be a sign of Beethoven's kinship with wider cultural and philosophical currents; a simple metaphor opens on a network of shared beliefs and patterns of thought. It also appeared to be a possible indication that some of Beethoven's intellectual and spiritual interests could be more centrally located in certain trends in German Romanticism than has usually been allowed, for these soulful trees are but one aspect of Romanticism's desire to achieve a unification of humanity with nature by deciphering the language of mere matter.

Beethoven's close kinship to Romanticism was already clear in his attraction to many of its dominant categories, especially those centering on extreme alternatives—death and resurrection, freedom and necessity, Arcadia and Elysium, the individual and the cosmos, permanence and change. Here, however, I will survey a few of the imaginative metaphors

and creative tropes that Beethoven held in common with his Romantic contemporaries. Of course, it is not altogether self-evident that these may be taken as simple confirmations that Beethoven ought to be counted among the Romantics. For although we have seen an emerging scholarly consensus as to the pervasiveness in Romanticism of certain archetypal tropes and images that formed part of the aesthetic and ideological preoccupations of the new movement, and even if we may identify Romantic mutations of underlying archaic images and metaphors, it has also become apparent that none of these can be shown to be exclusive features of Romanticism. Nevertheless, a shared palette of imagery may well be a strong indication of the pull exerted by the Romantic sensibility on Beethoven's imagination.

In the first version of *Fidelio*, written in 1805, Florestan's aria closes with a backward glance to the time before his separation from Leonore.

> Ah, those were beautiful days,
> When my glance clung to thine,
> When, seeing thee,
> My heart happily began to throb.
> Dearest, moderate your lamentations,
> Travel your path in peace;
> Tell your heart
> That Florestan was a worthy man.

These rather stiff sentiments were dear to Beethoven's own heart, for he was accustomed to recommending resignation as an anodyne for life's vicissitudes and especially as a remedy for separated lovers. But in the 1814 revision he and his new librettist, Georg Friedrich Treitschke, sensed a somewhat more dramatic possibility—Florestan's vision of Leonore arriving to release his soul to eternity (ex. 1):

> Do I not sense a mild, murmuring breeze?
> Like an angel in golden mists
> Coming to my side to console me;
> An angel . . . leading me to freedom
> in heavenly realms.

"Do I not sense a mild, murmuring breeze?" Leonore's presence is heralded by a gentle movement of air, a breeze that is a harbinger both of liberation and of reunion. The image is one that recurs elsewhere in Beethoven's vocal music during his fourth decade. In the text of his song cycle, *An die ferne Geliebte*, written apparently to Beethoven's order by a young

Example 1. *Fidelio,* Act 2 (no. 11). Florestan's aria. Poco Allegro.

Example 2. *An die ferne Geliebte,* Op. 98. "Stille Weste, bringt im Wehen."

Romantic poet, the murmuring breeze again reappears as an emblem of yearning for, and symbolic reunion with, a distant beloved (ex. 2):

> Silent West Wind, as you drift
> Yonder to my heart's chosen one,
> Bear my sighs, which die
> Like the last rays of the sun.

In his famous essay, "The Correspondent Breeze," M. H. Abrams held that the Romanticists' breeze, which on its surface is linked with the "outer transition from winter to spring, is correlated with a complex subjective process: the return to a sense of community after isolation, the renewal of life and emotional vigor after apathy and a deathlike torpor, and an outburst of creative power following a period of imaginative sterility" (37–38). This was Beethoven's plain intention in combining two poems by

Goethe as a text for his miniature cantata, *Calm Sea and Prosperous Voyage*, Op. 112, in which Aeolus "unlooses the strings" of the zephyr to relieve the "death-like stillness" that lies upon the immense waters. Invisible yet palpable, mild yet capable of raging force, the movement of air represents the emanations of the human spirit as a regenerative force (see Auden 75–81; Grigson 24–46). And it is in this same capacity that Florestan's breeze is foreshadowed in the Chorus of the Prisoners:

> Oh what joy to breathe the scent of open air:
> Only here, here is life.

In Beethoven's variants of the Correspondent Breeze, there is a stirring of the soul to wakefulness, a sense of an awakening, of a passage from dormancy to animation. This is so not merely in an abstract, metaphorical sense, but because of Florestan's isolation, helplessness, and immobility, all of his senses have been systematically starved—of food, water, light, air, sound, and human contact. He has been deprived of every form of sensory and spiritual nourishment. In *Fidelio*, the caressing breeze is both a breath of life and a sign of release from this bondage. The breeze enters the dungeon both as a reminder and a promise—of Florestan's beloved, of the bountiful greenness of the earth, and therefore of the potential for emergence into the air and light. That is why Florestan's "murmuring breeze" is close kin to Shelley's "azure sister of the spring," who sounds her "clarion o'er the dreaming earth" ("Ode to the West Wind") and to Wordsworth's "gentle breeze that blows from the green fields and from the clouds and from the sky" (*The Prelude*).

From decoding the hieroglyphics of nature to reading the constellations of the celestial vault was only a short step for the Romantics, who believed in a "magical physics" connecting the earth's natural elements and creatures with the stars in the heavens (Wetzels 58). Beethoven was sufficiently attracted to Kant's astrological speculations about the determining influence of the heavenly bodies upon life in the solar system that he copied several passages on this subject from Kant's early cosmological essay, *Allgemeine Naturgeschichte und Theorie des Himmels* (1755), into his *Tagebuch* (Solomon 279–80 [nos. 105, 106, 108]). And Goethe wrote, in a letter of 8 December 1798 to Schiller:

> The superstition of astrology has its origin in our dim sense of some vast cosmic unity. Experience tells us that the heavenly bodies which are nearest us have a decisive influence on weather, on plant life and so forth. We need only move higher, stage by stage, and who can say

where this influence ceases? . . . Man, in his presentiment, . . . will extend such influence to the moral life, to happiness and misfortune. Such fanciful ideas, and others of the same kind, I cannot call superstition; they come naturally to us and are as tolerable and as questionable as any other faith. (Gräf and Leitzmann 2: 174; Sondheim 243–44)

Like the Correspondent Breeze and the Talking Trees, the Starry Skies form an image of a nature animated by a numinous power; but it is an all-embracing image of the boundless space within which everything unfolds, an active space that in some way is a manifestation of the deity. Lines from Beethoven's *Gellert* Lieder, Op. 48, written in 1801 or 1802, show a lingering, Enlightened conception of a Christian God as watchmaker of the universe, setting "the numberless stars in their places" with mechanical, un-Romantic precision. This conception is one that Beethoven never wholly abandoned: in his copy of Christoph Christian Sturm's *Reflections on the Works of God in Nature,* he noted many passages describing the rational designs of nature as crafted by a divine artisan, particularly underscoring paragraphs praising God for the magnificence of his creation. In a section entitled "Immensity of the Firmament," Beethoven marked the following:

> King of heaven! Sovereign Ruler of worlds! Father of angels and men! O that my ideas were as vast and sublime as the extent of the heavens, that I might worthily contemplate thy magnificence! O that I could raise them to those innumerable worlds, where thou dost manifest thy glory even more than on our globe; that as I walk at present from flower to flower, I might then go from star to star, till I came to the august sanctuary where thou sittest upon the throne of thy glory! (Sturm 270)

Beethoven also habitually invoked the celestial to symbolize the rarefied sphere of beauty and pure feeling, where, as he put it in a letter to Johann Nepomuk Kanka, "the active creative spirit" could operate unimpeded by "the wretched necessities of life" (Anderson 1: 473–74). He was fond of telling correspondents how he preferred to dwell in an untrammeled, lofty sphere; to Franz Brunsvik he once observed, "As for me, why, good heavens, my kingdom is in the air. As the wind often does, so do harmonies whirl around me, and so do things often whirl about too in my soul—" (Anderson 1: 445). And, characteristically, he would lament: "Unfortunately we are dragged down from the celestial (*überirdische*) element in art only too rudely into the earthly and human sides of life" (Anderson 3: 1225).

In many of his lieder, ranging from his youthful "Adelaide," to his seven separate settings of three different texts entitled "Sehnsucht," to *An die ferne Geliebte,* Beethoven expresses the prototypically Romantic sense of

Example 3. String Quartet in E Minor, Op. 59 (no. 2).
Molto Adagio, mm. 16–20.

yearning in the pastoral mode, evoking warm, earthly landscapes framed in clouds and sunshine. In these, "Sehnsucht" exists on a human scale as the desire for love, for creative fulfillment, for tranquil communion with nature. By way of powerful contrast, however, in representations of the unearthly in the "starry vault" (*Sternenzelt*) of the Ninth Symphony's "Ode to Joy," in his "Abendlied unterm bestirntem Himmel," WoO 150, and in the Molto Adagio of the Razumovsky String Quartet, Op. 59, no. 2, written in 1806, Beethoven sought to locate what may be called an "antipastoral" essence in which the condition of alienation is taken to be almost insuperable. He told Carl Czerny that the Molto Adagio occurred to him when he was "contemplating the starry sky and thinking of the music of the spheres" (Czerny 9); and Karl Holz also learned this story, retelling it with more emphasis on the Romanticism of the imagery, recalling that the Adagio was inspired on a night when "the clear stars illuminated the heavens," and Beethoven, wandering through the fields of grain near Baden, glanced upward "questioningly, longingly, into the infinite expanse" (Nohl, *Beethoven* III; see also Kerst 2: 185). In the antipastoral mode, the astral regions are seen as cold, dark, sublime, infinite, chaotic, more-than-human. In clusters of images centering upon the starry skies, the mysteries of space, the turnings of the heavenly spheres, the attributes of the deity against the backdrop of the celestial vault, the immensity of the night, Beethoven seems to have found a natural outlet for his feelings of awe and wonder (ex. 3).

Ultimately, in the finale of the Ninth Symphony, Schiller's text combines astral imagery with utopian strivings for the improbable rewards of infinity. "Brothers, beyond the starry firmament there surely dwells a loving father." The contrast with the *Pastoral* Symphony is instructive, since both symphonies are constructed around literary scenarios of reconciliation. But where the earlier one symbolizes the restoration of an earthly Arcadia, the later symphony pictures the supernal striving for a celestial Elysium. One is enwrapped in memory, the other in dream, in discovery of utopian possibility rather than in recovery of a primal unity (ex. 4).

Example 4. Symphony no. 9 in D Minor, Op. 125.
Finale: Andante Maestoso, mm. 25–32.

The metaphor of the starry skies is capable of representing that which cannot be represented—infinity, boundlessness, metaphysical longing—precisely because it embodies the idea of division within nature. Thus, the vault of the heavens is simultaneously an object of wonder and worship, and of disorder striving for order. These contending, multiple implications pervade Sir William Jones's "Hymn to Narayena," several verses of which Beethoven transcribed into his Tagebuch:

> Spirit of Spirits, who, through ev'ry part
> Of space expanded and of endless time,
> Beyond the stretch of lab'ring thought sublime,
> Badst uproar into beauteous order start.
> Before Heaven was, Thou art:
> Ere spheres beneath us roll'd or spheres above,
> Ere earth in firmamental ether hung,

Some Romantic Images in Beethoven 233

Thou sat'st alone; till, through thy mystick Love,
Things unexisting to existence sprung,
and grateful descant sung.
(Solomon 266 [no. 62])

And all of these simultaneous implications reverberate in Beethoven's most frequently cited allusion to the starry skies—his reference in a conversation book of 1820 to a famous passage from Kant's *Critique of Practical Reason:* "Two things fill the mind with ever new and increasing awe and admiration the more frequently and continuously reflection is occupied with them; the starry skies above me and the moral law within me" (*Immanuel Kant's Werke* 5: 174; *Critique of Pure Practical Reason* 261). In Beethoven's abridgment, this came to read: " 'The moral law in us and the starry heaven above us.' Kant!!!" (Köhler et al. 1: 235). Surely, Beethoven felt the starry heavens in what Rudolf Unger called its "double aspect: in the secret-filled incomprehensibility and infinity of its perpetual distance and in the comforting immutability and reason-filled order of its perpetual present" (61). Or, in Kant's own formulation: "The sublime is to be found in an object even devoid of form, so far as it immediately involves, or else by its presence provokes, a representation of *limitlessness,* yet with a super-added thought of its totality" (*Critique of Aesthetic Judgement* 90).

The implied observer of astral immensity in Beethoven's Ninth Symphony and the second Razumovsky Quartet no. 2 is the familiar Romantic figure of the solitary hero, known so well from the landscapes of Caspar David Friedrich, the poetry of Wordsworth and Byron, the novels of the German Romantics, and the image of Napoleon on Elba. We find him also in Beethoven's Pastoral Symphony—as a sensitive Romantic traveler in search of a lost time, a Rousseauian time when humanity and nature were united, a time that was the mythic equivalent of an idealized childhood under the protection of a forbearing father and a bountiful mother. His persona is adopted by Beethoven himself in his pantheistic rambles through the Austrian countryside. And we also meet him in the oratorio *Christ on the Mount of Olives* (1803), a work pervaded by the conception of the solitary hero, one whose isolation is both an effigy of Christ's capacity for endurance and a foreshadowing of his death.

In *Fidelio,* the solitary hero is confined within an underground dungeon that exemplifies what has been called the Romantic Prison, a multivalent image that is a place both of punishment and of redemption. Despite its apparatus of sadism, its crypts, snares, and secrets, the dungeon is simultaneously the "happy prison," conceived, in Victor Brombert's description,

as "the protected and protective space, the locus of reverie and freedom," a place for poetic meditation and the expression of religious hope (5; see also Eitner). And because Beethoven and the Romantics were imbued with Christian notions of salvation through suffering, the prisoner came to be regarded as somehow a privileged personage, one who deserves deliverance precisely because he has suffered.

For the Romantics the prison has an uncanny quality because it carries mythic echoes of the underworld, of Hades, of the abyss, the labyrinth, the secret place. Rocco says, "I am under the strictest orders never to let anyone" enter "the underground chambers . . . And there is one cell into which I can never let you go, no matter how much I trust you." But like any normally inquisitive mythological heroine, Leonore insists on entering the inner sanctum, on opening the forbidden door. By engaging such mythic resonances, the prison achieves the capacity to condense polarities of innocence and criminality, good and evil, darkness and light, death and rebirth, separation and reunion. The prison becomes a locus of *Sehnsucht* in an infinity of forms, from the longing of Leonore and Florestan for each other to Florestan's hunger for all the insignia of survival: for light, air, wine, bread, and love. In their own ways, even Pizarro and Rocco are consumed by unfulfillable desires—Pizarro for revenge and Rocco for gold. If *Fidelio* has a dramatic weakness, it is that its celebratory finale largely deprives us of the sense of continuing longing and expectation, so central to Romanticism's preoccupation with incompletion. Only the music for "O Gott, welch' ein Augenblick" preserves the memory of loss, the sorrow of separation; without it, the tragic residue so fundamental to the Romantic outlook might have been altogether sacrificed in the general jubilation.

In the *La Malinconia* movement of his A Major String Quartet, Op. 18, Beethoven designated as his subject someone trapped within a different kind of darkness, stricken with melancholia, endlessly mourning, unable to rid himself of grief. And Beethoven signals confinement of an even more oppressive kind in his designation "Beklemmt," at the most emotional moment of the Cavatina of the String Quartet in B-flat Major, Op. 130 (ex. 5). We are not forced to choose among the multiple meanings of the word—"confined," "straitened," "oppressed," "weighted down," "anxious," "constricted," and even "suffocated"—for all of these at once may bear on Beethoven's intention. Together, they imply a crisis that calls out for resolution, for breaking out of an oppressive circle, either by way of a modernist *Grosse Fuge* or of the alternative finale to his quartet—a high-spirited, unproblematical classical rondo.

The invalid is another kind of prisoner. He too is afflicted, weary,

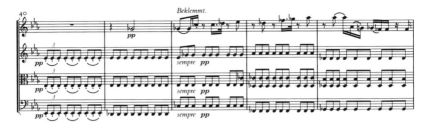

Example 5. String Quartet in B-flat, Op. 130. Cavatina, mm. 40–44.

confined, weighted down; in him, there is a need to cross a threshold, to awaken from a frightening dream (*Beklemmungszustand* means nightmare). He, too, yearns for the open space, looks upward to the realm of the deity. Beethoven's sufferer—later convalescent—prays for deliverance because his is more a sickness of the soul than of the body. Alienated, he is cut off from nature by an unhappy consciousness. The possibility of his redemption involves a severe trial, an illness, through which he may find his way back to love, to nature, to God, to the community. The "Heiliger Dankgesang" of Beethoven's A Minor String Quartet, Op. 132, is not simply a composer's confessional thanksgiving, but a prayer by the sin-sick soul, rewarded by an imperceptible quickening, by revival through contact with the Godhead, and finally by a rebirth. When one is weary, sick, there is a need for new strength. "Ermattet, klagend"—"weary, lamenting"—is Beethoven's designation for the Arioso dolente of the Sonata, Op. 110; but the fugue is headed "Nach u. nach sich neu belebend"—gradually reviving to life—in the same way that in Opus 132 "Neue Kraft fühlend" marks an emergence from confinement, a lifting of dejection, a return to the world (ex. 6).

Of course, an escape may result in finding another kind of enclosure; the enclosure itself may, indeed, be an object of desire, a protected good place, an Eden, Oasis, or Happy Island carved out of the wild, the desert, or the ocean: it may be what Auden described as "a place of temporary refreshment for the exhausted hero, a foretaste of rewards to come or the final goal and reward itself, where the beloved and the blessed society are waiting to receive him into their select company" (Auden 21). One such image of protected withdrawal had a particular resonance for Beethoven: over the years he repeatedly told of his desire to live an isolated life in close contact with the soil. "If my trouble persists, I will visit you next spring," he writes to his old friend Wegeler in 1801. "You will rent a house for me in some beautiful part of the country and then for six months I will lead the life of a

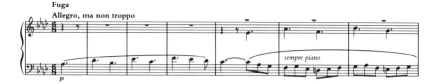

Example 6. Sonata in A-flat Major, Op. 110. Fugue, mm. 1–6.

peasant" (Anderson 1: 60). The prospect of Beethoven returning to the soil is daunting—at first, one wonders if it is merely a Romantic pose, or an enthusiastic declaration to a Bonn compatriot of continuing adherence to a once-shared Rousseauian sentimentalism. But, later on, we find the same hope expressed in Beethoven's private musings: "A farm, then you escape your misery!" he wrote in his Tagebuch in 1815 (Solomon 269 [no. 66]; see also 258 [no. 41]); and on the same folio sheet on which he referred to the enchantment of the forest, he wrote, "If all else fails, even in winter, the country itself remains, like Baden, Lower Brühl, etc. It would be easy to rent a lodging from a peasant" (Nohl 104n). In a conversation book of late September 1824 Beethoven seemed extremely urgent in renewing this ancient wish: "Go to Vösslau or another place. In winter, away, away, far from the city [and from] people. Behind the garden in Vösslau a *peasant* house in which you may create solely for the Infinite" (Köhler 6: 363). Here again, Beethoven connects the taking of a simple country house, in close contact with nature, to serving "the Infinite," as though by stripping himself of the worldly he would be able to reach the divine.

> Hither come and find a lodge
> To which thou may'st resort for holier peace,—
> From whose calm centre thou, through height or depth,
> May'st penetrate, wherever truth shall lead.
> (Wordsworth, *The Excursion*, 3.5.106–109)

The religious overtones of this trope connect with Beethoven's constant desire to retreat to conflict-free surroundings. ("Tranquillity and freedom are the greatest treasures," he wrote in his Tagebuch [Solomon 284 (no. 126)]). It relates directly to the words "Bitte um innern und äussern Frieden"—"plea for inner and outer peace"—which he used as a heading to the Allegretto vivace of the Dona nobis pacem of the Missa solemnis, Op. 123 (Nottebohm 151). Beethoven elaborated this salient idea in notations in sketchbooks for the Missa solemnis, indicating his intention to find musical equivalents for these thoughts: in one, he wrote, "Calm and gaiety issue from peace"; and in another, "In the upper registers, the soprano, too, can demonstrate inner calm and joy as the evidence of

peace" (Schmidt-Görg 19). Calm, joy, the infinite, and nature are threaded like beads on an unbroken strand of associated ideas. Only through inner peace, discovered in the peaceful seclusion of nature, can one find joy, and enter her dwelling in Elysium. "Oh Providence," Beethoven asked in his Heiligenstadt Testament, "do but grant me one day *of pure joy*—For so long now the inner echo of real joy has been unknown to me—Oh when,—oh when, Almighty God—shall I be able to hear and feel this echo again in the temple of Nature and in contact with humanity . . . ?" (Anderson 3: 1354). Beethoven's seclusion at Heiligenstadt in the fall of 1802 had not fulfilled "the hope I cherished . . . of being cured." But despite the Plutarchian tone of the Testament, his hopes had not faded altogether, and his convalescence still remained a potentiality.

The Romantic image of a distant beloved is most famously represented in Beethoven's song cycle, *An die ferne Geliebte*, Op. 98, written in 1816. In it, all of nature's agents vainly conspire to unite the lover with his beloved: the sailing clouds, the birds, the quiet west wind, the ripplets of the brook. Ultimately, however, what brings them closest is music—the lover's songs, which, when sung by the beloved, shall assuage their longing even though they may not bridge their literal separation.

> Then the distance that parted us
> Is surmounted by these songs,
> And a loving heart is reached
> By what a loving heart has hallowed.

Patently, the image was one of special gravity for Beethoven, who had sufficient experience of separation, loss, loneliness, and yearning for reunion; and these stimulated in him the usual Romantic sentiments—of emptiness, of longing, of the desire for forgetfulness, all of these exemplified in his letters to beloved women. "[S]ince you all left Vienna," he wrote to Therese Malfatti in 1810, "I feel within me a void which cannot be filled and which even my art, which is usually so faithful to me, has not yet been able to make me forget" (Anderson 1: 272–73). In his loneliness, he took comfort in whispers and visions; he wrote to Countess Josephine Deym in 1807: "A thousand voices are constantly whispering to me that you are my only friend, my only beloved. . . . Wherever I happened to be, your image pursued me the whole time" (Anderson 1: 175). To Marie Bigot (and her husband) after a painful misunderstanding earlier in the same year: "I went last night to the Redoute in order to amuse myself, but in vain; visions of all of you pursued me everywhere" (Anderson 1: 165). The beloved's image, however distanced, assuages his loss. This was an ingrained

pattern of adaptation: as a boy of sixteen, he tried to repair the death of his mother by visualizing "the dumb likenesses of her which my imagination fashions for me" (Anderson 1: 3). Ultimately, it seems, Beethoven was willing to settle for the image. He wanted desperately to unite with his "Unsterbliche Geliebte" (Immortal Beloved) — "Oh God, why must one be separated from her who is so dear" — but in his famous letter to her of 6–7 July 1812 he confessed that he prefers to retain her as a distant beloved: "Your love has made me both the happiest and the unhappiest of mortals — At my age I now need stability and regularity in my life" (Anderson 1: 376).

Whatever the biographical symmetries, however, Beethoven utilized the distant beloved to address more universal issues in his art. As Egmont's Clara, she is transmuted into a Goddess of Liberty: "Divine Liberty disclosed herself, taking the face and form of my beloved one. With blood-stained feet she approached me." In Florestan's vision, Leonore becomes "an angel appearing in garments of light." Beyond the literal evocations of parted lovers, the Romantic image of the distant beloved represents all those things — including the past, memory, freedom, and youth itself — that have been lost and have yet to be regained, or rather, that have the potential to be found again. For the Romantics, the distant beloved is a condensed symbol of estrangement, of longing, of homesickness, of the eternal feminine. Novalis went even further: "The beloved is an abbreviation of the universe" (*Schriften* 2: 47). She exists in the space between absence and presence, between wanting and having. Fixed, hovering beyond reach, she is the source of motion, she generates activity, she is the ideal, she is telos. She can be approached only by the forces of nature, which overcome their inanimate incorporeality in an attempt to realize a lover's unfulfillable project. Ultimately, it is her very unreachability — even a certain chimerical quality — that is essential to the Romantic temperament. In that sense, Schiller and Beethoven's "Freude, Töchter aus Elysium" is deeply anti-Romantic, for she holds out the imminent promise of fulfillment ("Wir betreten feuertrunken, Himmlische, dein Heiligtum!"), and she herself is capable of action to bring together what had been splintered and separated ("Deine Zauber binden wieder, was die Mode streng geteilt"). In essential contrast, the "ferne Geliebte" exalts hunger into a state of permanence, seeking eternally to sustain desire without surrendering to finite satisfactions (ex. 7).

Finally, the image of a distant beloved is closely related to another prevalent Romantic metaphor, that of the Veil of Isis (see Gode-von Aesch 97–113). Both are images of women, both are shrouded, one literally, the other by her remoteness in space and time. Both are objects of desire,

Example 7. *An die ferne Geliebte*, Op. 98.
"Nimm sie hin denn, diese Lieder."

but where the beloved awakens feelings of tenderness, the goddess at Saïs summons those of rage. If yearning is the invariable and essential Romantic attitude toward the Distant Beloved, the Romantics took a more aggressive stance toward the veiled Isis. "It's time to tear away the veil of Isis and reveal the mystery," wrote Friedrich Schlegel in the first of his *Ideen;* "whoever can't endure the sight of the goddess, let him flee or perish" (Schlegel 241). Novalis, in agreement, wrote, "He who does not wish to lift the veil is no worthy disciple of Sais" (*Schriften,* 1: 14). The frustrations engendered by an unappeased yearning for a distant beloved apparently need to be discharged. To make the erotic implications more explicit, and somehow to blame the object for arousing sexual feelings, Schlegel added, "Mysteries are female; they like to veil themselves but still want to be seen and discovered" (Schlegel 253 [no. 128]).

Of course, although they preached philosophies of love, the early Romantics would have denied that there might be unsublimated erotic implications in the rending of the veil of Isis, which, for them, was simply a metaphor of a quite different type, describing the culmination of the quest for truth, as in Schiller's "The Veiled Statue at Sais" (1795), Wackenroder's *Outpourings of an Art-Loving Friar* (Gode-von Aesch 99), and Novalis's fragment "The Apprentices at Sais" ("Die Lehrlinge zu Sais"), in which, when Hyazinth lifted the veil, "He saw, wonder of wonders, himself" (*Schriften* 1: 41). Here, in a caricature of Romantic *Innerlichkeit,* the quest for truth terminates as a platitude of achieved self-knowledge.

We really cannot know what led Beethoven to copy, frame, and keep in

full view upon his desk during his later years a German translation of the famous Egyptian hieroglyphics telling of the Veil of Isis, which he found in Schiller's essay "Die Sendung Moses."

> I am that which is.
> I am everything that is, that was, that will be. No mortal man has lifted my veil.
> He is of himself alone, and it is to this aloneness that all things owe their being.
> (Ley 129)

Perhaps Beethoven's interest in the temple of Saïs is related to his religious outlook or his attraction to a symbol that was appropriated in the rites of Freemasons and Illuminati. At Bonn, the young Beethoven's free-thinking teachers and Illuminist friends had permanently undermined his adherence to conventional religion. But his profound religious feelings perpetually sought an outlet: he was thus both ready and eager to accept the Romantic explorations of Eastern, classical, and primitive myths and rites; he luxuriated in the idea of the unity of the human race and of its manifold deities; he delighted in every expression of the polytheistic imagination. He even once dreamed of circumnavigating the world's religions — an oneiric quest through India and Arabia, culminating in Jerusalem (Anderson 2: 922). But it is also possible that Isis represented for him a quasi-Rosicrucian process of purification and resurrection; at least, this is implied in a letter of 1815 to Countess Marie Erdödy: "We finite beings, who are the embodiment of an infinite spirit, are born to suffer both pain and joy; and one might almost say that the best of us obtain *joy through suffering* . . . May God grant you greater strength to enable you to reach your *Temple of Isis,* where the purified fire may swallow up all your trouble and you may awake like a new phoenix" (Anderson 2: 527–28; emphasis in original).

Somewhere within a network of overlapping meanings, the Veil of Isis trope may tap the underside of Beethoven's conscious idealization of "die ferne Geliebte." Perhaps the perplexities of the feminine and the mysteries of sexuality here found an opaque outlet in an occult symbol. Of course, there remained still another possibility, of finding a real beloved beneath the Veil of Isis. In his retreat at Walden's Pond, Thoreau wrote: "The oldest Egyptian or Hindoo philosopher raised a corner of the veil from the statue of the divinity; and still the trembling robe remains raised, and I gaze upon as fresh a glory as he did, since it was I in him that was then so bold, and it is he in me that now reviews the vision" (Thoreau 1593). One wonders if Beethoven would have appreciated Thoreau's elegant solution to the twin riddles of the Distant Beloved and the Veil of Isis.

Note

This essay is dedicated to Alan Tyson. A fuller version of the essay will be published in *Haydn, Mozart, and Beethoven: Studies in the Music of the Classical Period. Essays in Honour of Alan Tyson*, ed. Sieghard Brandenburg (Oxford University Press).

Works Cited

Abrams, M. H. "The Correspondent Breeze: A Romantic Metaphor." *English Romantic Poets: Modern Essays in Criticism*. Ed. M. H. Abrams. Oxford: Oxford University Press, 1960.

Anderson, Emily, ed. *The Letters of Beethoven*. Trans. Emily Anderson. 3 vols. New York: St. Martin's, 1961.

Auden, W. H. 1950. *The Enchafèd Flood: or, The Romantic Iconography of the Sea*. Charlottesville: UP of Virginia, 1979.

Brombert, Victor. *The Romantic Prison: The French Tradition*. Princeton: Princeton UP, 1978.

Czerny, Carl. *On the Proper Performance of All of Beethoven's Works for the Piano*. Ed. Paul Badura-Skoda. Vienna: Universal Edition, 1970.

Eitner, Lorenz. "Cages, Prisons, and Captives in Eighteenth-Century Art." *Images of Romanticism: Verbal and Visual Affinities*. Ed. Karl Kroeber and William Walling. New Haven: Yale UP, 1978. 13–38.

Führer durch die Beethoven Zentenar-Austellung der Stadt Wien. Vienna: Selbstverlag der Gemeinde Wien, 1927.

Gode-von Aesch, Alexander G. F. *Natural Science in German Romanticism*. New York: Columbia UP, 1941.

Gräf, H. G., and A. Leitzmann, eds. *Briefwechsel zwischen Schiller und Goethe*. 3 vols. Stuttgart, 1955.

Grigson, Geoffrey. *The Harp of Aeolus and Other Essays on Art, Literature and Nature*. London: Routledge, 1947.

Hölderlin, Friedrich. *Hölderlin: Sämtliche Werke*. Ed. Friedrich Beissner. Grosse Stuttgarter Ausgabe. 8 vols. in 14. Stuttgart: Cotta and W. Kohlhammer, 1946–1985.

Kalischer, A. C., ed. *Beethovens Sämtliche Briefe*. Rev. Theodor v. Frimmel. 5 vols. Berlin: Schuster & Loeffler.

Kant, Immanuel. 1790. *Critique of Aesthetic Judgement*. Trans. James Creed Meredith. Oxford: Clarendon, 1911.

———. *Immanuel Kant's Werke*. Ed. Ernst Cassirer et al. 11 vols. Berlin: Bruno Cassirer, 1912–22.

———. *Critique of Pure Practical Reason*. 1788. *The Philosophy of Kant: Immanuel Kant's Moral and Political Writings*. Ed. Carl J. Friedrich. New York: Modern Library, 1949.

Kerst, Friedrich, ed. *Die Erinnerungen an Beethoven*. 2 vols. Stuttgart: Julius Hoffman, 1913.

Köhler, Karl-Heinz, et al., eds. *Ludwig van Beethovens Konversationshefte*. 10 vols. Leipzig: VEB Deutscher Verlag für Musik, 1968–93.

La Mara [pseud., Marie Lipsius]. *Beethovens unsterbliche Geliebte: Das Geheimnis der Gräfin Brunsvik und ihre Memoiren*. Leipzig: Breitkopf & Härtel, 1909.

Ley, Stephan, ed. *Beethovens Leben in authentischen Bildern und Texten*. Berlin: Bruno Cassirer, 1925.

Nohl, Ludwig. *Beethoven's Brevier*. Leipzig: Günther, 1870.

———. *Beethoven, Liszt, Wagner. Ein Bild der Kunstbewegung unseres Jahrhunderts*. Vienna: Braumüller, 1874.

Nottebohm, Gustav. *Zweite Beethoveniana: Nachgelassene Aufsätze.* Leipzig: Rieter-Biedermann, 1887.

Novalis. *Schriften: Die Werke Friedrich von Hardenbergs.* Ed. Paul Kluckhohn and Richard Samuel. Meyers Klassiker-Ausgaben. 4 vols. Leipzig: Bibliographisches Institut, 1929.

———. 1802. *Henry von Ofterdingen.* Trans. Palmer Hilty. New York: Ungar, 1964.

Schiller, Friedrich. "Die Sendung Moses." *Thalia* (1791) 10: 17–18.

———. *The Works of Friedrich Schiller: Poems.* Ed. Nathan Haskell Dole. Trans. E. P. Arnold Forster. New York: Bigelow, Brown, 1902.

———. *Schillers Werke: Nationalausgabe.* Ed. Julius Petersen and Gerhard Petersen et al. 42 vols. Weimar: Böhlhaus Nachfolger, 1943–84.

Schlegel, Friedrich. *Friedrich Schlegel's "Lucinde" and the Fragments.* Ed., trans. Peter Firchow. Minneapolis: U of Minnesota P, 1971.

Schmidt-Görg, Joseph. "Missa solemnis: Beethoven in seinem Werk." *Bericht über den internationalen musikwissenschaftlichen Kongress Bonn 1970.* Ed. Carl Dahlhaus et al. Kassel: Bärenreiter, 1971. 13–25.

Solomon, Maynard. "Beethoven's Tagebuch." *Beethoven Essays.* Cambridge: Harvard UP, 1988. 233–95.

Sondheim, Moriz. "Shakespeare and the Astrology of His Time." *Journal of the Warburg Institute* (1939) 2: 243–59.

Sonneck, O. G., ed. *Beethoven: Impressions of Contemporaries.* New York: Schirmer, 1926.

Sturm, Christoph Christian. *Betrachtungen über die Werke Gottes im Reich der Natur.* Reutlingen, Heerbrandt, 1811.

———. *Reflections on the Works of God in Nature and Providence, for Every Day in the Year.* Trans. Adam Clarke. Baltimore: Armstrong and Plaskitt, 1822.

Thoreau, Henry David. 1854. *Walden, or Life in the Woods. The Norton Anthology of American Literature.* Ed. Ronald Gottesman et al. New York: Norton, 1979.

Tyson, Alan. "Prolegomena to a Future Edition of Beethoven's Letters." *Beethoven Studies.* Ed. Alan Tyson. Vol. 2. London: Oxford UP, 1977. 1–19.

Unger, Rudolf. "'Der bestirnte Himmel über mir . . .': Zur geistesgeschichtlichen Deutung eines Kant-Wortes." *Aufsätze zur Literatur- und Geistesgeschichte.* Vol. 2 of *Gesammelte Studien.* Berlin: Junker & Dünnhaupt, 1929. 40–66.

Wetzels, Walter D. "Aspects of Natural Science in German Romanticism." *Studies in Romanticism* (1971) 10: 44–59.

"Lorenzo's" Liverpool and "Corinne's" Coppet:

The Italianate Salon and Romantic Education

NANORA SWEET

*T*he culture of British Romanticism may have been broader and deeper than we once suspected, when our model of Romanticism was a canon of five or six poets and the cachet of those poets was cultural refusal, alienation, and isolation. That culture may have been a more persistent and productive one, too, than we suspected when our rehearsals of its literary history were dominated by narratives of disruption—of apostasy, failure, exile, and even untimely death. Much recent feminist and historicist work in Romantic studies has broadened and deepened the field beyond such "limits of Romanticism."[1] Seeking new continuities, some scholars have worked to recover the fiction, non-fiction, and drama of the period and also the many poetic careers beyond five or six that made up literary culture in Britain between 1789 and 1837.[2] Others have recovered new cultural settings and engagements for the six "canonical" poets.[3]

This new scholarship has given us a version of British Romanticism more engaged in Euro-American history and more contingent also on the differences of race, gender, creed, and class that always—and interestingly—vex our common history. This British Romanticism is one that we may link in new ways to the Romanticisms of the Continent and America and that we may extend to cultural practices beyond the conventional 1789–1837 "limits" of the Romantic period.[4] This volume, *The Lessons of Romanticism*, seeks in particular to identify and understand the array of literary and cultural practices that were and are forms of "Romantic education."[5] My essay proposes that "the Italianate salon" is a specific form of Romantic education: a bourgeois, vernacular, and cosmopolitan institution whose influence persisted through the nineteenth century and into the twentieth. The Italianate salon flourished in a Romantic culture that—like the new version of British Romanticism I describe—was both broadly international and fundamentally enlivened by differences of gender and class.

In her 1985 essay "Against Tradition," Marilyn Butler reminded us that to historicize was first to "particularize" or even "parochialize." In that spirit, my immediate subject is a parochial-seeming cluster of Romantic-period writers—William Roscoe, Felicia Hemans, Maria Jane Jewsbury—a group whose Liverpool-Manchester milieu is provincial, bourgeois, and Dissenting. I have a broader intention as well, and that is to move from the culturally specific to the culturally general, from the parochial to the international, and in the process to bypass the national setting that has been British Romanticism's traditional site. The *conceptual* fulcrum for my argument is the notion of disestablishment. This concept is indeed most recognizable in the ecclesiastical workings of parochial British culture. Yet it served Ann Douglas well in her 1977 book *The Feminization of American Culture* as a description of early republican America. I would extend the term "disestablishment" further and use it to describe the Euro-American historical process since the Renaissance. The *historical* fulcrum for my argument will be the salon as developed by William Roscoe at Liverpool and by Germaine de Staël near Geneva. Roscoe's Athenaeum and Staël's Coppet are premier sites of the Italianate culture that served disestablishment and gave nineteenth-century culture an international project of Romantic education.

Like other feminist and historicist rereadings of Romantic culture, my work joins canonical and noncanonical writers in a common and continuous cultural history. The circles that I describe here have affinities, for instance, with the celebrated Pisan Circle of Byron and the Shelleys. In her 1981 book *Romantics, Rebels, and Reactionaries*, Marilyn Butler historicized the Pisan Circle in deep, new ways but in a literary history still disrupted by canonical formations. In Butler's Shelley-centered account, the Cult of the Mediterranean South was a brief efflorescence, as short-lived as the canonical later Romantics themselves. This "disrupted" history of the Cult of the South occludes important Romantic continuities, for the cult did indeed survive to influence Victorian and modern culture through the legacy of the Italianate salon. As developed by Staël and Roscoe, this educational practice informed Renaissance and risorgimento writing by Bulwer-Lytton, Fuller, Eliot, the Brownings, Hawthorne, James, Forster, and others. Through the twin terms Renaissance and Risorgimento, synonymous with rebirth and resurgence, the nineteenth century enacted cultural and political disestablishment and transferred history from an aristocratic to a bourgeois basis.

Butler's essays "Repossessing the Past" and "Against Tradition" propose, as I do here, that we reread in particularist ways that are also tellingly general. In our own strenuously global moment, such rereadings could repay us with a "regreening" of Euro-American culture, a recuperation of its characteristically bourgeois tendencies in stronger, wider, and deeper

terms.[6] For instance, the West still depends on disestablishment for its most humane and responsive institutions, particularly the nongovernmental organizations, or NGOS, like CARE and Amnesty International that mediate between Western culture and the accidents of its history. The great prototype of the NGO is the International Red Cross, born in northern Italy of the risorgimento (following the bloody battle of Solferino in 1859) and still headquartered in Staël's Geneva. In our era, Geneva remains the center of a diplomatic and critical internationalism, one that is characteristically high bourgeois, vernacular, Protestant, and republican. No bourgeois culture is an unproblematic one, of course, however successful and international. For that reason alone, it is timely that we find less embarrassed ways of regarding Romanticism's bourgeois legacies.

A Cultural Problem Posed

This essay began in response to a problem I encountered while researching the career of Felicia Hemans (1793–1835). Intrigued and soon convinced by Stuart Curran's suggestion in "Hemans as Regency Poet" that Hemans was the Regency's de facto laureate, I yet wondered how a provincial woman poet could become the laureate manqué to a monarch manqué. My answer would lie in cultural practices hidden from a literary history that subscribed to limited notions of Romantic education. Hemans was educated and sponsored by a perplexing set of Anglo-American and continental writers and intellectuals who seemed at once cosmopolitan and provincial, and high and low bourgeois. Independently and through Hemans, these figures were the progenitors of important vogues, high and low, of the Anglo-American nineteenth century: the Italianate mode and parlor sentimentality. Multifaceted in their careers, wide in their influences, these figures have eluded received literary and cultural history, and our sense of Romantic continuity in the Anglo-American nineteenth century is the poorer.

One set of figures revolves around William "Lorenzo" Roscoe (1753–1831) and his Liverpool Athenaeum; it includes Felicia Hemans of Liverpool and North Wales and Maria Jane Jewsbury (1800–1833) of Manchester. Hemans's early education and career were sponsored by Roscoe, and from 1828 to 1830 Hemans and Jewsbury enjoyed an informal salon in Wales and then suburban Liverpool. Roscoe's Athenaeum also accommodated figures ranging from William Hazlitt to Herman Melville. Another and more celebrated group revolves around Germaine de Staël (1766–1817) and her salon at Coppet outside Geneva; it includes A. W. Schlegel and, more important for us, the economist and historian J.-C.-L. Sismondi (1773–1842). These circles shared with the Pisan Circle of Byron and the

Shelleys an interest in Italian republicanism, both its medieval and Renaissance past and its present struggle with the Holy Alliance.

The Liverpool and Geneva circles were connected by correspondence, influence, enterprise, and controversy; they disseminated and even marketed each other's work.[7] Staël's mother, Suzanne Necker, proposed to translate Roscoe's antislavery pamphlet *A General View of the Slave Trade* (1788); Staël praises his histories of the Medicis in a note to her *Corinne, or Italy*.[8] Roscoe's Whig peace-party connections extended to the Berrys, Walpole, and the Prince of Wales. It was Roscoe who arranged for the publication in Liverpool and London of Hemans's juvenilia and who made possible her first volume's dedication to the Prince of Wales (see Hemans, *Poems*). With her *Restoration of the Works of Art to Italy* (1816), Hemans injected Roscoe's histories of the Medicis into postwar poetry, in part through the poem's influence on the fourth canto of Byron's *Childe Harold*. Next, in her *Tales and Historic Scenes* (1819) and *The Vespers of Palermo* (1823), Hemans disseminated Sismondi, especially his *Histoire des républiques Italiennes* (1809–18). Throughout their careers, both she and Jewsbury popularized Staël, and Jewsbury promoted Hemans. In his later *Illustrations of the Life of Lorenzo de' Medici* (1822), Roscoe debated with Sismondi the character of the Italian Renaissance; and Roscoe's son Thomas translated Sismondi's literary criticism as *A Historical View of the Literature of the South of Europe* (1823). In Liverpool, this same Thomas produced verse annuals that used Hemans's work; and other members of Roscoe's family continued his projects.

Influential among themselves, these groups also influenced Anglo-American culture. Staël and Sismondi played key roles in the making of the Romantic Cult of the South.[9] Hemans was the most widely published woman poet of the nineteenth century and served as an important poetic precursor for Tennyson, Longfellow, and Barrett Browning.[10] In commercial terms, she appears as the founder of a Victorian sentimental "parlor culture" that throve in Britain and America.[11] From a broader perspective, Hemans may indeed have "forged," as Stuart Curran suggests, "the broadly cosmopolitan, democratic, and liberal consensus of much nineteenth-century culture" ("Women" 194).

William Roscoe's influence was broadly cultural and political as well. He was elected from Liverpool, the nation's chief slave-trading port, to the 1806 Parliament, where he voted against that trade. From the 1770s into the 1820s, Roscoe wrote scores of political appeals, pamphlets, and poems against slavery and in favor of France, peace, and Reform. During the same decades, he served as the principal creator of liberal, intellectual Liverpool, a setting that hosted Unitarian notables like Spanish émigré Blanco White and W. E. Channing and writers and artists, including William Hazlitt, Washington Irving, J. J. Audubon, Herman Melville, and Nathaniel Haw-

thorne. When Irving was sent to work in a Liverpool counting house, he studied in the Athenaeum and later credited Roscoe with inspiring *The Sketch Book*, which contains the portrait "Roscoe." Melville the sailor and Hawthorne the consul knew Liverpool—Melville wrote retrospectively in chapter 30 of *Redburn* about the Roscoean culture there. This novel's tributes to Roscoe include terming him "the modern Guicciardini of the modern Florence" (142). Hawthorne later served as American consul in Liverpool before writing *The Marble Faun*. Irving and Hawthorne probably drew on Liverpool's Mediterranean collections for their writings on Columbian Spain and Renaissance Italy.

Toward a Culture of Disestablishment

Hemans and Roscoe are Britons oriented toward the Continent and toward America; and the making of such Britons, however influential, has been difficult to explain within the received terms of British culture. Not tied to the landed establishment or its most parochial feature, the Church of England, Hemans and Roscoe did not experience the classical education entrenched in Britain's "public schools" and its chartered universities. Likewise, although they worked alongside the circles and academies of Dissent, they remained distinct from these as well, avoiding the controversies that exiled Paine and Priestley and silenced many others such as Anna Barbauld. Finally, when possible, they pointedly avoided the worldly publishing circles of the metropole. Hemans visited London once, Roscoe rarely, and Jewsbury's venture into London ended in exile and death. In fact, the more formally these hardworking middle-class writers drew on the rich resources of Established, Dissenting, and metropolitan institutions, the more they imperiled their much-prized careers and even their lives.

For instance, after Waterloo Hemans left the Roscoe circle to seek support from the Tory establishment: she addressed Sir Walter Scott, obtained John Murray for her publisher, and enlisted the help of *Quarterly Review* clerics like Reginald Heber and Henry Hart Milman. But Heber's close critique of Hemans's manuscript poem on comparative religion left her prized project a fragment ("Superstition and Revelation"), a failure she regretted to the end of her life; and Milman's handling of her drama *The Vespers of Palermo* in London did not prevent its being conventionalized in performance.[12]

For his part, Roscoe was a self-taught man who extended his education in ancient and especially modern languages and literatures through friends from the nearby Warrington Academy.[13] The cherished result of this informal education was Roscoe's *Life of Lorenzo de' Medici* (1795), whose success led to calls for a sequel from powerful London and Westminster Whigs,

with the well-traveled Lord Holland supplying new documents. The result-ing *Life and Pontificate of Leo X* was judged lackluster; it damaged Roscoe's reputation and caused a distraction in his business life, coinciding with banking overextensions toward Liverpool friends (Hazlitt xxi–xv).

Maria Jane Jewsbury of Manchester early declared her independence of the establishment by writing satirical and melodramatic portrayals of Lon-don as a literary lion's den in *Phantasmagoria* (1825) and *The Three Histories* (1830). When she used her 1825 publication to gain admission to Words-worth's Rydal Mount, she found the reception in that patriarchal, Tory setting an equivocal one and fell into a nervous collapse. Visiting Hemans in North Wales, she discovered an alternative to Wordsworth's paternalism and recovered her confidence. Emboldened once again, Jewsbury chanced London's lion's den, for three years serving (anonymously) as the *Athe-naeum*'s lead reviewer. As a single woman (whom Hemans's biographers delicately portray as lesbian), Jewsbury felt keenly the pressures and expo-sures of literary London and within three years left her career for marriage, India, and death from cholera.[14] Figures like Roscoe, Hemans, and Jews-bury, then, flourished precisely when they did not engage the establish-ment or metropole and instead embraced the energies of disestablishment.

Narratives of British cultural history, however, are typically focused on the contest between Establishment and Dissent and on the making of a metropolitan empire centered in London. A cultural history for disestab-lishment will need new terms and a narrative of its own. *Disestablishment* itself, in its "particularist" sense, refers of course to the gradual loosening of ties between the Established Church of England and political and social eligibility. This process was markedly under way during the 1820s, with the repeal of the Test and Corporation Acts in 1828 and a degree of Catho-lic emancipation in 1829. As a broader Anglo- or Euro-American historical process, disestablishment unfolds through the following shifts of cul-tural influence: *from* such defined institutions as land and its inheritance, Church and King, education via classical text, and a system of "place" mili-tary and civil; and *to* institutions that contest and resist establishment and even definition—money, the countinghouse, a mercantile consular diplo-macy, and the modern languages learnable in the home and by women. Disestablishment as a process is always incomplete and always ongoing; it is a means of cultural continuity that can counter the "disruption" model of cultural history that has limited Romantic studies.

The genius of figures like "Lorenzo" Roscoe and "Corinne" de Staël consisted in their seeing British disestablishment within an international framework and then exploiting its workings there, Roscoe furthering Liver-pool trade, Staël her republican hopes for France. For them, the setting of disestablishment was a wide arc of bourgeois trading cities—from Geneva

to Liverpool and beyond, to Philadelphia, Boston, and New York. For them, the quintessential institution that disseminated the culture of disestablishment was an educational one, the salon or "athenaeum," whose vernacular education forms the concluding subject of this essay, which, in the form of the Italianate salon itself, emerges most clearly in the particularities of its careers and settings.

Roscoean Athenaeum, Staëlien Salon

William Roscoe grafted onto Liverpool a civic and Italianate culture as broad ranging as that of his idol Lorenzo de' Medici, whose wool-carder antecedents were in turn as petit bourgeois as those of Roscoe.[15] The son of a pub owner, Roscoe read for the law, then became a prominent banker, the founder of a series of cultural institutions, and a Renaissance man in his own right. He achieved distinction as a poet, politician, scientist, biographer, even children's writer.[16] Late in his career he wrote on penal reform in Britain and America contra Bentham. As editor of Pope, in 1824 he participated in the Bowles controversy. Patronized by Walpole and Holland, Roscoe included among his contacts the Aikens, the Berrys, the Princes of Wales and Gloucester, and Mary Wollstonecraft.

In the late eighteenth century, Liverpool was rife with privateering and was the center of a slave trade that Roscoe and his Quaker and Unitarian friends abhorred. These conditions made the city paradoxically the perfect setting for civic culture as Roscoe envisioned it. For him, the fast-growing, commercial Liverpool of the later eighteenth century was not simply a rich province of London; nor was it a city purely in transit between antiquated royal charter and full representation at Westminster. For Roscoe, Liverpool was a semi-independent city-state. Indeed, Liverpool's many privateers gave it an outlaw commerce — that is, independent foreign policy — during peacetime and a naval militia during war.[17] Practicing its own internal diplomacy, Liverpool was negotiating a free-trade league with other western and midland cities when interrupted by the war with France (Picton 1: 235). As Melville portrays Liverpool in *Redburn*, it was the world's most modern port city, resembling New York more than London, and setting the commercial and technical pace for both (154). For Roscoe, Liverpool had both the resources and the need for a higher liberal culture.

To supply this higher culture, Roscoe undertook the education of his fellow Liverpool bourgeois in the civic values of the Italian Renaissance. Like Lorenzo de' Medici, Roscoe became an energetic cultural founder, spearheading a series of mostly transitory yet somehow recurring "institutions": an Academy of Painting and Sculpture, a Botanic Garden, again an art gallery, and Liverpool's Royal Institution. The history of Roscoe's cultural

foundations as they disperse and re-form offers a prototype of the culture of dis- and re-establishment. Most enduring of Roscoe's foundations was his Athenaeum (opened in 1799), a merchants' reading and conversation room where Roscoe gently held court as if he were in a male salon.[18] In his portrait of Roscoe in *The Sketch Book*, Washington Irving emphasizes the masculine and bourgeois setting and the humanizing purpose of Roscoe's Athenaeum:

> To find, therefore, the elegant historian of the Medici mingling among the busy sons of traffic, at first shocked my poetical ideas; but it is from the very circumstances and situation in which he has been placed, that Mr. Roscoe derives his highest claims to admiration. ("Roscoe" 21)

Ironically, the Athenaeum was most richly underwritten when Roscoe's own investments failed and his Italianate library and artwork were auctioned and repurchased by friends for the reading room and (later) Liverpool's Walker Gallery of Art. Roscoe's cultural designs became part of national culture when his protégé, the émigré Anthony Pannizzi, became principal librarian for the British Museum and originated its great reading room.

On the Continent, Germaine de Staël was the logical heir in the Napoleonic era to the notion of an international high-bourgeois salon presiding over the culture of disestablishment: her mother was Suzanne Curchod, celebrated *salonnière* in Lausanne and Paris; her father Jacques Necker, finance minister to Bourbon, then revolutionary France. From her own salon in Paris, Staël promoted republican alternatives to Terror and Napoleon. Banished from France, she established at Coppet a meeting place of French, German, and Swiss intellectuals and artists. In her novel *Corinne ou l'Italie* (1807), she codified a gendered discourse of "Italy" that would shape nineteenth- and even twentieth-century notions of that cultural idea, especially in Anglo-American culture. Staël's title character Corinne is both an improvisational woman laureate and successor to Petrarch; the center of a salon where Italy's character is anatomized; and a woman writer exiled from parochial England. When Napoleon ordered her next book, *De l'Allemagne*, destroyed on the Continent, Staël came to England in 1813 to see it published and to be lionized as Corinne. Not fully understood by the Whigs who patronized her, the anti-Napoleonic Staël still could not be denied in Britain. Her visit and her books made available there the model of a salon led by a woman, one devoted equally to the problematics of a woman's literary career, especially in England, and to high-bourgeois republican politics.

Aspiring women writers like Jewsbury and Hemans formed the most avid market for Staël's persona and intellectual model. In Manchester,

the young Maria Jane Jewsbury completed her first book, *Phantasmago-ria* (1825), a collection of literary *jeux* and serious criticism. Through mutual contacts in the annuals market, Jewsbury met Felicia Hemans. Like Corinne, Hemans was said to be half-British and half-Italian; and she confessed in the margins of her *Corinne*: "C'est moi" (Chorley 1: 304). More important, her portraits of Italian aesthetics and history in *The Restoration of the Works of Art to Italy* (1816) and *Tales and Historic Scenes* (1819) were sustained by the aesthetics of *Corinne* and punctuated by allusions to the "civic widows" memorialized in Corinne's own "Improvisation in the Countryside of Naples."[19]

During their extended visit in the summer of 1828, Jewsbury and Hemans emulated the *haut bourgeois* salon of Corinne (Clarke 74–76). As Norma Clarke describes it, "The women spent their days roaming the countryside, reading, talking, and resting in dingle and nook while the children ranged more widely. In the evenings there was more talking, more reading, and music" (75). Jewsbury mined that summer for a collection of poetry dedicated to Hemans, *Lays of Leisure Hours* (1829), and the fictional triptych à clef, *The Three Histories* (1830). The latter depicts the Staëlien salon in British culture, its first novella "a composite of Felicia Hemans and Maria Jane Jewsbury out of Madame de Staël's Corinne" (Clarke 83), its second a showcase for Hemans's persona as the muse of the Roman Campagna. Hemans brought the resources of Roscoe's Athenaeum into the Staëlien salon that she and Jewsbury fashioned for themselves.

Felicia Dorothea Browne was born into a Liverpool family that included "Tuscan" consuls who were prominent in the Mediterranean wine trade. In the year of Hemans's birth, 1793, war with France and resulting finan-cial panic disrupted the wine trade, and the Brownes removed to Wales; yet Felicia's ambitious mother made certain that her family could still draw on Liverpool's resources. These included Roscoe's books, early printings of Sismondi's histories and criticism, and Roscoe's help in launching Felicia Browne's career (Nicholson 8). Felicia Hemans went on to become a poet of substance and learning during the Regency, publishing ten volumes be-tween 1808 and 1821 and specializing in the long forms of the progress poem, narrative, and polemic.

As Regency gave way to Reform, and the putative "later Romantics" died in exile, Hemans continued to be a central figure in literary culture, moving between Tory and liberal sponsorship as before and in the best disestablishment manner. Turning from long poems to lyrics, she lent lus-ter to the magazines and verse annuals in which commercialized poetry flourished after 1825.[20] Younger women poets like Jewsbury and Landon now found Hemans's work a necessary inspiration, and she was celebrated in the bipartisan salons of the Countess of Blessington.[21] Because Hemans

catered to commercial markets, she earned the distrust of high bourgeois successors like Barrett Browning. Her influence in some measure survived that distrust, however, for like Roscoe's, it was transatlantic. A favorite of Boston Unitarians W. E. Channing and Andrews Norton, Hemans served as a prototype for the sentimental culture that Ann Douglas defined in 1977 as that of disestablishment: Norton invited Hemans to America to edit a magazine; the American poet Lydia Sigourney was known as the "American Hemans."

Lorenzo's Lessons, Corinne's Curriculum

The Italianate culture associated with Coppet and Liverpool thus carried its freight of high-bourgeois liberalism and low-bourgeois sentimentality into the Anglo-American nineteenth century. This influential middle class and feminizing culture and its representative Felicia Hemans continue to embarrass even those who would recover them for literary history.[22] I suggest that we can counter that lingering embarrassment by going beyond the depiction of cultural *practice* in the Italianate salon and by supplying as well the cultural *content* or curriculum of this newly recovered version of Romantic education. First and foremost, a salon in practice is quintessentially a vernacular institution, and in the bourgeois settings of Roscoe and Hemans, an education in the *vernacular* was preferred. Romance languages were encouraged as "accomplishments" for women; they also granted practical advantages to traders; and a salon is by definition a vernacular setting. Other forms of education in Britain were not free to meet the vernacular needs of an increasingly bourgeois culture. Establishment institutions were committed to a classical curriculum; Dissenting academies offered a compromise between classical and vernacular cultures that left one feeling lacking in both. (John Keats's well-known struggle for Greek and Italian illustrates this dilemma.) As things stood, both vernacular education and the bourgeois culture dependent on it would always feel and always be belated.

Roscoe, Hemans, and Jewsbury were essentially untrammeled by Britain's formal traditions of learning, whether Established or Dissenting. Roscoe pursued his education by apprenticing himself to a bookstore owner and studying selectively with friends. As the daughters of merchants fallen on hard times, Hemans and Jewsbury were educated at home and then self-educated; these writers made European vernacular culture the core of their educations. Further circumstances urged an international, vernacular education on them: Hemans's part-Italian family of wine traders and Tuscan consuls; Roscoe's scholarly and political connections in Italy; Jewsbury's excitement over Staël's lionization in London in 1813

and her celebrated salon in Geneva. Roscoe and Hemans did learn Latin as well as Romance languages, but the Horace that Hemans translated appears as another Mediterranean poet along with Petrarch and Tasso, while Roscoe used Latin to read documents about the Medicis.

Roscoe and Hemans helped educate liberally inclined Britons and Americans in vernacular culture and also in bourgeois history. The Italy of the Bulwer-Lytton, Brownings, Hawthorne, and George Eliot is more legible in the context provided to that country by Roscoe and Sismondi. Quite simply, Roscoe, Hemans, and their circles were committed to a postclassical vernacular culture and a postimperial bourgeois history that evaded and succeeded the metropolitan cultures associated with imperial capitals. This historical dimension may have been the salon's greatest gift to an English bourgeoisie that felt itself still waiting to enter history—history, that is, as defined by Established entitlement. Such belatedness meant for the British bourgeoisie that it could neither embrace nor learn from another history, the one it shared with a broader world undergoing *dis*establishment. What was not clear to unenfranchised Britons was that the protracted process of disestablishment *was* history and had been so in European cities for hundreds of years. What was not clear to the same Britons was that the bourgeois forces that evaded, contested, undermined, and supplanted Establishment culture *were* culture and had been so for hundreds of years.

To a bourgeoisie then and now, the Roscoe-Staël curriculum teaches the history and culture of disestablishment. Its privileged sites are the long-standing bourgeois European republics like Geneva and the semi-independent cities of Italy. On the secular side, disestablishment culture is the bourgeois city anchored *haut* and *petit bourgeois* to its financiers and artisans—externally, a city-state striving for independence from metropole and empire; internally, a republic with representation reaching more or less deeply into the artisan class. On the religious side, disestablishment is Reformational, with Reformation less a watershed event than a process that knows precursors (e.g., Arnaud de Brescia, Savonarola) and remains stubbornly incomplete and capable of continued new moments (the Puritan revolution, the French Revolution). As Calvin's Geneva and Savonarola's Florence suggest, this Reformation is tied to the antimetropolitan and populist impulses of the bourgeois republic.

In *The Three Histories,* Maria Jane Jewsbury presents an exemplary program for the linguistic and literary side of this curriculum. Her "Enthusiast" Julia reads Staël and those promoted by Staël: Petrarch, central figure in the pan-Mediterranean poetry Hemans translated in 1818; Goethe, early codifier of the Italianate in *Wilhelm Meister* and his Italian journals; and Schiller, the Sturm und Drang master whose powerful plots and motifs

resurface in the risorgimento culture (especially its opera) that circulated between Italy and Britain during the mid–nineteenth century. Jewsbury grants the feminine a key role in disestablishment culture; she warns the would-be Corinne that bourgeois culture has a voracious appetite for the *salonnière*-laureate "out of *Corinne*"—her Julia is ravaged by London's literary lion's den, her Egeria made a dolorous angel. In her anonymous journalism for *Athenaeum,* Jewsbury continued to comment on the disposition of the woman poet in bourgeois culture: in the first of her "Literary Sketches," she considers Hemans as a Reform-era "speaker of the female literary House of Commons" (104). In Jewsbury, themes of sentimental education, internationalism, the high bourgeoisie, and republican reform lightly cling to the icon of Corinne, female laureate of vernacular culture.

As Jewsbury sensed, Felicia Hemans was more than a dolorosa; and her role in nineteenth-century culture owed as much to her historical education by Lorenzo's Athenaeum as to her literary one by Corinne's Coppet. The able Felicia learned four Romance languages and German, with some Latin and Welsh. Her three volumes of juvenilia debate the role of the woman poet in culture; they comment at length on the Peninsular War and prospects for renewed republicanism in Europe; they assess the world empire that always empties homes and betrays commitments. Hemans read continuously and purposefully for her twenty books of poems; in the first ten she appended copious notes, often in Spanish, French, or Italian. Her "curriculum" was English and European vernacular culture in the original: Renaissance and Enlightenment poets in five languages; the emerging British canon of Shakespeare and Milton; her contemporaries writing in large forms (Schiller, Scott, Baillie, Byron, Campbell); Italian and German literature; travel writing; Roscoe's *Lorenzo;* writers important to the Necker-Staël salons—Gibbon, Montesquieu, Chateaubriand, the Schlegels; and most important, Staël herself (*Corinne, De l'Allemagne,* and *Dix Années d'Exil*) and Sismondi. Hemans read and used works by Sismondi in the original by 1821, while others waited two years for his criticism in translation and his Italian history, abridged in 1832 for the Cabinet Cyclopedia. When Jewsbury recommended Wordsworth to her, Hemans countered with Sismondi's Italian history and his literary history of "the Midi" (Chorley 1: 172–77).

Sismondi's career was as multifaceted as Roscoe's, for he was a man of commerce and a laissez-faire economist, agronomist, Italian and French historian, literary historian, novelist, ecumenist, and communitarian liberal. His commitment to lifelong education and city-state republicanism match Roscoe's own. For its devotion to the political and class dynamics of postclassical, anti-imperial, bourgeois republics, Simonde de Sismondi's *Histoire des républiques Italiennes du moyen âge* (1809–18) became the risor-

gimento's favored text. Like Sismondi, Hemans developed a persistent critique of republics that are incompletely reformed and tainted with imperial entanglements (an autocratic Ferrara, a revenge-driven Genoa, a Carthage betrayed to Rome). Like him, she creates a prophetic history in which republican setbacks make the enfranchisements to come (of the bourgeoisie, of women) all the more inevitable.

Sismondi's historical dramaturgy gave Hemans's work most of its political depth and its new dramatic form, the "historic scene." In her *Tales and Historic Scenes* (1819), Hemans works with the earlier stages of Sismondi's story, those prior to the emergence after 1300 of such overpowering male figures as Rienzi, Savonarola, and Lorenzo. In these earlier stages, key male figures—such as Crescentius, Conradin, di Procida—serve as sacrificial flash points of republican resistance. In Hemans's skillful hands, these figures cede center stage to their female connections, mothers, fiancées, wives, widows. Adapting Sismondi to her purposes, Hemans factors women into history. Hemans's *Tales* and its Italianate sequel *The Vespers of Palermo* (1823) are full of failed yet fertile attempts at a feminist "liberty."

Because it sidestepped the intractable parochial conflicts built into British culture, the Italianate salon offered the perfect education to an adept bourgeois, whether female or male; it taught that in order to enter history, the bourgeoisie need not wait for Parliamentary Reform or the abolition of civic disabilities. Instead, as educated by "Lorenzo" Roscoe, the middle classes could claim a five-hundred-year history in Europe—and Sismondi would make this a thousand years. A principally Italian history showcases the testing of republican practices—unsavory ones like a revenge ethic or the exchange of women or slaves, and Reformist ones like laureateships, salons, libraries, representative municipal government, or (to cite a Hemans title) "Woman on the Field of Battle" in the form of the Red Cross. It is bourgeois institutions like these and the texts written about them that form a curriculum particularly suited to nineteenth-century Euro-America. The Italianate salon might again compel the attention of a world where venerable trading cities such as Geneva and Singapore continue to play an unpredictable but crucial role.

Notes

1 I have quoted from the title of a recent anthology edited by Mary Favret and Nicola Watson, *At the Limits of Romanticism: Essays in Cultural, Feminist, and Materialist Criticism*, whose intent is to take us to, if not beyond, these limits.

2 Important recoverers of Romantic-period fiction: Marilyn Butler (*Jane Austen*), Gary Kelly (*English Fiction*); of nonfiction: Gary Kelly (*Revolutionary Feminism* and *Women, Writing, and Revolution*) and John Barrell; of drama, Julie Carlson; of further poetic

careers, Marlon Ross, Susan Wolfson; and Hugh Haughton, Adam Phillips, and Geoffrey Summerfield.

3 Sample rereadings of canonical poets in their cultural settings and for their cultural engagements include those by James Chandler on Wordsworth, E. P. Thompson on Blake, Julie Ellison on Coleridge (103–213), Jerome Christensen on Byron, Stephen Behrendt on Shelley, and Marjorie Levinson on Keats.

4 An exemplary work of comparatist Romanticism that also addresses the differences that shape our cultural history is Julie Ellison's *Delicate Subjects*, whose study of "Romanticism, Gender, and the Ethics of Understanding" spans the work and settings of Friedrich Schleiermacher, Samuel Taylor Coleridge, and Margaret Fuller. David Simpson's *Romanticism, Nationalism, and the Revolt against Theory* also pursues comparatism and cultural practice, the better to understand Anglo-Americanism; but unlike Ellison, Simpson would rescue literary practice from some of the vexations of historical difference.

5 In a related piece of scholarship, Alan Richardson has recently shown that education was as compelling topically and philosophically in the Romantic period as it is now and that under the rubric of education, canonical and noncanonical versions of Romanticism become an indivisible whole.

6 I allude here to Jonathan Bate's proposal in *Romantic Ecology* that in the post–Cold War era a natively English "green" Romanticism replaces a Marxist "red" one. The choice seems to me a false one, for there is vitality in the liberal international culture that came before Communism, and we continue to call on that vitality both for historical continuity and in historical crisis. I suggest that we review the powers of that culture before accepting the local retrenchments prescribed in Bate's program.

7 Details of influence involving Staël, Sismondi, and Hemans occur throughout Brand and also Sweet, "History"; those involving Staël, Hemans, and Jewsbury occur in Clarke ch. 1–3; Ross ch. 7–8; Peel and Sweet; and Wolfson 134–37, 155–62. Details here and below involving Roscoe derive from George Chandler, Hazlitt, MacKenzie-Grieve, and Picton.

8 Staël ch. 6, 425n4.

9 On Staël and Sismondi and the Cult of the South, see Butler, *Romantics* 119–20.

10 See Reiman's Introduction to the Garland editions of Hemans's work (v). Formalist, textual, and feminist treatments of Hemans's canonical role appear, respectively, in Tucker 542–45; Leslie ch. 7, ln6–7; ch. 16, 16; conclusion; and Leighton ch. 1. The feminist counter-canon approach in Leighton yields a more negative version of Hemans than does my cultural-critical work.

11 On Hemans's role in sentimental parlor culture and its poetry, see Cruse 18, 178, 222, 225–26, 220; and Walker 24–27.

12 About her abandoned long poem on religion Hemans said, "My wish ever was to concentrate all my mental energy in the production of some more noble and complete work" (Chorley 2: 257). Hemans resumed this project in more scattered form, first in the Whig venue of the *New Monthly Magazine* (where her "Lays of Many Lands" series appeared from 1823 to 1825) and then under the Tory guidance of Robert Percival Graves (Leslie ch. 11–15). About her drama and Milman, see Chorley 1: 64, 67.

13 See Hazlitt xii–xiii; Mackenzie-Grieve 21–23, 175, 201, 203, 250, 252–53, 275–79.

14 On Jewsbury's "masculine" role-playing, see for instance Clarke 36–37. Jewsbury's London-to-exile-to-death destiny was duplicated by the poet L. E. Landon, with the even more grisly results of a death by poison.

15 On Roscoe, see George Chandler; Hazlitt; MacKenzie-Grieve; and Picton 1: 184, 209, 225, 227, 234, 239–41, 269–83, and 307.

16 Roscoe is currently anthologized as a Romantic-period children's poet: his "The Butterfly's Fall and the Grasshopper's Feast" (1806) appears in Jerome McGann's *The New Oxford Book of Romantic Period Verse* (253–54).

17 On Liverpool's naval and diplomatic independence, see Picton 1: 192, 236, 387, 389, 414.

18 The Athenaeum still exists in Liverpool, now on Church Alley. In keeping with its liberal tradition, in July 1996 it hosted a televised symposium on peace in Ireland. Roscoe's books have pride of place there, even as his Italian art anchors the Walker Gallery's medieval and Renaissance collections.

19 My published and forthcoming essays develop these readings ("History"; "Hemans's"; and with Ellen Peel, "*Corinne*").

20 Noting the prominence of women writers in the years around the Reform Bill, Janet Courtney subtitled her book on those years "A Chapter in the Women's Movement."

21 See especially the tribute to Hemans by Walter Savage Landor, who was a devotee of Blessington's salon, in "To the Author of *Festus*; on the Classick and Romantick" (*Complete Works* 15: 163–66).

22 In "Hemans," for instance, Stuart Curran called Hemans's "feminine vision" of liberalism "a tactical mistake with major consequences." And Tricia Lootens has described Hemans's critical vision in Hegelian terms as an "enemy within" the state, inevitably self-divided and enfeebled. Hemans never cites Hegel; instead her citations of Sismondi's historical and political philosophy tell a vigorous rather than enfeebled story.

Works Cited

Barrell, John. *The Infection of Thomas DeQuincey*. New Haven: Yale UP, 1991.

Bate, Jonathan. *Romantic Ecology: Wordsworth and the Environmental Tradition*. London: Routledge, 1991.

Behrendt, Stephen. *Shelley and His Audiences*. Lincoln: U of Nebraska P, 1989.

Brand, C. P. *Italy and the English Romantics: The Italianate Fashion in Early Nineteenth-Century England*. Cambridge: Cambridge UP, 1957.

Butler, Marilyn. *Jane Austen and the War of Ideas*. Oxford: Clarendon-Oxford, 1975.

———. "Repossessing the Past: The Case for an Open Literary History." *Rethinking Historicism: Critical Readings in Romantic History*. By Marjorie Levinson et al. Oxford: Oxford UP, 1981.

———. *Romantics, Rebels, and Reactionaries: English Literature and Its Background 1760–1830*. Oxford: Oxford UP, 1981.

———. "Against Tradition: The Case for a Particularized Historical Method." *Historical Studies and Literary Criticism*. Ed. Jerome J. McGann. Madison: U of Wisconsin P, 1985. 25–47.

Carlson, Julie. *In the Theatre of Romanticism: Coleridge, Nationalism, and Women*. Cambridge: Cambridge UP, 1994.

Chandler, George. *William Roscoe of Liverpool*. Introd. Sir Alfred Shennan. London: Batsford, 1953.

Chandler, James. *Wordsworth's Second Nature: A Study of the Poetry and Politics*. Chicago: Chicago UP, 1984.

Chorley, Henry F. *Memorials of Mrs. Hemans*. 2 vols. London: Saunders & Otley, 1836.

Christensen, Jerome. *Lord Byron's Strength: Romantic Writing and Commercial Society.* Baltimore: Johns Hopkins UP, 1993.

Clarke, Norma. *Ambitious Heights: Writing, Friendship, Love—The Jewsbury Sisters, Felicia Hemans, and Jane Welsh Carlyle.* London: Routledge, 1990.

Courtney, Janet. *The Adventurous Thirties: A Chapter in the Women's Movement.* 1933. Freeport, New York: Books for Libraries, 1967.

Cruse, Amy. *The Victorians and Their Books.* London: Allen, 1935.

Curran, Stuart. "Hemans as Regency Poet." MLA Convention. San Francisco, 30 Dec. 1991.

———. "Women Readers, Women Writers." *The Cambridge Companion to British Romanticism.* Ed. Stuart Curran. Cambridge: Cambridge UP, 1993. 177–85.

Douglas, Ann. *The Feminization of American Culture.* New York: Knopf, 1977.

Ellison, Julie. *Delicate Subjects: Romanticism, Gender, and the Ethics of Understanding.* Ithaca: Cornell UP, 1990.

Favret, Mary A., and Nicola J. Watson, eds. *At the Limits of Romanticism: Essays in Cultural, Feminist, and Materialist Criticism.* Bloomington: Indiana UP, 1994.

Haughton, Hugh, Adam Phillips, and Geoffrey Summerfield, eds. *John Clare in Context.* Cambridge: Cambridge UP, 1994.

Hazlitt, William. "A Memoir of the Author." *Life of Lorenzo de' Medici.* By William Roscoe. Ed. William Hazlitt. London: David Bogue, 1846. ix–xxxiv.

Hemans, Felicia. *Poems, England and Spain, Modern Greece, etc. 1808, etc.* Vols. 64–70 of *The Romantic Context: Poetry.* Ed. Donald H. Reiman. 128 vols. New York: Garland, 1976–78.

Irving, Washington. "Roscoe." *The Sketch Book of Geoffrey Crayon, Gent. 1819–20.* New York: Burt, 1859. 20–26.

Jewsbury, Maria Jane. *Phantasmagoria; or, Sketches of Life and Literature.* 2 vols. London: Hurst; Edinburgh: Constable, 1825.

———. *The Three Histories.* London: Westley, 1830.

———. "Literary Sketches. No. 1. Felicia Hemans." *Athenaeum* (Feb. 1831): 104–5.

Kelly, Gary. *English Fiction of the Romantic Period 1789–1830.* London: Longman, 1989.

———. *Revolutionary Feminism: The Mind and Career of Mary Wollstonecraft.* New York: St. Martin's, 1992.

———. *Women, Writing, and Revolution, 1790–1827.* Oxford: Clarendon-Oxford, 1993.

Landor, Walter Savage. *Poems.* Vol. 3. Ed. Stephen Wheeler. Vol. 15 of *The Complete Works.* Ed. T. Earle Welbey. 16 Vols. London: Chapman, 1929–36.

Leighton, Angela. *Victorian Women Poets: Writing against the Heart.* Charlottesville: UP of Virginia, 1992.

Leslie, M. I. *Felicia Hemans: The Basis of a Biography.* Diss. U of Dublin, 1943.

Levinson, Marjorie. *Keats's Life of Allegory.* Oxford: Blackwell, 1988.

Lootens, Tricia. "Hemans and Home: Victorianism, Feminine 'Internal Enemies,' and the Domestication of National Identity." *PMLA* 109 (1994): 238–53.

Mackenzie-Grieve, Averil. *The Last Years of the English Slave Trade: Liverpool 1750–1807.* 1941. New York: Kelley, 1968.

McGann, Jerome J., ed. *The New Oxford Book of Romantic Period Verse.* Oxford: Oxford UP, 1993. 253–54.

Melville, Herman. *Redburn: His First Voyage.* 1849. Garden City, NY: Doubleday, 1957.

Nicholson, Francis. *Memoirs and Proceedings of the Manchester Literary and Philosophical Society* 54 (1910): 1–40, no. 9.

Peel, Ellen, and Nanora Sweet. "*Corinne* in England: Felicia Hemans, Maria Jane Jewsbury,

and Elizabeth Barrett Browning." *Rethinking the Novel:* Corinne *in Critical Interpretations.* Ed. Karyna Szmurlo. Lewisberg, PA: Bucknell UP. Forthcoming.

Picton, J. A. *Memorials of Liverpool, Historical and Topographical.* 2nd ed. Vol. 1. Liverpool: Walmsley, 1903. 2 vols.

Reiman, Donald H. Introduction. Hemans v–xi.

Richardson, Alan. *Literature, Education, and Romanticism: Reading as Social Practice, 1780–1832.* Cambridge: Cambridge UP, 1994.

Ross, Marlon B. *The Contours of Masculine Desire: Romanticism and the Rise of Women's Poetry.* New York: Oxford, 1989.

Simonde de Sismondi, [J.-C.-L.]. *Histoire des républiques Italiennes du moyen âge.* 5th ed. 8 vols. Brussels: Société Typographique Belge, Ad. Wahlen, 1856.

Simpson, David. *Romanticism, Nationalism, and the Revolt against Theory.* Chicago: U of Chicago P, 1993.

Staël, Madame de. *Corinne; or, Italy.* Trans. Isabel Hill (odes trans. L. E. Landon). New York: Burt, [1833].

Sweet, Nanora. "History, Imperialism, and the Aesthetics of the Beautiful." Favret and Watson 170–84.

———. "Hemans's 'The Widow of Crescentius': Beauty, Sublimity, and the Woman Hero." *Approaches to Teaching British Women Poets of the Romantic Period.* Ed. Stephen C. Behrendt and Harriet Kramer Linkin. New York: MLA. Forthcoming.

Thompson, E. P. *Witness against the Beast: William Blake and the Moral Law.* New York: New Press, 1993.

Tucker, Herbert F. "House Arrest: The Domestication of English Poetry in the 1820s." *New Literary History* 25 (1994): 521–48.

Walker, Cheryl. *The Nightingale's Burden: Women Poets and American Culture before 1900.* Bloomington: Indiana UP, 1982.

Wolfson, Susan. " 'Domestic Affections' and 'The spear of Minerva': Felicia Hemans and the Dilemma of Gender." *Re-Visioning Romanticism: British Women Writers, 1776–1837.* Ed. Carol Shiner Wilson and Joel Haefner. Philadelphia: U Pennsylvania P, 1994. 128–66.

Liberty, Connection, and Tyranny:

The Novels of Jane Austen and the

Aesthetic Movement of the Picturesque

JILL HEYDT-STEVENSON

*H*ow liberated should a landscape be from the regulating hands of improvers or the unconstraining hands of picturesque design? Should the landscape be belted or free; should curves be severely serpentine or careless and easy? Should avenues five miles long be cut down to clear the way for new plantings? Should a landscape architect alter the course of a river and plant a pleasure garden on English soil "in the style of Watteau"? (Aslet 1936–37).[1] How much freedom of movement, either through the land or through the network of social classes should the individual—especially a woman—be permitted? Should a heroine have the freedom to express emotions so violently that they almost kill her (*Sense and Sensibility*); to disobey her guardian by marrying the man she loves (*Persuasion*); to marry her cousin (*Mansfield Park*); to marry out of her financial class or change her mind about an engagement or walk across the fields and get her petticoats muddy and her cheeks pink and completely outrage her neighbors and future relatives (*Pride and Prejudice*)?

In Austen's novels, arguments about the construction of a national identity converge with arguments about the construction of womanhood and the construction of landscape. When we examine this convergence, we find that Austen explores the junction between the boundaries of personal liberty allowed to women and those allowed to the landscape itself, privileging for her own heroines bonds with the wilder, unornamented, picturesque landscape. I will argue here that we can more fully understand this convergence and better address some of the questions listed above when we examine the aesthetic debates concerning the picturesque that occurred between (roughly) 1790 and 1811. Recognizing Austen's affiliation with picturesque aesthetics—and particularly with the theorists Uvedale Price and Richard Payne Knight—reveals a complex nexus among the novels, the nation, the picturesque, and Romantic aesthetics. And although critics have suffered

from several blind spots when they have tried to assess Austen's relationship to the picturesque,[2] she was, in fact, lucidly informed about the picturesque controversies among various landscape gardeners and aestheticians that were played out during her lifetime. Austen lived fully in the world of landscape architecture, witnessing at firsthand the impact of picturesque improvement and the conflict between the preservers and the improvers: her wealthy relatives living at Godmersham Park and Goodnestone Farm had their land improved in the style of Capability Brown, and Repton himself transformed Stoneleigh Abbey, much to the family's dismay.[3]

Simply put, readers have not taken seriously Austen's comprehensive knowledge of this aesthetic.[4] Further, they have failed to differentiate between picturesque aesthetics and picturesque improvement. Although the latter distinction is crucial, it is one that is rarely, if ever, acknowledged in discussions of the picturesque, where the two kinds of landscape styles tend to get lumped together under one umbrella term, picturesque. This essay begins with the convictions, first, that the picturesque is far too complicated to be summarily dismissed as the hackneyed third in the triumvirate of the sublime, beautiful, and picturesque, and, second, that Austen, well aware of aesthetic debates, deliberately endorses picturesque aesthetics and satirizes picturesque improvement.[5]

Picturesque Improvement

. . . a thraldom [sic] unfit for a free country—Sir Uvedale Price 1: 338

It is now, I believe, generally admitted, that the system of picturesque improvement, employed by the late Mr. Brown and his followers, is the very reverse of picturesque.—Knight, *Landscape* 1. 17

In order to see how Austen's heroines are linked to the debates about English nationalism and the appearance and treatment of the landscape, it is important to have a clear sense of the differences among the various landscape styles. The debate centered on whether to preserve or alter, and thus whether to maintain or to use, though both camps believed they were preserving what was distinctly English. The picturesque theorists called for a wilder beauty; in contrast, the improvers claimed that those who wanted to tell them to keep their land undomesticated were directly compromising an owner's ability to make use of his property. Reacting to the charge of the improver, Humphry Repton, Price, and Knight contended that their own version of the aesthetic was powerfully nationalistic, that they were *protecting* the British landscape from improvements that would "disfigure" the face of the land (Price, *Essays* 1: 331–32). And Knight la-

mented the "sacrilegious waste / Of False improvement, and pretended taste" (*Landscape* 2. 317–19).

Brown and Repton's designs—termed the modern system of gardening—signified for Austen, Price, and Knight a "fashionable" outlook, divorced from the guidance of history and destructive of traditional community. The "preservers" (Knight and Price) endorsed a looser, less fastidious garden design that emphasized verdant, overshadowing trees, and density of shrubbery. This did not mean, however, as some have charged, that they wanted the lawn to look like a Salvator Rosa painting—that Knight or Price had, in short, "gothic Fantasies" (Hunt 154). Instead, Knight petitioned for "just congruity of parts combined / To please the *sense*, and satisfy the *mind*" (*Landscape* 2. 39–40). In arguing against Repton, he was arguing for a less formal landscape, one whose design takes its cue organically from the nature of the landscape itself, rather than from preconceived rules: "No general rule of embellishment can be applicable to all the varieties of natural situation; and those who adopt such general rules, may be more properly said *to improve by accident*, than either Mr. Price or myself" (11n; Knight's italics).[6]

Humphry Repton did drastically improve the landscape: we find (in his early work) a formal, minimalist design that favors sweeping lawns and scattered trees, and often the removal of villages and commons for the sake of the prospect. According to these principles of improvement, the landscape architect clumps trees and bushes into distinct patches, circles the entire property with a "belt," and shaves the grass so that it sweeps smoothly up to the very base of the estate. Thus the house sits at the top of a rise, unmediated or unmodulated by trees or shrubbery.

A reader/viewer studying Repton's Red Books (hand-painted "before and after" views of his proposed alterations) will see that his aesthetic transformations of the landscape, though often beautiful, are dependent upon the eradication of commons, of signs of commerce, and of laborers' homes. For example, in his "before and after" view of the fort, near Bristol, the "before" view shows thirty-six adults and six playing children, primarily dressed in brown, dark red, and dark blue, walking on the common; nearby are many rows of brown homes. In the "after" picture there are only two ladies and one child, dressed in white with a touch of pink, walking by several chairs charmingly and intimately grouped under the trees. The brown houses are gone and replaced with three handsome white dwellings in the distance behind trees. In other words, a beautiful *private* park replaces a common area and eradicates the urbanized scene, supplanting it with a spacious property that the few privately appreciate. Repton explains that "the late prodigious increase of buildings had so injured the prospect from this house, that its original advantages of situation were almost de-

stroyed" (8). Repton's editor, J. C. Loudon, argues that the improver "may be considered as combining all that was excellent in the former schools . . . with good taste and good sense" (vii). Yet Loudon's estimation of Repton ignores the question of who is privileged to remain in the landscape.

Fundamental to the debates between the picturesque theorists and the improvers is the question of control, and it is this issue of control that is also central to Austen's *Mansfield Park:* the question of what and who is privileged to remain in the landscape is the pivotal one in the novel. Critics have long recognized how in *Mansfield Park* and in other novels Austen satirizes Capability Brown and Humphry Repton's schools of picturesque landscape improvement, but no one has explored in detail the important fact that in so doing she sympathizes with Uvedale Price and Richard Payne Knight and thus refrains from satirizing the picturesque as a *whole.*[7]

Let us now look specifically at *Mansfield Park.* During an evening dinner party, the company discusses the improvement of Sotherton and other estates: Rushworth claims, "It is the most complete thing! I never saw a place so altered in my life. I told Smith I did not know where I was" (53).[8] Rushworth has already disconnected the landscape from the house, from the inhabitants and from the past—leaving it only to the memory of many—by having had "two or three fine old trees cut down that grew too near the house" (55). But such mutilation is nothing compared to the projected destruction of the old avenue. In an often-cited quotation, Fanny expresses distress at this prospect when she quotes Cowper: " 'Ye fallen avenues, once more I mourn your fate unmerited' "(56).[9] Yet Austen is not just attacking improvement; her sympathies connect intimately to those of Uvedale Price, who observes that "the destruction of so many of these venerable approaches" is the "fatal consequence" of fashion. "Even the old avenue, whose branches had intertwined with each other for ages, must undergo this fashionable metamorphosis" (1: 249, 256). Price narrates: "At a gentleman's place in Cheshire, there is an avenue of oaks; . . . Mr. Brown absolutely condemned it; but it now stands, a noble monument of the triumph of the *natural feelings* of the owner, over the narrow and systematic ideas of a professed improver" (1: 249–50n; italics mine). Rushworth, clearly a man of no great "natural feelings," points out that "Repton, or anybody of that sort, would certainly have the avenue at Sotherton down" (Austen 55), an avenue that we learn later is "oak entirely" and measures *half a mile long*" (82–83; italics mine).

Indeed, in Austen's novels, the issue of how much control one should exert over a landscape is not a localized aesthetic issue, but instead directly impinges on the treatment of and expectations for women; Austen links debates about the freedom of landscape to debates about the freedom of woman. For example, Fanny, like the avenue Rushworth will cut down,

is expendable and must be made to fit into the overall "aesthetic" plan. The picturesque theorists argued that such an emphasis on the "plan" over the organic layout atomized the natural world, severing relations between trees and between the house and the landscape. Price observes that picturesque improvement not only disconnects but is despotic: trees and other bushes are clumped together or

> are *cut down without pity,* if they will not range according to a pre-scribed model; till mangled, starved, and *cut off from all connection,* these *unhappy* newly drilled corps "Stand bare and naked, trembling at themselves." (1: 256, 338; italics mine)

Fanny, herself, is "cut off from all connection" and "cut down without pity," first, when she arrives as a child, and second, when she is expected to marry Henry Crawford. Let me examine these moments in some detail.

When she is first deposited at Mansfield Park, Mrs. Norris and Sir Thomas harbor the despotic fantasy that they can mold and fashion Fanny without themselves or anyone else being affected. Austen dramatizes this by implementing the metaphor of landscape design in the language describing Fanny's literal and psychological placement in the household. Fanny's bedroom is chosen literally to "keep her in her place": Mrs. Norris argues that the "little white attic will be much the best *place* for her, so near Miss Lee, and not far from the girls, and close by the housemaids. . . . Indeed, I do not see that you could *place* her any where else" (9–10; italics mine). Both Mrs. Norris and Sir Thomas's sketches of Fanny's domestic landscape exclude her from any liberty or equality. He defines Fanny by fixing her in a place of subordination and endeavors to keep her both literally and psychologically depressed: "There will be some difficulty in our way . . . as to the distinction proper to be made between the girls as they grow up; . . . without depressing her spirits too far, [we will] make her remember that she is not a *Miss Bertram*" (10). Sir Thomas fantasizes that he can control Fanny's impact on the family by cutting his niece off from equal connection with his children.

His system for such custodial "gardening" fails: Fanny shows that she will "grow" where she will when she refuses to marry Crawford—when she refuses to accede to her uncle's "prescribed model" for matrimony; significantly, he condemns her because she has indeed attempted to exercise her own taste and judgment: He says "I thought you free . . . from that independence of spirit, which prevails so much in modern days. . . . But you have now shewn me that you can be wilful and perverse, that you can and will decide for yourself, without any consideration or deference for those who have surely some right to guide you" (318). And later when Fanny takes her own private walk in the shrubbery, Mrs. Norris says, "She

likes to go her own way to work; she does not like to be dictated to; she takes her own independent walk whenever she can" (323).

Price and Knight draw a parallel between the political tyrant and the improvers, who advocate "a species of thraldom [sic] unfit for a free country":

> It seems as if the improver said, "you shall never wander from my walks; never exercise your own taste and judgment, never form your own compositions; neither your eyes nor your feet shall be allowed to stray from the boundaries I have traced." (Uvedale Price 1: 338)

Sir Thomas himself resembles Price's description of the "despotic" improver, who, in attempting to "improve" Fanny by forcing her to marry Henry Crawford, will not let her "wander from [her] walks" or "exercise [her] own taste and judgment" or "form [her] own composition"—that is, her own life plans. As Price says, "There is, indeed, something despotic in the general system of improvement; all must be laid open; all that obstructs, levelled to the ground; houses, orchards, gardens, all swept away" (Uvedale Price 1: 338).

Fanny's depression is a measure of just how "successful" Sir Thomas has been, for the very lack of compositional "disposition" in the family structure powerfully affects her personal disposition. William Gilpin, the picturesque theorist and travel guide, explains that—in picturesque terms— "disposition" is "the art of grouping and combining the figures, and several parts of a picture" and is "an essential, which contributes greatly to produce a *whole* in painting"—in short, to create harmony and repose (*An Essay on Prints* 9–10). In contrast, Sir Thomas and Mrs. Norris are concerned with a kind of unity based only on what Gilpin would call the "design," or the way that each part, "*separately taken*" (Gilpin's italics), produces a whole; thus the individual parts remain "scattered" and "have no dependence on each other" (7). What is ironic about Sir Thomas and Mrs. Norris's compositional strategy, of course, is that organizing the family by "design" rather than by "disposition" disconnects yet reconnects the members together in a pathological way. For example, the family remains atomized while competition and rivalry bond them together: sister against sister, brother against brother, sisters against cousin, aunt against niece, children against father, and so on. To use the theatrical term, each individual wants "center stage," or, to use Gilpin's picturesque term, each one wants the focus of "catching lights" (xi). Like a picture with too many subjects, the characters, as disconnected parts, compete with each other for prominence.

Fanny and Edmund are ultimately able to find such connection based on harmony and repose in their retreat to the retired little village between gently rising hills where they will live protected in a parsonage just "a stone's throw of the knoll and church." The deeply conservative plea for

preservation over improvement in the novel leads to the eradication of the ones who represent newness and change: Maria, Mrs. Norris, Mary and Henry; as their absence "improves" Mansfield Park, so will the repudiation of picturesque improvement and the endorsement of picturesque aesthetics "improve" the landscape of England itself: Knight, like Austen, will "Protect from all the sacrilegious waste / Of False improvement, and pretended taste, / One tranquil vale . . ." (*Landscape* 2.313, 317–19).

However, a central irony emerges here if we interpret Austen as only conservative in this rejection of improvement, for her apparently conservative plea for preservation honors Fanny's connection to the natural world and functions as a subversive plea for the necessity of women's freedom and liberty.

Landscape and the Discourse of the Body

Limbs . . . never taught to move by rules,
But free alike from bandages and schools.
—Knight, *Landscape* 1.44, 49–50

In "The Ideology of the Aesthetic," Terry Eagleton argues that "aesthetics . . . has little enough to do with art. It denotes instead a whole program of social, psychical and political reconstruction on the part of the early European bourgeoisie. . . . Aesthetics is born as a discourse of the body" (327). I want to argue that picturesque aesthetics constitute an instance in which the issues of the body, of sexuality, of women, and of the desire for liberty intertwine.[10] In fact, the sometimes overt, sometimes covert feminism and liberation this aesthetic introduces did not go unnoticed by its contemporaries, though it is significant that in recent years literary critics have focused primarily on the opposite—what they see as repressive and oppressive tendencies in this movement and in these theorists. In other words, the picturesque that contemporary Marxist critics see as a system that dispossessed the poor of human sympathy, some of Knight's contemporaries saw as a system that would cause a revolution.[11]

In *The Landscape*, Knight makes explicit the connection between the emancipation of the body, the mind, and the landscape from "iron bonds," and urges that England adopt a style of landscape gardening that will allow nature to be "unfetter'd," her body "free and unconfined," and her "Limbs . . . never taught to move by rules, / But free alike from bandages and schools" (1.44, 49–50). Knight describes the landscape in specifically female terms, not only employing the feminine pronoun to speak of nature—conventional, after all—but invoking in his analogies the experience of women. For example, abhorring the tortures that fashion forces

women and the landscape to endure, Knight writes in his *Analytical Inquiry* that because women, like the unaltered landscape, possess inherent appeal, they have least need of those that are artificial; he goes on to describe the fashions in women's clothing, which closely resemble the current fashion in landscape improvement:

> Yet art has been wearied, and nature ransacked; tortures have been endured, and health sacrificed; and all to enable this lovely part of the creation to appear in shapes as remote as possible from that in which all its native loveliness consists." (2–3)

It was, in fact, the shaping, arranging, and improving of the landscape—whose function is analogous to the confining clothing—that disturbed the picturesque theorists most; controlling nature by trimming, shaving, cutting, pruning, or uprooting it violates and abuses the landscape.[12]

Price and Knight's criticisms of the improved landscape resemble those of feminist critics who argue that a comparison between women and the landscape both exploits and excludes women, while using their bodies as metaphors of erotic interest—where the male gaze "tends to . . . freeze the flow of action in moments of erotic contemplation" (Mulvey 19). For example, Annette Kolodny argues in *Lay of the Land* that there have been two responses to the American landscape—the desire to violate it and the desire to regress psychologically in its presence. She argues that we are still "bound by the vocabulary of a feminine landscape and the psychological patterns of regression and violation that it implies" (146). The picturesque, however, does allow us to conceive of the landscape in feminine terms without reducing it to this binary opposition. Kolodny's description of "the images of abuse" that are heaped upon the virgin landscape resemble Price and Knight's complaints about Brown's "improvements," which they maintained consisted of assault and plunder:

> . . . —See yon fantastic band,
> With charts, pedometers and rules in hand,
> Advance triumphant, and alike lay waste
> The forms of nature, and the works of taste!
> To improve, adorn, and polish, they profess;
> But shave the goddess, whom they come to dress;
> Level each broken bank and shaggy mound,
> And fashion all to one unvaried round;
> (Knight, *Landscape* 1.275–82)

Here Knight describes how improvement, in attempting to smooth surfaces ("shave" and "level"), actually "lay[s] waste" any singularity in nature. We can understand that the improver's frantic effort to "fashion to one

unvaried round" strives to create a landscape representative of the "ideal" mother in whose presence "we are unwilling to move, almost to think" (Uvedale Price 1: 88). Thus picturesque aesthetics counter both passive regression to the mother and rape of the virgin bride.

The development of the picturesque thus had an unintentional yet powerful impact on relaxing and liberating the gender limitations that Burke imposed on the system of the sublime and beautiful, based as it is on highly conventional and rigid masculine and feminine characteristics. Price and Knight wanted to establish that there were more than two kinds of aesthetic experience (the sublime and the beautiful), and by introducing the picturesque (as I have explained), they hoped to correct the system of improvements initiated by Brown and continued by Repton, improvements they felt were grounded in a debased version of the beautiful that was insipid and diminished in its simplicity.[13] Thus the picturesque entered into the famous Burkean dichotomy of the sublime and the beautiful as a destabilizing and mediating term, taking the energy from the sublime and the languor from the beautiful and intermixing them. What we see is a landscape that, in contrast to the beautiful and sublime, is erotic, for it transforms "Mother nature," as it were, into a lover: characterized as the "coquetry of nature," the picturesque makes "beauty more amusing, more varied, more playful, but also, '[l]ess winning soft, less amiably mild'" (Uvedale Price 1: 89).[14] This playful and complex landscape invites action and response, for its visual and textural intricacy "reveals and conceals, and this excites and nourishes curiosity" (1: 22). And curiosity provokes our own energy: it "prompts us to scale every rocky / promontory, to explore every new recess, [and] by its active agency keeps the fibres to their full tone" (1: 88–89). In promoting the picturesque, which mediates between two extremes and which is feminine but founded on energy and vitality, Knight and Price break down Burke's binary oppositions and they champion an aesthetic that describes the feminine as active, varied, and powerful.

Burke's system, as we know, is based on the opposite, on the necessity of a weak feminine principle, for the feminine beautiful is characterized by "easiness of temper," while the masculine sublime is characterized by "immense force and labor" (Burke 110, 78).[15] Clearly, Burke's system already contained within it strongly eroding forces, of which he seemed supremely unaware. Burke's—and his contemporaries'—inability to transcend the social construction of nature leads to gender biases that are far less objective than Burke himself believed. His conception of these categories as opposites is flawed, for while he touts the beautiful as the place of safety and security, it is in fact a very dangerous aesthetic experience: "It is . . . the deceptive *par excellence*" (Ferguson 75). Yet the picturesque secured this

erosion by breaking down the bipolar system of beauty versus sublimity, a binary system in which women are associated with beauty and thus with vulnerability.[16] The picturesque thus takes us out of that gender-based "cat-and-mouse game" in which "an enervated feminine beauty must be regularly stiffened by a masculine sublime whose terrors must then be instantly defused, in an endless rhythm of erection and detumescence" (Eagleton 330–31).[17]

I am explicitly arguing against the widely held notion that it is always politically and critically reactionary to associate a female character with landscape, and that, specifically, picturesque descriptions of nature are only patriarchal fantasies in which male theorists transform the female body into a fetish (Fabricant). It is significant, though I do not have the time here to discuss the issue fully, that women were the "first to perceive the picturesque" and continued to participate in picturesque viewing.[18] Thus I take issue with the notion that the picturesque is a "rather bourgeois taming of the sublime," or a domestication of the sublime into the "orderly and cultivated," or a "manipulation of flux into form, infinity into frame" (Stewart 75). First of all, this aesthetic emphasizes not form but fluctuation; second, it eschews the orderly and cultivated for lush texture, abundant foliage, and rich contrasts of light and shade; and third, it highlights not "framing" but the play between the frame and chaos: in the aesthetic and in the novels, the paradox of the copy and the original is unresolvable, for we cannot determine whether the landscape or the landscape sketch came first, since art and nature are engaged in a process of reflexive influence. Further, the picturesque troubles the opposition of culture and nature as well: by combining culture and nature simultaneously, rather than empowering one side at the expense of the other, this aesthetic consistently upsets the hierarchical rigidity that favors culture over nature. What can be said, however, is that the critics have placed the picturesque in opposition to the system of the sublime and the beautiful as a whole; Hussey places it in opposition to Romanticism and other critics in opposition to authentic artistic experience—and in each case, it takes on the "feminine" role of the weaker, or lesser category, movement, or experience. Along these lines, W. J. T. Mitchell argues the point in *Iconology* that in interdisciplinary studies in general, art and literature are placed in binary opposition, and that when the sign (art) is opposed to the word (literature), the sign becomes symbolic of nature, the feminine, the passive, and the weaker of the pair, but ultimately the most dangerous because of its potentially subversive power (43). Thus a feminist point of view reveals to us that only a privileging of male power could interpret the picturesque as "taming" and "domesticating" the sublime, rather than noticing the power it potentially offers to women.

I am not ignoring what cultural materialism has taught us about aes-

thetics (Copley), and I am not idealizing the picturesque theorists: while containing in it the seeds of feminism (both woman and landscape should be free of artificial constraints), the picturesque also offers (to quote Toril Moi) one of those "paradoxically productive aspects of patriarchal ideology (the moments in which the ideology backfires on itself, as it were)" (64). Both inadvertently and deliberately, Knight and Price break down the binary gender opposition in Burke's system, link the picturesque to personal liberation, and thereby offer in picturesque landscape a liberating model for the female body.[19] Their championing of the "natural," "unfettered" landscape, a championing that also celebrates the "natural" and "unfettered" woman, offered writers of this era a fresh vision of woman and of the landscape.[20] When theorists write in sexual terms about a landscape that should be free from "iron bonds," using women's confinements as negative examples, they implicate the body, women, the body politic, and the land.[21]

How then do these issues play themselves out in Austen's conception of a woman's power and position? The heroine's connection with nature differs from novel to novel; for example, in *Persuasion* Austen emphasizes the grief and loss associated with the picturesque, while in *Pride and Prejudice* she highlights the vitality and energy of this kind of landscape.[22] Elizabeth's unconventional beauty, witty playfulness, physical energy, and decorous flirtatiousness dramatize the way in which her mind, like the picturesque landscape, seems "unfetter'd," her body "free and unconfined," and her "limbs . . . never taught to move by rules, / But free alike from bandages and schools" (Knight, *Landscape* 1.43, 49–50). In aligning Elizabeth with the values of landscape design that favor energy, playfulness, and sensuous appeal, Austen creates a character whose physical and mental presence challenges traditional and patriarchal assumptions about beauty, decorum, and class.[23] Elizabeth's vitality demonstrates Austen's preference for energy over control and rigidity, a selection that suggests her partiality for the picturesque as opposed to the improved landscape. Like the picturesque, Elizabeth overcomes dichotomies between beauty and sublimity, passivity and aggression, intellect and emotion, by embracing both sides of these oppositional principles.

Austen's incorporation of picturesque theory interfuses the issues of liberty, control, and license for landscape and for woman. Elizabeth arrives at Netherfield "glowing" from having walked alone across open country (32), obviously having asserted both her liberty (by traveling alone) and her desire for connection (in wanting to see her ill sister). When Elizabeth walks into the room, the Bingley sisters focus on her independence by fixating on her (apparently) muddy petticoat rather than on her vitality, a vitality so emphatic that they can barely "keep their countenance,"[24] can just barely screen their emotions, that is, until she's out of the room:

"She really looked almost wild . . . her hair so untidy, so blowsy!"

"Yes, and her petticoat; I hope you saw her petticoat, six inches deep in mud, I am absolutely certain; and the gown which had been let down to hide it, not doing its office." (35–36)

It is significant that Darcy, though attracted to her beauty, is plagued by the similar anxieties as to when liberty becomes license: he "was divided between admiration of the brilliancy which exercise had given to her complexion and doubt at the occasion's justifying her coming so far alone" (33). The conflict Darcy feels in enjoying Elizabeth's appearance is based on what he perceives as a possible discordance between vitality and decorum and between liberty and license, because Elizabeth, like the picturesque landscape, redefines manners, redefines the equation between beauty and passive torpor. He resolves this conflict in part by acknowledging that in fact her health is improved by this act of assertion:

"I am afraid, Mr. Darcy," observed Miss Bingley, in a half whisper, "that this adventure has rather affected your admiration of her fine eyes."

"Not at all," he replied; "they were brightened by the exercise."—A short pause followed this speech. (36)

This episode dramatizes the argument between picturesque theorists and landscape improvers: the improvers believed that to include natural energy, liberty, and spontaneity in garden design, one must sacrifice seemliness and propriety. The improver Humphry Repton claimed that the picturesque would reject "propriety and convenience" (Uvedale Price 3: 6) and asserted the concern that in picturesque design "health, cheerfulness, and comfort" must be sacrificed to the "wild but pleasing scenery of a painter's imagination," a place where one would find not beauty but a "ragged gipsy . . . [a] wild ass, [a] Pomeranian dog, and [a] shaggy goat" (3: 7, 8).[25] And Anna Seward argues that Knight's system in *The Landscape* is the "Jacobinism of taste," an aesthetic that will lead to living in "tangled forests, and amongst men who are unchecked by those guardian laws, which bind the various orders of society in one common interest"; she longs for the improved landscape, with "lawns . . . smoothed by healthful industry."[26]

Yet, picturesque theorists argued that landscape design could be more playful and spontaneous without "neglecting" health, "convenience and propriety" (3: 49). In landscape, this means that, coinciding with picturesque aesthetics, one would have a formal garden by the house and wild nature in the Park (3: 53), a design we see manifested at Pemberley itself, where Elizabeth "had never seen a place for which nature had done more,

or where natural beauty had been so little counteracted by an awkward taste" (245). Specifically, Elizabeth's connection to Darcy and his connection to Pemberley reinforces custom and moral heritage, as did the Price and Knight picturesque.

Further, picturesque aesthetics declare that decorum and the integrity of the English landscape did not have to be sacrificed to improvements that would leave every estate and garden looking the same — cut out of one mold, one frame, "fashion[ed] all to one unvaried round" (Knight 1.282). Unlike the improved landscape or improved beauty (Caroline being a good example), Elizabeth does not conform to cookie-cutter ideals of beauty, for her beauty has not been "vitiated by false ideas of refinement" (Uvedale Price 3: 40), and this Darcy acknowledges: "In spite of his asserting that her manners were not those of the fashionable world, he was caught by their easy playfulness" (23). Freedom for the landscape and for woman become intertwined. The health of the nation and of woman depends upon a dual emphasis on liberty and connection: the picturesque therefore pushes the borders that define what Eagleton calls "that meticulous disciplining of the body which converts morality to style, aestheticizing virtue and so deconstructing the opposition between the proper and the pleasurable" (Eagleton 329).

Austen thus associates Elizabeth with the Price and Knight picturesque and differentiates her from the complete wildness of Lydia, for Elizabeth's beauty combines formality with energy. And yet, critics of Austen's novels have tended to interpret her texts precisely as if they consist of such binary oppositions as those between decorum and vitality or "the individual and society" or "freedom and responsibility, or liberty and license."[27] In contrast, I am asserting that the presence of picturesque aesthetics in this particular episode at Netherfield underscores how the novel breaks down such dualisms. Elizabeth Bennet is not the wild Lydia; neither is she the docile, passive Jane — she mediates between extremes that never do get resolved. Even at the end, she is elbowing the borders of wifely decorum by sending money surreptitiously to her sister.

We find in all of her novels that Austen shows how disconnection and tyranny are inextricably bound and demonstrates how the fate of the national landscape is linked to women's autonomy and self-expression. Lady Catherine, Sir Thomas, Mary, Emma, and Mrs. Norris are among the most extreme improvers (or as Price would call them, "deformers"), for, like the landscape improvers, they dictate to others in their urge to impose on others, mandating that "all that obstructs should be levelled to the ground." As we see in so early a work as *Northanger Abbey*, General Tilney's garden, where every square inch is improved, resembles a miniature Versailles: tyrant that he is, his garden contains "walls . . . countless

in number, endless in length," and "a whole parish [seemed] to be a work within the inclosure"; indeed, his gardens, he believes, "are unrivalled in the kingdom" (178).

That Austen is intolerant of the despotic tendency to "improve" the lives of others by dictating to them becomes even more significant when we realize that she historically contextualizes this "personal" distaste for tyranny within the specific political/aesthetic conditions of her own time. This congruence between Austen and the picturesque theorists has significant consequences for our understanding of her novels: scholars have, on the whole, described her as a conservative Tory. And it is true that by endorsing picturesque aesthetics and sympathizing with the aesthetic values of Price and Knight, Austen positions herself as fundamentally conservative in her view of the land: preserve but don't alter the landscape and, especially important, emphasize the importance of social and moral heritage and the preservation of customary ways over new and fashionable landscape innovations. Yet an ironic twist emerges here, for in associating herself with Price and Knight's position on landscape, Austen, the conservative Tory, endorses what was the Whig position (as represented by Knight and Price).[28] Moreover, the theorists' stance, while it may appear to us as fundamentally conservative, was a radical one to take in the 1790s: Price and Knight's position on freeing the landscape from "the iron bonds" of tyranny was linked in the minds of some with Jacobin sympathy (Liu). Finally, and most important, Austen's conservative position on landscape in turn leads to a liberal and feminist attitude toward women, for in identifying her heroines with the landscape of picturesque aesthetics, she associates them with freedom, playfulness, introspection, and connection to others, to their landscape, and to their nation.

Notes

1 This can be found in Humphry Repton's *Red Book for Stoneleigh* (1809), quoted in Clive Aslet's article on Stoneleigh Abbey.

2 Most critics have been loath to associate Austen with an aesthetic that has become notoriously synonymous with art for art's sake (Martin Price), hackneyed tourism (Andrews), a patriarchal fantasy (Fabricant), and class oppression (Bermingham). In order to justify its presence in her novels, they have seen her merely as a satirist of the aesthetic (Llewelyn, Craik, Lascelles, Bermingham), or they have seen both sympathy and criticism but found themselves unable to explain why she should have a dual re-action (Mansell, Litz). Finally, a very few critics have acknowledged her sympathy for the picturesque without contextualizing it historically (Synder).

3 For example, the *Red Book for Stoneleigh* (1809) shows that Repton altered the course of the river, bringing it nearer the south end of the house and sought to preserve an island Leigh wanted removed. Significantly, the family did not approve of these extensive changes. The correspondence between Leigh and Repton reveals strong

differences of opinion over the nature of these improvements and suggests that his transformation caused direct conflict (see Aslet 1937). Invented by Repton, Red Books were created individually for each project. By simply lifting a flap, the owner could see handpainted "before and after" pictures of the landscape renovations Repton envisioned for the property.

4 In this sense, my work is in theoretical alignment with that of Claudia Johnson's, whose recent book, *Jane Austen, Women, Politics and the Novel*, argues that "Historical scholars . . . deny [Austen] any direct access or pondered relation to [pressing social and political issues]. Whether linking her to Shaftesbury, Rousseau, or Burke, for example, critics shuffle in fear of granting Austen too much, and taking away with one hand what they have given with the other, they couch their arguments about her intellectual antecedents and leanings in the vaguest possible terms of 'affinity,' 'temperament,' or 'unconscious awareness'" (xvii).

5 R. W. Chapman says that Austen "was no doubt acquainted with Price and Payne Knight, and with other polemical writers on landscape and landscape gardening" (26). John Halperin states that Austen read Price and Knight, but he offers no documentation (26). Park Honan is silent on the subject. It does seem reasonable and probable to me that she would have read these works in the lending library at Bath, which she used and which was quite extensive, or that these books would have been in the libraries at Godmersham Park or Goodnestone Farm or at Chawton Manor. On the lending library at Bath, see Margaret Kirkham, who explains that there were "good book shops" and "ten circulating libraries in Bath . . . filled with new books in French and Italian, as well as in English. . . . In Bath, Jane Austen must have had access to virtually any author she wished to read and a quiet reading-room too if she wanted it" (64).

6 Marilyn Butler observes that the followers of Brown tended to see nature as a place where one finds "greater opportunities for sober usefulness" while the followers of Price and Knight (whom she calls progressive) are "liable to see [the country] as a place for the individual to expand in freedom, cultivating the self" (97).

7 See Alistair Duckworth, who argues that it is "misleading" to assume that Austen's "distaste for Repton" implies a "preference for the more naturalistic styles of Price and Knight . . ." (41–42).

8 All quotations from Jane Austen's novels are taken from the Oxford edition, ed. R. W. Chapman.

9 Gilpin also quoted these lines. See his *Observations on the Western Parts of England* 542. Repton would take down the avenue because it would have been unfashionably associated with seventeenth-century French gardening styles, such as one might find at Versailles.

10 However, this focus on liberation can only check the potentially sexist nature of the eroticism of the picturesque if it implies liberation for women as well as for men. Mary Poovey argues that during the French Revolution freedom for the individual did not apply to both men and women, and in fact "intensif[ied] the paradoxes already inherent in propriety: discussions of the inequality of women's position and the complexity of female 'nature' almost completely disappeared from polite discourse . . ." (30). Marilyn Butler backs up the notion of a "conservative backlash," for the anti-Jacobin novel of the 1790s focuses on the inevitable destruction of the heroine who is deluded into ruin by the coupling of political and sexual liberation.

11 This context illustrates just how controversial it was for Price and Knight to attack Brown in the late 1790s. Bermingham, for example, describes Knight (whose mother, by the way, was a servant) as a man whose "class-bound prejudices . . . dispossessed

the poor of human sympathy and imagination" (71); Knight's contemporaries branded him a Jacobin and accused him of supporting the French Revolution in his didactic poem *The Landscape*. And Frank Messmann points out that Knight's "advocacy for greater freedom in gardening . . . cannot be separated from views which he expresses elsewhere on greater individual freedom" (84).

12 Alison Sulloway catalogs the fashionable constraints young women were subjected to: starving, purging, standing in stocks with backboards strapped over their shoulders and iron collars; steel busks, bands that forced the shoulder blades to meet, steel rods up the back, stays, and so on (194). Sulloway's chapter "Reconciliation in the Province of the Garden," discusses the oppression of the women and the symbolic resonance of the garden in terms of such matters as obedience, oppression, and sexuality, but she does not contextualize these ideas in terms of landscape debates of the period.

13 It is important to explain that Price and Knight, although having different reactions to Burke, appreciate the beautiful, such as one would find in a Claudian landscape. Price, for example, admired Burke and believed he was expanding, rather than overturning, Burke's system: "I have ventured indeed to explore a new track, and to discriminate the causes and the effects of the picturesque from those of the two other characters: still, however . . . it is a track I never should have discovered, had not [Burke] first cleared and adorned the principal avenues" (Uvedale Price 2: 197). Knight, in contrast, found Burke's *Philosophical Enquiry* to be "brilliant, but absurd and superficial" (*Analytical Inquiry* 197).

14 Here Uvedale Price is quoting from *Paradise Lost:* "less winning soft, less amiably mild" are actually Eve's words of criticism directed at Adam's appearance. She has looked from her image to his and finds him "less winning soft, less amiably mild" than she is. Thus in using this quotation, Price interjects a powerful element of the masculine into the picturesque (which is described mostly in female terms) and thereby breaks down the binary opposition between the masculine and the feminine. Milton's Eden is described in terms of the aesthetic category of the beautiful, as is Eve (4.1.479).

15 From a feminist point of view, Burke's obvious misogyny and quest to naturalize cultural biases and psychological fears and project them onto the landscape degrades women and nature. Frans De Bruyn does note that Burke's involvement in the affairs of India led him to revise significantly this original estimate of the superiority of men over women and the sublime over the beautiful. De Bruyn argues that Burke, in his *Speech on Mr. Fox's East India Bill*, "excoriat[es] the East-India company for disregarding the customary 'reverence paid to the female sex in general, and particularly to women of rank and condition' " (430). De Bruyn interprets this as Burke's belief that "any viable civil order must be founded on positive affection rather than primarily fear or terror, and [Burke] concludes that the degree to which a given society values beauty serves as an accurate measure of the adequacy of its social institutions" (433). However, de Bruyn points out that "Burke's defence of the beautiful and the sentimental idealization of women thus ironically serve as pretexts for the exercise of sublime power" (431); thus, his underlying purpose in idealizing them as exemplars of civilized values is to justify and defend the existing order.

16 The sublime and the beautiful line up according to Helen Cixous's analysis of patriarchal binary thought (binary oppositions such as activity/passivity; sun/moon; culture/nature; and so on), an oppositional system whereby the "feminine" side is powerless (Moi 104).

17 Eagleton does not connect this to the picturesque, and of course his overall point of

view differs from mine; he argues that "the aesthetic is at once eloquent testimony to the enigmatic origins of morality in a society which everywhere violates it" (338).

18 Elizabeth Wheeler Manwaring argues this point (171). Most of the records, however, were of a private nature and never published. The very fact that the Bluestockings approved of this aesthetic suggests that they found some kinship, as women and as individuals, in an informal, less fettered world (see 171–75 for examples). Further, when they describe picturesque scenes, women clearly identify as women with the natural world at a very personal level, and like men, women who write about nature use gendered language, with parts of the female body as descriptive nouns and verbs ("bosomed high in tufted trees"; 219). See Sarah Scott, author of *Millennium Hall* (1762) and Elizabeth Diggle, who records the Highland scenery she travels through in distinctly female terms by giving a "recipe" for a picturesque scene in the Highlands (qtd. in Andrews 216 [Journal, 1788], Glasgow University Library, MS. Gen. 738).

19 It is significant that Price did not acknowledge that Burke's conception of the beautiful resembles the picturesque improver's conception of the beautiful—both are weak and diminished: And here is a case of the patriarchal world view unwittingly undermining itself.

20 Although her emphasis is different, Jeanne Moskal makes a similar point in her article on Mary Wollstonecraft (1992); our joint conclusion about Burke and the feminism of the picturesque seems to have been conceived at the same time (see my dissertation, "Verbal Landscapes").

21 In *Representations of Revolution*, Ronald Paulson argues that the aesthetic categories of the picturesque, beautiful, sublime, and grotesque became ways to process the revolution (150).

22 I have discussed these issues in other places; see "First Impressions and Later Recollections: The 'Place' of the Picturesque in *Pride and Prejudice*"; my dissertation, "Verbal Landscapes and Visual Texts: Jane Austen and the Picturesque"; and 'Unbecoming Conjunctions': Mourning the Loss of Landscape and Love in *Persuasion*."

23 Certainly it is now admissible, without preamble, to discuss the sexual energy underlying Austen's "cool" surfaces. See Alison Sulloway and Alice Chandler.

24 See Roger Sales, who demonstrates that Austen is continually keeping and losing her "countenance" (31), as evidence that her texts are "open and unresolved" (145).

25 See also Kim Ian Michasiw, who claims that I am arguing that an association with Price and Knight implies that one is "going native" or going over to Matthew Arnold's barbarians (98).

26 Quoted in Marilyn Butler (p. 91). From Anna Seward to J. Johnson, Esq., *Letters of Anna Seward*, 1784–1807, 6 Vols., Edinburgh, 1811, iv. 10–11.

27 Exceptions to this approach can be found; see Susan Morgan and Roger Sales.

28 See also Everett's *Tory View of Landscape*, a valuable new study that resists any easy alignment of Whig with progressive and Tory with reactionary views.

Works Cited

Andrews, Malcolm. *The Search for the Picturesque: Landscape Aesthetics and Tourism in Britain, 1760–1800*. Stanford: Stanford UP, 1989.

Aslet, Clive. "Stoneleigh Abbey, Warwickshire—I–II: The Seat of Lord Leigh." *Country Life* (13 Dec. 1984): 1844–48 and (20 Dec. 1984): 1844–1937.

Austen, Jane. *The Novels of Jane Austen*. Ed. R. W. Chapman. 5 vols. Oxford: Oxford UP, 1988.

Bermingham, Ann. *Landscape and Ideology: The English Rustic Tradition 1740–1860*. Berkeley: U of California P, 1986.

Burke, Edmund. *A Philosophical Enquiry into the Origin of our Ideas of the Sublime and Beautiful*. Oxford: Oxford UP, 1990.

Butler, Marilyn. *Jane Austen and the War of Ideas*. Oxford: Clarendon, 1975.

Chandler, Alice. "'A Pair of Fine Eyes': Jane Austen's Treatment of Sex." *Studies in the Novel* 7 (1975): 88–103.

Chapman, R. W. *Jane Austen: Facts and Problems*. Oxford: Clarendon, 1948.

Copley, Stephen, and Peter Garside, ed. *The Politics of the Picturesque*. Cambridge: Cambridge UP, 1994.

Craik, W. A. *Jane Austen in Her Time*. London: Nelson, 1969.

De Bruyn, Frans. "Edmund Burke's Gothic Romance: The Portrayal of Warren Hastings in Burke's Writings and Speeches on India." *Criticism* 29 (1987): 415–37.

Duckworth, Alistair. *The Improvement of the Estate: A Study of Jane Austen's Novels*. Baltimore: Johns Hopkins UP, 1971.

Eagleton, Terry. "The Ideology of the Aesthetic." *Poetics Today* 9.2 (1988): 326–38.

Everett, Nigel. *The Tory View of Landscape*. Yale UP, 1994.

Fabricant, Carole. "Binding and Dressing Nature's Loose Tresses: The Ideology of Augustan Landscape Design." *Studies in Eighteenth-Century Culture* 8 (1979): 100–35.

Ferguson, Frances. "Edmund Burke, or the Bathos of Experience." *Glyph, Johns Hopkins Textual Studies* 8 (1981): 62–78.

Gilpin, William. *An Essay upon Prints*. London, 1768.

———. *Observations on the Western Parts of England, Relative Chiefly to Picturesque Beauty*. 1798.

Halperin, John. *The Life of Jane Austen*. Baltimore: Johns Hopkins UP, 1980.

Heydt, Jill. "First Impressions and Later Recollections: The 'Place' of the Picturesque in *Pride and Prejudice*." *Studies in the Humanities* 12.2 (1985): 115–24.

Heydt-Stevenson, Jill. "Verbal Landscapes and Visual Texts: Jane Austen and the Picturesque." Ph.D. Diss. U of Colorado, 1990.

——— "'Unbecoming Conjunctions': Mourning the Loss of Landscape and Love in *Persuasion*." *Eighteenth-Century Fiction* 8.1 (1995): 51–71.

Honan, Park. *Jane Austen: Her Life*. New York: Fawcett Columbine, 1987.

Hunt, John Dixon. *Garden and Grove: The Italian Renaissance Garden in the English Imagination, 1600–1750*. Princeton: Princeton UP, 1976.

Hussey, Christopher. *The Picturesque: Studies in a Point of View*. Hamden, CT: Archon Books 1967.

Johnson, Claudia. *Jane Austen, Women, Politics, and the Novel*. Chicago: U of Chicago P, 1988.

Kirkham, Margaret. *Jane Austen and Feminism*. New York: Methuen, 1986.

Knight, Richard Payne. *The Landscape: A Didactic Poem*. 2nd ed. London: Bulmer, 1795.

———. *An Analytical Inquiry into the Principles of Taste*. 4th ed. London: Hansard 1808.

Kolodny, Annette. *The Lay of the Land: Metaphor as Experience and History in American Life and Letters*. Chapel Hill: University of North Carolina Press, 1975.

Lascelles, Mary. *Jane Austen and Her Art*. London: Oxford UP, 1939.

Litz, A. Walton. "The Picturesque in *Pride and Prejudice*." *Jane Austen Society of North America* 1 (1979): 15–21.

Liu, Alan. "The Politics of the Picturesque." *Wordsworth: The Sense of History*. Stanford: Stanford UP, 1989. 61–137.

Llewelyn, Margaret. *Jane Austen: A Character Study* London: Kimber, 1977.

Loudon, J. C., ed. *The Landscape Gardening and Landscape Architecture of the Late Humphry Repton, Esq., Being His Entire Works on These Subjects.* London, 1840.

Mansell, Darrel. *The Novels of Jane Austen: An Interpretation.* New York: Barnes and Noble, 1973.

Manwaring, Elizabeth Wheeler. *Italian Landscape in Eighteenth-Century England.* New York: Oxford UP, 1925.

Messman, Frank. *Richard Payne Knight: The Twilight of Virtuosity.* Paris: Mouton, 1974.

Michasiw, Kim Ian. "Nine Revisionist Theses on the Picturesque." *Representations* 38 (1992): 76–100.

Mitchell, W. J. T. *Iconology.* Chicago: U of Chicago P, 1986.

Moi, Toril. *Sexual/Textual Politics: Feminist Literary Theory.* New York: Routledge, 1985.

Morgan, Susan. *In the Meantime: Character and Perception in Jane Austen's Fiction.* Chicago: U of Chicago P, 1980.

Moskal, Jeanne. "The Picturesque and the Affectionate in Wollstonecraft's *Letters from Norway.*" *Modern Language Quarterly* 52.3 (1991): 269–94.

Mulvey, Laura. "Visual Pleasure and Narrative Cinema." *Screen* 16.3 (1975): 15–24.

Paulson, Ronald. *Representations of Revolution.* New Haven: Yale UP, 1983.

Poovey, Mary. *The Proper Lady and the Woman Writer: Ideology as Style in the Works of Mary Wollstonecraft, Mary Shelley, and Jane Austen.* Chicago: U of Chicago P, 1984.

Price, Martin. "The Picturesque Moment." *From Sensibility to Romanticism.* New York: Oxford UP, 1965. 259–92.

Price, Sir Uvedale. *Essays on the Picturesque, As Compared with the Sublime and Beautiful; and, on the Use of Studying Pictures, for the Purpose of Improving Real Landscape.* 3 vols. London: 1794, 1795, 1810.

Repton, Humphry. *Observations on the Theory and Practice of Landscape Gardening.* London: T. Bensley, 1805.

———. *Red Book:* May 1809. Private Collection. Photocopy in Warwickshire C.R.O.

Sales, Roger. *Representations of Regency England.* New York: Routledge, 1993.

Stewart, Susan. *On Longing: Narratives of the Miniature, the Gigantic, the Souvenir, the Collection.* Baltimore: Johns Hopkins University Press, 1984.

Sulloway, Alison. *Jane Austen and the Province of Womanhood.* Philadelphia: U of Pennsylvania P, 1989.

Synder, William. "Mother Nature's Other Natures: Landscape in Women's Writing, 1770–1830." *Women's Studies* 21 (1992): 143–62.

The Royal Academy and the
Annual Exhibition of the Viewing Public

C. S. MATHESON

*O*ver the past five years several significant studies of Romantic-era art have sought to locate British artists, British art, and its attendant discourses within a new configuration of the public sphere. David Solkin's *Painting for Money,* Iain Pears's *The Discovery of Painting,* and Morris Eaves's *The Counter-Arts Conspiracy* are notable contributions to a reevaluation of the activities of art making and dissemination during an era that witnessed fundamental shifts in the notion of representation, the role of the aesthetic, and, more materially, in the nature, scale, and place of public art exhibition. Although these works offer a persuasive institutional narrative of British Romanticism, they are less mindful of the impact of institutional and discursive change on contemporary art audiences. I will turn my attention therefore to a constituency largely neglected in new historical accounts of Romantic art production: the viewing public. This essay will examine the institutional art gallery in late-eighteenth- and early-nineteenth-century Britain as a site of ideological and aesthetic instruction of the spectator and demonstrate how this exchange is manifested in some of the printed ephemera generated by art exhibition. I've chosen to concentrate upon materials associated with the Royal Academy's annual Spring Show, and specifically two devices that consciously locate and define, direct and assert the composition of the academy's viewing public: the exhibition catalog and graphic representations of the academy's main galleries during their exhibitions.

Both what we might term the retrospective exhibition print and the exhibition catalog (figs. 1, 2, and 3) are highly regulated modes of disseminating information about the physical arrangement of the gallery space, the artworks that collectively form its display, and, more obliquely, information about the nature, social location, and deportment of spectators. Visual representations of gallery interiors and viewers, such as the

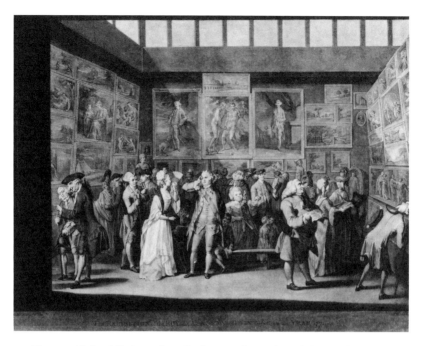

Figure 1. Richard Earlom after Charles Brandoin, *The Exhibition of the Royal Academy of Painting in the Year 1771*, 1772 (courtesy of the Lewis Walpole Library).

works reproduced below, are part of a conscious and, for the most part, political construction of a public for contemporary art in late eighteenth-/ early nineteenth-century Britain. Like the exhibition catalog, retrospective exhibition prints are productions with a material relationship to the hierarchized, institutional space of the gallery. The first duty of the exhibition print is to record (and thus ratify) the constitution of the annual show through convincing graphic accounts of individual performances, the relation between performances within the salon, and the cumulative visual impact of the exhibition. A second duty, which merges with the pedagogical mandate of an institution like the Royal Academy, is to testify to the efficacy and power of the spectacle by representing a strategic cross section of viewer responses. Exhibition catalogs and exhibition prints simultaneously inform and regulate their audiences; their tendencies are similar while their functions, as we shall see, are complementary. Visual accounts of the annual Royal Academy show by artists as diverse as Charles Brandoin, Johann Heinrich Ramberg, and Thomas Rowlandson offer suggestive information concerning the place and deployment of printed catalogs in the academy's main exhibition salon. Exhibition prints

A

CATALOGUE, &c.

Note, The Pictures, &c. marked with an (*) are to be difpofed of.

—— A L L E N,
At Rome.

1 POMPEY the Great, after his defeat, is accofted by Cratippus, who comforts him.
2 Cleopatra weeping over the afhes of Marc Antony.

J O H N B A C O N, Affociate,
Wardour-ftreet, Soho.
3 * A ftatue of Mars, a caft from an original model.

J O H N B A K E R, R. A.
Denmark-ftreet, Soho.
4 A flower-piece.

T H O M A S B A N K S,
New Bird-ftreet, Oxford-road.
5 A cherub decorating an urn, a model.
6 A head of a late model to the Royal Academy, a drawing.

Figure 2. Royal Academy catalog for 1771, p. 3
(courtesy of the Beinecke Library).

reveal how exhibition catalogs direct the physical movement of spectators within the gallery, modify their gazes (especially in the case of female viewers), and shape sociable exchanges between spectators.

Given the ideological potential of the catalog, it is not surprising that the form emerged in Britain in the midst of vigorous debates over the au-

A

C A T A L O G U E.

☞ The PICTURES are numbered as they are placed in the Room. The Firſt Number over the Door.

The PICTURES, &c. marked (*) are to be diſpoſed of.

R. A. Royal Academician.
A. Aſſociate.
H. Honorary.

1	A Landſcape	*T. Gainſborough, R.A.*
2	Portrait of a lady	*T. F. Rigaud, A.*
3	Fruit & flowers, with a portrait of the Leghorn Runt. *J. Cole*	
4	Maria, from Sterne.	*T. Gaugain*
5	Portrait of a gentleman.	*H. Robinſon*
6	The burning of the French fleet at La Hogue, 1692.	
		T. Mitchell, H.
7	Portraits of their royal highneſſes, Prince William Henry, and Prince Edward.	*B. Weſt, R.A.*
8	View of Mariſtow on the river Tavy, Devon.	
		W. Tomkins, A.
9	A view of the Quebeck after the engagement, and Capt. Farmer taking leave of his people.	*R. Paton*
10	The Quebeck blowing up, after burning four hours.	
		R. Paton
11	Portrait of a gentleman.	*R. Liveſay*
12	Portrait of a lady.	*Sir J. Reynolds, R.A.*
13	Portrait of a Newfoundland dog.	*C. Catton, jun.*
14	Portrait of a gentleman	*T. Gainſborough, R.A.*
15	The troops at Warley-camp reviewed by his Majeſty, 1778.	
		P. J. De Loutherbourg

Figure 3. Royal Academy catalog for 1781, p. 3
(courtesy of the Beinecke Library).

thority and direction of the fine arts. The catalog began as a simple answer to a shift in the nature and scale of public art display—specifically as a response to the circumstances that fostered annual institutional exhibitions in the country. The first exhibiting body of professional artists in Britain, the Society of Artists, grew out of a philanthropic venture initiated by

William Hogarth in the 1740s. Hogarth formed a scheme to donate paintings to embellish Thomas Coram's newly instituted Foundling Hospital for Exposed and Deserted Infants. His gifts to the hospital were gradually matched by submissions from other artists aware of the professional and sentimental benefits of association with so high profile a charity. The commodious grounds of Coram's Fields, the novel display of contemporary British art in the hospital's public rooms, not to mention the edifying spectacle of the neatly uniformed children, combined to make the Foundling Hospital a popular morning destination for the leisured class. British artists were very fortunate to discover an exhibition venue that was not only fashionable and well patronized but "symbolic of the nation's best characteristics," as an eighteenth-century tourist characterized it.[1] John Pye maintains in *The Patronage of British Art* that the nation's artists owed their first claims to respectability as a community to their extended involvement with the Foundling Hospital. For the artists themselves, the experience of placing their work before an extensive, curious, morally primed, and civic-minded audience convinced them of the necessity of organizing regular public exhibitions.

In 1760 the Foundling Hospital artists mounted a separate exhibition under the auspices of the Society for the Encouragement of Arts, Manufacture and Commerce. A simple, eight-page typographic catalog of the works on display was produced and sold as a practical (and perhaps more genteel) alternative to collecting a sixpence admission fee at the door.[2] Initially the group seems to have regarded the catalog as a convenient promotional supplement to the display; as one artist phlegmatically observed, "Without a catalogue, their names and places of residence would remain unknown." For such participants, the catalog bore less relation to the immediate life of the exhibition than to the commercial afterlife of the artist and his studio/showroom. The events of the following year, however, brought the catalog into a sharper material relationship with the exhibition gallery and its patrons. The 1761 exhibition organized by the newly minted Society of Artists almost collapsed under the weight of its own success, for an unexpectedly huge number of spectators were attracted by the novelty of a public art exhibition. The organizers' difficulties were compounded by the fact that many visitors shared catalogs rather than purchasing their own. A subsequent letter sent from the artists to the society complained that the rooms had been "crowded and incommodated by the intrusion of great numbers whose stations and education made them no proper judges of painting and sculpture, and who were made idle and tumultuous by the opportunity of a shew."[3]

The society attended to the physical dangers of overcrowded rooms and a troublesome breach in class distinction by doubling the price of the

catalog, raising it from sixpence to one shilling and making its purchase mandatory for each spectator: "No person shall be admitted without taking one, the same to serve as a ticket." One shilling, as Giles Waterford notes in connection with the British Institution exhibitions early in the next century, was a price sufficient to exclude the lower orders from participation.[4] As a further measure, Samuel Johnson was called upon to rationalize the admission charge in the preface of the following year's catalog. While the society was "far from wishing to depreciate the sentiments of any class of the community," he wrote, "everyone knows that all cannot be judges or purchasers of works of art."[5]

The exhibition catalog was initially adapted to answer a simple problem of identifying and discreetly marketing the artists' work, despite Johnson's insistence in his 1762 preface that the exhibition's purpose was "not to enrich the Artists, but to advance the Art." Johnson's careful separation of an agenda for art from the commercial expectations of its practitioners is indicative of the difficulties that faced the artists once they moved from the sheltering civic respectability of the Foundling Hospital. The Society of Artists' catalog evolved from a basic device produced for the mutual convenience of artists marketing their aesthetic wares and for viewers, whom Johnson identifies as "judges or purchasers of works of art," to a device that more actively sought to legislate the profile and behavior of a viewing public. The physical and material difficulties surrounding the growth of exhibiting away from the Foundling Hospital's unified circle of artists and morally unified audience are played out through the catalog. In rapid order the Society of Artists' catalog came to dictate the social conditions of exhibition and its public by standing as an active agent of the society's admission policies.

Clearly, then, the catalog constitutes an expression of political impulses as well as a gesture of aesthetic facilitation; the information the catalog dispenses evokes and extends the ideologically chartered environment of the gallery as it lists, orders, and identifies the individual paintings at exhibition. Catalogs control the public in their relation to admission policy, address the public authoritatively in their prefaces, and eventually come to physically manipulate the public's movement through the institutional space of the gallery. This combination of functions is captured in visual representations of gallery interiors and scenes of exhibition, particularly as the period progresses. Exhibition prints follow naturally from the editorial acts manifested in and enacted through the catalog.

One faction of the Society of Artists of Great Britain hived off to form the inner circle of the Royal Academy of Arts. The Royal Academy's first exhibition was held in 1769 in Pall-mall chambers that had successively housed Lambe's auction rooms and Dalton's print warehouse. A number

of the conventions of exhibition normalized by the Society of Artists were adapted by the Royal Academy, including charging a shilling's admission fee to its Spring Show. The practice is rationalized in the advertisement of the Royal Academy's first catalog in 1769:

> As the present exhibition is part of the institution of an Academy supported by Royal munificence, the public may naturally expect the liberty of being admitted without any expense.
>
> The Academicians, therefore, think it necessary to declare that this was very much their desire, but they have not been able to suggest any other Means, than that of receiving Money for Admittance, to prevent the Room from being filled by improper Persons, to the entire Exclusion of those for whom the Exhibition is apparently intended."[6]

The qualifications of this brief preface effectively illustrate the academy's ambivalence over the nature of its obligation to a viewing public. The "natural" expectations and liberties of one portion of their audience must be denied as a result of the demonstrated character and behavior of another. What is theoretically liberal and correct is sacrificed to what seems practically and socially expedient—a dilemma that apparently divides the architects of the scheme from their original conception of the exhibition, and the exhibition itself from the otherwise liberal character of the academy.

Something of the ambivalence of the catalog advertisement is captured two years later in an early visual representation of a Royal Academy exhibition, Richard Earlom's 1772 mezzotint, *The Exhibition of the Royal Academy of Painting in the Year 1771*, engraved after a watercolor drawing by Charles Brandoin (see fig. 1). The Royal Academy's difficulties in admitting and vetting the body of the public find a corollary in the divided impulses of Brandoin and Earlom's exhibition scene. In *The Exhibition* viewers are presented with a range of individuals possessing dramatically varied aesthetic backgrounds and expectations (as their dress, posture, and pantomimic responses to art suggest), but it is not entirely clear whether a narrative or a satirical account of their public conjunction is being offered by the artist. *The Exhibition* is advertised in Sayer and Bennett's 1775 print catalog as a work "wherein the pictures [appear] as actually placed, and a pleasing groupe of connoisseurs &c who were actually present, correctly drawn by Mr. Brandoin, and engraved in metzotinto by Richard Earlom."[7] Although the commercial description of the print foregrounds its historicizing intent by pointedly marketing the work as a delineation of "actually placed" pictures and "actually present" connoisseurs, an obvious element of drollery is evident in Brandoin's treatment of most of the assembled spectators. The print hesitates between functions, much as the early Royal

Academy catalogs suggest an institution hesitating between making provision for and regulating a viewing public.

Perhaps one of the difficulties facing Brandoin in the 1770s is the lack of a clear visual precedent for representing an institutional exhibition. Brandoin must therefore borrow from and adapt an existing graphic idiom for his task, a debt that becomes more marked when his design is in turn engraved. The range of spectators in *The Exhibition,* the flat planes of images assembled in the gallery's cluttered hang, and the composition's satirical edge strongly evoke scenes of spectators before print-shop windows—a minor but distinct genre of urban representation from the second half of the eighteenth century onward. Prints of print-shop windows and their viewers also served as engaging promotional devices for entrepreneurial publishers: John and Carrington Bowles, Matthew Darly, Samuel William Fores, and Hannah Humphrey are a few of the publishers/printsellers who commissioned scenes in which their shops figured.

Some of the chief characteristics of this genre are found in the anonymous print *Spectators at a Print Shop in St. Paul's Churchyard* (c. 1760), a well-known depiction of Carrington Bowles's shop next to the Chapter House in St. Paul's Churchyard (fig. 4). This colored mezzotint functions as an accurate visual catalog of the satirical prints, comic scenes, and academic portraiture that comprised Bowles's stock, but its real charm lies in its lively transcription of viewer response to these wares. In the *Spectators* a fashionably dressed woman forcibly directs her gallant's attention to the figure of an expostulating divine, an engraved portrait of the evangelical George Whitefield. From the laughing denial registered in the male viewer's hands and body, one may gather that the woman's emphatic gesture is not prompted by sudden piety but rather by some dimension of their private relationship. The direct and searching gaze she turns upon her companion and the closed fan she wields to extend her reach, rather than to shield her eyes or face, suggest that she has abandoned the strictures of female modesty and decorum. The portrait of Whitefield in Bowles's shop window is unexpectedly used as weaponry in a sexual political skirmish.

Diana Donald comments that the humor of this print lies in its admission of the disparity between works of art and unidealized art viewers, a characteristic she also ascribes to Brandoin's account of the 1771 exhibition (see fig. 1) and Ramberg's 1787 representation of the Royal Academy (fig. 5).[8] One might argue instead that the humor of the *Spectators* turns upon naive attempts to establish *continuity* between the prints and life, that is, upon the highly personalized—if seemingly incongruous—readings of images generated by viewers of different backgrounds. These individualistic acts of interpretation are typically the source of comic energy in

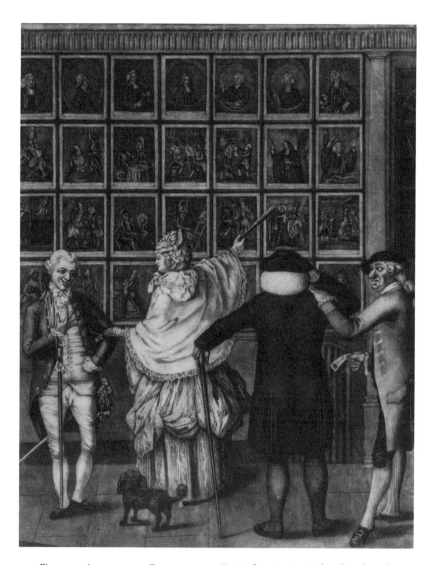

Figure 4. Anonymous, Spectators at a Print Shop in St. Paul's Churchyard, c. 1760 (courtesy of the British Museum).

print-shop views. Works such as the *Spectators* and many later prints of this nature celebrate the social and aesthetic anarchy set in motion by print-shop window displays. A good number of establishments combined high and popular materials in their windows and presented the result to viewers without overt pedagogical direction. Furthermore, the public of print-shop windows was naturally drawn from a wider social spectrum than that of an institutional art exhibition. The carnivalesque mixture of viewers from

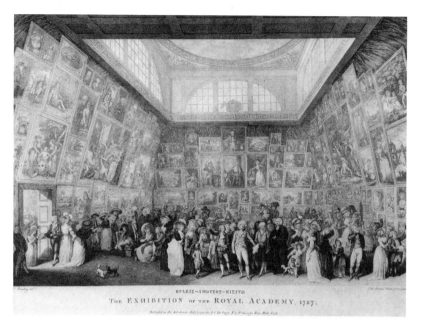

Figure 5. Pietro Martini after Johann Heinrich Ramberg, *The Exhibition of the Royal Academy, 1787*, 1787 (photo by A. A. Mckay).

diverse stations these popular spectacles fostered was recommended to tourists as one of the sights of eighteenth-century London. Some citizens and officials, however, charged that the windows attracted idle loungers, pickpockets, prostitutes, and errant apprentice boys and that the display of licentious prints had an injurious effect upon the morals of the populace, particularly upon female viewers.[9] This association with immorality is admitted in the *Spectators,* as a respectably attired male viewer engrossed in the window display is apprehended by an officer holding a paper bearing a single fateful word: "Arrest." The print thus confirms contemporary complaints about print-shop windows as dangerous public sites, but amusingly inverts them into a testimonial to the universally captivating nature of Bowles's display.

As seen in figure 1, Brandion and Earlom's use of these established graphic conventions to characterize a new breed of exhibition and its audience is obviously problematical. The tensions inherent in yoking visual references to an unregulated and in many senses subversive exhibition venue to the annual show of an institution trying to clarify and legitimize its civic function are played out within the design. One concern of the work becomes differentiating between the authority of diverse spectators — specifically, between spectators who possess connoisseurship and those who

do not. As the nature of the exhibition is initially defined through one's response to the spectators and only secondarily by the artworks on display, this distinction is crucial. Offering several visual focal points, *The Exhibition . . . in the Year 1771* creates a loosely knit body of male and female viewers ranked according to the nature and depth of their aesthetic contemplation. As we shall see, the exhibition catalog is one tool for signifying the tendencies of their gazes.

In the left corner of the *The Exhibition* two of the "pleasing groupe of connoisseurs," identifiable in fact as an artist known as the Chevalier Manini and Dr. Robert Bragge, a dealer in art and antiquities, amiably confer over paintings turned away from the general view of the gallery goers.[10] Manini and Bragge were well-known figures at art auctions and related events, as their inclusion in James Brotherton's satiric print *Eight Heads of Artists and Amateurs* (c. 1770), "drawn from ye life," attests. The pair also appear in the engraved headpiece of an elaborate shop-bill depicting the premises of Dorothy Mercier, a printseller and stationer located in Windmill-street, Golden Square.[11] The presence of these virtuosi in the Royal Academy's Pall-mall rooms strategically links the academy's annual exhibition back to the sphere of judges and purchasers of art. With Bragge familiarly drawing Manini's attention to some aspect of a composition disregarded by other spectators and witheld from viewers of the print, the pair's situation in the gallery and their lively private exchange offer a teasingly literal definition of connoisseurship as the apprehension of qualities not apparent to the general observer.

Compositions that attract an educated gaze among the exhibition's spectators are invisible to readers or viewers of the print, as with the work contemplated by a bespectacled clergyman at the rear of the gallery, who rather unprofessionally misses a painting of Adam and Eve on the back wall, and that regarded by the dandified figure of a gentleman-connoisseur who claims a prominent place in the foreground. The connoisseur's critical and searching scrutiny, literally magnified by the quizzing glass in his hand, is bluntly juxtaposed to the variously limited gazes of the women immediately before and behind him. Seated on an undecorated plank bench, an elderly female viewer reads from an open exhibition catalog while the disaffected object of her tuition droops beside her. The gaze of a more fashionable woman at the connoisseur's elbow is physically limited and decorously regulated. She purposely shields her face, either from coquettishness or a desire to discreetly examine James Barry's *Temptation of Adam*, which hangs at the rear of the gallery. Barry's composition was well received by critics that year, although a number of spectators found its nudity shocking. One contemporary reviewer memorably attributed this feature of the work to Barry's recent travels, "an insufficiency of drapery"

apparently being "a fault common to most painters immediately after the tour of Europe, on account of the difference in climate."[12]

The cast-eyed, cock-hatted man to the right of *Adam* has been identified by Diana Donald as John Wilkes, the radical politician and MP for Middlesex.[13] Wilkes's attendance at the academy's exhibition is logical, given both his public office and his surprisingly extensive history of involvement with the fine arts.[14] His visage can be cross-referenced to a number of articles offered for sale in Sayer and Bennett's 1775 catalog, including a print by Pine after Kitercherman listed as *"John Wilkes,* The Patriot of Patriots," and another work in which he is fulsomely described as a "friend to Liberty, Lover of his King, Opposer of Ministerial Tyranny and Defender of his Country."[15] As a subject of frequent satiric and graphic representation, Wilkes provides a visual association between this account of the Royal Academy exhibition and the print-shop window—an intriguing point, given the fact that Earlom's print was likely displayed in turn at Sayer and Bennet's busy Fleet Street shop. Perhaps for this reason the portrait of Wilkes is more strongly marked in Earlom's mezzotint than in the original watercolor design now deposited at the Huntington Library and Art Gallery.

Wilkes's participation in the exhibition of 1771 also forces the viewer to confront the political dimensions of this function of the academy. His presence might be read both as an affirmation of the public efforts of the institution and as a warning that its policies, civic mandate, and level of inclusiveness were subject to scrutiny. Five years after the publication of *The Exhibition . . . in the Year 1771,* Wilkes attacked the monarch in a parliamentary speech for removing the famous Raphael Cartoons from view at Hampton Court and depositing them in an inaccessible private residence near St. James's Park: "[C]an there be a greater mortification to any Englishman of taste, than to be thus deprived of feasting his delighted view with what he most desired and had always considered as the pride of our island, as an invaluable national treasure, as a common blessing, not as private property?"[16]

Wilkes's attendance at the exhibition evokes crucial issues of publicity and cultural property, but there seems to be great uncertainty in the print about how to manage these associations. Brandoin mutes the radical politician's presence through a piece of low comedy, chiefly the physical contrast between the statesman and author of a scurrilous essay on women and his unidealized female companion. The joke is made more barbed by Brandoin's use of a painting of a reclining female nude, positioned on the wall behind Wilkes's head so that it emerges as if an embodiment of his thoughts. In spite of these innuendos, Wilkes's physical and political position in the gallery is significant; he occupies a recessed space between

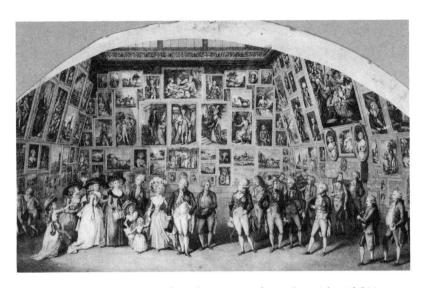

Figure 6. Pietro Martini after Johann Heinrich Ramberg, *The Exhibition of the Royal Academy, 1788*, fan-leaf 1788 (courtesy of the British Museum).

the mannered connoisseur and the stolid, John Bull–like spectator in the foreground, effectively bridging these different stations and modes of viewing. He is not oriented toward any specific painting in the exhibition: his posture suggests movement through the space rather than fixed contemplation of the works. His catalog is held aloft in a manner that might swiftly become rhetorical or combative—a fitting image perhaps, given the nature of Wilkes's art activism during the years framing this composition.

The catalog that Wilkes brandishes draws the viewer's eye to the full-wigged head of the citizen-spectator in the foreground. The apparent reliance of this viewer on the institutional document suggests that he is a relative newcomer to the world of art and connoisseurship. In subsequent representations of gallery interiors (figs. 5, 6, and 7), the maturity or authority of viewers comes to be expressed in their visible degree of intellectual detachment from the catalog. To judge from the disparity between the dress and physique of this figure and the elegant serpentine lines of the male portraiture adorning the gallery walls, John Bull is presently outside the cycle of commissions or patronage. Diana Donald comments on the piquant satire of thus "picturing the inept responses of John Bull to the new pleasures of fashionable culture."[17] Although he may lack the grace of an idealized masculinity signified in the portraits, or the tone of the dandified connoisseur, the solid attention he displays seems the most reliable indication of a future for such events.

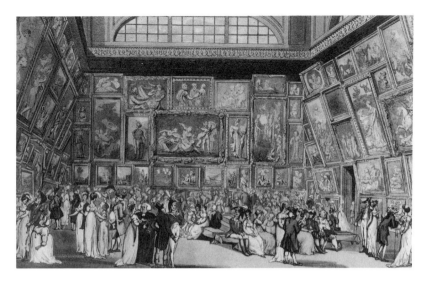

Figure 7. A. Pugin after T. Rowlandson,
Exhibition Room, Somerset House, 1808
(courtesy of the Print Collection, Lewis Walpole Library).

A much more concerted act of differentiation and construction of the viewing public occurs after the relocation of the Spring Show in 1780 from Pall-mall to the academy's new rooms at Somerset house. Joseph Baretti reports in *A Guide through the Royal Academy* (written to satisfy those brought by "vagrant curiosity or a desire for instruction . . . into the Apartments of the Royal Academy") that the old palace of Somerset was purchased and lavishly remodeled after "Mr Burke and other men in Parliament . . . suggested the propriety of making so vast and expensive a design at once an object of national splendour as well as convenience."[18] Perceptions of the civic position and obligations of the Royal Academy were also tidied and readied as preparations proceeded for installation within William Chambers's elaborate architectural facade. Joshua Reynolds's Ninth Discourse, "delivered on the occasion of the Royal Academy's removal to Somerset-place," speaks of the necessity of forming an art to

> raise the thoughts, and extend the views of the spectator . . . which, by a succession of art, may be so far diffused, that its effects may extend themselves imperceptibly into public benefits, and be among the means of bestowing on whole nations the refinement of taste: which, if it does not directly lead to purity of manners, obviates at least their greatest deprivation, by disentangling the mind from appetite, and conducting the thoughts through successive stages of excellence, till

that contemplation of universal rectitude and harmony which began by Taste, may, as it is exalted and refined, conclude in Virtue.[19]

Relocation of the exhibition from Pall-mall to Somerset house seems to have prompted some reexamination of the academy's relations with its exhibition patrons. This suspicion is borne out by two slight alterations in the content and format of the 1780 catalog. In the guide to the first Royal Academy exhibition at Somerset house, the hesitant and qualified Advertisement from the inaugural 1769 publication makes a surprising reappearance. In one sense the academy seems to be starting over from scratch in its relations with its public, after little change in the twelve intervening years of exhibition. At the same time, however, a second feature makes new provision for a spectator moving about the gallery and examining particular compositions within the crowded display. In 1780 the awkward practice of organizing the exhibition catalog alphabetically by artist, with paintings listed out of their exhibition order beneath each name, is finally abandoned.[20] The catalog is modified into a sequentially numbered list that follows the arrangement of paintings in the various rooms, beginning with the composition placed immediately over the door in the main exhibition gallery. Rather than suggesting that an artist's work stands as an autonomous unit within the exhibition, the 1780 catalog emphasizes the vigorous mixture of compositions adorning the gallery walls; the new arrangement of the catalog symbolically folds the individual artist's productions into the larger public spectacle.

The 1787 print of the exhibition drawn by Johann Heinrich Ramberg and engraved by Pietro Martini (see fig. 5) recalls Reynolds's claims about the academy's "representative publicness"[21] and supports its position through a combination of historical allusion and selective documentation of the gallery and spectators. A Greek phrase above the title of the print reproduces a legend that appeared over the doorway of the main exhibition room in the period. Translated as "Let no Strangers to the Muses Enter,"[22] the inscription establishes the print's function as a continuation of the material fabric of the exhibition room and therefore the print as a performance sanctioned by academic policy.[23] Viewers enter the 1787 print through a phrase that lyrically alludes to the institution's admission requirements and that nominally recreates the passage of the public into the great exhibition room. The imperative inscription indicates to viewers that a graphic translation of the event is governed by the same social and political expectations as the public spectacle itself.

The press of the crowd in this main exhibition space is eased by Ramberg's provision of a still focal point in the person of the Prince of Wales, guided through the room by the president. In a large watercolor draw-

ing of the composition held in the British Museum, the prince's visual preeminence is further emphasized by the scarlet coat he wears amid his immediate subfusc circle. The disposition of the figures of Reynolds and the prince offers a persuasive illustration of the structure of patronage manifested in the academy, as the spectators in the gallery (and the eyes of viewers of the print) are made to revolve with almost ritualistic care around this member of the royal house.[24]

Relations between the rival art societies in the decade leading up to the foundation of the Royal Academy were sufficiently fraught for Reynolds to claim in his first discourse that a national academy could not have been realized without the monarch's intervention in the artists' affairs, a claim that is directly illustrated by the inclusion of a royal proxy in this composition. Even the cynical anonymous author of *Observations on the Present State of the Arts* admits that royal patronage was a "sufficient protection" for the academy in a time of scarifying internal battles. Although the author allows that patronage is useful in the abstract, he, along with a good number of Ramberg's contemporaries, was much less certain about the efficacy of the Prince of Wales's role as patron. The prince frequently attended Royal Academy dinners, but few saw evidence that the academy "derived any benefit from these compliments which he has condescended to pay to the President."[25] Some claimed that the prince was added to the list of the academy's protectors simply because he sat for Reynolds, who did his portrait—a performance that is in fact visible on the wall behind the central group in Ramberg's print.

The prince's open catalog in *The Exhibition of the Royal Academy, 1787* advertises his participation in and compliance with the institutional event. His attention, flagged and advertised by the text, is pedagogically significant, given the vigorous behavior still to be observed in viewers on the margins of the prince's own circle. An unflattering review of the 1787 exhibition in the *Gentleman's Magazine* speculated that a decline in the quality of exhibited work proceeded "not from the defect of the artists, but from their unwillingness to submit their best performances to *vulgar taste.*"[26] The vulgar taste deplored by the *Gentleman's Magazine* is admitted in the physical deportment of a number of the spectators, particularly in a couple who have enthusiastically clambered aboard a bench for a better view of the royal entourage. The man's unrefined pointing and caricatured features are contrasted with the self-conscious immobility of his female companion, whose partially lowered fan and direct gaze suggest only a half-hearted observation of the strictures of female decorum. These figures might be more comfortably situated at such favorite haunts of the Prince of Wales as Vauxhall or Ranelegh. The pair's attention is directed to the prince and channeled in turn by the prince's gaze and Reynolds's instructional gesture

to John Opie's canvas *The Assassination of David Rizzio*. While these viewers fail of their own accord to attend to history painting, two influential public figures provide an intermediary step that may bring them eventually (along with the viewer of the print) to a proper, edifying focus upon the grand manner. This vignette becomes an effective illustration of the process outlined in the Ninth Discourse, in which viewers' thoughts are conducted "through successive stages of excellence" to refinement of taste and virtue. Elsewhere in the gallery, the exhibition catalog assists in drawing up a typology of the romantic spectator. The gaze of a youthful female entering the main exhibition salon from the antechamber is pointedly regulated by the institutional text, just as the gazes of most of the female spectators are mediated by the catalog or through a discoursing male companion. An example of the latter, the May-December combination, is positioned to the right of the self-reliant figure of the connoisseur. The figures of the prince and the connoisseur are placed as complementary reference points within the composition. In Ramberg's watercolor drawing this point is literally made, since the connoisseur wears a blue coat in contrast with the prince's red coat. Both figures attract the attention of naive viewers; each embodies a distinct aspect of patrician authority and each offers a lesson that may assist in shaping the behavior of the assembled spectators.[27]

An interesting contrast is developed in the print between different modes of communicating information on the artists and paintings. The prince negligently holds a catalog open against his walking stick but attends to Reynolds, whose gestures and commentary are directed toward one of the few history paintings in the 1787 show. Such oral dissemination of connoisseurship was a common practice in regard to noble or private collections, where frequently a housekeeper, steward, or other domestic attendant would be appointed to act as an animate catalog to appropriate visitors. Ramberg's references to the practices of the noble cabinet serve two significant political ends in the design: this mode of offering aesthetic information becomes a means of asserting and maintaining social distinction within the press of the exhibition crowd, as well as genteelly promoting contemporary British painting to an audience composed at least in part of potential patrons and collectors. The suggestion that a work such as *The Assassination of David Rizzio* might be destined for a royal cabinet is an oblique but not ineffective form of connoisseurship.[28] However, at the same time, a number of difficulties are created by alluding to the practices of the private cabinet within the commerce of a crowded public space. Ramberg and Martini had to directly address these tensions in their graphic account of the following year's exhibition.

Ramberg's prescription for diffusing the persistent unwieldiness of the crowd in *The Exhibition . . . 1787* is a drastic excision in the body of the

public. The retrospective print of the 1788 exhibition (see fig. 6) removes the public from the gallery altogether and replaces it with a more manageable grouping of tutor and students. This new cast might be read as an allusion to the educational mandate of the academy itself, or as a reference to the relative youth of a national audience for British art; in either case, far greater caution is exercised by the artist in admitting spectators into a representation of the event, as the telling detail of a *slightly* open door to the gallery indicates.

The viewer moves from this overdetermined scene of instruction to the massed ranks of female royals in the foreground, a highly contrived group bound in an intricate continuum of costume, gesture, and exhibition catalog. It is significant that the physical and chronological spaces between the female members of the family are bridged by the open text. A powerful ideological signifier is deployed to isolate and unify the female spectators as a group, thus diffusing their presence in the gallery through a visible assurance of the continued institutional regulation of their gaze. This regulation is extended from the smallest princess, not much larger than the catalog her sister proffers, to a queen bodily and visually oriented toward the academy's chief patron (he for *istoria* alone, she for *istoria* in him). By contrast, the male royals, gathered in the foreground in a manner that recalls the swagger of grand tour portraiture, display distinct postures and related independence from the institutional text. In most cases their catalogs are phallically rolled and held by their sides. The male spectators exist autonomously within the public space defined by the academy's main exhibition room, while their female counterparts are firmly gathered and confined within a picturesque subset of the event.

The intricate gendering of gazes in *The Exhibition . . . 1788* becomes more charged in light of the publication history of Ramberg and Martini's performance. Their 1788 print was also sold in modified form as a fan-leaf (see fig. 6), shown here in an unmounted specimen taken from the Schrieber collection in the British Museum. The turning of the exhibition into a commodity—a fashion accessory—is an obvious indicator of the social location of the event, but it is even more interesting to note that the fan-leaf form directs this construction of academy history and policy specifically back to female viewers. The commercial packaging of the print reinscribes the lessons of the composition itself regarding women in the public space of an institutional gallery. As a device that can screen the eyes or deflect the gazes of others, a fan determines the extent or direction of female vision, just as the exhibition catalog seems to do in the 1788 print.

Thomas Rowlandson's design *Exhibition Room, Somerset House* is a fitting epilogue to the several decades of representational struggle we have been charting. His rendering of the academy's main exhibition room (see fig. 7),

published in Ackermann's *Microcosm of London,* displays Rowlandson's familiarity with what had become the conventions of institutional gallery representation, as well as some significant and studied points of divergence from the genre. It is apparent that Rowlandson is still bound to communicate detailed information on the exhibition space itself, but he is much less exact than his precursors in what he records about the pictures comprising the show. Both Brandoin and Ramberg produce designs that faithfully set out the content and arrangement of the exhibition: in Brandoin's case, architectural exactitude lends credibility to his documentation of paintings and parodic representation of their audience, while attention to material detail in Ramberg's 1787 and 1788 accounts contributes to the pedagogical authority of the compositions. *The Exhibition of . . . 1787* participates in the moral rhetoric of the academy and defines the viewing public in relation to the institution's conviction that it is the nation's chief repository of taste, a task continued in modified form in Ramberg's account of the 1788 event.

Rowlandson's attention is not directed to explaining the political or historical features that define the distinct nature of the academic spectacle, nor ratifying the organization and hanging of a particular exhibition. The sketchily represented paintings in his design bear no direct relation to the content of the exhibition of 1807, the show closest to the publication date of the print. As indicated in the commentary accompanying the plate in *Microcosm,* the paintings are regarded as an additional opportunity for the artist to display "much separate manner in the delineations . . . and such an infinite variety of small figures, contrasted with each other in a way so peculiarly happy, and marked with such appropriate character."[29] Rowlandson dwells on the sociability of the gallery and its relation, as the title of Ackermann's volume implies, to equivalent sites in the capital. His composition explores the implications of viewing the Royal Academy show in relation to other sites of public interest, such as the Royal Exchange, the Foundling Hospital, Fleet Prison, and the Bank of England. By challenging earlier claims of the academy's unique civic nature, Rowlandson effectively exposes the devices that had recently been used to construct its position.

Rowlandson makes light of the notion that the Royal Academy bears a special weight of cultural responsibility by pointedly inserting two particular narratives among the assemblage of paintings. At the left of the composition a group of spectators contemplate a large generic rendering of the *Rape of Europa,* while at the right a spirited *St. George Slaying the Dragon* is distinguished by its bright palette. It is amusing that the viewing public ranges between the mythologically and heraldically evoked constructs of Europe and England, considering that the 1807 Royal Academy exhibition was dominated by works on the subject of Nelson and his exploits.

Together, the *Rape of Europa* and *St. George Slaying the Dragon* function as a species of comic précis of history painting, a reductio ad absurdum of the grand manner to one heroic and one antiheroic prototype. Spectators in the scene who are attentive to these defining compositions are the ones who are most pilloried. In the left foreground Rowlandson replaces the stock gallery figures of a discoursing man and younger female companion with a silenced male and a young woman who gestures interrogatively at her catalog. Her escort exhibits obvious signs of confusion or embarrassment, related perhaps to the subject matter of the *Rape of Europa,* but it is worth noticing that his smaller companion finds no reason to deploy the fan she carries. On the right, a suspiciously frail, bespectacled virtuoso leans on his cane for a nearer look at a rampant symbol of British nationhood.

Rowlandson's approach to representing and containing the crowd in this scene may express his sense of a general maturation of the viewing public. In the foreground, a range of different social and professional types—with a clergyman and officers to ensure the peace—are detached from the generalized frenzy and anonymity of the back reaches of the room and distinctly grouped for the viewer. This assurance of professional and social distinctions among participants in a collective event eases the cumulative effect of a strolling, chatting, noticing, lounging audience that lacks other clear signs of regulation. The public is not shown here as requiring the example of an authoritative or learned viewer, and catalogs are deployed in the creation of comic incidents. Many spectators hold open texts that are significantly reduced from their actual scale, but very few are shown consulting them. The Exhibition Room at Somerset house is a picturesque backdrop against which to display "the peculiar mode by which different persons shew the earnestness with which they contemplate what they are inspecting, and . . . an absorbed attention to the object before them."[30]

In both the exhibition catalog and these several graphic representations of academic exhibition, aesthetic education is overtly joined to political instruction. Catalogs control the public in their relation to admission policies, address the public directly in their prefaces and advertisements, and eventually manipulate the public's movement through an institutional space—actions that are continued in visual accounts of Royal Academy exhibitions. Catalogs placed in gallery scenes become a means of creating a useful visual index of spectators establishing an aesthetic hegemony within the gallery, and of gendering the gaze. Ramberg and Martini's prints offer themselves as paradigms for the constitution of future exhibitions—a text of the paternal relationship between art, its constituencies, and the state. Rowlandson's play around these aspects of the academy's annual show and its printed records turns us toward the next era of public exhibition.

Notes

1 See *Sophie in London* 177.

2 See *Society for the Encouragement of Arts, Manufactures and Commerce*.

3 Quoted in "Recollections of Circumstances" 1015.

4 See Giles Waterford et al. 131.

5 See Society of Artists of Great Britain iv–v.

6 See the Royal Academy of Arts, *Exhibition*.

7 Brandoin and Earlom's print was published by Robert Sayer and sold for 10s. 6d. Sayer and Bennett's 1775 catalog reveals that their stock consisted of a healthy combination of the sacred and profane: portraits of royalty, public personages, society beauties, historical compositions in the grand manner (such as a print by James Watson after Angelica Kauffmann's *The Parting of Hector and Andromache*) and leavening doses of "droll, humorous and entertaining prints," a number of them designed by Collett, Grimm, and Brandoin. See Robert Sayer and John Bennett 3.

8 See Diana Donald, "Characters and Caricatures" 366.

9 See *A Satirical View of London* 149–50: "The humourous mode of satirizing folly is very prejudicial to the multitude in many respects;—in the loss of time to those who stop to contemplate the different figures; the opportunities given to pickpockets to exercise their art . . . it is an authenticated fact, that girls often go in parties to visit the windows of print-shops, that they may amuse themselves with the view of naked figures in the most indecent postures.

"Before these windows, the apprentice loiters unmindful of his master's business; and thither the prostitutes hasten, and with fascinating glances endeavour to allure the giddy and vain. . . ." See also *La Roche* 262–63.

10 In 1771 the Chevalier Manini exhibited two works at the Society of Artists: *Armida before Geoffredo* from Tasso and *Mount Parnassus* from Bocalini. Bragge (d. c. 1777) is mentioned by Horace Walpole in a letter dated 11 Dec. 1743 as a "virtuosi" who offered him information on the provenance of a work by Correggio. See Walpole 18: 355. For further details concerning Bragge's place within the structures of eighteenth-century connoisseurship, see Pears.

11 This rare shop-bill featuring a view of the interior of Mercier's print and stationery shop is deposited in the Douce Collection, Bodleian Library. The etching is by Chatelain after Gravelet.

12 Quoted in Whitley 1: 284.

13 Donald, "Characters and Caricatures" 365.

14 Wilkes was treasurer of the Foundling Hospital and president of the Society of Artists. He condemned the king's removal of the Raphael Cartoons from Hampton Court, supported a scheme in the 1770s to decorate St. Paul's Cathedral with paintings (scotched by the Bishop of London), and later agitated for the purchase of the Robert Walpole Houghton pictures with which to found a National Gallery.

15 The other portraits are *John Wilkes, Esq.*, which identifies its subject in a lengthy subtitle as "MP for Middlesex, Alderman of the Ward of Farringdon . . . Friend to Liberty, Lover of his King, opposer of Ministerial Tyranny and Defender of his Country" and *John Wilkes*, "a whole length in robes, 4 times elected MP for Middlesex." For Sayer as a partisan of Wilkes, see Angelo 2: 45.

16 See *Wilkes* 2: 61.

17 Donald, *The Age of Caricature* 80.

18 See Baretti 3.

19 See Reynolds 171.

20 A correspondent with the *Public Advertiser,* 12 April 1775, complains bitterly about the original organization of the catalog and offers an alternative method: "Many Persons, who visit the annual Exhibitions of the R.A., and other Societies, have found the Mode of classing the Works of the Masters in the printed Catalogue very inconvenient and troublesome, being not at all conformable to the Disposition of them in the Room . . . it is very difficult to find any particular Performance sought for without much Trouble and Patience; and the blending [of] various and distant Numbers upon the Pieces, which succeed each other, creates a confused and disagreeable Process. Now as most People pursue their View in a progressive Course round the Rooms from Left to Right, it is submitted whether the Exhibitions may not be render'd more convenient and agreeable by ordering the Arrangement of the Pieces in the Room and in the Catalogue to go Hand in Hand; that is, after the Pieces are properly placed in the Room, then to Number them progressively . . . This Method would be more easy and pleasant to the Company, as well as doing Justice to the Artist; for it is the Merit of a Picture that leads us to enquire who the Painter is—not the Name of a Painter that induces us to engage in a vain Search after his Performance . . ."

21 See Habermas 5.

22 William Sandby's translation of the inscription is much harder-edged: "Let none but men of taste presume to enter" (1: 157). Baretti notes that the Greek phrase was adapted from one that appeared over the door of Plato's library—"Let no Stranger to Geometry enter"—and was suggested by "the learned physician" Sir George Baker.

23 Whitley notes that the publisher of the print, Antoine C. de Poggi, was an Italian artist and art dealer on close terms with Joshua Reynolds. According to the Getty Provenance Index, de Poggi was commercially active between 1776 and 1836. In 1794 he sold the first part of Reynolds's collection of drawings from rooms at 91 Bond St. De Poggi's position as a picture dealer and link in the commercial chain of art reception adds an interesting dimension to the observations on contemporary British art given out in Ramberg's design. See Whitley 111 and Frederickson et al. 1: 1021.

24 By 1787 the Prince of Wales was a dodgy candidate for the exemplary role ascribed him by Ramberg's design. The scandals surrounding his behavior, finances, and amours had reached a frenzy the previous year with rumors of his marriage to Mrs. Fitzherbert and whispers of her pregnancy. Ten satirical prints directed at the Prince of Wales were published in 1785, 39 in 1786, and 15 in 1787. To borrow the title of a satirical print by William Mansall in which he is featured (pub. 26 March 1786), the prince was part of the "Caricature's Stock in Trade" throughout 1786 [Stephens and George 6931]. On 13 April 1786, S. W. Fores of the Caricature Warehouse published a print entitled *The Royal Academy* [Stephens and George 6944], in which the prince and his friend Col. George Hanger engage in a pugilistic exhibition against a background decorated with such works of art as a Windsor landscape and *The Dying Gladiator.* Perhaps Ramberg's representation of the prince in a different graphic key was meant to be an act of rehabilitation, in which case considerable power was being ascribed to this institutional environment.

25 See "Old Artist" 20–21.

26 See Rev. of *The Exhibition of the Royal Academy, 1787*, p. 542.

27 To judge from Huisch's account (392), the prince and the connoisseur are set apart by more than the geography of the exhibition room. Huisch states that the prince's taste belonged to an inferior category that favored works of "the least elevated description . . . exquisite imitations of Dutch painters of brass pans, large cabbages, glasses

of wine and beer, or the light of candle . . . His painted brass pans are the best in the world; in fact, in the vulgar walks of art he is reported to have had the best collection in the country."

28 A similar promotional use of the conventions of private display was made several decades later by the administrators of the British Institution. The British Institution was formed to promote the fortunes of British artists by creating an alternative public exhibition space from which paintings could be sold. It is worth noting that its gallery walls were hung with a vivid scarlet paper, copied from the decoration of Windsor Castle.

29 See Ackerman 1: 10.

30 Ackermann 1: 10.

Works Cited

Ackermann, Rudolph. *The Microcosm of London, or, London in Miniature*. Vol. 1. London, 1808.

Angelo, Henry. *Reminiscences of Henry Angelo*. Introd. Lord Howard de Walden. Vol. 2. London: Kegan Paul, 1904.

Baretti, Joseph. *A Guide through the Royal Academy*. London, 1781.

Donald, Diana. "Characters and Caricatures: The Satirical View." *Reynolds*. Ed. Nicholas Penny. London: Royal Academy of Arts, 1986.

———. *The Age of Caricature: Satirical Prints in the Reign of George III*. New Haven: Yale UP, 1996.

Eaves, Morris. *The Counter-Arts Conspiracy: Art and Industry in the Age of Blake*. Ithaca: Cornell UP, 1992.

Frederickson, Burton B., et al. *The Index of Paintings Sold in the British Isles during the Nineteenth Century: The Provenance Index of the Getty Art History Information Project*. Vol. 1. Oxford: Clio P, 1988.

George, Dorothy M. *Catalogue of Personal and Political Satires in the British Museum*. Vol. 5.

Habermas, Jürgen. *The Structural Transformation of the Public Sphere: An Inquiry into a Category of Bourgeois Society*. Trans. Thomas Burger. Cambridge: MIT P, 1991.

Huisch, Robert. *Memoirs of George the Fourth, Descriptive of the Most Interesting Scenes of His Private and Public Life*. Vol. 2. London, 1830.

La Roche, Sophie von. *Sophie in London 1786: Being the Diary of Sophie v. la Roche*. Trans. Clare Williams. London: Jonathon Cape, 1933.

"Old Artist." *Observations on the Present State of the Arts, with the Characters of Living Artists*. London, 1790.

Pears, Iain. *The Discovery of Painting: The Growth of Interest in the Arts in England 1680–1768*. New Haven: Yale UP, 1988.

Public Advertiser. Press Cuttings from English Newspapers on Matters of Artistic Interest, 1686–1835. Vol. 1. National Art Library, Victoria and Albert. 175.

Pye, John. *The Patronage of British Art*. 1845. London: Cornmarket P, 1970.

"Recollections of Circumstances Connected with the History of the Arts in Great Britain, and Especially with the Progress of Public Exhibitions of Art." *Literary Panorama* 3 (Jan. 1808): 1015.

Rev. of *The Exhibition of the Royal Academy, 1787*. *Gentleman's Magazine* (June 1787): 542.

Reynolds, Joshua. *Discourses on Art*. Ed. Robert R. Wark. New Haven: Yale UP, 1975.

Royal Academy of Arts. *Exhibition of the Royal Academy MDCCLXIX, THE FIRST*. London, 1769.

Sandby, William. *History of the Royal Academy*. Vol. 1. London, 1862.

Satirical View of London at the Commencement of the Nineteenth Century, A. London, 1801.

Sayer, Robert, and John Bennett. *For 1775. Sayer and Bennett's Enlarged Catalogue of New and Valuable Prints.* London: rpt. Holland, 1970.

Society for the Encouragement of Arts, Manufactures and Commerce. *A Catalogue of the Pictures, Sculptures, Models, Drawings, Prints &c of the Present Artists. Exhibited in the Great Room of the Society for the Encouragement of Arts, Manufactures and Commerce, on the 21st of April, 1760.* London, 1760.

Society of Artists of Great Britain. *A Catalogue of the Pictures, Sculptures, Models, Drawings and Prints, &c.* London, 1762.

Solkin, David H. *Painting for Money: The Visual Arts and the Public Sphere in Eighteenth-Century England.* New Haven: Yale UP, 1993.

Stephens, F. G., and M. Dorothy George. *Catalogue of Prints and Drawings in the British Museum.* Division 1: Personal and Political Satires. 11 vols. London: Trustees of the British Museum, 1870–1954.

Walpole, Horace. *Horace Walpole's Correspondence with Sir Horace Mann.* Ed. W. S. Lewis, W. H. Smith, and G. L. Lam. Vol. 18. New Haven: Yale UP, 1954.

Waterford, Giles, et al. *Palaces of Art: Art Galleries in Britain, 1790–1990.* London: Dulwich Picture Gallery, 1991.

Whitley, W. H. *Artists and Their Friends in England, 1700–1790.* Vol. 1. London: Medici Society, 1928.

Wilkes, John. *The Speeches of John Wilkes.* Vol. 2. London, 1771.

Romantic Psychoanalysis: Keats, Identity,

and "(The Fall of) Hyperion"

JOEL FAFLAK

*W*hereas in *Paradise Lost*, God is introduced by Milton to sanction his authority as a writer of epic verse, Book 3 of Keats's "Hyperion" begins by discarding the apparatus of epic, for by Keats's time the hermeneutics of epic discourse had been unsettled by a poetic language subject to temporality rather than transcendence. In his notes to *Paradise Lost*, Keats states that Milton "must station" the poem within the religious and historical contexts that shape it as a cultural artifact (*Complete Poems* 525), what Keats elsewhere calls the Reformation's "resting places and seeming sure points of Reasoning" (*Letters* 96). The discourse of "Hyperion" and "The Fall of Hyperion," however, confounds the generic and critical expectations we mobilize to indicate its cultural or historical specificity. Reading these poems as either attenuated or climactic episodes within a larger canonical or authorial narrative, an earlier criticism treats the fragments as privileged artifacts or elides them into twin supplements of the same project, the failure of one antithetically justifying the success of the other.[1] Marjorie Levinson sees in this organic need to "finish off" the poems a brave attempt to defend against the rather mundane fact that Keats died.[2] She locates the texts, as prostheses, together within a postorganicist "system of revision" (174) that does not make their destabilized ontology answerable to a metaphysics of presence.[3] Like Levinson, several readers address the poems' tentative identities through the economy of a loss of (textual) omnipotence that either explicitly or implicitly falls under the rubric of psychoanalysis.[4] This essay will pursue a somewhat different approach by arguing that the *Hyperions*, through their staging of identity, mark one of the sites where Romanticism *invents*, rather than merely anticipates, psychoanalysis.

Using Keats as a paradigm to psychoanalyze the culture from which he emerges, Levinson's approach also constitutes what Jerome McGann calls a "socio-historical" (63) critique of (literary) texts. Historical analysis

can reveal the "networks of social relations" (18) texts produce and are produced by in what Keats calls the "service of the time being" (*Letters* 96).[5] As Tilottama Rajan writes, however, the New Historicist turn toward a socially and politically engaged Keats "historicizes [him] but without crediting Keats himself with any understanding of the poet's relationship to 'history'" ("Keats" 1). This "new Keats," that is, is no less a fiction than earlier aestheticized versions of him, because "Keats" exists for us at the irrecoverable primal scene of our cultural unconscious. Freud describes the primal scene as originating either from a real event as it was repressed by the unconscious, or from a fantasy that reconstructs the scene from other forms of unconscious cathected desire. Between these two possibilities, Freud can "venture upon no decision" ("Case" 238), and he suggests that while past events may be temporally continuous with our later reconstitution of them, it is more likely that their displacement through the unconscious radically destabilizes how we reconstruct their historical significance. The past is contiguous with the present only through a transference that is at the same time unavoidable and unknowable. As an attempt to revisit the primal scene(s) of history, therefore, the work of historical analysis always rests upon shaky epistemic moorings.

Transference operates according to the logic of Freud's death instinct, manifested in analysis by the patient's compulsion to repeat rather than remember the effects of the primal scene of (sexual) trauma. "By postulating the death drive," writes Ned Lukacher, "Freud attempts to account for the absolute resistance to recollection that he meets in the transference" (87). Paraphrasing Dominick La Capra's critique of New Historicism, Levinson nonetheless argues that transference needs to inform the work of historical analysis, because of its often unconscious tendency to misrepresent temporality in terms of the "'standard binary oppositions between the universal and the particular, permanence and change, continuity and discontinuity'" (Introd. 13). The return to the past, Levinson notes, takes us "back to the future," and transference can provide a model for how we got/get "there." According to La Capra, the temporality of repetition and change in psychoanalysis is both "stabilizing" and "disconcerting" (34), and we misunderstand it if we apply to it an Aristotelian logic of diachronic temporality versus synchronic atemporality. Transference operates instead according to a "'complex repetitive temporality.'" "By that phrase," continues Levinson, "La Capra invokes Freud's notion of the way in which the *originality* of an event—its status *as* an event in a psychic narrative (that is, as traumatic) and as *originary,* in the sense of engendering and, thus, explanatory—is constituted retrospectively both through its 'real life' repetition and, in a third phase, by the displaced repetition precipitated through the analysis" (Introd. 13).

The idea of the death drive and the transference it mobilizes also implies a radical epistemic shift in the ontology of the subject. Lukacher uses the primal scene, not in its narrower sense of an episode of sexual trauma, but as a "trope for reading and understanding" the trauma of being human/human Being. The impasse between recollection and construction entails behind the "persona of human subjectivity" (87) a transference in which the reader/analysand repeats the forgetting of his past Being, just as for Heidegger the "history of metaphysics masks the history of Being" (83). The origin of the subject's Being in the primal scene, like the origin of the history of Being in metaphysics, is lost at its primordial forgetfulness, has never existed, and so cannot be sought in the forgetfulness of the past but only in the future through the scene's "projective repetition . . . as it is elaborated through the transference" (42). Paraphrasing Althusser, Lukacher argues, "[T]here is no subject to the primal scene; it is the primal scene itself which is a subject insofar as it does not have a subject" (13–14; emphasis in original). As the process by which history conceals the subject from himself rather than a specific historical episode or trauma, then, the primal scene is the "source" of a traumatic inability to remember, its subject lost in the temporal difference between remembering and forgetting.

The idea of the primal scene forgotten through the historical process of transference can be revisited on the "origin" of psychoanalysis in Romanticism that the present study will attempt to read in the *Hyperions*. Romanticism and psychoanalysis are primal scenes against which we define (the loss of) our identities, and both are engaged in a forgetting of their own pasts. The *Hyperions'* mode of textual production (dis)places the subject within a cultural moment that is (un)settled by that moment's historical relativity. The texts stage this (dis)placement, and their future readers have been inscribed upon its shifting horizon. The texts exist as part of a transference mobilized by the historical contingencies that produced them, a transference that persists in the complex repetitive temporality of our own (textual) engagements with them. Staging this (dis)position of the subject, the *Hyperions* posit an identity that is (de)mystified by its (lack of) transcendence over its past and (de)constructed at its threshold with the future. The poems resist historicization, then, in the way that Romanticism resists historicization. That Romanticism is defensively concerned about how it would be historicized by its future readers is symptomatic of how it already anticipates the limitations of any historicist analyses of it. Keats's "grand march of intellect" (*Letters* 96), although self-consciously situated at the beginning of the nineteenth century, projects the meaningfulness of its cultural moment toward a future time. In a similar manner Shelley (dis)places specific readings of a "great Poem" within a larger cultural or literary genealogy that is "infinite" and argues that the "peculiar

relations" brought to bear upon "high poetry" by each age neither exhaust nor expose the "inmost naked beauty" of a poem's "meaning" (500).

The prospective urgency of these statements, however, carries with it the retrospective anxiety about origins that erases the present in the moment of its constitution. Like our own attempts to recover "Romanticism," the *Hyperion* poems constitute the attempt, like that of the analytic session, to substitute a construct in place of the origin they desire, a construct that is always the work of the future.[6] And so Romanticism takes us back to the future of psychoanalysis. Keats's metaphors of the individual life as a "Large Mansion of many Apartments" (*Letters* 95) or as a "vale of Soul-making" (249) anticipate Freud's developmental paradigm of psychic evolution, and the dynamics of psychoanalysis supplement the *Hyperions* because they are traumatically repeated in a displaced and problematic form. Psychoanalysis, however, also takes us back to the future of Romanticism. One must caution, that is, against either allegorizing Romanticism in terms of psychoanalysis or invoking the disciplinary authority of psychoanalytic theory to make sense of literature. Reading back from psychoanalysis to how it is *invented* rather than merely anticipated in Romanticism, one can acknowledge instead the disruptions that manifest the unconscious or "unthought" *between* them of which they are "not aware" (Felman 6). The incipient or tentative nature of self-awareness in the discourse of Romanticism points to what always remains "unthought" within subjectivity, its blindness to its own insights. Substituting Victorian edifice for Romantic fragment, the post-Romantic Arnold, for instance, read this blindness as "premature" and "incomplete" rather than as the sign of a displaced or missed awareness symptomatic of all discourses or of the ideologies they generate. The incipient nature of Freud's discoveries was likewise resisted and misread by post-Freudians, even though Freudian analysis itself signified a reaction against a normative Victorian ideology that produced it. We must ourselves resist becoming "New Victorians." The psycho-aesthetic economy of Romanticism unsettles, at the same time that it is expressed by, the ideological and theoretical constraints of the discourse(s) it generates; and Romanticism is not only the nascent form of psychoanalysis but is also its unconscious, as in the argument (although a disapproving one) by Philippe Lacoue-Labarthe and Jean-Luc Nancy that Romanticism has become the "unconscious . . . in most of the central motifs of our modernity" (15).

Genealogy, as Foucault defines it, "opposes itself to the search for 'origins'" ("Nietzsche" 77) and addresses instead the "dissociation of the self, its recognition and displacement as an empty synthesis" (81). Reading genealogically between Romanticism and psychoanalysis, then, entails the question of the ontological undecidability of a subject caught between

recollection and construction and thus leads us to the primal scene and transference, both as figures of critical understanding and as aesthetic tropes that Romanticism explores. To account for the transference between the repetition of "Hyperion" within "The Fall of Hyperion," one can ask three questions: How does the displacement of the first text's ostensibly monologic narrative about the gods by the second text's dialogic dream structure alter either text's identity? What type of narrative strategy does this displacement generate? How is this strategy implicated in our reading between the texts? To answer these questions I shall first establish a theoretical (particularly Lacanian and Kristevan) lexicon for the *Hyperions*, but shall also read this lexicon back to them as a way of framing their psychoaesthetic economy of the subject and of examining how Keats's texts and analytic theory both supplement and unsettle one another. I shall then explore how narrative negotiates between analysis and literature within the texts and add some brief final comments about what this negotiation teaches us about Romanticism.

The *Hyperions* inscribe a revisionary site, like the analytic session, wherein "Hyperion" reads its past, and "The Fall of Hyperion" in turn reads the past of "Hyperion" as a site of trauma. In Freudian analysis the patient "repeats," "remembers," and "works through," in the presence of the analyst, archaic attachments to the objects repressed in her unconscious.[7] The patient resists remembering (that is, understanding) trauma by acting out or repeating it, by transferring its negativity onto the analyst. The analyst helps the patient to work through this transference consciously (and thereby to dissolve it) by remembering through its present effects those of the past, thereby (re)claiming an identity left fragmented by trauma. As we have seen, however, the repetitive structure of the transference disrupts the work of analysis, so that the work of the present confounds the recuperation of the past. This negativity is more fully explored by Lacan, for whom transference is mobilized by the unconscious, which remains "resistant to signification." Transference is a "missed encounter with the Real" (*Four Fundamental Concepts* 129) or what is *always beyond* signification. Moreover, the analyst's countertransference with the patient—the negativity of what the analyst unconsciously projects onto the patient—complicates and cannot be separated from the phenomenon of transference, which Lacan accounts for as an elision of desire that is always the desire of the other.

(Counter)transference, then, produces a dialogue between two subjects placed, to borrow Kristeva's phrase, "in-process/on trial" (*Revolution* 26) through a narrative process that both produces and destabilizes their identities. Peter Brooks argues that this is typical of "most narratives, which

speak of their transferential condition—of their anxiety concerning their transmissibility, of their need to be heard, of their desire to become the story of the listener as much as of the teller" (*Psychoanalysis* 50). Hence transference characterizes the condition of all texts; the transference "is textual because it presents the past in symbolic form, in signs, thus as something that is 'really' absent but textually present" (53–54). Within the text of this displaced narrative schema, then, what the text speaks back to its author and to its reader de-centers both identities so that they become, through the conflicting effects of (counter)transference, interchangeable. The text is the resistant site of the unconscious as the "discourse of the other" (Lacan, *Ecrits* 55) inscribed in the transference between analytical subjects, of which the author (or analyst as a subject *presumed* to know) assumes only a provisional and imaginary role in relation to the reader (or analysand), and vice versa. The work of analytical self-enlightenment, then, brings us to what Shelley calls the "dark abyss of—how little we know" (478) as much as it attains to self-knowledge, so that our "whole life is thus an education of error" (477).

Reading the narrative of transference back to the *Hyperions* enables one to address how Hyperion resists remembering the Titans' traumatic fall, which the text repeats through the mediation of *Paradise Lost*, revisioned as the Greek theogony. By transferring analytic responsibility onto Milton, Keats displaces trauma within the apparatus of epic, the analytic usefulness of which he does not question until Book 3, where the text fragments. Readers often locate the text's dissatisfaction with epic in its generic or narrative stasis. Figured as monoliths in ruin, the Titans "encumber the text itself . . . and immobilize the undeviating march of narrative" (Aske 92). Or, moving from epic in the first text to dream vision in the second marks the shift from a narrative of sculptural classical blindness to one of picturesque Romantic insight, "The Fall" 's "scenic education" organizing "the education of the narrator" (Goslee 98). One view sees epic obstructing the temporality of narrative, while the other sees it offering the wrong narrative vehicle to express the temporality of self-discovery. Between the idea of "Hyperion" as an "epitaph to its own fragmentation" (Aske 94) or a "static and stony" (Goslee 96) frustration of narrative, however, I wish to read the Titans, not as static personalities but as subjects destabilized by trauma, their identities made fluid by the psychoanalytic search for self as it develops to discover its own scene of analysis. Revisiting the trauma of "Hyperion," "The Fall" makes explicit and reconfigures the analytic scene embedded in "Hyperion," first by entering into an analysis of it with Moneta, and second by entering into an analysis of "The Fall" itself with its future readers.

In "Hyperion" various subjects, now differentiated from themselves as

fragmented, de-centered, and dependent others, search for their once inte-grated and autonomous cultural identities, now part of an unconscious past they can no longer read. Saturn expresses this loss of omnipotence in his opening speech to Thea: "I have left / My strong identity, my real self, / Somewhere between the throne and where I sit / Here on this spot of earth" (1.112–15), and his self-alienation is dramatized in the poem through a series of similar analytic encounters. However, the structure of these en-counters, both individually as dialogues that gesture toward interpersonal communication and collectively as what Bakhtin calls "heteroglossia" or "a multiplicity of social voices" (263), is, like the trauma it fails to remem-ber, repressed by the text's attempt to project through epic a monologic social vision.[8] Judith Little argues that the Titanic discourse of meditative self-examination marks "Hyperion" as a "poem of contemplation, not of action," a text "working itself into a statement of evolutionary develop-ment" (140) between the Titans and the Olympians. Yet dialogue in both poems is dramatic in that it stages the subject as part of the "discourse of the other" through which the subject reads her own (de)centered iden-tity, and is social in that it interpolates this identity through a multiplicity of discursive "others," the personal always already inscribed by the social or cultural, yet simultaneously resisting its ideological containment. "The Fall of Hyperion," then, where the poet encounters the archaic object of his relationship with "Hyperion" internalized within the text as the imago of an abandoned identity, foregrounds dialogism as part of a larger analytic process.

The larger psychoanalytic allegory of reading inscribed between the texts evokes an ambivalent textual subject who both analyzes and is ana-lyzed by the discourse that inscribes her. Furthermore, her identity is (de)constructed through both imaginary and symbolic modes of psychic production. Reconceptualizing Freud's Oedipal schema, both Lacan and Kristeva theorize an imaginary phase, associated with "mother," preced-ing the subject's inscription by the phallic authority of the "father," which grants symbolic competency within the social order of language. However, both ascribe to this "Symbolic" differing degrees of structural stability.[9] In Lacan's "Imaginary," the subject assumes an imago of herself as a total-ized and autonomous (rather than fragmentary and dependent) entity. This mirror stage "situates the agency of the ego, before its social deter-mination, in a fictional direction, which will always remain irreducible" (*Ecrits* 2) and which mobilizes subjectivity before language "projects the formation of the individual into history" (4). By threatening to seduce the subject within the narcissistic illusion of her identity, however, the Imagi-nary also resists the contingencies of history that determine the subject as split within the Symbolic by the otherness of the unconscious.

Lacanian ambivalence toward the Imaginary positing of the subject is recast in Kristeva as the "very precondition" (*Revolution* 50) that both precipitates and disrupts subjectivity. She redefines the Imaginary as the "semiotic" or "fundamental stage—or region—in the process of the subject . . . hidden by the arrival of [Symbolic] signification" (*Revolution* 40). Registering things like the effects of the (mother's) body, "'psychical' marks" (25), and affect, the semiotic is the "nonexpressive totality formed by the drives and their stases in a motility that is as full of movement as it is regulated" (25), and it functions with the Symbolic as "inseparable modalities" within a larger "signifying process that constitutes language" (24). Kristeva thus also defines the semiotic aesthetically as a "practice that facilitates the ultimate reorganization of psychic space, in the time before an ideally postulated maturity" ("Adolescent" 10). Functioning both as a psycho-aesthetic mode and genre, this "adolescent imaginary" allows the subject "to construct a discourse that is not 'empty,' but that he lives as authentic" (11). Its writing inscribes a provisional, *intentionally* illusionary, and "open psychic structure" (8) within the always already disillusioned register of the Lacanian Symbolic.

Like the (de)constructive force of (counter)transference, and through the Imaginary and Symbolic modalities that register its effects, the adolescent imaginary suggests how the subject of the *Hyperions* is both generated and displaced. This open narrative apparatus, which I shall explore more fully in the next section, resists and unsettles the closed and repressive structure of epic. The cultural (psycho)analysis of symbolic poetic tradition that the *Hyperions* undertake, that is, is resisted by the counter-analysis of the personal apparatus of subjectivity, expressed through the open narrative structure of a cultural case history within which the reader is interpellated as both a personal and cultural subject. Within this case history, the Olympians signify something other than evolutionary development. As I stated earlier, "Hyperion" finds the Titans unable to remember their defeat by the Olympians. Repeated variously in Saturn, Hyperion, and Apollo as mirror images of an analysand striving to "find reason why [he] should be [presently] thus" (1.131, 149), the effects of this resistance are transferred onto various analytical figures: Thea (1.23–71; 2.89–100), Coelus (1.306–48), Oceanus (2.163–246), Clymene (2.247–303), Enceladus (2.107–10; 2.303–55), and Mnemosyne (3.46–79). Their various "discourses of the other" reflect back to this composite analysand imagoes of both his Imaginary and Symbolic identities. Addressing Thea, Oceanus, Clymene, and Enceladus, for instance, Saturn transfers what he is unable to confront within himself by searching his "own sad breast" (2.128) to "find no reason why [*they*] should be thus" (131; italics mine). The text appears to work through the multiplicity of this analytic process in Book 3 when Apollo, read-

ing a "wondrous lesson" (112) in the analytical authority of Mnemosyne's face, feels within himself a godlike "Knowledge enormous" (113). Fixing a "steadfast" (122) and "level glance" (120) on her features, he experiences "wild commotions" (124), "Most like the struggle at the gate of death" (126), at which point he "Die[s] into life" (120), as if to work through the trauma of his lost divinity in a way that Saturn and Hyperion could not. "During [this pain] Mnemosyne upheld / Her arms as one who prophesied" (133–34), as if silently to confirm the dissolution of her countertransference with Apollo, as well as his transference with her. Where "Knowledge enormous" suggests that Apollo has himself become a subject presumed to know, however, "commotions" suggests confusion, covered over by the trope of apocalypse that pretends to remove any need for mediation. The withdrawal of the (counter)transference precludes an otherness that (as "The Fall" will suggest) is the necessary condition of the subject's entry into Symbolic "life."

The fragmentation of Book 3 indicates at the boundaries of the text the climax of the (counter)transference between Keats and Milton. Keats's struggle with epic can be read as an attempt to transfer analytical authority onto Milton as the paternal figure who guarantees Keats's Symbolic epic competency. The fragmentation of the poem, as well as its subsequent rewriting as "The Fall," however, also suggests an attempt to account for the countertransference of Milton, whose silent influence as a reader of Keats's efforts has now become for Keats, through the disciplinary effects of poetic tradition, "death." "Miltonic verse," Keats writes, "cannot be written but it [in] the vein of art" (*Letters* 325–26), which is to say, *through* art as an Imaginary mediation that resists the Symbolic knowledge that "we are mortal" (*Letters* 33). The beginning of Book 3 thus signals an analytical shift by discarding the epic as a form of authoritarian (psycho)analysis (an authority implicitly resisted from the poem's beginning by its failure to invoke its muse) and by recasting the various dialogic confrontations of the first two books in terms of the encounter between Apollo and Mnemosyne. Mnemosyne implores Apollo to "Show [his] heart's secret" (76), but communication between them is disrupted by the unconscious that Apollo cannot name: "Mnemosyne! / Thy name is on my tongue I know not how" (82–83). The effects of this "discourse of the other" in Mnemosyne are displaced by negatively speaking to Apollo the identity that she does not possess as the displacement of his own. Yet although the Lacanian complexity of this encounter manifests itself as the analytic scene embedded in the first two books, it does not altogether jettison their significance. Instead, Saturn, Hyperion, and Apollo can be read together as versions of what Kristeva calls the abject — the "in-between, the ambiguous, the composite" — along a paradigmatic narrative axis that arranges

them according to a teleology of desire rather than history. Within this teleology Saturn is the abject or discarded rem(a)inder of Apollo that "disturbs [the] identity, system, order" (*Powers* 4) of his emergent domain, signified in Hyperion as a type of transitional figure "in-between" Saturn and Apollo. Apollo himself remains part of the transference that the fragmentation of the text can neither dissolve nor contain. Similarly, the figures who precede Mnemosyne are also rem(a)inders of a prior analytical identity always already destabilized by its countertransference with Saturn/Hyperion as King (1.52; 2.184), god (2.110), and father (2.252). Apollo emerges from this transference as the "golden theme" (3.28) or son but does not ultimately elude its grasp, for in this master/slave dialogue the "satisfaction of human desire is possible only when mediated by the desire and the labour of the other" (Lacan, *Ecrits* 26).[10]

In "The Fall" the displaced teleology of "Hyperion" becomes a transferential structure of repetition, part of the later text's allegory of reading for Keats's earlier encounter with Milton. "The Fall" recasts this "discourse of the other" as part of the complex dream narrative of the (counter)transference between the narrator and Moneta, but also through the transferential effects of its Imaginary future reader. In doing so "The Fall" neither merely reverses the analyst/analysand relationship between Milton/Keats nor reinscribes this relationship in terms of Keats/the reader. The crucial figure of "The Fall" is Keats's projection of a time when his "warm scribe my hand" will be in "the grave" (1.18) as a corpselike synecdoche for poetry. Andrew Bennett reads this figure symptomatically through Keats's "anxiety of the audience" (12), so that the "posthumous life of writing" (8) becomes inextricably bound up with the "posthumous life of reading": "'Hyperion' figures death as a pre-condition for inspiration . . . a mortal creativity . . . [whereas "The Fall"] is crucially concerned to figure *reading* as an activity irreducibly bound up with death" (151). Because the death of the author is (pre)figured in the death of the reader, Keats invites the reader to dream the death of the text (and his own death by reading it) so that Keats can "short-circuit or prefigure this disastrous but inescapable logic of remains, and the inevitable event of the death of the reader" (12–13). Because his reader-response eschatology is inscribed in the text's (future) effects, Bennett repeats what he sees as Keats's own repression of the psychic determinism of the death drive.[11] But Bennett's reading also suggests that the "dream" of the text and the "reality" of the reader are both mutually (de)constructed by the effects of the "other" as part of an imaginary structure that is mobilized by Thanatos as a psychic mechanism, rather than overcome by it. By reconfiguring the analytic scene embedded within "Hyperion" as part of its allegory for future readers, "The Fall" reads analysis as a site of both negativity *and* potentiality, rather

than life or death, through a radical (de)construction both of and by the otherness of the text's writerly and readerly identities.

The *Hyperions* incite in the reader internal psychic responses symptomatically parallel to those of alienation and dissociation evoked both in and by the poem. Like Keats's Saturn and like Keats himself attempting to internalize Milton's universe, she can familiarize herself with her world's foreignness, but she cannot possess analytical autonomy within this world because the effects of the textual other displace her identity into a transitional site between self and other resembling the unsettled subject who emerges from analysis. In Kristevan analysis (and in the type of analysis that "Hyperion" enters in the figure of Apollo), this displacement works by abjection, both an unavoidable and necessary precondition of selfhood, which operates within a less than Symbolic affective and psychic register. Abjection is "the first authentic feeling of a subject in the process of constituting itself as such" (*Powers* 47): "One must keep open the wound where he or she who enters into the analytic adventure is located. . . . [It is] a heterogeneous, corporeal, and verbal ordeal of fundamental incompleteness" (27). I have already noted that where Lacan's Symbolic does not permit identity, Kristeva's semiotic registers the mobilization of the subject through a type of Imaginary writing before she inhabits her Symbolic identity. This Imaginary also inscribes the future reader on the horizon of its heterogeneous textual landscape. One could argue, then, that "Hyperion" functions in a Lacanian manner to alienate through its Symbolic effects the subject's Imaginary autonomy. "The Fall," however, is Kristevan, inscribing the simultaneous generation and destabilization of future identities out of the semiotic of an archaic subjectivity to which it perpetually returns. Put another way, as fragments the texts are abjected somewhere between the Symbolic structure, however heterogeneous, that only an external critical narrative can assign to them and the semiotic motility that this structure fails, or is unable, to register. Let us turn, then, to the narrative deployment of this abject identity.

Kenneth Muir maintains that "aside from its too Miltonic style," the "narrative power" of the first "Hyperion" is only "intermittently displayed" (110). Yet why should readerly desire ascribe continuity to the text's discontinuous structure? The first "Hyperion" begins as the monologic exegesis of the fall of the gods but repeats several fallings within the Greek pantheon, "Amazed" (2) as they are in Book 3 in a narcissistic purgatory of "alternate uproar and sad peace" (1).[12] As we have already seen, Keats shatters the unsettled reflection of the Titans' narcissism in this book in order to expose its underlying ambivalence, figured in the invocation, where the thrice-

repeated petition to the Muse to "leave" (3) the Titans effectively exceeds the text's narrative and epic expectations. Moreover, she is unnamed and her gender (clearly feminine in her Miltonic form and in Book 2 [83]) shifts as the narrator calls upon the "Father of all verse" (13) (apparently Apollo) to "Flush everything that hath a vermeil hue" (14), a color that is elsewhere used to suggest the gilded, yet now-Imaginary, condition of the Titans' fallen world, at the same time that it inflects the hopefulness of Hyperion's ascension. The desire for the Symbolic father's voice precludes the colored ambivalence of these other descriptions, as though a phallic authority will now negotiate the passage from the world of epic into the Symbolic world of "The Fall of Hyperion." If he is the *paternal* (as opposed to the filial) "golden theme" of Book 3, however, Apollo has just "left his fair mother / And his twin-sister sleeping in their [Imaginary, pre-Oedipal] bower" (31–32) to encounter the feminine presence of the "awful Goddess" (46) Mnemosyne. Moreover, the poem appears to leave its Symbolic epic apparatus for an even more severe scene that anticipates the purgatorial dreamworld of "The Fall." But whether the maternal facilitation of that poem's "mother-tongue" is a (by then archaic) precondition to the poet's Lacanian Symbolic voice or is registered within it as a Kristevan semiotic potentiality appears to remain embedded within the indeterminate identity of the second text, which is only said "to rehearse" (16) its entry into the Symbolic.

Apposite to the manifest attempt of "Hyperion" to recall the trauma of the Titans' defeat is the text's latent desire toward this archaic state of "infancy" initially figured in Saturn's stance of "bowed head . . . listening to the earth, / His ancient mother, for some comfort yet" (1.20–21). (Coelus will later also implore Hyperion to return "To the earth!" [1.345]). Infancy signifies an autonomy prior to the Olympic succession, just as Thea is a "goddess of the infant world" (26). Her "mourning words" (49), then, translate the text's "feeble tongue / . . . like accents . . . frail / To that large utterance of the early gods" (49–51). The ambivalence of mourning/morning and of the adjectival/verbal "like," however, metonymically displaces the intentional structure of the text's grieving discourse. Thea's speech also signals her ability to mourn a productivity absent from the inertia of Saturn's melancholia, a latent potentiality figured again in Oceanus's speech as "murmurs, which his first-endeavouring tongue / Caught infant-like from the far-foamed sands" (2.171–72).[13] Clymene (whose identity "none regarded" [2.248]), in an attempt to transmute Saturn's grief, recounts how she "took a mouthed shell / And murmured into it, and made melody" (270–71), just as in Shelley's *Prometheus Unbound* Asia breathes into the "many-folded" (3.3.80) and "curved shell which Proteus old / Made [her] nuptial boon" (3.3.65–66), "Loosening its mighty music" (81) of a "voice to be accomplished" (67). The effects of Clymene's

"dull shell's echo" (2.274) "did both drown and keep alive [her] ears" (277). In "each gush of sounds" (281) from that "new blissful golden melody" (280) was "A living death" (281) that eventually signifies itself to her as "The morning-bright Apollo" (294) (as opposed to Thea's "mourning-dulled" description of Saturn in Book 1). Like Hyperion as he pejoratively names "the rebel Jove" (1.249) an "infant thunderer," Enceladus calls Clymene's speech "baby-words" [2.314], a phrase that exposes the semiotic potency of a new identity that Enceladus represses by misrecognizing its power latent within Clymene's manifestly "timid" discourse.[14] Spoken as the mother of muses to her poet-son, Mnemosyne's brief genealogy of Apollo's "young day" (3.73) recounts the genesis of his subjectivity heralded in Clymene's speech. Moreover, it also recuperates Saturn's and Hyperion's fall into ambivalence by foregrounding this now-archaic origin as having mobilized a creative potentiality still operative within the economy of Apollo's emergent, if destabilized, subjectivity.

As the figure through which the later poem analyzes this economy, the narrator/poet of "The Fall" is, like "every man whose soul is not a clod" (13), "nurtured in his mother-tongue" (15). Fittingly, he participates in this analysis in the presence of Moneta, emerging in the present text as a Kristevan female analyst who assumes the work of the various analysts in the previous text.[15] Unable to find "the syllable of a fit majesty / To make rejoinder to Moneta's mourn" (235–36), the narrator, according to her suggestion, translates " 'electral changing misery' " (251) into a discourse that is " 'Free from all pain' " (252–53). Beyond the Symbolic discourse that both regulates and suppresses her uncontainable (maternal) grief, however, the narrator must still confront "the terror of her robes, / And chiefly of the veils" (255–56) that conceal the semiotic affective register of her face's "immortal sickness" (263), which is, like Clymene's "living death," "death-wards progressing / To no death" (264–65). It is here that the "affect of the other," figured in Moneta's eyes (270–76), inscribes the narrator's emergent subjectivity as it is both generated and destabilized and acts as a figure of reading embedded within the text's larger allegory of reading, which defers the naming of the text's identity as the narrative of a "poet" or "fanatic" to the "other discourse" of a future reader. Because Moneta cannot mirror the narrator's presence to him (her eyes see him "not"), her impenetrability suggests a Lacanian otherness that does not allow him an identity within the Symbolic. Yet her "visionless" (272) and "blank splendour" (274), which likewise "comforts those she sees not" (275), irradiates *for the narrator* a "benignant" (270) influence. On one level Moneta's "immortal sickness" is the sickness of the Lacanian Imaginary, disallowing death as the experience of an otherness that necessarily determines Symbolic "identity," but thereby also suggesting the repetitive condition of desire within the Lacan-

ian Symbolic. But the narrator witnesses in *her* otherness a sense of both the negativity and potentiality of *his* own subjectivity, the primal scene of which he then goes on to analyze at 1.294 as the textual imago of his epic voice in the first "Hyperion." Moneta's interpretation of the narrator's dream allows him to "see as a God sees" (1.304), but this ability is only provisional, for his "lofty theme" (306) is only a "half-unravelled web" (308), both partially constructed and partially undone. Her hermeneutic authority is similarly displaced when the narrator interprets his surrounding landscape to figure her, like Saturn and Thea, as part of the paralyzed statuary (382–88) of fallen gods similar to those represented in the first poem.

This textual overdetermination shifts readerly desire back toward a retrospective analysis of "Hyperion"'s dialogic transposition between the gods as shifting metaphorical selves within the recursion of the text's various scenes of reading. In this manner "Hyperion" can again be read intertextually with Shelley's *Prometheus Unbound,* in which Panthea, who visits the bound Prometheus in Act 1, in Act 2 returns to Asia, who attempts to read the psychic negotiations taking place within Prometheus by looking into Panthea's face, now a site of potential recognition and communication between Asia and Prometheus: "Lift up thine eyes, / And let me read thy dream" (2.1.55–56). Eventually Asia reads Prometheus's "written soul" through a "wordless converse" (2.2.110), to which the text alludes but never articulates. These intratextual sites suggest a hermeneutic schema between author and reader, and serve, as Tilottama Rajan argues, as a "model" for a dialogue that presents "reading as a psychological and not just a semiological process" (*Supplement* 308). Shelley's poem conceives the potentiality of social apocalypse as a psychological trauma remembered and worked through (again, in potential, if not actual form) as the reading of "dreams" and "written souls." The attempts to recoup displaced desire within an analysis of history in Keats's poem occurs somewhat differently through scenes of reading that center on a questioning subject who requires the dialogic supplementation of the other's face and, more important, of the affect expressed by that face, to validate the destabilized schema of his own identity. Because the communicative potential of these scenes is projected rather than fulfilled, they both produce and dismantle the dialogue of identification that they inscribe, suggesting a transference that is a "missed encounter with the Real." In Book 1 of "Hyperion," Saturn "feels" the presence of Thea before he sees her "face," which he then asks her to lift (as Asia does Panthea) so that he might "see [their collective] doom in it" (1.97): "Look up, and tell me if this feeble shape / Is Saturn's" (98–99). In Book 2, Thea eventually supplements this gesture by observing "direst strife" (92) after "sidelong [fixing] her eye on Saturn's face" (91), her acknowledgment of which, however,

she does not articulate in the text, her obtuse gaze again suggesting a less than direct communication with the other whose desire she only *appears* to understand. Later, Oceanus asks if the rest of the pantheon have seen their conqueror's face, which forced him to "bid sad farewell / To all [his] empire" (238). The ambivalent nature of his question as both interrogative and rhetorical is, however, left undecided. In Book 3 Apollo reads as "Perplexed" (49) the "purport" (47) of the "looks" of the as-yet-unnamed "awful Goddess," a doubt left unanswered by the text's fragmentation. Finally, as I have already shown, "The Fall" goes on to examine how the narrator's identity is (de)constructed negatively by Moneta's otherness.

Dialogue within the texts, however, is not altogether predicated by negativity. By semiotizing affect, the text potentially empowers the questioning subject's own identity through "the affect of the other," thereby suggesting a reciprocated dialogue between them that is different from the failed potential of "the fallen Gods" (2.379) who hide their faces "from the light" (381) cast by Hyperion's radiant "brightness" (373). Certainly the seeds of Hyperion's fallenness are sown in the fact that he seems to be, like the subject of Lacanian analysis, disturbingly contentless.[16] This "empty" content, however, is disseminated elsewhere in the poem's textual landscape as various sites of semiotized potentiality. Hyperion's daily round is described as "hieroglyphics old" (1.277) that "sages and keen-eyed astrologers / . . . with labouring thought / Won from the gaze of many centuries" (277–79). Although they are now the fragmented ruins of "remnants huge" (281), "Their wisdom long since fled" (283), they are nonetheless refigured within the text as sites where the enigma of history might still be deciphered. Moreover, the passage recasts history phenomenologically as a cultural subject from whose seemingly blank "gaze" was "[w]on" the text of "hieroglyphics old." Within the context of the poem's semiotic topology of face and affect, this process suggests a type of cultural psychoanalysis negotiated as the analytic encounter between individual subjects and intermingles the cultural and the personal as part of the same analytic process, although not clearly indicating to what extent they are similar or different. These vestiges are reinscribed in "The Fall" as "imageries from a sombre loom" (1.76), which, though laying "All in a mingled heap confused" (77), suggest a potentially recuperable semantic past. Their Symbolic history, that is, has been jettisoned into the genotext of both a cultural and a personal past that now exists within the phenotext of the Symbolic order of the poem as both semiotic and semiotized traces, the residue of its previous interpellation within the Symbolic that has not altogether been lost.

Asking the Muse to abandon the text marks the narrator's desire to abject its constructed identity. Shortly after this point Apollo "Die[s] into life" to become the mortal self latent within the preceding figures of the other

gods. Keats abandons the text, however, leaving the reader to ask what potentiality this cathartic shift might release. "The Fall of Hyperion" then asks for the reader's interpretation and, in doing so, manifests the dialogical element generally latent within the first "Hyperion." As the poem's narrative structure both articulates and is articulated by the reader's working through the text, the relationships between shifting textual subjects generate a transference that registers the textual unconscious as a "structure of repetition" (Culler 376) and that evokes in the reader cognitive as well as performative responses: the former attempts to establish behind the text's signifiers a concealed truth, whereas the latter forgoes this effort and sees the signifiers as the production of a certain type of meaning elicited within the reader, a "transformational field" by which the poet "gives up any notion of an absolute truth and creates a form sensitive to the historicity of the text as the site of individual and cultural exchange" (Rajan, *Supplement* 212, 214). Roles and identities change in the *Hyperions* according to the logic of a metanarrative apparatus radically different from that of epic. Books 1 and 2 of "Hyperion," for instance, alternate between their narratives "in the self-same beat" (2.1), as if to dramatize the dialogical halves of a divided self. In a somewhat different manner, the figures of Thea, Mnemosyne, and Moneta function intertextually as facets of a temporalized hermeneutic composite (like that of Saturn/Hyperion/Apollo) that resist the monologic authority of Oceanus. Thematically, the gods are described as monolithic and sculptural entities (hence Keats's attempt to convey an epic, if implicitly tragic, grandeur); yet as figures within a text, they function as fluid metaphors of an indeterminate self. The former constitutes identities as an array of bounded egos within a fixed Symbolic tableau, while the latter suggests an unconscious textual or semiotic force that drives the (counter)transference, destabilizing identities and foregrounding the differences both within and between those identities.

One instance of textual repetition in "The Fall of Hyperion" elicits this complex production of meaning and points to a textual unconscious because it appears to exist, like Freud's parapraxes, outside the poet's deliberate control:

> The tall shade veiled in drooping white
> Then spake, so much more earnest, that the breath
> Moved the thin linen folds that drooping hung
> About a golden censer from the hand
> Pendant.
> (2.194–97)

> Then the tall shade, in drooping linens veiled,
> Spake out, so much more earnest, that her breath

Stirred the thin folds of gauze that drooping hung
About a golden censer from her hand
Pendant;
(2.216-20)

These passages are merely descriptive and they function to link the speeches of Apollo and Moneta; they thus appear to mark the relatively stable boundaries of textual identities. Yet they could also be oversights that Keats might have emended had he completed the text, a temporal contingency that reminds us of the fact that both our readings and our identities as readers are ambivalently determined by this contingency, elicited at a more conscious level as Keats displaces the text's significance to a time after his death. Our reading of these passages, foregrounding both identity and difference, becomes, then, our encounter with the textual unconscious as a missed encounter with the Real of Keats's death.

Perhaps the most telling way in which the structures of cultural and personal identities transect and destabilize one another rests in the disruptive interpellation of "Hyperion" into the open narrative structure of "The Fall of Hyperion." The first poem is now, like Coleridge's contributions to the *Lyrical Ballads*, "an interpolation of heterogeneous matter" (Coleridge 2.8). Yet where in Coleridge's "Christabel" the poem's trauma never emerges as part of an analytical scene, the traumatic presence of "Hyperion" emerges within "The Fall" as part of a transference with the earlier text that the poet and, by his own insistence, the reader attempt to work through. As I have already suggested, "The Fall" resembles Keats's revisitation of the primal scene of his writing of the first poem as a site of trauma. The discarded epic of "Hyperion"'s self-examining schema of conflicted and alienated subjects is refigured in "The Fall of Hyperion" as the displacement and condensation of a series of palimpsestically layered dreams. The first dream encounters the original poem as the trace memory of its Miltonic predecessor, what "seemed refuse of a meal / By angel tasted, or our Mother Eve" (31-32). Whatever "pure kinds" (34) these "remnants" (33) and "empty shells" represent, however, the narrator "could not know" (34)—an epistemological rupture that suggests that the textual origin inscribed by the primal scene of writing in "Hyperion" is irrecoverable. The shift to a second dream, induced by the "full draught" (46) of a "cool vessel of transparent juice" (42), then becomes "parent of [the narrator's] theme" (46); yet is this the patrimony of the first "Hyperion," the "refuse" of its "meal," or the poetic adult that that now-Imaginary text will become in "The Fall of Hyperion"? Or does it allude to an even further regression to Milton's text? As the consecutive stagings of "The Fall" dig archaeologically back through their own textual past, they recover the

text of the original "Hyperion" at 1.294, although it is now significantly less Miltonic and thus dissociated from the genesis of its epic conception, another origin that that poem tried but failed to construct in place of the one it desired to reclaim. Like Saturn as the abject of Apollo, it has become an abject presence within the second poem.

Here the text returns to the first poem's representation of Saturn prone on his "ancient mother"—a return to a level of subjectivity even more archaic than that represented by either Mnemosyne's "ancient power" (3.75) or Moneta's "Holy Power" (1.136). At the end of Canto 1 the narrator pauses to "glean [his] memory / Of [Moneta's] high praise—perhaps no further dare" (472–73), as if to anticipate his inability to recount through his dream the archaic source from which in the Symbolic he has been metonymically displaced. Yet the deferral of "The Fall" to an ever receding origin (which is the unremembered trauma generating the first text's transference with Milton, hypothetically duplicated through the endless effects of future readings) traces a repetitive rather than sheerly regressive narrative pattern of analysis. Andrew Bennett borrows Gerald Prince's trope of the "disnarrated" (147) to describe what the text has the potential to say in a "negative or hypothetical mode" (147) but suppresses in the name of its present telling. I would account for the "disnarrated" in terms of the counter-transference of the analytic others whose discourse is spoken through the discursive effects of the analysand with whom they are engaged in the analytic scene of the text(s), the most radical of these analytic figures being the analyst/reader of "The Fall" as a subject presumed to know. Framed as a text whose unfolding dream structure can only be read back to it by its future readers, "The Fall" asks to be read as the allegory of an ongoing and interminable analytic process that inscribes the reader within the fluid, transhistorical boundaries of this process.

As a revisitation of the primal scene, "The Fall of Hyperion" elicits, in our reading of it, the narrative of a complex temporal understanding, an anatomy of arrested episodes within a larger temporal determinacy confirming to us that we are, according to Oceanus, "not the beginning nor the end" (1.190). Because desire is never satisfied, "full narrative closure and theoretical totalization" (La Capra 35) are utopian dreams that are only partially realized through the provisional use of narrative structure as a series of metaphoric markers. That is, narrative exposes the temporal destiny of the gods as having to tell their narratives and so reveal the mortal and ideologically destabilized apparatus of their subjectivity. Instead of narrative coherence, then, the *Hyperions* work by a narrative insistence generated by the temporal contingencies of their narrative disruptions, Keats's attenuated revisions, and the reader's status as a destabilized subject "in process/on trial." This insistence is linked thematically to the texts' efforts

to come to terms with themselves, particularly at the beginning of Book 3 of "Hyperion" and in the opening passage of "The Fall of Hyperion." It is also disclosed in the reader's desire to refigure the transformational field of the texts within the explanatory structure of narrative. Like the psychoanalytic narrative limited by the time-boundedness of history, both cultural and personal, the text (in our reading of it) must also submit, as Peter Brooks argues, to the "timelessness of the unconscious" (*Psychoanalysis* 118) that it contains but can never subdue. Brooks argues that the transference between narrative and the unconscious manifests a convoluted and "strange logic" and betrays the "suspicion and conjecture" of "a structure of undecidability which can offer only a framework of narrative possibilities rather than a clearly specifiable plot" ("Fictions" 77). This shift is suggested in the modulation from the structural apparatus of epic to the deconstructive afflatus of dream vision. The reader, like Saturn, Hyperion, or the poet/fanatic, must chart a path through the identities of "others" divided from her within the text of her own reading. These are the abjected forms of the poet's desire, disseminated by a textual unconscious that will not allow the reader to reclaim them as a wholly integrated ego. These others read back to the reader a selfhood like that of Saturn, who searches in his heart but cannot read *alone* any "reason why [he] should be thus."

The *Hyperion*s negotiate Romanticism through a type of Lacanian mirror stage by tracing a complex narrative, from the Romantic subject's Imaginary (albeit conflicted) sense of her own omnipotence in "Hyperion," to "The Fall of Hyperion," a text symptomatic of Romanticism's emerging awareness of its own contingency within the Symbolic order of history. This contingency places the first "Hyperion," specifically Oceanus's genealogy of the gods, among other nineteenth-century projects like those of Hegel, Marx, or Darwin that attempt to trace metanarratives of the process of history. Where these works use psychoanalytic mechanisms (such as the master/slave dialectic in Hegel and Marx or the developmental figure of progressive evolution in Darwin) as a means of empowerment to reinforce their own internal authority, "The Fall of Hyperion" deconstructs these mechanisms in order to reinscribe them as structures of desire by tracing a self-deconstructing genealogy that subdues the projected telos of the *Hyperion*s' narrative to "the service of the time being." In this sense, "The Fall" ushers Romanticism through a type of inverse mirror stage that abandons Symbolic poetic tradition in the way that *Adonais* abandons it: as a postanalytic survivor swimming beyond, rather than drowning within, the "trembling throng" (489) of this Symbolic authority. The Symbolic order of the later poem thus remains unsettled from within by its transference with the Imaginary traces of an earlier text it cannot supersede. In this sense, the *Hyperion*s negotiate our own destabilized, abject positions

by both tying us to and projecting us outside of the "service of the time being." Our readings of the *Hyperion*s and of Romanticism—our repeated narrative engagements with the otherness of Romanticism's texts—are initiated in part by things like Keats's aborted revisions of both poems, which inscribe the truncated, liminal territory of an abject universe lacking "seeming sure points of Reasoning" (*Letters* 96). Because we have once again been situated precariously upon its horizon by psychoanalysis, it is a world that certain Romantic texts can teach us, or, depending upon whose couch one is lying, *not* teach us, how to inhabit.

Notes

I wish to acknowledge the invaluable suggestions offered by Tilottama Rajan and Ross Woodman during the revision of this essay, and by Michael Sider, who helped me to understand the subtleties of Keats's relationship to history and not to dismiss the past too easily.

1 Wasserman makes the representative statement for organic unity by refusing to deal with the poems: "[T]he two pieces on Hyperion are fragments; they lack a total structure, cannot be organic wholes, and therefore cannot be explicated, in the full sense of that word" (10). See also Muir and Bostetter 8–9.

2 See *The Romantic Fragment Poem* 167–73 for Levinson's deft handling of the history of criticism about the poems.

3 See *Keat's Life of Allegory* 191–226, in which Levinson rewrites her earlier account of the *Hyperion*s' "textual genetics . . . to explain the peculiar success and failure of the poems in terms of Keats's general literary project" (192). See also Balachandra Rajan 211–49 and Tilottama Rajan, *Dark Interpreter* 143–203.

4 These latter readings address in the texts a transitional period that suggests the psychoanalytic narrative of a loss of omnipotence, experienced developmentally as the movement in infancy from some primal narcissistic facilitation, defined by the illusion of omnipotence, toward some later stage within which this illusion is shattered. See Levinson, *The Romantic Fragment Poem* 107–87, de Man, Parker, Schapiro, and Bloom 112–42.

5 The critical character of Keats as a Romantic writer has, thanks largely to the influence of a new historicism in Romantic studies (of which McGann's work is exemplary), changed dramatically over the last twenty years. In his introduction to a special Keats bicentenary issue of *European Romantic Review*, Grant Scott argues that the "current historicizing of Keats," by writers such as Levinson, McGann, Keach, and Hoagwood and, most recently, in Roe's volume, *Keats and History*, is "a reaction against the Harvard Keatsians, who . . . affirmed Keats's virility by placing him 'among the English Poets.' . . . The most recent trend in Keats criticism has sought to return the poet to his original cultural and social milieu" (iv–v).

6 For a similar point, see Levinson, *The Romantic Fragment Poem* 181.

7 See Freud's "Remembering, Repeating and Working-Through (Further Recommendations on the Technique of Psycho-Analysis II)," "The Dynamics of Transference," and "Observations on Transference-Love." See also Kristeva, *Revolution in Poetic Language* 19–107 and *Tales of Love* 21–57.

8 For the distinction between epic and novel, see Bakhtin 3–40.

9 While Lacan appears to deconstruct the theoretical hegemony into which Freudian psychoanalysis had settled at the expense of its own radical insights, Kristeva refashions Lacan's structuralist bias from within a poststructuralist perspective. Lacan is influenced by Saussurian and Jacobsonian structural linguistics. For him the Symbolic is heterogeneous and less than stable but is heavily invested in the hegemony of the linguistic signifier and hence is theoretically privileged. In this sense, the Lacanian subject is both identity-less *and* trapped within the Symbolic. Kristeva's Symbolic, however, is not the subject's exclusive domain. As a univocal and monological theoretical category, it allows Kristeva to demonstrate how subjectivity is mobilized outside of Symbolic discourse. She accounts for the textual topography of this heterogeneity in terms of its genotextual and phenotextual registers. The genotext organizes a semiotic "space" or process within language "in which the subject will be *generated*" (*Revolution* 86) and precedes the arrival of signification in the form of the Symbolic phenotext, which is "restricted to the two poles of univocal information between two full-fledged subjects" (87) and which obeys the structural rules of grammar and logic. This distinction places in relief the difference between Lacan's structuralist bias and its focus on language's status/stasis as "signification" and Kristeva's poststructuralist emphasis on language as part of a "semiosis" or "signifying process," terms that reflect a Bakhtinian "dialogism" and a feminist imperative that accounts for the mother's body as the site of significative forces that both exceed and transgress the structures of language.

10 Hyperion's exchange with Coelus figures significantly in this master/slave dialogue wherein Hyperion appears as an imago of the son Apollo that Saturn becomes, a transformation negotiated in the transference between Hyperion and Coelus, who has witnessed his "first born [Saturn] tumbled from his throne" (2.323) by his own son. Coelus speaks to Hyperion as part of a missed encounter with his "real" son, and Saturn in turn speaks to his "real" conqueror-son only through the missed encounters with Thea, Oceanus, and Enceladus, all for whom Coelus is likewise an Imaginary father. Yet the ambivalence of this transference is tempered by the potentiality of Coelus's disembodied "voice" (306), which speaks "from the universal space" (307) (like Demogorgon's cave in Shelley's *Prometheus Unbound*) of a genotext out of which Apollo's Symbolic presence is generated. (I shall examine this textual potentiality more closely in section III.) In a speech that parallels Thea's recognition in Saturn of the ambivalence of a "supreme god / At war with the frailty of grief" (2.92–93), Coelus sees in Hyperion, an "evident god" (1.338), a similarly mortal "grief" (335) and urges him to enter the "van / Of circumstance" (343–44), thereby facilitating the passage from Imaginary identity to Symbolic subjectivity.

11 See Tilottama Rajan's *Supplement of Reading*, which argues for a more productive hermeneutic for reading Romantic texts. Bennett cites his indebtedness to Rajan's study but wages her "completion" of the text by the reader against his "tragic recognition that the supplement of reading, rather than completing the text, might stand in its place, both concealing and exposing its incompletion" (184n). See also Rajan's review of Bennett's book. Ross Woodman also argues for the productivity of the future reader:
 In his revision of "Hyperion" [Keats's] hand holding a pen becomes the conscience of the reader. "Whether the dream now purpos'd to rehearse," Keats writes, addressing his future readers, "Be poet's or fanatics will be known / When this warm scribe my hand is in the grave." It will be known, that is, when the reader reaches out to take hold of Keats's "scribe" to make a writing of his or her reading, constructing or deconstructing in the process a revisionary text. (7)

12 Paul de Man ("Resistance" 16–17), briefly citing the rhetoric of the *Hyperion*s as the

site of a particular resistance to theory, examines how the etymology of (the) "fall" can be disseminated in several conflicting ways both within and between the poems.

13 Laplanche and Pontalis quote Daniel Lagache's statement that makes sense of the work of mourning in the *Hyperions*: "[I]t has been said that the work of mourning consists in 'killing death'" (486). Briefly, then, Saturn's inertia, like that of the other fallen gods, results from his melancholia, or an inability of the subject to "sever its attachment to the object that has been abolished," that is, the imago of his now-archaic divinity. In its more severe form, melancholia results in a type of psychosis. See also Freud, "Mourning and Melancholia." In a provocative reframing of the work of history in the poems, Tilottama Rajan argues that the work of melancholy in "The Fall" is part of its "cultural responsiveness" ("Keats" 17), its attempt to signify that which escapes the use value of history.

14 Enceladus's statement is especially telling, since he is, according to Lemprière's *Bibliotheca Classica*, which was one of Keats's references for mythological sources, "the most powerful of all the giants who conspired against Jupiter" (cited in *Complete Poems* 705).

15 Leon Waldoff implicitly contextualizes Moneta according to her analytical function: "Identity requires a mirroring Other, and the quest for identity in 'The Fall' takes place in the presence of a feminine figure in whose response to himself the poet seeks to discern, as if in a mirror, an answer to the question of who he is" (197). Ultimately, Waldoff reads the text's subjectivity within a conservative and recuperative economy of psychic functioning resembling ego-psychology, whose faith in the structural integrity of identity Lacan vehemently opposed.

16 Tilottama Rajan, in another context, refers to this identity as the "empty schema [of] the subject in Lacanian psychoanalysis" (*Supplement* 305).

Works Cited

Arnold, Matthew. *Poetry and Criticism of Matthew Arnold*. Ed. A. Dwight Culler. Boston: Houghton Mifflin, 1961.

Aske, Martin. *Keats and Hellenism: An Essay*. Cambridge: Cambridge UP, 1985.

Bakhtin, M. M. *The Dialogic Imagination: Four Essays*. Ed. Michael Holquist. Trans. Caryl Emerson and Michael Holquist. Austin: U of Texas P, 1981.

Bennett, Andrew. *Keats, Narrative and Audience: The Posthumous Life of Writing*. Cambridge: Cambridge UP, 1994.

Bloom, Harold. *Poetry and Repression: Revisionism from Blake to Stevens*. New York: Yale UP, 1976.

Bostetter, Edward E. *The Romantic Ventriloquists: Wordsworth, Coleridge, Shelley, Keats, Byron*. Rev. ed. Seattle: U of Washington P, 1975.

Brooks, Peter. "Fictions of the Wolfman: Freud and Narrative Understanding." *Diacritics* (spring 1979): 72–81.

———. *Psychoanalysis and Storytelling*. Oxford: Blackwell, 1994.

Coleridge, Samuel Taylor. *Biographia Literaria; or Biographical Sketches of My Literary Life and Opinions*. Ed. James Engell and W. Jackson Bate. Princeton: Princeton UP, 1983.

Culler, Jonathan. "Textual Self-Consciousness and the Textual Unconscious." *Style* 18.3 (1984): 369–76.

de Man, Paul. "Keats: The Negative Road." *English Romantic Poets*. Ed. Harold Bloom. New York: Chelsea, 1986. 343–61.

———. "The Resistance to Theory." *Yale French Studies* 63 (1982): 3–20.

Felman, Shoshana. "To Open the Question." *Yale French Studies* 55/56 (1977): 5–10.

Foucault, Michel. "Nietzsche, Genealogy, History." *The Foucault Reader*. Ed. Paul Rabinow. New York: Pantheon, 1984. 76–100.

Freud, Sigmund. "The Dynamics of Transference." 1912. *The Complete Psychological Works of Sigmund Freud*. Standard ed. Trans. James Strachey. Vol. 12. London: Hogarth, 1958. 97–108. 23 vols. 1953–74.

———. "Observations on Transference-Love (Further Recommendations on the Technique of Psycho-Analysis III)." 1915. Vol. 12 of *Complete Psychological Works*. 1958. 157–71.

———. "Mourning and Melancholia." 1917. Vol. 14 of *Complete Psychological Works*. 1957. 237–58.

———. "Remembering, Repeating and Working-Through (Further Recommendations on the Technique of Psycho-Analysis II)." 1914. Vol. 12 of *Complete Psychological Works*. 1958. 145–56.

———. "The Case of the Wolf-Man: From the History of an Infantile Neurosis." *The Wolf-Man by the Wolf-Man*. Ed. Muriel Gardner. New York: Noonday, 1991. 153–262.

Goslee, Nancy Moore. *Uriel's Eye: Miltonic Stationing and Statuary in Blake, Keats, and Shelley*. University: U of Alabama P, 1985.

Keats, John. *Letters of John Keats*. Ed. Robert Gittings. Oxford: Oxford UP, 1970. Rpt. 1977.

———. *The Complete Poems*. Ed. John Barnard. 2nd ed. New York: Penguin, 1977.

Kristeva, Julia. *Powers of Horror: An Essay on Abjection*. Trans. Leon S. Roudiez. New York: Columbia UP, 1982.

———. *Revolution in Poetic Language*. Trans. Margaret Waller. New York: Columbia UP, 1984.

———. *Tales of Love*. Trans. Leon S. Roudiez. New York: Columbia UP, 1987.

———. "The Adolescent Imaginary." *Abjection, Melancholia, and Love: The Works of Julia Kristeva*. Ed. John Fletcher and Andrew Benjamin. New York: Routledge, 1990. 8–23.

Lacan, Jacques. *Ecrits: A Selection*. Trans. Alan Sheridan. New York: Norton, 1977.

———. *The Four Fundamental Concepts of Psycho-Analysis*. Ed. Jacques-Alain Miller. Trans. Alan Sheridan. New York: Norton, 1981.

La Capra, Dominick. *Soundings in Critical Theory*. Ithaca: Cornell UP, 1989.

Lacoue-Labarthe, Philippe, and Jean-Luc Nancy. *The Literary Absolute: The Theory of Literature in German Romanticism*. Trans. Philip Barnard and Cheryl Lester. Albany: State U of New York P, 1988.

Laplanche, J., and J. B. Pontalis. *The Language of Psycho-Analysis*. Trans. Donald Nicholson-Smith. London: Karnac Books and the Institute of Psycho-Analysis, 1988.

Levinson, Marjorie. *The Romantic Fragment Poem: A Critique of a Form*. Chapel Hill: U of North Carolina P, 1986.

———. *Keats's Life of Allegory: The Origins of a Style*. New York: Blackwell, 1988.

———. Introduction. *Rethinking Historicism: Critical Readings in Romantic History*. New York: Blackwell, 1989. 1–17.

Little, Judith. *Keats as a Narrative Poet: A Test of Invention*. Lincoln: U of Nebraska P, 1975.

Lukacher, Ned. *Primal Scenes: Literature, Philosophy, Psychoanalysis*. Ithaca: Cornell UP, 1986.

McGann, Jerome. *The Beauty of Inflections: Literary Investigations in Historical Method and Theory*. Oxford: Clarendon, 1985.

Muir, Kenneth. "The Meaning of 'Hyperion.'" *John Keats: A Reassessment*. Ed. Kenneth Muir. 2nd ed. Liverpool: Liverpool UP, 1969. 103–23.

Parker, Patricia. "Keats." *Critical Essays on John Keats*. Selected by Hermione de Almeida. Boston: G. K. Hall, 1990. 103–28.

Rajan, Balachandra. *The Form of the Unfinished: English Poetics from Spenser to Pound*. Princeton: Princeton UP, 1985.

Rajan, Tilottama. *Dark Interpreter: The Discourse of Romanticism*. Ithaca: Cornell UP, 1980.

———. *The Supplement of Reading: Figures of Understanding in Romantic Theory and Practice*. Ithaca: Cornell UP, 1990.

———. Rev. of *Keats, Narrative and Audience: The Posthumous Life of Writing*, by Andrew Bennett. *European Romantic Review* 6.1 (1995): 137–41.

———. "Keats, Poetry, and the Absence of the Work." *Modern Philology*. Forthcoming.

Roe, Nicholas, ed. *Keats and History*. Cambridge: Cambridge UP, 1995.

Schapiro, Barbara. *The Romantic Mother: Narcissistic Patterns in Romantic Poetry*. Baltimore: Johns Hopkins UP, 1983.

Scott, Grant F. "Introduction." *European Romantic Review* 6.1 (1995): i–ix.

Shelley, Percy Bysshe. *Shelley's Poetry and Prose*. Ed. Donald H. Reiman and Sharon B. Powers. New York: Norton, 1977.

Waldoff, Leon. *Keats and the Silent Work of the Imagination*. Urbana: U of Illinois P, 1985.

Wasserman, Earl. *The Finer Tone: Keats's Major Poems*. Baltimore: Johns Hopkins UP, 1953.

Woodman, Ross. "Romanticism and Reading: The Case of 'The Fall of Hyperion.' " "Romanticism and Reading" Special Session. MLA Convention. New York. December 1986.

"Their terrors came upon me tenfold": Literacy

and Ghosts in John Clare's *Autobiography*

RICHARD G. SWARTZ

*A*s John Clare explains in his fragmentary and unfinished *Autobiography*, he struggled throughout his adult life to overcome the influence popular superstitions exercised over his imagination: "Tho I always felt in company a disbelief in ghosts," Clare writes, "yet when I was alone in the night my fancys created thousands" (*Prose* 40). This lingering belief in ghosts affected more than his personal sense of well-being; much, I hope to demonstrate, was at stake in this struggle. Clare's failed efforts to disavow popular superstition mark him as a divided being caught between the separate domains of popular and high literary culture. It is therefore fitting that one learns of his haunted "fancys" from his incomplete *Autobiography*, the text in which he attempts to make narrative sense of both his divided cultural position and the cultural aspirations that magnify that division. The *Autobiography* implicitly asks whether Clare is able to define himself as a "Poet," a role or ego ideal he borrows from those authors who, in his mind, best exemplify it: Thomson, Cowper, and Wordsworth, as well as Coleridge, Lamb, Hazlitt, and Byron. It was not enough to have published poetry, or to be, in strictly practical terms, an active writer of verse. Rather, Clare asks himself whether he can comfortably assume the culturally defined ego ideal of the Poet, that is, whether he can represent himself in the position of what we now recognize as the high Romantic author—indeed, to follow this logic of displacement and self-doubt to its logical conclusion, whether he can represent himself in any culturally defined position of full, self-authorized subjectivity. His belief in ghosts puts the issue very much in doubt.[1]

Ghosts and ghost stories appear with impressive frequency in early-nineteenth-century autobiography. To be more precise, the story of having surmounted a childish belief in ghosts is a principal theme of two distinct modes of autobiographical writing: working-class and Romantic autobiography. There are, however, distinct differences between the Romantic and

working-class ghosts. In Romantic autobiography, the belief in ghosts, which invariably begins when the child reads marvelous tales, prefigures the emergence of the adult's higher imaginative powers. In contrast, for the working-class autobiographer the ghost belongs to an illiterate and superstitious popular culture whose influence the child must outgrow, and outgrow precisely by becoming literate. Clare's *Autobiography* does not comfortably fit either paradigm, although his ghosts, like the typical ghosts of working-class and Romantic autobiography, are deeply associated with issues of literacy, education, reading, and authorship. On the one hand, unlike other autobiographers of humble origin, Clare fails to surmount his fear of ghosts—although, neither does he, significantly enough, completely disavow the popular culture to which these superstitions belong. On the other hand, unlike the Romantic autobiographer, Clare does not view his fancy-created ghosts as signs of an exalted imagination, or of his access to full subjectivity, or of his assimilation to the text-based idioms of literary culture.

As the term "ego ideal" suggests, much of my argument draws upon psychoanalytic vocabulary to describe the autobiographical subject of Clare's text, although it does so as a means of intimately relating that text, and the (vacillating) formation of that subject, to historical questions having to do with literacy. The story of a man whose reading and writing skills were acquired outside of the legitimate institutions that defined what it meant to read and to write, as well as the story of a self-educated member of the laboring classes who cannot outgrow his childhood superstitions, Clare's *Autobiography* struggles to decide who its autobiographical subject is, or even who it ought to be. Yet in the process of struggling with its ghosts, the *Autobiography* reveals the extent to which early-nineteenth-century culture consists of multiple and competing literacy practices. In this sense, the *Autobiography* contests the assumption that there was, or is, a single and identifiable literacy *as such,* one which, presumably, furnishes literate individuals in all times and places with a distinct set of cognitive skills and intellectual dispositions. The concept of a monolithic, pure literacy as such has the effect of delegitimating other marginal or competing literacy practices, marking them as deficient or effectively rendering them invisible *as* literacies. (Indeed, I shall suggest that the ideology of literacy *as such,* or what Brian Street calls "the reification of literacy in itself" ["Introduction" 4], may be what prevents Clare from fashioning an adequate autobiographical ego ideal.) Clare's marginal position as an author gives him the opportunity to suggest that there are indeed alternative literacies. Thus while it is deeply haunted by the very cultural dislocations it describes, the *Autobiography* may still remind us that the laboring classes of the eighteenth and nineteenth centuries practiced their own indigenous forms of

literacy, and therefore force us to abandon the increasingly discredited idea that the popular culture of the period was an exclusively oral culture.[2]

Literacy, Literary Culture, and the Ego Ideal

To author an autobiography presupposes that one is, as Reginia Gagnier observes, "a significant agent worthy of the regard of others" (141). I want to revise this observation by suggesting that Gagnier's "significant agent worthy of regard" is a type of what psychoanalysis calls the ego ideal. Freud proposed that the ego ideal is both the primary means of socializing the subject and the basis of group affiliations. For Lacan, whose complication of Freud forms the basis of what follows here, the ego ideal, a figure of self as worthy of approval and admiration, is shaped by one's identification with socially and culturally sanctioned figures of respect, love, or fascination. Because it is formed from such identifications, the ego ideal is openly and explicitly a social construct, although it originally emerges as a substitute for the lost narcissism of the imaginary stage, when individuals were their own ideals. Lacan insists that the acquisition of language is the primary factor organizing this transformation from the narcissistic, self-idealizing condition of the imaginary stage to the socially oriented condition of the ego ideal. Readers familiar with his argument will recall that for Lacan, language divides the subject by submitting it to the formative authority of culture and the symbolic order. Accordingly, Lacan argues that the ego ideal is constructed through the self-alienating process of symbolic identification—that is, an identification that requires the ego to view itself from the self-alienating perspective of society. In the words of Slavoj Žižek, symbolic identification is "identification with the very place *from where* we are being observed, *from where* we look at ourselves so we appear to ourselves likeable, worthy of love," and therefore it "constitutes the mechanism by means of which the subject is integrated into a given socio-symbolic field" (105, 110). Paradoxically, then, symbolic identification allows individuals access to autonomous subjectivity by subjecting them to the external determinations of socially governed meanings, codes, and values. One cannot therefore consciously choose to assume a given ego ideal, since these ideals are governed by social and cultural imperatives beyond the individual's conscious control. Gagnier gestures toward this structure of self-alienated identification when she remarks that "for the working-class autobiographers . . . subjectivity—being a significant agent worthy of the regard of others, a human subject, as well as an individuated 'ego' for others—was not a given" (141).

Although Gagnier does not put it in these terms, the problem facing John Clare and other working-class autobiographers was that the autobio-

graphical ego ideal is regulated by cultural capital, or one's relation to what the dominant culture considers to be *linguistic practices* "worthy of regard." Hence Gagnier's "significant agent" of autobiography could not simply be literate, but had to be literate in particular ways. While many working-class autobiographers resolved this dilemma (we shall see how momentarily), Clare did not. Paradoxically, what made his autobiography possible—rising literacy rates—also conspired against it. The available historical evidence suggests that literacy rates reached an unprecedented peak by the 1750s, only to level off, if not to decline, until the 1840s, when they began climbing again. This second wave of popular literacy was the direct result of formal schooling, which means that it was generally imposed and regulated from above. In contrast, the first wave of popular literacy arose through very different means. It resulted from and was nurtured by popular forms of educational provision, and was practiced in terms that were thoroughly conditioned by the social imperatives of popular life—popular reading was oriented toward entertainment, for example, and other acts of social affiliation.[3] Throughout the eighteenth century the educated classes looked upon popular literacies with a general sense of misgiving that, at the outbreak of the French Revolution, transformed into active distrust. Long before then the response was to thoroughly separate proper from vulgar linguistic practice by fostering the belief that unofficial literacies were no better than deficient copies of higher, official literacy—or worse still, the belief that unofficial literacies as such simply did not exist. This denigration of popular literacies depended upon the corresponding view that official literacy—the dominant literacy practices of the socioeconomically dominant minority—was the domain of English *as such* (a cultural formation corresponding to what I am calling literacy *as such*). English *as such* was of course always something more (and something other) than a purely linguistic phenomenon: it was (and is) a hierarchical system of codes for differentiating between proper forms of pronunciation, lexical usage, grammar, syntax, and compositional styles. More important in this context, this system of codes also designated what counted as reading, how reading was to be valued, and so forth.

While the most common metaphor for English *as such* was eloquent speech, official literacy was not founded upon forms of speech (although these were significant elements of it), but upon a specific canon of published texts. In a profound and historically decisive misrecognition, pure, nonidiomatic English *as such* was assumed to be a form of verbal fluency when it was in fact a literary ideolect based upon a narrowly defined set of printed texts (Barrell 135).[4] For example, William Enfield's enormously successful work *The Speaker: or, Miscellaneous Pieces, Selected from the Best English Writers* was an anthology of literary passages intended to instruct

the public in more than the correct forms of elocution, composition, and sound literary judgment. Yet as its full title indicates, *The Speaker's* larger purpose was to acquaint its readers with canonical texts of a (newly formed) national literary tradition.[5] The very popularity of *The Speaker* testifies to the fact that only those who had been assimilated to this text-based ideolect could be regarded as socially and culturally significant subjects. As Enfield states in another work, "real distinction and dignity are attendant on learning and science" (*Essay* 16). Indeed, those who were not assimilated to this ideolect not only lacked "dignity"—they could not even be regarded as fully social beings. John Britton's *Autobiography* illustrates how dominant literacy practices heightened the division between the literate and the illiterate. Upon first coming to London, Britton joined friends "to read essays, poetry, & c., from different authors, with the view of improving, and criticising each other in the arts of reading, pronunciation, grammar, and intonations" (53). This "useful occupation" teaches Britton how "educated manners, with London discourse and habits, contrasted with the clownish deportment, the uneducated and uncouth language, and the broad, prolonged pronunciation of my village companions" (60). The "uneducated and uncouth" do not belong to the text-based world Britton values but are instead relegated to the pretextual, illiterate world of oral culture. Having invented oral culture as its Other, then, literary culture assigned it to the asocial domain of the irrational, primitive, childish, and inarticulate.

In his efforts to be recognized as a poet, Clare faced, and actively resented, this particular ideology of literacy. Aware that his poetry had been criticized for its excessive provincialisms, Clare knew that his "rustic" diction, his lack of formal education, and his social position as the son of a rural laborer all conspired to identify him with the suspect domain of popular culture and not the spiritual community of literary culture. Bound by a rigid social logic, the only role he could aspire to—in other words, the ego ideal mandated to him as an autobiographer—was that of the "Peasant Poet," or "Uneducated Poet." Yet Clare had plenty of evidence that the situation of the Peasant Poet was not a happy one. As Stephen Duck, Ann Yearsley, and others had discovered before him, poets of humble origin were at once acclaimed as natural geniuses and condemned as literary mimics whose quaint efforts at verse only prove that one cannot write authentic poetry, the highest of all genres, without the benefits of a formal education.[6] By the time he began writing the *Autobiography* in the mid-1820s, Clare had already long since rejected the impossibly double-bound Peasant Poet role. In fact, he had nothing but contempt for those who viewed him as a social curiosity who could mimic but never genuinely embody the ideals of the high Poet.

Given the cultural dominance of English *as such,* once Clare decided to write an autobiography he would have to account for the fact that he was capable of writing it in the first place. Clare's personal story is thereby implicated in a larger cultural debate about the nature, value, and significance of literacy: about what could be regarded as significant and valued literacy skills, about who might possess these skills, and in what ways these skills might be exercised and displayed. None of this, of course, is peculiar to Clare, or to his *Autobiography:* it is no exaggeration to say that literacy—its acquisition, its meaning and value, its uses and aims—is the dominant topic of nineteenth-century autobiography. As I have said, autobiography both illustrates and originates in a cultural struggle to define literacy *as such.* It is significant that this struggle often manifested itself in discussions of popular superstitions. Before discussing the details of Clare's attempt to fashion an ego ideal, then, it is first necessary to explore the role of superstition in "high" and "low" autobiography.

Coleridge and Lovett

As is well known, Romantic autobiographies tend to praise the role that childhood reading plays in shaping the adult imagination. Invariably, it is tales of the marvelous that perform this magic function (Richardson 112–27). Perhaps the best known expression of this theme is found in Book 5 of Wordsworth's autobiographical poem, *The Prelude.* Wordsworth writes that children must be allowed to cultivate their "cravings for the marvellous," because it teaches them to "wish for something loftier, more adorned, / Than is the common aspect, daily garb, / Of human life" (5.564 and 599–601). Like Wordsworth, Samuel Taylor Coleridge argues that children will outgrow their superstitious attachment to the marvelous, fantastic, and supernatural. In his first, fledgling effort to "relate the events of His own Life," written in a series of letters to Thomas Poole in 1797 (*Collected Letters* 1:302), Coleridge acknowledges that the transition from the child's world of imagined ghosts to the adult's world of empowered imagination is not without its dangers. He admits, for example, that one of the "Arabian Nights' entertainments . . . made so deep an impression" on him that he was "haunted by spectres, whenever I was in the dark . . ." (*CL* 1:347). If there is some danger, the benefits are nevertheless enormous, since the young Coleridge's specters are actually childish prefigurations of the sublime. Rather than a source of cultural embarrassment, then, his childish belief in ghosts is a valued sign of his "natural" and easy assimilation to literary culture. The child's original superstitions are partially surmounted, but they are also to a certain extent preserved, in another, more self-

conscious and intellectually enabling form: "From my early reading of Fairy Tales, & Genii . . . —my mind had been habituated to the *Vast*" (*CL* 1:354). Coleridge therefore insists that children should be "permitted to read Romances, & Relations of Giants & Magicians, & Genii," because there is "no other way of giving the mind a love of 'the Great', & 'the Whole' " (*CL* 1:354).

Coleridge's argument thoroughly reinforces the primary literacy myth of his time, which is, as I have stated, that the only sanctioned form of literacy is the text-based ideolect of literary culture. In Coleridge's version, the myth is transformed so that it now refers to the relationship between the adult's imaginative powers and the child's overly literal investment in the marvelous. Because the child's belief in "spectres" is the crucial first step in this dialectic, and because that belief is acquired through reading, Coleridge implies that an adult's sublime vision is a result of his having transformed written texts into extensions of his own shadowy, imaginative being. Thus while children are possessed and haunted *by* the text, imaginative adults *possess* the text, which is now a token of their intellectual and imaginative powers. However, Coleridge's informal autobiography cannot define the relationship between mind and text without at the same time projecting an Other whose original, childishly narcissistic relation to the text remains unchanged. The somewhat comical Other of Coleridge's exemplary reader is an overly literal, narcissistic reader who is still troubled by ghosts, which are of course nothing but phantoms of his own invention. While "It is true," Coleridge writes, "that the mind *may* become credulous & prone to superstition" (*CL* 1:354), properly educated children outgrow their superstitious attachment to the text. Coleridge's narcissistic, literal reader is, in contrast, the structural equivalent of the linguistically disenfranchised popular culture that literary culture projects as its own primitive Other. Granted, there are differences between the erroneous reader Coleridge describes as "credulous & prone to superstition" and the popular laboring poor, if only because the latter is assumed to be devoid of any reading practices worthy of the name. But the equivalence between Coleridge's literal-minded reader and popular culture is finally more telling than any specific differences between the two. Since both are effects of the cultural logic governing literary culture, both are necessarily defined as childish, superstitious, and incapable of the kind of elevated self-possession Coleridge values.

Coleridge's superstitious fears are but moments in a cultural dialectic, according to which fearful and wonder-filled children undergo a seamless transformation into adults in full possession of their cultural heritage; in contrast, self-educated working-class autobiographers undergo a more

troubled transition from superstitious childhood to adult literacy. The working-class autobiographers writing in the first half of the nineteenth century therefore tell an entirely different story, one based upon discontinuity and *dis*identification. The discontinuity that informs these narratives arises from the fact that the working-class autobiographer criticizes or belittles popular superstitions and must therefore represent the adult, enlightened world of high literacy as one that stands in opposition to the popular world of local tales, gossip, penny books, and ghosts. To acquire adult literacy one must, at some deep level of one's identity, utterly break with the popular domain of superstition; there is no dialectical or transformative continuity linking the two domains of childhood fears and adult imagination. What saves these autobiographers from the complications Clare confronts is their overtly political motivation. They adopt an enlightenment critique of superstition, reworking it to serve an expressly political desire to rescue the still largely illiterate laboring classes from the confines of intellectual and cultural, as well as political, disenfranchisement.

Consider, for example, *The Life and Struggles of William Lovett in His Pursuit of Bread, Knowledge, and Freedom.* Lovett's, like many similar autobiographies, is not a narrative of the self, at least not in Romantic terms; rather, it is a narrative of *class* identity dedicated to the enlightenment of the laboring poor (Hackett).[7] Given that, it should be no surprise that Lovett promotes literacy practices and values that differ significantly from those promoted by Coleridge. Specifically, Lovett, like many working-class autobiographers of the early nineteenth century, shapes his narrative to fit the ego ideal of "useful knowledge," or the belief that the intellectual, moral, and social improvement of the laboring classes was a direct result of reading. This ideal was malleable and inclusive enough to be embraced by both Chartist autobiographers and conservative figures such as Charles Knight, founder of the *Penny Magazine.* Like them, Lovett could represent himself as a worthy subject of autobiographical narrative because he wrote with the conviction that he represented the aspirations of a newly literate audience of the laboring poor. At the same time, Lovett joins these writers in rejecting much of popular culture, including its linguistic forms and prevalent superstitions. Many of them went out of their way to lose their provincial accents. Many of them complain that their childhood and youth were cursed by the influence of popular superstitions. Lovett, for example, complains of "the numerous stories regarding those nocturnal visitants, told to me in infancy, reiterated in boyhood, and authenticated and confirmed by one neighbor after another, who had witnessed, they said, their existence in a variety of forms"; so compelling was this evidence, Lovett adds, that "it was many years after I came to London before I became

a sceptic in ghosts" (Lovett 11). He goes on to argue that the only cure for widespread superstitions would be a system of national education: "I mention these silly things," writes Lovett,

> to show that superstition of one kind or another was the curse of my boyhood. . . . And those rulers, who by a wise system of education can succeed in enlightening the rising generation, so that they may laugh down such absurdities, will render to society a benefit none can estimate so well as those who have been victims of such superstitious delusions; for, notwithstanding the progress of knowledge among our people, by means of the press, the school and the rail, the belief in ghosts is still widely entertained. (Lovett 13–14)

Lovett sincerely wishes to deliver the "people" from the "curse" of superstition, but his plea on the behalf of "a wise system of education" serves another purpose as well. In disavowing "superstitious delusions," he is able to securely position himself as the narrator of his own life, since, according to a logic typical of the working-class autobiography, popular superstitions, particularly the belief in ghosts, are signs of the original ignorance the autobiographer has escaped and now must condemn. To identify with the proper and culturally legitimated domain of literacy, then, it is first necessary to disidentify with another, delegitimated domain of illiteracy. Nor was Lovett alone in promoting this logic of cultural disidentification. Other men of humble origin, such as Thomas Holcraft, James Hogg, James Dawson Burn, James Lackington, and John Britton, wrote autobiographies that confirm the rational, metropolitan values of intellectual and literary culture by ridiculing the belief in ghosts.[8] But they did so at their own peril. As David Vincent argues, such routine condemnations of popular superstition isolated the working-class intellectual "from vital sources of belief, imagination and historical rights," while simultaneously creating "new lines of demarcation" between the literate and illiterate, the enlightened and the ignorant within the working classes themselves (Vincent, "Decline" 42).

Clare and Popular Superstition

Coleridge and Lovett illustrate two dominant tendencies of early-nineteenth-century autobiography: a dialectical narrative in which the ghost is transformed by children into a figure of their own consciousness, and a discontinuous narrative of disidentification that breaks with the illiterate and superstitious world of popular culture. These, then, are the paradigms of self-representation on which Clare is compelled to draw and with which he was clearly uncomfortable. The dilemma Clare faces is in the end an utterly devastating one. To begin with, since ghosts (or rather the belief in ghosts)

represent Clare's popular origins, they can only be potential sources of embarrassment. According to the logic of his own narrative, then, Clare must surmount the influence of rural superstitions if he is to be credibly regarded as a literate adult. Yet he does not want to relinquish these embarrassing superstitions because they remain crucial signifiers of a culture he does not wish to disown. Specifically, he cannot bring himself to condemn the very discursive forms and popular texts that foster the belief in ghosts.

To offer a telling example, in describing the "very haunted mind" of an old neighbor, John Billings, Clare reports that although he was "an inoffensive man" he had "scarce been out on a journey with the night without seeing a gost . . . or some such shadowy mystery & such reccolections of midnight wanderings furnished him with storys for a whole winters fireside." It is interesting to note that, just as old Billings was both a captivating storyteller and a gullible man, he was also a highly credulous reader:

> He believed everything that he saw in print as true & had a cupboard full of penny books *The King & the Cobbler The Seven Sleepers* accounts . . . of spirits warning men when they were to die he had never read Thomson or Cowper or Wordsworth or perhaps heard their names yet nature gives everyone a natural simplicity of heart to read her language. (*Prose* 39)

Billings represents the world Clare presumably ought to have surmounted—and, in part, wishes to surmount: a world of superstitious tales, penny books, credulous readers, and ghosts. And at least initially, it would appear that this halfhearted attempt to disavow the world of ghosts aligns him with Lovett and other nineteenth-century working-class autobiographers who portray themselves as enlightened autodidacts who have escaped the crippling effects of popular ignorance and illiteracy. Moreover, Clare, like Coleridge, devalues the credulous and superstitious reader while fully identifying with the more sophisticated reader who has been shaped by the linguistic and intellectual paradigms of official literary culture. In this sense, "Thomson or Cowper or Wordsworth" represent a world that is far removed from that of Clare's old neighbor. By naming these poets, ones Billings has never read and probably never heard of, Clare effectively opposes the old man's credulity and superstition to the world of the great Poets, as ignorance is opposed to knowledge.

The matter is nevertheless more complicated than these generalizations allow. Clare cannot entirely decide which forms of reading he should value. Thus in the passage above he balances a Romantic vision of literacy, one which positions him as an outsider capable of commenting on the world of poor readers, against a decidedly *un*-Romantic vision in which high literary culture does not constitute the only possible literacy practice.

Therefore it would not quite be accurate to say that Clare opposes the two different worlds of literacy; rather, he allows himself to explore both sides of a shifting and uncertain border between them. In fact, at one point Clare suggests that the two worlds are equivalent: in addition to the penny ghost stories Clare has already mentioned, Billings also owns "several rules & receipts for saving & cheap living a collection of proverbs & a long poem of forty or fifty verses . . . he felt as happy over these . . . as I did over Thomson Cowper & Walton which I often took in my pocket to read" (Clare 40). Billings is as happy—and, implicitly, as morally secure—with his religious tracts, proverbs, conduct books, and other pieces of popular reading as Clare is with his Thomson or Cowper. While his portrait of Billings as a self-improving reader potentially serves conservative interests, since it assures educated readers that popular literacy is anything but subversive, the point to emphasize here is that Clare does not *entirely* disavow popular reading habits even as he appears to do so. (At the very least, he does not reject them with the same vehemence with which he repudiates the culturally imposed role of the Peasant Poet.) Instead, his affection for Billings is emblematic of a lingering identification with (and therefore failed disavowal of) the very cultural forms and literacy practices that originally taught him to believe in ghosts.

Clare not only describes what the poor read but how they read: how they create opportunities to read, the ways in which they value reading, and other details of their reading practices.[9] Billings is one of the millions who collect penny books, texts that have the same status and value as his fireside "storys."[10] To offer another example, Clare writes that "one of my greatest amusements while in London was reading the booksellers windows—I was always fond of this from a boy" (*Prose* 86). Indeed, this particular habit was typical of the poor; booksellers' windows were considered a resource for exercising one's reading skills.[11] According to Brian Street, such fragmentary texts (window displays) and fragmentary reading practices (pausing before a shop window) point to a kind of discursive cohesion that "is not to be found at the overt level of the authored script but at deeper levels of culture and ideology, levels missed by those . . . who dwell on a particular, culture-specific form of literary writing" (Street, "Literacy Practices" 69). Understood in these terms, Clare remains a popular reader even in literary London, one who by habit continually seeks out even the most fragmentary texts, bits of reading, some of which are anonymous (penny books), and some of which have nothing whatsoever to do with the coherencies of the "authored script" (shop windows). As these and other examples attest, then, Clare does not assume that there is a distinctly oral popular culture existing in splendid isolation from the world of print, but instead insists that there are two culturally and ideologically

distinct styles and modes of acquiring, practicing, and valuing literacy—one identified with the world of penny books, shop windows (and so forth) and the other identified with the domain of official literary culture.[12]

As long as Clare examines popular superstitions in relation to popular reading habits, he is capable of valuing the latter in positive terms. Indeed, on the basis of such passages it can almost be said that Clare is a kind of ethnographer of cultural difference, or a kind of participant observer capable of remarking on both cultures and their reading practices. Yet, as we shall see, when he remarks on the ways in which superstitious beliefs still haunt his adult psyche, his ghosts begin to take on a more disruptive, disturbing character. They become psychological tropes capable of shattering the logic of symbolic identification and therefore of exposing the difficulties in his relationship to official culture.

The Romantic Author as Ghost

In one highly charged passage describing his residence in London, Clare places himself in the role of literary culture's superstitious, haunted Other. In London, Clare confesses, he found he could not surmount his childhood fear of ghosts—even in that great city he was afraid to walk out at night "for fear of meeting with supernatural [agents] even in the busy paths of London." "Though I was a stubborn disbeliever of such things in the day-time," he adds, "at night their terrors came upon me tenfold" (*Prose* 94). Ghosts may belong to the rural regions of Clare's youth, but they somehow manage to return in the London night, at a time when he ought to know better. I suppose that some readers may find an element of ideological protest in Clare's confession, one capable of endorsing the eruptive effects of the imaginary against the oppressive givens of the dominant symbolic order. Yet as a form of protest it is, I submit, entirely self-disabling, since it ultimately reinforces the dominant culture's tendency to associate the rustic with the imaginary, the regressive, the childish, and the linguistically deficient. It may be more accurate to see these night terrors as manifesting Clare's divided cultural identity. From this perspective, the uncanny return of popular beliefs that the dominant literary culture had taught him to surmount constitutes a failure to assume, in Coleridgean terms, the prescribed ego ideal of Romantic autobiography. In other words, Clare fails to identify with "the very place *from where* [he is] being observed" (Žižek 105), the eyes of dominant culture. According to the logic of this identification with the dominant, Clare's persistent belief in ghosts represents a failure to mature and, by extension, constitutes a failure to take on the mandate of self-authorized and so empowered subjectivity.

Having said that, I also want to suggest that Clare's London ghosts have

another source. Authorship—not simply the material practice of writing, publishing, and so forth, but the sense of high literary authorship as cultural ideal—held a tremendous fascination for Clare. In his imagination, Wordsworth, Byron, Lamb, and Hazlitt, among others, personified this authorial ego ideal; they were for Clare, in the words of Michel Foucault, embodiments of "conscience, consciousness, and eloquence" (Foucault 207). Yet his attitude toward these authors is anything but that of simple admiration. At times he explicitly rejects many of them, together with the ideals they embody: "I had a romantic sort of notion about authors," Clare writes, "& had an anxious desire to see them fancying they were beings different from other men but the spell was soon broken" (*Prose* 81). Just as the *Autobiography* sullenly refuses to accept the prescribed role of the Peasant Poet, then, it also tells the story of a man who wishes to break the spell that had transformed these "authors" into objects of intense identification. Despite what he says, however, Clare's initial identification with these "beings different from other men" does not decrease but instead takes the form of a failed *dis*identification that is, finally, as binding as any positive identification could be.

In this regard, it is interesting that the *Autobiography* shows as much interest in authors as it does in texts—authors who, I am arguing, represent another source of Clare's haunting. In a passage discussed earlier, Clare compares the *texts* Billings reads—penny books, *The King & the Cobbler, The Seven Sleepers*—to the authorial *names* Clare knows ("he had never read *Thomson* or *Cowper* or *Wordsworth* or perhaps heard their *names*"—italics mine). It is striking how these proper names resonate with what Foucault calls "the paradoxical singularity of the name of an author" (122)—striking, but not surprising, since Foucault immediately adds that the author's name "points to the existence of certain groups of discourse and refers to the status of this discourse within a society and culture" (123). Here the discourse in question is literary discourse, whose values are, in Clare's eyes, absolute. Even his alienation from individual authors in that culture cannot tarnish the value Clare discovers in authorship and the authorial name. Billings may suffer from a "very haunted mind," but unlike Billings, Clare is capable of being haunted by literary *names*, by the Poet as cultural ideal. That is why his challenge to the ideological dominance of official literary culture has a more profound effect on his attempts to produce a self-consistent autobiographical ego ideal than does his effort to value the literacy practices he inherited from popular culture. Let us see how this dilemma plays itself out.

If, as I stated earlier, Clare's discussion of popular superstitions reveals that there are two distinct social economies of literacy, two sets of educational practices, two distinct marketplaces of print, and two distinct

discourses of literacy, it therefore challenges the embedded idea that "con-science, consciousness, and eloquence" belong only to those educated in the official literary ideolect. Yet insofar as Clare recognizes that popular and official culture represent competing literacies, he demystifies his most significant form of self-definition by challenging the most profound ideological justification for literary culture—namely, that literacy is co-extensive with language and literacy culture *as such* and is not simply one linguistic and cultural ideolect among others. I use the word "demystify" advisedly because, as Clare's fascination with the "names" of literary culture indicate, he can no more forgo his profound fascination with the Romantic ego ideal than he can overcome his fear of ghosts.

Clare's shadowy struggle with his own ideals becomes more disabling as the *Autobiography* progresses. As he enters the social life of London literati and encounters his idealized authors face to face, it becomes increasingly apparent that, despite his suspicion of a monolithic literacy, these idealized authors are capable of becoming near-ghostly figures that haunt his imagination. In the following passage, for example, Clare begins to describe Charles Lamb's rambling but effortless conversational style with obvious admiration, but then abruptly closes the description by mildly satirizing his own fascination with the man:

> [H]is talk now doubles & trebles into a combination a repetition urging the same thing over & over again till at last he leaves off with scarsely a 'goodnight' in his mouth & disappears leaving his memory like a pleasant ghost hanging about his chair. (*Prose* 89)

The memory of Lamb, "like a pleasant ghost," enters the text as an affectionate and only moderately ambivalent metaphor of the beloved dead. Although this is gentle satire aimed both at Lamb and at Clare himself, the light touch of irony does not allow Clare to fully disidentify with Lamb and what he represents. He may have been disappointed by the great authors of London society, but the idealized author of his putative ego ideal survives this disappointment by transforming into a ghost. It is true that this ghost is a figurative one, but the fact remains that another ghost has appeared in Clare's text, only this time it takes the preeminently Romantic form of a haunting memory. Lamb as ghost is the effect of a vacillating identification, an idealized object that, in becoming approachable and near, seems to disintegrate, only to immediately assume the phantasmic form of a lost love object, a specter lingering as an elusive presence in Clare's haunted mind.[13]

As if to multiply the effect of ghostliness, the paragraph preceding Clare's sketch of Lamb offers a similar, if somewhat inverted, version of the same figure. Here he describes Hazlitt in terms that further complicate his figuration of the ghost:

> [H]e seems full of the Author & I verily believe that his pockets are crammed with it he seems to look upon Mr. This & Mr. T'other names that are only living on cards of morning Calls & Dinner invitations as upon empty chairs as the guests in 'MacBeth' did on the vacancy where Banquo's ghost presided. (*Prose* 89)

This sketch of Hazlitt clearly conveys Clare's contempt for the fashionable London literati, most of whom, in his opinion, are pretenders, empty objects of a true author's weary and superior gaze. Hazlitt is so much the "Author"—and therefore, in Clare's view, so sure of his distance above "Mr. This & Mr. T'other"—that he can only show astonishment when anyone of a lesser sphere presumes to interrupt his high communion with his own soul. Of course, Hazlitt, in his comical superiority, is in no danger of actually seeing any apparitions. Hazlitt sees only empty chairs. The actual Macbeth figure in this sketch is Clare himself, since he sees what Hazlitt cannot: Banquo's ghost, and not the mere vacancy where a ghost presides. "When all is done," Lady Macbeth tells Macbeth as he stares in horror at Banquo's ghost, "you look but on a stool"; yet Clare looks not upon empty chairs at all but a room full of Banquos. Since "Mr. This & Mr. T'other" are "empty chairs" to Hazlitt and Banquos to Clare, the logic of the passage dictates that these ghosts are displaced representatives of Hazlitt himself. Hazlitt produces ghosts, fantastic traces of himself, before Clare's fascinated gaze. Of special interest is the way this allusion to *Macbeth* anticipates and colors the description of Lamb that quickly follows: there, too, Clare but looks upon an empty chair, one filled, in that case, with the "pleasant ghost" of the enchanting Charles.

Clare's response to official literary culture, then, like his relationship to popular culture, is characterized by a pattern of partial disavowals and ambivalent identifications. Accordingly, his struggle to fashion an ego ideal becomes a kind of crippling self-debate, one symptomatic of his cultural dislocation. More precisely, the *Autobiography* represents Clare as simultaneously aspiring to be included in the literary community of English *as such* and resisting both that aspiration and the sense of abjection it promotes. Because he lacked the kind of institutionally supported readership Lovett could take for granted—because, in fact, unlike Lovett, he does not even remotely entertain the possibility that his provincial world of tales, superstitions, and ghosts should be eradicated in favor of "useful Knowledge" and a system of national education—Clare is left struggling to understand his identification with the cosmopolitan world of fashionable and enlightened authors, as he struggles to understand his identification with Lamb. And as I have suggested, his sense of self-division becomes the most pronounced when he struggles to clarify his relationship to

both unofficial and official literacies. Ghosts are troubling symptoms of this struggle, and therefore signs of the predicament that threaten Clare's ability to fashion a coherent narrative of his own life.

Nor, finally, are Lamb and Banquo the only ghosts of literary identification in the *Autobiography*. On a more sublime note, Clare's description of Byron's funeral ardently displays the very dynamics of identification the *Autobiography* elsewhere attempts, in increasingly ambivalent ways, to challenge:

> [T]he train of a funeral suddenly appeared on which a young girl gave a deep sigh & uttered 'Poor Lord Byron' I looked up at the young girl's face it was dark & beautiful & I could almost feel in love with her for the sigh she had uttered for the poet it was worth all the newspaper puffs & magazine mournings that ever were paraded after the death of a poet The common people felt his merits & his power & the common people of a country are the best feelings of a prophecy of futurity they are the veins and arteries that feed & quicken the heart of living fame. (*Prose* 99–100)

Clare proposes that "fame" belongs to "the common people," whose admiration of Byron is the only valid testimony to that poet's greatness. Yet even as he pays homage to the common reader, however, Clare projects his own intense identification with the idealized author onto them. Because the energies of idealization are so palpably present here, once again, a Romantic author assumes the enchanting form of ghostliness. Byron is not a literal ghost, of course, nor is he a source of terror, as Clare's literal ghosts of rural popular culture and dark London streets surely are. But he is dead, and in death he lingers in "the heart of living fame" as an object of identification so vivid that it is mirrored by this "dark & beautiful face" that sighs for the poet's memory in what, for Clare, is a moment of displaced homoerotic passion. It is worth recalling that at one point during his long hospitalization for nervous exhaustion, Clare believed he *was* Byron. That, I suppose, was the epitome of his self-haunting.

Notes

Thanks to Lucinda Cole for her helpful comments on this essay.

1 Recent analyses of the contradictory forces at work in Clare's career and poetry include those by Johanne Clare; Helsinger; Lucas; and Haughton and Phillips.

2 Recent theorists and historians of literacy have severely questioned several dominant literacy myths, including the traditional distinction between orality and literacy. For useful bibliographies on this work, see Cook-Gumperz; Street, "Literacy Practices" and "Introduction"; Street and Street; Vincent, *Literacy*; and Mitch. See also Cole and Swartz. The term "literacy myth," prominent in Brian Street's work, derives from Graff.

3 Writing in 1769, Thomas Leland (70) acknowledges the existence of plural literacies: "Different degrees of understanding and judgement, different passions, habits, tempers, and occupations, must of necessity prevail among men, and must produce different forms and manners of elocution."

4 See also Bourdieu; Smith; and Guillory 56–71. On elocution treatises, see Shortland.

5 Clare obviously read and was influenced by his sister's copy of Enfield (Crossan).

6 For scholarship on the Uneducated or Peasant Poet, particularly Yearsley, see the bibliography provided in Cole and Swartz.

7 In describing autobiographies by Lovett and others as *working-class autobiographies*, I follow scholarly convention. Otherwise, wherever possible, I use the more inclusive and less anachronistic terms *the laboring classes* or *the laboring poor*.

8 See Bamford 1:140–47; see also Holcraft 57, 61–62; Hogg 14; Burn 66–68; Lackington 34–43; and Britton 36–37, 57–59. See also Somerville, who discusses his childhood belief in fairies and fortune-telling (10–11). For additional examples, see Vincent, Introduction 8 and "Decline".

9 In this and similar passages, the *Autobiography* acknowledges that popular literacies were sustained by popular forms of educational provision that functioned independently of upper-class patronage or control. Despite that, Clare, like Lovett and other working-class autobiographers, frequently represents himself as a solitary learner— even as he provides evidence that indigenous literacies were sustained by "complex, community-based, and structured learning patterns" (Howard). Similar contradictions abound in the lives of many "Uneducated Poets," including Yearsley (Cole and Swartz 148–49).

10 The Diceys, great entrepreneurs of the broadside and chapbook trades, claimed their texts encouraged their consumers to read "other like Stories, till they have improv'd themselves more in a short time than perhaps they would have done in some years at School" (qtd. in Deacon 33). It is interesting that although at least one of Clare's songs circulated in penny form, he insisted that he did not desire "that kind of fame" (Clare 58).

11 Yearsley has a similar anecdote (Cole and Swartz 149). On booksellers' windows as popular reading sites, see Webb 24.

12 On interpenetration of print and oral culture, see Deacon and Vincent, *Literacy* 196–227.

13 Psychoanalysis figures identification as a kind of haunting. On eighteenth- and nineteenth-century discourse on ghosts and its influence on Freud's figuration of consciousness as ghostly, see Castle 120–89; on identification as "phantasmatic staging," see Butler 93–119.

Works Cited

Bamford, Samuel. *Passages in the Life of a Radical and Early Days*. 2 Vols. London: Unwin, 1905.

Barrell, John. *English Literature in History 1730–80: An Equal, Wide Survey*. New York: St. Martin's, 1983.

Bourdieu, Pierre. "The Production and Reproduction of Legitimate Language." *Language and Symbolic Power*. Ed. John B. Thompson. Trans. Gino Raymond and Matthew Adamson. Cambridge: Harvard UP, 1991. 43–65.

Britton, John. *The Auto-Biography of John Britton.* London, 1850.

Burn, James Dawson. *The Autobiography of a Beggar Boy.* 1859. Ed., introd. David Vincent. London: Europa, 1978.

Butler, Judith. *Bodies That Matter: On the Discursive Limits of "Sex."* New York: Routledge, 1993.

Castle, Terry. *The Female Thermometer: Eighteenth-Century Culture and the Invention of the Uncanny.* New York: Oxford UP, 1995.

Clare, Johanne. *John Clare and the Bounds of Circumstance.* Kingston, ON: McGill-Queen's UP, 1987.

Clare, John. *The Prose of John Clare.* Ed. John William Tibble and Anne Tibble. New York: Barnes and Noble, 1970.

Cole, Lucinda, and Richard Swartz. "'Why Should I Wish for Words?': Literacy, Articulation, and the Borders of Literary Culture." *The Limits of Romanticism: Essays in Cultural, Feminist, and Materialist Criticism.* Ed. Mary Favret and Nicola Watson. Bloomington: Indiana UP, 1993. 143–69.

Coleridge, Samuel Taylor. *Collected Letters of Samuel Taylor Coleridge.* Ed. Earl Leslie Griggs. 6 Vols. Oxford: Clarendon, 1956–71.

Cook-Gumperz, Jenny. "Literacy and Schooling: An Unchanging Equation?" *The Social Construction of Literacy.* Ed. Cook-Gumperz. New York: Cambridge UP, 1986. 16–44.

Crossan, Greg. "Clare and Enfield's *Speaker.*" *Notes and Queries* 34 (1987): 27–28.

Deacon, John. *John Clare and the Folk Tradition.* London: Sinclair Brown, 1983.

Enfield, William. *The Speaker: or, Miscellaneous Pieces, Selected from the Best English Writers.* London, 1774.

———. *Essay on the Cultivation of Taste.* Newcastle, 1818.

Foucault, Michel. *Language, Counter-Memory, Practice: Selected Essays and Interviews.* Ed., introd. Donald F. Bouchard. Trans. Donald F. Bouchard and Sherry Simon. Ithaca: Cornell UP, 1977.

Gagnier, Regina. *Subjectivities: A History of Self-Representation in Britain, 1832–1920.* New York: Oxford UP, 1991.

Graff, Harvey J. *The Literacy Myth: Literacy and Social Structure in the Nineteenth-Century City.* New York: Academic P, 1979.

Guillory, John. *Cultural Capital: The Problem of Literary Canon Formation.* Chicago: U of Chicago P, 1993.

Hackett, Nan. "A Different Form of 'Self': Narrative Style in British Nineteenth-Century Working-Class Autobiography." *Biography* 12 (1989): 208–26.

Haughton, Hugh, and Adam Phillips. "Introduction: Relocating John Clare." *John Clare in Context.* Ed. Geoffrey Summerfield, Hugh Haughton, and Adam Phillips. New York: Cambridge UP, 1994. 1–27.

Helsinger, Elizabeth. "Clare and the Place of the Peasant Poet." *Critical Inquiry* 13 (1987): 509–31.

Hogg, James. *Memoir of the Author's Life and Familiar Anecdotes of Sir Walter Scott.* Ed. Douglas S. Mack. Edinburgh: Scottish Academic P, 1972.

Holcraft, Thomas. *Memoirs.* Cont. by William Hazlitt. London, 1816.

Howard, Ursula. "Self, Education, and Writing in Nineteenth-Century English Communities." *Writing in the Community.* Ed. David Barton and Roz Ivanič. London: Sage, 1991. 78–108.

Lackington, James. *Memoirs of the Forty-Five First Years of Life of James Lackington.* 13th ed. London, 1791.

Leland, Thomas. *A Dissertation on the Principles of Human Eloquence*. London, 1769.

Lovett, William. *The Life and Struggles of William Lovett in His Pursuit of Bread, Knowledge, and Freedom*. London, 1876.

Lucas, John. "Revising Clare." *Romantic Revisions*. Ed. Robert Brinkley and Keith Hanley. New York: Cambridge UP, 1992. 339–53.

Mitch, David F. *The Rise of Popular Literacy in Victorian England: The Influence of Private Choice and Public Policy*. Philadelphia: U of Pennsylvania P, 1992.

Richardson, Alan. *Literature, Education, and Romanticism: Reading as Social Practice, 1780–1832*. New York: Cambridge UP, 1994.

Shortland, Michael. "Moving Speeches: Language and Elocution in Eighteenth-Century Britain." *History of European Ideas* 8 (1987): 639–53.

Smith, Olivia. *The Politics of Language 1791–1819*. Oxford: Clarendon, 1984.

Somerville, Alexander. *The Autobiography of a Working Man*. Ed. John Carswell. London: Turnstile, 1951.

Street, Brian. "Literacy Practices and Literacy Myths." *The Written Word: Studies in Literate Thought and Action*. Ed. Roger Säljö. New York: Springer-Verlag, 1988. 59–72.

———. "Introduction: The New Literacy Studies." *Cross-Cultural Approaches to Literacy*. Ed. Brian Street. New York: Cambridge UP, 1993. 1–21.

Street, Joanna, and Brian Street. "The Schooling of Literacy." *Writing in the Community*. Ed. David Barton and Roz Ivanič. London: Sage, 1991. 143–66.

Vincent, David. Introduction. *The Autobiography of a Beggar Boy*. James Dawson Burn. 1859. London: Europa, 1978. 1–33.

———. "The Decline of the Oral Tradition in Popular Culture." *Popular Culture and Custom in Nineteenth-Century England*. Ed. Robert D. Storch. New York: St. Martin's, 1982. 20–47.

———. *Literacy and Popular Culture: England 1750–1914*. New York: Cambridge, 1989.

Webb, Robert K. *The British Working Class Reader*. London: Unwin & Allen, 1955.

Wordsworth, William. *The Prelude 1799, 1805, 1850*. Ed. Jonathan Wordsworth, M. H. Abrams, and Stephen Gill. New York: Norton, 1979.

Žižek, Slavoj. *The Sublime Object of Ideology*. New York: Verso, 1989.

✤ GENDER, SEXUALITY, AND
THE (UN)ROMANTIC CANON

A Lesson in Romanticism:

Gendering the Soul

SUSAN J. WOLFSON

I do not mean it an injury to women, when I say there is a sort of Sex in Souls. . . . the Soul of a man, and that of a Woman, are made very unlike. . . . The virtues have respectively a masculine and a feminine cast. — *The Tatler*

Souls are of no sex, any more than wit, genius, or any other of the intellectual faculties. . . . the soul may have as fair and ample a chamber in the brain of a woman as of a man. — *Biographium Fœmineum*

I have been led to imagine that the few extraordinary women who have rushed in eccentrical directions out of the orbit prescribed to their sex, were male spirits, confined by mistake in female frames. But [is it] philosophical to think of sex when the soul is mentioned [?] . . . the love of pleasure may be said to govern [the lives of most women]; does this prove that there is a sex in souls? — Wollstonecraft, *A Vindication of the Rights of Woman*

Is it true what is so constantly affirmed, that there is no Sex in Souls? — I doubt it — I doubt it exceedingly. — Coleridge, *Notebooks*

There is a sex in our SOULS as well as in their perishable garments. — Coleridge, *The Friend*

*Q*uaint as talk of the soul may seem today, it saturated the culture of the Romantic age. When writers spoke of education — political, aesthetic, moral, or more generally philosophical — sooner or later they talked about the soul. Wordsworth redeemed the deadening lesson of earthly life, on which the first four stanzas of his "Immortality" Ode foundered, by theorizing that "The Soul that rises with us, our life's Star, / Hath had elsewhere its setting" (59–60), and that too soon this "Soul shall have her earthly freight" (126). Contesting this Platonism, Keats advocated an existential "system of Spirit-creation" (*LJK* 2: 102–3) — how the heart's experiences in the medium of the world form a "*Soul* or *Intelligence destined to possess the sense of Identity.*" The gendering in both schemes matters in no small part because it seems so assumed, so

unargued. Wordsworth's Ode is a story of "the growing Boy" (68) whose soul's true home is with a masculine God rather than female Earth, and which acquires a feminine possessive ("her earthly freight" [126]) only in this female prison house. Keats's revisionary scheme may seem to revise gender as well: the soul-nurturing heart is "the teat from which the Mind or intelligence sucks its identity—As various as the Lives of Men are—so various become their souls, and thus does God make individual beings, Souls, Identical Souls of the sparks of his own essence." Yet even as Keats says, in effect, by the teat one knows the man, like Wordsworth's story, his is fundamentally patrilinear: the sparks of God's essence are the identical basis of the various lives of "Men." The feminine is at best a servant and at worst a prison matron to male spiritual development.

When a distinctly female soul is described by Wordsworth, Keats, and others, it is typically cast into a poetics of inspiration for which the master trope is male creation with a female muse, and it is implicitly allied to a "masculinist" ideological heritage of appropriating and subordinating the feminine.[1] For all its transcendental resonance, soul-talk thus has substantial sociohistorical import, especially (as my epigraphs show) within the emerging debates about essentialism, gender, and social existence. Some adherents of the sex of souls proposed a complementarity that, as *The Tatler* put it, was no "injury to women"; but the injury of an always attendant gendered hierarchy was sufficiently visible to provoke women such as Wollstonecraft, whose argument for a social revolution in *A Vindication of the Rights of Woman* more than once involves her insistence on the equality of souls.[2] The radicalness of this insistence ruffles the reaction of Benjamin Silliman, scientist and Yale professor, whose best resource is to hystericize Wollstonecraft's rhetoric in the second of his "Letters of Shahcoolen" (c. 1801): "This female philosopher indignantly rejects the idea of a sex in the soul, pronouncing the sensibility, timidity and tenderness of women, to be merely artificial refinements of character, introduced and fostered by men" (238). Wollstonecraft's boldest move, it is clear, was to suggest the artifice of attributing sexual identity to the soul, defined by "the orbit prescribed to [one's] sex" (35).

When Wollstonecraft indulges an "ingenious conjecture" that "the few extraordinary women who have rushed in eccentrical directions" out of this orbit "were *male* spirits, confined by mistake in female frames" (35), the phrase "confined by mistake" does not point to a monstrous accident of creation but to the monstrous constraint of cultural prescription. Stressing the linguistic orbits of this prescription, her italicized *male* presses a critical question: Is the soul of an intellectually vigorous woman an essentially "male" element trapped in a female body, or is this denomination of gender part of the trap? Another Romantic theorist, Coleridge proposed a

liberal androgyny, speculating that "a great mind must be androgynous" (*TT* 2: 190–91)—a remark that, beginning with Woolf, is cited frequently in modern feminist criticism. Yet if there seems to be a broad, smooth, and easy passage from Wollstonecraft's rationalist brief for the moral equality of men and women's souls, to the Coleridgean liberalism of androgynous genius, to a denatured Woolfian idealism of genius, the infernal course, especially for women, is fast and durable. The part of Coleridge's text that does not get quoted (or only rarely) shows that he (as Woolf) was thinking only of "feminine" qualities in male minds; elsewhere, he is far less liberal about the invasion of male political and aesthetic territory by actual women.[3]

This elision alerts us to an important contradiction in the spiritual economy of sex in souls—one reflected elsewhere in Romantic-era writing not only in men's texts but also in the (not always coherent) critiques of women's texts. Coleridge's conviction is animated by his general theory about what drives creative desire. It is the physical body's "yearning to compleat itself by Union" that impels him to ask, "Is there not a Sex in Souls?" and to explain: "Were there not an Identity in the Substance, man & woman might *join*, but they could never *unify*—were there not throughout, in body & in soul, a corresponding and adapted Difference, there might be addition, but there could be no combination" (12 Mar. 1811; *CLC* 3: 305). Union of difference is a Coleridgean principle, famously elaborated in the description of "poetic Imagination" in chapter 14 of *Biographia* as a "power" that "brings the whole soul of man into [the] activity" of balancing or reconciling "opposite or discordant qualities" (2: 15–16). But if this generative interaction of opposites would seem to find its natural ground in the creative union of sexual difference, something other than sexual complementarity is at work in the text Coleridge summons to gloss this process:

> "Doubtless," as Sir John Davies observes of the soul (and his words may . . . be applied . . . to the poetic IMAGINATION.)
>
> > Doubtless this could not be, but that she turns
> > Bodies to spirit by sublimation strange,
> > As fire converts to fire the things it burns,
> > As we our food into our nature change.
>
> > From their gross matter she abstracts their forms,
> > And draws a kind of quintessence from things;
> > Which to her proper nature she transforms
> > To bear them light, on her celestial wings.[4]

Measured by the analogy of Imagination, this is a she-soul with a difference. It is not an equal opposite but a subordinate and secondary agent

of a general metaphysics that, following Davies' subtitle, creates *the Soule of Man.*

Endorsed by classical paradigms and the feminine anima of Latin, this gendering is a familiar pattern, both psychologically and as cultural logic, in male-authored tales of masculine desire. Yet the enactments are compelling less for any confident tracing of this pattern than for perplexities and instabilities, qualities that call for more attention than some recent, and quite influential, arguments about Romanticism and gender have given.[5] Male Romantic writers may contend with uneasy sensations of their souls being or becoming feminine, the gender difference often naming a decentered power of creation, and so courting important questions about male poetic authority. And contemporary female writers, as eager as Wollstonecraft to claim an intellectual dignity for women's souls that the main lines of literary and cultural tradition have reserved for men, do not find easy ways to resist this tradition or to imagine enabling alternatives. Must women who refuse the socially prescribed orbit be called "*male* spirits, confined by mistake in female frames," and so assent to this self-alienation? Or is the cultural alienation of the extraordinary woman— the *un*prescribed orbit—a potential position from which to challenge the idea of a sexual essence in the soul? This essay tracks the reverberation of these questions and the instabilities of understanding from which they emerge as one of the most important "lessons of Romanticism." The syllabus requires a review of some (perhaps familiar) soul-stories in texts by men—Coleridge, Wordsworth, Shelley, and Keats—before we can set these stories against the poetics of gender that shape some (perhaps unfamiliar) soul-stories by two women, Jewsbury and Hemans.

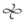

Wordsworth may propose a modern poetics in the Prospectus to *The Excursion,* but he proves classical when he casts "the Soul" as female, "an impulse to herself" (12) to be courted for "spousal verse" (57). Keats tests a similar arrangement when he stages a courtship between Cupid and his Psyche true. Yet for a male poet to describe his soul as feminine or to imagine it in a female body, especially at moments of creative crisis, may be to expose his apprehension of the fundamental alienation and otherness of his poetic power. In the struggle for inspiration in Book 1 of *The Prelude,* for example, it is an image of an unmanageable feminine soul that bears Wordsworth's frustration. Unable to perform the honorable toil of a major poetic project, and thus risking default in his claim to "manhood now mature" (1.653), the poet casts his impotence as an impotent feminine soul—the difference of gender configuring the crisis:

<center>my soul</center>

Did once again make trial of her strength
Restored to her afresh; nor did she want
Eolian visitations; but the harp
Was soon defrauded, and the banded host
Of harmony dispers'd in straggling sounds
And, lastly, utter silence
(Thirteen-Book "Prelude" 1.102–8)

The thwarting of heroic trial has a gender-specific staging: a would-be he-poet caught in toils so inimical to his sense of promise ("utter silence") as to compel an alien, feminine gendering.

Wordsworth will eventually claim a male "Poetic" soul and purge the feminine soul from the epic imperative by pastoralizing and maternalizing it. It is not to the love imaged by "the Lamb / And the Lamb's Mother" (this is "human merely") but to a "higher" or "divine" love that he weds his "brooding Soul" (13.154–65). "This love more intellectual" ("spiritual" by the D text [188]), he explains, needs a "moving soul" of "Imagination," the synonym for "absolute strength / And clearest insight, amplitude of mind, / And reason in her most exalted mood" (166–70). This hierarchy redeems the perplexities of Book 1, especially in its image of a rational feminine. The groundwork was laid after the famously desperate interruption of Book 1—"Was it for this . . . ?" (272)—a crisis that pivots the verse into retrospective history of the alliance of the boy's soul with transcendental, supernatural powers. In the narrative that begins, "Fair seed-time had my soul" (306 ff.), the feminine is gradually effaced from the soul and assigned to a lower place and a role of service (albeit at times severe) to the "mind of man" (352): the story is of "Nature . . . when she would frame / A favor'd Being" (364–65).

This is not to say that the frame is always secure; it is only, and critically, to note how Wordsworth's narrative finds direction with this new mapping of gender. Defeminized, and thus shorn of association with incapacity, the soul returns to the verse supercharged and boosted by a self-constituting rhetoric of apostrophe, Wordsworth's most confident language of the soul throughout the poem: "Thou Soul that art the Eternity of Thought!" (1.430).[6] Wordsworth amplifies this confidence in Book 2 with a restored language of gender and the soul. He subordinates the feminine, telling us that he received much "from Nature and her overflowing soul" (2.416)— so much that a revision records this debt as due to "Nature overflowing in my soul" (D: 397). And this egocentricity stakes out a nascent masculine independence: "by the regular action of the world / My soul was unsubdu'd" (2.380–81).

Yet notwithstanding this claim, the overflow of the feminine thus conceded and seemingly mastered traces another course in Book 2, and this is one not secondary but foundational to Wordsworth's psychobiography: the dyad of the infant and the maternal soul. One of the "best conjectures" with which the poet can "trace / The progress of our being" is that of the "Bless'd . . . infant Babe" whose "soul / Claims manifest kindred with an earthly soul" in the passion of "his Mother's eye" (237–43). If this kindred bond is the cherished point of origin in the poet's history, it also predicts the vexations of the poem's compositional present. The next time "soul" appears in Book 2, after the poet's cryptic reference to the death of his mother, this manifest kindred has become a possession by haunting:

> the soul,
> Remembering how she felt, but what she felt
> Remembering not, retains an obscure sense
> Of possible sublimity, to which,
> With growing faculties she doth aspire,
> With faculties still growing, feeling still
> That, whatsoever point they gain, they still
> Have something to pursue.
> (2.334–41)

In this pursuit, the masculine soul becomes feminine, a regendering that shadows kindred sensations of a self decentered, "strengthen'd with a superadded soul, / A virtue not its own" (347–48).

In a radical effort to stabilize this psychic decentering, Shelley has the Poet-hero of *Alastor* spurn the natural (always feminine-inscribed) world, rejecting its macro-domestic sphere to pursue a seemingly antithetical, epipsychic visionary feminine. Yet the larger plot is to contemn all these versions of the feminine, using the gender to sum the site of every frustrated desire and every false hope. The first signal is the narrating poet's impassioned invocation of a masculine audience—"Earth, ocean, air, beloved brotherhood!" (1)—which abides as his cherished fidelity. When he goes on to assert the bonding of his "soul" to these "beloved brethren" (16) by "our great Mother," the genders pose the critical question: Is the feminine a secondary agent of brotherly bonds, or does it name a primary dependency?[7] The question stirs in the fuller syntax of the exhortation:

> If our great Mother has imbued my soul
> With aught of natural piety to feel
> Your love, and recompense the boon with mine . . .
> (2–4)

It matters that Shelley's phrases allude to similarly tentative syntax in the epigraph Wordsworth recently affixed to the most famous male-centered soul-story of the age, the "Intimations" Ode: "And I could wish my days to be / Bound each to each by natural piety." Implied in Shelley's allusion is the Ode's soul-history (stanzas 5–6), wherein nature, acting "with something of a Mother's mind," weakens the bond of the growing Boy to the true "imperial" origin of his "Soul."[8] Shelley's *If* and the informing Wordsworthian tensions bear into *Alastor* a trouble about what, exactly, gender does signify in the story of the masculine soul.

The pressure of this question in *Alastor* soon displaces the feminine into a figure of inaccessible mystery, a nature that is the enemy of transcendence and poetic power alike:

> Mother of this unfathomable world!
> Favour my solemn song, for I have loved
> Thee ever, and thee only; I have watched
> Thy shadow, and the darkness of thy steps,
> And my heart ever gazes on the depth
> Of thy deep mysteries.
> (18–23)

The previously tendered "natural piety" with which a maternal feminine "imbue[s]" the soul of a brotherhood now mirrors a knowledge withheld. A shadowy mother, associated with "black death" (24), at once possesses and refuses to "render up the tale / Of what we are" (28–29). By gendering this secret as feminine, Shelley signifies both its otherness to masculine consciousness and, by force of its maternal site, its vital necessity. The poem's language of gender is entailed in this initial perplexity. First projecting the feminine as the answerer to masculine soul, the poet avenges frustration by emptying the feminine of value.

These motions are not so much sequential as mutually implicated, an involution apparent in the pivotal dream of a veiled maid (149 ff.). She appears to the Poet as his supernatural epipsyche: "Her voice was like the voice of his own soul" (153), she speaks "Thoughts the most dear to" him, and is "Herself a poet" (160–61). As in Coleridge, the sexing of souls in this romance is a critical, saving grace: a dyad of male and female is needed to argue a potential self-reflection into a trope of procreative desire. Yet the argument is tenuous, and we have only to read Shelley's fragment "On Love" to see why. In its argument that love offers "the ideal prototype of every thing excellent or lovely that we are capable of conceiving as belonging to the nature of man" (*SPP* 473–74), the conceiving is not sexual but self-reproductive. The attendant politics of gender (serving a

quasi-exclusive "nature of man") is not of equals uniting but of masculine desire saving itself from narcissism with an idealizing feminine reflector, "a mirror whose surface reflects only the forms of purity and brightness: a soul within our soul" (ibid.). In *Prince Athanase* (a spiritual poetics akin to that in *Alastor*), Shelley willingly concedes that the visionary's inner vacancy renders him one who, with no other "near to love, / Loves then the shade of his own soul, half seen / In any mirror" (275–91).[9] In view of such shady mirroring, his value of a differentiated "sex in souls" is apparent, for without this difference, as Coleridge puts it, "there might be addition, but there could be no combination." In the visionary scheme of *Epipsychidion*, Shelley underscores the trope of self and other both with this portentous title and its prepositional gloss: desire is for a "soul *out of* my soul" (238; italics mine).[10] But the question of whether this is other, creative difference or sterile narcissism is the perpetual ambivalence of Shelley's psycho-metaphysics. The ideal of exogamous spiritual union implied by the poem's title competes with the intensified sameness in the poet's designation of soul mate as soul-sister. "Spouse! Sister!" the poet invokes his desire (130), and imagines the center of their paradise in a similar conflation: a "Soul . . . / Burns at the heart of this delicious isle" (477–78), whose "chief marvel" is a pleasure-house reared by "some wise and tender Ocean-King" and "Made sacred to his sister and his spouse" (488–92).

The shading of other into self is but one sign of Shelley's uncertainty about the value of gender in securing a productive tale of visionary desire; another is the repeated betrayal of union to vacancy. In *Epipsychidion*, the key phrase, "this soul out of my soul," names no possession but a complaint of absence: "Whither 'twas fled, this soul out of my soul" (238). In *Alastor*, the Poet's path is always one of "following his eager soul" (311), as if this were irrevocably out of and decentered from the self—a chimera beyond possession. The syntax of "Obedient to the light / That shone within his soul, he went, pursuing" (492–93) spells the ambiguous metaphysics of psyche and epipsyche: is this a call from without or a compulsion from within? It is only in the "echoes of an antenatal dream," Shelley concedes in *Epipsychidion*, that a soul out of the soul may be claimed as "a soul within the soul" (455–56) and only in the "soul" of this Elysian fantasy that two may become "inseparable, one" (539–40). As the full language of this dreamscape makes desperately clear, such desire is never free of an opposite consciousness of separation and division, for which gendering becomes an ironically treacherous trope. The difference of gender that promises creative union recoils in the hyper-distance of a fugitive ecstasy and an intractable void.

In *Epipsychidion*, this recoil infects poetic capacity itself:

The winged words on which my soul would pierce
Into the height of love's rare Universe,
Are chains of lead around its flight of fire.
(588–90)

To the sole soul betrayed to words of lead, the female epipsyche is be-
trayed to tormenting despair: "I pant, I sink, I tremble, I expire!" (591). It
is a short step from this frustration to resentful antagonism, and this is
the story of *Alastor*. The "dark flood" that overwhelms the visionary in the
aftermath of his epipsychic dream at once betrays the promise of femi-
nine nurture and accelerates his dissolution. Awakening to a newly vacant
nature, the poet-dreamer cannot hereafter distinguish spiritual yearning
from fatal enchantment. Nature's dearest haunts are as "soul-dissolving"
(453) as the supernatural dream.

The fatal consequence is forecast by the epic simile that Shelley writes
for this torment:

> While day-light held
> The sky, the Poet kept mute conference
> With his still soul. At night the passion came,
> Like the fierce fiend of a distempered dream,
> And shook him from his rest, and led him forth
> Into the darkness.—As an eagle grasped
> In folds of the green serpent, feels her breast
> Burn with the poison, and precipitates
> Through night and day, tempest, and calm, and cloud,
> Frantic with dizzying anguish, her blind flight
> O'er the wide aëry wilderness: thus driven
> By the bright shadow of that lovely dream,
> Beneath the cold glare of the desolate night,
> Through tangled swamps and deep precipitous dells,
> Startling with careless step the moon-light snake,
> He fled.
> (222–37)

The simile "As an eagle grasped" unfolds a potent grammar of reversed
expectations. Assisted by enjambment at line 227, the syntax momentarily
poses "eagle" as a subject and "grasped" as a predicate, its direct object
seemingly impending: we expect to read of this Poet's passion, even as it
takes control of him, having the heroic stature of a struggling eagle. Yet in
a wicked turn of the line, Shelley reveals that this eagle is not grasping,
but is grasped by a stronger force—a green serpent, which figures in the

analogy as the fierce fiend in possession of the poet's soul. This syntactic reversal involves a crucial reversal of gender: not only is this a she-eagle, but her defeat evokes negative comparison to the famous icon of Napoleon's triumph.[11]

To feminize the Poet's possessed soul in this landscape of natural torments is to herald the release, a consummation devoutly to be wished, from everything feminine. The deepest logic of *Alastor* becomes the spiritual devaluation of anything gendered as feminine—or to put this another way, the feminine gendering of anything whose value is ultimately to be denied, a category summed in the poem's last lines as "Nature's vast frame, the web of human things, / Birth and the grave, that are not as they were" (719–20). The frame poet leaves his brethren with a scene of mother nature as a text of spiritual despair and with a desire inscribed entirely by and for men: a dyad of a poet and his male "epipsyche," the lost "Poet."[12] *Alastor* concludes in this solidarity of masculine spirits with one another, and against all powers gendered, in protective anticipation, as feminine.

Keats's soul-stories are sensitive both to the Shelleyan poetics of evanishment and to the regressive desire that courts such consequence: the urge, as the poet of *I stood tip-toe* puts it, to lose "the soul . . . in pleasant smotherings" (132). Yet *Endymion,* despite its oft-noted neo-Platonic answer to *Alastor*'s dualism, repeatedly courts Shelley's scenario of dissolution. Dream-raptured with the moon, the hero recalls his "dazzled soul / Commingling with her argent spheres" (1.594–95); betrayed to a waking world, he feels its elements "missioned to knit / My soul with under darkness" (1.701–2). From beginning to end, his soul is dedicated to the feminine, in the shape of deities or mortals or of both. To prevent the perpetual repetition of such surrender, even so pleasurably, Keats intuitively reviews the role of genre in the genders of soul lost and found. In "Ode to Psyche," the primer of the story, he declines narrative, which solicits trajectories of pursuit and loss, and calls upon a genre that risks no more than enthusiastic petition, the ode. The agenda of courtship is deliberately liminal: evoking the Coleridgean idea of sex in souls, the poet invites a feminine soul into his working brain, wherein it may be seduced and made creative. Morris Dickstein may be right in pointing out that the "allegorical meaning" is one in which Psyche ultimately signifies more as "mind or soul than as beautiful girl" (199), but the sexual trope ought not to be discounted. Recall Keats's earlier, self-involved formulations of this process, wherein, for instance, he describes reading and writing poetry as "the deed / That my own soul has *to itself* decreed" (*Sleep and Poetry* 97–98; italics mine). By dividing and arranging this self-stimulation as an encounter of different sexes, Keats is able to imagine an access of creative and mental power on the analogy of male erotic success, romancing the feminine in a script of

masculine self-empowerment. If, as Marjorie Levinson has noted, Keatsian inspirations have a strong tendency toward *auto*erotic configurations (27), Keats's heterosexual doubling sets an alertly preemptive defense.

Yet the total articulation of "Ode to Psyche" is a delicate but profound uncertainty about the success of this strategy. While its poet anticipates erotic union—the climactic feature of Psyche's chamber in his mind is "a bright torch, and a casement ope at night, / To let the warm Love in!" (66–67)—this preparatory scene is embedded in a wider, "untrodden region of [the] mind" (51) involving things "dark-cluster'd" (54) in "shadowy thought" (65). No wonder that some of Keats's later romances imagine aggressive containments, such as the desire Lycius voices to Lamia, "to entangle, trammel up and snare / Your soul in mine, and labyrinth you there / Like the hid scent in an unbudded rose" (2.52–54). Yet even as Lycius in this aspect exposes the politics of gender at work in the caginess of "Ode to Psyche," his eventual failure (again a narrative) makes this voice for Keats a fragile bravado. Keats's late stories of soul-courtship most often tell of success with a vengeance, where a feminine power lays devastating claim to the masculine soul. In such scenes, a she-soul plays no part but is replaced by a feminized threat to the masculine soul. "Ode on Melancholy" turns from the quiet retreat of "Ode to Psyche" to urge a "wakeful anguish of the soul" under the tutelage of the stern goddess, "Veil'd Melancholy." The poet's soul that would "taste the sadness of her might" must also relinquish self-possession and "be among her cloudy trophies hung" (29–30).

In Keats's most desperate scenes of the soul, his late poems to Fanny Brawne, the stakes are higher and feminine solicitude more uncertain. He suspects that she may not "prize [his] subdued soul"—a noun revised from "heart" ("To Fanny" 49)—and begs her on another occasion, "O, let me once more rest / My soul upon that dazzling breast!" ("What Can I Do . . . ?" 48–49). In "I Cry Your Mercy," the petition to this hyper-infused female object of desire—"O, let me have thee whole,—all,—all—be mine!"—plays its term of frustrated plenitude, "whole," into a muted internal rhyme with the unavailing female "soul" and subjects this linking to an "all,—all"-or-nothing result: "Yourself—your soul—in pity give me all, / Withhold no atom's atom or I die." Projected by a sensation of a radical absence in the man who desires her, the soul of a woman assumes a vital power, but a power which the scheme of gender makes as alien as it is essential to masculine self-sufficiency.[13]

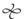

These texts show Romantic men formulating a poetics of the soul that is also a poetics of gender, and doing so in terms that are too often a palpable design against women. So what happens when the writer is a woman?

One answer appears in Jewsbury's *History of an Enthusiast* an account of a young woman's yearning for a "Fame" that "would make amends for being a woman—I should not pass away and perish" (25). How this involves her soul is spelled out by a chapter epigraph (43) credited to Professor Wilson:[14]

> As far as human soul may be let loose
> From impositions of necessity,—
> Forgetting oft, in self-willed fancy's flight,
> All human ties that would enchain her dreams
> Down to a homelier bliss; and loving more
> The dim aerial shadow of this life,
> Even than the substance of the life itself.

In this image of necessity, not only is the errant, "self-willed" soul gendered feminine, but its chains bind it to the sentimentalized place culture has assigned to women: home.

Eventually Julia writes a satiric poem that frankly names home in all its guises as "fetters to our souls" (149), echoing Wollstonecraft's sneer at the "specious slavery which chains the very soul of woman" (144). But well before this, Jewsbury's story of this restless female soul tests the professor's traditional wisdom, using among its maneuvers a female appropriation of male-authored poetry. When Cecil Percy, a potential suitor, warns Julia that her cherished books will produce "more loss than gain," Julia retorts with her own version of Asia's song at the close of Act 2 of *Prometheus Unbound*:

> My soul is an enchanted boat,
> Which, like a sleeping swan, doth float
> Upon the silver waves of *their* sweet singing.
> And each doth like an angel sit
> Beside the helm conducting it,
> Whilst all the winds with melody are ringing.
> It seems to float, ever, for ever,
> Upon that many-winding river,
> Between mountains, woods, abysses,
> A paradise of wildernesses!
>
>
>
> And we sail on, away, afar,
> Without a cloud, without a star,
> But by the instinct of sweet music driven.
> (*History* 59; Jewsbury's italics)

Julia's *their* revises and shifts the reference of Asia's *thy* (she's addressing a voice in the air), to the voices of her books, the feeders of her intellec-

tual soul. Her wording not only refuses Cecil Percy's prescriptions—it also revises Percy Shelley's script (in which Asia is devoted to Prometheus) for her own ends, namely, a story of female desire not subordinate to the urgencies of men in crisis. It is not long after that Julia imagines a "communion of spirit" with a male epipsyche, an idea, she says, that "seems to give my soul wings" (64).

Jewsbury summons Shelley again to describe Julia's mental energy, "emparadised in dreams of intellectual beauty" (103). Not only does this language claim for Julia the tenor of Shelley's famous *Hymn to Intellectual Beauty* (1817; 1819), but the allusion is enriched by an echo of a text that Shelley knew as well as Jewsbury, Wollstonecraft's *Vindication of the Rights of Woman*, and the larger discourse in which it plays. Lamenting the low value accorded by men to women's "intellectual beauty" (47) but still urging women to "ambition and those nobler passions that open and enlarge the soul" (10), and insisting on the idea of a soul that can be "perfected by the exercise of its own reason" (53), Wollstonecraft sets this notion of equal opportunity under "the Creator" corrosively against ideologies that would "deprive us of souls, and insinuate that we were beings only designed . . . to gratify the senses of man when he can no longer soar on the wing of contemplation" (19). Advancing this polemic, Jewsbury concludes her *History* with Julia risking the stigma of being thought a "second Mary Wolstonecroft" ([*sic*] 143) and willing to speculate about "soul of no sex— versatile powers" (144).

Yet Jewsbury's *History* is uncertain about how to weigh the economy of soul in Julia's total narrative. One sign is the tone of Julia's summary turn to Shelley for sympathy in her prospective adventure. She is speaking to her sister's husband (who has been concerned about her health):

> I must be left to myself—I am so very, very weary. There are four lines written by one with whom, in many things, I can sympathise too well, and I repeat them to myself almost in my sleep—he is addressing the wind, and says
> > O lift me as a wave, a leaf, a cloud;
> > I fall upon the thorns of life—I bleed;
> > A heavy weight of hours has chained and bowed
> > One too like thee, tameless, and swift, and proud.
> Julia closed the repetition of these lines with a sigh. . . . Captain Egerton sighed also, but he relinquished her hand, and in a few moments was left in the room alone. (160)

This is the close of *The History of an Enthusiast*, its sighs shaded by Julia's empty "Fame" as a London celebrity, a life that has so paled after five years

that she feels the pull of conservative soul-prescriptions, lamenting the utter absence of any "child-like surrender of the soul to fresh and vigorous impulses," and gripped by a "sense of present loneliness [that] paralyzes all the finer functions of the soul" (114–15). As if to confirm these sensations of soul in social fate, Jewsbury's plot has Julia's enthusiasms alienate Cecil, who finds a proper English wife.

Yet she vexes this conservative corrective in two ways. For one, and despite Julia's regret, she casts the character of Cecil to suggest that he is not much of a loss: a dull twit, a "cold" and "passionless" spirit (as even Julia describes him), capable of satisfying only the most pallid poetics of the soul in his exhortation of Julia to leave her life of "vanities" and enter "that solemn chamber of the soul wherein conscience sits enthroned as judge" (122). For another, Jewsbury closes the *History* not with her enthusiast exposed and doomed to emptiness, nor (alternatively) recuperated to domesticity, but energized by a decision to leave England and travel on the Continent. If this female enthusiast's precise future is left untold, what is most evident in the close of her history is that England in the 1830s seems to have no place for such souls.[15]

Hemans's poetry of the female soul contends with similar ambivalences, in which the orthodox values for which she was celebrated are in visible tension with the kind of female soul-fettering that sustains these values. This pressure is compelling in light of the general adoration of Hemans in Regency and high Victorian culture as the soul of femininity—the epitome of the "tenderness and loftiness of feeling, and an ethereal purity of sentiment, which could only emanate from the soul of a woman," as Francis Jeffrey put it in 1829 (37). Lest we think this is only gallant male bias, here is a woman's diagnosis of Hemans's soul: "I admire her genius—love her memory—respect her piety & high moral tone," Barrett Browning writes to their mutual friend Mitford; "But she always does seem to me a lady rather than a woman, & so, much rather than a poetess—her refinement, like the prisoner's iron . . . enters into her soul" (*Letters* 2: 88). These impressions are justified by much of Hemans's poetry, especially the religious pieties of her last poems, which, under the burden of her fatally ill health, seek the traditional consolation of the soul's release from the ailing body.[16] In this spiritual dualism, there are more than a few meditations on the vanity of worldly fame as nurture to the female soul—such as "Women and Fame" (*Poems* 497):

> Fame! Fame! thou canst not be the stay
> Unto the drooping reed,
> The cool, fresh fountain in the day
> Of the soul's most feverish need.

Yet even this caution emerges from and does not entirely displace a rhetoric that constantly feels the attractions against which it guards: "Thou hast a voice, whose thrilling tone / Can bid each life-pulse beat," Hemans also says to "Fame." In earlier poems, moreover, when Hemans was alive to her prospects in this world, the female soul is much more restless.

Like Jewsbury, Hemans wonders about the soul of female desire, whose fevers are not only not allayed but often aggravated by domestic stays. This tension unsettles even the early poem with so unpromising a title as *The Domestic Affections* (1812), written by then Felicia Browne. While its opening forecasts Jeffrey's "Mrs. Hemans," the poem as a whole darkens its orthodoxies with hints at a terrible economy for the woman's soul. It begins with standard polarities—material versus spiritual life, worldly ravages versus domestic bliss—mapped with a language of gender claiming universal, transcendent value. Fostered by the nurturing female soul, the domestic affections restore world-weary men's souls and, beyond this service, remind us all of the soul's true home:

> Her angel-voice his fainting soul can raise
> To brighter visions of celestial days!
> And speak of realms, where virtue's wing shall soar
> On eagle plume—to wonder and adore!
> And friends, divided here, shall meet at last,
> Unite their kindred souls—and smile on all the past.
> (164–65)

Yet these unities, kindred and divine, contend with other divisions. One point of stress is the difference between women's spiritual work at home and the extra-domestic expansions of male genius. The argument anchors masculine genius in the nurture of domestic affections, even casting the spiritual excitements of life in the world, "Fame" and "Freedom," as feminine, as if to make them co-nurturers. But the aesthetic elaboration is fraught with conflict.

Consider the explanatory emblem of the aspiring eagle, the image of masculine genius:

> On Freedom's wing, that ev'ry wild explores,
> Thro' realms of space, th' aspiring eagle soars!
> Darts o'er the clouds, exulting to admire,
> Meridian glory—on her throne of fire!
> Bird of the sun! his keen, unwearied gaze,
> Hails the full noon, and triumphs in the blaze!
> But soon, descending from his height sublime,
> Day's burning fount, and light's empyreal clime;

Once more he speeds to joys more calmly blest,
'Midst the dear inmates of his lonely nest!

Thus Genius, mounting on his bright career,
Thro' the wide regions of the mental sphere . . .
(157)

Male Genius enjoys a freedom and energy for which the descent to the "lonely nest" of home, however calmly blest its joys, seems a death-in-life; the word "lonely" is a giveaway. In a domestic bliss founded on the female healing of male souls, the result for women, Felicia Browne finds herself saying (first in subordinate clauses and then in sustained meditations), is too frequently a radical depletion of their spiritual reserves. The praise of the woman's "angel-voice" for a power to raise a man's "fainting soul" to "brighter visions of celestial days" is tellingly preceded by a notation that she must "conceal, with duteous art, / Her own deep sorrows in her inmost heart!" A parenthesis a few lines on whispers the necessary suppression of her soul's pangs: "(Still fondly struggling to suppress *her own*)" (164). The italics are the poet's, the graphic pressing against the parentheses that would contain their stress. By the end of her poem, her imagination is concentrating on the unequal economy that sustains gendered souls. In a significant shift, soul's ease for a woman—when gentle spirits "sooth her soul, / With soft enchantments and divine control"—is projected into the world beyond death. Her "parting soul" becomes an "exulting spirit" only as it "leaves her bonds of clay" (170–71).

This anticipation evokes traditional Platonisms that affect male poetics of the soul: the fundamental allegiance of *Alastor*, we recall, and an evolving one in Wordsworth's orthodoxy. But where the schemes of their poems tend to reject the inconstancies of the feminine and nature together (reading one in terms of the other), the strains of *The Domestic Affections* expose a culturally specific release for woman from a natural and domestic sphere that is supposed to ground her sense of soul. It is a poignant commentary on cultural constraint that *The Domestic Affections* ends with a celebration of an "Elysian clime" that is for women what the domestic sphere is for men, an escape from worldly ravages:

Yes! in the noon of that Elysian clime,
Beyond the sphere of anguish, death, or time;
Where mind's bright eye, with renovated fire,
Shall beam on glories—never to expire;
Oh! there, th'illumin'd soul may fondly trust,
More pure, more perfect, rising from the dust;
Those mild affections, whose consoling light

Sheds the soft moon-beam on terrestrial night;
Sublim'd, ennobled, shall for ever glow,
Exalting rapture—not assuaging woe!
(171–72)

This delivery *to* is also a delivery *from*. Only thus ("there") can a woman's soul be "illumin'd" into a rapture paralleling that of male Genius in the mortal world. Young Miss Browne felt this gendered denial more than once. Writing to her aunt of her admiration of the "noble Spaniards" in the Peninsular campaign of 1808, she gushes, "[M]y whole heart and soul are interested for the gallant patriots," but adds that she realizes "females are forbidden to interfere in politics" (Chorley 1: 31).

What a girl's soul may do with this interest, if she is not to trespass into male glory and genius, is suggested by one of Hemans's most popular poems in the nineteenth century, "Evening Prayer, at a Girls' School" (*Poems* 374–75). Upon this scene Hemans superimposes the melancholy woman's life that impends: "in those flute-like voices, mingling low, / Is woman's tenderness—how soon her woe!" Her refrain, "Therefore pray!" comes to sound like a bitter, prefigurative consolation for the looming domestic afflictions to the female soul: "Meekly to bear with wrong, to cheer decay, / And oh! to love through all things. Therefore pray!" If prayer is the language of the soul, Hemans's scene of instruction is devastating, for its deepest lesson is that the girls' future memory of these vespers will be their only nurture, "As a sweet dew to keep your souls from blight" amid all that "Earth will forsake."

If a woman's soul is moved beyond this forbearance, Hemans keeps its impulses bound to the affections and corrects any interference in politics with tragic depletions. In "The Indian City" (*Records*), Maimuna, a Muslim widow on a pilgrimage to Mecca, is moved to violent passion when her son is slain by Brahmin children for inadvertently wandering onto their holy grounds. Hemans evokes her grief in the image of a stilled, seemingly resigned soul—"Her soul sat veil'd in its agony" (89)—and then turns this soul into a double soul whose division is a site of transformation:

And what deep change, what work of power,
Was wrought on her secret soul that hour?
How rose the lonely one?—She rose
Like a prophetess from dark repose!
And proudly flung from her face the veil,
And shook the hair from her forehead pale,
And 'midst her wondering handmaids stood,
With the sudden glance of a dauntless mood.
(90)

As compelling as this transformation is Hemans's representation of it in the language of the soul, using this word to chart an emergence from veiled stillness and passivity to an unveiled regal passion and a spirit committed to violent action. At the same time, Hemans's inhibition before this kind of emergence impels her to stabilize its energy by reinscribing the gender of Maimuna's secret soul of power. Maimuna's passion inspires a war that wreaks the havoc she had pledged, but her female soul cannot survive its lost affections, "the yearning left by a broken tie." Even as the city that destroyed this tie is itself destroyed, her fate joins that of the vanquished city rather than that of the victorious armies. The barometer of this fate is her soul, imaged as the prisoner of a walled city on the verge of collapse:

> Sickening she turn'd from her sad renown,
> As a king in death might reject his crown;
> Slowly the strength of the walls gave way—
> *She* wither'd faster, from day to day.
> All the proud sounds of that banner'd plain,
> To stay the flight of her soul were vain;
> Like an eagle caged, it had striven, and worn
> The frail dust ne'er for such conflicts born,
> Till the bars were rent, and the hour was come
> For its fearful rushing thro' darkness home.
> (93–94)

In one stroke, this passage rewrites the gender and the fate of the aspiring eagle of Genius and Freedom in *The Domestic Affections*. Here, the eagle is the woman's caged soul, longing for release from the agonies of the worldly triumph it had kindled; its most deeply desired soaring is a flight from life to death. Escalating the conflict that strains *The Domestic Affections*, "The Indian City" posits not the domestic nest but female life itself (the italics are Hemans's) as the prison from which the female soul seeks release. The only energy Hemans leaves to this woman warrior's soul is its brief arousal to a final expression of maternal love. Mourning her son's death on her own deathbed causes "a fitful gust" to issue "o'er her soul again" that urges Maimuna to beg that they be laid to rest together (95).

Jewsbury's more heroic version of the female soul in grief is "Arria" (*Phantasmagoria* 1: 122–24), but it is revealing that her cultural syntax, even so fortified, yields a similarly fatal figure. Arria, "a Roman Matron," is imprisoned with her husband Pætus, whom she means to urge to die with honor, "by his own right hand." But already "in soul and strength subdued" by his fetters, he merely expires, and it is left to "the wife and woman high" symbolically "to teach *him* how to die" (123). This is the essential demonstration of "woman's soul" in its mode of heroic "woman's love":

Ages, since then, have swept along; —
 Arria is but a name, —
Yet still is woman's love as strong,
 Still woman's soul the same; —
Still soothes the mother and the wife,
Her cherished ones 'mid care and strife:
It is not painful, Pætus — still
Is love's word in the hour of ill.
(124; emphasis in original)

Whether in heroic sacrifice or in the toils of domestic affection, "woman's soul," in Jewsbury's imagining, has an essential, universal identity. Lucy Aikin's *Epistles on Women* (1810) used such Roman models to argue this strength into a claim that "Souls have no sex":

See there the ghost of noble Portia glide,
Cato to lead, and Brutus at her side!
Souls have no sex; sublimed by Virtue's lore
Alike they scorn the earth and try to soar;
Buoyant alike on daring wing they rise
As Emulation nerves them for the skies.
See Paetus' wife, by strong affection manned,
Taste the sharp steel and give it to his hand.
(Epistle 3, *Epistles* 57)

The verb "manned" is a telling contradiction of the claim of "no sex," however — as if conceding that women when they strive to heroism all they can, but form a more affectionate man.[17]

For Hemans, the pressure of gender is especially acute in writing of the soul of the female artist, a figure analogous to Jewsbury's "Enthusiast." When the eponym of "The Sicilian Captive" (*Records*) sings to her captors of her lost home, her "soul [grows] strong" from the inspiration, as she feels Sicily's "soul flow o'er my lips again" (176). But such inspiration wrestles with a soulful mourning for a home so far away: "Doth not thy shadow wrap my soul?" (175). The soul of the artist steadily declines and weakens in this shadow: when, recalling the "sweet sounds" of Sicily, the captive exclaims, "The soul to hear them faints in dreams of heaven away!" (177), the denouement is guaranteed. At the close of the song (also the poem's last lines), we are told, "She had pour'd out her soul with her song's last tone; / The lyre was broken, the minstrel gone!" (179).

In the monologue of the sculptor, "Properzia Rossi" (*Records*), artistic creation emerges as a less than abundant recompense for the "aching soul" in the pain of unrequited love (51). Lines from the unsigned epigraph give the cue:

> Tell me no more, no more
> Of my soul's lofty gifts! Are they not vain
> To quench its haunting thirst for happiness?
> Have I not lov'd, and striven, and fail'd to bind
> One true heart unto me, whereon my own
> Might find a resting-place, a home for all
> Its burden of affections?
> (47)

While the opposition between "happiness" and "lofty gifts" is a stock Romantic trope for the pains of genius, even of consciousness (everyone understands Manfred), Hemans unsettles the cliché by giving it a female voice: Rossi is exiled from happiness not just by genius but by the cultural contradiction of gender and genius.[18] In this contradiction, she, like the Sicilian Captive, can imagine no art for her soul purchased without her annihilation; her monologue begins thus:

> One dream of passion and of beauty more!
> And in its bright fulfillment let me pour
> My soul away!
> (47)

For male poets, as we have seen, sex in souls invokes the feminine to nurture and complete a masculine soul—or if not, to suffer slander as the gender of every bafflement to such desire. Hemans and Jewsbury try to work around these arrangements, but their attempts entail a price—either cultural alienation (Jewsbury's Julia has to leave England for the sake of her soul) or as Hemans keeps imagining, the alienation of the affections into a sterile "addition" of art rather than the creative "combination" of love (to recall the terms of Coleridge's letter).

Even so, Hemans frames Rossi's lament in a way that challenges the negative economy of affection and female art. Not only is the Roman Knight for whom she pines away something of a dolt (in this way, like Jewsbury's Cecil), but Rossi's art, her sculpting, yields fulfillment, even a sense of vital natural "power," which she greets

> . . . proudly, with its rushing train
> Of glorious images:—they throng—they press—
> A sudden joy lights up my loneliness,—
> I shall not perish all!
> The bright work grows
> Beneath my hand, unfolding, as a rose,
> Leaf after leaf, to beauty; line by line,
> I fix my thought, heart, soul, to burn, to shine,

Thro' the pale marble's veins. It grows—and now
I give my own life's history to thy brow,
Forsaken Ariadne!—thou shalt wear
My form, my lineaments; but oh! more fair,
Touch'd into lovelier being by the glow
 Which in me dwells . . .
(49)

While Rossi's statue of forsaken Ariadne is transparently her mournful epi-psyche, and Rossi herself is such for Hemans, the unity of "thought, heart, soul" that Hemans represents in this moment of creation poses a tenuous suggestion of a different psychic economy, both for Rossi and herself: what women's souls may inspire if they allow "all these deep affections, that o'erflow / [The] aching soul" (51), to inform and enjoy the bright work of art.

One of Hemans's last poems, written in 1834 in the frustration of sickness, elevates and explicitly identifies with this imagined moment in Rossi's work. The "soul" of "Design and Performance" is given entirely to artistic inspiration and labor, and, significantly, it is not gendered. The frustration is not of any domestic affection, but of mortality itself:

They float before my soul, the fair designs
Which I would body forth to life and power,
Like clouds, that with their wavering hues and lines
Portray majestic buildings:—dome and tower,
Bright spire, that through the rainbow and the shower
Points to th' unchanging stars; and high arcade,
Far-sweeping to some glorious altar, made
For holiest rites. Meanwhile the waning hour
Melts from me, and by fervent dreams o'erwrought,
I sink. O friend! O link'd with each high thought!
Aid me, of those rich visions to detain
All I may grasp; until thou see'st fulfill'd,
While time and strength allow, my hope to build
For lowly hearts devout, but *one* enduring fane!
(*Poems* 623)

If, as Coleridge argues, there is a sex in souls, Hemans's design of the soul richly reconceives the ideologies of gender that grant only men's souls the privilege of desire and a claim to power. An important element of her design is its incorporation of male-authored poetry. There are strains of Shelley's "Ode to Liberty," not only in its language of the soul ("My soul spurned the chains of its dismay, / And in the rapid plumes of song / Clothed itself, sublime and strong" [5–7]), but also in its visionary archi-

tecture: "a city such as vision / Builds from the purple crags and silver towers / Of battlemented cloud" (61–63). And at her sonnet's turn, there is a more resigned repetition of the crisis of vision at the end of *Epipsychidion* ("The winged words on which my soul would pierce / Into the height of love's rare Universe, / Are chains of lead around its flight of fire.— / I pant, I sink . . ." [588–91]). There are also recollections of Wordsworthian imaginings: "Earth has not any thing to shew more fair: / Dull would he be of soul who could pass by / A sight so touching in its majesty: . . . towers, domes" ("Composed upon Westminster Bridge"); and a subdued version of the heart-swelling vision given to his despondent Solitary ("Clouds of all tincture, rocks and sapphire sky, . . . composing thus . . . that marvellous array" [*Excursion* 2.854 ff.]). Romantic men court an external soul to acknowledge decentered inspiration, and Hemans's intertextual inspirations amount to a similar acknowledgment of externality. Other texts, like souls outside, solicit a generative union with difference—to recall the terms by which Coleridge argues for a sex in souls. Hemans's distinction is to decline the trope of gender in this interaction.

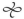

For a woman to write of sex in souls is to confront the cultural dissonance of writing of the soul as a *woman*, addressing a literary tradition in which the female soul serves male privileges and interests. Some women internalize this tradition, feeling it as personal and cultural truth. To Wollstonecraft's biological heir, the question of sex in souls was at best unresolved: "You speak of women's intellect," Mary Wollstonecraft Shelley writes to a friend:

> I know that however clever I may be there is in me a vaccillation [*sic*], a weakness, a want of "eagle winged['] resolution that appertains to my intellect as well as my moral character . . . My Mother had more energy of character—still she had not sufficient fire of imagination— In short my belief is—whether there be sex [in] souls or not—that the sex of our material mechanism makes us quite different creatures— better though weaker but wanting in the higher grades of intellect.— (11 June 1835; *Letters* 2: 246)

Yet if Shelley defers the question of sex in souls to embrace the determinism of the body (material mechanism, what we call essentialism), Jewsbury and Hemans show how the very dislocation that Shelley so internalizes can, with different negotiation, become productive for Romantic-era women. From their point of alienation, women may find themselves able to wonder about releasing spiritual poetics from a politics of gender, even enabled to imagine forms of desire neither dependent on nor limited by a sex in souls.

Already in the making in the early 1830s was another figure of design and performance, Sand's Lélia, whose sensational birth into print inspired the reviewer for *Athenæum* (which was quite hospitable to women writers) to warn readers that this heroine was "a monster, a Byronic woman— endowed with rich and energetic faculties, delicate perceptions, rare eloquence, fine talents, but no heart—a woman without hope and without soul" (646).[19] Published in this monstrosity was something that Hemans and Mary Shelley had not yet imagined and Jewsbury only half did—the knowledge that women, too, could enter the romance of alienation, specifically by disdaining the "soul" assigned to them as the gendered bearer of cultural hope. This is a story that some post-Romantic women would explore more fully: "Beth was a poet herself—& there was the reigning thought—No woman was ever such a poet as she wᵈ be," writes Barrett in an autobiographical tale, with some elaborations pertinent to the question of this essay: "when she grew up she wᵈ wear men's clothes. . . . One word Beth hated in her soul . . . & the word was 'feminine.' Beth thanked her gods that she was not & never wᵈ be feminine."[20] If women in the age of Romanticism were not so confident, the persistent tensions of their texts are a critical legacy for girls such as Beth, energizing her not only to reject the feminine "in her soul" but to find new gods to thank for this ungendering—an emphatic anti-essentialism that we continue to test in the lessons of Romanticism today.

Notes

My thanks to Ron Levao, Terry Kelley, Starry Schor, and Peter Manning for valuable attention to this essay, and to the North American Society for the Study of Romanticism, Thomas Pfau, Robert Gleckner, and Duke University for giving it a lively forum at the conference they organized in 1994, "The Political and Aesthetic Education of Romanticism." A different version has been published as "Gendering the Soul in Romanticism," in *Romantic Women: Voices and Counter-voices*, ed. Paula Feldman and Theresa Kelley (Hanover, N.H.: UP of New England, 1995), 33–68.

1 Among frequently cited arguments in this line are the first chapter of Homans, Tayler and Luria (esp. 113–15), Richardson, the first chapter of Ross, and Mellor.

2 "Surely," insists Wollstonecraft, "she has not an immortal soul who can loiter life away merely employed to adorn her person, that she may amuse the languid hours" of any man whose "serious business of life is over" (29). She herself expresses gratitude "to that Being who impressed . . . on my soul" the falsity of giving "a sex to morals" that would authorize different standards of behavior for men and women (36). For "if the dignity of the female soul be as disputable as that of animals," she proposes to any potential antagonist, then women "are surely of all creatures the most miserable" (45; cf. 63).

3 Meaning (in a Keatsian way) to "sketch a plan of the soul," Woolf cites Coleridge's speculation but notes that he "certainly did not mean, when he said that a great mind is androgynous, that it is a mind that has any special sympathy with women; a mind

that takes up their cause or devotes itself to their interpretation." Her own idealized canon of androgynous writers, moreover, is composed only of men (including Coleridge and Keats) in whom "the woman part of the brain" has "effect" (102, 107) and uses the male pronoun for "writer." Showalter, who notes the last point (288), sees Woolf undertaking an aesthetic evasion of the political, social, and experiential realities of gender (264), a case that I think survives Moi's counterargument that Woolf's thinking about androgyny is most important for its theoretical intent to "deconstruct the . . . binary oppositions of masculinity and femininity" (13).

4 *Nosce Teipsum: Of the Soule of Man and the Immortalitie Thereof* (1599), IV, sts. 11–13; Bate and Engell note some misquotation on Coleridge's part (*BL* 2: 17n2).

5 Thus Homans argues that only women's poetry is pressured by a sensation of the "alien centers of imaginative power," a dislocation in which "the sources of poetic power are not felt to be within the self" (104).

6 My point about the rhetoric of apostrophe refers to Culler's influential essay, "Apostrophe"; Mellor takes such moments as most truly representative of the poem's politics of gender, attributing to Wordsworth a "surpassing confidence [in] the construction of an autonomous poetic self that can stand alone" (148), precisely because it has dominated or effaced the feminine (18, 144–53). Quotations, unless otherwise indicated, follow Reed's collation of the 1805 manuscripts, "A-B Stage Reading Text" (1: 107–324).

7 The fullest study of the ambiguous place of the feminine in these homosocial dynamics is Sedgwick's; see especially the chapter on Shakespeare's sonnets.

8 The epigraph first appears in the revised text of published *Poems* of 1815, the year Shelley was composing *Alastor*. Quotations are from *Shelley's Poetry and Prose*, cited as *SPP*. For a sharp reading of the attenuated language of the epigraph and the consequences for the "Ode," see Ferguson 98–101. For an incisive account of the involvement of *Alastor* with the Ode, see Keach.

9 Quotation follows Rogers' edition. Shelley's note in her edition describes this poem as "a good deal modelled on *Alastor*" (156)—with the stark difference that its story makes explicit the betrayal of the poet's soul by female agency.

10 For various interpretations of the root, prefix, and suffix of Shelley's title, see Wasserman 418–19.

11 The eagle-poet is further feminized, Veeder proposes, by the penetrating snake, "the now phallic beloved" (94–95).

12 I owe the description of this dyad to Rajan (76), although she is not concerned with gender.

13 Thus, I think Ross only partly right in his claim that Keats's "'mature' poetry . . . is forced to contain or crystallize the feminine as a sign of his manhood, as evidence of his self-control" (73).

14 This is John Wilson—after 1820 professor of philosophy at Edinburgh University and, as "Christopher North," a regular contributor to *Blackwood's*.

15 This severing of domestic romance from female spiritual quest at the conclusion of Jewsbury's *History* (an implicit concession of a cultural contradiction) is one of the ideologically fraught narrative patterns of nineteenth-century women's fiction, according to DuPlessis (1–19); the removal of Julia to Europe predicts the "critical dissent from the dominant narrative" that DuPlessis sees as an emergent strategy in twentieth-century women's writing (5).

16 See for example, "The Angels' Call," "A Thought of the Sea," "Distant Sound of the Sea," "The Return to Poetry," "Intellectual Powers," and "Sickness Like Night."

17 Although her introduction "disclaim[s] entirely the absurd idea that the two sexes

ever can be, or ever ought to be, placed in all respects on a footing of equality" (v),
the respects it does consider were quite broad: "let the daily observation of mankind
bear witness, that no talent, no virtue, is masculine alone; no fault or folly exclusively
feminine" (vi).

18 For an interesting survey of Romantic alignments of gender and genius, see Battersby
13, 35–38, 46–47; ch. 8 (73–80); and ch. 10 (91–102).

19 *Lelía* was published in 1833; the last sentence in *Athenœum*'s review is worth quoting:
"We shall not again dip our pen in this mire of blood and dirt, over which, by a strange
perversity of feeling, the talent of the writer, and that writer a woman! has contrived
to throw a lurid, fearful and unhallowed light" (347). I am indebted to Leighton (81)
for alerting me to this review.

20 *Browning's Correspondence* 1: 361; the editors date the composition of this untitled essay
in the early 1840s and discern Elizabeth Barrett in the portrait of Beth.

Works Cited

Aikin, Lucy. *Epistles on Women, Exemplifying Their Character and Condition in Various Ages
and Nations. With Miscellaneous Poems*. Boston: Wells & Wait, 1810.

Barrett Browning, Elizabeth. *The Letters of Elizabeth Barrett Browning to Mary Russell Mitford
1836–1854*. Ed. Meredith B. Raymond and Mary Rose Sullivan. 3 vols. Winfield, KS:
Wedgestone, 1983.

———. *The Brownings' Correspondence*. Ed. Philip Kelley and Ronald Hudson. 10 vols. Win-
field, KS: Wedgestone. 1984–1992.

Battersby, Christine. *Gender and Genius; Towards a Feminist Aesthetics*. Bloomington: Indi-
ana UP, 1989.

*Biographium Fœmineum. The Female Worthies: or, Memoirs of the Most Illustrious Ladies of all
Ages and Nations . . . who have shone with a particular Lustre, and given the noblest Proofs
of the most exalted Genius*. 2 vols. London: Crowder, 1766.

Chorley, Henry F. *Memorials of Mrs. Hemans, with Illustrations of her Literary Character from
her Private Correspondence*. 2 vols. London: Saunders and Otley, 1836.

Coleridge, Samuel Taylor. *Collected Letters of Samuel Taylor Coleridge*. Ed. Earl Leslie Griggs.
6 vols. Oxford: Clarendon, 1956–71. Cited as *CLC*.

———. *Satyrane's Letters: Letter II (To a Lady)*. *The Friend* No. 16 (7 Dec. 1809). *The Friend*.
Ed. Barbara E. Rooke. 2 vols. Princeton: Princeton UP, 1969.

———. *The Notebooks of Samuel Taylor Coleridge*. Ed. Kathleen Coburn. Vol. 3. Princeton:
Princeton UP/Bollingen, 1973.

———. *Biographia Literaria, or Biographical Sketches of my Literary Life and Opinions*. 1817.
Ed. James Engell and W. Jackson Bate. 2 vols. Princeton: Princeton UP, 1983. Cited
as *BL*.

———. *Table Talk* (recorded by Henry Nelson Coleridge and John Taylor Coleridge). Ed.
Carl Woodring. 2 vols. Princeton: Princeton UP, 1990. Cited as *TT*.

Culler, Jonathan. "Apostrophe." 1977. Rpt. in *The Pursuit of Signs: Semiotics, Literature, De-
construction*. Ithaca: Cornell UP, 1981. 135–54.

Dickstein, Morris. *Keats and His Poetry: A Study in Development*. Chicago: U of Chicago P,
1971.

DuPlessis, Rachel Blau. *Writing beyond the Ending: Narrative Strategies of Twentieth-Century
Women Writers*. Bloomington: Indiana UP, 1985.

Ferguson, Frances. *Wordsworth: Language as Counter-Spirit*. New Haven: Yale UP, 1977.

[Hemans]. Browne, Felicia Dorothea. "The Domestic Affections." *The Domestic Affections and Other Poems*. London: Cadell and Davies, 1812.

Hemans, Felicia. *Records of Woman: With Other Poems*. Edinburgh: Blackwood; London: Cadell, 1828.

———. *Poems of Felicia Hemans*. Edinburgh: Blackwood, 1873.

Homans, Margaret. *Women Writers and Poetic Identity*. Princeton: Princeton UP, 1980.

[Jeffrey, Francis]. Rev. of *Records of Woman* (2nd ed.) and *The Forest Sanctuary* (2nd ed.). *Edinburgh Review, or Critical Journal* 50 (Oct. 1829): 32–47.

[Jewsbury, Maria Jane]. *Phantasmagoria; Or, Sketches of Life and Literature*. 2 vols. London: Hurst, Robinson; Edinburgh: Constable, 1825.

———. *The History of an Enthusiast*. 1830. *The Three Histories*. Boston: Perkins and Marvin, 1831.

Keach, William. "Obstinate Questionings: The Immortality Ode and *Alastor*." *The Wordsworth Circle* 12 (1981): 36–44.

Keats, John. "I stood tip-toe on a little hill" and "Sleep and Poetry." *Poems*. London: Ollier, 1817; Oxford: Woodstock, 1989.

———. "Ode to Psyche," "Ode on Melancholy," and *Lamia*. *Lamia, Isabella, The Eve of St. Agnes and Other Poems*. London: Taylor and Hessey, 1820; Oxford: Woodstock, 1990.

———. *The Letters of John Keats, 1814–1821*. Ed. Hyder E. Rollins. 2 vols. Cambridge: Harvard UP, 1958. Cited as *LJK*.

———. *The Poems of John Keats*. Ed. Jack Stillinger. Cambridge: Harvard UP, 1978.

Leighton, Angela. *Victorian Women Poets: Writing against the Heart*. New York: Harvester / Wheatsheaf, 1992.

"*Lélia: a Novel*. By George Sand." Rev. *The Athenæum* 309 (28 Sept. 1833): 346–47.

Levinson, Marjorie. *Keats's Life of Allegory: The Origins of a Style*. London: Blackwell, 1988.

Mellor, Anne K. *Romanticism and Gender*. New York: Routledge, 1993.

Moi, Toril. *Sexual/Textual Politics: Feminist Literary Theory*. London: Methuen, 1985.

Rajan, Tilottama. *Dark Interpreter: The Discourse of Romanticism*. Ithaca: Cornell UP, 1980.

Richardson, Alan. "Romanticism and the Colonization of the Feminine." *Romanticism and Feminism*. Ed. Anne K. Mellor. Bloomington: Indiana UP, 1988. 13–25.

Ross, Marlon B. *The Contours of Masculine Desire: Romanticism and the Rise of Women's Poetry*. New York: Oxford UP, 1989.

Sedgwick, Eve Kosofsky. *Between Men: English Literature and Male Homosocial Desire*. New York: Columbia UP, 1985.

Shelley, Mary. Note to "Prince Athanase." *The Poetical Works of Percy Bysshe Shelley*. Ed. Mrs. Shelley. London: Moxon, 1840. Rpt. in *The Complete Works of Percy Bysshe Shelley*. Ed. Thomas Hutchinson. London: Oxford UP, 1917.

———. *The Letters of Mary Wollstonecraft Shelley*. Ed. Betty T. Bennett. 3 vols. Baltimore: Johns Hopkins UP, 1980–88.

Shelley, Percy Bysshe. "Prince Athanase." *The Complete Works of Percy Bysshe Shelley*. Ed. Neville Rogers. 4 vols. Oxford: Clarendon, 1975.

———. *Shelley's Poetry and Prose*. Ed. Donald H. Reiman and Sharon B. Powers. New York: Norton, 1977.

Showalter, Elaine. *A Literature of Their Own: British Women Novelists from Brontë to Lessing*. Princeton: Princeton UP, 1977.

Silliman, Benjamin. Second letter, "The Letters of Shahcoolen." c. 1801. Rpt. in *A Vindication of the Rights of Woman*. By Mary Wollstonecraft. Ed. Carol H. Poston. 2nd ed. New York: Norton, 1980. 237–40.

Tatler, The. Nº 172 (Tuesday, 16 May 1710). *The Tatler; or, Lucubrations of Isaac Bickerstaff, Esq.* 4 vols. London: Tonson, 1764. 3: 246–50.

Tayler, Irene, and Gina Luria. "Gender and Genre: Women in British Romantic Litera-
 ture." *What Manner of Woman: Essays on English and American Life and Literature.* Ed.
 Marlene Springer. New York: New York UP, 1977. 98–123.

Veeder, William. *Mary Shelley and "Frankenstein": The Fate of Androgyny.* Chicago: U of
 Chicago P, 1986.

Wasserman, Earl R. *Shelley: A Critical Reading.* Baltimore: Johns Hopkins UP, 1971.

Wollstonecraft, Mary. *A Vindication of the Rights of Woman.* Ed. Carol H. Poston. 2nd ed.
 New York: Norton, 1988.

Woolf, Virginia. *A Room of One's Own.* 1929. New York: Harcourt. 1957.

Wordsworth, William. "Ode: Intimations of Immortality from Recollections of Early Child-
 hood." *Wordsworth's Selected Poems and Prefaces.* Ed. Jack Stillinger. Boston: Houghton,
 1969.

———. *The Excursion. William Wordsworth: The Poems.* Ed. John O. Hayden. 2 vols. Middle-
 sex: Penguin, 1977.

———. MS. D. *The Fourteen-Book "Prelude."* Ed. W. J. B. Owen. Ithaca: Cornell UP, 1985.

———. *The Thirteen-Book "Prelude."* Ed. Mark L. Reed. 2 vols. Ithaca: Cornell UP, 1991.

What Happens When Jane Austen and

Frances Burney Enter the Romantic Canon?

WILLIAM GALPERIN

*T*he formulation of my title, despite its interrogatory form, is actually a response—or at least the beginning of one—to what is arguably the central question currently confronting studies in romanticism: "Is there or was there an identity we can call romantic?"[1] Posed a decade ago by Jerome McGann and, more recently, by critics and scholars who have focused largely on women's writing of the period, the question is predicated on a relatively simple, seemingly incontestable, recognition: namely, that "not every production in the Romantic period," as McGann writes, "is a Romantic one" (19) and that the British "Romantic period," for pedagogical as well as scholarly purposes, should at the very least be contextualized within the broader category (and speciality) of British literature and culture between, say, 1785 and 1835. Thus, the question—"Was there or is there an identity we can call romantic"?— interrogates two interlocking matters: the usefulness of romanticism as a pedagogical and interpretive category in our time (*Is* there an identity we can call romanticism?) and the dominance or supposedly "dominant influence" (McGann 19) of the ideology of romanticism in the interval during which the various works we call romantic were actually produced (*Was* there an identity we can call romanticism?).

The problem regarding the category of romanticism, both as to its accuracy and viability, is irreducibly two-pronged. After all, our sense of the "increasingly dominant influence" of romanticism in its time nicely cobbles the historicity of romanticism, as it were, with a historiography that grants romanticism *après la lettre* a peculiar anteriority that doubles ultimately as literary history.[2] But just as important, our growing skepticism or impatience with the limitation of the period to the five or six authors forcibly in the sway of an ideology that, for want of a better term, we call romantic is reciprocally an act of recovery that limits the reach of a certain kind of romanticism in this period by disallowing its influence later on.[3]

The development of Wordsworth's reception in the nineteenth century, culminating in Matthew Arnold's prefatory essay to a collection in 1879 of Wordsworth's poetry, illustrates the peculiar interface of historicity and historiography that has, until recently, shaped our sense of the romantic achievement. For the historical Wordsworth, the poet whose writing career spanned well over a half a century, is a very different poet in the absence of Arnold's historiography from what he is with Arnold's decidedly selective recovery, which limited his career to some two decades or, in the words of the title of the most influential modern study of the poet, to "Wordsworth's Poetry, 1787-1814."[4] And yet, in the same way that Wordsworth without Arnold is a very different and a less conventionally romantic poet from the Wordsworth construed by and through Arnold, his poetry in the interval during which romantic literature and art were produced—that is, his poetry between the years 1787 and 1835—reveals a Wordsworth whose sensibility or ideology is arguably less a tale of two or more poets and two or more ideologies than a Wordsworth whose "identity" as such is more expansive than the construction of Wordsworth according to the usual kind of literary history or periodization.[5]

We are, therefore, confronted with two possibilities regarding the identity of romanticism. We can limit that identity in the same way that Arnold limits Wordsworth or in the same way that canonical practice has effectively limited romanticism to the six or so figures (and their followers and colleagues) who are recognizably romantic in some humanistic or ideologically marked way. Or else we can follow the example of Wordsworth in reconceiving the identity of romanticism so that it is, properly speaking, more encompassing and commensurate with the *range* of cultural productions in the period generally.[6] Such an expansion, needless to say, runs the risk of turning romanticism into a meaningless category, by making it all things to all people. However, in the spirit of the initial interrogative and its inferable reply—which need not be constrained to a simple yes or no—I want to propose a more expansive notion of romanticism, without also making it so expansive that it loses all explanatory power.

With the example of a more catholic, less contained, Wordsworth in mind, I am proposing, then, that we expand romanticism—that we *can* expand it to include other writers whose "romanticism" as such may appear little more than an accident of birth or contemporaneity: that both Jane Austen and Frances Burney, for example, should be included in discussions of romanticism and its particular identity. For not only are Burney and Austen routinely regarded as double-parked alongside the romantic movement, but as *women* novelists, they represent a tradition and a culture whose illumination in recent critical writing poses perhaps the greatest threat to the continued representativeness of the "big six" in conceptions

of the period.[7] Thus, in proposing that we consider Austen and Burney as romantic writers, I am attempting a double move. First, I am suggesting that the engagement of these novelists with romantic issues, no matter how dialectical or oppositional, testifies to the centrality of romanticism as a movement taken up with questions, or, as the case may be, contradictions, of individual agency and social change. Second, I am proposing that, in a reciprocal turn, romanticism is less a single or dominant movement than a movement beside itself. In its steady fluctuation away from and toward its own mode of being (to borrow Paul de Man's formulation in "Literary History"), romanticism in *this* sense is more a hegemony of the sort Antonio Gramsci would later conceive, which is to say, a counterhegemony. It is an order whose various constituents, including those that critics have conveniently dubbed male and female, are absorbed but *not* subsumed in an identity that is *recognizably* romantic—in dealing, again, with questions of individuality, agency, community, and liberty—without necessarily being reducible to the identity we have traditionally called romanticism.

Antitheatricality and the Theater at Mansfield Park

This latter formation can be seen quite clearly in Austen's *Mansfield Park*, which is not only the most inscrutable and, on the surface, the least romantic of Austen's works but is also a text simultaneously taken up with antitheatrical prejudice, which is very nearly a romantic commonplace. Thus, besides reminding us that the well-documented romantic turning away from the theater in fact constituted an aversion to public performance, *Mansfield Park* also shows that antitheatricality, indeed romantic antitheatricality, was scarcely as one-dimensional or as ideologically contained as it appears to most readers in retrospect.[8] It is customarily argued, of course, that romantic antipathy to the theater and the various "closet dramas" produced as a consequence (including works such as Byron's *Manfred* and Shelley's *Prometheus Unbound*, which were not intended for performance, or plays like Wordsworth's *The Borderers*, which were virtually unperformable) reflected the ideal of what Byron termed a "mental theatre" (186–87). In such a theater, as Byron's terminology suggests, drama was returned to the site of reading (and to the scene, by implication, of writing or conception) and, according to those advocating such a return, was thereby spared the peculiar, and indeed demonstrable, dilution that took place when written plays were transferred to the stage.

At the same time, however, the curatorial aspect of romantic antitheatricality, with its fidelity to the work of art, was finally secondary to what was gained (in the romantic imagination at least) in the mere reading of a play in the "mental theatre." This particular gain was articulated by

Charles Lamb in his famous essay on the tragedies of Shakespeare when he observed that "while we read [*King Lear*] . . . we are Lear" (107). Despite the fidelity to the artwork, in other words, or to the creative spirit that the ideal of closet drama is presumed to uphold, romantic antitheatricality was deeply grounded in a privileged sense of the human subject in general.

What all of this suggests is that closet drama was in the end less a lyricizing of the theater (or a marshaling of drama in the service of individual genius, as its proponents routinely argued) than a formalization of what might be termed the privileged act of reading. For only this latter aspect of antitheatricality, with its existential gain, explains why, in breaking *out* of the closet, drama—or theatricality—also poses such a threat to the Romantics: why Coleridge, in discussing contemporary drama in the appendix to the *Biographia,* is compelled to describe the theater as "moral and intellectual *Jacobinism* of the most dangerous kind" (2: 190). More fully than with just about any other romantic occasion, the closeted act of reading underscores—theatricalizes—the paradoxical and regulated ecumenicism that, for better or for worse, continually haunts romanticism: the democratization that is served not simply when the author of *The Prelude* (or *Prometheus Unbound*) manages to be our best self or representative, but more immediately (and ideally) when every man and woman—when every reader, in short—turns out to be a king.

It is normally the business of criticism to turn up such contradictions in romantic texts. However, as the example of *Mansfield Park* makes clear, it is a feature of a more expansive romanticism to anticipate criticism in precisely this function. That is, *Mansfield Park* simply makes explicit a self-critical or counterhegemonic disposition *already* prevalent in seemingly essentialist texts like Lamb's or Coleridge's, where antitheatricality verges, as I have suggested, on the very theatricality or leveling it stigmatizes. In the case of Lamb this critique or theatricalization of the romantic—ostensibly democratic—subject is evident moreover in the racism that provokes revulsion at the "sight" of "the courtship and wedded caresses of Othello and Desdemona" (108) as well as in the nearly phobic, and equally anticommunitarian, aversion to the human body as a prison into which both theatergoer and Shakespearean hero are mutually "crampt and pressed down" (99). In Coleridge's *Biographia* the theatricalization of the humanistic and antitheatrical position is accomplished more overtly by casting the debate on theatrical productions (in which the Coleridgean persona takes the negative position) in dialogue or dramatic form.

And in *Mansfield Park,* which turns in large degree on an extended episode involving the construction of a private theater at Mansfield Park and the preparation for a performance there of August von Kotzebue's anti-aristocratic (i.e., Jacobin) play *Lovers' Vows,* the tendency to theatrical-

ize and thereby to expose an otherwise naturalized position of subjective, comparatively conservative, authority is even more overt and, following my formulation, even more romantic. Not only does antitheatricality compel Austen to promote a particular kind of selfhood in *Mansfield Park*—notably the sincere and autonomous self represented by the heroine Fanny Price—but it also modulates, as in Lamb, to a deconstruction of that "romantic" self, which involves by turns a relinquishment of the very authority—specifically *narrative* authority—of which the very private Fanny is simultaneously a theatricalization.

It is not simply, therefore, that the narrator's observations regarding the unsavory motivations of the characters advocating the performance of *Lovers' Vows* are always off-base in Austen's novel. It is rather that the narrator's criticism of these characters, however apposite, is implicitly leagued with a privileged position of sincerity and integrity that the novel—in the spirit of Elizabeth Inchbald's translation of this play for both the English stage and, by all accounts, the one at Mansfield Park—knows better than to leave unexamined or untouched by the very theatricality that this position opposes.[9] Despite the narrator's apparent endorsement, Fanny's well-known response to being pressured into participating in the play by others—"No, indeed, I cannot act" (131)—is part of a larger theatricalization in which sincerity turns out to be anything but the inability to act. In the wake of a demonstration in which sincere statement ("I cannot act") is also, and nearly tautologically, the definition of sincerity, sincerity is more properly the inability to know one is acting a quite specific role. Unlike proponents of the theatrical such as Mr. Yates and Henry Crawford, who, whatever their failings, know better than to suppose that they are never acting or are always themselves, the sincere self, like Fanny, is simply one that is pressed into a selfhood (or interpellated in the Althusserian sense) without knowing that this is a station (and a rather privileged one) at which she has only arrived.

This point is stressed in the description of Fanny's room, which follows typically on the heels of her refusal to take a role in the theatrical. Although inferior to the many other rooms that were unavailable to her and probably heated (unlike hers), Fanny's room focuses in a subtle and even sinister way on the particular (and it must be emphasized recent) endowment that has driven her—and the narrator in her image—to a seemingly inviolable position of exteriority. Indeed, Fanny's room discloses a position virtually identical to the one in Lamb, where the closeted or private subject immersed in reading *Lear* exposes the peculiar enfranchisement that romanticism, while arguably promoting, seeks simultaneously to redress.

Thus, romanticism—and romanticism, it is worth noting, in fairly specific textual manifestations—is very much an issue in Fanny's room,

notably "for the three lower panes of one window, where Tintern Abbey held its station between a cave in Italy and a moonlight lake in Cumberland" (137). But it devolves upon other, more fundamental details—chiefly the references to ownership and to Fanny's speculations on her own behavior, which these references contextualize—to make a point that Austen's narrator, like Lamb, seems barely able to comprehend:

> Her plants, her books—of which she had been a collector, from the first hour of her commanding a shilling—her writing desk, and her works of charity and ingenuity, were all within her reach;—or if indisposed for employment, if nothing but musing would do, she could scarcely see an object in the room which had not an interesting remembrance connected with it.—Every thing was a friend, or bore her thoughts to a friend; and though there had been sometimes much of suffering to her—though her motives had been often misunderstood, her feelings disregarded, and her comprehension under-valued; though she had known the pains of tyranny, of ridicule, and neglect, yet almost every recurrence of either had led to something consolatory. (136)

What is striking in this passage—in this "lime-tree bower" of sorts—is its overdetermined character. On the one hand, we are certainly to rejoice with Fanny in this room of her own, both as a place to which she can retreat as well as a cathedra from which she can reverse and otherwise forgive the many wrongs committed against her. On the other hand, there is—in the reiterative use of "her" and in the connection between ownership and entitlement—something unsettling that is scarcely relieved by the superiority and omniscience to which the description modulates. It is as if, in her enthusiasm for this place, Austen's *narrator* has temporarily forgotten whose place it is, allowing Fanny to serve as a kind of surrogate for herself and vice versa.

The many commentators, therefore, who follow Austen's lead in contending that *Mansfield Park,* as the author explained to her sister, represents "a complete change of subject [from *Pride and Prejudice*]—ordination," not only adopt a rather narrow interpretation of ordination (assuming it to refer solely to the protagonist Edmund Bertram's clerical vocation); more important, they fail to recognize in what way the representation of ordination—or interpellation—constitutes a "complete change" from the early novel. This change, as I see it, is essentially the difference between the great homes in the two works, Pemberley and Mansfield Park. It is a movement away from something naturalized (Pemberley), which mostly masks and mystifies its imposition on the landscape, toward something that can no longer conceal the contradictory culture—the "England . . . too pure . . .

for slaves to breathe in"—for which Mansfield Park, a slaveholder's seat whose very name recalls the judgment of 1772 *outlawing* slavery in England (from which the above quote is taken), is clearly a metonymy.[10]

Unlike *Pride and Prejudice,* where nature and culture are for the most part captivatingly integrated (following the dictates of the picturesque), *Mansfield Park* is ultimately a work of knowing the dancer from the dance—or of seeing the body apart from ideology or choreography. And it is in this sense—in the sense of the book as world or of Mansfield Park as a designation proper to both book *and* place—that Austen's novel is about ordination. With an assist now from antitheatrical prejudice, an aspect of romanticism that expands inevitably to a *greater* romanticism, *Mansfield Park* is about the scripts finally that its most sincere characters, notably the hero and heroine, subscribe to as natural, yet that *all* of the principals, most notably Austen's narrator, expose by variously performing.

Burney versus Austen

If we accept Austen's bearing on a complex of issues we can call romanticism, or on the expanded sense of romanticism that her entry, so to speak, into the romantic canon highlights, it would appear even more likely that the admission of Frances Burney into this erstwhile "company" would have a comparable effect. In addition to her considerable influence on Austen, specifically the example set by her free and indirect style with its "dominant specularity," Burney's sprawling (and, at times, barely disciplined) narratives, with their attention to "female difficulties," would seem an ideal site for the counterhegemonic formation I am proposing. Yet if this is so, it is mostly by negative example. For just as Burney's omniscient narrator is ultimately appropriated by the theatrical—or romantic— function of *Mansfield Park,* as I have described it, so it is reciprocally the case that Burney's most direct encounter with romanticism, her novel of 1814, *The Wanderer; Or, Female Difficulties,* follows the trajectory of literary history in producing a version of romanticism that has been diverted and tamed from a more expansive, less ideologically hidebound formation. Even more than Burney's earlier novels, whose sheer bulk can be attributed in large part to the author's reluctant embrace of patriarchal values and ideology,[11] *The Wanderer* owes its prolixity to a more systematic, if largely ambivalent, vitiation of romanticism in the name of feminism.

There is, needless to say, an irony to this vitiation. In literally parting romanticism from the feminism in which its counterhegemonic disposition resides—in this case by making the aristocratic Juliet Granville rather than revolutionary Elinor Joddrel the eponymous wanderer whose odyssey leads through a thicket of difficulties especially reserved for women—

Burney not only loses the thread that binds romanticism to feminism in a liberationist sense; she projects through her heroine a vision of romanticism that, for admirers and detractors alike, would eventually become—thanks chiefly to its regulated ecumenicism—the *received* sense of romanticism in the nineteenth and twentieth centuries. Nor is it surprising, then, that in forming her romantic subject as an aristocrat—whose journey is typically a circular return to her rightful station [12]—Burney allows additionally for the demonization of revolution as woman.

For it is the consequence of Burney's quarrel with romanticism—with romanticism, that is, in a more catholic sense—that it reconfigures the constituents of a counterhegemony, one connecting idealist and feminist strains to the enlargement and sophistication of both, in a more distinctly hegemonic formation. In making her wanderer both a representative woman beset by "female difficulties" and a representative aristocrat who has been temporarily removed from her rightful and predestined station, Burney shows that hegemony works not through oppression but, as Raymond Williams has famously argued, by accommodation. Juliet's exposure to female difficulties, and to the real precariousness of women's lives in an ostensibly free and democratic culture, renders the aristocrat and the dominant culture she figures (replete with both a heroic bishop trapped in revolutionary France and a noble father for the heroine) responsive but not answerable to women's culture and its emergent concerns.

Burney, for her part, appears aware of this problem, which she confronts, or more properly allegorizes, rather late in the novel by having Albert Harleigh identify the female antagonist—the revolutionary Elinor—as possessing a "noble, though perhaps, a masculine spirit" (862). It is true, of course, that Elinor's "masculinity" is, in Burney's calculus, plainly instrumental in her attraction to totalizing systems of change like the revolution in France. Yet it is also the lens through which *as a woman* she perceives and ultimately enacts contradictions in notions such as the "rights of woman," which (as she both states and demonstrates) follow the same, largely solipsistic, trajectory as the rights of man. These contradictions, moreover, lead both Elinor and the novel to authentically romantic moments, which are, among other things, authentically feminist moments in their resistance to *all* dominant ideologies, progressive *and* conservative.

Early on, for instance, Elinor is provoked by the topic of the French Revolution—and the charge of barbarism levied against it by Harleigh—to a series of questions that slide perceptibly from an apparently rhetorical function:

> Can any thing be so absurd, so preposterous, as to seek to improve mankind individually, yet bid it stand still collectively? What is edu-

cation, but reversing propensities, making the idle industrious, the rude civil, and the ignorant learned? And do you not, for every student thus turned out of his likings, his vagaries, or his vices, to be new modeled, call this alteration improvement? Why, then, must you brand all similar efforts for new organizing states, nations, and bodies of society, by that word of unmeaning alarm, innovation? (19)

Drawing an analogy between the progress of the individual and that of society, Elinor's rebuttal of the Anti-Jacobin position ultimately founders on its own rhetoric and does so, I would argue, quite purposively.

For the progressive narrative that Elinor proposes in rebuttal is no different from or more compelling finally than the notion of improvement, which is the only kind of qualitative change the conservative position admits. Her description of education, by which she hopes to sway Harleigh to her position, appears—especially with the interrogative—to be anything but enthusiastic. And this is reinforced in her concluding image of society as body, which additionally underscores the discipline to which improvement, or innovation, as the case may be, is tantamount. It is not, then, that Elinor agrees with her interlocutor; it is that she is one step beyond both Harleigh *and* herself in recognizing the counterrevolutionary implications in the progressive argument, which, as she also demonstrates, does not mean that she is not still an anti-anti-Jacobin. Indeed, all that Elinor must do, by way of maintaining her romanticism, is be mindful, as are Lamb and Austen, of the contradiction inherent in a "collective" whose improvement (as her initial query announces) is effectively tied to the coronation of the individual. And she continues in this expansive vein until Burney demonizes her by depicting her as both obsessive and deranged.

The derogation of Elinor and her ideology is there from the very beginning of *The Wanderer,* and it takes a pressured reading such as I have just exerted to complicate what only gradually becomes an increasingly facile identification of Elinor with the excesses of the age. Nevertheless, that these complications exist in Burney's text and exist, moreover, as a countermovement to Burney's ultimate appropriation of romanticism and its figure of the "wanderer" to decidedly patriarchal or moderately feminist ends cannot be dismissed as mere happenstance. Rather, the various dead ends and, with them, the alternatives regarding social change to which Elinor's observations routinely lead us—especially in the novel's early stages—underscore the theoretical reach of an identity that we can call romanticism in that it entails an abandonment of virtually all vocabularies and typologies of change and their attendant narratives. Thus, when nearly a hundred pages later Elinor, in a dialogue with the novel's mysterious heroine, protests that she is not an enemy of marriage between social unequals, her

expatiation on the "liberty" gained through such leveling initiatives adumbrates a position or possibility to which no *extant* narratives can connect:

> If you imagine me an enemy to what the old court call unequal connexions, you do me egregious injustice. I detest all aristocracy: I care for nothing upon earth but nature; and I hold no one thing in the world worth living for but liberty! and liberty, you know, has but two occupations, — plucking up and pulling down. To me, therefore, 'tis equally diverting to see a beggar swell into a duchess, or a duchess dwindle into a beggar. (110–11)

As in her previous observation, Elinor's conventionally progressive claims for liberty are transformed midway into a critique of a conventionally progressive narrative. By the time, in fact, that the word "liberty" is uttered a second time it has proceeded from something like authentic freedom to what, as Elinor suggests, remains a diversion from that end. To see a beggar become a duchess, or a duchess become a beggar, is not to witness productive social change but to be diverted from liberty by maintenance of narratives that are interchangeably progressive *and* aristocratic. This is a world, in short, where mobility and change coexist comfortably and seamlessly with the usual — and still arbitrary — gradations of status and authority.

And it is a world, furthermore, with which *The Wanderer,* like the foreshortened romanticism it necessarily promotes, is entirely comfortable. Even as Burney allows Elinor her critical function in this text, she is much more intent upon writing a narrative that effectively traces one woman's odyssey from beggar (indeed a beggar in blackface) to aristocrat. The only difference is that where Elinor's image of liberty diverted from its true ends involves the fantasy of what is at least a real beggar, Burney's narrative about a woman who merely pretends to be a beggar (and whose sense of entitlement is readable throughout) is far more retrograde in effectively asserting — even while continuing to enumerate Juliet's female difficulties — that beggars should remain beggars. Thus, where Elinor's is a deconstruction of a certain aspect of romanticism in the service of the very liberty toward which texts as various as *Mansfield Park,* Lamb's theater criticism, and Wordsworth's poetry as a whole all point, Burney's is a reconstruction or taming of romanticism to more hegemonic purposes. And yet, as the sheer presence of Elinor makes clear, Burney apparently knew better than always to accept her own authority or, more specifically, the authority of her own narratives. Thus, while she remains — her exclusion from the romantic canon notwithstanding — among the earliest authors of what became, especially with the humanistic amendments of Arnold and his descendants, the received sense of romanticism in *our time,* Burney is

at moments more romantic, more a feminist, and in this sense more like Jane Austen than literary history has generally appreciated.

Coda: Shelley's Triumph *and Its Readers*

Thus far I have been focusing on an expanded romanticism that is especially readable in texts that have, not surprisingly, been excluded from the contemporaneous works we call romantic. However if, as I am maintaining, romanticism constitutes enough of a counterhegemony to accommodate or, at the very least, to have significant bearing on works as ostensibly unromantic as Austen's and Burney's, it must, in a reciprocal turn, be sufficiently expansive not only to include works that are quintessentially romantic by the usual measures of literary history and periodization, but, more important, to enlarge in some new or different way our understanding of them. With this last in mind, I turn briefly to the example of Percy Shelley, in particular to his posthumously published fragment, *The Triumph of Life,* whose transformation, under this dispensation, is quite pronounced. In making this turn, I am altogether mindful that there is probably no text more central to the debates swirling around canonical romanticism in the last quarter century, or that has exerted more pressure on our efforts to narrow and define an ideology that we can reliably term romantic, than Shelley's poem. Nevertheless, in the very way that Shelley's poem has functioned as romanticism's fault line almost from the inception of the so-called "romantic reassessment" in the late '50s and early '60s, *The Triumph of Life* has also been given special license to address its faults or to accommodate them in a strangely hegemonic operation by which a specifically conceived romanticism is not altered or transformed so much as strengthened.

That Shelley's fragment would prove a bulwark in this nearly paradoxical way was already evident in Harold Bloom's dialectically contained reading of the poem's skepticism (*Shelley's Mythmaking* 220–75). As readers will recall, Bloom's interpretation was part of a larger study of Shelley's "mythmaking" that Bloom deemed virtually synonymous with a romantic achievement that, as he additionally urged, had been insufficiently appreciated or understood. In a reading therefore that culminated in a daring recuperation of Shelley as both an apocalyptic poet and a secular humanist, Bloom managed to convert the apparent failure of imagination in the face of materiality, or in the face of what Shelley's poem calls "life," into a humanistic polemic. The defeat of the human imagination by life in Shelley's seemingly infernal vision, Bloom argued—the "triumph of life"—is largely personal, local, and, in the spirit of the humanistic ideology central to both Shelley's mythmaking *and* romanticism, necessarily reversible.

The debate on Shelley's poem continued and, in the minds of many, was brought to a deadlock in Paul de Man's (in)famously deconstructive reading, which initially appeared in a collection of essays edited by none other than Bloom himself. In the essay "Shelley Disfigured," de Man up-ended Bloom's argument, and the humanistic conception of romanticism in whose service it was pressed, by reminding readers that the materiality that Bloom and others had construed through the body (and had thereby contained thematically and, by turns, dialectically) was problematically and more immediately a condition of the sign itself. According to de Man, it is the theme of language or figuration that, in the peculiarly self-referential discourse of Shelley's poem, supplants all other themes, notably the skepticism and idealism that can be folded into one another in what Tilottama Rajan has subsequently termed "a paradigm of romanticism" (326).

De Man is by no means the only critic to have revised our sense of Shelley's poem or of Bloom's reading of romanticism. Nevertheless his *particular* rebuttal of Bloom and, with it, his contestation of any reading of the poem that might hew to an idealistic position (or, for that matter to its dialectically contained yet always convertible opposite—skepticism) did more than spell an end to Bloom's unflinchingly humanistic approach. It represented a challenge of sorts that other critics, confronted (like Bloom) with Shelley's apparent skepticism, quickly rose to. Jerrold Hogle's poststructural reading, for example, takes as its raison d'être the dynamic and unwieldy figuration to which de Man attends. But Hogle, more like Bloom than de Man, marshals that (dis)figuration in a teleology of plenitude that however retrogressive (and consequently impossible) is grounded in a psychic economy wherein skepticism and idealism are, in the manner of "Shelley's process," transferable and very much alive (319–42). And Tilottama Rajan, who also takes de Man's reading of the poem's "unreadability" (326) as a starting point, recurs to the actual manuscript of Shelley's fragment by way of also demonstrating that "disfigurement is not just the effacement of figures" but "also the production of new figures" and, in the hermeneutic dispensation of romanticism as she construes it, new meaning (327).

Rajan's reading is particularly relevant to my purpose—but not because it proves the endurance of a certain idealism in discussions of romanticism (and of this poem in particular). It is relevant because its recourse to the idealistic position is arguably *less* a recuperation of that position according to conventional wisdom than a resituation of idealism within the broader precincts of an expanded romanticism. The only difference I can detect between Rajan's approach and mine is that in expanding romanticism dialectically rather than counterhegemonically, by conceiving it still as narrative or romance rather than as a site of competition, produc-

tion, and oppositionality, Rajan's reading of Shelley represents a long way around the problem. In other words, far from attenuating romanticism in ways that virtually every reader of the poem concedes, *The Triumph of Life*, no less than, say, *Mansfield Park*, is an instance of an *already attenuated* romanticism for which no apologies or polemical interventions are ultimately necessary. Thus, while Rajan is fundamentally correct in asserting that the poem's rhythms of repetition—chiefly those linking the poem's narrator to Rousseau—figure a vitality in excess of both trauma and teleological completion, she is forced by a hermeneutics that is largely dialectical and largely romantic (in a still conventional sense) into a painstaking demonstration of the way "negative statements" in Shelley's poem "are in their turn negated, so as to produce the trace of something positive, though only as a shadow that futurity casts upon the present" (331).

Such a dialectic, needless to say, is much more sophisticated than the one in Bloom, where negation comes to little more than a bad day's work for Shelley. In conscripting the poem to the endless work of reading and living, Rajan takes a crucial step in removing *The Triumph of Life*, and the peculiar idealism of which it is strangely a repository, from a transparently final solution, good or bad. Nevertheless, Rajan's insistence on the poem's direction, or rather her claim that the poem's revisability is not unidirectional in a purely deconstructive sense, overlooks the most extraordinary aspect of Shelley's achievement here, underscored, in turn, by the poem's fragmentary status: namely, that the goal that Rajan explicitly discountenances, yet which remains an inferable disposition of the "futurity" in whose direction the poem inclines, is already at hand and, like the purloined letter, virtually in plain sight. Rajan comes close to acknowledging this reversal when she equates the experience of (reading) the poem with the experience or condition effectively prophesied by the poem's process. Yet the commitment of her reading to futurity and to the narrative, by implication, of which futurity is again a goal, requires that she overlook another goal and plenitude that Shelley has placed before her. This is so because the latter plenitude, which displaces futurity as a vanishing point or horizon of possibility in the poem, is fathomable only by relinquishing the romantic narrative of futurity to which that plenitude is attached in Rajan's argument and on which it seemingly depends. Shelley's poem requires, then, that we submit to a sense of romanticism that is sufficiently expansive, and sufficiently responsive to life *lived*, so that its ends and expectations are unmoored from romance and aligned more immediately with the unromantic and the quotidian.

The Triumph of Life is less a poem about the vitiation of romantic narrative—about the paradise that, having been lost, can never be regained or reconstituted save as a condition of being lost again—than a poem whose

title must be interpreted at face value. I say this because the narrative to which the poem is ostensibly most responsive—the romantic narrative of paradise lost/regained—is one that, under a more expansive romanticism, has been vitiated already and is curiously beside the point, either as a basis for skepticism or for the more tempered, more hegemonic, romanticism that can accommodate skepticism.

Thus, against either the poem's narrator or Rousseau, both of whom maintain the exteriorized subject-position attendant to romantic narrative, *The Triumph of Life* allows simultaneously for a thoroughgoing capitulation to life. It allows, in other words, for a reading from the *inside*, or from the perspective of those caught in life's "jubilee" (III). For such a reading, a reading from the position of the "captive multitude" (119) that an expanded romanticism warrants, demonstrates that the position of "untameable" exteriority occupied by the narrator and by virtually every commentator on this poem is, for all its aspirations, instrumental in resisting the very possibility it apparently cherishes. An "inside-out" reading of Shelley's poem situates the romantic visionary *against* a futurity so close at hand now, so little dependent on narrative linkage or upon mythmaking, that its representation *in vision* is necessarily a misrepresentation of a "new life" more immediately visible and, in effect, a desacralization. Thus, while Shelley's romantic narrator has clearly modeled himself on those personages who, having resisted or rejected life, are among the visionaries dubbed the "sacred few" (128), *The Triumph of Life* simultaneously (and ironically) reserves that designation for a few others—indeed a multitude—who have *already* succeeded in retrieving romanticism from its goals and, living as they do, have successfully retrieved romanticism from its discontents.

Notes

1 My thanks to Jerrold Hogle for this particular rubric and for organizing the panels under it at the 1994 North American Society for the Study of Romanticism Convention (where an earlier version of this essay was delivered).

2 This critical tendency is especially evident in the earlier criticism of Harold Bloom, especially *The Visionary Company* and *The Ringers in the Tower,* both of which postulate a dissenting tradition that effectively brackets high romanticism, whose origins, then, can be traced to Spenser and the later Milton, and whose influence, in the aftermath, extends to the writings of Stevens and Crane in our century.

3 This, again, is the central argument of McGann's *Romantic Ideology,* which cautions against reading romanticism in the Bloomian manner or as a contemporary legacy.

4 I am referring, of course, to Geoffrey Hartman's groundbreaking study of 1964, which marks the culmination of Arnold's approach to Wordsworth. For further discussion of Arnold's role in the formation of a humanistic reading of both romanticism and Wordsworth, see Galperin, *Revision and Authority in Wordsworth* 15–28.

5 For a more detailed exploration of a Wordsworth whose poetry is—overall—a site of

competing ideologies, and continuously contesting itself, see Galperin, *Revision and Authority*.

6 See, for example, Galperin, *The Return of the Visible in British Romanticism*, which expands romanticism by including contemporary popular spectacles such as the Panorama and the Diorama, both of which resisted an organizing human center.

7 For the impact of contemporaneous women's writing on our conception of romanticism, see especially Anne K. Mellor, *Romanticism and Gender*.

8 For a fuller discussion of the relationship between Austen's novel and romanticism, especially in regard to their complicated stance toward theatricality, see Galperin, "The Theatre at Mansfield Park."

9 Unlike with the other, more literal translations of *Lovers' Vows*, the most salient feature of Inchbald's 1798 translation is its avowed English-ness, which is especially evident in the references in her version to both England and to the English that were not in Kotzebue's original text. These references all focus on the issue of sincerity in Kotzebue's play, whose every character, or so it seems, has wandered from another selfhood or identity. Where the original *Lovers' Vows* may be regarded as a play in which a more natural or authentic identity asserts its claim over a selfhood forged by culture and society, Inchbald's (and, by implication, Austen's) text is far less sanguine about the possibility of anything so fundamental. For additional discussion of this issue, particularly as it bears on Austen's novel, see Galperin, "The Theatre at Mansfield Park."

10 Drawing on Austen's documented approval of the writings of British abolitionist Thomas Clarkson, Margaret Kirkham suggests a link between the title of Austen's novel (and the home, coincidentally, of a plantation—hence a slave owner—in Antigua) and the Mansfield Judgment, "which established that slavery was illegal in England," and which Clarkson typically called a "great act." In his opinion Lord Mansfield cited the Elizabethan judgment that "England was too pure an air for slaves to breathe in" (*Jane Austen: Feminism and Fiction* 116–19).

11 For discussion of the politically ambivalent character of Burney's fictions, see Kristina Straub. For a reading of Burney as more focused feminist, see Julia Epstein.

12 For a treatment of the circular journey as a romantic topos, see especially M. H. Abrams. For the political implications of such a narrative as well as the progressive or linear narrative to which it is opposed, see Michael McKeon.

Works Cited

Abrams, M. H. *Natural Supernaturalism: Tradition and Revolution in Romantic Literature.* New York: Norton, 1971.

Arnold, Matthew. "Wordsworth." *English Literature and Irish Politics.* Ann Arbor: U of Michigan P, 1973. 36–55. Vol. 9 of *The Complete Prose Works of Matthew Arnold.* Ed. R. H. Super.

Austen, Jane. *Mansfield Park.* Ed. James Kinsley. Oxford: Oxford UP, 1970.

———. *Pride and Prejudice.* Ed. James Kinsley. Oxford: Oxford UP, 1970.

Bloom, Harold. *Shelley's Mythmaking.* New Haven: Yale UP, 1959.

———. *The Ringers in the Tower: Studies in Romantic Tradition.* Chicago: U of Chicago P, 1971.

———. *The Visionary Company: A Reading of English Romantic Poetry.* 2nd ed. Ithaca: Cornell UP, 1971.

———, ed. *Deconstruction and Criticism.* New York: Continuum, 1979.

Burney, Frances. *The Wanderer; Or, Female Difficulties*. Ed. Margaret Anne Doody. Oxford: Oxford UP, 1991.

Byron, George. "Letter to John Murray." *Byron's Letters and Journals*. Vol. 8. Ed. Leslie Marchand. Cambridge: Belknap-Harvard UP, 1978.

Coleridge, Samuel Taylor. *Biographia Literaria*. Ed. James Engell and W. Jackson Bate. 2 vols. Princeton: Princeton UP, 1983.

de Man, Paul. "Literary History and Literary Modernity." *Blindness and Insight*. New York: Oxford UP, 1971. 142–65.

———. "Shelley Disfigured." *Deconstruction and Criticism*. Ed. Harold Bloom. New York: Continuum, 1979. 39–73.

Epstein, Julia. *The Iron Pen: Frances Burney and the Politics of Women's Writing*. Madison: U of Wisconsin P, 1989.

Galperin, William H. *Revision and Authority in Wordsworth: The Interpretation of a Career*. Philadelphia: U of Pennsylvania P, 1989.

———. "The Theatre at Mansfield Park." *Eighteenth-Century Life* 16.3 (1992): 247–71.

———. *The Return of the Visible in British Romanticism*. Baltimore: Johns Hopkins UP, 1993.

Gramsci, Antonio. *Selections from Cultural Writings*. Ed. David Forgacs and Geoffrey Nowell-Smith. Trans. William Boelhower. Cambridge: Harvard UP, 1985.

Hartman, Geoffrey H. *Wordsworth's Poetry 1787–1814*. New Haven: Yale UP, 1964.

Hogle, Jerrold. *Shelley's Process: Radical Transference and the Development of His Major Works*. New York: Oxford UP, 1988.

Kirkham, Margaret. *Jane Austen: Feminism and Fiction*. Totowa: Barnes and Noble, 1983.

Kotzebue, August von. *Lovers' Vows*. Trans. Elizabeth Inchbald. London: Longman, 1808.

Lamb, Charles. "On the Tragedies of Shakespeare." *The Works of Charles and Mary Lamb*. Ed. E. V. Lucas. Vol. 1. London: Methuen, 1908. 97–111.

McGann, Jerome. *The Romantic Ideology: A Critical Investigation*. Chicago: U of Chicago P, 1983.

McKeon, Michael. *The Origins of the English Novel*. Baltimore: Johns Hopkins UP, 1987.

Mellor, Anne K. *Romanticism and Gender*. New York: Routledge, 1993.

Rajan, Tilottama. *The Supplement of Reading: Figures of Understanding in Romantic Theory and Practice*. Ithaca: Cornell UP, 1990.

Shelley, Percy Bysshe. *Poetry and Prose*. Ed. Donald H. Reiman and Sharon Powers. New York: Norton, 1977.

Straub, Kristina. *Divided Fictions: Fanny Burney and Feminine Strategy*. Lexington: U of Kentucky P, 1987.

Williams, Raymond. *Problems in Materialism and Culture*. New York: Schocken, 1981.

Domesticating Gothic: Jane Austen,

Ann Radcliffe, and National Romance

MIRANDA J. BURGESS

*W*alter Scott outlined his first formal pedigree for the European novel while reviewing Jane Austen's *Emma* for the *Quarterly Review* in 1815, and it was in keeping with the interests of the Tory *Quarterly* that Scott treated literary history as the consequence of a Burkean kind of inheritance. Itself "the legitimate child of the romance," the modern novel has begotten two children: a sentimental and prodigal firstborn, whose own descendants flourish in France, and a cadet—serious, dependable, and domestic, English to the bone—whose favorite children are Austen's works, the modern novel's inheritors (Scott, rev. 189). In 1832, in his magnum opus preface to *St. Ronan's Well*, Scott lent concreteness to this family history with an account of his own literary genealogy. At the same time, for the first time, he granted literary history an explicitly national importance. The best writers of fiction, he argued, seek "*celebrare domestica facta*," a celebration begun by "the authoress of Evelina" and continued by her descendants—"Edgeworth, Austin [*sic*] . . . and others"—before culminating in Scott and his *St. Ronan's Well*, "the most legitimate" of British novels (Preface 5). Scott's account of the novel's romance heritage is nothing especially new, but his shaping of legitimist rhetoric to an overtly nationalist criticism is striking. Invoking what William Hazlitt called "this most barefaced of all impostures, this ideot sophism, this poor, pettifogging pretext of arbitrary power, this bastard interpretation of divine right,—Legitimacy" (178), Scott drew the ideological heart of post-Napoleonic British conservatism into his literary history. The history of the novel as Scott wrote it recapitulates the history of the monarchy, upholding and naturalizing—as in new Tory justifications of Hanoverian government—the superior claims of a younger branch to the English throne. The domestic novel, though a young and distant branch of romance, has the best right to fill its place. Also significant here is Scott's magisterial notion of romance's place. Precisely because of their "domes-

tic" interests, which unite the intimate sphere of the family with the needs of the national arena, novelists are the acknowledged legislators, if not of the world, then certainly of Britain.

In making a literary ancestor of Austen, Scott dedicated her novels to his own ongoing project of cultural renovation and preservation through fiction. His genre reforming was domestic in both senses implied by his quotation from Horace: the homeland *and* the home. For Scott, it culminated in the pageantry he orchestrated for the 1822 visit of George IV to Edinburgh. With a whirl of plaids and bagpipes, he sought to convince all Britain, including Edinburgh, that Scotland was "a nation of Highlanders" (Sutherland 258) — without renouncing the reflexivity of an exercise that essentially urged his fellow citizens to bring his own "Scottish Waverley novels" to life (see *Hints Addressed to the Inhabitants of Edinburgh*). Whereas Scott directed his greatest energy toward the homeland, Austen acted a counterpart role in the private sphere, and it was precisely because Austen had already forged a new role for romance as one of the movers and shakers of cultural history, without attempting to palliate or disguise the genre's artifice, that Scott was able to reconcile generic self-reflexion with his naturalized, genetic legitimation of romance. For Austen successfully confronted the major problem that had faced conservative romantic nationalism since the economic and political upheavals of the 1790s: the suspicion that its conceptions of authority, history, and literary value were unnatural and therefore illegitimate. In her domestic novels, which are also national romances, Austen rested the full weight of legitimacy, not, like Hazlitt, on representation or consent, nor, like his opponent Edmund Burke, on virtue, chastity, and nature, nor even, like Richard Hurd and the gothic revivalists, on Britain's native cultural inheritance, but on romance itself. Although the threats of "illegitimacy" and generic instability surface often in Austen's novels, her reformation of romance, seen retrospectively from a position of generic solidity, permitted Scott to naturalize literary history as the result of the legitimate inheritance of genres, rendering romance's descent unproblematically linear and smooth and turning it to the service of nationhood.

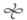

The national romances of Jane Austen reveal an often overlooked conservative thread in romantic nationalist discourse. This conservatism was subtle in its tactics, willing to incorporate and redeploy the energies of economic and political liberalism, and feminist and colonial resistance. It was ultimately more ideologically successful than anti-Jacobin reaction or demonstrations for king-and-country, as Scott's turn from militia drilling to romance writing and pageantry proves. For Austen refashioned and re-

circulated the conventions and techniques of so-called Jacobin novels and national tales—the fictions, respectively, of English radical and colonial nationalist protest. In meeting them on their own ground, defusing the social protests and the generic disruptions that served as their vehicles, she provided a model for conservative novelists from Scott to Elizabeth Gaskell and beyond, establishing the national importance of the domestic novel for the nineteenth century. Her works stretch the borders of the genre Maria Edgeworth had named "the national tale": it was not only England's colonies and dominions that produced fictions of resistance to "foreign" usurpation and cultural conquest, but England itself as well. As Austen defined it, the English national tale was a conservative genre of resistance to the radical discourse that Austen portrayed as a "foreign" corruption of natural, native English romance.

In her important survey of the kinds of historical and political fiction at the turn of the nineteenth century, Katie Trumpener outlines the conventions of the national tale: a novel of national identity preserved in a dialectic between home and nation. While Trumpener's definition reproduces Scott's account of the "legitimate" novel, she also updates and politicizes his generic taxonomy. Her first study example is Sydney Owenson's *The Wild Irish Girl* (1806), which concludes with the marriage of its royal Irish heroine to the son of her English absentee landlord. Because traits "both natural and national" attract Horatio to Glorvina, their marriage creates a "family alliance" that is also "prophetically typical of a national unity of interests and affections between those who may be factitiously severed, but who are naturally allied" (Morgan 112, 253). As a domestic paragon with a talent for historiography and the harp, Glorvina epitomizes the Britishness that Owenson recommends to Ireland's future: a unity-in-difference best symbolized in the reconciliations of romance. Owenson's novel takes part in a generic tradition in which marriage reconciles symbolic and competing solitudes. But at the same time, Trumpener argues, Owenson heads, with Edgeworth, a new tradition, both akin and opposed to the historical romances of Scott and his imitators (693). The national tale, that is, occupies the domestic end of the nationalist romantic project. And the domestic becomes a predominantly progressive—even radical—concern.

In highlighting the nationalist implications of domestic fiction, Trumpener removes Austen's novels from the genealogy she shares with Scott. Austen belongs to a group of "'lady novelists'" characterized by extreme domesticity of focus; Owenson and Edgeworth, in contrast, form an intermediate ground between these homebound ladies and the masculinized historical tradition exemplified by Scott and John Galt, revealing the dialectic between the two generic histories (689). Yet Austen imitated and parodied Owenson's and Edgeworth's works, as well as those of Ann Rad-

cliffe, their ancestor in the national tale (693). Neither mere burlesque nor limited to her earliest works, Austen's response to Radcliffe's anti-Jacobin gothic romances and Owenson's national tales in *Northanger Abbey* provided a model for her own English version of national romance. In an 1809 letter, she comments that the "Irish Girl does not make me expect much" from a sequel—though "If the warmth of [Owenson's] Language could affect the Body it might be worth reading in this weather" (*Jane Austen's Letters* 251). Her winter reading prefigures the scene in *Northanger Abbey* in which Catherine Morland and Isabella Thorpe "meet . . . in defiance of wet and dirt, and shut themselves up, to read novels together." Unlike her characters, whose avid consumption of Radcliffean gothic cements what she sarcastically terms their "very warm attachment" and "literary taste" (37, 39), Austen remains unmoved by Owenson's and Radcliffe's claims that "nature" undergirds their marriage plots. What Owenson treats as a heartfelt union of hero and heroine, Austen dismisses as a rhetorical effect produced by overpassionate language. Symbolic marriage, however desirable, remains a function of romance. And so, Austen will demonstrate, does the "nature" of the English nation.

A glance at these nationalist novels of the early nineteenth century reveals the conflicting political positions latent in any new genre such as the national tale.[1] Like the gothic romances and national tales Austen revised, her national romance uses symbolic marriages to unite competing cultures and classes and to celebrate what it defines as England's national character, under threat from the cultural change it construes as "foreign." But her romances work, more influentially than their liberal and conservative predecessors, not by linking national character with natural domestic virtue but by declaring explicitly and joyfully the conventionality and artifice of the heroine's final domestic happiness, and their own generic conventions. Austen's novels acknowledge, often explicitly, the artificiality, the riskiness, and contingency of their conclusions: what Austen recognized was the potential that accusations of artifice held out to a conservative nationalism. Austen's embrace of the literary was made possible by the very contradictions that Hazlitt and others, in the 1790s and after, had used against conservative discourse.

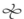

To plot Austen's position on a multiaxial graph of contemporary contradiction and crisis: two late-eighteenth-century revolutions form the origin and center—the French Revolution and its Napoleonic aftermath, and that English revolution in political and economic authority that McKendrick, Brewer, and Plumb, and Corrigan and Sayer, and other historians and sociologists call "commercialization" or "*embourgeoisement*." Austen's spe-

cific political loyalties, it should be noted, have proved elusive, fueling discussions of the novelist as, variously, a proto-Marxian critic of market liberalism (Evans), a utopian aristocrat (Butler), and a feminist radical (Kirkham). These arguments prove neither Austen's political vagueness nor the bad faith of her critics, but they highlight the degree to which determining the politics of British female novelists in this period has depended on their often illegible place in the French Revolution debates. Viewing socioeconomic upheaval as Austen herself responded to it, however—as it was embodied in the debate on the legitimacy of England's "gothic" inheritance and the changes wrought by the Copyright Act of 1774—reconciles and complicates the various conflicting Austens of recent account. And allowing Austen to appear in the complex role of a self- and historically conscious conservative helps to define her national romances as well.

It was only in eighteenth-century France that a declared political revolution took place at the fin de siècle. It is equally important for novelists, however, that Britain in the same period underwent a copyright revolution conducted by a coalition of the powerful and the upwardly mobile. Siding with upstart provincial booksellers against the established monopoly in the 1774 *Beckett v. Donaldson* case, the House of Lords threw out the de facto perpetual copyrights held by the London trade and replaced them with time-limited contracts between writers and sellers (see Walters). In deciding *Donaldson*, the lords invoked hereditary privilege to silence the disputes of their social inferiors—but by finding in favor of the entrepreneur (or pirate) Donaldson, damning his respectable opponents as " 'impudent, monopolizing men,' " the lords ended whatever illusions might have remained about the separation of aristocratic power from the commercial sphere. At the same time, by forcing writers to contract with booksellers for particular editions and sellers to hone their marketing and distribution in order to turn a profit within a much briefer copyright period, *Donaldson* institutionalized competition and contract in the republic of letters— now explicitly become, as critics lamented, a literary marketplace. But the *Donaldson* decision also paved the way for the reissue of old books as classics in fancy-bound series—an impulse toward literary nationalism that, by the early nineteenth-century, had expanded to include the previously unregarded genre of the novel. Anna Barbauld's fifty-volume bound and matching set of *British Novelists* (1810), with critical introductions, defined (and marketed) a canon of "great" fiction, as editors had been doing with poems since Thomas Warton published his *History of English Poetry* in 1774. Not least among editors and printers of novels, then, the profit motive gave birth to a national literary traditionalism—a canon-forming drive.

The debate on revolution and the ambivalent effects of the new copyright law produced parallel contradictions in England's existing national

myths. Liberal theory had relied from its inception on the natural, affective order of English families, an assumption that undergirds the politics of John Locke's *Two Treatises of Government* (1690) and, more shakily, David Hume's account, in the *Treatise of Human Nature* (1740) and the *Essays Moral, Political, and Literary* (1740–58), of the passions as a source of human authority.[2] This reliance on family feeling now gave place to Edmund Burke's fear, expressed in the *Reflections on the Revolution in France* (1790), that traditional reverence for the chastity and beauty of women and the authority of husbands and fathers, which he admitted was only a "pleasing illusion," was fast crumbling into skepticism (67). Burke's lament embodied the discomfort of Hanoverian apologists turned conservatives, who had long celebrated the forced abdication of James II as a return to English nature—a restoration of "gothic" principles of English liberty and a sign of progress away from Catholicism and feudalism, an end of revolutionary history—but now found their own putatively final and decisive revolution uncomfortably replayed in France. The erstwhile Catholics across the channel shouted slogans of British Protestant modernity (*liberté, fraternité*) while behaving in ways that erstwhile liberals such as Burke felt only emphasized the gothic barbarity of the revolution they sought to defend. In conservative minds, the "gothic inheritance" gave way to gothic Terror.

The part played in the Revolution Debate by English Jacobin women in particular—often writers of gothic romances, whose incipient feminism cooperated with and strengthened their reformist politics—revealed the artificial and economic origins of the naturalized conception of the state beloved of liberal theorists and their own romance-writing apologists. Above all, Mary Wollstonecraft emphasized the artifice of contemporary ideals of feminine character, the degree to which French goals resembled English gothic ideals, not least in French constructions of the family—and the unjust results in England and France, especially for women. Her own two treatises of government, the *Vindications* and her *Wrongs of Woman*, exposed the conception of "woman's nature" that underwrote the cooperation of moral theory with political requirements. At the same time, they emphasized the intimate links between the "gothic" barbarity that New Whigs such as Burke lamented in the French Revolution and the New Whigs' own ideal of England's gothic past (compare Burke, *Reflections* 62, 66–67, with Wollstonecraft, *Vindication of the Rights of Men* 10, 48).

Wollstonecraft made these connections by pressing the self-deconstructive tendencies of the late-century gothic revival, forcing it to expose its own latent contradictions. These contradictions appeared in aesthetics and literary history in ways that repeated the uneasy balance within ideologies of commerce as expressed in the conflicting canonizing and marketing drives of the book trade. In his treatise on national aesthetics, *Observations*

Relative to Picturesque Beauty (1788), for example, William Gilpin praised English architects for giving up "awkward imitation . . . to strike out a new mode of architecture . . . without searching the continent for models" (1: 16). But even as he admired the Englishness of gothic structures, he took special pride in their ruin, as he pointed out in his admiration for the great abbeys of the North of England: "Where popery prevails, the abbey is still intire and inhabited"—but England's ruined abbeys are "naturalized to the soil," a pleasing backdrop for a liberal nation and its industrious and rational citizens (1: 13–14). This naturalness, Gilpin declared, is evident even where the ruins are replicas, put up to adorn the grounds of England's great houses.³ Richard Hurd's *Letters on Chivalry and Romance* (1762) similarly reframed literary history as a contest between native and foreign models: neoclassical works are "more perfect," but "Gothic architecture has it's [*sic*] own rules, by which . . . it is seen to have it's [*sic*] merit, as well as the Grecian" (61). Before Burke's elegy on the "pleasing illusions" of "the age of chivalry" was Hurd's lament for the "revolution" away from gothic style: "What we have lost, is a world of fine fabling; the illusion of which is so grateful to the *charmed Spirit*" (120).

Gilpin's and Hurd's ambivalent elegies on English national character resound through Burke's more overtly political *Reflections*—the immediate target of Wollstonecraft's protests against English gothic. Thus the gothic contradiction created a schism not only in aesthetics but also in political theory, where it came together in a single narrative with aesthetic debate. Burke scolds the French, who, having "possessed in some parts the walls and in all the foundations of a noble and venerable castle," "might . . . have built on those old foundations" instead of "pulling down an edifice which has answered . . . for ages the common purposes of society" (31, 53). But the English love of "old foundations," Burke argues, prevents a revolution from ever taking place in England: "The very idea of the fabrication of a new government is enough to fill us with disgust and horror. We wish . . . to derive all we possess as *an inheritance from our forefathers*" (27–28). With the anniversary of England's own 1688 revolution close in memory, Burke cannot simply advocate retaining tradition for tradition's sake. Instead, he creates a complex alchemy between English aesthetic and political tradition and the laws of human nature. The alchemy kicks in as Burke, like Hume before him, reveals natural "common . . . sense" as the true father and ruler of English tradition: "[S]ense . . . hath built up the august fabric," and wishes, "like a prudent proprietor, to preserve the structure from . . . ruin" (81). Sense keeps English politics true to nature, and "[u]pon that body and stock of inheritance we have taken care not to inoculate any cyon alien to the nature of the original plant" (28). Legitimacy is a function of primogeniture tempered by a higher nature.

These parallel contradictions in the literary and political public spheres produced parallel resolutions. Both are embodied in Austen's novels, and especially in their distinctive relation to the gothic: to what contemporaries argued was England's native tradition both in letters and politics. As a literary genre, the gothic was favored by the English Jacobins, including Wollstonecraft and William Godwin, as well as by antirevolutionary New Whig and conservative novelists, social theorists, and literary historians from Radcliffe and Regina Maria Roche to the young Scott, Burke, Hurd, Horace Walpole, and Clara Reeve. As a historical theory and national style, it formed an important strand in conservative as well as in radical politics (see Smith 35). In her national romances, Austen burlesques gothic and laughs impartially at its mingled visions of aristocratic corruption and revolutionary tyranny. Despite her outspoken reservations, however, she retains and reuses many of the gothic elements she laughs at, countering both Wollstonecraft and her opponent Radcliffe on their chosen political and literary ground.

Thus Austen's self-conscious national romances simultaneously depend on and resolve the contradictions in English romance writing and social theory. Two sets of scenes—one set in Ann Radcliffe's *The Italian* (1797) and one in Austen's *Northanger Abbey* (1818)—will illustrate the difference between Austen's response to Wollstonecraft's theory and the gothic revivalists she opposed, and the response of more traditional conservatives, whose romances supported the gothic visions of Hurd and Burke. Beneath Austen's new way of thinking about privacy and nation lie the urgent problems of nature, fiction, and English tradition that, after Burke and Wollstonecraft, had undermined the conservative force of "nature." Austen's proposed solution, however, is less the symbolic resolution of her novels in happy domesticity than her re-creation of that resolution in a chain of English households. *Northanger Abbey* begins the process I will call domesticating gothic: bringing the most visible conventions of the genre home from Italy, where Radcliffe has used them to distance the English reader from political instability; home from the turf of Wollstonecraft and the English Jacobins, who have assailed in gothic novels and novelized polemic the justice of modern English politics and ancient tradition: home in the sense of a return to the domestic *and* the national fold. Radcliffe's gothic scenes become landmarks on a map on which Austen traces, with increasing assurance, the ties between family, fictions, and politics.

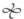

Radcliffe's stylized rhetorics of the sublime and beautiful mark her entry into the arguments about gender and aesthetics in which Wollstonecraft and Burke conducted their debate on nature, politics, and gothic inheri-

tance. The most striking set piece in her politicized aesthetics appears at the center of the novel, as the hero, Vincentio di Vivaldi, and heroine, Ellena Rosalba, escape from the convent where she has been imprisoned — and "stop," despite fear of pursuit, "to admire the scene." Each enjoys a separate segment of the circumferential view:

> "See," said Vivaldi, "where Monte-Corno stands like a ruffian, huge, scared [sic], threatening, and horrid!—and in the south, where the sullen mountain of San Nicolo shoots up, barren and rocky! From thence, mark how other overtopping ridges of the mighty Appennine darken the horizon far along the east, and circle to approach the Velino in the north!"
>
> "Mark too," said Ellena, "how sweetly the banks and undulating plains repose at the feet of the mountains; what an image of beauty and elegance they oppose to the awful grandeur that overlooks and guards them! Observe, too, how many a delightful valley, opening from the lake, spreads its rice and corn fields, shaded with groves of the almond, far among the winding hills; how gaily vineyards and olives alternately chequer the acclivities; and how gracefully the lofty palms bend over the higher cliffs." (78–79)

Deictics notwithstanding, neither turns to look: Vincentio continues to gaze on the sublime power of the mountains and Ellena at "beauty," fertility, undulation, and domestic cultivation. Their parallel but separate pleasures complement each other as the "beauty and elegance" of the plains temper the "awful grandeur that overlooks and guards them," or (as their diction is meant to suggest) as the bracing sensation of awe produced by the masculine sublime, with its links to political as well as aesthetic power, complements the enervating effect of the feminized and maternal beautiful in Burke's *Philosophical Enquiry into . . . the Sublime and Beautiful* (1759).[4] This division of labor within the aesthetic allows Radcliffe to enforce the idea of naturally separate spheres for (public) men and (private) women.

Wollstonecraft's radically constructionist account of "female nature" exposes such links with "beauty" as a political fiction, a product of "specious homage," "false refinement," and "the constitution of civil society" (*Vindication of the Rights of Woman* 73, 76). At first, Radcliffe seems poised to counter Wollstonecraft on her own culturalist ground. Like Radcliffe herself, Ellena founds her claim to worth on her work as a professional in "the field of cultural production," a maker of elegant and luxurious consumer goods.[5] She spends "whole days in embroidering silks, which were disposed of to the nuns of a neighbouring convent, who sold them to the Neapolitan ladies, that visited their grate, at a very high advantage" (9). But even as Radcliffe emphasizes Ellena's status as a cultural producer, she re-

plies to Wollstonecraft—not as Austen will do, by embracing cultural pro-
duction as a source of useful social fictions, but by reasserting the already
shaky Burkean aesthetics that Wollstonecraft had countered (158–59).

The consequences of Radcliffe's denial become especially clear when re-
lations with peasants are brought into the picture. For a third voice joins
in these scenes of taste: that of Paulo, Vincentio's robust indentured ser-
vant. Paulo responds to Ellena's cries of aesthetic pleasure as Ellena does
to Vivaldi's. Respectful but not empathic, Paulo is preengaged, occupied
with a pleasing view of his own:

> "Ay, Signora!" exclaimed Paulo, "and have the goodness to observe
> how like are the fishing boats, that sail towards the hamlet below, to
> those one sees upon the bay of Naples. They are worth all the rest of
> the prospect, except indeed this fine sheet of water, which is almost
> as good as the bay." (159)

Paulo takes pleasure, not in sublimity or beauty but in signs of habitation
that remind him of his Neapolitan home. The boats he longs for figure in
an earlier aesthetic set piece in the novel. Places of picturesque labor as
well as objects of peasant desire, they provide an unconscious spectacle
for nobles who find aesthetic—and covertly political—gratification in the
peasants' natural enjoyment of their workday, which Radcliffe represents
as largely given up to singing and dancing:

> [T]he . . . company listened to voices modulated by sensibility to finer
> eloquence, than is in the power of art alone to display . . . while they
> observed the airy natural grace, which distinguishes the dance of the
> fishermen and peasants of Naples. . . . Frequently . . . such magic
> scenes of beauty unfolded, adorned by these dancing groups . . . as no
> pencil could do justice to. (37)

Singing about their work, the peasant fishers, like Paulo, never transgress
the boundaries that separate their "picturesque" labors from the delicate
and leisured taste of their watchers (37). As Radcliffe organizes her aes-
thetic scenes, the peasants' lack of aesthetic taste—a tenet of theorists from
Hume to Burke—ensures obedience and joyous acceptance of their place.[6]

Accordingly, so long as the upper class remains willing to allow space
for the domestic, self-interested, and social taste of peasants, the peasants
will continue to participate docilely in the compositions of the aristocrat's
picturesque eye. The distance between gentleman and peasant laborer will
remain firmly in place while the gentleman surveys, as part of his own
aesthetic (if not actual) demesne, the peasant's delight in his surround-
ings. Those who refuse to tolerate the taste of their inferiors are doomed to
suffer rebellion, as the monk Schedoni, Ellena's uncle and usurper of her

father's lands and title, finds as he journeys with his niece and a peasant guide through a country carnival:

> He . . . bade the peasant be silent; but the man was too happy to be tractable. . . . Every object here was to him new and delightful; and, nothing doubting that it must be equally so to every other person, he was continually pointing out to the proud and gloomy Confessor the trivial subjects of his own admiration. "See! Signor, there is Punchinello, see! how he eats the hot maccaroni! And look there, Signor! there is a juggler! O! good Signor, stop one minute, to look at his tricks. See! he has turned a monk into a devil already, in the twinkling of an eye!" (274)

Ellena "consent[s] to endure" the scene and the peasant's commentary, but Schedoni, intent on quelling his carnival humor, continues to order " 'Silence!' " (274).

Among the varied scenes at the fair is a troop of traveling players enacting a domestic tragedy. The peasant means nothing particular in his cry of " 'Look! Signor, see! Signor, what a scoundrel! what a villain! See! he has murdered his own daughter!' " (274). But his careless speech becomes subversive precisely because Schedoni forecloses the peasants' exercise of their taste, an act that leaves him vulnerable to incursions by the peasantry on his own taste's boundaries. Schedoni's guilt shows on his face: he has himself attempted to murder Ellena, whom he believes to be his daughter. On noticing Schedoni's passion, the guide assumes a "significant look" and familiar tone as he recounts a story of murder and usurpation that resembles Schedoni's own (282). The aristocrat's haughty disengagement gives the peasant a hold on him—a hold that quickly becomes literal, as, having "followed Schedoni to the . . . end of the chamber," the peasant "took hold of his garment, as if to secure his attention to the remainder of the story" (283). Even when Schedoni "rose, with some emotion, and paced the room . . . the peasant kept pace with him, still loosely holding his garment" (283).

Those aristocrats, conversely, who indulge their servants' sociability win their lasting but respectful attachment. When Paulo offers to amuse Vincentio with a mysterious tale, Vincentio invites his servant to sit beside him and listens with an attitude of explicit forbearance. His tolerance ensures his own control of Paulo's narrative, and Paulo moves around in his story in response to Vincentio's demands for digressions and commands to "proceed" (81–82). But Paulo's loyalty runs deeper than his effective storytelling for Vincentio's pleasure. Having rescued Ellena and arranged his marriage to her, Vincentio offers to free Paulo and grant him a large sum of money, whereupon the peasant weeps at Vincentio's feet in "a passion of joy and

affection" and begs to remain in vassalage (405). Paulo's love for his master shows the benefits of Vincentio's tolerance: his loyalty permits the marchese to forget his own defensive haughtiness and makes a reassuring spectacle for the "noble spectators," who applaud Vincentio's "generous" promise that the weeping Paulo "should always remain . . . 'near me'" (407–8).

The novel agrees with Burke that "good order" requires that "the people . . . not find the principles of natural subordination by art rooted out of their minds" (215). To Radcliffe, a naturalized aesthetics is the best prevention. In a final tableau symbolizing the idealized social relations heralded by the marriage of Vincentio and Ellena, Radcliffe stages "a scene of fairy-land" comprising the "beautiful" Vivaldi villa and the "bold" and "lofty" view it "commanded," a realm large enough to accommodate all classes (413):

> Vivaldi and Ellena had wished that all the tenants of the domain should . . . share the abundant happiness which themselves possessed; so that the grounds, which were extensive enough to accommodate each rank, were relinquished to a general gaiety. (414)

All ranks join in the festivities without ever meeting to offend each other's tastes: Radcliffe capitalizes on Paulo's loyalty and Vincentio's toleration. Consequently, Paulo and the peasants are the happiest of all the guests as they dance—or "'frisk,'" as Paulo puts it with an aggressive simplicity not his own, "'in my own dear bay of Naples, with my own dear master and mistress'" (Radcliffe 414). Offered his freedom, Paulo refuses to leave his master, continuing to celebrate, in loaded terms, his "liberty" (Burke 59). Rebellion, or even what Burke called a "monstrous medley of all conditions, tongues, and nations," is less a political than an aesthetic, and natural, impossibility (59).[7]

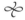

Radcliffe's self-conscious use of aesthetic taste to realign classes and genders, restoring them to their "natural" places in the home and the polity, makes *The Italian* a forerunner not only of the national tale but of the early-nineteenth-century conservative novel as well—a mixture of self-reference and didacticism that would aim at producing in the reader's own domestic life its artificial but essential domestic conclusion. But Radcliffe's retreat into utopias dressed as nature was not a solution to appeal to Austen. To establish domestic harmony, in its national as well as its homely sense, required the kind of "pleasing illusion" that would affirm rather than efface its role in "good order": a fiction that would acknowledge the artifice of its domestic displacement of gothic terror.

Austen answers both Radcliffe and Wollstonecraft by rewriting their

scenes of beauty and sublimity in *Northanger Abbey*. Just as Radcliffe places her characters atop an Italian summit with a "circle of mountains" at their feet, so Austen's heroine and hero, Catherine Morland and Henry Tilney, climb a small rise in Somerset, so that "the whole city of Bath" is gradually unfolded as a "landscape" at their feet (111). Austen's ironized version of Radcliffe's set piece revises its vision of naturally separate tastes as Henry gives Catherine—who unlike Ellena knows "nothing of taste"—"a lecture on the picturesque." Like Radcliffe's Vincentio, with his love of blasted scenery, Henry has a taste for the sublime in landscape, and he rhetorically turns picturesque beauty to sublime grandeur so that Catherine and he can both imagine it clearly, demonstrating the desirable effects of sublimity in landscape by invoking "a rocky fragment" and a "withered oak" amid the "beauty" Catherine admires (110-11). Less delicate than Ellena, Catherine can appreciate Henry's taste for the sublime—if only because she appreciates Henry. She is "so hopeful a scholar, that . . . she voluntarily rejected the whole city of Bath, as unworthy to make part of a landscape" (111). Having gained his point, Henry ends the discussion:

> Delighted with her progress, and fearful of wearying her with too much wisdom at once, Henry suffered the subject to decline, and by an easy transition from a piece of rocky fragment and the withered oak which he had placed near its summit, to oaks in general, to forests, the inclosure of them, waste lands, crown lands and government, he shortly found himself arrived at politics; and from politics, it was an easy step to silence. (111)

Curiously, conservative romance and radical theory agree about women's relationship to the sublime: Radcliffe demonstrates in *The Italian* that women naturally admire the beautiful and unvaryingly fail to appreciate the sublime, while Wollstonecraft argues in her *Rights of Woman* that women and servants are denied access to "the sublime curb of principle" (105) and the poetic sublime by a training in sensation—and romance reading—that teaches them to prefer "the graceful before the heroic virtues" (126) and blinds them to their own "sublime hopes" of an afterlife (100). But Austen, in her new national romance, takes a radically different position: Catherine *can* gain access to the sublime, and she does so *without* being "allow[ed] . . . to participate in the inherent [political] rights of mankind" that Wollstonecraft argues are needed to overthrow the "arbitrary" "sexual distinction" (*Rights of Woman* 265–66). In forging her own practical aesthetics, then, Austen denies Radcliffe's arguments for a domestic and beautiful feminine nature as fully as she rejects Wollstonecraft's call for political change that will open the aesthetic and political sublimes to women. But Catherine must learn, all the same, to confine

her taste for the sublime within certain limits, giving up her excessive pleasure in the gothic novel, which threatens the resolution of Austen's own novel's: Austen reconfigures Wollstonecraft's social revolution as a "revolution in [Catherine's] . . . ideas" (171). Henry carefully orchestrates Catherine's learning, introducing her to sublimity while exerting his authority as a teacher—and as a man—to restrain her developing taste. His limit is the boundary between the private and public spheres, the point where Catherine famously confuses gothic novels with revolutions, and he transforms taste into politics by making a (Burkean) metaphor of his own, blasted "British oak." Past this point Catherine cannot, does not, and indeed *should* not want to follow—as Henry well knows, and as his direction of their discourse ensures.

To aid in his disentanglement of politics and aesthetics, gothic and riots, Henry invokes the materiality of the Radcliffean book in terms that will shape Austen's conclusion. The "something very shocking" that Catherine breathlessly expects "will soon come out of London" is in fact "nothing more dreadful than a new publication which is shortly to come out, in three duodecimo volumes, two hundred and seventy-six pages in each, with a frontispiece to the first, to two tombstones and a lantern" (112–13). Such a "dreadful" duodecimo work, a portable, concealable, and thus seductively antisocial volume, is a fashionable item whose standardized content does not diminish the anticipation of its eager readers. Yet the book's materiality, which contributes to its "dangers," can also be used to contain them. When Catherine calls Radcliffe's *Mysteries of Udolpho* "the nicest book in the world," Henry retorts: " 'I suppose you mean the neatest. That must depend upon the binding' " (107). He reduces Catherine's potentially dangerous admiration for gothic novels to fashion and the desire for something new. Claudia Johnson has complained that he bullies Catherine (*Jane Austen* 37); yet Henry is more the agent than the target of Austen's irony, and the conclusion reinscribes his weighty influence: Austen stills the voices of her hero and heroine to remind readers that they, too, hold a duodecimo novel in their hands. While Henry and Catherine's romance remains unresolved, Austen says, the "anxiety . . . can hardly extend, I fear, to the bosom of my readers, who will see in the tell-tale compression of the pages before them, that we are all hastening together to perfect felicity" (250). Like the popular novels that Henry makes safe, Austen's book is not just a potentially "dreadful" work of romance but a predictable artifact, bought precisely for its predictability, and therefore rendered sociable and harmless.

But *Northanger Abbey* offers more than popular gothic romance: Austen turns the commercial availability and generic conventions of romance to political advantage. Her final sentence reiterates the book's encounter with a faceless literary marketplace, and its subjection to unknown critics and

readers, but it simultaneously claims the anonymity and wide distribution of the novel as a stimulant to a healthy moral debate:

> I leave it to be settled by whomsoever it may concern, whether the tendency of this work be altogether to recommend parental tyranny, or reward filial disobedience. (252)

In asking her readers to "settle" the moral, Austen briefly names the reader's power over the text before reasserting the power of the book to "recommend" morals and to shape the ethical discussions of its readers as they "hasten together" toward conclusions.[8]

For Austen's own novel is not a "dreadful" three-decker gothic. The very changes in copyright law that created the uneasy balance between the "republic of letters" and literary marketplace permitted novelists to manipulate not only the content and form of their novels, but the styles and sizes of their bindings as well, emphasizing on the level of the book itself the purpose to which its reader should put it (Bronson; Kernan). Austen wrote *Northanger Abbey*, arguably her most polemical novel, in a form that denied the demands of the circulating libraries for three-volume gothics by appealing to the still unusual private middle-class buyer of novels. Even on posthumous publication in 1818, her two-volume work was less expensive than the three-volume works of the novelists of the 1790s: as half of a four-volume set, it sold for 24s., bound (*Jane Austen's Letters* n.pag.; see also "New Publications" 256), whereas Radcliffe's *Mysteries of Udolpho* (1794) cost $1 bound (Rev. of *Mysteries* 278), and *The Italian* 15s. sewed (Rev. of *The Italian* 35). Her prices were the same as that for Wollstonecraft's two-volume *Vindication of the Rights of Woman,* published twenty years before Austen's novels and priced much lower than the early-nineteenth-century standard (Rev. of *Vindication* 198; see also Altick; Lovell). As this comparison with a political treatise suggests, the two-volume book was a common form for topical political pamphlets and popular sermons. By insisting on the cheap two-volume form for her own national romances and at the same time retaining the Radcliffean duodecimo binding, Austen promoted consumption and domestic reading of her novels while insisting on their political and didactic force.[9]

Austen's declared and implicit investment in print culture is crucial to the question of what it means for an English novel to be a national romance. Henry Tilney couches moral choices in literary terms when he asks Catherine to choose between competing histories of letters and England's gothic past:

> "Remember the country and the age in which we live. Remember that we are English, that we are Christians. Consult your own under-

standing, your own sense of the probable, your own observation of what is passing around you—Does our education prepare us for such atrocities? Do our laws connive at them? Could they be perpetrated without being known, in a country like this, where social and literary intercourse is on such a footing; where every man is surrounded by a neighbourhood of voluntary spies, and where roads and newspapers lay every thing open?" (197–98)

What has gone surprisingly unnoticed in this speech is Henry's invocation of England's traffic in books: the public press and its distribution networks, the turnpike roads and canals that had riddled England for thirty years.[10] Having discredited the naturalness of English gothic, Henry takes up, makes explicit, and politicizes the submerged artificiality in the gothic revival's celebration of canon and tradition, emphasizing the role of print production in producing social order.

Among the more significant implications of this embrace of print culture is Austen's refashioned account of the aesthetic tastes of working people and their effect on social order. In *Persuasion*, for example, published bound with *Northanger Abbey* in 1818, Austen parodies *The Italian*'s concluding "meeting" of the classes. As the Musgrove sisters lie side by side, unconscious on the Cobb at Lyme Regis, fishermen gather "to enjoy the sight of a dead young lady, nay, two dead young ladies, for it proved twice as fine as the first report." But despite the gazers' evident, erotic-political relish, "[t]o the best-looking of these good people Henrietta was consigned" without scruple (111). Unlike Radcliffe, Austen acknowledges the potential overlap of classed and gendered tastes, even allowing her own fishers to turn Radcliffe's tables and make aesthetic objects of the gentry. Yet Austen's heroine imposes order on the scene, and Austen's own self-conscious, self-reflexive control over the novel ensures that the workmen never think to break it. Her fiction dismisses the dangers of class miscegenation even as it acknowledges and reproduces the threat.

It is Austen's popular packaging of improving and individuating reading that makes her novels part of the prehistory of the modern mass culture industry, as Horkheimer and Adorno and Habermas have described it. The new popular novelist set herself the task of producing families who would form a secure and virtuous web across England, from the metropolis to the provinces; who would absorb and defuse the dangers of reading and of radical critiques of aesthetic and political artifice. A socially conservative counterpart to the male-dominated radical corresponding societies, Austen's envisioned chain of femininized reading households would ensure, as Henry Tilney enthusiastically puts it, "a neighbourhood of voluntary spies . . . where roads and newspapers lay every thing open,"

guaranteeing social order (159). Burke's natural families and Wollstone-craft's fictive ones become for Austen an exuberant trust in the circulation, distribution, and virtuous reading of such novels as her own. *Northanger Abbey* reconfigures the reading public as individual women engaged in moral reflection in the intimate sphere of the family.[11] It makes available the moment at which conservatives harnessed the privacy of the "popular twelve" for their own use.

Austen countered lending library and radical gothic alike with a romance that hailed its reader as what Nancy Armstrong has called a "domestic woman": the bearer of a subjectivity that the national romances by Austen and by others would produce and teach. In so doing, she embraced the radical view that the role of women in families is indeed a conservative political fiction—but, for Austen, a desirable and nationally vital fiction, generated and supported by writing, selling, and reading moral novels. In 1815, Scott praised Austen for creating "such characters as occupy the ordinary walks of life," contrasting her skilled illustrations of domestic life with Maria Edgeworth's "power of embodying and illustrating national character" (Rev. of *Emma* 193). He overlooked Austen's prescriptions for English national character, for it is precisely domestic privacy, with its power to absorb and redeploy ideological contradictions, that gives her romance its national force. It was only after genre had emerged, in retrospect, as genealogy that Scott fully acknowledged Austen's national myth, and his own: that a legitimate social order can be produced by romance reading in a chain of homes across England.

Notes

1 See Moretti 263–65. But I also have in mind here the recent arguments for difference and contest within British Romantic cultures with which Alan Liu, Mary Favret, and Nicola Watson, among others, have set out to complicate cultural criticism of the period; it seems to me that their arguments about the "culture" of Romanticism could be usefully translated into a reconception of genre history as well.

2 I will not rehearse here the various turns and vexations in the historiography of English liberalism, which emerged as a clear (and to such writers as Austen, Burke, and Scott, I think, clearly conservative) category only at the end of the eighteenth century (Burgess 140–44). I am arguing here, in line with Appleby's response to Pocock (see especially 133), that the category of virtue, often domesticated and feminized, was assimilable into liberal, individualist, and commercial political theories—and further, that such market-liberal theories are traceable *to* Locke and *through* the work of figures as diverse as Thomas Paine and Burke. See also Matthews.

3 See the accounts of this contradiction in Smith and Duncan. Duncan's account differs from my own in assigning a separate "radical nationalist" character to the elegiac account of English gothic and a conservative impetus to the distaste for foreign invasion. Duncan notes (25) that these impulses come together in Burke's *Reflections;* I would suggest that they are in conflict within conservatism from the start.

4 In Part 2, Burke defines sublime terror as the result of "strength, which is *natural* power," or of "the power which arises from institution in kings and commanders" (116). But it also results from "greatness of dimension, vastness of extent, or quantity," especially "such an effect as a tower an hundred yards high, or a rock or mountain of that altitude" (127); from "*Darkness, Solitude* and *Silence*" (125); and from "grandeur" (140). In Part 3, he discusses the beautiful as a function of "grace" (102), the "smoothness; the softness; the easy and insensible swell" that accompanies "gradual variation" (214–17), and "delicacy" (218). Burke associates sublimity with fathers and beauty with mothers, for "the authority of a father, so useful to our well-being . . . hinders us from having that entire love for him that we have for our mothers, where the parental authority is almost melted down into the mother's fondness and indulgence" (206–7). Women, in contrast, "learn to lisp, to totter in their walk, to counterfeit weakness. . . . In all they are guided by nature. Beauty in distress is much the most affecting beauty" (204).

5 To borrow Bourdieu's term for that form and field of capital that represents itself as money's opposite and strongest competitor. See in particular 112–41.

6 In "On the Standard of Taste," Hume argues that the "finer emotions of the mind are of a very tender and delicate nature, and require the concurrence of many favourable circumstances to make them play with facility and exactness, according to their general and established principles. The least exterior hindrance to such small springs . . . disturbs their motion, and confounds the operation of the whole machine" (*Essays* 232). In the *Treatise* he contends that "the skin, pores, muscles, and nerves of a day-labourer are different from those of a man of quality: So are his sentiments, actions and manners. The different stations of life influence the whole fabric, external and internal" (402). Burke suggests that the sublime exercises the mind just "as a due exercise is essential to the coarse muscular parts of the constitution." But "great bodily labour . . . weakens, and sometimes actually destroys the mental faculties" (*Philosophical Enquiry* 4:256). For an analysis of such "sportive labour" as Radcliffe portrays, see Barrell.

7 The "absurd" excess of the novel's final, aestheticizing scenes has led Claudia Johnson, in *Equivocal Beings* 136–37, to conclude that they must be read ironically—or at least as ideological contradictions of Radcliffe's own painful and disordered plots—but their consistency with the novel's earlier set pieces of aesthetic discrimination suggest that the contradictions within Radcliffe's naturalized aesthetics result from ideological desperation—perhaps in response to Wollstonecraft's gendered critique of aesthetics—rather than from self-criticism.

8 I differ here from readers, such as Brown (51), who see this conclusion as an ironic attack on Austen's readers.

9 In an 1813 letter to her sister, written soon after the publication of *Pride and Prejudice* (also in two duodecimo volumes), Austen declared her preference for the smaller and less "serious" octavo over the quarto binding: "Ladies who read those enormous great stupid thick quarto volumes . . . must be acquainted with everything in the world. I detest a quarto [but] . . . They will not understand a man who condenses his thoughts into an octavo" (*Jane Austen's Letters* 304). The octavo was the form of choice for new poetry and philosophy, and the quarto for presentation editions. By publishing her own novels not in octavo but duodecimo—Radcliffe's binding, and a cliché of the popular gothic, as the hero of *Northanger Abbey* suggests—she playfully insists on her didactic reinvention of the novel. Austen's serious moral reflections and two-volume structure address her reader in the chosen book form of "light literature." She differs from Radcliffe by carefully controlling the kinds of privacy her novels produce.

10 See Aikin, especially 105–37. Aikin's range includes the northern Midlands, and

although the North Gloucestershire of the Tilneys lies outside the circle he discusses, he comments that "the prodigious additions made within a few years to the system of inland navigation" is "now extended to almost every corner of the kingdom" (136). Transport networks began their period of rapid development in the 1730s; the desire for "the unbounded extension of canal navigation" had not, by Aikin's writing in 1795, begun to slow (137). Gothic revivalists also commented on the progress of transportation systems (e.g., Gray 262); that they lamented the destruction of picturesque scenes by canals and roads, as Gilpin does (1:ix–x), makes Austen's praise all the more significant. Raven (35, 54–55) discusses the importance of canals and turnpike roads to the kind of provincial book distribution that Henry describes. Aikin's dating coincides with Belanger's argument that book circulation to the provinces increased in the second half of the eighteenth century (18–19); for the condition of the trade before that, see Feather 419–20. The books that mislead Catherine are part of the civilizing trade Henry cites.

11 Austen, that is, produces a female partner for the self-conscious and class-conscious English reader that Klancher 49–50 sees produced by the upmarket literary periodical of the early nineteenth century.

Works Cited

Aikin, John. *A Description of the Country from Thirty to Forty Miles round Manchester.* London: Stockdale, 1795.

Altick, Richard. *The English Common Reader: A Social History of the Mass Reading Public 1800–1900.* Chicago: U of Chicago P, 1957.

Appleby, Joyce. *Liberalism and Republicanism in the Historical Imagination.* Cambridge: Harvard UP, 1992.

Armstrong, Nancy. *Desire and Domestic Fiction: A Political History of the Novel.* Oxford: Oxford UP, 1987.

Austen, Jane. *Northanger Abbey and Persuasion. The Novels of Jane Austen.* Ed. R. W. Chapman. 3rd ed. Vol. 5. London: Oxford UP, 1932. 5 vols.

——. *Jane Austen's Letters to Her Sister Cassandra and Others.* Ed. R. W. Chapman. 2nd ed. Oxford: Oxford UP, 1952.

Barrell, John. "Sportive Labour: The Farm Worker in Eighteenth-Century Poetry and Painting." *The English Rural Community: Image and Analysis.* Ed. Brian Short. Cambridge: Cambridge UP, 1992. 105–31.

Belanger, Terry. "Publishers and Writers in Eighteenth-Century England." *Books and Their Readers in Eighteenth-Century England.* Ed. Isabel Rivers. Leicester: Leicester UP, 1982. 5–25.

Bourdieu, Pierre. *The Field of Cultural Production: Essays on Art and Literature.* Ed. Randal Johnson. New York: Columbia UP, 1993.

Bronson, Bertrand Harris. "Printing as an Index of Taste." *Facets of the Enlightenment: Studies in English Literature and Its Contexts.* Berkeley: U of California P, 1968. 326–65.

Brown, Julia Prewitt. *Jane Austen's Novels: Social Change and Literary Form.* Cambridge: Harvard UP, 1979.

Burgess, Miranda J. "Courting Ruin: The Economic Romances of Frances Burney." *Novel* 28 (1995): 131–53.

Burke, Edmund. *A Philosophical Enquiry into the Origin of Our Ideas of the Sublime and Beautiful.* 2nd ed. London: Dodsley, 1759.

——. *Reflections on the Revolution in France.* Ed. J. G. A. Pocock. Indianapolis: Hackett, 1987.

Butler, Marilyn. *Jane Austen and the War of Ideas*. 1975. Oxford: Clarendon, 1987.

Corrigan, Philip, and Derek Sayer. *The Great Arch: English State Formation as Cultural Revolution*. London: Blackwell, 1985.

Duncan, Ian. *Modern Romance and Transformations of the Novel: The Gothic, Scott, Dickens*. Cambridge: Cambridge UP, 1992.

Evans, Mary. *Jane Austen and the State*. London: Tavistock, 1987.

Favret, Mary A., and Nicola J. Watson, eds. *At the Limits of Romanticism: Essays in Cultural, Feminist, and Materialist Criticism*. Bloomington: Indiana UP, 1994.

Feather, John. "The Commerce of Letters: The Study of the Eighteenth-Century Book Trade." *Eighteenth-Century Studies* 17 (1984): 405-24.

Gilpin, William. *Observations Relative Chiefly to Picturesque Beauty, Made in the Year 1772, on Several Parts of England; Particularly the Mountains and Lakes of Cumberland, and Westmoreland*. 2nd ed. 2 vols. London: Blamire, 1788.

Gray, Thomas. *Journal in the Lakes. The Works of Thomas Gray in Prose and Verse*. Ed. Edmund Gosse. 1884. New York: AMS, 1968.

Habermas, Jürgen. *The Structural Transformation of the Public Sphere: An Inquiry into a Category of Bourgeois Society*. Trans. Thomas Burger. Cambridge: MIT P, 1989.

Hazlitt, William. "The Times Newspaper." *Literary and Political Criticism. The Complete Works of William Hazlitt*. Ed. P. P. Howe. Vol. 19. New York: AMS, 1967. 177-82.

Horkheimer, Max, and Theodor W. Adorno. *Dialectic of Enlightenment*. Trans. John Cumming. New York: Continuum, 1989.

Hume, David. *Treatise of Human Nature*. Ed. L. A. Selby-Bigge. 2nd ed. Oxford: Clarendon, 1978.

———. *Essays Moral, Political, and Literary*. Ed. Eugene F. Miller. Rev. ed. Indianapolis: Liberty, 1987.

[Hurd, Richard]. *Letters on Chivalry and Romance*. London: A. Millar; Cambridge: Thurlbourn and Woodyer, 1762.

Rev. of *The Italian*, by Ann Radcliffe. *European Magazine* 31 (1797): 35.

Johnson, Claudia. *Jane Austen: Women, Politics and the Novel*. Chicago: U of Chicago P, 1988.

———. *Equivocal Beings: Politics, Gender, and Sentimentality in the 1790s*. Chicago: U of Chicago P, 1995.

Kernan, Alvin. *Printing Technology, Letters, and Samuel Johnson*. Princeton: Princeton UP, 1987.

Kirkham, Margaret. *Jane Austen: Feminism and Fiction*. Sussex: Harvester, 1983.

Klancher, Jon. *The Making of English Reading Audiences, 1790-1832*. Madison: U of Wisconsin P, 1987.

Liu, Alan. "Local Transcendence: Cultural Criticism, Postmodernism and the Romanticism of Detail." *Representations* 32 (1990): 75-113.

Lovell, Terry. *Consuming Fiction*. London: Verso, 1987.

Matthews, Richard K., ed. *Virtue, Corruption, and Self-Interest: Political Values in the Eighteenth Century*. Bethlehem: Lehigh UP, 1994.

McKendrick, Neil, John Brewer, and J. H. Plumb. *The Birth of a Consumer Society: The Commercialization of Eighteenth-Century England*. Bloomington: Indiana UP, 1982.

Moretti, Franco. *Signs Taken for Wonders: Essays in the Sociology of Literary Forms*. Trans. Susan Fischer, David Forgacs, and David Miller. Rev. ed. London: Verso, 1988.

Morgan, Lady [Sydney Owenson]. *The Wild Irish Girl*. London: Pandora, 1986.

Rev. of *Mysteries of Udolpho*, by Ann Radcliffe. *Monthly Review* ns 15 (1794): 278-83.

"New Publications." *Quarterly Review* 18 (1818): 253-58.

Pocock, J. G. A. *Virtue, Commerce, and History: Essays on Political Thought and History, Chiefly in the Eighteenth Century*. Cambridge: Cambridge UP, 1985.

Radcliffe, Ann. *The Italian; or, The Confessional of the Black Penitents.* Ed. Frederick Garber. Oxford: Oxford UP, 1968.

Raven, James. *Judging New Wealth: Popular Publishing and Responses to Commerce in England, 1750–1800.* Oxford: Clarendon, 1992.

Scott, Walter, Sr. Preface. *St. Ronan's Well.* New York: Routledge, n.d.

[———]. Rev. of *Emma,* by Jane Austen. *Quarterly Review* 14 (1815): 188–201.

[———]. *Hints Addressed to the Inhabitants of Edinburgh and Others, in Prospect of His Majesty's Visit.* By an Old Citizen. Edinburgh: Bell and Bradfute, Manners and Miller; Constable, Blackwood, Waugh and Innes; and Robertson, 1822.

Smith, R. J. *The Gothic Bequest: Medieval Institutions in British Thought, 1688–1863.* Cambridge: Cambridge UP, 1987.

Sutherland, John. *The Life of Walter Scott.* Oxford: Blackwell, 1995.

Trumpener, Katie. "National Character, Nationalist Plots: National Tale and Historical Novel in the Age of *Waverley.*" *ELH* 60 (1993): 685–731.

Rev. of *A Vindication of the Rights of Woman,* by Mary Wollstonecraft. *Monthly Review* ns 8 (1792): 198–209.

Walters, Gwyn. "The Booksellers in 1759 and 1774. The Battle for Literary Property." *Library* 5th ser. 29 (1974): 287–311.

Wollstonecraft, Mary. *A Vindication of the Rights of Men* and *A Vindication of the Rights of Woman.* Vol. 5 of *The Works of Mary Wollstonecraft.* Ed. Janet Todd and Marilyn Butler. New York: New York UP, 1989. 7 vols.

———. *Wrongs of Woman.* Vol. 1 of *The Works of Mary Wollstonecraft.* Ed. Janet Todd and Marilyn Butler. New York: New York UP, 1989. 7 vols.

Learning What Hurts:

Romanticism, Pedagogy, Violence

ADELA PINCH

*R*omantic criticism has been perennially preoccupied with the subject of violence. At least since Mario Praz's casting of European romanticism as an adjunct to sadism and suicide in *The Romantic Agony* earlier in this century, romantic writing has seemed to be in the throes of agonies of all kinds. In the 1970s and early 1980s, the influential work of Paul de Man taught us to see "romanticism" as the name for the violence of literary language itself: a language that tropes and disfigures what we thought we knew, a counterspirit (to borrow Wordsworth's words) that wastes and destroys. In de Manian reading, linguistic unintelligibility exacts sacrifice and dismemberment: the accidents of language, the dangerous slips between literal and figurative meaning, come to have the force of catastrophe, and the texts' admissions of language's power to wound yield up the images, for example, of a drowned man, a disabled boy, a blind beggar. More recently, under the aegis of the New Historicisms, we honed in on the ways in which romantic writing participated in its own very violent historical moment. In Alan Liu's study of Wordsworth, for example, "history" and "violence" become functionally synonymous. Distinguishing his method from an older historicism that plots literature against a continuous historical ground, Liu theorizes historical change as a violence that ruptures into poetry. "History" is, in his phrase, "the poetics of violence," and Wordsworth's poetry takes shape through its overdetermined negation and admission of the violence of the French Revolution, as well as familial and social violence of both body and mind. Meanwhile, critics tracking the genealogy of the idea that criticism itself can be an act of violence have persuasively argued that such ethical worries about the violence of criticism, the violence of poetry—and about what comes to count as violence anyway—originated, as I hope this essay will confirm, with romantic writers themselves.[1]

Although we can locate the origin of our obsession within our object of

study, we might still want to ask why and how romanticists learned to find violence so compelling a literary subject, and how this topic might speak to contemporary critical needs. Might we wish to follow up on Eve Sedgwick's fascinating piece, "A Poem Is Being Written," and speculate that our own early education in poetry may bear the mortifying marks of a rhythmic discipline? In her essay—certainly romantic, even Wordsworthian in its retrieval of early childhood as a source of poetic power, and its invocation of a saving continuity between child and adult that competes against the writer's sense of belatedness—Sedgwick meditates on the conjunction between her early love of poetry and infrequent, though highly charged, spankings. "It is in this way," she confesses,

> [t]hat both the cropped immobilized space of the lyric and the dilated space around it of narrative poetry were constructed in and by me, as well as around and on me, through the barely ritualized violence against children that my parents' culture and mine enforced and enforces. . . . The lyric poem was both the spanked body, my own body or another one like it for me to watch or punish, and at the same time the very spanking, the rhythmic hand whether hard or subtle of authority itself.[2]

In this understanding, poetry *is* violence, translated into another realm: the "barely ritualized violence against children" sublimed into form, as metonymical conjunction becomes metaphorical identity. For Sedgwick, this conversion is a way of making sense of the child's humiliation, converting her "violence-marked body" (125) from a compulsion into a choice. But the mode of understanding that underlies this interpretation is based on a principle that would have been very familiar to romantic writers' own thinking about childhood learning: the principle of association, which holds that two experiences that meet in childhood may unite in some freakish, unalterable way.

In this essay I will suggest that there might indeed be some lessons for contemporary romanticist engagement with violence to be found within romantic-era debates about education. Recent studies have demonstrated that romantic writers' views on education may have been more complicated than we thought, and that the truism that romantic poets were against violent education—and came close to believing that all education was a form of violence—can be challenged.[3] I will contribute, somewhat obliquely, to this discussion by focusing on the romantic era's reception of William Shenstone's poem "The School-Mistress." Published in 1742, "The School-Mistress" remained a popular anthology piece through the end of the century and the beginning of the next, and was read at school by, among

others, Wordsworth and Byron.[4] This poem's homely, quaint Spenserian style assisted the vogue for Spenserian form in late-eighteenth-century poetry and romantic poetry, influencing, for example, Beattie's *The Minstrel* and Wordsworth's Salisbury Plain poems.[5] It might seem odd to focus a consideration of romanticism and violence on this pretty-much forgotten poem. But the schoolmistress herself, plus the history of the poem — including the strange omissions and repressions that characterized its reception — will be beating their way through this essay, taking us briefly into debates about Spenser, pornography, and corporal punishment, before returning us to some speculations about contemporary romantic criticism.

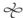

Composed in exaggeratedly archaic "Spenserian" diction, "The School-Mistress" is a paean to the simple virtues of a rustic village school supervised by a benevolently tyrannical teacher, the representative of many who toil away in obscurity:

> In ev'ry Mart that stands on Britain's Isle
> In ev'ry Village less reveal'd to Fame
> Dwells there, in cottage known about a Mile,
> A Matron old, whom we *School-Mistress* name;
> Who boasts unruly Brats with Birch to tame.
> (10–14)

The school yard is organized around a birch tree, the very sight of which — thanks to the strange laws of association — makes the little pupils tremble:

> Not a Wind might curl the Leaves, that blew,
> But their limbs shudder'd, and their Pulse beat low;
> And as they look'd, they found their Horror grow,
> And shap'd it into Rods, and tingled at the View.
> (24–27)

And the poem itself is shaped around a climactic scene in which this "tingling" becomes quite dramatic, when the schoolmistress beats one of the boys with a rod from the birch.

This beating scene is structured through a complex network of relationships involving reading, representation, voyeurism, and violence. The unfortunate youth is punished for attending to the picture of Saint George that illustrates the reverse side of his hornbook, rather than attending to its letters:

> Their Books of Stature small take they in Hand,
> Which with pellucid Horn secured are;

To save from Fingers wet the Letters fair:
The Work so quaint that on their Backs is seen,
St. *George*s high Atchievements does declare:
On which thilk Wight that has y-gazing been,
Kens the forthcoming Rod, unpleasing sight, I ween.

(111–17)

(I will return to this particular infraction later.) Boys, like hornbooks, have front sides and backsides, and that is where the boy is beaten:

Brandishing the Rod, she doth begin
To loose the Brogues, the Stripling's late delight,
And down they drop, appears his dainty skin,
Fair as the furry coat of whitest Ermalin.[6]

The beating itself, meanwhile, is witnessed peripherally, from the point of view of the errant boy's sister, who tries to intercede with the school-mistress on her brother's behalf, even tearfully offering herself as a sacrificial victim in her brother's place. But to no avail—here is the stanza describing the beating scene in full:

But ah! what Pen his woeful Plight can trace,
Or what Device his loud Laments explain!
The form uncouth of his disguised Face!
The pallid Hue that dyes his Looks amain!
The plenteous Show'r that does his Cheek distain!
When he in abject wise implores the Dame,
Ne hopeth ought of sweet Reprieve to gain;
Or when from high she levels well her Aim,
And thro' the Thatch his Cries each falling stroke proclaim.

(136–44)

Lest we be too moved by this piteous description of the "Wight of Bum y-galled" (156), however, the rest of the poem spells out its didactic design, which is, according to the descriptive "index" that Shenstone supplied at the back of the 1742 volume, to illustrate "the secret connextion betwixt *Whipping,* and *Rising* in the world." The simple narrator praises the unsung schoolmistresses of various patriots, and exclaims,

Yet sprung from *Birch,* what *dazling* Fruits appear!
Ev'n now sagacious *Foresight* points to show
A little Bench of heedless Bishops here,
And there a Chancellor in Embryo;
Or Bard, sublime, if Bard may e'er be so.

(199–203)

In his essay on the strange fortunes of "The School-Mistress," Isaac Disraeli picked up on the resonances in these lines of Thomas Gray's better-known phrases concerning the fate of the "mute inglorious Miltons" and undiscovered patriots in the "Elegy Written in a Country Churchyard," composed in the years after Shenstone's poem.[7] In Shenstone's rustic fantasy, a little whipping can raise his rustics out of obscurity, whereas in Gray's pastoral the "village-Hampdens" remain great in potential only. What Gray seems to have learned from "The School-Mistress" was to renounce—and glamorize the renunciation of—its extraordinarily crude exposition of upward mobility.

What did Wordsworth and other later readers learn from this poem? How are we to take it? The history of this poem's reception seems to have involved recognitions and misrecognitions both of its shifting tones and of the contexts that shape it. Shenstone claimed to have intended the poem to be a joke. In letters he is self-conscious about the exaggeratedly Spenserian style ("my Schoolmistress, I suppose, is much more in Spenser's way than any one would chuse to write in that writes quite *gravely*"), and about the "ridicule which might fall on so *low* a subject." Disraeli affirmed the strange fortune of the poem to have been taken seriously: it properly belongs, he writes, "to a refined species of ludicrous poetry," which is

> comic yet tender, lusory yet elegant, and with such a blending of the serious and the facetious, that the result of such a poem may often . . . produce a sort of ambiguity; so that we do not always know whether the writer is laughing at his subject, or whether he is to be laughed at.[8]

However, most late-eighteenth- and early-nineteenth-century readers responded to the poem's sentimental rather than to its bathetic qualities. To Wordsworth, for example, it was an exemplary poem of rural life, one that described "not transitory manners reflecting the wearisome unintelligible obliquities of city-life, but manners connected with the permanent objects of nature and partaking of the simplicity of those objects." Wordsworth even suggested that Shenstone had *pretended* to treat the poem as burlesque because he was too timid to take its rustic, homely subject seriously:

> On its first appearance . . . the poem was accompanied with an absurd prose commentary [the index], showing . . . that the whole was intended for burlesque. In subsequent editions, the commentary was dropped, and the People have since continued to read in seriousness, doing for the Author what he had not courage openly to venture upon for himself.[9]

Wordsworth's response and the response of other readers to the poem may have been shaped in part by shifts in ideas about Spenser and

Spenserianism, for the burlesque of "The School-Mistress" marks the falling and rising, not only of boys but of different cultural forms. In the later eighteenth century, commentators produced at least two different readings of Spenser, seeing the poet either as harsh in diction and form, recondite in theme, and sublime in effect, or else as a repository of "faerie" quaintness and nostalgic sentiment. Earlier in the century, the "barbaric" Spenserian stanza was seen as suitable for humorous verse, though even by Shenstone's time the more sentimental, nostalgic Spenser had begun to emerge, as is evidenced even in his headnote to the poem: "What particulars in Spenser were imagined most proper for the Author's Imitation on *this Occasion*, are, his *Language*, his *Simplicity*, his Manner of *Description*, and a peculiar *Tenderness* of *Sentiment*, visible throughout his Works."[10] Throughout the rest of the century, competing conceptions of Spenserian allegory, Spenserian diction, and Spenserian form got remembered and misremembered. But certainly by the romantic period, "The School-Mistress" had slipped into a literary environment in which homely Spenserianism spoke of gentleness, tender pathos, and native English genius.

Thus I would argue that the sentimental reception of the poem by the romantics reflected not simply a growing affection for low and rustic subjects, but also the *formal* lessons of the poem. For the poem's many admirers and imitators, what the schoolmistress herself and her rod of birch may have had to teach in particular was a certain kind of beat: the Spenserian stanza. The schoolmistress's gender links her to a long history of female figures as emblems for grammar and language itself—and links her to the form of the poem. The emblem that connects her to the iconography of grammar (and looks forward to Wordsworth's "parent hen" in the pedagogical passages of *The Prelude* [1805: 246–56]) is the chicken who has free range of the schoolroom:

> One antient Hen she took delight to feed,
> The plodding Pattern of this busy Dame!
> Which, ever and anon, as she had need,
> Into her School, begirt with Chickens, came.
> (82–85)

Early modern iconography coupled the image of the allegorical figure of "Grammar" herself (rod in hand, of course) with the image of a hen with chickens, underlining the contrast between the spontaneous learning of animals and that of human children, who need discipline.[11] The gendering of the poem's figure thus might make us rethink what we mean when we speak of a mother tongue: not a language that comes naturally to us, but one we learn under a severer tutelage. In addition, moreover, if the hen is the "plodding pattern" of the schoolmistress, the schoolmistress is the

plodding pattern of the poem's plodding pattern—the Spenserian stanza—as she beats her way methodically through the poem. Steven Knapp wittily suggested that Wordsworth's leech-gatherer served as a personification of the quasi-Spenserian stanzas of "Resolution and Independence"; I would nominate the schoolmistress as the embodiment of Spenserianism plodding through the poetry of the late eighteenth-century and the romantic period.[12]

We could support this idea by noticing the way the schoolmistress's presence is absorbed by the stanza form, filling it out much as her laboriously described dress billows to take up almost an entire stanza, crowding her miniature pupils out. "Begirt" (85) with chickens, dress, and spinning wheel, she wheels slowly through the poem, mimicking the stanza's incremental motion. At times she is so absorbed into the poem's form that she becomes scarcely visible: we don't really see her, but we hear her effects—for example, rounding out the characteristic alexandrine of the beating scene, as through the thatched roof of the schoolhouse the victim's cries "each falling stroke proclaim" (144). Sensible to us through her effects on matter (the boy's flesh), she is that which, formally, organizes meter. The most authentically Spenserian-sounding passage of the poem is an impressively gloomy description of her allegory-entwined rod:

> And in her Hand, for Scepter, she wou'd wield
> Tway Birchen Sprays; with pallid Fear entwin'd,
> With dark Distrust, and sad Repentance fill'd;
> And keen Regret, and sharp Affliction join'd,
> And Vengeance uncontroul'd, and Discipline unkind.
> (50–54)

The Spenserian stanza and corporal punishment get mixed up together, as both resonate with ideas about national ambition, and as the notion of Spenser itself comes to embody the poles of Shenstone's poem—a quaint, gentle concern for the education of rustic boys and ambitious national violence. Or, in the poem's terms, those poles are represented by the rod on one side, St. George on the other.

If the romantics learned lessons about Spenserian form from Shenstone's schoolmistress, she also may have left other marks on their poems. One student of Wordsworthian allusion has expressed surprise that "The School-Mistress," cited by the poet as an exemplary mode of the writing of rural life, finds no echoes in his poetry. However, we may need to speculate further, looking for traces of "The School-Mistress" dispersed associatively in Wordsworth's writing, much as the schoolmistress herself is dispersed in Shenstone's poem. Can we exclude from the sphere of her rhythmic influence *The Prelude*'s representation of nature as an instruc-

tress, no gentle teacher, but one who delighted "sometimes to employ / Severer interventions, ministry / More palpable"? The dynamics of rising, falling, and stroking associated with "The School-Mistress" can be detected in the rhythmic "strokes" of the boat-stealing episode that illustrates nature's severer teaching: the oars of the stolen boat "struck and struck again / In cadence," and the boy "rose upon the stroke." Furthermore, a trip to the concordance confirms that the appearance of a birch tree may have been indelibly attached, via a similar associative logic, to the imagery of Shenstone's poem. The trees evoke a "School-Mistress"-like conjunction of brightness, rising, and falling. In the "River Duddon" sonnets, for example, we find "golden locks of birch, that rise and fall," and "birch-trees risen in silver colonnade." As a schoolboy Robert Southey wrote a parody of Shenstone and was, as we shall see, obsessed with the birch: ten years later, that tree rises at a magical moment in *Thalaba the Destroyer.*[13] The signatures of "The School-Mistress" may have been sublimated into romantic writing in the form of a chastening but thrilling verticality.

The shifting ideologies of Spenserian form and some faint traces of poetic influence, however, do not exhaust the question: What does it mean that romantic-era readers and writers could have misrecognized so bathetic a poem, sentimentalizing and internalizing its unserious lessons about beating and rising? How could Wordsworth have glossed over the "gross and violent stimulants" the schoolmistress uses to "elevate" her subjects? We could further speculate that the poem's female figure—while cast as quaint, feminine, and more seductive than antagonistic—may have managed questions about power and poetry that romantic writers worried about: regarding the politics of form and their own subjective formation at the hands of a violent schooling. Both Coleridge and Charles Lamb, students at Christ's Hospital (known to have been "a great flogging and bullying school" in the late eighteenth and nineteenth centuries), later linked the rhythms of the whip-happy master, Mr. Boyer, to certain rhythms in prose. The "gentle" Charles Lamb recalled this "rabid pedant" to have devised a most peculiar way of linking beating with political prose:

> In his gentler moods, when the *rabidus furor* was assuaged, he had resort to an ingenious method, peculiar . . . to himself, of whipping the boy, and reading the Debates, at the same time; a paragraph, and a lash between; which in those times, when parliamentary oratory was most at a height and flourishing in these realms, was not calculated to impress the patient with a veneration for the diffuser graces of rhetoric.

Reflecting on his own prose style, and confessing an aversion to a rhythmic prose style approaching meter, the sometimes self-flagellating Coleridge noted, "[B]ut into *this* fault my taste was too carefully disciplined, and my

ear too well educated, by old Boyer, the *orbilius plagosus* of Christ's Hospital to leave me under any temptation of falling."[14] If Coleridge had a metrical style beaten *out* of him, we need only look to a "late romantic," Swinburne, for a case in which the suffering of the body is inseparable from the pleasures of meter: his Sapphic imitations demonstrate that his attachment to difficult classical meters was bound up with the schoolroom discipline through which he mastered them and was mastered by them. Although Thomas De Quincey noted with relief that at his own school, "all punishments that appealed to the sense of bodily pain had fallen into disuse," he described the sufferings of his brother, "Pink," at the hands of a flogging teacher.[15] Southey's schoolboy poetry and letters are laced with references to beating: the birch furnishes him with subject matter for witticisms, parodies, and poetic imitations. He was thrown out of Westminster School in 1792 for penning an attack on corporal punishment in a schoolboys' journal called *The Flagellant*. The journal was shut down, and Southey wrote a lament that linked his travails resulting from censorship with those of a better-known writer:

> I am expelled the Flagellant is dead
>
>
>
> Nor I alone in this eventful year
> Of wicked libels and sedition hear
> To hope that Truth would shelter me how vain,
> When Truth and Eloquence both failed for Paine![16]

A pun on the celebrated author's name somewhat grandiosely lifts the sufferings of the schoolboy under the rod into political writing.

Seeing an affectionate response to Shenstone's tyrannical instructress as a kind of refuge from the masculine agonies of the schoolroom would, moreover, make sense of another aspect of the poem, one that renders the romantics' misrecognition even more striking while revealing its inner logic. For "The School-Mistress" belongs in at least one other context that sentimental readings of the poem might prevent us from perceiving when we hear those falling strokes through the schoolhouse walls: it fits squarely into a pornographic tradition of flagellation poetry that spans the eighteenth century and was increasingly elaborated in the romantic period. The flagellant schoolmistress and the emphasis on the different hues and crystal tears dyeing the cheeks of the victim, on rhythmic beating, on the snowy flesh—even the strange triangular dynamics that result from the presence of an (often female) spectator of the beating scene—all these elements of Shenstone's poem were regular features in flagellation literature. It was a truism that school thrashing could lead to "a passion . . . to receive the same chastisement from the hands of a fine woman." Women beating

boys or men was a scenario of particular interest: "I hate indeed to see a rod in the hands of a man," wrote one correspondent to a seamy periodical of the 1780s: "there is something in it so effeminate, so unmanly, that I would rather have a woman perform the birchen correction." Shenstone's schoolmistress is thus the country cousin or rustic foremother of the dominatrices of romantic-era works such as "Venus School Mistress; or Birchin Sports" (1808–10).[17]

I point out these pornographic undertones to show that "The School-Mistress" evokes a large debate about what violence teaches—and what counts as violence. This debate may also illuminate how we learned to link corporal violence with literary form, the beating of a body with the beating of a poem. "The School-Mistress," with its graphic beating scene and its purported moral about the connection "betwixt whipping and rising in the world" (whether burlesque or not), appears amid pedagogical debates about the effects and effectiveness of corporal punishment. The sexual side of school beating would have been familiar even to readers who were innocent of flagellation erotica: it was a persistent issue in mainstream discussions of education. An opponent of school beating suggested in the *Gentleman's Magazine* in 1780 that abolition of the practice was the only way for "some schoolmasters . . . [to] escape suspicion of deriving their attachment to the rod from motives which are best explained by [pornographers]." Vicesimus Knox, who anthologized Shenstone's poem in his *Elegant Extracts,* was among the defenders of whipping—the "party of the Thwackums"—as was Dr. Johnson, who opined that "there is less flogging in our great schools than formerly, but then less is learned there; so what the boys get at one end they lose at the other."[18] Eighteenth- and early-nineteenth-century opponents largely followed Locke's argument, in *Some Thoughts Concerning Education,* to wit that effective commerce between those two "ends"—between body and mind—was impossible. Bodily violence precluded sublation into greatness. Its effects stayed in the body, teaching the child only to "preferr [sic] the greater *Corporal Pleasure,* or avoid the greater *Corporal Pain.*" Violence bred violence:

> Such a sort of *slavish Discipline* makes a *slavish Temper.* The child submits, and dissembles Obedience, whilst the fear of the Rod hangs over him; but when that is removed . . . he gives the greater scope to his natural Inclination; which by this way is not at all altered, but on the contrary heightned [sic] and increased in him; and after such restraint, breaks out usually with the more violence.[19]

Both the devotees of erotic flagellation—and those scandalized by the very idea—linked it to the experience of the schoolroom, thus arguing that

corporal punishment indeed stays in the body, short-circuiting the path to ambition by teaching only a pleasure in the very pain it inflicts.[20]

In juxtaposing my own agonies and those of romantic writers on the "secret connections" between violence and poetry, beating and form, with the debates in the eighteenth and nineteenth century about the "secret connections" of corporal punishment, I am suggesting that critical arguments sublating beating into poetic form may perhaps be caught up in the same associations that sustain arguments on behalf of corporal punishment. We have learned to make these connections according to the same philosophical and rhetorical understandings of how bodily harm may be connected to other rhythms, similar languages of rising and falling, ends and ambitions. In saying this I am not suggesting that we solve the problem of deciding what actually hurts (or deciding what effect hurting in school has) by insisting on distinguishing between "real" violence and rhetorical violence—or by simply invoking their reversibility.[21] But we can say that the history of "The School-Mistress" suggests, first, that the very terms in which we discuss violence might be seen as generated in the romantic period's ambivalence about the schoolroom, and second, that it reminds us that the criteria by which we determine whether something—an act, or a word, or even the most bodily of injuries—counts as violence (or the extent to which that category seems inclusive or exclusive) are always shifting, determined by political and sexual context, location, and gender.

For example, reading "The School-Mistress" as a scene of instruction in the context of debates over corporal punishment might suggest that the poem could also open up moments when *differences* between violence and what it teaches, between beating and the "beating" of a poem, make themselves heard. During the decades of revolutionary and postrevolutionary violence, for example, the connections that Shenstone's poem sets up between the whipping of schoolboys, greatness, and poetry may have been simultaneously learned and unlearned. Schools were violent places. We are most familiar with evidence of brutality at the elite public schools where there existed, through the nineteenth century and beyond, a whole discourse about beating, national leadership, and sexuality—in the words of the faux-Regency flagellation poem, *The Rodiad*: "Nothing a gentleman's demeanor teaches / More than a graceful downfall of the breeches." What happened in the schools was always connected to national politics—as in Southey's schoolboy "Ode" cited earlier, or as in Wellington's apocryphal remark that "the battle of Waterloo was won on the playing fields of Eton." Increasingly after 1770 and into the early nineteenth century, there were (often violent) schoolboy revolts at the big public schools. Byron began his career as a rebel in the 1808 schoolboys' mutiny at Harrow, in which

some boys plotted to blow up the entire school. But historians have argued that from 1780 to 1850, in spite of movements toward reform, there was "abundant evidence that flogging and brutality were rife in nearly all types of school, from the public school to the common day school." Reformer James Kay-Shuttleworth noted as late as 1838 that there seemed to be a consensus that "the best way to make boys learn was to whip them well." [22]

Finally, my own essay has ranged from a relatively formalist reading of the history of "The School-Mistress" through a more historicist, contextualist one that insists on hearing the cries of real schoolboys, in order to make my point. We might reflect that the history of our education as romanticists over the past few decades has consisted of learning and unlearning the distinction between the violence of rhetoric and bodily harm, as our own romantic education has taken us from the lurid figures of a de Manian romanticism peopled with mutilated, disfigured forms through a historicist romanticism that insists on the material harm that accompanied certain kinds of poetic exclusions. Perhaps, rather than spinning back and forth in seeing distinctions between real and metaphorical violence, and refusing to make such distinctions, what we need to do is to step outside this preoccupation. We might note the costs and benefits to be gained, from both gestures that refuse to distinguish between rhetorical and literal violence and from gestures that insist on a difference. Both critical impulses have taken the violences they focus on—language as that which wounds or history as that which hurts—as occupying the place of the "real." And both impulses, I would argue, stem from a romantic embarrassment about representation. That is, violence may appeal to literary critics because it seems to break through what is most conventional, least powerful, and most disappointing about poetic language: that it has, in addition to its minimally intelligible, material dimensions, a representational and communicative dimension; and that, as effective as poems may be as forms of discipline or harm, they are also formal representations. [23] In this connection I would like to return to the seduction of Shenstone's schoolboy by the other side of the hornbook. What attracts his gaze are not simply "St. George's high Atchievements" (115)—presumably dragon-slaying, sword-wielding activities more attractive to a boy destined to rise in the world with the assistance of the whip than whatever homily the other side of the hornbook spells out. It is also the "Work so quaint" that enthralls him, the pseudo-immediacy of one image over another. Learning to think of violence and representation as truly interconnected may be like practicing the kind of reading that the schoolboy gets whipped for when he insists on taking the image of "St. George's high Atchievements" as an inseparable part of the hornbook to which his letters are glued: insisting on reading the flip sides, both the letters and the images that back them.

Notes

1 See Mario Praz, *The Romantic Agony*. On violence in de Manian reading, see, for example, de Man, *The Rhetoric of Romanticism* 67–81, 93–123, 263–90; Cynthia Chase, *Decomposing Figures* 9, 13–31, 150; see also Neil Hertz, "Lurid Figures." On violence and history, see Alan Liu, *Wordsworth: The Sense of History* 55–64, 138–218. A recent reading of Wordsworth returns us to a violent Wordsworth: see David Collings, *Wordsworthian Errancies*. On romantic writers' anxieties about critical violence, see Steven Knapp, *Personification and the Sublime* 7–50; Tobin Siebers, *The Ethics of Criticism* 27–29, 34, 40–41; Julie Ellison, *Delicate Subjects*.

2 See Eve Kosofsky Sedgwick 115. Sedgwick goes on to complicate the associationism of this interpretation by demonstrating how the beating scenario she associates with lyric poetry takes on significance retrospectively through narratives of sexual difference. For a reading of Wordsworth influenced by Sedgwick's essay, see my "Female Chatter: Meter, Masochism, and the *Lyrical Ballads*."

3 See Alan Richardson, *Literature, Education, and Romanticism*.

4 A shorter version of "The School-Mistress," consisting of twelve stanzas, appeared in Shenstone's *Poems upon Various Occasions* (1737); it was expanded to twenty-eight stanzas, with advertisement and index, and published separately in 1742; in 1748, a further expanded version of thirty-five stanzas appeared in the second edition of Dodsley's *Collection of Poems by Several Hands in Three Volumes*. Unless otherwise indicated, I will be referring to the 1742 edition of *The School-Mistress, A Poem*.

5 Duncan Wu (126) determines that Wordsworth would have read the poem at Hawkshead. In a letter written to Thomas Poole in March 1797, Coleridge described his own early schoolmistress as "the very image of Shenstone's" (56). Shenstone appears in one of Byron's Harrow notebooks. On "The School-Mistress" 's influence on the late eighteenth-century and romantic Spenserian revival, see Greg Kucich 52–56.

6 These lines are from the 1748 version of the poem (see n4).

7 See Isaac Disraeli 1: 247.

8 See Shenstone, *Letters* 145; see also Isaac Disraeli 1: 241–42.

9 See William Wordsworth, *Letters of Dorothy and William Wordsworth* 255, and "Essay Supplementary to the Preface" 3: 76. That Wordsworth knew of the 1742 index suggests that he knew both this and the later version of the poem; thus an argument about the romantics' sentimental reception of the poem cannot be based on the assumption that they only knew the later edition. Although it is likely that some romantic-period readers would have known only the later edition, Shenstone's revisions actually rendered the poem both more and less ludicrous, more and less committed to bathetic violence.

 Another indicator of the romantic-era reception of "The School-Mistress" is Thomas Hood's parody, "The Irish Schoolmaster," which, by rendering Shenstone's homeliness more absurd—and rendering the whip-happiness of the pedagogue more extreme—would seem to stabilize the tonal ambivalence of Shenstone into a quaint sentimentality of bygone days.

10 "Advertisement" to *The School-Mistress* (1742). On eighteenth-century understandings and romantic views of Spenser, see Kucich n5; Earl Wasserman, *Elizabethan Poetry in the Eighteenth Century* 92–139; and Jonathan Brody Kramnick, *The Making of English Literary History*.

11 See, for example, Cornelis Cort, "Grammatica" (engraving), from *The Seven Liberal Arts, after Frans Floris* (1565), reprinted in Manfred Sellink 124.

12 See Knapp n1 and 106–20. On the Spenserian stanza as something romantics may

have learned painfully, see Karen Swann's discussion of Wordsworth's and Hazlitt's comments on the stanza's fundamental *resistance* to English and to subjectivity in her discussion of Wordsworth's Spenserian child-beating scene.

13 On Wordsworth's failure to allude to Shenstone, see Edwin Stein 10. See also Wordsworth, *The Prelude* 1: 369–71, 385–86, 403, and "The River Duddon" 5: 10, 21: 12, and 3: 248, 255. For Southey's youthful exercises, see *Thalaba the Destroyer* n16, 11: 23.

14 On Christ's Hospital in this period, see Ian Gibson 73; Lamb 2: 20; Coleridge, *Essays on His Time* 3.2: 379; see also Leigh Hunt 51, 67–72.

15 On Swinburne, meter, and flagellation, see his notes on "Anactoria"; and Yopie Prins, *Victorian Sappho: Declining a Name*, forthcoming. See also De Quincey 3: 252, 1: 294–95.

16 See Southey, "Ode on 1792": my thanks to Nicholas Roe for this passage. For Southey's "Adieu to Birch" (1792), see *New Letters of Robert Southey* 1: 7–8; on the affair of *The Flagellant*, see *Life and Correspondence of Robert Southey* 1: 40, and William Haller, *Early Life of Robert Southey* 40.

17 See the preface to *Venus School Mistress, or Birchin Sports* and letter from "Fanny Quintickler." Flagellation literature often masqueraded as educational debate, as in one volume seemingly innocuously titled *Elements of Tuition and Modes of Punishment*, published by the radical and pornographer George Cannon. See also Iain McCalman, *Radical Underworld* 215–16.

18 See Boswell, *Life of Johnson*, qtd. in Laurence Stone 281. For Vicesimus Knox's views, see his *Liberal Education*.

19 See Locke 112, 113.

20 On the connections between flagellation, libertinism, and radicalism in the late eighteenth and early nineteenth centuries, see Iain McCalman n17, 204–31.

21 See Theresa De Lauretis, and Nancy Armstrong and Leonard Tennenhouse. For a Foucauldian approach that considers the rise of "literature" as a disciplinary institution to be a substitute for corporal punishment, see Richard Brodhead.

22 Falsely attributed to George Colman and dated 1810, *The Rodiad* was published in 1871 by John Camden Hotten. On flogging in schools, see W. A. C. Stewart 94, where James Kay-Shuttleworth is quoted. On dates of late-eighteenth- and early-nineteenth-century school uprisings, see Keith Thomas's fascinating *Rule and Misrule* (15); see also Elie Halevy 534–38 on politics and schools in Regency England.

23 For a discussion of the ways in which historicist and deconstructive materialisms converge in a concern for the exclusion or impossibility of the human, and a defense of what she calls romantic formal idealism, see Frances Ferguson, "Historicism, Deconstruction, and Wordsworth" and "On the Number of Romanticisms."

Works Cited

Anonymous. "Indelicacy of School-punishment Exposed." *Gentleman's Magazine* (Oct. 1780): 463.

Armstrong, Nancy, and Leonard Tennenhouse. Introduction. *The Violence of Representation: Literature and the History of Violence.* London: Routledge, 1989. 1–26.

Brodhead, Richard. "Sparing the Rod: Discipline and Fiction in Antebellum America." *Representations* 21 (1988): 67–96.

Cannon, George. *Elements of Tuition and Modes of Punishment.* London: George Cannon, 1794.

Chase, Cynthia. *Decomposing Figures: Rhetorical Readings in the Romantic Tradition.* Baltimore: Johns Hopkins UP, 1986.

Coleridge, Samuel Taylor. *Essays on His Time.* Ed. David V. Erdman. *Collected Works of Samuel Taylor Coleridge.* Vol. 3, pt. 2. Princeton: Princeton UP, 1978.

——. *Selected Letters.* Ed. H. J. Jackson. Oxford: Oxford UP, 1987.

Collings, David. *Wordsworthian Errancies: The Poetics of Cultural Dismemberment.* Baltimore: Johns Hopkins UP, 1994.

De Lauretis, Theresa. "The Violence of Rhetoric." *Technologies of Gender: Essays on Theory, Film, and Fiction.* Bloomington: Indiana UP, 1987. 31–50.

de Man, Paul. *The Rhetoric of Romanticism.* New York: Columbia UP, 1984.

De Quincey, Thomas. *The Collected Writings of Thomas De Quincey.* Ed. David Masson. Vols. 2, 3. Edinburgh: Black, 1889–90. 14 vols.

Disraeli, Isaac. *Curiosities of Literature.* 2nd ser. 2nd ed. Vol. 1. London, 1824.

Ellison, Julie. *Delicate Subjects: Romanticism, Gender, and the Ethics of Understanding.* Ithaca: Cornell UP, 1990.

Ferguson, Frances. "On the Number of Romanticisms." *ELH* 58 (1991): 471–98.

——. "Historicism, Deconstruction, and Wordsworth." *Solitude and the Sublime: Romanticism and the Aesthetics of Individuation.* New York: Routledge, 1992. 146–71.

Gibson, Ian. *The English Vice: Beating, Sex, and Shame in Victorian England and After.* London: Duckworth, 1978.

Halevy, Elie. *England in 1815.* London: Ernest Benn, 1960.

Haller, William. *The Early Life of Robert Southey, 1774–1803.* 1917. Rpt. New York: Octagon, 1966.

Hertz, Neil. "Lurid Figures." *Reading De Man Reading.* Ed. Lindsay Waters and Wlad Godzich. Minneapolis: U of Minnesota P, 1989. 82–104.

Hood, Thomas. "The Irish Schoolmaster." *Whims and Oddities.* London, 1826. 32–40.

Hunt, Leigh. *The Autobiography of Leigh Hunt.* London: Cresset, 1948.

Knapp, Steven. *Personification and the Sublime: Milton to Coleridge.* Cambridge: Harvard UP, 1985.

Knox, Vicesimus. *Liberal Education, or, A Practical Treatise.* London, 1781.

Kramnick, Jonathan Brody. *The Making of English Literary History: Print Capitalism and the Past, 1700–1769.* Cambridge: Cambridge UP, 1998.

Kucich, Greg. *Keats, Shelley, and Romantic Spenserianism.* University Park: Penn State UP, 1991.

Lamb, Charles. "Christ's Hospital Five and Thirty Years Ago." *Works of Charles and Mary Lamb.* Ed. E. V. Lucas. Vol. 2. London: Methuen, 1903. 12–22.

Liu, Alan. *Wordsworth: The Sense of History.* Stanford: Stanford UP, 1989.

Locke, John. *Some Thoughts Concerning Education.* Ed. John W. and Jean S. Yolton. Oxford: Clarendon, 1989.

McCalman, Iain. *Radical Underworld: Prophets, Revolutionaries, and Pornographers in London, 1795–1840.* New York: Cambridge UP, 1988.

Pinch, Adela. "Female Chatter: Meter, Masochism, and the *Lyrical Ballads.*" *ELH* 55 (1988): 835–52.

Praz, Mario. *The Romantic Agony.* Oxford: Oxford UP, 1933.

Prins, Yopie. *Victorian Sappho: Declining a Name.* Princeton: Princeton UP. Forthcoming.

Richardson, Alan. *Literature, Education, and Romanticism: Reading as Social Practice, 1780–1832.* Cambridge: Cambridge UP, 1994.

Sedgwick, Eve Kosofsky. "A Poem Is Being Written." *Representations* 17 (1987): 110–43.

Sellink, Manfred. *Cornelis Cort.* Rotterdam: Museum Boymans-van Beuningen, 1994.

Shenstone, William. *The School-Mistress, A Poem. In Imitation of Spenser.* London: Dodsley, 1742. Rpt. Oxford: Clarendon, 1924.

———. *The Letters of William Shenstone.* Ed. Margaret Williams. Oxford: Blackwell, 1939.

Siebers, Tobin. *The Ethics of Criticism.* Ithaca: Cornell UP, 1988.

Southey, Robert. *Life and Correspondence of Robert Southey.* Ed. Rev. Charles Cuthbert Southey. London, 1849.

———. *Thalaba the Destroyer. Poetical Works.* Vol. 11. Boston: 1875.

———. "Adieu to Birch." 1792. *New Letters of Robert Southey.* Ed. Kenneth Curry. Vol. 1. New York: Columbia UP, 1965. 7–8.

———. "Ode on 1792." Bod. ms. Eng. Letters c. 22.

Stewart, W. A. C. *Progressives and Radicals in English Education 1750–1970.* London: MacMillan, 1972.

Stone, Laurence. *The Family, Sex and Marriage in England, 1500–1800.* New York: Harper, 1977.

Swann, Karen. "Public Transport: Adventuring on Wordsworth's Salisbury Plain." *ELH* 55 (1988): 811–34.

Swinburne, Algernon. "Anactoria." *Poems and Ballads.* Ed. Morse Peckham. Indianapolis: Bobbs Merrill, 1970.

Thomas, Keith. *Rule and Misrule in the Schools of Early Modern England.* Reading: U of Reading, 1976.

Venus School Mistress, or Birchin Sports (preface), and letter from "Fanny Quintickler." *The Rambler's Magazine* (Nov. 1786): 418–19. Also quoted in Gibson n14, 237, 195.

Wasserman, Earl. *Elizabethan Poetry in the Eighteenth Century.* Urbana: U of Illinois P, 1947.

Wordsworth, William. "The River Duddon." *The Poetical Works of William Wordsworth.* Ed. E. de Selincourt and H. Darbishire. Oxford: Oxford UP, 1940–49. 5 vols.

———. *Letters of Dorothy and William Wordsworth: The Early Years 1787–1805.* Ed. E. de Selincourt and Chester L. Shaver. 2nd ed. Oxford: Clarendon, 1967.

———. "Essay Supplementary to the Preface." *Prose Works.* Ed. W. J. B. Owen and Jane Worthington Smyser. Vol. 3. Oxford: Oxford UP, 1974. 62–84.

———. *The Prelude 1799, 1805, 1850.* Ed. Jonathan Wordsworth et al. Vol. 1. New York: Norton, 1979.

Wu, Duncan. *Wordsworth's Reading, 1770–1799.* Cambridge: Cambridge UP, 1993.

Reforming Byron's Narcissism

STEVEN BRUHM

*N*arcissism: the tendency to see external objects through the lens of one's own desires, to transform the world egomaniacally into a backdrop for one's private interests. Narcissism: the cluster of symptoms including "an overestimation of subjective mental processes, an intensification of the critical conscience, a preference for isolation, a pervading feeling that life is empty and meaningless, a tendency toward incestuous impulses, and a fascination with beauty" (Boker 3). It is through this cluster that we usually interpret Byron's madness, badness, and danger to women.[1] His "fascination with beauty" coupled with the "preference for isolation" leads Manfred, for instance, to assume Astarte narcissistically into his own ego and thus to obliterate her:

> She was like me in lineaments—her eyes,
> Her hair, her features, all, to the very tone
> Even of her voice, they said were like to mine;
> But soften'd all, and temper'd into beauty . . .
> I loved her, and destroy'd her!
> (2.2.105–17)

We have here the material implications of Shelleyan idealism, where "there is something within us which from the instant that we live and move thirsts after its likeness . . . the ideal prototype of every thing excellent or lovely that we are capable of conceiving . . . a mirror whose surface reflects only the forms of purity and brightness" (Reiman 473–74).[2] This search for the ideal prototype, defining Shelley's concept of love while at the same time paralyzing his *Alastor* poet, illustrates what Anne K. Mellor has recently called "masculine Romanticism," the male lover's effacement of the female "into a narcissistic projection of his own self" (25). Unable to sustain an existence apart from male psychological energies, the Byronic

female dies, clearing the ontological and poetic space for a (further) narcissistic indulgence of the Byronic hero's agony.

Given Shelley's definition of Romantic male desire, then, the Byronic hero's narcissism is more a matter of degree than of kind—unless, of course, the kind of love Byron is representing has a less idealistic bent than Shelley's, and a less heterosexual one than Mellor's. In *Byron and Greek Love*, Louis Crompton quotes an apocryphal Byron letter that claims, "I expected a while ago to write a drama on Greek love—not less—modernizing the atmosphere—glooming it over—to throw the whole subject *back into nature, where it belongs*. . . . But I made up my mind that British philosophy is not far enough on for swallowing such a thing neat. So I turned much of it into 'Manfred'" (371; italics mine). And if we do not want to see a homoerotic narcissism in a play that is so "clearly" heterosexual and biographical—reflecting the scandalous relationship with Augusta—we can still locate in some of Byron's other narcissistic narratives a connection between narcissism and homoerotic desire: *Childe Harold,* the travelogue more about the poet's psychological fixations than about European vacation spots, inscribes Robert Rushton and John Edleston, two boys with whom Byron had once been in love, into the foreground of the poet's consciousness; and the poem sequence addressed to Thyrza, initially read as Byron's complaint over a lost female love and as the genesis of his "preference for isolation" and "pervading feeling that life is empty and meaningless," as Boker has said, is now accepted as having been written for Edleston after his death in 1810. If these poems, which awakened a nation to declare Byron famous, are actually founded on homoerotic rather than "ideal" and "pure"—namely heterosexual—attachments, then we may locate in Byron the stirrings of a psychological configuration that, by the end of the nineteenth century, would be transmogrified into a direct relation between homosexuality and narcissism, a relation understood to be pathological and diseased. As Freud would write, homosexuals "are plainly seeking themselves as a love object" (14: 88). But in his "Thyrza" lyrics and his late fragmented drama *The Deformed Transformed,* Byron's treatment of this search does something else: by deploying the homoerotic possibilities of narcissistic desire, Byron critiques the kind of masculine Romanticism that Mellor has identified and offers us a prototype of a secretive, yet openly telegraphed, homoerotic subject position that may be a founding principle of male Romantic desire. ("Heathcliffe, I *am* Nellie"?)

As Jerome Christensen has pointed out, "Lord Byron learned his homosexuality from books—old books" (54). In those old books Byron would have found the story that has been used to condemn him more than any other male Romantic writer, the story of Narcissus. The allusion to the myth of Narcissus that critics and psychoanalysts are so wont to invoke

when discussing Byron must be centered in Pausanias's version of the story, in which the errant boy looks into the pool and sees not himself (for Pausanias, such a thesis is too silly) but rather his twin sister: "Narkissos," writes Pausanias,

> had a twin sister; they were exactly the same to look at with just the same hair-style and the same clothes, and they even used to go hunting together. Narkissos was in love with his sister, and when she died he used to visit the spring; he knew what he saw was his own reflection, but even so he found some relief in telling himself it was his sister's image. (376)

Almost paraphrasing Manfred's description of his relation to Astarte, this version had popular currency in eighteenth-century fictions and aesthetic tracts, and no doubt serves as a source for Byron's literary construction of narcissism.[3] But what is most interesting in Pausanias is the way desire for the sister is a latecomer in the original love of oneself: Pausanias changes the original because he cannot believe one might unknowingly fall in love with one's other, reflected self; and Narcissus, moreover, makes the same alteration, since "he knew what he saw was his own reflection, but even so he found some relief in telling himself it was his sister's image." The primary attraction here is for sameness, a sameness that must be transferred onto the other. And in the earlier versions of the tale, that otherness is located precisely *within* sameness, in that Narcissus sees the same-sex reflection as another man. As Louise Vinge reminds us, the sex of the reflected image in Ovid's tale is unquestionably male, *puer*, figuring Narcissus's same-sex desire for another of whose identity Narcissus is quite unwitting (15). For Yves Bonnefoy, this same-sexuality establishes a rich and problematic obfuscation or interchangeability between the love of oneself and the love of another of one's own sex: "Narcissus must first believe that he loves another in order to be able to love himself" (493). Ovid's text, moreover, refuses to moralize on this obfuscation or on the gender preference that underlies it, focusing instead on the whims of the gods (Vinge 19). Another Greek version of the tale, that of Conon, draws a parallel between Narcissus's desire for himself and the situation of Ameinias, a male lover whom Narcissus had spurned and who killed himself because of his unfulfillable desire. "In Conon's version," writes Vinge, "Narcissus is loved exclusively by men. The homosexual element has not, as in Ovid, been mixed with female passion" (20).[4] What this collection of tales ultimately circles around, then, is the depiction of same-sex desire, one obstructed by compulsory heterosexuality in general and by Byron criticism in particular. In *Manfred*, Byron may not be demonstrating his masculine Romanticism or his narcissistic "murder" of his sister so much

as he may be signaling a destructive version of heterosexual desire that is predicated on a denial of same-sexual desire; in Byron's book-learned sexuality, love of the other sex is a late adjunct to the love of the same.[5]

To describe such homoerotic desire as narcissistic is to cast in Latin, Ovidian, and somewhat anachronistic terms what Byron would have known more thoroughly through that other old literary source of libidinal narcissism, Plato's essays on man-boy love. Byron knew Plato's *Symposium* through a glass darkly, since the only English translation available to him, that of Floyer Sydenham, sanitized the notion of Platonic love by changing the gender of the beloved to female (Crompton 89). (No doubt, Shelley's unbowdlerized *Symposium* of 1818 served as a corrective of this translation for Byron.) But as Crompton emphasizes, the one section of the *Symposium* that Sydenham was unable to pervert—or de-pervert—was the speech of Aristophanes, in which he argues that lovers are really seeking their other half, which has been separated by Zeus, so that they may reunite with them in a spiritual whole (90). For Aristophanes, as for Shelley, desire is the seeking out of self, the epipsyche that will join with the psyche to create a whole. Since Peter Thorslev, critics of Byron have held that Aristophanes's speech is the philosophical source of the poet's disastrous treatment of women: these critics focus on the hermaphrodite, the paradigm of heterosexual desire in the *Symposium,* as a prototype for the brother-sister incest theme.[6] But Aristophanes himself says little about the men who proceeded from the hermaphrodite, other than that they are "lovers of women" and usually "adulterers" (*Symposium* 62). Rather, most of Aristophanes's story is concerned with men who are searching for their other "male" half; the quest is usually homoerotic. And while the myth of Aristophanes is clearly satirical, it ultimately outlines an ideal of same-sex union. This ideal is also articulated in the *Phaedrus,* where the beloved

> does not know and cannot explain what has happened to him; he is like a man who has caught an eye-infection from another and cannot account for it; he does not realize that he is seeing himself in his lover as in a glass. . . . He is experiencing a counter-love which is the reflection of the love he inspires, but he speaks of it and thinks of it as friendship, not as love. Like his lover, though less strongly, he feels a desire to see, to touch, to kiss him, and to share his bed. And naturally it is not long before these desires are fulfilled in action. (64)

The outburst of lovemaking that follows in Socrates's description, if an outburst it be, represents for Plato the contemptible carnality that stalls one's search for the higher truths of wisdom. But as the work of Michel Foucault (*The Use of Pleasure*) and David Halperin (*One Hundred Years*)

makes clear, the purpose of these Platonic dialogues is not so much to rule out homoerotic desire as it is to bring it under the control of the will; and Socrates himself argues that for soldiers the consummation of physical desire, though unbefitting a philosopher, "is no mean prize" (*Phaedrus* 65). Their very desire to seek the beautiful results in their partial attainment of it through a fuller, richer military valor (as evidenced by Plato's Theban band, gays in the military writ large). In this reading, male-male love, rather than being the antithesis of truth (as Shelley argues in his "Discourse on the Manners of the Ancient Greeks"), is necessary to the search for truth. The principal meaning of narcissism in the gay psychological profile, then, is not self-absorption but the seeking out of the other—the beautiful boy whose desirability leads to higher truth.

It is precisely this valorizing of homoerotic desire that Jerome Christensen warns us against when reading Byron. For Christensen, the "Greek love" about which Byron read led to an investment of "sexual desire only in Greek boys." Byron does not conceive his "pure," platonic relationship to Edleston as lacking or unfulfilled, Christensen argues, because for Byron sexual desire was a political act, directed toward those Greek boys whom he wanted to liberate: in other words, Byron "entered" Greece in order to free it; Greece acted as a site where " 'liberation' . . . can be rendered as feeding back just those classically 'Greek' principles that supply the rationale for imperial rule" (55–57). Thus, he concludes, Byron's Greek jargon "artificially creates a body of traders . . . forming the basis for and boundaries of association" (61). Christensen's assumption that "sexual desire" can only be measured by genital contact (which seems to me far too restrictive a register for the kind of diagnosis the critic ultimately makes) begs the question of what kind of homosexuality Byron learned from Plato, and how it might figure in his representation of homo-narcissism. For while Christensen argues that Greek love could mobilize a sense of imperialistic class differences in the powerful Byron, Michel Foucault reads Plato in exactly opposite terms: he argues that it is the effect of male-male love in general and of Aristophanes's definition in particular to posit a mirror-equality between lovers, one that "abolishes the game of dissymmetries that structured the complex relations between man and boy" (233). For David Halperin, this abolition is replayed in Socrates's relationship to Alcibiades, and thus marks the whole tenor of Platonic, homoerotic love:

> Plato all but erases the distinction between the "active" and the "passive" partner—or, to put it better, the genius of Plato's analysis is that it eliminates passivity altogether: according to Socrates, both members of the relationship become active, desiring lovers; neither remains a merely passive object of desire. (132)

Byron effects a similar breakdown of power relations when he describes himself as both "'*Padrone*'" and "'*amico*'" to the Greek boy Nicolo Giraud, an "oscillation" that, for Christensen, "would remain a constant threat to the stability of the Byronic poetic subject" (59). And we also remember Byron's giving up his bed to his ill last love object, Lukas Chalandrutsanos, a "weakness," said Pietro Gambra, that "rose only from a noble source and a generous aim—his pity for the innocent unfortuante" (qtd. in Moore 180–81). Thus if Byron did learn his sexuality from "old books" (and indeed which of us hasn't?), then perhaps what he learned is not the pathologizing and the eventual eradication of difference—what we have come to designate as "narcissism" in the gay male—nor the exercise of class power. Instead, what we see in Byron's homoerotic works is the way his classical sources and their queer narcissistic frissons inform and code his own same-sexual expression.

The homoerotic foundations of narcissism not only hover about the Byronic text like a spurned and rejected Echo, but are reflected like Ameinias in the poetry. An interrogation of such reflections might begin with one of Byron's earliest pieces of Romantic drag, the stanzas to Thyrza. For the queer reader, the very nomenclature resonates with homoerotism: Thyrza is a female biblical name belonging to Abel's wife. And Abel is, of course, the brother of Cain, a figure who speaks in the Byron canon for the author's constructed literary persona, a figure who doubles Abel at the same time that he destroys him. These queer energies—my lover is the wife of my brother-enemy, a homoerotic triangle extending from Radcliffe's gothic to Cronenberg's *Dead Ringers*—are then redoubled by Byron's ascription of the name to Edleston, the young chorister of humble birth whom Byron had adored at Cambridge, whose reputation had been clouded by rumors of "indecency" (Marchand 1: 257), and who died of consumption in May 1810. The titular poem, "To Thyrza," is a conventional elegy for a man about whom Byron had candidly written, "I certainly *love* him more than any human being" (Marchand 1: 124), and, as Crompton notes, it finds its place in a tradition of elegies ranging from *Lycidas* to *Adonais* to Tennyson's *In Memoriam*. But unlike these other love lyrics to dead men, "To Thyrza" registers the early Byronic materialism, the suspicion of a metaphysics that would ensure Edleston's everlasting life either in heaven or on earth. The speaker has loved the boy "in vain," for "the past, the future fled to thee, / To bid us meet—no—n'er again!" (7–8). And while the poem moves toward a conventional elegiac *consolatio*, employing Platonic ideals of pure and virtuous love as instruction for how to secure heavenly rewards it resists its own optimism by the emphasis on the limitations of the physi-

cal: "Oft have I borne the weight of ill, / But never bent beneath till now!" (43–44); and by the use of the conditional: "If rest alone be in the tomb, / I would not wish thee here again" (47–48); "if in worlds more blest than this . . ." (49), the boy's love "fain would form my hope in Heaven" (56). One thinks here of Wordsworth's great expression of doubt in the midst of "Tintern Abbey": "If this / Be but a vain belief" (50–51). Like the earlier "Epitaph on a Friend," Byron's poem is remarkable for inscribing a refusal of past and future—negating the supposed consolations of a heaven-earth relationship. Instead, it emphasizes the corporeal intensity and vulnerability and ultimately the loss of the relationship between lover and beloved.

But if the poem charts a desire whose mise-en-scène is the temporal and the embodied rather than the transcendent and spiritual, then it also comments upon the nature of the embodied transaction. That nature, I want to suggest, is narcissistic in conventional ways. While the poem begins with the usual bewailing of a life cut short and the equally standard inscription of sorrow by the poetic speaker left behind, it then takes a rather audacious turn:

> And didst thou not, since Death for thee
> > Prepar'd a light and pangless dart,
> Once long for him thou ne'er shalt see,
> > Who held, and holds thee in his heart?
> (13–16)

The note struck here is reminiscent of that in Byron's poem to the living Edleston, "The Cornelian," in which the boy's virtues are gathered together—or reductively appropriated—in the line, "I am sure, the giver lov'd *me*" (8; italics mine). Here we sense that familiar Byronic narcissism; only this time its "victim" is a male, not a female. In this grieving love lyric we are no longer in the register of the subject's own virtues, nor are we even to consider the speaker's sorrow for the loss of the subject's virtues; rather, we are to consider the *speaker*'s virtues, his desirability as it is imagined, in the figure of prosopopeia, through the dead subject (or shall we now say "object"?). This is a strategy we find repeatedly in Byron's consolation poems: in "Epitaph on a Friend," written to an unknown person also of lower birth, the speaker imagines how the "gentle spirit" of the dead boy will "hover nigh" to "read, recorded on my heart, / A grief too deep to trust the sculptor's art" (11–15). And later, in "To Thyrza," the speaker asks "who like [himself] had watch'd thee here? / Or sadly mark'd thy glazing eye / In that dread hour ere death appear" (17–19). Rather than bemoan the loss, the poem seems instead to celebrate the intensity with which the loss is felt, and the intensely individual subject that such loss constructs; Crompton writes that when Byron "held the stricken boy in his arms and

broke down himself, he felt whole at last: Euryalus had rescued Nisus" (191). In psychological terms, the speaker has narcissistically appropriated the prismatic array of desires to focus on himself and his intense lovability rather than on the loss of the other. What death has put asunder, clinical narcissism joins together.

Yet if we understand this narcissism in the terms of its Greek origins, we obtain a different reading of "To Thyrza." What is called egotism in the nineteenth century and narcissism in the twentieth is, in the terms laid out by Aristophanes and the *Phaedrus,* an intermingling of male lovers, a transference from lover to beloved such that it becomes impossible to distinguish between desires. (And wasn't the "crime" of Ovid's Narcissus that he could not tell the difference between himself as a desiring subject and himself as a desiring object?) The reflexive merging of subject and object is for Shelley (as it is for Coleridge, Schlegel, and Schelling) the very heart of Romanticism. In Byron's Thyrza elegy, it defines the boys' erotic life together, a life where "Affection's mingling tears" (28) replicated the "whisper'd thought of hearts allied" (31), as the magnetism of erotic bonds displayed itself in the "pressure of the thrilling hand" (32). And for Louis Crompton, this "affection" is the expression of closeted emotion that is central to Crompton's study. And if this "thrilling" is taken in its eighteenth-century meaning of "[a] subtle nervous tremor caused by intense emotion or excitement . . . producing a slight shudder or tingling through the body; a penetrating influx of feeling or emotion" (*OED*), the "thrill" of the erotic touch does not represent a narcissistic isolation of the Byronic lover so much as a closed-circuit communication of pleasure that moves through the lover and the beloved, and that transforms subject and object into subject and subject. The lorn speaker's "heart-drops" of "Affection" gush over —which is to say, the beloved's sorrow for the world is picked up, appropriated, and sustained by the lover as part of the continuum of male-male interpsychic communication. And this interpsychic communion continues after death: the speaker requests, "Impart some portion of thy bliss" (51), and "Teach me—too early taught by thee!" (53). The speaker here becomes both agent for and recipient of (both "forgiving and forgiven" [54]) the improper emotion of despair (and perhaps other improper emotions?). The speaker is always alone, yet always connected, always a lover and always beloved, always complete and always in process, always erotic and always desiring eros. Thus, the poem becomes not only about loss and frustration, but also about transference and communion as they are inscribed in "narcissistic" desire. And in this sense, Ovid's boy leaning over his image in the pool is recast as Conon's Narcissus identifying with Ameinias. Byron's is a scene of desire for another man, an intense appreciation of beauty and love that is unwitting of—and having no care for—its source in the perceiver.

In fact, if Byron's homo-narcissism inscribes any kind of frustration, it is the frustration of those who watch from outside the closed circle of narcissistic bliss. The speaker describes this union as one that the world cannot penetrate: "Ours too the glance none saw beside: / The smile none else might understand" (29–30). That communication, furthermore, exists even after the boy is dead. In "One struggle more and I am free," the speaker leads a superficial existence that "smiles with all, and weeps with none" (12), as if the social life of surfaces were a game and narcissism really the condition of pondering depths and secrets. These secrets, he explains to the dead lover in "the haunts of men," intermingle the lover and the beloved and exclude the outside world: "I would not fools should overhear / One sigh that should be wholly *thine*" (15–16; Byron's italics). What we learn here, perhaps, is a lesson about our own narcissism. As Byron betrays his "open secret" (to use D. A. Miller's sense of the term[7]), as he tells us he has a secret he won't tell us, he establishes in us an ambivalent relation to his narcissistic disclosure/enclosure. As we read the Thyrza lyrics, we are made aware that we are looking in on the Byronic union, yet we are kept outside it. We find out that the narcissist is condemnable not only because he stares at himself but because he demands to be *stared at*, commanding a gaze that wants to interpret but cannot, because the gazer exists outside the circle of erotic knowledge. The narcissist demands that we stare at him—and what Romantic figure was stared at more than Byron?—if only in order to demonstrate that we cannot know what we are seeing: "none saw beside," "none else might understand." And it is perhaps this thwarted dialogism that Byron's personal physician, John William Polidori, had in mind when he cast his former employer as a vampire, Lord Strongmore. As Polidori's hero, Aubrey, watches the mysterious, Byronic, and narcissistic Strongmore,

> the very impossibility of forming an idea of the character of a man entirely absorbed in himself, of one who gave few other signs of his observation of external objects, than the tacit assent to their existence, implied by the avoidance of their contact: at last allowed his imagination to picture some thing that flattered its propensity to extravagant ideas. He soon formed this person into the hero of a romance, and determined to observe the offspring of his fancy, rather than the individual before him. (34–35)

If narcissism is the state of staring at another in order to be thrown back on one's own desires, then perhaps it is the reader, or Byron's phobic contemporaries, whom the Thyrza sequence constructs as narcissistic.

Thus Byron is "queer" not merely in the sense that he entertained a love for boys, a love both "violent" and "*pure*" in all its Socratic ambiguities

(Marchand 8:24; Byron's italics). Moreover, his queerness resides not only in the fact that he lived in a homoerotic closet from which narcissism caused him to draw the blinds to keep out prurient onlookers. Rather, Byron is queer in that he forces us to reevaluate our very notion of what Romantic male sexuality might be. Contemporary queer theory, following Eve Kosofsky Sedgwick, has characterized male sexuality in Romanticism as governed by the "transmutability of the intrapsychic with the inter-subjective," a dynamic that leaves "two potent male figures locked in an epistemologically indissoluble clench of will and desire" (*Epistemology* 187). This transmutability is what Sedgwick calls the terrorism of homosexual panic, the fear that a man might know another man too well, that he might get inside him psychologically and otherwise. In both *Between Men* and *Epistemology of the Closet,* Sedgwick locates this paranoid terrorism at the turn of the nineteenth century, when the intersubjective agencies of sentimentalism, the rise of the bourgeois family, and the proliferation of capitalist homosocial bonds coalesced to place men in a strikingly magnetic, strikingly panicked relationship to one another. Thus, as Otto Rank makes clear in his early essay on the double, the narcissistic love of oneself is transferred in dream work, and in fiction, into a doppelgänger, the feared and loathed other of one's own desires.[8] But as Sedgwick's work maintains, this panic is that of a straight sexuality, a regime self-imposed by men who vehemently *want* to keep other men at arm's length. Byron undoes the paranoid terrorism of the panic: his closet transforms the intersubjective into the narcissistic not so as to threaten erotic identity but so as to celebrate it. In "Thyrza" I become my lover and my lover becomes me within the (almost) impermeable confines of a closet that the cold world cannot know. I long for you and you long for me and we do so like no others. In a way very different from paranoid terrorism, it takes one to know one.

III

As its sources in the *Symposium* and *Phaedrus* would suggest, the reconfiguration of the boundaries of the Romantic closet makes for a political imperative that extends beyond the personal tone of the love lyric. This politics is inscribed in Byron's early meditation on heroic and erotic love, his translation of the Nisus and Euryalus episode from the *Aeneid*. A depiction of a soldier and his boy-lover en route to the sacking of Troy, this poem again evokes Byron's narcissism in the form of his egomaniacal penchant for boys whose inferior age and social status magnified his superiority and influence. And in this sense, it echoes what Jerome Christensen has identified as Byron's imperialistic domination of the Greek boys he was claiming to liberate. Yet the poem also echoes Socrates's speech in the *Phaedrus* by

emphasizing the equalizing effects of love into erotic oneness: "In peace, in war, united still they move; / Friendship and glory form their joint reward, / And, now, combined they hold their nightly guard" (16–18). If Greek—and indeed Byronic—love turns on asymmetries in age and status, Byron's borrowings from Virgil here document the interchangeability of lover and beloved—two becoming as one. When the young Euryalus is captured, Nisus ponders whether he should "rush, his comrade's fate to share!" (334) and "die with him, for whom he wish'd to live!" (338) or whether "His life a votive ransom nobly give" (337). The choices here are to change places with the beloved or to die with him, but either way the noble lover shares the beloved's disempowerment. Both love and war destroy power asymmetries, and as Nisus kills his beloved's murderers, he, too, is mortally wounded:

> Thus Nisus all his fond affection prov'd,
> Dying, reveng'd the fate of him he lov'd;
> Then on his bosom, sought his wonted place,
> And death was heavenly, in his friend's embrace!
> (397–400)

The poem then ends with a declaration of the soldier/lover's valor and fame, a peroration that feels somewhat facile and hubristic—what we conventionally call narcissistic—in its trading of human life for everlasting fame. But if we read the story with reference to the *Phaedrus*, it becomes a magnetic site for the fragments of narcissistic desire: the man's desire for the beautiful boy transforms into an equalizing erotic bond whose effect is the protection and love of the other through an interchangeability with the other. Narcissism—what is transferred in homosexual panic into paranoid terrorism—is here a mutually embracing and politically efficacious union.

If "Nisus and Euryalus" flirts with the erotic interchangeability of men and its implications for military valor, Byron's dramatic fragment *The Deformed Transformed* begins to analyze that relationship fully. Begun in 1822 and left unfinished, *The Deformed Transformed* presents the hunchbacked and unloved Arnold who escapes his cruel mother and flees to the forest. Here, at a fountain, he sees his own ugliness and, like Frankenstein's monster in a similar antinarcissistic moment, decides to kill himself. He is halted by a Stranger, modeled on Goethe's Mephistopheles, who conjures a string of beautiful male bodies out of the same fountain in which Arnold had seen himself and transforms him into the beautiful, strong soldier Achilles; the Stranger then assumes Arnold's own rejected body and accompanies him as a doppelgänger. Arnold and the Stranger head out to assist in the battle of Rome in 1527, where Arnold meets the hapless Roman maid Olimpia, falls in love with her, and attempts to win her love. The play breaks off with some suggestion that Olimpia momentarily returns

his affections, but that she eventually becomes attracted to the Stranger, who wears Arnold's form, because he is more interesting and witty. When he learns this, Arnold kills Olimpia. In some ways the play follows the conventional narcissistic paradigm as Freud would outline it: the subject's development begins with the narcissistic identification of the reflected self as a way of manufacturing self-love (primary narcissism), which then is transferred onto the other—the female Olimpia. Heterosexual desire is cast as the mature fruition of a desire that begins as eros for oneself. However, the projected *Othello*-like slaying of Olimpia suggests that Arnold never really worked through his primary narcissism and that this retardation results naturally in narcissistic self-loathing and misogyny. *The Deformed Transformed*, then, is Mellor's masculine Romanticism fully and sardonically brought to light.

Yet if we look closely at the first act, which documents the transformation—an act critics agree represents the only real energy and interest in a play that quickly deteriorates into cliché—we see the degree to which homoeroticism structures a number of Byronic agendas in Arnold. Let us consider for a moment the parade of pretty boys that are trotted out before Arnold: the "fair" Caesar (1.1.198), the "lovely" and "beautiful" Alcibiades (212), the "broad brow," "curly beard," and "manly aspect" of Mark Anthony (230–31), the shade of Demetrius Poliocretes, "Who truly looketh like a demigod, / Blooming and bright, with golden hair, and stature" (246–47), indeed the "Glory of mankind" (256), and finally the winner, Achilles, "The god-like son of the Sea-goddess, / The unshorn boy of Peleus, with his locks / As beautiful and clear as the amber waves / Of rich Pactolus" (266–69). George Steiner contends that as Arnold chooses "the radiant form of Achilles," "it requires no Freudian to note the covert relation between Achilles' heel and Byron's own deformity" (211). Nor, I would argue, does it require a Freudian to note the homoerotic overtones with which Byron infuses Arnold's desire for Achilles, the lover of Patroclus, in a line like this one: "I gaze upon him / As if I were his soul, whose form shall soon / Envelope mine" (282–84). The queerly charged potential of being enveloped by Achilles' body is inscribed in the source for Byron's play, Joshua Pickersgill's *The Three Brothers* (1802), in which the "various men distinguished for that beauty and grace" are paraded in front of Arnaud (Arnold) and "Arnaud's heart heaved quick with preference" (quoted in Robinson 180). This heaving preference, this thinly coded cruisy desire enacts a double movement: it conflates the love of another with the narcissistic love of self, and it makes this love of "beauty" intensely physical, corporeal: indeed, the only character to be rejected out of hand is Socrates, who, mental beauty aside, has a body so ugly that, as he puts it, "I had better / Remain that which I am" (219–20).

In Plato and Virgil, this desire for the physical is a manly desire that risks effeminacy at the very moment of its consummation. Byron's fragment gestures to the same fear. As Arnold pants for the possibilities before him, the Stranger consistently constructs him as female in his desire: "You are far more difficult to please / Than Cato's sister, or than Brutus' mother, / Or Cleopatra at sixteen" (198–200); he calls Arnold impatient "As a youthful beauty / Before her glass. *You both* see what is not, / But dream it is what must be" (288–90; Byron's italics). By constructing Arnold as female, and as narcissistic, Byron hints not only at a misogyny but at a certain representation of the eighteenth-century sodomite as narcissistically female. As early as 1632, Henry Reynolds suggested that the narcissistic boy, pace Socrates, was weakened, unmanly, effeminate (Vinge 185). By 1662, Louis Richer had conflated Ovid's and Pausanias's versions of the myth so that when the Narcissus of his *L'Ovide bouffon* looks into the water, he sees himself, but himself transformed *into a woman* (Vinge 191). Such compulsory heterosexualizing (or parodic camping) is also seen in Rousseau, whose narcissistic Valère is represented as female in a portrait (Vinge 278). These continental moments have their English counterparts, of course, on the Restoration stage, with which Byron was extremely familiar. As Randolph Trumbach points out, "The fop's effeminacy . . . came [in the 1720s] to be identified with the effeminacy of the then emerging role of the exclusive adult sodomite" (134), and if we think of Sir Fopling Flutter, John Harvey, or Colley Cibber's Sir Novelty Fashion, we can place Byron in a tradition that associates the feminine with the sodomitic. That tradition, as Linda Dowling demonstrates, is predicated on the widely held eighteenth-century equation of the Hellenistic (and homoerotic) with "civic incapacity," the product of "aimless and self-regarding egoism" (9). Yet Byron's appropriation of such narcissistic "femininity" represents an attempt to undo the phobic and persecutory associations of male-male love by means of narcissitic softening. If narcissistic desire "feminizes" Arnold, it does so only to embolden him, in that he *becomes* the Achilles he beholds: his cruising, Socratic, yet "feminine" desire for a manly self provides him access to that self. My point is not to applaud an appropriation of the feminine that then destroys the feminine; rather, it is to posit in Byron a conscious transgression, one that effectively contradicts the foundations of Georgian homophobia. Indeed, Arnold's transformation associates him in that proto-Victorian warrior ideal that Dowling says replaced the effeminate and debilitated and came to constitute in the late nineteenth century a homoerotic masculine ideal.

Part 1 of *The Deformed Transformed*, then, dramatizes a homophilic narcissim that exploits Greek tropes of male possession to demonstrate the ways in which the asymmetries of power, status, and age break down as

one man is enveloped by another; moreover, it dramatizes the jubilant erosion of the self-other division upon which the Romantic egotistical sublime—Mellor's "masculine Romanticism"—is founded. To this end, Achilles serves as an apt figure for Arnold to emulate and to be enveloped by, not only because he is beautiful and strong, but because, as Foucault tells us, it was common Greek practice "to talk about the relationship of Achilles to Patroclus . . . to determine what differentiated ·them from one another and which of the two had precedence over the other (since Homer's text was ambiguous on this point)" (195).[9] In other words, one could not tell who in this dyad was the active lover and who was the passive beloved. Such interchangeability, achieved through narcissism, allows Byron to reimagine the potentially panicked relation between men. He dramatizes what it might look like for the transmutable to be erotically welcome between men rather than paranoid or terrifying. He has opened up a space for a queer reading of Romanticism that exploits the dissolution of the self-other boundary, and that revises that boundary from a threatened and policed border to a homoerotically inviting space. Thus Arnold is on the mark when he punctuates his union with Achilles by proclaiming "I love, and I shall be beloved! Oh, life!" (1.1.420).

If the ecstasy of being beloved as one loves accurately describes the homophilic narcissism of the play's first part, it also modifies what will become heterosexual passion in parts 2 and 3 (although the binary opposition between homo and hetero identity was not operative for Byron). As Arnold "becomes" Achilles, the play changes registers from a consideration of the monstrous, homophilic, "queer" hunchback to the overtly masculinist tyrannical soldier[10]: for Byron, to be enveloped by masculinity is not only homoerotic but also terrifyingly productive of masculine ideologies. With this transformation, the queer discourse—that which is critical of such masculinist, heterosexual ideologies—is transferred onto the Stranger, now called Caesar, who becomes the critical foil for Arnold's marauding endeavors.[11] As they continue, these endeavors complete Byron's sexual allegory, by demonstrating the ways in which military masculinity depends upon the expression of both misogyny and homophobia: misogyny, in that the siege on Rome is an attempt to drive out the "Harlot" of Catholicism (2.3.26) who has rendered Rome "an hermaphrodite of empire," a "*Lady* of the Old World" (1.2.9–10), and whose femininity has weakened its glory; homophobia, in that corrupt Rome is an ideal target for destruction—"scarce a better to be found on earth, / Since Sodom was put out" (1.1.502–3)—and that one of Rome's representatives who is to be attacked is Benvenuto Cellini, the Florentine sculptor and goldsmith, charged as a "dirty sodomite" (qtd. in Dynes 208). Rome becomes a fitting site for the deployment of such masculinity, since its very founding

depended upon the murder of one twin brother by the other (Romulus's slaying of Remus). And here we see the inversion of the (homo)sexual politics of Byron's earlier lyrics: whereas the Cain-like Byron becomes the victim mourning his dead "wife" Edleston, here the hypermasculine figure recapitulates the slaying of the twin and the destruction of the feminine. Moreover, what Arnold destroys is precisely the figuration of effeminate sodomy that moments earlier had given him the identity he now claims. He severs the erotic possibilities of sameness and symmetry, invoking a compulsory differentiation that becomes, both politically and psychologically, a brutally split and splitting subject. And as the erotic narcissist becomes the pernicious paranoid, Byron makes a startlingly candid critique of his own masculinist heroism, one that contradicts the image of himself that he worked so hard to construct.

For Byron, this is a critique of what Mellor calls the narcissism of masculine Romanticism, but narcissistic masculinity only in its heterosexual register (Mellor does not distinguish between sexualities). Byron renders unto Caesar, the queer, aloof, dispassionate hunchback, the last word on narcissism and its relation to eros:

> You would be *loved*—what you call loved—
> *Self-loved*—loved for *yourself*—for neither health
> Nor wealth—nor youth—nor power—nor rank nor beauty—
> For these you may be stript of—but *beloved*
> As an Abstraction—for—you know not what—
> (Text of Fragment, 3.61–65; Byron's italics)

"You are jealous," Caesar charges Arnold, jealous "of Yourself" (fragment to 3.69–70). Like the masculine Romantic, Arnold loves, but that love recognizes no external object, no other. Even the final line of the fragment betrays a masculine desire that is at once poignant and sardonically pathetic in its narcissism: "You have possessed the woman—still possess," says Caesar to Arnold; "What need you more?— / To be myself possest—" answers Arnold, "To be her heart as she is mine.—" (Text of Fragment, 3.99–101). For Byron, one must *deserve* love if one is to be beloved; one must *do* the activity that will render one worthy of love. To be beloved (the passive receptivity of the Greek model) is to be the lover, the active pursuer. Whereas the erotic union of Arnold and Achilles produced an immediate jouissance—"I love, and I shall be beloved! Oh, life!"—the heterosexual union is always doomed to be thwarted, partial, asymmetrically disrupted, as Arnold continually bemoans his egotistical inability to be egoless. What the play may ultimately argue, then, is not that homoerotic narcissism is a perversion of "natural" heterosexual desire, but rather that it offers a paradigm by which heterosexual desire itself can be deformed and transformed.

According to Michael Warner, "[T]he theorization of homosexuality as narcissism is itself a form of narcissism peculiar to modern heterosexuality," because it allows heterosexuality to posit the very existence of self- and other-object choice, and thereby *"allows the constitution of heterosexuality as such"* (202; Warner's italics). This construction of the hetero through the suppression of the homo is, of course, a phenomenon of the late nineteenth century, not of the 1820s; in *The Deformed Transformed*, Byron is not arguing that one must suppress the love of the same sex in order to be able to love the other. Nor does Byron anticipate the psychoanalytic assumption that same-sex desire is a narcissistic object choice caused by the inability to cathect external objects. What Byron is doing is foreclosing a principle that will later become essential in the diagnosis and pathologizing of the gay man: that is, the connection between the homoerotic, the love of sameness, and the denial of the demands of the outside world. For Byron, homoerotic narcissism is the trope that posits the dissolution of the self-other boundary at the same time that it registers the sexual possibilities of that boundary. It is in the transformation of this narcissistic dialogue from same-sexual to other-sexual that his narcissist becomes destructive and that the masculine Romantic — that is, the Byronic heterosexual male — is born.

Notes

I was assisted in my preparation of this essay by a fellowship from the Social Sciences and Humanities Research Council of Canada. All references to Byron are taken from the McGann edition (see works cited).

1 Boker is taking this list of symptoms from Freud. For other discussions of Byron, narcissism, and (hetero)sexuality, see D. L. Macdonald and Atara Stein.

2 In the "Discourse on the Manners of the Ancient Greeks Relative to the Subject of Love," Shelley argues that the love object really only exists in the lover's mind, "which selects among those who resemble it, that which most resembles it; and instinctively fills up the interstices of the imperfect image, in the same manner as the imagination moulds and completes the shapes in clouds, or in the fire, into the resemblances of whatever form, animal, building, etc., happens to be present to it" (Notopoulos 408). Of course, Shelley did not invent this definition of Romantic desire. For August Schlegel, the only proper poet is a narcissist, enveloped by fascination for himself. (For the full text of Schlegel, see Louise Vinge 305–6.) And for brother Friedrich,

> the eye sees in the mirror of the river only the reflection of the blue sky, the green banks, the swaying trees, and the form of the gazer lost in contemplation of himself. When a heart full of unconscious love finds itself where it hoped to find another's love, then it is struck with amazement. But soon man lets himself be tempted again, and deceived by the magic of self-observation into loving his own shadow. Then the moment of graciousness has come, then the soul once more constructs its shell, and blows the last breath of perfection through its form. The spirit loses itself in its translucent depths and, like Narcissus, rediscovers itself as a flower. (Friedrich Schlegel 105–6)

3 Louise Vinge writes: "The euhemeristic version of Narcissus' love as a love of his dead twin sister was . . . presented in several authoritative works in the 18th century [including the works of Abbé Banier, Benjamin Hederich, and Diderot] as being a more correct and true story than Ovid's invented fable. It was so wide-spread that it can be considered well-known" (266). To this Vinge adds: "Despite the fact that the Greek versions, particularly Pausanias' twin sister version, are commoner in encyclopedias and handbooks in the 18th century than in previous centuries, they do not have any effect on the literary treatments of the theme of that century. The information which is used is still ultimately derived from Ovid" (313). This statement, I suggest, is too categorical. As I will indicate later, Pausanias was not opposed to Ovid in treatments of male gender so much as he was often conflated with Ovid in the representation of the sodomite as narcissistic and effeminate.

4 Vinge argues, in fact, that the effacement of the homoerotic motif from the myth only came about in the twelfth century, when Christian moralists transformed the tale into an exemplum on vanity (65). Obviously, such a transformation not only made a moral point about self-knowledge but also managed (temporarily) to confine the bestial implications of same-sex desire to obscurity.

5 This conception startlingly recapitulates the emergence of the words "homosexuality" and "heterosexuality" in Western usage and diagnosis. As Jonathon Ned Katz reminds us, the term "homosexuality," privately coined by German law reformer Karl Maria Kertbeny, was first used publically in 1869, whereas the term "heterosexuality" did not appear until 1880.

6 For other uses of the hermaphrodite section of the Aristophanes myth, see Caroline Franklin and Diane Long Hoeveler.

7 Miller writes of secrecy:

> I have had to intimate my secret, if only *not to tell it;* and conversely, in theatrically continuing to keep my secret, I have already rather *given it away.* But if I don't tell my secret, why can't I keep it better? And if I can't keep it better, why don't I just tell it? I can't quite tell my secret, because then it would be known that there was nothing really special to hide, and no one really special to hide it. But I can't quite keep it either, because then it would not be believed that there *was* something to hide and someone to hide it. . . . More precisely, secrecy would seem to be a mode whose ultimate meaning lies in the subject's formal insistence that he is radically inaccessible to the culture that would otherwise entirely determine him. (194–95)

8 Rank writes, "The stage of development from which paranoids regress to their original narcissism is sublimated homosexuality, against the undisguised eruption of which they defend themselves with the characteristic mechanism of projection" (74). This projection, he argues, takes the form of the doppelgänger (85).

9 For a more complete discussion of this pairing in Shakespeare's *Troilus and Cressida,* see ch. 1 of Gregory Bredbeck, *Sodomy and Interpretation.*

10 As Samuel Chew noted in 1915, "With the second scene of the play the mood is changed. Arnold no longer *wishes;* he has acquired all his desires save love." See Samuel Chew 147. For Daniel Watkins, this change of mood heralds the downfall of a play that was conceived during Byron's increased republicanism of 1821. Because of his political concerns, Byron "wrote the drama with even less patience and precision than usual, allowing his ego and impulse toward autobiography to obscure other interests" (Watkins 27). In other words, the play is vague for Watkins because Byron was unusually narcissistic at the time of its composition, whereas I would suggest the opposite: the play is fascinating because Byron is narcissistic, and his narcissism does

not work counter to the political republicanism that captures Watkins's attention, but rather is part of it.

11 Caesar is, among other things, the beloved of the Bithynian king, Nicomedes, as mentioned in Jeremy Bentham's 1795 essay on pederasty. He may also be the "Caesar of sexuality" Byron uses to describe himself in his relation with Nicolo Giraud (qtd. in Christensen 61–62; see Marchand 2:14).

Works Cited

Bentham, Jeremy. "Offences against One's Self: Paederasty, Parts 1 and 2." Ed. Louis Crompton. *Journal of Homosexuality* 3 (1978): 389–405; 4 (1978): 91–107.

Boker, Pamela A. "Byron's Psychic Prometheus: Narcissism and Self-Transformation in the Dramatic Poem *Manfred.*" *Literature and Psychology* 28 (1992): 1–37.

Bonnefoy, Yves. *Mythologies.* Trans. Gerald Honigsblum. Chicago: U of Chicago P, 1991.

Bredbeck, Gregory W. *Sodomy and Interpretation: Marlowe to Milton.* Ithaca: Cornell UP, 1991.

Chew, Samuel. *The Dramas of Lord Byron: A Critical Study.* New York: Russell, 1964.

Christensen, Jerome. *Lord Byron's Strength: Romantic Writing and Commercial Society.* Baltimore: Johns Hopkins UP, 1993.

Crompton, Louis. *Byron and Greek Love: Homophobia in 19th-Century England.* London: Faber, 1985.

Dowling, Linda. *Hellenism and Homosexuality in Victorian Oxford.* Ithaca: Cornell UP, 1994.

Dynes, Wayne, ed. *Encyclopedia of Homosexuality.* New York: Garland, 1990.

Foucault, Michel. *The Use of Pleasure.* Trans. Robert Hurley. Vol. 2 of *The History of Sexuality.* New York: Vintage, 1985.

Franklin, Caroline. *Byron's Heroines.* Oxford: Clarendon, 1992.

Freud, Sigmund. *The Standard Edition of the Complete Works of Sigmund Freud.* Vol. 14. Trans. James Strachey. London: Hogarth, 1957. 24 vols.

Halperin, David M. *One Hundred Years of Homosexuality, and Other Essays on Greek Love.* New York: Routledge, 1990.

Hoeveler, Diane Long. *Romantic Androgyny: The Woman Within.* University Park: Pennsylvania State UP, 1990.

Katz, Jonathon Ned. "The Invention of Heterosexuality." *Socialist Review* 21 (1990): 7–34.

Macdonald, D. L. "Incest, Narcissism and Demonality in Byron's *Manfred.*" *Mosaic* 25 (1992): 25–38.

Marchand, Leslie A., ed. *Byron's Letters and Journals.* Vols. 1 (1973), 2 (1993), 8 (1978). Cambridge, MA: Belknap, 1973–82. 12 vols.

McGann, Jerome J., ed. *Lord Byron: The Complete Poetical Works.* Vols. 1 (1980), 4 (1986), 6 (1991). Oxford: Clarendon, 1980–93. 7 vols.

Mellor, Anne K. *Romanticism and Gender.* New York: Routledge, 1993.

Miller, D. A. *The Novel and the Police.* Berkeley: U of California P, 1988.

Moore, Doris Langley. *The Late Lord Byron: Posthumous Dramas.* London: John Murray, 1961.

Notopoulos, James A. *The Platonism of Shelley: A Study of Platonism and the Poetic Mind.* New York: Octagon, 1969.

Pausanias. *Guide to Greece.* Vol. 1. Trans. Peter Levi. Baltimore: Penguin, 1971.

Plato. *Phaedrus and Letters VII and VIII.* Trans. Walter Hamilton. Markham, Ont.: Penguin, 1985.

———. *The Symposium.* Trans. Walter Hamilton. Markham, Ont.: Penguin, 1987.

Polidori, John William. *The Vampyre and Ernestus Berchtold; or The Modern Prometheus*. Ed. D. L. Macdonald and Kathleen Scherf. Toronto: U of Toronto P, 1994.

Rank, Otto. *The Double: A Psychoanalytic Study*. Trans. Harry Tucker Jr. Chapel Hill: U of North Carolina P, 1971.

Reiman, Donald, and Sharon B. Powers, eds. *Shelley's Poetry and Prose*. New York: Norton, 1977.

Robinson, Charles E. "The Devil as Doppelgänger in *The Deformed Transformed*: The Sources and Meaning of Byron's Unfinished Drama." *Bulletin of the New York Public Library* 74 (1970): 177–202.

Schlegel, Friedrich. *"Lucinde" and the Fragments*. Trans. Peter Firchow. Minneapolis: U of Minnesota P, 1971.

Sedgwick, Eve Kosofsky. *Between Men: English Literature and Male Homosocial Desire*. New York: Columbia UP, 1985.

———. *Epistemology of the Closet*. Berkeley: U of California P, 1990.

Stein, Atara. "'I Loved Her and Destroyed Her': Love and Narcissism in Byron's *Manfred*." *Philological Quarterly* 69 (1990): 189–215.

Steiner, George. *The Death of Tragedy*. New York: Knopf, 1963.

Thorslev, Peter. "Incest as Romantic Symbol." *Comparative Literature Studies* 2 (1965): 41–58.

Trumbach, Randolph. "The Birth of the Queen: Sodomy and the Emergence of Gender Equality in Modern Culture, 1660–1750." *Hidden from History: Reclaiming the Gay and Lesbian Past*. Ed. Martin Duberman et al. Markham, Ont.: Penguin, 1989. 129–40.

Vinge, Louise. *The Narcissus Theme in Western European Literature up to the Early 19th Century*. Trans. Robert Dewsnap. Lund: Gleerups, 1967.

Warner, Michael. "Homo-Narcissism; or, Heterosexuality." *Engendering Men: The Question of Male Feminist Criticism*. Ed. Joseph Boone and Michael Cadden. New York: Routledge, 1990. 190–206.

Watkins, Daniel P. "The Ideological Dimensions of Byron's *The Deformed Transformed*." *Criticism* 25 (1983): 27–39.

"This Horrid Theatre of Human Sufferings":

Gendering the Stages of History in

Catharine Macaulay and Percy Bysshe Shelley

GREG KUCICH

*T*he revisionary impulse sweeping through recent studies of British Romanticism clearly owes much of its energy to our ever developing reconsiderations of women writers and the dynamics of gender and genre at work across the period's spectrum of writing.[1] Recovering the cultural significance of Romantic women's writing has clarified the importance of formerly marginalized genres in which women authors flourished—such as the verse epistle, the sonnet, the drama, the novel of manners—while disclosing the exclusionary ideologies of dominant, or masculinist, Romantic genres like the epic and the visionary ode. At the center of these paradigm reformulations lies a shared critical commitment to historicize the literatures of Romanticism, particularly to extend recent historicist revaluations of Romanticism by investigating the network of conflicting social forces and values that conditions women's writings and their relation to male-authored texts. Much as this revisionary historicism has opened up the generic and ideological boundaries of Romanticism, it has yet to engage significantly the genre of historical writing itself, and the ideological codes it can both enforce and challenge.

The pioneering work of Marlon Ross, Anne Mellor, Gary Kelly, and Nanora Sweet, among others, shows that we are just beginning to consider the construction of a women's history, what Julia Kristeva would call a "women's time" (188), in literary Romanticism, while the work of the period's female historians remains largely unexplored. For that matter, as recent collections of essays on both Shelley and Keats demonstrate (e.g., Bennett and Curran; Roe), our readings of canonical Romanticism have always been relatively inattentive to the substantial role of historiography in shaping the period's dominant aesthetic and political values. To extend our reappraisals of gender and genre into the domain of historical writing, by male and female authors, is thus to broaden considerably our

revisionary maps of the contours of "Romantic ideology" and the gender negotiations that inform it.[2]

History became a foundational ground for all knowledge in the late eighteenth and early nineteenth centuries, and the truth it offered was, in Christina Crosby's recent phrase, "man's truth"—a gendered structure of understanding that excluded women and other marginalized groups from "historical and political life" (1). Recent feminist theorists and historians, like Janet Todd, Joan Scott, Elaine Showalter, and Jane Marcus, have worked to transform the epistemological frames, the "temporal categories" in Showalter's phrase (31), of that masculine structure of knowledge, positioning what Josephine Donovan calls a "women's way of seeing, a women's epistemology" (98) against the exclusionary forms of masculine historiography. The hegemony of "man's truth" in the eighteenth and nineteenth centuries, however, like the dominance of Western colonialism, did not go unchallenged. Our contemporary feminist projects of historical revisionism may, in fact, trace some of their important origins to the alternative historical discourses produced by women writers, and the male authors they influenced, of the late eighteenth and early nineteenth centuries.

That the period's women writers were alert to and keenly critical of the knowledge constructed by "men's history" may be judged from Catherine Morland's representative response to conventional historiography in Jane Austen's *Northanger Abbey*: "History, real solemn history," she declares, "I cannot be interested in. . . . I read it a little, as a duty, but it tells me nothing that does not either vex or weary me. The quarrels of popes and kings, with wars or pestilences, in every page; the men all so good for nothing, and hardly any women at all—it is very tiresome" (123). If the "truth" of "solemn history" thus alienated female consciousness, inciting Anna Jameson to complain that "history . . . disdains to speak of [women]" (xvii), its exclusions also provoked the formulation of alternative, feminist models of history that seek to transform the contours of "man's truth" by writing women's experience back into historical and political life. And the resulting struggles over the gendering of history emerged as one of the primary sites of ideological contestation where Romanticism interrogated its own dominant codes of knowledge and power.

Although the meteoric rise of history as a major critical discipline in the eighteenth and early nineteenth centuries may have featured prominent male figures like Gibbon, Hume, Robertson, Voltaire, Condorcet, Kant, and Hegel, its expansive development also witnessed the emergence of many British women writers who self-consciously understood themselves as female historians committed to the construction of an alternative, feminist historiography. Their challenges to "solemn history" were so creatively

rich and controversial as to give them a central and, in some cases, trans-
formative role in the development of Britain's historical consciousness.
The combined productions of Catharine Macaulay, Mary Wollstonecraft,
Mary Hays, Jane Austen, Lucy Aikin, Charlotte Smith, Hester Piozzi,
Helen Maria Williams, Hannah More, and Anna Jameson, among many
others, resulted in an astonishingly innovative variety of historical texts
that included substantial critiques of Britain's Tory government, its aris-
tocratic institutions, and its patriarchal social codes. Hannah More, for
instance, specifically criticized the "disingenuous" and "injurious" prac-
tices of Hume's masculine historicism and formulated her own revisionary
theories of history in a series of major essays on the "study" and "use"
of history (7: 73). Lucy Aikin, censuring the abstract nature of traditional
historiography, produced multiple volumes on the intersection of the per-
sonal and political in the lives of Elizabeth, James I, and Charles I. A young
Jane Austen joined this critical tradition, wickedly mocking Goldsmith's
historicism in her own parodic *History of England,* composed by, as she
querulously puts it, "a partial, prejudiced, & ignorant Historian" (1). This
record of critical female historians could go on, without even mentioning
the numerous volumes of poetry and fiction by women, such as Felicia
Hemans's *Records of Woman* or Mary Shelley's *Valperga,* which deploy
alternative historiographical frameworks. Although one would not want to
claim a unified agenda, or even a consistently feminist program, for such a
disparate body of writing, we may accurately find these works, as a group,
presenting a significant challenge to the structures of masculine "truth"
embedded in "solemn" history.

Perhaps the most intriguing aspect of that challenge entails the "ideo-
logical cross-dressing," to invoke Anne Mellor's term (*Romanticism and
Gender* 171), it could motivate. Mellor's reconfiguration of literary Roman-
ticism along gender lines, though self-conscious about its categorical
binarism, is particularly illuminating in its suggestions about the fluidity
with which male and female Romantic writers cross gender boundaries,
adopting gender-coded forms of writing and thinking outside of their own
biological sexual positions. Conceptualizing the period in terms of such
gender negotiations, of which Keats's "effeminate" literary gestures and
Emily Bronte's "virile" creative habits offer noteworthy examples (Mellor,
Romanticism and Gender 171), can yield an unusually complex model of
Romanticism, one based on continual flux and border crossings through
which authors, and even individual texts, traverse a variety of gender-
coded positions along the continuum of "masculine" and "feminine"
Romanticism. We have only begun, however, to trace the specific patterns
of influence, education, and social conditioning that provoke these trans-
migrations. Mellor does not substantially investigate, for instance, what

particular social or personal forces moved Keats to adopt a feminine position in much of his poetry. And while Stuart Curran ("Romantic Poetry") and Marlon Ross note the general impact of Charlotte Smith, Joanna Baillie, and other women writers on Wordsworth's generation of male poets, they do not show in detail how women's texts may have specifically altered the gender positions of those male writers. It is through this very dynamic of exchange and influence that feminist historiography may particularly deepen and complicate our readings of the gender negotiations informing Romantic literary culture. For the revisionary writings of prominent female historians like Macaulay could significantly modify the conceptions of history, gender, and truth held by male as well as female readers.

The transformative impact of Macaulay's feminism on Percy Shelley is particularly revealing, especially considering our recent tendencies to find Shelley a principal upholder of Romanticism's masculinist poetic ideologies—a "cannibaliz[er]" of "female attributes" (Mellor, "On Romanticism and Feminism" 7). Our attention to his engagement with Macaulay's revisionary historicism should complicate our developing sense of his own gender positioning and its capacity for fluid change.[3] Moreover, his incorporation of Macaulay's ways of reading the past into his own historical drama, Charles the First, can also point to an important generic convergence between drama and history, an integration of historical and theatrical "staging" that helped open up new possibilities for the kind of feminine dramaturgy that Catherine Burroughs, Marjean Purinton, Daniel Watkins, and others are now beginning to characterize as one of the most significant intersections of gender and genre in Romantic literature. Finally, our recognition of the conflicted form of gender mobility that Macaulay's historicism helped motivate in Shelley's work may deepen our understanding of the extent to which the ongoing tensions and limits of ideological border crossings inform and condition Romantic writing on the whole.

During the twenty-year period in which she produced her eight-volume, republican History of England (1764–83), Macaulay emerged as one of the most sensational women and important political writers of Europe and America, provoking passionate reviews from both hostile and supportive periodical writers while gaining entry into the most illustrious circles of liberal politicians in England, France, and America. She vied with Hume to become the principal authority of her time on British history, directly engaging him in periodical disputes, and her passionate championship of the history of English republicanism made her one of the central figures in the revolutionary debates that consumed European and American political discourse of the late eighteenth century. Among her famous acquaintances

and admirers, she counted Price, Priestley, and Wollstonecraft in England, Washington, Jefferson, and Franklin in America, and Mirabeau, Brissot, and Condorcet in France. By 1769, Horace Walpole exclaimed, "She is one of the sights that all foreigners are carried to see." She was "a very prodigy," recounted Lord Lyttleton, portraits of her appearing "on every print-seller's counter" (qtd. in Hill 23). Patience Wright, the famous American sculptor, made a life-size wax figure of her in 1772. And Madame Roland, several days before her execution, purportedly wished that she could have become the Catharine Macaulay of France.

This notoriety largely derived from Macaulay's unique status as a female historian engaged in political battle with a field of exclusively male counterparts. The sensational impression of such a spectacle may be measured by Samuel Foote's popular play of 1768, *The Devil upon Two Sticks*, which features an avidly feminist intellectual, Margaret Maxwell—described as "a Lady of great political knowledge, and a zealous supporter of the rights and privileges of her sex" (1)—who is openly and more than a little parodically modeled on Macaulay. Margaret's heated confrontations with her reactionary brother, Sir Thomas, over the rights of citizens and, more particularly, women made a theatrical sensation out of Macaulay's radical political philosophy and her spectacular crossing into an intellectual field formerly gendered as exclusively male. The theatricality of Macaulay's gender negotiations deserves special notice, for her own dramatic form of staging history actually performed a strategic function in her general effort to reformulate the gender and genre of historiographical writing—a function, I would suggest, that specifically helped inspire Shelley's own historical revisionism in *Charles the First*.

It is a sign of the complex subtlety of Macaulay's gender reformations, and a mark of our relative unfamiliarity with such practices in historiographical work, that her recent critics deny her a feminist orientation. Her biographer, Bridget Hill, claims that "neither her *History* nor her political polemic was primarily concerned with [women]" (147). Susan Staves does note her "transgressions" against "social constructions of gender," but she ultimately finds Macaulay's polemical historicism more engaged with constitutional rights than gender concerns (173, 165). These assessments would seem blind to the recurrent foregrounding of gender conflict and opposition in nearly every aspect of Macaulay's public life and writing. Contemporary evaluations of her historicism nearly always focused on the alterity of her own gender position. Her supporters celebrated her as "the female patriot," "the female Galileo in history" ("The History of England" 82). Her enemies denounced her as a sexual aberration who had forsaken traditional feminine attributes to adopt what Elizabeth Montagu derisively called "masculine opinions." Numerous critics rather brutally condemned

her lack of feminine charms supposedly evident in her plainness, her tallness, her ugliness—even, one critic charged, her "toothlessness" (qtd. in Hill 133, 239). When, late in life, she married a man twenty-six years her junior, she was excoriated as a kind of voracious sexual monster and substantially marginalized from social and publishing circles.

Far from seeking to downplay such contentious gender identifications, Macaulay highlighted them in order to stress her feminist opposition to the structures of "man's truth" in "solemn history." She introduces herself in the preface to her *History of England,* for instance, as a "female historian" advocating "the cause of liberty and virtue" in "a path of literature rarely trodden by my sex" (1: xvii, x). Taking that step, Macaulay declares, constitutes a self-consciously radical departure from traditional feminine experience and an equally pointed challenge to what she calls the "tedious" character of masculine historiography (3: 215). Thus she announces her determination "to outstep the limits of female education" (*Letters* 5) and presents herself, in a public declaration of her professional aims, as a "female opposer" to the dominant historiographical practices of her time ("Account" 331). Our own general unfamiliarity, until recently, with the subtle forms such opposition could take in women's writing may help explain why the gendered character of Macaulay's historical revisionism has not been emphasized by twentieth-century critics. For instead of simply writing about female historical personages, or directly supporting the rights of women, she engages in those more complicated types of challenges to masculine ideology that we are now learning to recognize in "feminine" Romanticism. Her critique specifically centers on the totalizing inclination of "solemn history" to delineate grand sweeps of historical process that subsume and efface individual subjects, particularly women, within universal paradigms of historical development.

For all of its rich variety of narrative strategies, mainstream eighteenth-century historical writing shares a tendency to theorize its accounts of the past within abstract, totalizing frames of linear progress and decline. The drama of this type of history subordinates human actors to such universal patterns of growth and degeneration, which may be construed variously as the liberal progressions of Whig history, the millennial advances of Priestley and the early advocates of the French Revolution, the perfectibility scenarios of Godwin's *Political Justice,* the cyclical patterns of destruction and renovation outlined by Volney, Condorcet, and Cuvier, the brutal oscillations of supply and dearth in Malthus's population theory, or the degenerative motion of Gibbon's history of empire. The most sophisticated form of this universalizing strategy collapses the historical lines of progress and decline into a dynamic tension of contrary motion. Thus Hume presents a theory of "contrary" linear "direction[s]" of progress

and decline that is developed with increasing sophistication by historians throughout the late eighteenth and early nineteenth centuries (508). Indeed, the leading historiographical theorists of this era—such as Gibbon, Goldsmith, Condorcet, Volney, Cuvier, Hegel, Malthus—may differ widely in their political investments and in their conclusions about the relative progress of different cultures at different historical moments, but they all tend to conceptualize human history with abstract models of universal tension between the linear contraries of progress and decline. For liberal historians like Godwin and Condorcet, those contraries make up an idealized pattern of gain and loss through which history works out its ultimate progress toward the New Jerusalem of political reform. Missing from all these highly theoretical accounts of history is the particularized story of the human subject, especially the marginalized individual. Instead of detailing that human record, these universal narratives of linear history make up what Crosby calls "man's truth" in their general exclusion of human subjectivity and their more specific effacement of female identity.

That particular kind of truth became an important ground of knowledge during the Romantic period, as the contrariety models of universal history provided an imaginatively rich, politically charged source of inspiration for a visionary poetics of cultural progress like Shelley's. Most of Shelley's critics have separated his visionary idealism from any historical base, emphasizing his notorious distaste for material history.[4] When Godwin urged him to study "History . . . in its most comprehensive sense" as a detailed "record" of "all that man has done," Shelley immediately committed himself to the project and ordered a list of historical works by such writers as Gibbon, Hume, Herodotus, Plutarch, and Thucydides (*Letters* 1: 340–42). But he soon came to view the "History" recounted in these works as nothing but a sustained "record of crimes & miseries," the study of which felt "hateful and disgusting to my very soul" (*Letters* 1: 340). His seeming reluctance to carry out such a "hateful" program of studies left him confessing several years later, "I am unfortunately little skilled in English history; and the interest that it excites in me is so feeble that I find it a duty to attain merely to that general knowledge of it which is indispensable" (*Letters* 2: 21). This alienation from history must be qualified, however, by Shelley's lifelong voracious consumption of a staggering array of historical works, including his carefully annotated reading of the two major eighteenth-century histories of England, Hume's and Macaulay's. His seeming indifference to historical writing, in fact, was only directed, and then only for a time, at material accounts of the past, pedestrian "record[s] of crimes & miseries." The totalizing theories of masculine historiography attracted him from the beginning of his poetic career and gave him an ongoing model for shaping, as he puts it, "historical materials"

into "idealized history" (*Shelley's Prose* 331, 289). Such an idealized, or as he terms it on another occasion, "systematical" historicism (*Shelley's Prose* 328), in fact, provided the conceptual and narrative frameworks for the visionary agendas of most of his major poetical, philosophical, and political projects, from his delineation of "The Past, the Present, & the Future" in *Queen Mab* (*Letters* 1: 324), to his "Vision of the Nineteenth Century" in *The Revolt of Islam* (*Shelley: Poetical Works* 31), through his millennial scenarios of human history in *Prometheus Unbound*, to his visions of political progress in *A Philosophical View of Reform, A Defence of Poetry*, and *Hellas*.

The visionary poetics emerging from these "idealized" historical constructions specifically relies, to varying degrees of sophistication, on the totalizing structures of linear contrariety that Shelley was learning from historiographical predecessors like Godwin, Condorcet, Hume, and Malthus. *The Revolt of Islam*, for instance, delineates the material experiences of Laon and Cythna as a symbolic record of the contradictory advances and setbacks of the French Revolution, which are also situated within an even more abstract allegorical framework of historical cycles of good and evil that eventuate in the eternal rule of the Spirit of Good. In a more complex strategy of historical idealization, Prometheus's agony and triumph become emblematic of a more generalized, redemptive history of the French Revolution's contradictions, which culminates in the apocalyptic visions of cultural salvation at the end of acts 3 and 4 of *Prometheus Unbound*. When modifying the universal patterns of eighteenth-century historical contrariety into these visionary scenarios of human regression and progress, Shelley also repeated his predecessors' elision of individual experience and, particularly, female subjectivity from historical life. For much as his visionary poetry maintains a passionate commitment to political reform, its totalizing form of historicism discourages any sustained attention to the subjects, particularly the marginalized ones, who are swept up in the idealized historical motions he constructs. Female characters like Mab, Asia, and the Visionary Woman of *The Revolt of Islam* frequently act as the Clio of Shelley's historical vision. But the history they preside over is still a rather solemn if idealized version of man's truth, whose totalizing structures of understanding exclude women from any significant agency unless they perform the roles of masculinized heroic leaders, as in Cythna's transformation into the Laone of *The Revolt of Islam*. Shelley's example can thus suggest how the exclusionary ideology of visionary Romanticism derives in significant detail from the masculinist structures of understanding promulgated by eighteenth-century historiography.

We may therefore find Macaulay's resistance to the universalizing formulations of man's truth in the eighteenth century representing an important early feminist critique of the kind of masculine Romanticism

that Shelley, and other members of his visionary company, would later practice. Macaulay actually bases this critique on a suspicion of idealized renderings of history, particularly those devised by visionary poets. "Poets in general are, of all people," she affirms,

> the most ignorant in matters of policy. The flights of poetic fancy are too wild for the exercise of subjects bound within the limits of rationality, fitness, convenience, and use. An imagination sufficiently warm and varied for the productions of poetry has seldom solidity enough for investigation, is apt to be affected with objects of shew, and to dwell with pleasure on the romance of life. (*History* 4: 8)

For Macaulay, this misguided romanticizing of history most often takes the form of the universalizing procedures of masculine historiography that impose abstract patterns of cultural progress on individual human experience. She occasionally exhibits a desire to champion the "slow, yet gradual, progress" of liberty in British history (3: 77), but she resists formulating any categorical structure of political development in her reading of the past. In fact, she pointedly rejects the optimistic progressivism of liberal historians by emphasizing the discrete and contradictory character of great events like the Reformation, the English civil war, and the French Revolution, instead of presenting them as unified episodes of political progress along a steadily developing historical continuum. Such idealized accounts she ultimately dismisses as "delightful reveries," the "airy works of the imagination" (*Letters* 16–17).

Macaulay's alternative is to humanize and domesticate the past, replacing abstract patterns of historical development with localized evocations of the interior lives of individual subjects. Hume's masculine historicism, she charges, is precisely deficient because its author is "perfectly ignorant as to characters [and] motives" (*History* 6: vi). Her own revisionary form of history, in contrast, "is called upon to scrutinize with exactness . . . [the] character" of specific personalities, finding in what she calls the "disposition" of human hearts the deepest truths of experience and the fullest insights into historical causation (4: 419; 1: 69). In thus foregrounding "knowledge of the human character" as the great aim of historical writing (5: 48), Macaulay regularly punctuates her narration of facts and records with penetrating descents into the hearts and minds of her subjects. She focuses attention, for instance, on Elizabeth's "heart," on the "character" of James I, on the "qualities of [James II's] heart," on the "natural gentleness" of Queen Mary's "disposition" (1: 2, 69; 8: 278, 316). Macaulay often complicates and individualizes these voyages into the heart's labyrinth by emphasizing the turbulent divisions and contradictions of spirit that so often beset human consciousness. "History," she elaborates, should exam-

ine "those leading and often opposite principles and inclinations, which form the different characters of men" (6: v). In carrying out such a journey into the divided hearts of her historical protagonists, she dwells at length on "the turbulency" of Laud's "character" and the "rank[ing]" conflicts of interest that plague Cromwell's breast, eventually causing him unbearable "grief and vexation" (4: 150; 5: 195).

Macaulay's attentiveness to Cromwell's "grief" partakes of a specific mode of interiority aligned with her era's more widespread feminist revisions of masculine codes of knowledge. For the subjectivity she renders exhibits above all the pathos of human suffering, and her sympathetic identification with fragile mortality shares in the "ethic of care," to use Carol Gilligan's phrase, that Charlotte Smith, Joanna Baillie, Mary Shelley, and other women writers of this time opposed to the analytic rationality and the abstracting tendencies of masculine forms of historical inquiry like Hume's and Godwin's.[5] For Macaulay, "the fountain of historical knowledge" flows from "bitter sources" (6: 130), making her narration an individualized "history of human misery" (8: 59). Her response to this poignant record is to look upon the past with "an eye of compassion" and a mind inclined to "sympathising tenderness" (8: 59; 6: 21). She even announces in an important theoretical preface that she has "shed many tears" while immersing herself in the life of the past (6: xii). This sympathetic humanizing of history leads Macaulay to focus much of her narration on what she calls in her *Letters on Education* "the situation of sufferers" (177). Her tender empathy with that "situation" even allows her to pity the sufferings of those she deplores on political grounds. Thus she laments Edmund Waller's "agonies of mind" when his conspiracy against Parliament is exposed (*History* 4: 10). Similarly, she finds the fallen Earl of Shaftesbury a "pitied object . . . of wretchedness" (7: 423). Even Cromwell, whose "villainous treachery" she abhors, excites her sympathy in his decline, when an "uneasy" conscience provokes that "grief" that darkens his final days (5: 195).

The aspect of "sympathising tenderness" that bears most significantly on Macaulay's feminist revisionism is its tendency to prioritize the affectionate ties of communal relations, that valued form of emotional exchange frequently held up by Macaulay's feminist contemporaries against the isolating tendencies of masculine Romanticism's visionary pursuits. It is here that Macaulay's historicism becomes most personal and domesticated. For she not only highlights what she terms the "family affections" of Britain's political leaders throughout her narrative (6: 28), but she also focuses attention on the domestic situations of ordinary subjects who people the more common pathways of her historical journeys into the human heart. Thus she reserves some of her most enthusiastic encomiums for the un-

named wife of Judge Cook, who "does honor to the female sex" by encouraging her husband to stand up against the tyranny of Charles I (2: 206). And she sympathizes generally with all those unnamed friends, relatives, and loved ones "who are attached" to her more famous historical personages "by the ties of blood, or the yet stronger ties of affection" (6: xiii).

This special regard for the ties of family affection that unite the generations of time produces one of the most sensational bursts of emotionalism in the entire period's historiography and what is certainly the most striking display of "compassion" in all of Macaulay's writing. Hence she woefully depicts the disruption of family bonds during the Irish rebellion of 1641:

> The persons, homes, cattle, and goods of the English were seized; an universal massacre ensued; nor age, nor sex, nor infancy were spared. In vain did the unhappy victim appeal to the sacred ties of humanity, hospitality, family connection, and all the tender obligations of social commerce. . . . In vain did the pious son plead for his devoted parent. . . . In vain did the tender mother attempt to soften the obdurate heart of the assassin, in behalf of her helpless children; she was reserved to behold them cruelly butchered, and then undergo a like fate. The weeping wife, lamenting over the mangled carcass of her husband, experienced a death no less horrid than that which she deplored. . . . Children were boiled to death in cauldrons; some wretches were flayed alive; others were starved to death; others had their eyes plucked out, their ears, nose, cheeks, and hands cut off. . . . Parents were roasted to death before their children, and children before their parents. (3: 70–72)

Macaulay's sensational demonizing of the Irish here may seem grossly nationalistic and wildly inappropriate for serious political history, for "solemn history." But the extremity of its portraiture of disevered family ties is certainly strategic, a mark of her conscious transformation of traditional masculine historicism into an alternative feminist history of the human heart in communal relationship. The totalizing abstractions of "man's truth" thus give way in Macaulay's feminist reformulation to the most deeply felt and commonly shared sympathies for the "situation of sufferers."

This transformative intervention in mainstream historiography was not lost on Shelley, who began to humanize his own historiographical procedures, and the poetic practices they supported, after reading Macaulay in 1820. The shift was already developing by the summer of 1819, when he began *The Cenci,* partly out of an uneasiness with the abstractions of "idealized" history and visionary poetics. "Newly awakened" by "the study of dramatic literature," Shelley explains, he would now jettison what he calls

the "visions" of his earlier poetry for the "sad reality" of the Cenci family record. *The Cenci* would offer a new kind of historical drama designed to explore "the secret caverns of the human heart" (*Shelley: Poetical Works* 275–76). That commitment to the poignant interiority of his characters moved Shelley toward a Macaulay-like form of sympathetic historicism manifested throughout *The Cenci* in dramatic renderings of familial affection and the pathos of its disruption—such as Bernardo's passionate affirmation of Lucretia's maternal love for him: "O more, more / Than ever mother was to any child, / That have you been to me!" (2.1.7–9); Lucretia's reciprocal expressions of maternal devotion to Beatrice and Bernardo: "My dear, dear children!" (2.1.105); or Beatrice's tender arrangement of her family members into a lovingly bonded group as they await execution: "Brother, sit near me; give me your firm hand. . . . Bear up! Bear up! / O, dearest Lady [Lucretia], put your gentle head / Upon my lap, and try to sleep a while" (5.3.117–20). Now it would be a stretch to locate fully *The Cenci,* considering the gothic egotism of its principal male and female characters, within the category of Macaulay's "sympathetic" historicism. But Shelley's new integrations of history, drama, and "the human heart" do mark an altered trajectory in his own historicism that was at least pointing, by 1819, toward a related convergence of priorities in Macaulay.

After spending three months reading her *History of England* during the summer of 1820, as part of his preparation for a new historical drama on the fall of Charles I (*Letters* 2: 479),[6] Shelley initiated a much more substantial revaluation of his entire historical hermeneutic. The idealized theories of linear development that so profoundly conditioned his early historicism now began to recede before a developing sympathy for the human pathos inscribed in those "record[s] of crimes & miseries" that formerly disgusted him. He now found Homer's *Iliad* preferable to the *Odyssey,* for instance, because of the "tenderness and inexpiable sorrow" of the history it recounts (*Letters* 2: 250). Mary Shelley's novel *Valperga* struck him as praiseworthy because of its dramatization of "living . . . passions" from the past (*Letters* 2: 353). Byron's historical dramas, in contrast, seemed not human enough, requiring a greater sympathy with "human nature" that would "soften [them] down" (*Letters* 2: 349). Such a corrective "softening" of the past actually informed Shelley's next major act of historical construction, *A Defence of Poetry.* Amid the abstract cycles of cultural development outlined in the *Defence,* Shelley emphasizes the human frailties of the giants of literary tradition: Homer, he acknowledges, was a "drunkard," Virgil "a flatterer," Horace a "coward," and Spenser, worst of all, a "poet laureate." Moreover, he situates the history of dramatic literature within the "manners," the "social life," of particularized historical moments (*Shelley's Prose* 285–86, 295). Throughout the ensuing months, Shelley now generally associated

dramatic writing with such humanized recoveries of the past. Hence Cervantes' dramatic efforts appeared to him notable for "awakening pity," and his own early conceptions of the play on Charles I entailed a fundamental sympathy for "the spirit of human nature" over the abstract considerations of political "prejudice" (*Letters* 2: 286, 219).

It is in these intersections of dramatic writing, historical invention, and something like "sympathetic tenderness" that Shelley drew most significantly from Macaulay's precedent in *The History of England*. Macaulay often conceived of personalized history in theatrical terms, characterizing her sympathetic record of human experience in one memorable phrasing as "this horrid theatre of human sufferings" (2: 9). Indeed, her most striking accounts of "the situation of sufferers" frequently appear like stage pieces. Her moving account of Sir Henry Vane's execution, for instance, cries out for theatrical representation:

> On the scaffold his countenance and manner were so serene and composed, that whilst he was talking to a knot of his friends, the spectators cried out, "Which is the man who is to suffer? which is Sir Henry Vane?" On this the prisoner, stepping forward, saluted the multitude on each side the scaffold with his hat off, and then returned to the company. [When Vane's eloquent critique of his judges is interrupted by the sounds of trumpets, he calls out:] What mean you, Gentlemen. . . . Seeing the judges have refused to seal with their hands that which they have done I am come to seal with my blood that which I have done. [More trumpets; then with his head on the execution block, Vane prays aloud:] Bless the Lord who hath accounted me worthy to suffer for his name; blessed be the Lord that I have kept a conscience void of offence to this day.
>
> Whilst the hand of the executioner was suspended over the head of this illustrious sufferer, it was remarked by the spectators, and, in particular, by a curious and ancient traveller, "That his countenance did not change, and that his nerves were as little affected by the violent and fatal stroke, that contrary to every other instance where he had seen the same kind of death inflicted, his head lay perfectly still immediately after it was separated from the body. (6: 123–25)

Now theatricality in eighteenth-century historical writing was not confined to Macaulay, or to women writers. One need only consider Burke's notorious lament over the fall of Marie Antoinette and the charges of theatrical sensationalism it provoked. But where Burke's dramaturgy endorses public institutions and ideologies like chivalry and aristocracy, Macaulay's theatricality constructs a domestic space of emotional exchange, a humanizing of the public sphere in which the spectacular staging of a state

execution ultimately focuses on the particularized nerves of sufferers and the "ties of affection" that unite friends, relatives, spectators, even "curious travellers." The curiosity of that sympathetic spectator is not unlike the "sympathetic curiosity" that Joanna Baillie theorizes as the moving principle of a feminine drama of personalized social relations (9). Macaulay's creation of such a gendered site of emotional exchange through the generic integration of drama and history may very well have provided an influential model for the historical dramas of women writers like Baillie and Felicia Hemans. And we may learn much from her precedent in our new efforts to comprehend the formation of a feminine dramaturgy around the turn of the nineteenth century. That example certainly moved Shelley to experiment with his own form of feminized historical drama in *Charles the First*, begun by January 1822.

Sometime ago, Kenneth Neil Cameron noted Shelley's special indebtedness to Macaulay for his characterizations of the principal figures in *Charles the First*. His renderings of Laud, Strafford, Charles, and Henrietta, the queen, all resemble Macaulay's portraits, Cameron argues, occasionally even reproducing her general phrasing. We may find his most specific borrowing, however, more particularly entailing his incorporation of the "sympathetic tenderness" that conditions her historical dramaturgy. The fool's punning reference to the king as "Baby Charles" (ii.388) draws specifically on Macaulay's emotional depiction of James's anguished worry over his son Charles's safety on a dangerous sea voyage: "[T]he king," Macaulay writes, "throwing himself upon a bed, in another passion of sighs, tears, and lamentations, exclaimed, 'I told you this before; I am undone! I am undone! and shall lose baby Charles!'" (1: 200). This melodramatic exchange of "family affections" in Britain's monarchy offers one of the most striking domestications of political history in Macaulay's entire corpus. That Shelley should feature it prominently in his own historical drama suggests the extent to which the "sympathetic tenderness" of Macaulay's feminized dramaturgy was modifying his own understanding of historical experience and the poetry it could inspire.

The overwhelming focus of that new emphasis in *Charles the First* lies with Shelley's sympathetic renderings of the interior "situation of sufferers" and the domestic turmoil they must endure. His opening scene, for instance, features vivid portraits of Leighton's tortured "mind," the "desolate heart[s]" of oppressed citizens, and the domestic dislocations of "houseless orphans" among London's poor (1.90, 154–55). The fool, Archy, acts as a kind of sympathetic historian for Charles's reign, noting the "tears and blood" that permeate England's world of "mourning" on the brink of civil war (2.410; 5.3). And Shelley's primary attention to this very moment of impending doom in Charles's personal history reveals his own

inclination to discard political abstractions and historical theorizations for the drama of the suffering subject. Indeed, where he had once, in *A Philosophical View of Reform*, condemned Charles as a murderous conspirator (*Shelley's Prose* 231), he now follows Macaulay's tendency to suspend political judgment and "shed tears" (6: ix) over the "unspeakable grief" (3: 350) of Charles's personal crisis and its domestic miseries. No triumphant Promethean hero, or egotistically sublime Cenci-like villain, Charles appears in Shelley's drama as a broken, yet poignantly generous individual whose "gentle heart . . . suffers" for the pain of all who share his lamentable fate (2.6–7). His strongest action amid the imminent collapse of his kingdom is to embrace his weeping wife, exclaiming "Oh, Henrietta!" and offering her comfort in the midst of his court's urgent political debates (2.325). This sympathetic domestication of a court whose politics Shelley despised manifests a humanized vision of the past delivered in the communal registers of feminist historiography. And if we regard Shelley's historiographical ground as an ongoing basis for his poetic agendas, we may find this transformation of "man's truth" into a feminist theater of sympathy constituting a major form of ideological cross-dressing central to his developing poetics.

It would be reductive, however, to argue that Shelley's experimental genderings of historical and dramatic genres in *Charles the First* constitute his unqualified migration into a feminized mode of understanding. For the Promethean historicism of his earlier years, much as he may have swerved away from it at times, remained a potent influence throughout his efforts to conceptualize the entire scope of *Charles the First*. Indeed, he closely read and annotated Hume's *History of England* throughout his work on the play, and his plot notes, now in the Bodleian Library, directly repeat both the chapter headings of Hume's civil war narrative and the sequential linearity of Hume's more abstract narrative—a record of universal historical motions, we recall Macaulay charging, deficient in its lack of sympathy for the human side of history. Shelley's divisions between antithetical historical procedures, in fact, may help explain why he found *Charles the First* "a devil of a nut . . . to crack" and eventually gave up on the drama, leaving it as an incomplete fragment (*Letters* 2: 373). His continuing attachments to the "solemn history" of "man's truth" are still more plainly evident in the idealized political progressions controlling the narrative of *Hellas,* his last major historiographical poem. It might thus be more accurate, in the end, to consider Shelley, borrowing Mellor's formulation, a historiographical transvestite rather than a transsexual (*Romanticism and Gender* 171).

It is in the very divisions of Shelley's engagement with Macaulay, however, that our inquiries into the gender and genre of historical writing may tell us the most about the contours of Romantic ideology. For we may finally come to see a work like *Charles the First*—and the same could be

said of *The Cenci, Prometheus Unbound,* or *A Defence of Poetry*—occupying a variety of gender positions along the spectrum of masculine and feminist historiography. That realization should challenge any presuppositions about the stability of masculine or feminine Romanticism as ideological categories. Masculine Romanticism, in particular, may thus appear not so much as a self-contained, absolute system of power to be resisted by women and outsiders, but rather, more like nineteenth-century colonialism, as a fluid, many-sided phenomenon driven by its own instabilities, contradictions, and self-interrogations. Our revaluation of the period's feminist historiography can therefore not only realign the contours of Romantic ideology but also provoke important questions about the porous nature of gender boundaries and divisions throughout Romantic writing.

Notes

1 The current revaluation of twentieth-century scholarly accounts of Romanticism has provoked so much conversation and controversy that Jerrold Hogle organized two special sessions at the 1994 North American Society for the Study of Romanticism Conference at Duke University on the question: "Was (or Is) There an Identity We Can Call Romanticism?" That question has been pursued most urgently in a series of recent feminist critiques of Romanticism by Ross, Curran ("Romantic Poetry"), Mellor, Page, Feldman, and Wilson, among others. Questions about gender and the role of women writers also figure prominently throughout the major realignments of canonical Romanticism enacted in new anthologies of Romantic-era writing edited by McGann, Wu, Perkins, Breen, Ashfield, and Mellor and Matlack.
2 The argument that follows about the gendering of history in the late eighteenth and early nineteenth centuries builds on my previous study, "Romanticism and Feminist Historiography."
3 For a detailed discussion of Shelley's gender dualities and divisions, see Gelpi.
4 Stuart Curran comments in his 1985 review of Shelley scholarship, "The notion . . . of history in Shelley would profit from greater attention" ("Percy Bysshe Shelley" 624). Recent studies of Shelley's historical imagination include those by Kipperman, Haley, and Kucich ("Eternity and the Ruins of Time: Shelley and the Construction of Cultural History").
5 Mellor relies on Gilligan's notion of an "ethic of care" in order to characterize the sympathetic and communal priorities of feminine forms of Romanticism (*Romanticism and Gender*).
6 Shelley's historical sources for *Charles the First* also include Hume's *History of England,* Whitelocke's *Memorials of the English Affairs,* and Clarendon's *The History of the Rebellion and Civil Wars in England.* These sources, along with the Macaulay text, have been noted by White, Cameron, and Woodings. Their discussion of Shelley's historical sources generally presents Hume and Whitelocke as principal influences while relegating Macaulay to a relatively insignificant role. This inattention to Macaulay's importance for Shelley clearly derives from the absence of any concern with gender in these earlier critical accounts of Shelley's historicism.

Works Cited

Ashfield, Andrew, ed. *Romantic Women Poets 1770–1838*. Manchester: Manchester UP, 1995.

Austen, Jane. *Northanger Abbey*. London: Penguin, 1985.

———. *The History of England*. London: British Library, 1993.

Baillie, Joanna. "Introductory Discourse." *A Series of Plays*. Vol. 1. London, 1821. 3 vols. 1–71.

Bennett, Betty T., and Stuart Curran, eds. *Shelley: Poet and Legislator of the World*. Baltimore: Johns Hopkins UP, 1996.

Breen, Jennifer, ed. *Women Romantic Poets, 1785–1832*. London: Dent, 1992.

Burroughs, Catherine. "English Romantic Women Writers and Theatre Theory: Joanna Baillie's Prefaces to the *Plays on the Passions*." Wilson and Haefner. 274–96.

Cameron, Kenneth Neil. "Shelley's Use of Source Material in *Charles I*." *Modern Language Quarterly* 6 (1945): 197–210.

Crosby, Christina. *The Ends of History*. New York: Routledge, 1991.

Curran, Stuart. "Percy Bysshe Shelley." *The English Romantic Poets*. Ed. Frank Jordan. New York: Modern Language Association, 1985. 593–663.

———. "Romantic Poetry: The I Altered." *Romanticism and Feminism*. Ed. Anne K. Mellor. Bloomington: Indiana UP, 1988. 185–207.

Donovan, Josephine. "Toward a Women's Poetics." *Feminist Issues in Literary Scholarship*. Ed. Shari Benstock. Bloomington: Indiana UP, 1987. 98–109.

Feldman, Paula R., and Theresa M. Kelley, eds. *Romantic Women Writers*. Hanover: UP of New England, 1995.

Foote, Samuel. *The Devil upon Two Sticks*. London, 1768.

Gelpi, Barbara Charlesworth. *Shelley's Goddess: Maternity, Language, Subjectivity*. New York: Oxford UP, 1992.

Gilligan, Carol. *In a Different Voice*. Cambridge: Harvard UP, 1982.

Haley, Bruce. "Shelley, Peacock, and History." *Studies in Romanticism* 29 (1990): 439–61.

Hemans, Felicia. *Records of Women: With Other Poems*. London: T. Cadell, 1823.

Hill, Bridget. *The Republican Virago: The Life and Times of Catharine Macaulay, Historian*. Oxford: Clarendon, 1992.

"History of England, The" *Critical Review* 23 (1767): 81–88.

Hume, David. *The History of England*. Vol. 2. New York, 1851. 6 vols.

Jameson, Anna. *Characteristics of Women: Moral, Political, and Historical*. Vol. 1. London, 1832. 2 vols.

Kelly, Gary. *Women, Writing, and Revolution 1790–1827*. Oxford: Clarendon, 1993.

Kipperman, Mark. "History and Ideality: The Politics of Shelley's *Hellas*." *Studies in Romanticism* 30 (1991): 147–68.

Kristeva, Julia. "Women's Time." *The Kristeva Reader*. Ed. Toril Moi. New York: Columbia UP, 1986. 187–213.

Kucich, Greg. "Romanticism and Feminist Historiography." *Wordsworth Circle* 24 (1993): 133–40.

———. "Eternity and the Ruins of Time: Shelley and the Construction of Cultural History." Bennett and Curran 14–29.

Macaulay, Catharine. *The History of England*. 8 vols. London, 1764–83.

———. "Account of the Life and Writings of Mrs. Catharine Macaulay Graham." *European Magazine and London Review* 4 (1783): 330–34.

———. *Letters on Education: With Observations on Religion and Metaphysical Subjects*. London, 1790.

Malthus, Thomas. *An Essay on the Principle of Population*. London, 1798.

McGann, Jerome, ed. *The New Oxford Book of Romantic Period Verse*. Oxford: Oxford UP, 1993.

Mellor, Anne K. "On Romanticism and Feminism." *Romanticism and Feminism*. Ed. Anne K. Mellor. Bloomington: Indiana UP, 1988. 3–9.

———. *Romanticism and Gender*. New York: Routledge, 1993.

Mellor, Anne K., and Richard E. Matlak, eds. *British Literature 1780–1830*. New York: Harcourt, 1996.

More, Hannah. *The Complete Works of Hannah More*. Vol. 7. New York, 1855. 7 vols.

Page, Judith. *Wordsworth and the Cultivation of Women*. Berkeley: U of California P, 1994.

Perkins, David, ed. *English Romantic Writers*. 2nd ed. New York: Harcourt, 1995.

Purinton, Marjean. *Romantic Ideology Unmasked: The Mentally Constructed Tyrannies in Dramas of William Wordsworth, Lord Byron, Percy Shelley, and Joanna Baillie*. Newark: U of Delaware P, 1994.

Roe, Nicholas, ed. *Keats and History*. Cambridge: Cambridge UP, 1995.

Ross, Marlon B. *The Contours of Masculine Desire: English Romanticism and the Rise of Women's Poetry*. New York: Oxford UP, 1989.

Scott, Joan Wallach. *Gender and the Politics of History*. New York: Columbia UP, 1988.

Shelley, Mary Wollstonecraft. *Valperga*. 1823. New York: Woodstock Books, 1995.

Shelley, Percy Bysshe. *Shelley's Prose: or The Trumpet of a Prophecy*. Ed. David Lee Clark. Albuquerque: U of New Mexico P, 1954.

———. *The Letters of Percy Bysshe Shelley*. Vol. 2. Ed. Frederick L. Jones. Oxford: Clarendon, 1964. 2 vols.

———. *Shelley: Poetical Works*. Ed. Thomas Hutchinson. Oxford: Oxford UP, 1988.

Showalter, Elaine. "Women's Time, Women's Space: Writing the History of Feminist Criticism." *Feminist Issues in Literary Scholarship*. Ed. Shari Benstock. Bloomington: Indiana UP, 1987. 30–44.

Staves, Susan. "'The Liberty of a She-Subject of England': Rights Rhetoric and the Female Thucydides." *Cardozo Studies in Law and Literature* 1 (1989): 161–83.

Sweet, Nanora. "History, Imperialism, and the Aesthetics of the Beautiful: Hemans and the Post-Napoleonic Moment." *At the Limits of Romanticism: Essays in Cultural, Feminist, and Materialist Criticism*. Ed. Mary A. Favret and Nicola J. Watson. Bloomington: Indiana UP, 1994. 170–84.

Todd, Janet. *Feminist Literary History*. New York: Routledge, 1988.

Watkins, Daniel. *A Materialist Critique of English Romantic Drama*. Gainesville: UP of Florida, 1993.

White, Newman I. "Shelley's *Charles the First*." *Journal of English and Germanic Philology* 21 (1922): 431–41.

Wilson, Carol Shiner, and Joel Haefner, eds. *Re-Visioning Romanticism: British Women Writers 1776–1837*. Philadelphia: U of Pennsylvania P, 1994.

Woodings, R. B. "'A Devil of a Nut to Crack': Shelley's *Charles the First*." *Studia Neophilologica* 40 (1968): 216–37.

———. "Shelley's Sources for 'Charles the First.'" *Modern Language Review* 64 (1969): 267–75.

Wu, Ducan, ed. *Romanticism: An Anthology*. London: Blackwell, 1994.

Contributors

STEVEN BRUHM is Assistant Professor of English at Mount Saint Vincent University, where he teaches Romantic literature and queer theory. He is the author of *Gothic Bodies: The Politics of Pain in Romantic Fiction* (1994) and is writing a book on the use of the Narcissus myth in queer cultural production.

MIRANDA J. BURGESS is Assistant Professor of English at the University of New Brunswick. She has published on Frances Burney, William Faulkner, and cultural theory, and has forthcoming an essay on Charlotte Smith. She is completing a book about the diversity of romance in eighteenth-century and Romantic Britain. Her current research is on genre and the historicity of culture in Britain and Ireland, 1750–1832.

JOEL FAFLAK teaches at the University of Western Ontario, where he is finishing his dissertation, entitled "Romanticism and the Scene(s) of Psychoanalysis."

DAVID S. FERRIS is Associate Professor of Comparative Literature at Queens College, City University of New York, and Associate Professor of Comparative Literature, English, and German at the Graduate School, City University of New York. He is the author of *Theory and the Evasion of History* (1993) and editor of *Walter Benjamin: Theoretical Questions* (1996). He is completing a book, *Silent Urns: Romanticism, Greece, and the Culture of Modernity*.

WILLIAM H. GALPERIN is Professor of English at Rutgers University, New Brunswick. He is the author of *Revision and Authority in Wordsworth* (1989) and *The Return of the Visible in British Romanticism* (1993), and is at work on another book, tentatively titled *The Historical Austen*.

REGINA HEWITT is Associate Professor of English at the University of South Florida. Her publications include *The Possibilities of Society: Wordsworth, Coleridge, and the Sociological Viewpoint of English Romanticism* (1997) and numerous articles connecting literature and sociology.

JILL HEYDT-STEVENSON is Assistant Professor of English and the Humanities/Comparative Literature at the University of Colorado—Boulder. She is Associate Editor of the Cornell Wordsworth volume, *The Late Poems of William Wordsworth: 1820–1850* (forthcoming). In addition, she has published articles on Jane Austen and S. T. Coleridge and is completing a book on Austen and the picturesque.

H. J. JACKSON, Professor of English at the University of Toronto, has edited several volumes of selections of Coleridge's work, for Oxford University Press; coedited two volumes

of his *Shorter Works and Fragments*, for Princeton's set of his *Collected Works;* and is editing volumes 3 to 6 of his *Marginalia* in the same series.

THERESA M. KELLEY is Professor of English at the University of Texas at Austin and author of *Wordsworth's Revisionary Aesthetics* (1988) and *Reinventing Allegory* (1997), and other essays on eighteenth-century and Romantic aesthetics, the sister arts tradition, rhetoric, John Keats, William Wordsworth, J. M. W. Turner, and Robert Browning. She is coeditor with Paula Feldman of *Romantic Women Writers: Voices and Countervoices* (1995).

GREG KUCICH is Associate Professor of English at the University of Notre Dame. His publications include *Keats, Shelley, and Romantic Spenserianism* (1991) and recent articles on gender, history, and Romantic women writers. Current projects include an edited collection of critical essays on nineteenth-century women writers, an edited collection of new readings of Percy Bysshe Shelley, and a new book on gender and Romantic historiography. He is also coeditor of *Nineteenth-Century Contexts: An Interdisciplinary Journal.*

C. S. MATHESON is an Associate Professor in the Department of English, University of Windsor, Ontario. She is currently completing a study of Romantic-era art exhibition and the public sphere.

THOMAS PFAU is Associate Professor of English at Duke University. Among his publications are *Wordsworth's Profession: Form, Class, and the Logic of Early Romantic Cultural Production* (1997), *Idealism and the Endgame of Theory: Three Essays by F. W. J. Schelling* (1994), and *Friedrich Hölderlin: Essays and Letters on Theory* (1987). He has also published numerous articles in scholarly journals and essay collections, including a special issue of *South Atlantic Quarterly* on Romanticism, which he coedited with Rhonda Kercsmar. He is working on a book exploring conceptions of "intelligence" in nineteenth-century aesthetics, music, and philosophy.

ADELA PINCH is Associate Professor of English at the University of Michigan—Ann Arbor. She is the author of *Strange Fits of Passion: Epistemologies of Emotion from Hume to Austen* (1996) and other essays on eighteenth- and nineteenth-century English literature.

MARC REDFIELD is Associate Professor of English at the Claremont Graduate School. He is the author of *Phantom Formations: Aesthetic Ideology and the Bildungsroman* (1996).

NANCY L. ROSENBLUM is Henry Merritt Wriston Professor and Professor of Political Science at Brown University. Among her works in political theory are *Another Liberalism: Romanticism and the Reconstruction of Liberal Political Thought* (1987); she has also edited *Thoreau: Political Writings* (1996) and *Membership and Morals: The Personal Uses of Pluralism in America* (forthcoming).

MARLON B. ROSS teaches English and African American Studies at the University of Michigan—Ann Arbor. The author of *The Contours of Masculine Desire* (1989), he is working on a literary-cultural history of writing by African American men entitled *The Color of Manhood.*

MAYNARD SOLOMON is writing a book entitled *Beethoven: Beyond Classicism,* and is preparing a revised and expanded edition of *Beethoven,* his 1977 biography of the composer. His most recent book is *Mozart: A Life.* His other books include *Beethoven's Tagebuch 1812–18, Memoirs of Beethoven,* and the anthology *Marxism and Art.* His *Beethoven Essays* received the Kinkeldey Award of the American Musicological Society as the most outstanding book of 1988. He has held visiting professorships at Columbia, Yale, and Harvard Universities, and at State University of New York at Stony Brook.

RICHARD G. SWARTZ is Associate Professor of English at the University of Southern Maine, where he also teaches in the Media Studies Program. He has published articles on William Wordsworth, Dorothy Wordsworth, and Romantic tourism, and is coediting an anthology of essays on political violence in the 1990s. He is completing a book on William Wordsworth and the cultural contexts of Romantic authorship.

NANORA SWEET teaches Literature and Women's Studies at the University of Missouri— St. Louis. Her essays on Felicia Hemans and her milieu are appearing in *At the Limits of Romanticism, European Romantic Review, Approaches to Teaching Women Poets of the British Romantic Period,* and *Rethinking the Novel: Corinne or Italy in Critical Interpretations.*

JOSEPH VISCOMI is Professor of English at the University of North Carolina at Chapel Hill. He is the author of *Blake and the Idea of the Book* (1993) and coeditor of volumes 3 and 5 of Blake's *Illuminated Books* (1993) and of the Blake Archive at http://jefferson.village.virginia.edu/blake.

KAREN A. WEISMAN is Associate Professor of English at the University of Toronto and the author of *Imageless Truths: Shelley's Poetic Fictions* (1994), as well as several articles on culture and theory from the late eighteenth century up to the present.

SUSAN J. WOLFSON is Professor of English at Princeton University; her most recent book is *Formal Charges: The Shaping of Poetry in British Romanticism* (1997). She is the author of several essays on gender in Romantic-era literature, the most recent of which, "Shakespeare and the Romantic Girl Reader," is forthcoming in *Nineteenth-Century Contexts.* She is completing a book on Romanticism and gender titled *Figures on the Margin.*

INDEX

Abbott, Andrew, 92, 100 n4
Abrams, Meyer H., 41, 82, 91, 229
Adorno, Theodor, 6, 23–24, 27–29, 407
Aeschylus, 61
Aiken, John, 409–10 n10
Aiken, Lucy, 367, 450
Alcott, Bronson, 60
Althusser, Louis, 6, 306, 380
Altieri, Charles, 86 n7
Arendt, Hannah, 109
Aristotle, 113, 210 n35
Arnold, Matthew, 129, 138–39, 307, 337, 385
Austen, Jane, 251–67, 271–74, 377–82, 384,
 386, 392–96, 399, 401, 403–8, 450

Babbitt, Irving, 42
Baillie, Joanna, 255, 451, 457, 461
Ball, Sir Alexander, 95–97
Barbauld, Anna Letitia, 134, 248, 396
Barry, James, 290–91
Barthes, Roland, 145
Bate, Jonathan, 130–33, 151 n12, 257 n6
Baudrillard, Jean, 148
Beach, Joseph Warren, 153 n26
Beattie, James, 415
Beethoven, Ludwig von, 225–42
Benjamin, Walter, 9–10, 15–18, 22, 24–26,
 28, 43, 47–50, 123 n7, 157, 159
Bennett, Andrew, 313, 321, 324 n11
Bentley, G. E., Jr., 201
Berkovitch, Sacvan, 74 n20
Berlin, Isaiah, 69
Bernstein, Charles, 80–81
Blair, Hugh, 214–15
Blake, William, 4, 11–18, 21, 26, 29, 85,

134, 147–49, 154 nn35–36, 159, 169 n16,
 173–203
Blanchot, Maurice, 41, 43–44
Bloom, Harold, 191, 201–2, 386–88, 389 n2
Boker, Pamela A., 429–30
Bonnefoy, Yves, 431
Bostetter, Edward E., 164
Bourdieu, Pierre, 150 n7
Brandoin, Charles, 281, 286–89, 291, 298
Brombert, Victor, 234–35
Brooks, Peter, 308–9, 322
Brown, Capability (Lancelot), 262, 264,
 267, 268
Brown, John, 58, 61–62
Browning, Elizabeth Barrett, 247, 253, 362
Bulwer-Lytton, Edward, 245, 254
Burke, Edmund, 269, 275 n4, 276 nn13
 and 15, 293, 392–93, 397–401, 403, 405,
 408, 409 n4, 460
Burke, Kenneth, 31
Burney, Frances, 377–78, 382–86, 392
Butler, Marilyn, 245, 275 nn6 and 10
Byron, George Gordon, Lord, 56, 59, 80,
 164, 234, 245–47, 255, 328, 340, 343, 371,
 378, 415, 423–24, 429–44, 459

Calvin, John, 201, 254
Cameron, Kenneth Neill, 461
Campbell, Thomas, 134, 255
Carlyle, Thomas, 61, 72 n8
Channing, William E., 247, 253
Chateaubriand, François René, 57, 255
Christensen, Jerome, 430, 433–34, 438
Clare, John, 157–68, 328–33, 336–43
Clarke, Charles Cowden, 118–19

Hulme, T. E., 42
Humboldt, Wilhelm von, 63
Hume, David, 397–98, 401, 409 n6,
 450–51, 454, 457, 462
Hurd, Richard, 343, 398–99
Hussey, Christopher, 270

Inchbald, Elizabeth, 380, 390 n9
Ingarden, Roman, 7
Irving, Washington, 247, 251

Jameson, Anna, 449–50
Jameson, Fredric, 6, 157–58
Jeffrey, Francis, 51 n4, 362–63
Jewsbury, Maria Jane, 245–46, 249, 251–55,
 360–63, 366–68, 372 n15
Johnson, Claudia, 275 n4, 405, 409 n7
Johnson, Joseph, 181, 202–3, 206 n15
Johnson, Samuel, 214, 217–18, 285, 422

Kant, Immanuel, 4, 10, 20–22, 24, 104, 111,
 123 n9, 230, 234
Keats, John, 108–22, 139, 141, 161, 253,
 304–23, 349–50, 352, 358–59, 448,
 450–51
Klancher, Jon, 93–94, 217, 410 n11
Klee, Paul, 16, 157
Kleist, Heinrich von, 165
Knight, Richard Payne, 261–64, 266–69,
 271–74
Kolodny, Annette, 268
Kristeva, Julia, 308, 310–12, 314–16, 324 n9,
 448
Kroeber, Karl, 73 n15, 97, 133–39, 141, 152
 n21

Lacan, Jacques, 308–18, 324 n9, 330
LaCapra, Dominick, 305
Lacoue-Labarthe, Philippe, 43–47, 50–51,
 307
Lamb, Charles, 328, 340–43, 379–81,
 384–85, 420
Landon, Letitia, 134, 252, 257 n14
Lawrence, D. H., 59
Levinson, Marjorie, 5, 8, 34 n13, 79–81, 86
 n6, 142, 150 n3, 151 n12, 304–5, 359
Lindenberger, Herbert, 86 n4
Linnaeus, 165–66
Little, Judith, 310
Liu, Alan, 24, 27, 79, 86 n3, 142–43, 150
 n8, 154 n30, 167, 413
Lloyd, David, 47
Locke, John, 220, 397, 408 n2, 422

Lockridge, Laurence S., 100 n9
Longfellow, Henry Wadsworth, 247
Lovejoy, Arthur O., 1–2, 23, 41
Lovelock, J. E., 132
Lovett, William, 335–36, 342, 344 n9
Lukacher, Ned, 305–6
Lukács, Georg, 6
Lunar Society (Birmingham), 91–93, 100
 n5
Luther, Martin, 95, 201

Macaulay, Catharine, 450–62
Malouf, David, 159–64, 166–68
Malthus, Thomas, 150 n5, 153 n22, 453–55
Mann, Thomas, 76
Marx, Karl, 6, 8, 66, 127–28, 322
McClintock, Barbara, 138
McGann, Jerome J., 7, 42, 73 n17, 82, 84–
 85, 106–7, 118, 123–24 nn2–3, 5, and 9,
 147, 304, 376
McKusick, James, 162, 168 n7
Mee, Jon, 202
Mellor, Anne K., 372 n6, 429–30, 440,
 442–43, 450–51, 462
Melville, Herman, 246–48
Mileur, Jean-Pierre, 4, 33 n1
Milman, Henry Hart, 248
Milton, John, 255, 276 n14, 304, 309,
 312–15, 320–21, 389 n2, 434
Mitchell, W. J. T., 270
Moi, Toril, 271, 372 n3
More, Hannah, 134, 450
Muir, Kenneth, 314

Naess, Arne, 130
Nancy, Jean-Luc, 43–47, 50–51, 307
Napoleon, 57, 61, 234, 251, 358
Nietzsche, Friedrich Wilhelm, 56, 59, 61,
 66
Novalis, 25, 27–29, 227, 239–40

Opie, John, 296–97
Orr, David, 136–37, 153 nn22 and 24
Ovid, 431–32, 436, 441, 445 n3
Owens, Craig, 158
Owenson, Sydney, Lady Morgan, 394–95

Paine, Thomas, 11, 63, 145, 206 n16, 248,
 408 n2
Paley, Morton, 179–80, 201
Paley, William, 95–96, 100 n9
Palmer, Samuel, 202
Patterson, Lee, 30, 33 n3

Thompson, E. P., 176, 179–80, 205 n13
Thomson, James, 328, 337–38, 340
Thoreau, Henry David, 55–72, 153 n22, 241
Thorslev, Peter, 432
Tieck, Ludwig, 227
Tighe, Mary, 134
Trumbach, Randolph, 441
Trumpener, Katie, 394

Vigny, Alfred de, 57
Vincent, David, 336
Vinge, Louise, 431, 445 nn4 and 5
Virgil, 438–39, 441, 459

Wackenroder, Wilhelm Heinrich, 240
Waldoff, Leon, 325 n15
Walpole, Horace, 247, 250, 399, 452
Warner, Michael, 44, 444
Wasserman, Earl R., 323 n1
Watkins, Daniel P., 445 n10, 451
Watts, Isaac, 216
Weber, Samuel, 48–49
Wellek, René, 41
Whale, John, 85 n2
White, Gilbert, 165

Wilberforce, William, 60
Wilkes, John, 291–92, 301 n14
Williams, Helen Maria, 450
Winckelmann, Johann Joachim, 123 nn8 and 14
Wollstonecraft, Mary, 206 n16, 350–51, 360–61, 371 n2, 397–401, 403–6, 408, 450, 452
Wood, Gordon, 33 n7
Woodman, Ross, 324 n11
Woodmansee, Martha, 51 n4
Woolfe, Virginia, 351, 371–72 n3
Wordsworth, William, 22, 31, 58–59, 64, 70, 78–79, 83, 85 nn2–6, 130–35, 139–40, 142, 147, 162, 167, 214, 220, 230, 234, 249, 255, 328, 333, 337, 340, 349–50, 352–55, 364, 370, 377–79, 385, 413–15, 417–20, 435
Wylie, Ian, 92

Yearsley, Ann, 332
Young, Edward, 185–86

Žižek, Slavoj, 330, 339

Library of Congress Cataloging-in-Publication Data

Lessons of Romanticism : a critical companion / edited by Thomas Pfau and Robert F. Gleckner.

Includes bibliographical references and index.

ISBN 0-8223-2077-0 (alk. paper). — ISBN 0-8223-2091-6 (pbk. : alk. paper)

1. English literature—19th century—History and criticism. 2. English literature—18th century—History and criticism. 3. Romanticism—Great Britain. 4. Romanticism. I. Pfau, Thomas. II. Gleckner, Robert F.

PR457.L47 1998 820.9'145—dc21 97-31426 CIP